Exhibition Committee

Basil Gray, Esq, CB, CBE, *Chairman*

Mr Titus Burckhardt, UNESCO Advisor for the preservation of the city of Fez

Paul Keeler, Esq, Festival Director, World of Islam Festival Trust

Donald King, Esq, Keeper, Department of Textiles, Victoria and Albert Museum

Dr Martin Lings, Keeper Emeritus, British Museum and British Library

Ralph Pinder-Wilson, Esq, Deputy Keeper, Department of Oriental Antiquities, British Museum

B. W. Robinson, Esq, Keeper Emeritus, Victoria and Albert Museum

Robert Skelton, Esq, Deputy Keeper, Indian Section, Victoria and Albert Museum

Edmund de Unger, Esq

Secretary to the Committee
Joanna Drew, Director of Exhibitions, Arts Council of Great Britain

Exhibition Designer
Michael Brawne

Catalogue Editors
Dalu Jones
Dr George Michell

Exhibition Staff

Exhibition Officer Angelina Morhange

Administrator, Hayward Gallery Francis Ward

Foreign Transport Jeffery Watson, Jane Boyce

United Kingdom Transport Stanley Leppard

Installation Stanley Vigar, Norman McManus

Publicity Joan Asquith

Publications Donna Kipping

Secretaries Deidre O'Connell, Miranda Whitehead

Catalogue picture research Marge Tan

The Arts of Islam

An exhibition organized by
the Arts Council of Great Britain
in association with
the World of Islam Festival Trust.

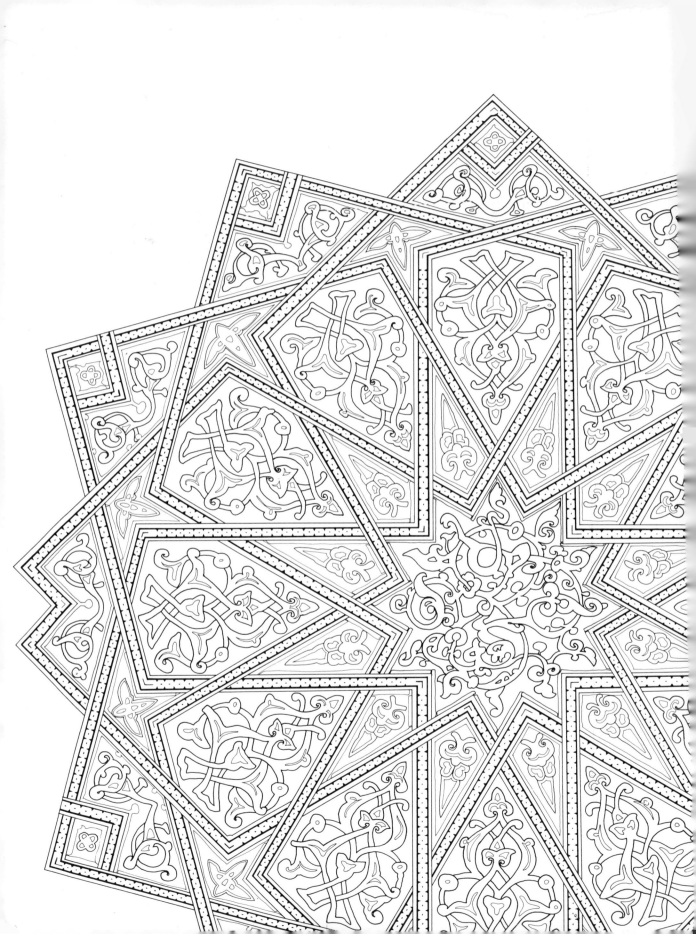

The Arts of Islam

Hayward Gallery 8 April–4 July 1976

The Arts Council of Great Britain 1976

Copyright © 1976 The Arts Council of Great Britain
ISBN 0 7287 0081 6 paper bound
ISBN 0 7287 0080 8 cloth bound

Catalogue designed by George Michell.
Typography by Don Martin.
Map and historical chart drawn by Peter Bridgewater.
Cover and line drawings by Garry Martin.

Printed in England by Westerham Press Ltd

Contents

Contents

Foreword and Acknowledgements

Some years ago Mr Paul Keeler approached the Arts Council with the proposal that a major exhibition of Islamic art should be mounted at the Hayward Gallery as part of a festival of Islamic culture in London. The Council welcomed the occasion to organize an exhibition of the arts of Islam, never before attempted on such a scale in London, or indeed in the West as a whole since the famous Munich exhibition of 1910, and was happy to collaborate with the World of Islam Festival Trust to bring it about. We wish to acknowledge the generous financial contribution from the Trust towards the costs of a necessarily expensive undertaking. Our collaboration over the past three years has been fruitful and our thanks go to the Chairman, Sir Harold Beeley, and the members and staff of the Trust who have throughout advised, helped and supported us.

Early discussions about the nature and range of the exhibition involved a number of scholars and specialists, and led to the formation of a committee to advise on its organisation under the chairmanship of Mr Basil Gray. The members of the Committee are listed on page 7 and we should like to express to them our deep gratitude for putting their knowledge at our disposal and for the time they have given to the realisation of the idea. We should like also to thank Mr David Sylvester, who resigned from the Committee a year ago owing to the pressure of other work, for his considerable help in the early stages of working out a concept for the exhibition.

Islamic art is a vast subject, covering as it does twelve hundred and fifty years of history, and impossible to contain within the walls of an art gallery. An encyclopaedic approach was considered undesirable as well as impracticable. A chronological survey across the lands of Islam was likewise rejected and instead it was agreed to attempt to define the essential character of Islamic art, to trace out the elements that are present in it, separately or more generally together, by which we seek to identify the Islamic creative spirit. These characteristic elements were taken to be calligraphy, geometry, the arabesque and the treatment of figuration. Thus the galleries at the Hayward are arranged to display the unity in Islamic art as well as its diversity; in one gallery objects of widely differing period, medium and scale but exemplifying to a high degree one or other of the essential elements are brought together to form a key to the whole exhibition.

In defining the scope of the exhibition, and in ignoring the art of the

nomadic peoples which has played a vital role in Islamic culture, the Committee has borne in mind also the other exhibitions which are taking place in London and elsewhere during the Festival, all of which treat special aspects of Islamic art and culture and are thus complementary to the present exhibition. It has not been found practicable to attempt to show on this occasion the contemporary arts of the lands of Islam, which would require a large area and involve media such as oil-painting and sculpture in the round which are not traditional in their history.

The organisation of an exhibition on this scale is a co-operative enterprise of considerable complexity, and the goodwill, patience and generosity which we have met in twenty-five countries has made a difficult task particularly rewarding. We are especially grateful to the many lenders to the exhibition who have entrusted us with precious and fragile objects; they are listed on page 19, headed by Her Majesty The Queen.

The presence in the exhibition of very important groups of loans from the national collections of Muslim countries is a source of great satisfaction to us and we are deeply indebted to the governments and cultural authorities of these countries for agreeing to participate so generously, thus significantly enlarging the scope and representative character of the exhibition.

We should like to express our indebtedness to Their Imperial Majesties The Shah an Shah Arya Mehr and The Shahbanou of Iran who have graciously consented to authorise the loan of the many splendid objects and manuscripts from Iran. We are also most grateful to H.E. Mr Mehrdad Pahlbod, Minister of Culture and Arts of the Government of Iran; to Dr F. Bagherzadeh, Director General of the Iranian Centre for Archaeological Research, who has been most sympathetic and patient in the negotiations; to Mrs Badri Attabaye, Keeper of the Imperial Library; to Dr Seyyed Hossain Nasr, Director of the Imperial Iranian Academy of Philosophy, and to the curators and staffs of the lending institutions.

In Egypt the Festival has the personal support of His Excellency Mohamed Anwar el Sadat who nominated H.E. Minister Tawfik Oweida, Secretary General of the Supreme Islamic Council of Egypt, to authorise the arrangements. We are greatly indebted to him and to H.E. Mr Youssef el-Sabaie, Minister of Culture and Information, to Dr Gamal Mukhtar, Chairman of the Antiquities Organization, to Dr S. M. el Sheneiti, Under Secretary of State at the National Library and Chairman of the Egyptian Book Organisation; and to Mrs Wafiyya Ezzy, Director General of the Museum of Islamic Art in Cairo.

The important loans from the National Museum of Iraq have been arranged thanks to Dr Isa Salman, Director General of Antiquities in the Ministry of Information and Dr Fawzi Rashid, Director of the National Museum.

In Syria we have had the valuable collaboration of Dr Afif Bahnassi, Director General of Antiquities and Museums and of Dr Muhammed el Kholy, Curator of the National Museum.

In Tunisia our grateful thanks go to Mr E. Baschaouch, Director

of the National Institute of Archeaology and Art, Prof. Ibrahim Chabbouh, Director of the National Museum, and Mr A. Gallouz, Director of the National Library, Tunis.

We should not omit to record our deep appreciation of the confidence shown in the value of the exhibition by the authorities responsible for the public collections of Islamic art in this country, in Europe, in India and the United States of America who have allowed us to borrow a number of their most valuable and important objects and manuscripts. Their juxtaposition with the loans from the Muslim countries give a unique importance to the occasion.

In our negotiations with various countries we were fortunate in receiving the guidance and encouragement of the ambassadors and other representatives of these countries and we should like to mention in particular H.E. Señor Don Manuel Fraga Iribarne, former Spanish ambassador in London and H.E. Monsieur Stavros Roussos, Greek ambassador in London.

We would especially like to express our thanks to Professor Klaus Brisch, Director, Museum für Islamische Kunst of the Staatliche Museen Preussischer Kulturbesitz, Berlin, and to Dr Richard Ettinghausen, Consultative Chairman of the Department of Islamic Art at the Metropolitan Museum, New York, and to Señor Don Casamar Perez, who was appointed by the Spanish Government as special representative for the exhibition, all of whom have helped us in obtaining loans in their countries.

Throughout we have received most valuable advice and assistance from the Foreign and Commonwealth Office, and in particular from Mr John Morgan, Head of the Cultural Relations Department and Miss Hilary Evans. British ambassadors and diplomatic representatives abroad have responded most readily to our requests for information and help and we have relied very heavily on their knowledge. We should like to thank especially Sir Philip Adams, KCMG, formerly Ambassador in Cairo, and Mr Willie Morris, CMG, the present Ambassador; Sir Francis Brooks Richards, CMG, DSO, Ambassador in Athens; Sir Anthony Parsons, KCMG, MVO, MC, Ambassador in Tehran; Mr John A. N. Graham, CMG, Ambassador in Baghdad; Mr N. C. C. Trench, CMG, Ambassador in Lisbon; Mr A. J. D. Stirling, Counsellor and Head of Chancery in Beirut; and Mr J. E. Marnham, CMG, MC, TD, Ambassador in Tunis. Dr Norman A. Daniel, CBE, Cultural Attaché at the British Embassy in Cairo and British Council Representative, has been responsible for the complex arrangements over the loans from Egypt and we cannot thank him enough. Likewise Mr John G. E. Muir, British Council Representative in Madrid, who has looked after all the arrangements for the Spanish loans. Dr Alan Barr, British Council Representative in Rome, Dr Michael J. Llewellyn Smith, former Cultural Attaché at the British Embassy in Moscow, and Mr William Marsden who succeeded him, Mr Eric Fitzsimmons, former Cultural Attaché at the British Embassy in Tunis and Mr J. E. Lankaster, who succeeded him, have undertaken much detailed negotiation on our behalf and been unfailingly patient and effective in meeting our many demands.

We consider ourselves fortunate that Mr Basil Gray agreed to chair the committee for the exhibition. He was of course one of the scholars responsible for the Persian exhibition held at Burlington House in 1931 and, in consultation with the Committee, he has selected this exhibition with characteristic vision and care. The selection of carpets and textiles has been the responsibility of Mr Donald King and Mr Edmund de Unger, to whom we are much indebted.

The catalogue is the work of a number of contributors whose names appear elsewhere. As is natural, no consensus on the nature of Islamic art emerges in texts written by scholars of widely differing points of view, and it should be said that the views expressed are those of our distinguished authors, and not of the Committee. We should like to thank them most warmly.

Those responsible for compiling the catalogue entries have in certain cases worked under considerable difficulties where the absence of information on unpublished pieces has complicated their task. A special word of thanks is due to the catalogue editors, Mrs Dalu Jones and Dr George Michell, who undertook a formidable task most capably. The decision to attempt to illustrate every object in the exhibition added to their work.

Mr Michael Brawne has brought his considerable knowledge and experience to designing the exhibition and solving the many practical problems which presented themselves.

Much detailed work in planning and coordinating the arrangements for the loans from the Muslim countries has been undertaken on our behalf by Mr Yasin Safadi, Assistant Keeper, Department of Oriental Manuscripts and Printed Books, British Library, whose assistance we greatly appreciate. His advice has been invaluable to Mr Jeffery Watson, Overseas Transport Officer of the Arts Council, who has carried the responsibility for assembling the loans from all over the world. In this complex task he has had the assistance of Mrs Jane Boyce. The loans coming from the Middle East have been packed in their countries of origin by Mr Norman McManus assisted in some cases by Mr Sidney Pottier, both members of the staff of the Arts Council.

Miss Angelina Morhange, who has acted as Exhibition Organiser within the Arts Council, has worked unceasingly coordinating the administrative arrangements.

A great many people in the lending countries have given invaluable help and advice and we would like to record our thanks to the following:

Austria

Dr Rudolf Fielder, Director General, and Dr Otto Mazel, Director, Manuscript Department, Österreichische Nationalbibliothek; Prof. Dr Wilhelm Mrazek, Director, and Dr Dora Heinz, Keeper of Textiles, Österreichisches Museum für angewandte Kunst; Prof. Dr Josef Ladurner, Director, Tiroler Landesmuseum Ferdinandeum, Innsbruck; Dr I. W. Mussi, MVO, Minister-Counsellor at the Austrian Embassy, London; and Dr Bernard Stillfried, Austrian Institute, London.

Canada

Mrs Dorothy Burnham, Curator, Mrs Michael Gervers, and
Mr John Vollmer, Associate Curators of Textiles; and Dr Lisa
Golombek, Curator, West Asian Department, all of the Royal
Ontario Museum, Toronto.

Denmark

Mr Palle Birkelund, Director of the Royal Library; Mr Johan
Hvidfeldt, Director, Rigarkivet; Mr Erik Lassen, Director, Museum
of Decorative Art; Mr André Leth, Director, David Collection;
Mr M. O. Olufen, Director and Dr Gudmund Boesen, Royal
Collection, Rosenberg Castle.

Egypt

H.E. Mr M. Saad el Din, former Under Secretary of Foreign and
Cultural Relations; Miss Sophie Ebeid; Prof. Souad Maher, the
Islamic Museum, Cairo; Dr Michael Rogers, the American University
in Cairo; Mr Muhammed Shalabi, Keeper of Manuscripts, National
Library, Cairo; Mr John Coles, First Secretary and Head of
Chancery, and Mr Peter Mackenzie Smith, Assistant Cultural
Attaché, the British Embassy, Cairo.

France

M. André Burgaud, Director of l'Association Française d'Action
Artistique, and M. Gaston Diehl; Mlle. Irène Bizot and Mlle. Mireille
Fabriga, Réunion des Musées Nationaux; M. Claude Bourget,
Cultural Attaché at the French Embassy, London; M. Jacques Dupont,
Director, and M. Georges Costa, Inspécteur Principal des
Monuments Historiques et Palais Nationaux; M. Henry-Pierre
Fourest, Chief Curator, Musée National de Céramique, Sèvres;
M. René Huyghe, Director, and Mme. Benedette Cordier, Deputy
Director, Musée Jacqucmart-André, Paris; M. E. de Margerie,
Directeur des Musées de France; M. Pierre Marot, Curator, Musée
Historique Lorrain, Nancy; M. François Mathcy, Chief Curator, and
Mme. Yvonne Brunhammer, Curator, Musée des Arts Décoratifs,
Paris; M. Roland Michaud; M. J-P. Reverscau, Curator, Musée de
l'Armée, Paris; M. Georges le Rider, Administrateur-Générale,
M. Etienne Dennery, former Administrateur-Générale,
M. M. Nortier, Chief Curator, Service des Prêts and Mlle. M.
Courrier, Curator, Bibliothèque Nationale, Paris; Mme. Marthe
Bernus-Taylor, Curator, Islamic Department, Musée du Louvre,
Paris.

German Democratic Republic

Dr Volkmar Enderlein, Director, Islamisches Museum, Berlin;
Dr Gerhard Radtke, Cultural Attaché at the Embassy of the G.D.R.;
Frau Dr Emma Reinecke, Ministry of Culture; Mr K. M. Duke,
Acting Cultural Attaché, British Embassy.

German Federal Republic

Prof. Dr Franz-Adrian Dreirer, Director, Kunstgewerbemuseum,
Berlin; Prof. Dr Erich Herzog, Director, and Mr E. Schmidberger,
Administrator, Staatliche Kunstsammlungen, Kassel; Dr Albert
Klein, Director, Hetjens-Museum, Düsseldorf; Dr Brigitte Klesse,
Director, Kunstgewerbemuseum, Cologne; Dr Brigitte

Lohmeyer, CVO, Counsellor for Cultural Affairs at the Embassy of the Federal Republic of Germany, London; Dr Andreas Lommel, Director, Staatliches Museum für Völkerkunde, Munich; Dr V. Moeller, Director, Museum für Indische Kunst, Berlin-Dahlem; Dr Annaliese Ohm, Director, Museum für Kunsthandwerk, Frankfurt am Main; Prof. Dr Ernst Patrasch, Director, Badisches Landesmuseum, Karlsruhe; Dr Axel von Saldern, Director, Museum für Kunst und Gewerbe, Hamburg; Dr F. Spuhler, Museum für Islamische Kunst, Staatliche Museen Preussischer Kulturbesitz, Berlin-Dahlem; Dr Ekkehart Vesper, General Director, and Dr Dieter George, Staatsbibliothek Preussischer Kulturbesitz, Berlin; and Dr Angela Völker, Curator, Bayerisches Nationalmuseum, Munich.

Greece

H.E. Prof. C. A. Trypanis, Minister of Culture and Sciences; Mr Grigorios Constantinopoulos, Director of Antiquities; Mr Angelos Delivorrias, Director, and Miss Emilia Pitta, Benaki Museum, Athens; Dr M. Dragoumis, Press Counsellor, Mr A. Kotzias, former Press Counsellor, Mr A. Kovatzis, Cultural Attaché, Mr A. Philon, Counsellor, and Mrs E. Cubitt at the Greek Embassy, London.

Holland

Dr Beatrice Jansen, Acting Director, and Mr P. A. Frequin, Administrator, Gemeentemuseum, The Hague; Dr S. H. Levie, General Director, and Mr C. A. Burgers, Assistant Keeper, Department of Sculpture and Decorative Arts, Rijksmuseum, Amsterdam.

Hungary

Dr Ferenc Fülep, Director General, National Museum of Hungary; Dr Pál Miklós, Director General, and Dr Francis Batari, Keeper, Department of Carpets and Furniture, Museum of Applied Art, Budapest; and Mr James M. E. Took, Cultural Attaché at the British Embassy, Budapest.

India

Sri. Mohan Mukerji, Additional Secretary, Department of Culture, Government of India; Dr R. C. Agrawala, Director of Archaeology and Museums Department, Rajasthan, Jaipur; Dr P. Banerjee, Acting Director and Dr C. Sivaramamurti, former Director, National Museum Janpath, New Delhi.

Iran

Mr John Hanson, Cultural Attaché at the British Embassy, Tehran; Dr M. Minovi, Shahnameh Foundation, Ministry of Culture; and Mme. Anne Seurat, Iranian Centre for Archaeological Research.

Iraq

H.E. Mr Abul Malik Yassin, the Ambassador, Embassy of Iraq, London; Mr R. A. K. Baker, British Council Representative, Baghdad; and Mr David Fieller, British Embassy, Baghdad.

Italy

Prof. Salvator Accardo, Direttore Generale per la Antichità e Belle Arti; Dr Georgio Bonsanti, Soprintendente Reggente Gallerie e Museo Estensa, Modena; Prof. Gian Carlo Cavalli, Director, Museo Civico

Medievale, Bologna; Dr Emma Micheletti, Museo Nazionale del Bargello, Florence; Signor Alessandro Mottola Molfino, Direttore Reggente, Museo Poldi-Pezzoli, Milan; Dr Mario Montuori, Director, Signora M. Barzotti, and Signora A. Beghé, the Italian Institute, London; and Prof. Franco Russoli, Soprintendente, Gallerie per la Lombardia.

Lebanon

H.E. Mr Peter Wakefield, CMG, British Ambassador to the Lebanon; Prof. John Carswell, the American University, Beirut; Emir Maurice Chehab, Director General of Antiquities; Mr P. B. Gotch, former British Council Representative and Mr Richard Hitchcock, British Council Representative, Lebanon; and Mr Yanni Petsopoulos.

Portugal

Mr T. Aitken, British Council Acting Representative, Lisbon; Dr José de Azeredo Perdigão, President, and Sra Maria Manuela s.o. Marques de Mota, Curator, Islamic Department, and Sir Charles Whishaw, the British Trustee, the Fondação Calouste Gulbenkian.

Spain

Excmo. Sr. Don Antonio Lago Carballo, Director General, Patrimonio Artistico y Cultural; Sr. Don Manuel Jorge Aragoneses, Comisario Nacional de Museo y Exposiciones; Sr. Don Alonso Baquer; Sr. Don Martin Almagro Basch, Director, National Archaeological Museum, Madrid; Sr. Don José Mária Alonso Gamo, Minister for Cultural Affairs, Sr. Don Luis Villalba, former Minister for Cultural Affairs, and Mrs Diana Blackwell, Spanish Embassy, London; Monsignor Lawrence Gatt, Apostolic Delegation, Madrid; Doña Balbina Martinez-Caviró, Director, Instituto Valencia de Don Juan, Madrid; Doña Angela Mendoza Eguares, Director, Archaeological Museum, Province of Granada; Mr Brian Levercombe, Scientific Attaché, British Council, Madrid; Sr. Don Frederico Marés, Director, Federico Marés Museum, Barcelona; Sr. Don José Luis Messia Marques de Busianos, Director General of the Cultural Relations Department at the Ministry of Foreign Affairs; Sr. Don Jesus Bermudez Pareja, Director, and Sr. Don Antonio Fernandez Puertas, Curator, National Museum of Hispano-Moresque Art, Granada; Prof. Xavier de Salas Bosch, Director, the Prado, Madrid; Sr. Don Fernando Fuertes de Villavicencio, Consejero-Delegado-Gerente del Patromonio Nacional; and Dr J. Zozaya, Keeper of the Medieval Department, National Archaeological Museum, Madrid.

Sweden

Mr Josef Edström, Riksarkivet, Stockholm; Dr Gert Hornwall, Chief Librarian, and Mr Åke Davidson, Keeper of Manuscripts, University Library, Uppsala; Dr Åke Meyerson, Director, and Dr Gudrun Ekstrand, Curator, Kungl. Livrustkammaren, Stockholm.

Switzerland

Mr A. S. Berkes, Curator, and Mme. Gertrude Borghero, Thyssen-Bornemisza Collection, Lugano; M. Claude Lepaire, Curator, and Mme. Anne de Herdt, Musée d'Art et d'Histoire, Geneva.

Syria

H.E. Mr Shaker Fahham, Minister of Education; and H.E. Mr Fawzi

Kayyali, Minister of Education and National Guidance; Mr J. H. Bunney, First Secretary, British Embassy, Damascus.

Tunisia

H.E. Mr M. Messadi, Minister of Cultural Affairs; Miss Wendy Barnes, the British Embassy, Tunis.

U.S.A.

Mr J. Carter Brown, Director, National Gallery of Art, Washington; Mr Charles E. Buckley, Director, St. Louis Art Museum; Mr Jan Fontein, Curator and Acting Director, Mr Adolph S. Cavallo, former Assistant Director for Collections, and Mr Larry Salmon, Curator of Textiles, Museum of Fine Arts, Boston; Mrs Irma L. Fraad, Curator, and Mr Charles Wilkinson, former Keeper of Islamic Art, Brooklyn Museum, New York; Mr Karl Katz, Director of Exhibitions and Loans, and Ms Eleanor Spaak, Assistant, Department of Islamic Art, the Metropolitan Museum of Art, New York; Mr Sherman E. Lee, Director, Ms Dorothy Shepherd, Curator, Mrs Anne E. Wardwell, Associate Curator, Department of Textiles, and Ms Orielle P. Kozloff, Assistant Curator in Charge of the Department of Ancient Art, the Cleveland Museum of Art; Ms Louise M. Mackie, Chief Curator, and Ms Patricia L. Fiske, Assistant Curator, the Textile Museum, Washington; Dr Pratapaditya Pal, Curator of Indian and Islamic Art, and Ms Mary Hunt Kahlenberg, Curator, Textile and Costumes Department, Los Angeles County Museum of Art; Mr Richard H. Randall Jr., Director, Mr William R. Johnston, Assistant Director, Walters Art Gallery, Baltimore; Ms Maude de Schauensee, Research Associate, Near Eastern Section, the University Museum, Philadelphia; Mr Jack V. Sewell, Curator of Oriental Art, the Art Institute of Chicago; Mr Seymour Slive, Director, Mr Cary C. Welch, Keeper of Islamic Art, and Ms Carol Sahlman, Loans Secretary, Fogg Art Museum, Cambridge; Mr A. Brett Walker and Ms Jacqueline Slee, Registrar, the University of Michigan Museum of Art; Mr Wallis F. Woods, Director, Seattle Art Museum; Mr Richard Stuart Teitz, Director, and Mr Stephen B. Jareckie, Registrar, Worcester Art Museum.

United Kingdom

Mr Robert St. John Gore, Historic Buildings Secretary, and Air Commodore C. C. M. Baker, CBE, Hardwick Hall, the National Trust; Mr Robert Harding; Sir John Pope-Hennessy, CBE, Director, and Mr D. E. Barrett, Keeper, Department of Oriental Antiquities, the British Museum; Mr Oliver Hoare; Prof. Michael Jaffé, Director, and Mr R. A. Crighton, Keeper of Applied Arts, the Fitzwilliam Museum, Cambridge; Prof. P. Lasko, Director, and Mr P. O. Troutman, Curator of Collections, Courtauld Institute of Art, University of London; Miss Lorna MacEchern; Mr D. T. Richnell, Director-General, British Library, Dr G. E. Marrison, Keeper, Mr J. P. Losty, Exhibition Officer, Department of Oriental Books and Manuscripts, British Library; Mr David Piper, Director, and Dr J. C. Harle, Keeper of Eastern Art, Ashmolean Museum, Oxford; Mr N. C. Sainsbury, Keeper, and Miss L. Sylvester, Assistant, Department of Oriental Books, Bodleian Library, Oxford; Prof. E. H. S. Simmonds,

President, and Miss D. Crawford, Secretary, Royal Asiatic Society;
Dr Roy Strong, Director, Mr J. C. Beckwith, Keeper, Department of
Architecture and Sculpture, Mr Claude Blair, Keeper, and Mr A. R. E.
North, Department of Metalwork, Mr R. J. Charleston, Keeper,
Department of Ceramics, and Mr J. Harthan, Keeper of the Library,
Miss W. Heffard, Miss T. Levey, Mrs J. Housego, Miss N. Rothstein,
Department of Textiles, the Victoria and Albert Museum; Dr Norman
Tribble, Keeper, Miss Jennifer Scarce, Assistant Keeper, Department
of Art and Archaeology, Royal Scottish Museum, Edinburgh;
Sir Robin Mackworth-Young, CVO, Librarian, the Royal Library,
Windsor Castle.

U.S.S.R.

Mme. A. Butrova, Deputy Head, Department of Foreign Relations,
Ministry of Culture; Dr Anatol Ivanov, Director of the Islamic
Department, State Hermitage Museum, Leningrad; and Dr A. A.
Kulakov, Director, Foreign Relations Department, Academy of
Sciences of U.S.S.R.

We are also most grateful to: Mr James de Vere Allen; Mrs Paddy
Baker; Dr May Beattie; Miss Mary Burkett, Director, Abbott Hall
Art Gallery; Mrs Yolande Crowe; Prof. Walter B. Denny, Assistant
Professor of Art History, University of Massachusetts; Dr James
Dickie, Institute of Arabic Studies, University of Lancaster; Sir John
Galvin; Mr Christopher Gandy; Prof. Oleg Grabar, Professor of Fine
Art, Harvard University; Mrs S. Humphries; Mrs Jean Jenkins,
Keeper Department of Musical Instruments, the Horniman Museum;
Father Bernard Kenney, and Monsignor Giovanni Tonucci, the
Apostolic Delegation, London; Mrs Donald King; Dr F. R. Maddi-
son, History of Science Museum, Oxford; Mr James McHugh;
Prof. T. Odhiambo, Chairman, Museum Trustees of Kenya; H.E. Dr
Donald O'Sullivan, Ambassador of the Republic of Ireland to
London; Mr John Picton, Deputy Keeper, and Miss Shelagh Weir,
Assistant Keeper, Department of Ethnography, the British Museum;
Prof. R. B. Serjeant, Director, Faculty of Oriental Studies,
Cambridge; Mr Michael Sixsmith; Mrs Anna Sixsmith; Mr Anthony
Turner; Mr John Walsh, Senior Lecturer in Turkish, University of
Edinburgh; and Mrs Katherine Watson.

Robin Campbell, *Director of Art*
Joanna Drew, *Director of Exhibitions*
Arts Council of Great Britain

Preface

The Arts of Islam exhibition is at the centre of a major study of Islamic civilization. Alone it is an important and complete exhibition, bringing together rare treasures from the four corners of the world. However, its full significance will only be seen if the exhibition is viewed within the context of the other exhibitions and events, which collectively make up the World of Islam Festival.

The Festival attempts to present the totality of Islamic culture and civilization. The principal themes of the Festival illustrate the essential aspects of the culture; the arts, the sciences, urban and nomadic life, poetry and music and of course what lies at the heart of the civilization, the Koran and its teachings.

The Festival represents a unique collaboration between scholars, institutions and governments from both the Islamic world and the West, and such a participation is bound to have a permanent effect on our knowledge of Islamic culture, as the very act of attempting to see something in a complete way leads us towards a definition which could well serve as a model for our time.

That the Festival could take place at all is a great tribute to the museums and libraries of London, and will bring before the public the magnificent and cumulative work that has been done by the many specialists on Islamic studies and their departments over the years.

The principal exhibitions besides The Arts of Islam are those devoted to the Koran in the King's library of the British Museum, to the science and technology of Islam at the Science Museum, to the nomad and to the city at the Museum of Mankind and to music and musical instruments at the Horniman Museum. There are as well exhibitions treating specialised aspects of Islamic art at the British Museum, the Victoria and Albert Museum, the Commonwealth Institute and at the Graves Art Gallery in Sheffield and the Whitworth Art Gallery in Manchester.

These major exhibitions are supported by a programme of concerts, lectures, seminars, books and films, which have all attempted to deal with those aspects of the culture best explored within a specific medium. The Festival should, therefore, fit together like a jigsaw puzzle and to be fully experienced, the visitor is invited to participate in all its varied facets.

Paul Keeler Festival Director, World of Islam Festival Trust

Index of Lenders

Her Majesty The Queen: 634
His Imperial Majesty The Shah an Shah Arya Mehr of Iran
Mashhad, Imam Riza Shrine Library: 504, 512, 518, 554, 558, 662
Mashhad, Imam Riza Shrine Museum: 82, 245–7, 459
Tehran, Imperial Library: 513, 568, 580, 587–8, 596, 619, 622, 632, 638
Tehran, Museum of Decorative Arts: 574
Tehran, Sipah-Salar Madrasa: 563, 572

Austria
Innsbruck, Tiroler Landesmuseum Ferdinandeum: 238
Schwarzenberg, H.S.H. Charles, Prince of Schwarzenberg: 59
Vienna, Österreichisches Museum für angewandte Kunst: 35, 45, 67, 98
Vienna, Österreichisches Nationalbibliothek: 557, 565

Canada
Toronto, Royal Ontario Museum: 83, 369

Denmark
Copenhagen, David Collection: 80, 121, 127–9, 131, 161, 183, 194, 265–6, 281–2, 299–300, 306, 308, 344, 358, 373, 396
Copenhagen, Museum of Decorative Art: 298
Copenhagen, Royal Collection at Rosenberg Castle: 74
Copenhagen, Royal Library: 517
Copenhagen, State Archives: 86

Egypt
Cairo, Museum of Islamic Art: 105, 107, 119, 130–1, 135, 138–41, 152, 155, 167, 169–71, 200, 218–27, 230, 237, 243–4, 267, 269, 272–3, 275–7, 317–8, 320, 430, 434–7, 442–6, 450, 455, 478–9, 482
Cairo, National Library: 515–6, 528, 536–7, 540–1, 581

France
Amon, F.: 285, 357
Apt, Church of Sainte-Anne: 8
Lyon, Musée Historique des Tissus: 13, 79
Milhaguet, Church of: 112
Nancy, Musée Historique Lorrain: 3
Paris, Bibliothèque Nationale, Cabinet des Manuscrits: 514, 529, 542–3, 597, 601, 603, 615, 620, 626, 631
Paris, Bibliothèque Nationale, Cabinet de Médailles: 160, 204
Paris, Musée de l'Armée, 229

Introduction to the Exhibition

9 detail

The explosion of Islam is one of the most extraordinary and crucial events of history. In less than eighty years the new religion proclaimed by the prophet Muḥammad had been carried by arms after his death in 632 from the Arabian peninsula to Central Asia in the east and to the Atlantic coast of Africa and Spain in the west. The great empire of the Sasanians which had dominated the middle east for four hundred years had disappeared and its long adversary the east Roman empire of Byzantium had been reduced to a fraction of its former size with the loss of the great provinces of Syria, Egypt and North Africa. These events are explicable in terms of the oppressive rule of bureaucracies; of the alienation of peoples from remote authoritarian control; or of sheer exhaustion after wars fought on an imperial scale. But such explanations do not touch the real significance of these events, which were truly revolutionary: not so much in terms of the displacement of persons or of economic disruption (though clearly there were big changes in these ways), as of change of spirit. It is true that there was considerable Arab penetration into Persia, especially into the eastern part, Khurasan, because this was a frontier region and, therefore, garrisoned, and because the desert terrain was favoured by immigrants from Arabia. Although conversion to the new faith in Persia was slow especially in the countryside, due to the use of Arabic for official business and the omnipresence of the Islamic law (*sharīʿa*) the impact on social life was great and those who had most to lose and most to gain in the cities were soonest converted to the Muslim faith. After two centuries, by the 9th, it had gone so far that the Persian language was in danger of becoming a mere dialect. The great Persian revival that followed was however not anti-Muslim but on the contrary led to great Persian influence in the development of Muslim thought and above all art. So Persia which had in 750 seized political dominance in the Islamic state came also to dominate its intellectual life.

If we look more closely at the art forms of the first centuries of Islam, we see first the continued use of the grammar of late Greco-Roman art; in mosaic and wall-painting, in architectural decoration and until 695 even in coin types. The capitals which crowned the columns in Syrian Raqqa or in Andalusian Cordoba are still clearly in the Roman tradition (nos. 472 and 488). Even after the Abbasid revolt and seizure of power, in the new round city of Baghdad founded in 762 al-Manṣūr sought for a marble mihrab from Syrian workshops

23

(no. 471). This niche, of clear classical form, well symbolises the assumption in the new Islamic community of the identity of religious and secular leadership (an idea inherited from Sasanian state and not far removed from the Byzantine concept). For the mihrab, the frame which once held the statue of an emperor had now to serve as station for the imam as leader of the Islamic community. So too the mimbar is not so much the pulpit of the West occupied by the preacher as the rostrum from which the will of the ruler was declared to his faithful subjects, and its occupancy was severely restricted to those who pronounced each Friday the assertion of the ruler's title in the *Khuṭba*.

The Umayyad princes may have been contented with the luxurious setting of well-appointed villas in Syria, not so much as was once thought because they could not tolerate city life as because they represented the aristocratic life of the displaced Byzantine élite. In Baghdad it was rather the hierarchic court of the Sasanian monarch which was imitated, essentially cosmopolitan, accustomed to age-old imperial rule over subject peoples and outward-looking in keeping open the trade routes to India and China. The palaces of Samarra on the Tigris, built in the mid-9th century, were decorated with stucco dadoes in the Sasanian style and furnished with Chinese white or green porcelain and local imitations of it (no. 256).

So it was this eastern heritage which from the 8th century onwards conditioned the outward forms of Islam; after the deliberate confrontation with the splendours of Byzantine architecture in the Dome of the Rock in Jerusalem (692) and the Great Mosque in Damascus, Islamic architecture went its own way in the indefinitely extendable congregational mosque, the great courtyards of Samarra or ibn Ṭūlūn in Cairo or Kairouan in Tunisia; or the multiplication of columnar units at Cordoba. In the community the Koran extended its control over every aspect of life, thus preventing any distinction between secular and religious and making a cultural bond among all who professed the faith, whatever their national origin. The Arabic language and even Arabic poetry of the 'times of ignorance' became literary models for all from east Persia to Spain. Arabic also dominated commerce and trade and Arab ships plied between Basra and Siraf on the Persian Gulf and the Far East.

In the sectional introductions it is repeatedly remarked how, in each of the crafts, techniques and skills were inherited from the earlier centres in the lands of Islam, but also how common styles developed so that shapes and decoration passed easily from one medium to another, and how there was a continuing tendency to community of artistic language throughout the Islamic world. A principal aim of the organisers of this exhibition has been to illustrate these features of Islamic art and to seek to identify and demonstrate the essential unities within its varied expressions. This purpose underlies the conceptual arrangement of the key Gallery I with its four specific categories of modes of design identified so as to ease the understanding and appreciation by the public of the artistic language in the exhibition as a whole.

What then are the essential characteristics of Islamic art? A defini-

tion may perhaps best be reached by considering what it excludes so as to isolate the positive factors. In the fully developed vocabulary of Abbasid and later of Fatimid art, and in the arts of the Samanids and Ghaznavids, we can still identify elements like the palmette, the vine, the eagle, the dancer; but they are depersonalised, their individual existence is denied; although they retain a kind of vitality, this has its source in a generalised concept of the category, which has developed a character of its own, conceptual and therefore able to associate on equal terms with other concepts like the inscription. They may live among the hastae of the Arabic script or the script itself may turn into a bird; or break into a leaf (nos. 294–5); or even sprout a human head (no. 180). It would be misleading to pretend that these elements had been reduced to two dimensions. For there is often more than one level in Islamic design, but the levels are conceptual rather than spatial. This kind of all-over decorative design is sometimes attributed to Islamic revulsion from the image, combined with a horror of empty space (*horror vacui*). This is far too negative an approach; there must have been a positive delight in exploring the variations or combinations in a not very large corpus of motifs which do not seem to have had symbolic meaning, though retaining echoes from the sources from which they were drawn: such as the Signs of the Zodiac, the Tree of Life, the Harpy, the eagle or the lion. The same treatment befell even the script itself which had often served as a principal motif. It could be transformed into meaningless combinations of letter-forms which yet recalled the value of writing, with its prestige as the vehicle of the sacred book. In the beautiful slip wares of Nishapur and Samarkand (nos. 279–89) the script may be both handsome in itself and significant; but its message is not really the proverb which it carries but the script itself. Kufic which started as the formal script of the vellum Koran (no. 498) was from the beginning not intended for easy reading but for recognition by the reader who already knew the text by heart. Some of this prestige rubbed off on any object into the decoration of which kufic entered. It has remained throughout Islamic history the primary mode of decoration. Consequently the art of the calligrapher or calligraphic designer has ranked first in esteem and far more names of calligraphers than of any other artists have been preserved. Monumental calligraphy on buildings is quite often signed as well as dated and small specimens of fine writing by famous scribes have been eagerly collected and bound up in albums (*muraqqa'*) alongside drawings and miniature paintings (nos. 580 and 631).

For whom did these artists work? Normally a patron would offer protection and support to a calligrapher as a member of a princely household or possibly the library and scriptorium (*kitābkhāna*) of a foundation like that of Rashid-al-Dīn (nos. 529–30) endowed under a deed of gift (*waqf*). There was rivalry for the services of such artists of the book and they therefore often moved from one centre to another, disregarding what are now national boundaries. The same is evidently true of other craftsmen and designers in metalwork, glass or pottery for instance. They carried with them the technical knowledge of sophisticated processes such as lustre painted pottery, nielloing of silver,

enamelling of glass, the use of mineral and earth colours in ceramic production, or pigments for book illustration. Sometimes such migrations were forced, such as the Mongol stripping of the glass workers from Aleppo; Timur's removal of tileworkers from Isfahan and Yazd, and of calligraphers and painters from Baghdad, to his new capital at Samarkand; of Baysunghur's removal to Herat of the Tabriz masters of the arts of the book; or of the Ottoman abductions from Tabriz in the early 16th century or that of the Uzbeks from Herat to Bukhara in the same period. Other craftsmen fled from such invaders, like the Khurasani inlay masters who established themselves in Mosul in the 13th century (nos. 195–7) and later in Damascus and Cairo; the calligraphers who left Baghdad for Shiraz at the time of Timur (1370–1405). All such movements favoured the spread of uniform standards throughout the lands of Islam.

Another factor which contributed to the community of taste and skill was the recognition of the primacy in cultural life of the seat of the caliphs in Baghdad (founded in 762) with all its reputation in cookery, music, poetry, silk-weaving, ceramics including tilework, stucco and painting. It became the model for admiration and imitation. In its heyday (late 10th–11th century) Fatimid Cairo was another centre for all the luxury crafts, and so too was Caliphal Cordoba, where a last branch of the Umayyad house flourished for nearly 300 years. It reached its highest point in art and letters under Ḥakam II (961–76), when it was the most civilized state in Western Europe.

236

We have remarked upon the interchangeability of design between the various arts and even of shape and on the persistence of some motifs, such as the classic arabesque, an infinitely extendable scroll, based originally on the palmette but often associated with other vegetal forms: interlace whether geometric or vegetal. But the arts of the book do not fall so neatly into this pattern of design. The Arabic script does of course dominate these arts, being the very medium of the text and the essential element in the illumination. So too the book-binding provides one of the best illustrations of the application of the arabesque and of geometric interlacing, closely parallel in lay-out to the architectural decoration. But the miniature art does at first sight appear to go beyond if not to transgress the principles identified as specially characteristic of Islamic art. Yet is this really so? First we should remember that the book held a special place of honour under Islam and that this extended to collections of Arabic poems like the *Kitāb al-Aghānī* (nos. 515–7). Again learning was protected and fostered, translations from Greek or Pahlavi encouraged, history esteemed. Such books as the 'Fixed Stars' of al-Ṣūfī (no. 500) were necessarily illustrated and the diagrams of automata edited by al-Jazarī belong to the courtly traditions inherited from the Sasanians. So the whole conception of patronage of the arts of the book implied that it was right to devote the highest care to the copying of fine books.

We have still to show that the miniature art itself conformed to the principles of Islam. Apart from illustrations to works of information under which we may include history (no. 530), the two main categories to be considered are the frontispiece and the illustration to works of

imagination, mainly poetic. The frontispiece is generally intended to honour the princely patron by depicting him, not as a true portrait but as an idealised effigy, in some suitable princely occupation, enthroned in diwan, hunting, playing polo, enjoying a feast in a garden or a pavilion. Here the book is associated with other media of the arts, especially inlaid metalwork, in maintaining an old Persian tradition but one which, we have seen, might be adopted as suitable to the Islamic ruler as protector of the faith and administrator of justice.

The other category of miniature accompanies lyrical, romantic or mystical poetry and gives a visual parallel to the poet's imagery in a way often in harmony with the text rather than exactly illustrating it. This was the special gift of Persia with its intense visual imagination; its love of the natural setting in garden or mountain landscape. Essentially the art is conceptual, just as are many of the other arts of Islam, never the depiction of an actual place or scene but the construction of an ideal scene in which the essential character of the passage chosen is elaborated by the brilliant depiction in loving detail of flower, tree or human form, of tile-clad building, cloud-filled sky, in a closed world as artificial or conceived as the poem itself. In its harmony of brilliant flat colours it is just as much a pattern of design as the geometric or the arabesque; it is a similar exercise more highly organised and complex but still within the same terms, so that it is always perfectly adapted to the book form, consorting naturally with calligraphy and illumination, in a single unified product of a team of artists under the control of the master librarian.

There can be no question that architecture has provided the main focus for Islamic art throughout its history. In this exhibition the display of colour projections specially made in all the principal lands of Islam is intended to make its presence as actual as possible. In addition, gathered round this unit, are examples of architectural decoration to illustrate it in its proper scale and most of the media employed. It is a disappointment that it has not proved possible to include examples of the use of tile mosaic decorated inscriptions which were so conspicuous in exterior decoration of buildings from the fourteenth century onwards in Persia, Transoxiana and the Ottoman Turkish domains. But enough is to be seen in the galleries to illustrate the range of ornament and especially the monumental use of Arabic as a major element in design.

We would call attention especially to the Umayyad marble panel from the Great Mosque of Damascus (no. 468), an elegant work of the Caliph al-Walid (714–5), which shows a new use of late Hellenistic motifs in a shape that is characteristic of this time, and comparable with the relief carving at the famous villa-palace of Mshatta. A similar style in wood, perhaps of a hundred years later, shows the tendril pattern developing into an infinitely expansive design typical of Islamic arabesque. But a fundamentally more abstract type of woodcarving was introduced at Samarra in the mid-9th century in which bird and animal motifs are translated into light and shade pattern by deep oblique carving (no. 438) and this was carried to Cairo by the Tulunids (nos. 435–6).

The most important medium for interior decoration, from Central Asia to Spain, was stucco panels carved *in situ* or moulded with repeat patterns. The technique was inherited from the Sasanian empire but was greatly developed and improved under Islam especially in Mesopotamia and Persia. Characteristic of the patterns in the Umayyad period are the substantial panels from the mosque of Uskaf Bani Junayd, situated on the great Sasanian irrigation canal, the Kātul or Nahrawān, about thirty miles south-east of Baghdad. Here (no. 473) we see a repeat pattern of individual motifs linked by small scale frames. The Samarra and Nishapur stuccoes are too fragile to travel, but their style is represented by a large flat mihrab panel from Anah on the Euphrates (no. 474) in which the deeply cut scrollery and central panel of palmettes is surrounded by stiff early kufic in the post-Samarra style of the 10th century.

It is generally said that this style was superseded by the impact of the Seljuq conquest. This view has recently been questioned and it may turn out that some features of the so-called Seljuq style were already developed before the time of the great Seljuq Sultans (1055–1157), on the one hand, and on the other that it is the twelfth century rather than the eleventh which saw the full development of the Seljuq style. This is splendidly demonstrated in the exhibition by major works of art in carved wood. The Seljuqs brought a strong revival in Islam, both militarily by their onslaught on the Byzantine empire (their great victory at Manzikert in 1071 brought the greater part of Anatolia permanently into Muslim hands) but also in their elevation of the Sultan as leader of the Muslim people to a position of absolute power in an eastern imperial tradition *vis à vis* the caliph, whom they wished to confine to spiritual functions. This esteem for the secular arm in the state was marked architecturally by the increased importance in the mosque of the ruler's station, which was now fenced off by a handsome screen known as the *maqṣūra* often surmounted by a dome. From Damascus comes panelling from a great maqsura screen carved in 1103 soon after the Seljuq conquest of the city in 1094 and for the Turkish atabek Yughtiqīn. With marvellous skill the great panels of poplar wood are carved with Koranic inscriptions in kufic lettering back to back and with vine trellises twining round the lettering (no. 448). Of rougher workmanship but showing all the strength of the new style of star and leaf motifs framed in wide flat strapwork and with square kufic dedicatory inscription dated 1153 is the pulpit (mimbar) from Mosul (no. 452). Also from Mosul is a pair of 12th century doors with kufic inscriptions as a main motif (no. 451). A similar renewal is to be seen under the Fatimid rule in Egypt, where influence from Persia was strong. Linked in hexagonal panels are motifs of musicians and hunters carved on beams which are the only remains of the Fatimid palace in Cairo (no. 443).

Kufic was still generally used for monumental inscriptions such as those painted in gay colours on the 11th century ceiling planks taken down for conservation from the roof of the Great Mosque at Kairouan, one of the great medieval buildings of Islam; (nos. 439–40) or in the carved wood panel from Raqqa on the Euphrates where the letters have

floriated terminals (no. 438). In the 12th century in Persia and later in Anatolia a new style of monumental kufic becomes the rule, with the tall hastae of the letters plaited. A fine example is to be seen in the great lustre tile panel from Kashan (nos. 376–7) with its inscription in high relief.

This form of kufic is exceptional, though characteristic for its time and occasionally seen in later examples from Ayyubid and early Mamluk times in Syria and Egypt of late 13th and early 14th century, such as the pen-box of al-Malik al-Manṣūr dated 1363 (no. 224). In general, however, monumental kufic is notable for its strong horizontal movement and sharply accented vertical and oblique strokes, a carved letter in relief or incised and of sculptural form: whereas the naskhi is a cursive two dimensional script admirably displayed on the flat surface of glass or metalwork. Nowhere is it seen to better advantage than on the mosque lamps of Syrian enamelled glass (nos. 138–40), where the transparency accentuates the counterpoint with the floral scrolling. It has been remarked that the use of naskhi as a chancery script by the Ghaznavids in the 11th century started its monumental career at the beginning of the 12th century. By the 13th century it was in common use in the applied arts throughout the Islamic world; its freedom of movement enables the designer to fill the girdles of basins or candle-sticks (nos. 219, 217) where the ground is densely covered with floral scrolls.

The Mongol invasions of the 13th century brought closer contact with China and Chinese craftsmen were moved to the Mongol capitals of Karakorum and Tabriz. There the Ilkhanid rulers of Persia passed through a Buddhist phase before their conversion to Islam in 1295. The Buddhist lotus became and remained a favourite addition to the repertory of design as well as the peony, ubiquitous in Chinese design. This innovation was extended even to Egypt but was assimilated to Islamic formal symmetrical design, and displayed in zones or other fields defined by plain framing bands. At this time there is a specially close relation between the splendid manuscript illumination (nos. 526, 528–9) both in Persia and Egypt and the inlaid metalwork, both relying on colour as well as design to achieve marvellously rich effects. It is to be noted that the apparent geometric lay-out of the design is, in fact, controlled by the eye and not by mathematical calculation of an advanced kind, and this seems to be true also of architectural decoration which does not follow strictly the structural forms into which exact calculation must of course have entered.

Chinese influence at this time had a more radical liberating effect on the art of miniature painting, freeing it from the diagramatic and silhouette character of earlier periods by the introduction of the concept of the picture space within its framed margins. For a time it seemed as though indefinite space might break the unity of the book but quickly the Persian sense of presentation found the solution in the high horizon as a viable substitute for the traditional monochrome background. This, with the opaque gold or deep blue sky, became the convention of the classic Persian miniature style from the second half of the 14th century till its decline in the 17th century.

In conclusion a few words can be added on the two arts of Islam which have found readiest acceptance in the West and with which we have long been familiar: the carpets and ceramics. Carpet design displays most clearly the principles of Islamic art, two-dimensional, symmetrical, complex in its combination of motifs drawn from floral, geometric, cloud and pseudo-kufic elements. The lay-out in field and border patterns symmetrically yet freely worked out corresponds to that of manuscript illumination, sometimes termed in French *tapis*. A direct connection between the artist of the book and carpet design is suggested in the sectional introduction and miniatures provide the only evidence for Ilkhanid and early Timurid carpets, of which no actual examples have survived. The same is true for the rich state canopies and tents, surviving examples of which are not older than the 16th century. Carpets have been known in the West at least from the beginning of the 15th century and their introduction into both Italian and Northern European painting has provided valuable evidence on their chronology.

Pottery too was reaching Italy from Syria in the 13th century when bowls were applied to church walls as colourful decoration and the lustre pottery of Muslim Spain was famous throughout the Mediterranean area in the 14th and 15th centuries. So too the products of the Turkish kilns at Iznik and Kutahya were exported to the West in the 16th and 17th centuries, as were also the textiles from the looms of Bursa. Their ready appreciation is shown by Italian imitations in both media. Indeed the so-called 'Rhodian ware', as it was known until the late 19th century, has never gone out of favour. The jug from Bologna (no. 412) was probably imported new and has been treasured ever since.

It was clearly the genius of the Islamic potter for design and colour which has gained for his products the acclaim wherever they have penetrated from East Africa to Britain and Germany. For the shapes are not remarkable for beauty or variety. They are serviceable, but in all periods perfect fields for Islamic design, particularly the circular shapes of dishes and bowls. There was an old tradition of ceramic wall-covering in the ancient middle east, but under Islam this was splendidly developed, carried to Spain and Portugal and thence to Holland and England. Exterior architectural decoration can only be hinted at here, but the Committee has made a special point of showing the effect of wall covering on a large scale in two different principles, of unitary counterplay in the Kashan lustre tiles and of overall design in the polychrome of Iznik in the large reconstituted panels.

Introduction to Islamic Art

390

By general and tacit consensus the expression the 'Arts of Islam', or 'Islamic Art', refers to all the arts of the Muslim peoples, whether those arts be religious or non-religious, while the analogous expression the 'Arts of Christianity' raises immediately the question as to what extent, and according to which criteria, the arts of the West can be so defined. Is for instance the art of the Renaissance – which borrows its forms from pagan antiquity – still a Christian art in the sense that Byzantine Romanesque and Gothic art are Christian art forms? And why? Is it simply because some of its themes have their source in the Bible? And is it because Renaissance, however classical in spirit is nevertheless marked by a Christian heritage? Where then is the point beyond which this heritage is not sufficiently clear to justify the term of Christian art?

Let us not forget that there has always been in the Christian world, even in its phases of greatest religious fervour, a place for artistic manifestations which are profane and therefore religiously indifferent, but which exist by right, according to the maxim that one must give to God that which is God's and to Caesar that which belongs to Caesar. In the world of Islam this separation of life into a religious sphere and a profane one does not exist: the Koran is both a spiritual and social law. We speak now of an Islamic world which is still intact, not fractured by European interference, of the very world which has produced the works of art which we admire in this exhibition. In this context the Koran, the book of God, and the Sunna, the way of life of the Prophet, regulate not only cult and common law but also the fundamental and recurrent facts of everyday life such as the way to greet, to wash, to eat. This means that Islam represents a total order which involves all the planes of human existence, the body as well as the soul, and which decides naturally the place which each art occupies and the role it will play in the spiritual and physical equilibrium of the *Dar al Islam* – literally, the House of Islam. It is by conforming to a certain hierarchy of values that the arts are integrated in Islam, and that they become Islamic art, whatever the source of their diverse elements may be.

The ignorance of this hierarchy is the basis of all the misunderstandings which are current about the art of Islam. The European observer who is not aware of this hierarchy of values – and we mean here any representative of Western culture – instinctively values the artistic level of other cultures by applying the scale of values which is

habitually applied in a European milieu. For him the measure of art is the role which representation – be it more or less primitive or near to nature – plays; it is the representation of the human being which is foremost in his mind, which is the touchstone.

In the Islamic order, on the contrary, figurative art does not take the first but the last place in the scale of artistic values. Figurative art is excluded from the liturgical domain, which means that it is excluded from the central core of Islamic civilisation and that it is only tolerated at its periphery with the proviso that it must not represent a sacred personage susceptible of being the object of a cult and that it must not have the pretention of imitating the work of the Creator. In this way the role conceded to figurative art is singularly narrowed, for by being cut off from cult it does not participate directly in the spiritual life of Islam. At the same time it is not allowed to reproduce nature but has to transform nature into a fabulous imagery so as to make it visibly unreal. There are certain exceptions to this – Persian miniatures are one – but these exceptions do not change the rule, and its overall effect. The proof lies in the fact that there is not one single mosque which is decorated with human figures. A whole dimension of artistic creation – the most important and the most vital for Christian and Western culture – is therefore non-existent in Islam. Is this, then, a grave weakness? We shall see that this apparent weakness is in reality the condition for the development of other dimensions and other artistic possibilities. Thus, in the sanctuaries the absence of images creates a void comparable to silence – but to a kind of silence which is not that of inertia but that of a state of undivided presence.

This is what is expressed by the limpidity of the architectural forms in Islam. In a general way the absence of anthropomorphic images, with their allied associations which are inevitably subjective, allows for the objective and impersonal character of Islamic art, a character which is most manifest in the architecture and in the decoration based on abstract forms. Both architecture and decoration stem from a qualitative geometry which excludes a priori all individualistic improvisation but which has nothing sterile in it. There is in this geometry of pythagoran origin a harmony and a memory of the music of the spheres. It is no accident that the architects whose names have come down to us were often mathematicians and astronomers as well as poets and musicians. The Muslim is not fascinated by the drama of individual artistic creation; rather his soul vibrates through the idea of the unity and immensity of God which are reflected in the cosmic order and also in the artefacts shaped by the hand of man – and shaped not according to his imagination alone, but also according to the nature of the object, by the bringing forth of the laws and the qualities which are inherent in the object itself.

But let us consider again the question of the hierarchical order of the arts of Islam. In a sense the central art in Islam is architecture because its function is that of building sanctuaries and because a whole series of other arts is dependent on it. But there is one art which is still nobler, and that is the art of writing, calligraphy, which owes its excellence to the paramount importance of the fact that it transmits the Koran, the

divine word directly revealed in the arabic language. From this point of view, as the visible record of the divine word, Arabic calligraphy is analogous in function to the painting of icons in the Eastern church. Extremes meet.

From a Muslim point of view Arabic calligraphy is irreplaceable, because the Koran has been revealed in the Arabic language and because its implicit divine nature is manifest even in its sound, with the Arabic script reproducing sonority as faithfully as possible.

From the same point of view a Koran translated into another language is no longer truly the Koran, contrary to what happens to the Gospel which has been translated into various liturgical languages. This is because the Gospels are not in the form of divine speech but are in some sense a historical narration. For this reason their content can be illustrated in images, something which would be absurd in the case of the Koran where it is the word-by-word faithfulness to the text (with its own phonetic symbolism) which counts.

We understand therefore why the Arabic spirit is present everywhere in the world of Islam, whatever mother tongue this or that Muslim people may use. Everywhere the Koran is quoted in Arabic and, just as the everyday life of a Muslim is punctuated by Koranic formulas, his environment – the mosque, the house, the place of work – is decorated with inscriptions whose text is usually taken from the Sacred Book. Every educated Muslim is more or less familiar with the Arabic script and this experience awakens in him a sensitivity to the interplay of abstract lines, an interplay which is both geometric and rhythmic. To study Arabic calligraphy and the rich variety of its different styles is to feel the heart-beat of Muslim art.

But if calligraphy is the noblest and the most common art in the world of Islam, architecture nevertheless still occupies a central position dominating the whole complex of artistic activities. Some of these – masonry, carpentry, stone and stucco sculpture, tile mosaic, tile covering of walls, stained glass – exist only as a service to architecture, while others, such as sculpture and painting on wood, are only occasionally linked to buildings. Calligraphy itself is linked to architecture in the form of monumental inscriptions. Sometimes its fluid lines contrast with the static character of architecture, sometimes they conform to it: there is a 'built' form of script composed of squares or rectangles, which sometimes is reduced to bricks projecting out of the surface of the walls.

From a European point of view all the arts subordinated to architecture are only decorative arts and therefore arts of secondary importance and of limited creativity. In the world of Islam these arts occupy the place reserved elsewhere for the figurative arts, for whose absence they compensate while at the same time they have a completely different function in that they transform the raw material giving it a nobler, almost spiritual, status made of crystalline regularity and vibration of light.

This art is objective not only because it is based on a real science but also because it never creates illusions. A stone will always remain a stone and will never be made to give the impression of being a live

body. It is true that monumental decorations sometimes incorporate zoomorphic elements – notably in the art of the Seljuqs – but these are reduced to strongly stylised heraldic forms. As for the arabesque based on plant forms, it develops according to its own decorative logic independently of any botanical models. In Ottoman art and in Mughal art the arabesque sometimes comes near to nature but nevertheless remains faithful to the laws of two dimensional decoration.

In the wider sense of the term the arabesque also includes the decoration of purely geometric forms such as the rosettes made of interlaced lines, which were developed from a regular division of the circle. The arabesque with plant form can in any case combine with the purely geometric arabesque and we then have a combination of melodious rhythm with crystalline perfection. Finally the different kinds of decoration can be combined with calligraphy. The decoration is added to architecture proper like a rich cloth, which covers the walls of the building. Without this cover Islamic architecture is often reduced to simple and static forms like the cube and the sphere.

There is in all Islamic architecture, and more particularly in the mosques, a sort of fluctuation between a sobriety or simplicity which recalls the origins of Islam and a richness of decoration, *ad majori dei gloriam*. The types of mosques differ according to ethnic environment but go back to one prototype which remains unchanging, a plan which is never forgotten so that at any given historical moment it is possible to revert to it, or to a stage in development near to it. This prototype is none other than the courtyard of the house of the Prophet in Medina, a courtyard which was used by the faithful for their communal prayers. This was a rectangular enclosure of which the part situated on the side facing Mecca had been transformed into a shelter by a flat roof supported on palm trunks. The primitive mosques, just like their model, are always made of an oratory with a horizontal roof on pillars open to the courtyard, which increases the liturgical space: when the worshippers are too numerous to find a place in the hall some of them are able to pray in the courtyard. The direction towards Mecca – or more precisely towards the Kaaba – is indicated by a niche, the mihrab, in the facing wall. For Muslims, the Kaaba symbolises the spiritual centre of the world. Its origin is attributed to Abraham. In front of the mihrab – which will become the preferred object of the sacred art of Islam – the imam stands to lead the communal prayers.

In a second phase of its evolution the site which is open in the enclosure, that is, the courtyard (*ṣaḥn*), is surrounded by porticoes. Instead of simple pillars to support the horizontal roof of the prayer hall, columns with arcades are used. These arcades are wider along the liturgical axis which links the mihrab to the courtyard. In this way they form a sort of central nave which is externally indicated by an elevated roof or by one or more domes. In the middle of the courtyard there is generally a fountain where the worshippers perform their ritual ablutions. Add to these the minaret from which the muezzin calls to prayer and we have the elements which will remain constant in the architecture of the mosque.

Variation from this model is the consequence of building methods

17 detail

which in turn correspond to the differences in environment and cultural heritage of the different Muslim peoples.

In Syria, which was to become the cultural centre of the first Muslim empire, mosques were built in stone with roofs resting on wooden beams, a method which has found its direct continuation in the countries of the Maghrib (Tunisia, Algeria, Morocco and Spain). In Persia and in Mesopotamia the building material was almost exclusively brick, which meant that the horizontal wooden roofs had to be replaced by a series of vaults resting on groups of pillars. By doing so each spatial compartment was given a certain autonomy which does not go against the function of the mosque which is to serve both communal cult and individual prayer. In consequence the Persian plan is always modelled on the traditional one – with its oratory open on the courtyard and surrounded by porticoes – but its elevation is characterised by high-niched portals (*iwān*) and by vaults and domes which make up a very different profile from that of the North African mosque. The Persian mosque, particularly the Persian mosque of Shi'a origin, is less a place of gathering for communal prayer than a sanctuary composed of a series of spaces increasingly interiorised and sacred. Through the 'high gate' often flanked by minarets one enters the courtyard surrounded by arcades and revealing a second triumphal gate, the deep vault of which somewhat prolongs the prayer niche, the mihrab, which is itself sheltered by a domed chamber.

In the Muslim architecture of India the Persian model is further developed. The whole facade of the oratory facing the courtyard becomes a sort of amplification of the mihrab. Thus the place for communal prayer is in practice the courtyard itself.

The Turkish Ottoman mosque develops in a completely different way. At the beginning it was a simple variation of the prayer hall covered by a horizontal roof and supported by pillars. This roof had been replaced by a series of domes, each resting on four pillars. This meant that the plan had to be divided into a certain number of regular squares. The transformation of this cluster of domes into a single dome over a single square space had to impose itself, and the synthesis was achieved, first on a modest scale, in its simplest form, and thereafter on a much larger scale which entailed the solution of serious and difficult static problems. These problems were solved by the adaptation, in islamic forms, of a method used by the Byzantine

35

architects of Hagia Sophia, whose huge central dome is counter-balanced by half-domes. These were arranged so as to facilitate the transition between the circular dome base and the cube of the building beneath. Thanks to this method the Ottoman mosque creates a perfect unity of internal space. It is true that the inner space of the mosque is separated from the courtyard, but this separation is justified by the harshness of the Anatolian climate.

What are the objects to be found in a mosque? We have already seen that the prayer niche, the mihrab, is particularly important in the religious art of Islam. Its walls are generally lined or covered with mosaics and its frame almost always contains Koranic inscriptions. Next to the mihrab in the great mosques devoted to the Friday communal prayer stands the mimbar or pulpit, which takes the form of a throne with steps and which is usually made of wood, so that it can be moved. Its high walls are generally decorated with carving or inlay. The mimbar is one of what we can call the liturgical objects, which also include the lectern for the Koran, the lamps hanging from the ceiling – often made of pierced metal or enamelled glass – and finally the mats or carpets which cover the ground and which have great importance because in the course of their prayers the worshippers rest their foreheads on the ground as well as sit on the floor to meditate and rest. The arts which produce the liturgical objects are by the same token linked to religion, while at the same time they are used in the making of practical objects. There are few of the minor arts which do not contribute in one way or another to the sanctuary complex.

The expression 'minor arts', which usually defines those manual crafts which are used for the fabrication of objects for everyday use, should not have any derogatory sense. A simple drinking cup can be an art object of great quality. This is particularly the case of the objects made for the households of rulers, which were generally created by the best craftsmen of the time. But the perfection of an object does not necessarily derive from the richness of the material used; on the contrary, the aim is to attain the highest artistic quality by the simplest means and by using sometimes the humblest materials: 'God has prescribed perfection in all things' according to the word of the Prophet. This ideal gives spiritual meaning not only to the work of the artist who in a way transforms raw material into gold, but also gives meaning to the acts and gestures of those who use the objects made by the craftsmen's work; to drink from a cup whose shape makes clay noble is to savour at the same time the ephemeral nature of things and a permanent beauty reflected in them. There are few things in the city of Islam which were created to last, and few are known which are without any quality of beauty.

Since at the basis of Islamic civilisation there is the sacred book, the Koran, it is not surprising that the arts of the book have been favoured in a special way. We have already mentioned the paramount importance of calligraphy in the art of Islam. In this context we have also to mention bookbinding, which is often of the highest quality, and illumination, generally of a decorative character. There is here a phenomenon to be considered which at first sight might seem strange –

the introduction in Islamic art of figurative painting in the form of miniatures which illustrate not the Koran but scientific or poetical texts. There is an affinity between the script and the miniature whose style is essentially linear. Miniature painting does not include perspective or shadow; there is no attempt to convey three-dimensional space. It is significant that all the miniature painters of whom we know the life history were first of all calligraphers. One must not forget that the art of the miniature is not just outside the religious sphere but also outside the social one, in that its masterpieces are hidden in the pages of books, in the same way as strange stories, disturbing and mysterious, are hidden in them.

The art of weaving is categorised as one of the minor arts of Islam, but it is often forgotten that the arts of costume play an important role – almost as important as that of architecture – in Islamic civilisation. This comparison is not arbitrary because, whereas architecture creates the necessary environment for the lives of men, the art of the costume in a way shapes man himself. There is little which influences the behaviour of most men more than the costumes they wear. The traditional dress of the people of Islam is characterised by its sobriety and dignity. It often combines a monastic simplicity with royal majesty. We are speaking now of a man's dress, which is more uniform than that of women. For Europeans, a population dressed in Muslim style often evokes the world of the Bible. And this is no mere romanticism, because the ideal which this costume expresses is in fact a continuation of the world of patriarchs and prophets.

All the arts which we have mentioned have as background the urban life. Our description of the categories of Islamic art would be very incomplete, in fact one-sided, without mention of Beduin art. By this word is indicated the art of the people who live in the open country – and more exactly, the Nomadic people who, in the Islamic civilisation, play a role which is both in opposition to and complementary to that of the people in a sedentary world. The town dwellers have nothing to learn from the Beduins in technical and artistic methods, but they have a lot to learn so far as the essence of their art is concerned, because the nomads have a genius for forms which are both simple and bold. They have a conception of greatness and nobility. Every time that nomad tribes have invaded a region with a sedentary culture the arts, which are the first element to be disrupted, are subsequently renovated so as to become more direct, more intense, of a greater depth. The art of the knotted carpet, undoubtedly of nomad origin, is the best example of the Beduin contribution to Muslim culture, and its artistic evolution is at the same time an illustration of the interaction between the two poles of the Muslim world, the sedentary and the nomadic. The nomads love rhythm as a reminder of permanent presence and they love infinite space. The sedentary people love to limit space, to frame it, to order it towards a centre; they prefer melody to rhythm. The nomads simplify the forms which they receive from sedentary peoples, they reduce them to symbols, while the settled people develop the elements taken from nomadic art enriching them with forms reminiscent of nature. The whole Muslim civilisation lives

through the exchange between these polarities. It is a living balance between the town and the desert – stability and movement, contemplation and militancy.

In order to account for the nature of Islamic art we have tried to define the different categories of artistic activity as the Islamic mind conceives them. There are, of course, other ways of distinguishing different aspects of Islamic art considering for instance its various styles or variants according to the different ethnic milieux. One will find nevertheless that, despite differences in style, the hierarchy of the arts as it has been described here remains the same everywhere.

It is always the art of writing, calligraphy, which supplies the key note, and the synthesis between architecture and decoration always rests on the same geometric principles. These are the two aspects of Islamic art which have no direct precedent in other civilisations – whatever some historians may believe, who want to trace Islamic forms to foreign influences.

The historical point of view has its rights certainly; in particular it allows for an understanding of Islamic art by reference to the way in which it has transformed the artistic heritage of preceding civilisations and by drawing attention to the choice which it has made from amongst their forms, what it has assimilated and what it has rejected. This approach, however, carries the temptation to over-estimate the foreign influences that at all moments of history, but most strongly at its beginning, have converged on the arts of Islam. The equilibrium between the various means of artistic expression has never changed under Islam. This equilibrium is based on the doctrine of the One Reality; it avoids certain means of expression and emphasises others and thus imposes upon itself alternately poverty and richness.

237a

Glossary

The glossary consists mainly of technical terms referred to in the catalogue entries and includes Arabic, Persian and Turkish words. It does not, however, claim to be definitive.

albarello A tall cylindrical jar with concave sides.

amir A military commander, prince or senior official. *Amīr al-muʿminīn*, Commander of the Faithful, a title proper to the Caliphs but used by some other rulers.

ansa (pl. ansae) (in Latin, a handle) An element in Koranic illumination, being a usually triangular projection into the margin from a decorative panel or frame.

aquamanile A vessel designed to hold and pour water.

arabesque Stylised plant motif, developed from the spiralling vine with leaves and tendrils.

āya A verse of the Koran.

baha'i faith The religion developed by Bahā Allāh from the doctrine of the *Bāb*, a 19th-century Persian mystic. It combines Islamic with Christian and other elements.

basmala The accepted abbreviation for the Koranic formula *bismillāh al rahmān al-rahīm*, 'in the name of God, the merciful, the compassionate,' used to preface inscriptions and manuscripts.

bevelling The carving of outlines at a slant, giving a rounded effect.

bihari script A decorative, angular script used in India during the medieval Sultanate period for writing Arabic, especially Korans.

blazon A badge bearing one or more devices to indicate personal prestige and political standing.

blind-tooling Ungilt ornament impressed on leather.

boss Projection in high relief to decorate metalwork and bookbindings.

caliph (Ar. *khalīfat rasūl Allāh*) Title of the supreme head of the Muslim community as successor to Muhammad, often called in inscriptions *amir al-muʾminīn*.

cameo technique The cutting of gems, ceramics and glass in high relief, especially in contrasting colours.

cartouche In surface decoration, a panel, rounded-oblong or oval, often enclosing inscriptions.

chamfered Cut obliquely (of an edge): furrowed or grooved (of a surface).

champlevé In surface decoration, cutting away the background, leaving the design in relief. The cut-away surfaces may (in ceramics) reveal the clay body, or (in metalwork) be then coated with coloured enamels.

cloisonné A metal surface decorated by division into compartments (cloisons) by soldered-on strips and then applying different-coloured enamels to different compartments.

colophon The inscription, generally closing a manuscript, where the scribe records his name and often the date and place of completion.

compound twill Twill weave in which a pattern is produced by bringing various weft threads to the surface of the cloth.

cuerda seca Decoration of tiles by painting them with different coloured glazes kept in place by waxed outlines, as opposed to faience mosaic.

cursive script One in which most letters are joined on, not written separately. This can alter their normal form.

damascene To decorate steel, especially swords, by etching, inlaying, encrusting or producing a watered appearance.

dervish Throughout Islam, a member of a religious fraternity, often Sufi i.e mystic. In Persian and Turkish, also a religious mendicant or ascetic (*faqīr*).

doublures The inner cover of a bookbinding.

dīwān Originally, account books: an anthology: a collection of poems by one author: a sofa, thence, a room so furnished, thence the ruler and his advisors in council: or simply a government office.

floriate Of scripts, decorated with floral forms (half-palmettes, rosettes, etc).

foliate Of scripts, those whose strokes terminate in leaf shapes.

frit A mixture of ground quartz and flux which, when used both for the glaze and, mixed with clay, for the body of pottery, ensures their proper fusion.

ghalyān Water-pipe for smoking tobacco (alias hookah, hubble-bubble, nargileh).

ghazal (pl. ghazaliyyat) A form of short lyric poem.

guillochis (or guilloche) Surface decoration in wavy lines twining and crossing symmetrically.

ḥadīth Tradition recording the deeds or words of Muḥammad and his Companions. After the Koran itself, the most authoritative source for Islamic theology and law.

hatay elements Of Chinese (Cathay) origin (used in Turkish ceramic patterns).

hijra Muḥammad's migration from Mecca to Medina in 622, from which the Muslim era (AH) is reckoned in lunar, not solar, years.

imam The prayer-leader in a mosque. Sometimes used of the Caliphs: and in Shi'a Islam, one of the line of recognised descendants and successors of Muḥammad.

imāmzāda In Persia, a saint's tomb, generally a small square or polygonal building surmounted with a single dome.

in-glaze painting In ceramics, painting colours into the glaze before firing.

jallī, jalīl Of scripts, majestic – i.e extra-large and imposing.

kaftan Ankle-length, long-sleeved outer robe.

kalyan See ghalyan.

kātib Scribe.

khamsa A collection of five poems, usually of romantic narrative.

khāngāh (ar. khānqāh) A meeting-house or hostel for Sufis.

khuṭba A sermon in the mosque before Friday prayers. It usually mentioned the ruler and thus had potential political significance.

kilim A patterned cloth in which coloured weft threads are interlaced with the warp only where required to form the pattern.

kitābkhāna At a ruler's court, the organisation for producing manuscripts; it employed scribes, miniaturists, gilders, bookbinders, etc.

koran The sacred book of Islam. As the very word of God revealed to Muḥammad, it must be carefully written, complete with all vowels, to avoid corruption.

kufic (from an erroneous ascription to Kufa in Mesopotamia). The monumental script of the early Korans and inscriptions – thick, compressed, angular, often discontinuous.

lajvardina ware (from *lājvard*, lapis lazuli or cobalt) Persian pottery painted in colours and gold over deep blue or turquoise glazes.

lakabi ware Pottery decorated in polychrome glazes, the different colours being kept apart by the grooved or raised pattern.

lam-alif The Arabic letters l and a combined in a V with the right arm vertical. Often used decoratively in inscriptions.

lampas A weave giving a pattern in relief on a smoother background.

lattice-work In book-binding, leather or paper cut in geometric or spiral patterns and placed on a coloured ground.

lustre ware Pottery or glass decorated by applying metallic pigments over the fired glaze and then gently re-firing.

madrasa (literally, learning-place) A seminary, teaching especially Muslim theology and law; a courtyard with one or more large arched recesses for classes and with students' quarters, usually adjoining a mosque.

marvering Decorating glass by winding opaque glass threads round the molten vessel and pressing them with a rod.

mukḥula A box for kohl (antimony) for painting eye-shadow.

maqāla A chapter or section of a book.

maqṣūra An enclosed space at the qibla end of the mosque reserved for the ruler.

mashrabiyya Lattice-work of turned or carved wood, particularly for enclosing balconies, making screens or minbars (pulpits).

mathnawī Poem in rhyming couplets, usually Persian, especially the mystical poems of Jalāl al-Dīn Rūmī.

merlons On a crenellated parapet, the projections between the embrasures.

mihrab A niche in a mosque indicating the direction of Mecca which worshippers must face when praying.

mimbar The pulpit-like structure in mosques from which the *khuṭba* or

Friday sermon is preached.

minai ware Persian 12th-13th century pottery decorated by applying delicate colours (often portraying human figures) over the fired glaze and gently re-firing.

mudhahhib A gilder or illuminator.

muraqqa' An album for mounting detached miniatures or specimens of calligraphy.

naqqāsh A decorator, draughtsman or painter.

naskhi The standard Arabic handwriting, thinner and more cursive than Kufic.

nastaliq An elegant handwriting developed from naskhi in 14th century Persia and common to most Persian manuscripts thereafter, with flowing horizontal and downward-oblique strokes.

niello A black compound used as a metal inlay, particularly on silver.

palmette A heart-shaped stylised plant motif with radiating symmetrical lobes.

pointing The Arabic signs for short vowels, generally omitted in texts other than the Koran.

qibla The direction of Mecca, which a Muslim should face when praying.

repoussé Metal decorated in relief by using a snarling iron from the back.

reserved pattern One formed by filling in the ground and leaving the motif in silhouette.

revetment Facing, such as a brick wall with plaster.

rīhānī (from the 9th century scribe Ali b. 'Ubayda al-Rīhānī) A monumental or ornamental variant of certain Arabic scripts.

rūmī From Rum, i.e Byzantium, Asia Minor or Anatolia: in Turkish ceramics, motifs of Islamic as opposed to Chinese origin.

sabīl Public fresh water fountain.

shabah mufragh (literally, cast brass) An alloy of copper, lead, zinc and tin.

shahāda The Muslim profession of faith *ashhadu inna lā ilāh illā Allāh wa Muhammad rasūl Allāh*, 'I bear witness that there is no god but God and Muhammad is His prophet.'

shāhnāma (literally, The Book of Kings) A Persian epic of pre-Islamic Persian legend and history by Firdawsī of Tūs (died 1020).

shamsa (From the Arabic *shams,* sun) In manuscript illumination, a large disc, generally with rays, at the opening of a manuscript and sometimes serving as an ex-libris for the patron who commissioned it. More generally, a decorative rosette or roundel.

sharī'a (Literally, the road) The corpus of Islamic law regulating for Muslims their religious and secular duties and prohibitions.

shi'a sect Muslims believing in a hereditary caliphate or imamate descending from Muhammad through his son-in-law 'Ali b. Abū Tālib.

shikasta A highly cursive Persian script, often difficult to read because of its unorthodox ligatures.

slip Liquid clay giving a white or coloured surface to earthenware.

spandrel The areas of wall either side of the upper part of an arch.

stippled Incised with dots.

sunni As opposed to Shi'a, one who rejects the theory of a hereditary caliphate or imamate.

sura Chapter of the Koran. There are 114, arranged in descending order of length.

ta'līq script Developed in 14th century Persia from the cursive Arabic naskhi. It has flowing

horizontal and downward oblique strokes.

thuluth A rounded Arabic script, less workaday, taller and more sinuous than naskhi, much used for Korans and inscriptions, especially Koranic ones.

tin glaze Glaze made white and opaque by adding tin oxide.

tooling The impressing of ornamental design on leather by using heated tools or stamps: usually gilded.

twelver shi'ite The shi'a sect believing in twelve Imams, the first being the son-in-law of Muhammad, 'Ali b. Abū Tālib, and the last having "disappeared" in 878, but due to return at the day of judgement. Other sects have fewer imams.

twill A weave in which warp and weft are interlaced to suggest diagonal ribs in the cloth.

underglaze painting Where pigments are applied to the surface of a vessel and covered with a transparent glaze.

'unwān (literally, title) Illumination forming the title page or frontispiece of an Arabic or Persian manuscript. It may also begin a new section of the manuscript.

warp The longitudinal threads on a loom, through which the weft is then threaded.

weft The transverse threads passed through the warp to make cloth.

waqf The legal form whereby property is transferred to a mosque or other pious purpose: the property so transferred. **Waqfiyya**, the written record of such a transfer.

waqwaq tree A legendary tree, found in the equally legendary Waqāq island, whose fruit resembled men and other animals. It sometimes talked.

Note on Transliteration and Translation

Arabic, Persian and Ottoman (i.e. pre-1928) Turkish are written in the Arabic alphabet of 28 letters, to which Persian and Turkish add another 4, making 32 letters as against the English 26, and 31 of these are primarily consonants (only 21 in English), short vowels being added only in the Koran and school-books.

Some of the extras are consonants like sh, which English renders by two letters, or distinguish between two consonants rendered in English by one letter (got and gin) or one combination (thin and this), or lack any regular English letter or letters to represent them. But there is a hard core of Arabic letters representing sounds unknown to the British palate: some indeed to the Persian and Turkish palate too, but the full Arabic alphabet continues to be used with confusing results.

All this complicates systematic transliteration if it is to reflect pronunciation. But where, as here, transliteration's main function is to render into English letters *written* symbols, not sounds, the need is a constant English symbol to render each additional consonant as written in the Near Eastern languages. No attempt is therefore made to reproduce Persian or Turkish pronunciation of consonants, e.g. by writing *masal* for *maihal* or *va* for *wa*, or the spoken assimilation of the article *al* in Arabic.

The difficult Arabic letters (i.e. those with no English equivalent sound) are rendered as follows:
Hard H by ḥ as *ḥammān*, hard S by ṣ as *ṣāliḥ*, hard D by ḍ as *ḍaraba*, hard T by ṭ as *ṭāhir*, hard Z by ẓ as *ẓulm*, 'ayn by ' as *'arafa*, qāf by q as *qalb*, hamza by ' (but only in the middle or end of words, as *mu'minīn, mabda'*),

and soft h in feminine endings by -a, or -at before a vowel, as *ḥijra, ḥijrat al-Nabī*.

Other consonants are rendered by their obvious English equivalents, including sh, ch, and kh (without underlining) but distinguishing the two th's – "thin" by th, "then" by dh, as *thumma* and *dhālika*, and the two g's, gin and got, by j and g, as *jamāl giriftan*, and the soft z as in "measure" by zh (Persian and Turkish only, and then mostly in borrowings from the French, as *zhandarm*).

The transliteration of vowels is more difficult: the short ones seldom appear in inscriptions and the long are not always written as spoken – e.g. the same unvocalised symbol can be pronounced at the end of a word as ā or ī. Here any rational transliteration has to reproduce pronunciation, not simply to render one Arabic symbol by a constant English one. The pure long vowels are ā, ū, and ī, the diphthongs iyy, aw and ay. Of the short vowels, fatha is a, damma is u and kasra is i. E and o are not used in Persian, whose music cannot be adequately rendered without them.

Elisions are reproduced when written as well as spoken, e.g. *bi'l*, "to the," where the alif disappears in writing, and disregarded when not written, as in *abū al fatḥ* or *fī al Qur'ān*. There are exceptions – in particular *wa'l*, "and the," instead of *wa al*, although the alif of *al* is still written.

The final vowel, or nunation, of nouns is generally omitted, e.g. *kitāb*, not *kitābu* or *kitābun*, except where followed by a suffix, e.g. *kitābuhu*. For verbs, the final vowel is reproduced in the perfect, e.g. *kataba* and *katabtu*, but omitted in the

aorist, e.g. *yaktub, aktub*, etc.

Theoretically the problems of transliterating inscriptions differ from those presented by Arabic words and names in the middle of an English text, and it would have been less pedantic and less troublesome for the printer had diacritical marks and quantities been confined to the transliteration of inscriptions. But it seemed confusing to render the names of people differently in inscriptions and elsewhere. However an effort has been made to economise in diacritical marks and quantities in other names and words, and to use, where such exist, the version to be found in standard English reference books. There is indeed much to be said for a robust attachment to traditional versions such as Mameluke, Turcoman, vizier, caliph and for eschewing Arabic words where there is a close English equivalent: but exceptions had to be made, and scholars whose Arabic is better than their English must not be forgotten.

Translation Arabic inscriptions, and those of Persian and Turkish artefacts are often in Arabic, employ a stereotyped vocabulary (for the supreme example see the sycophantic metal pen-box from Mamluk Cairo, no. 224). Nearly all the inscriptions here reproduced are either (*a*) long lists of titles applied to rulers, generals, etc.; while some of these may have a defined meaning, most are empty – and flatulent honorifics, though there is some distinction between those for soldiers, administrators and clerics: and (*b*) somewhat shorter lists of benedictions – glory, victory, prosperity, etc. – to the owners of the objects inscribed. Sometimes the same honorific or benediction is used more than once in the same inscription – presumably the craftsman's vocabulary gave out before the space he had to fill. For both categories, the principle has been to render each Arabic word by one standard English one. The power of English to represent both categories is limited not only by the comparative meaninglessness of the originals, but also by the discrepancy between Arabic's vast repertoire of sonorous language and the more economical and less effusive nature of English. Thus the English rendering should sometimes be considered more as a constant cypher group or symbol representing a given Arabic word than a translation of it, and too much importance should not be attached to the actual English word chosen.

The other main category of inscriptions is extracts from the Koran. Here the contributors have naturally drawn on standard translations, attributing their quotations where appropriate. There is thus no question of a uniform vocabulary.

Some pieces have other religious inscriptions, particularly invocations to God, using the many epithets applied to Him, the so-called "beautiful names" (*al-isma al-ḥusna*), often in the form *Yā Raḥmān, Yā Ghāfir*, O Merciful, O Forgiving: or to revered figures such as ʿAli and other Shiʾa imams. Here standardisation has been attempted.

Those responsible are deeply conscious that in spite of all their efforts, the rules laid down above have probably been broken in many places and that the complete uniformity aimed at has not been achieved.

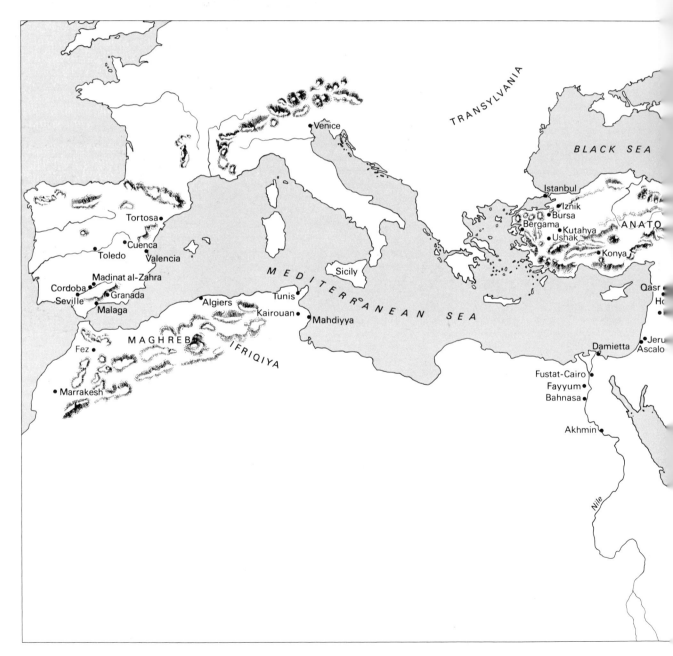

TRANSYLVANIA

BLACK SEA

Venice

Istanbul
Iznik
Bursa
Bergama
Kutahya
Ushak
ANATO
Konya

Tortosa
Cuenca
Toledo
Valencia
Madinat al-Zahra
Cordoba
Seville
Granada
Malaga

MEDITERRANEAN SEA

Sicily

Qasr
Ho

Algiers
Tunis
Kairouan
Mahdiyya

MAGHREB
IFRIQIYA

Fez

Jeru
Ascalo
Damietta

Marrakesh

Fustat-Cairo
Fayyum
Bahnasa

Akhmin

Nile

44

The map indicates cities, sites, regions and physical features referred to in the catalogue but is otherwise simplified. Modern political boundaries are omitted.

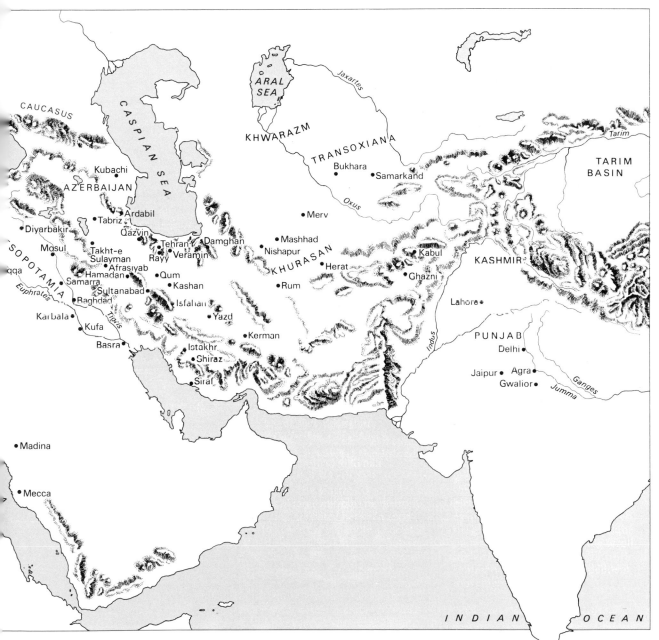

CAUCASUS

CASPIAN SEA

ARAL SEA

Jaxartes

KHWARAZM

TRANSOXIANA

TARIM BASIN

Tarim

Kubachi

AZERBAIJAN

Bukhara

Samarkand

Ardabil

Tabriz

Merv

Oxus

Qazvin

Diyarbakir

Tehran

Damghan

Mashhad

Mosul

Takht-e
Sulayman

Rayy

Veramin

Nishapur

Kabul

KASHMIR

...SOPOTAMIA

Afrasiyab

Hamadan

Qum

KHURASAN

Herat

Ghazni

..qqa

Samarra

Kashan

Rum

Euphrates

Sultanabad

Lahore

Baghdad

Isfahan

Indus

Karbala

Tigris

Yazd

PUNJAB

Kufa

Kerman

Delhi

Basra

Istakhr

Jaipur

Agra

Ganges

Shiraz

Gwalior

Jumma

Siraf

Madina

Mecca

INDIAN OCEAN

Map drawn by Peter Bridgewater

45

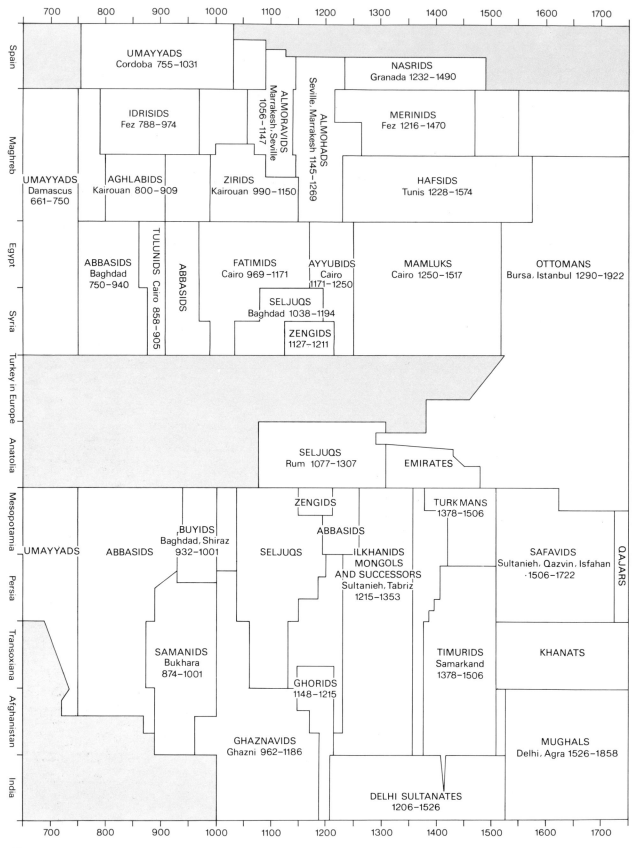

46

Index of Objects

The historical chart opposite does not to attempt to express the political complexity of the many periods of Islamic history and a large part of Central Asia, China, South-East Asia and sub-Saharan Africa are not represented. Throughout the catalogue dates are normally given in the Christian era though there are occasional references to Muslim dating. The Islamic era began in 622 AD which corresponds to AH 1 (*anno hijra*, the year of the move of Muḥammad to Medina).

294 Bowl
Los Angeles County Museum
East Persia, 10th century

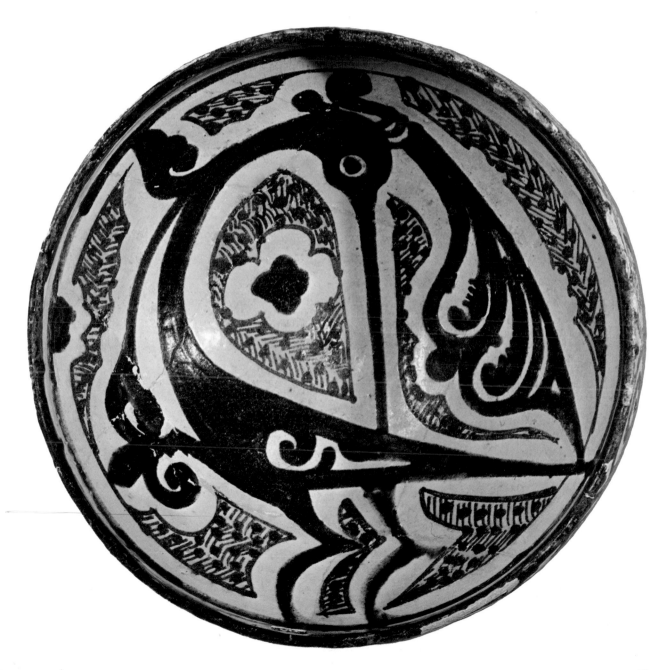

وقف

بسم الله الرحمن الرحيم وقف وحبس وسبل وابد وتصدق
العبد الفقير الى الله تعالى ابو سعيد سيف الدين كمري عبد الله الساقي الملكي الناصري
اعاد الله عليه من بركات القرآن العظيم جميع هذه الربعة الشريفة وعدتها ثلثون جزءًا
على كافة المسلمين ينتفعون بها في اقراء والمطالعة والنقل والدراسية وجعل مشتغرها المزيد
التي يعرف بانشاد بالصواية الصغرى المجاورة لجوس الملك الظاهري لحال ذلك كذلك الى ان
يرث الله الارض ومن عليها وشرط الواقف وسرط الواقف المذكور وما راعاليه ان الاربعة المذكورة
يكون مشترها با لقته التي بالربة المذكورة وافعال ان يخرج من المزيد المذكور ولا تعار ولا ترهن ولا
يخرج الا للاصلاح محتام على غيره او يدل ممن يرد لا عدو ماسعه فاما الاجال الذين يدعك الوند ان الله
سميع عليم وجعل الواقف المذكور النظر لنفسه وجال حياته ثم من بعده لمزيد الارشد فالارشد فاذا
انقرضت الذرية ولمن يكن احد يكون نظر ذلك لمن يكون من صلحاء المسلمين المزيد المذكور وقف هذا الواقف
على الله الذي لا يضيع اجر من احسن عملا وقع الاشهاد على الواقف المذكور سابع والعشرين من شهر
جمادى الاخر سنة سبع وسبعين وستمايه

Opposite
528 Koran
National Library, Cairo
Persia, 1314–5

224 Pen-box
Museum of Islamic Art, Cairo
Egypt, 1361–3

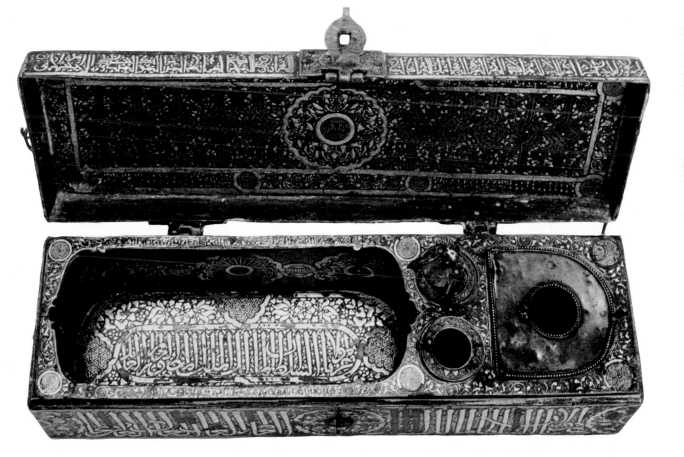

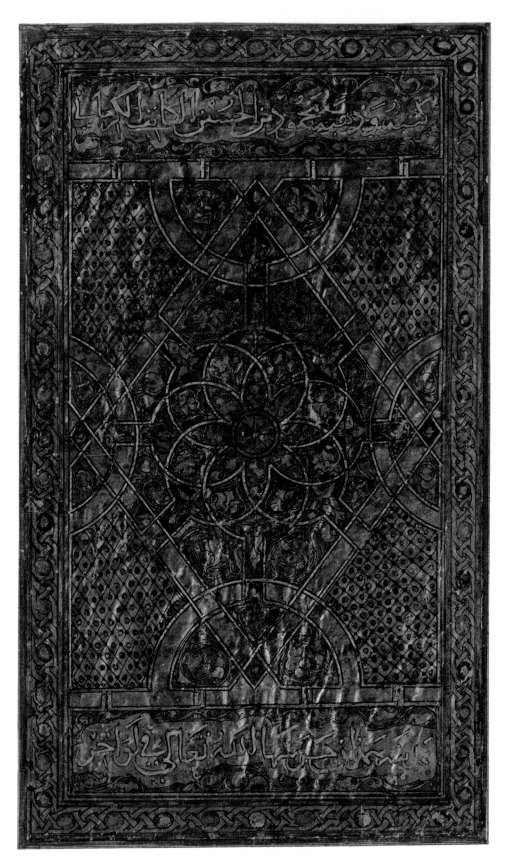

508 Koran
*University Museum,
Philadelphia*
Persia, 12th century

Opposite
526 Koran
*Iran Bastan Museum,
Tehran*
Persia, 14th century
not exhibited

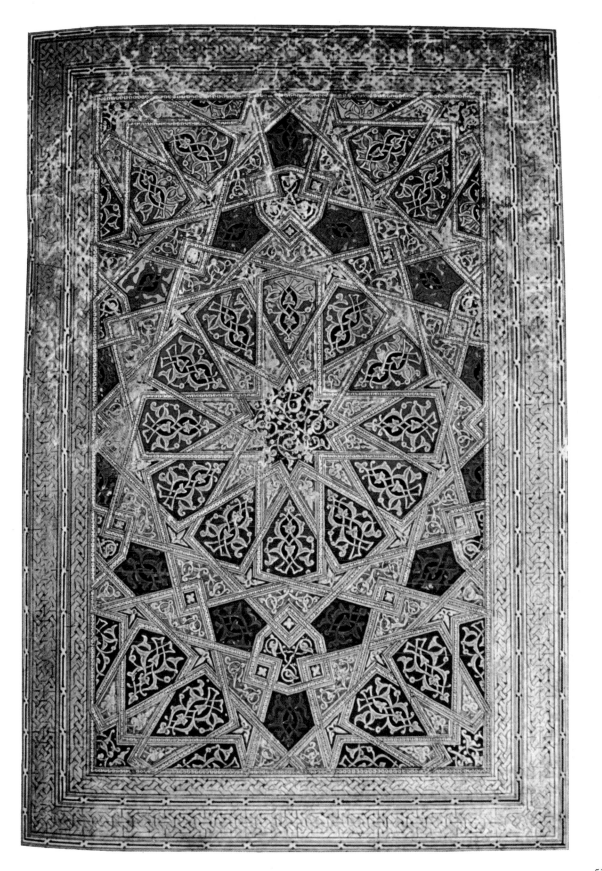

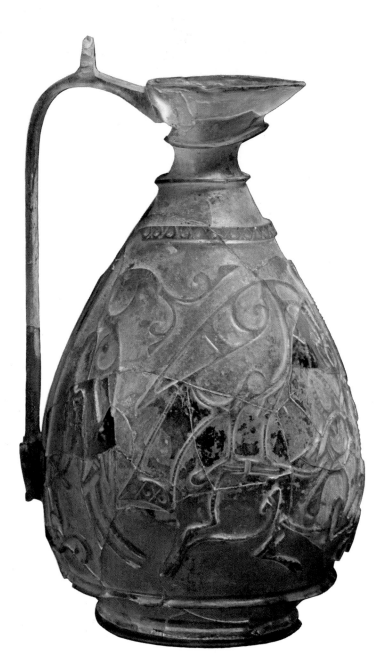

132 Ewer
Private collection
Persia, 10th century

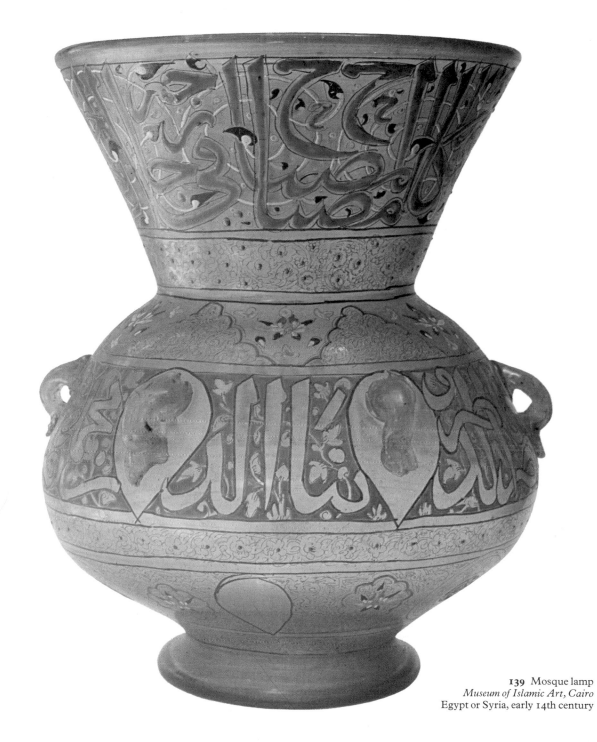

139 Mosque lamp
Museum of Islamic Art, Cairo
Egypt or Syria, early 14th century

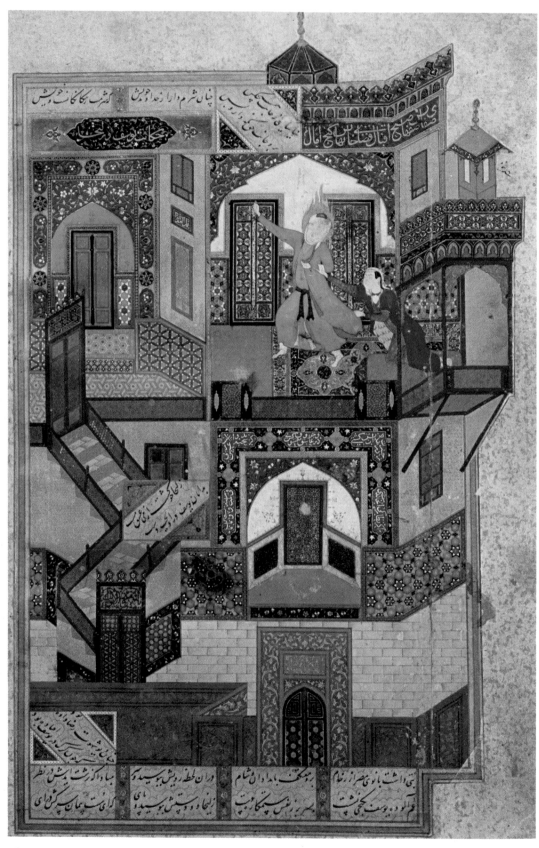

Opposite
612b Miniature
from *Falnāma*
Musée d'art
et d'histoire,
Geneva
Persia,
16th century

581
Miniature
from *Būstan*
National Library,
Cairo
Khurasan,
15th century

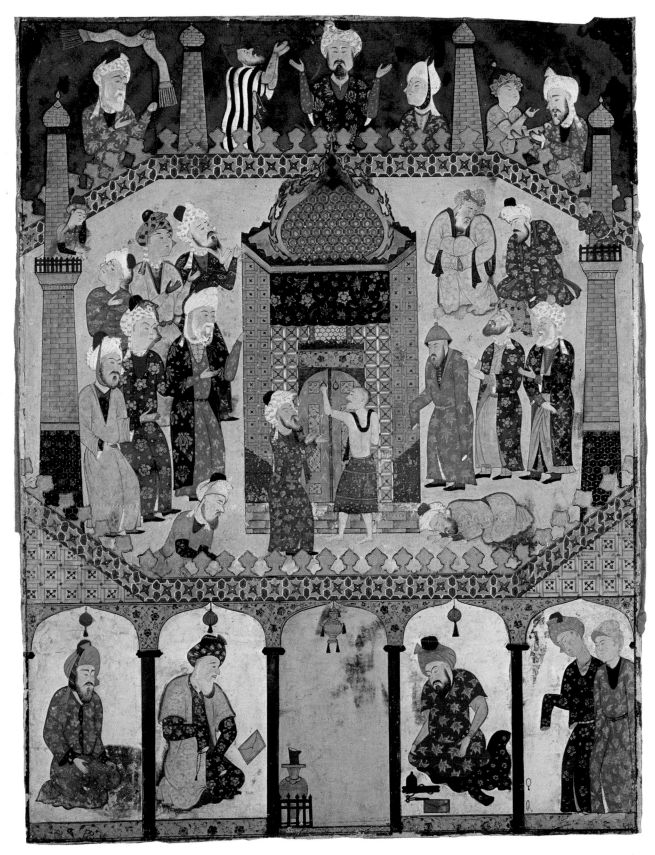

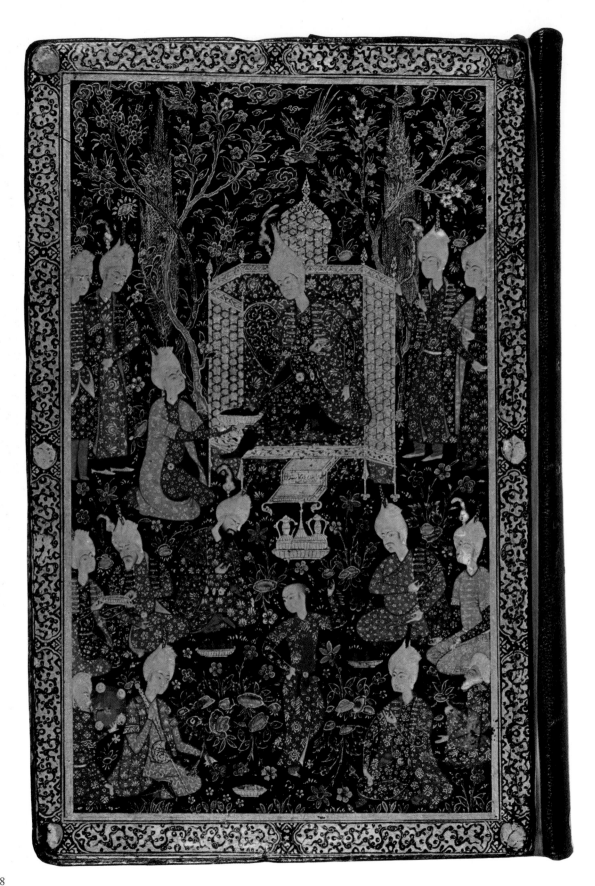

58

Opposite
605 Binding from *Nawā'ī*
British Library, London
Persia, 16th century

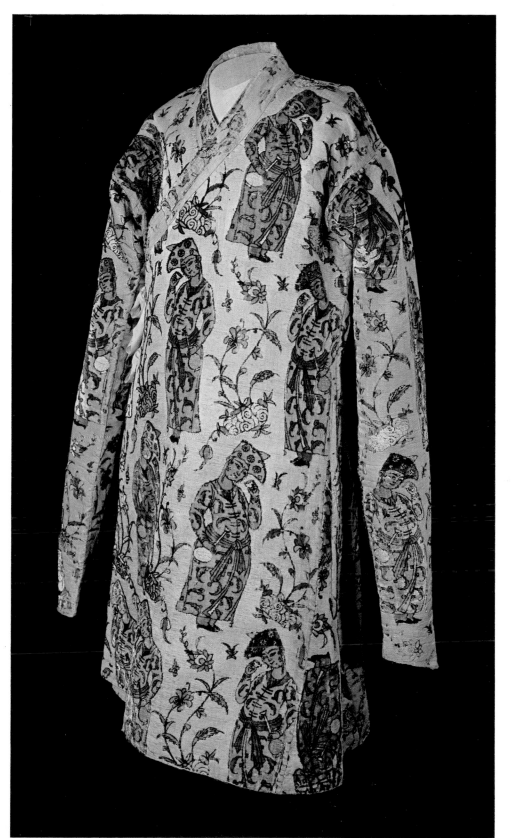

84 Velvet coat
Royal Armoury, Stockholm
Persia, first half
17th century

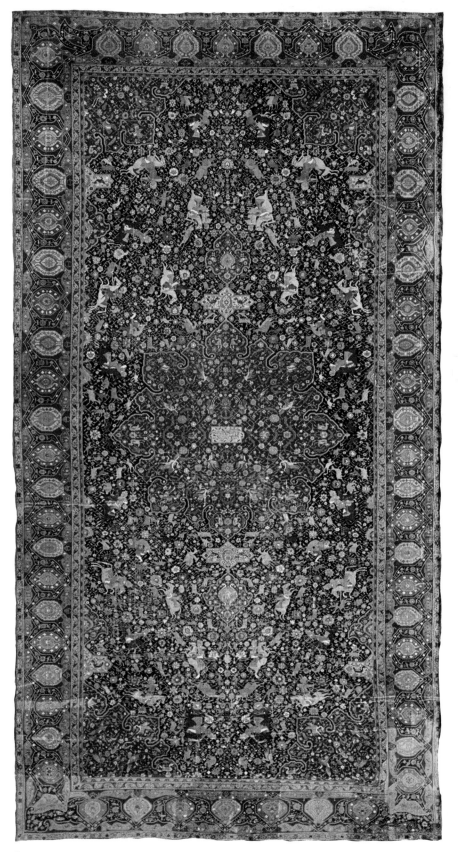

Opposite
83 Detail of velvet
Royal Ontario Museum, Toronto
Persia, early 17th century

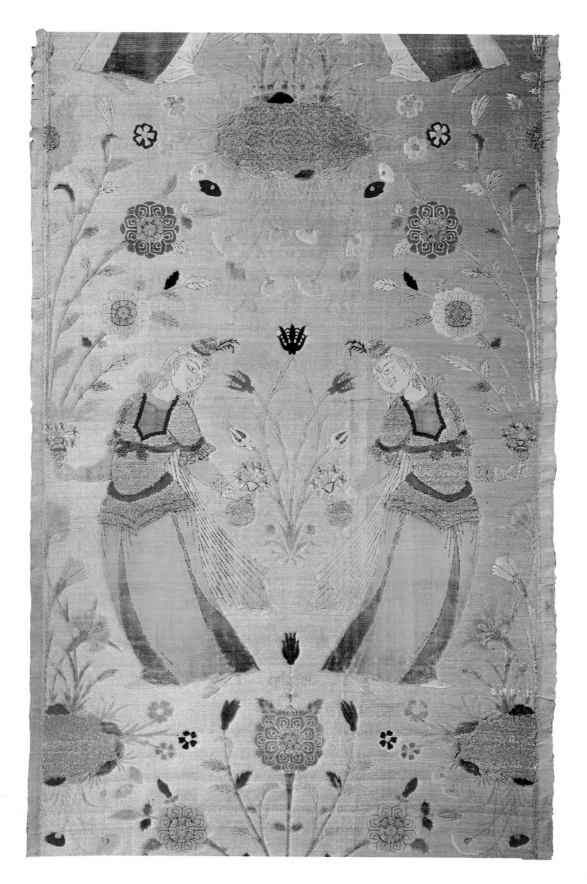

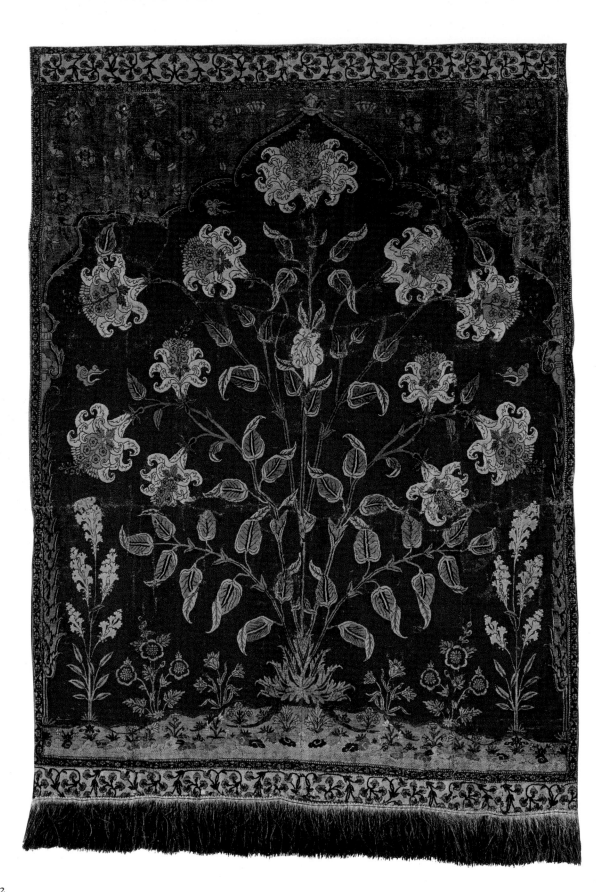

Opposite
100 Prayer rug
Thyssen-Bornemisza Collection, Lugano
India, second quarter 17th century

413 Bowl
Godman Collection, England
Turkey, about 1550

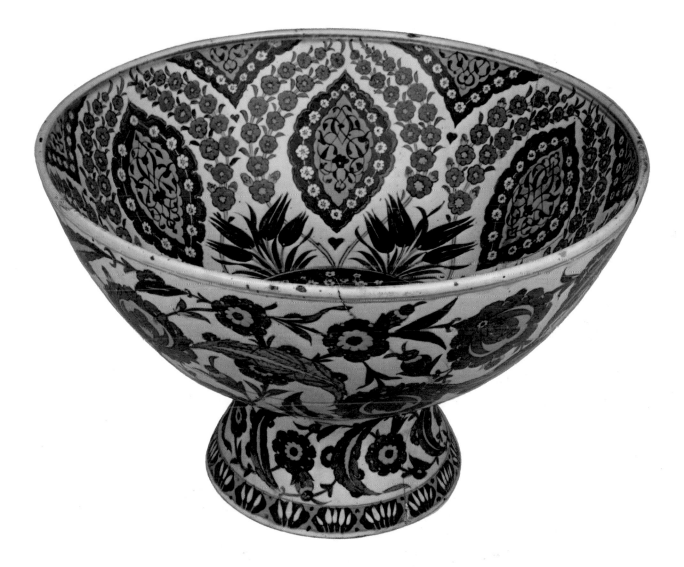

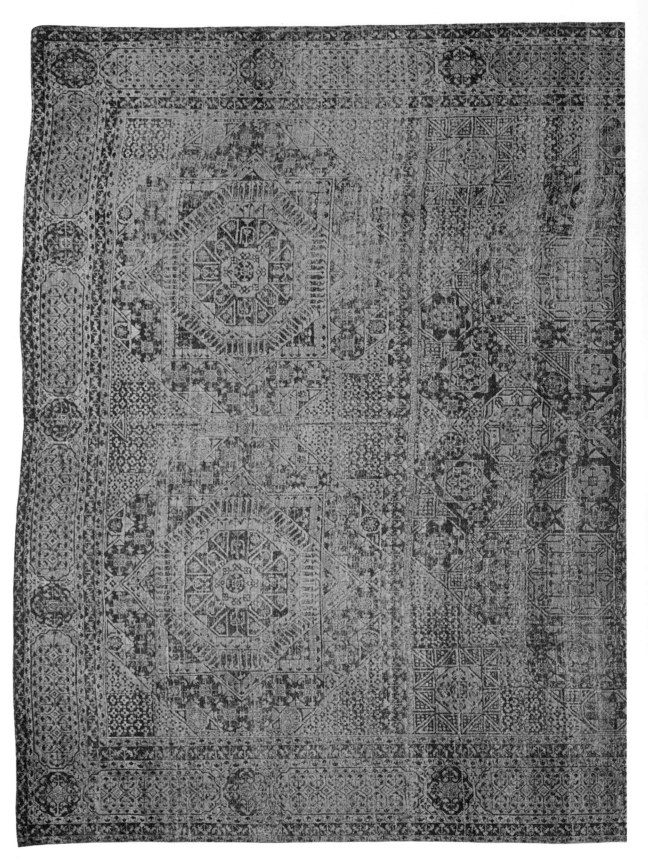

Textiles

The Islamic world has a long history of excellence in the field of decorative textiles. And this is not surprising when one considers that the religious and intellectual foundations of Islamic art tended to give it a natural bias towards two-dimensional, repetitive, infinitely extensible patterns, which is precisely what is required for textile design. Moreover, as the Islamic world commanded not only an abundance of the essential raw materials – silk, wool and dye-stuffs – but also the technological skills to exploit them, it was in a position, in addition to supplying local needs, to export considerable quantities of luxury textiles to non-Islamic areas, including Europe. Thus many of the patterned silk stuffs used in Europe during the Middle Ages were produced by Islamic weavers; there are superb examples of these exports in the present exhibition. Similarly, during the Renaissance and down to the present day, Oriental carpets have been exported in vast quantities to the entire civilised world; of these also many fine specimens are displayed here.

Techniques and Designs Decorative textiles are produced in a variety of ways. One familiar method is that of embroidery or needlework, in which a pattern is worked with needle and thread on a plain material. Islamic embroideries in gold thread have long been admired in Europe as well as in their native lands; the fine example shown here, a gold embroidered Turkish saddle-cloth which was given to King Gustavus Adolphus of Sweden in 1626 (no. 27), also illustrates the European taste for rich Oriental horse-furniture. The great variety of silk needlework produced, in local styles, in many parts of the Islamic world, lies largely outside the scope of the exhibition, but one sample has been included – a powerfully stylised 18th century piece from the Caucasus (no. 92).

In nearly all the finest Islamic textiles, however, the pattern is not added to the cloth with the needle after weaving, but is actually incorporated in the textile by the weaver during the weaving process. Of the various ways in which this can be done, one of the most important in the Islamic world is that of carpet-knotting. In this technique, warp threads are stretched on the loom and weft threads are interlaced with them at right angles as in weaving a plain cloth, but after every few weft threads additional lengths of thread are knotted or looped round the warp threads, so as to form a pile which stands more

41 detail

Opposite
35 Detail of Carpet
*Österreichisches Museum
für angewandte Kunst,
Vienna*
Egypt, 16th century

or less erect on the plain woven foundation. The two principal types of knot employed are commonly known as the Persian and Turkish knots, in accordance with the preference of the two countries, but both types are in general use and neither is confined to the area from which it takes its name.

The technique of carpet-knotting is well adapted to pattern making, for each knot produces a coloured spot in the pile, like a cube in a mosaic, and by using threads of different colours, the thousands or even millions of knots in a carpet can form designs of every degree of refinement and complexity.

Knotted carpets with complex patterns were made in Western Asia long before the advent of Islam, as is strikingly demonstrated by the superb example of about the 5th century B.C. found at Pazyryk and now in the State Hermitage Museum, Leningrad. A celebrated carpet of Sasanian Persia, the so-called 'Spring of Chosroes', discovered by the Muslim conquerors in the palace of Ctesiphon in the 7th century A.D., depicted a garden with flowers, fruit and shrubs. The idea of a garden in perpetual springtime – the flowers, the trees, the sounds of water and of birds – has remained especially pleasing to the peoples of Islam, many of whom dwell in relatively arid climates, and it is constantly evoked in their carpets and textiles. It is prized not only for its appeal to the pleasure of the senses, but also for its refreshment of the spirit, and it may even assume religious and cosmological significance by its allusion to the ultimate garden, that of Paradise. A type of design with a more specific religious purpose is the motif of the arch (or arches) often found in the prayer rugs upon which the devout Muslim, turning towards Mecca, recites his prayers. This arch evokes the niche or mihrab in the Mecca-facing wall of the mosque and with it is sometimes associated a representation of a mosque lamp, suggesting divine illumination, or of a cistern or ewer, suggesting the purity required of the individual. Apart from prayer rugs, carpets are used in the Islamic world primarily as decorative floor-coverings, much as they are in Europe and America, but since traditionally the Oriental house was otherwise very sparsely furnished the carpets were seen unencumbered and played a more dominant role in the effect of an interior. It was normal practice in the East to remove shoes before walking on carpets and a further difference from Western usage lies in the fact that the Oriental traditionally sat or knelt directly on the carpet, or on a low divan or cushion, so that he was not so much above, but rather *in* the carpet, and was thus more conscious of its tactile qualities and saw its design from a lower viewpoint, in sharper recession. Carpets were not, of course, designed to be hung on the wall like pictures, though unfortunately it is often necessary to exhibit them in this way.

The designs of carpets and other textiles were originated, not by weavers, but by designers, who might be professional painters or miniaturists. It is true that in tribal and village rugs, or in large-scale commercial production such as that of the Ushak area in Anatolia, a design, once established, might be repeated and adapted by the weavers for generations, even for centuries, without further recourse to a designer. But in the carpets and silk textiles produced in the work-

13 detail

shops of courts and cities, for palace use, for diplomatic gifts, or for the luxury trade, there was an incessant demand for new designs. The carpet weavers were executants, but necessarily highly trained, since the translation of the design into knotted pile depended on their skill of eye and hand. In making a small or narrow rug a weaver would normally work alone, but for a wide carpet several weavers would work together side by side; the idea of a single craftsman working alone for many years on a large carpet is a product of Western imagination. The weavers were part of a commercial system involving investments, markets, reasonable financial returns and a number of ancillary industries, notably that of the dyers, whose contribution to the finished carpet or textile is absolutely fundamental.

Unlike woollen rugs, which were often woven in a village house or a tribal tent, textiles of silk and gold thread (generally consisting of a gilt metal or gilt membrane strip wound spirally on a silk thread) were invariably produced in the workshops of courts and cities. Those woven by the tapestry technique, in which weft threads of various colours were interlaced with the warp threads only where each particular colour is required by the design, are akin to carpets, in that the weaver, relying on his skill of hand and eye, constructs the pattern bit by bit as a mosaic or map of differently coloured patches; fine examples of various periods are exhibited here (nos. 8 and 63). Most of the silk textiles in this exhibition, however, were woven in a different way, with the aid of a relatively complex mechanism known as the drawloom, which came into use from about the 3rd century A.D. onwards. On this apparatus the weaver interlaces the coloured weft threads with the warp threads across the whole width of the loom, while an assistant operates a system of cords to ensure that each individual thread appears on the front of the textile only where its colour is required to contribute to the pattern, while elsewhere it is rejected to the back. The drawloom is essentially a device for the precise and automatic repetition of a basic unit of pattern across the width and along the length of the textile, so that it naturally produces repeating patterns, generally though not always, smaller in scale than the patterns of carpets, which need not be repetitive. Silk and gold textiles of this kind were used chiefly for dress, for domestic furnishings – hangings, cushion covers and the like – and for other luxury goods such as saddle covers.

Medieval Islamic Textiles The two main textile traditions existing in the territories conquered by the invading Arab armies in the 7th century were that of the Sasanian Empire in Persia and the Byzantine Empire in the Mediterranean area. These continued to cater for the needs of the indigenous populations and subsequently, as the conquerors began to acquire a taste for such luxuries, for the Muslims also. Thus two of the earliest silk fragments in the exhibition (nos. 1–2), found in Egypt and datable between the 7th and 9th centuries, derive from earlier Mediterranean traditions and apart from their Arabic inscriptions show no particular Islamic characteristics, although in one case (no. 1) the inscription indicates that the silk was

10 detail

produced in a *ṭirāz* or official weaving factory, established in North
Africa to supply the textile needs of the Islamic state. Two splendid
silks which were used to wrap the relics of saints in Europe (nos. 3–4)
were produced at the eastern extremity of the Islamic world, one of
them in the Bukhara area and the other, datable to the middle of the
10th century, in Khurasan. They illustrate the Islamic inheritance from
the Persian textile tradition. Their patterns of great beasts seem
strange to modern eyes but are characteristic Persian symbols of
absolute power. These two silks with their patterns surrounded by
borders also give some hint of the appearance of contemporary
carpets, though no actual carpets have survived from this period.

A remarkable group of silks from the 10th–12th century was dis-
covered about 50 years ago in a necropolis near Rayy in Persia. Two
pieces probably from the original find are shown here (nos. 5, 9)
together with two others which became known somewhat later, but are
believed to come from the same site (nos. 6–7). They illustrate the
characteristic Islamic feeling for the decorative value of fine calligraphy
and a growing refinement in the ornamental detail of the patterns, in
which mythical birds and monsters continue to play a leading role.
Related patterns of beasts and birds, often enclosed in circles, appear in
silks of the 11th–13th century from Southern Spain (nos. 10–12) and
Anatolia (nos. 13–14). An added technical refinement, introduced
about this time, enabled the silk weavers to replace the uniform flat
texture of silk compound weaves with the two-textured effect of the
lampas weave, in which a raised, loosely textured pattern stands out
against a smoother background. At about the same period the silk
weavers began to make increasing use of gold thread.

The Mongol invasions disseminated a taste for Chinese dragons and
other Chinese motifs, as seen in a famous Central Asian silk exhibited
here (no. 15). Other silks of the 14th and 15th centuries from the Near
East (nos. 16, 19, 20), Spain and North Africa (nos. 17–18) show how
the old patterns of animals and birds in circles were replaced in this
period by patterns of stripes or interlace and by lattice patterns with
plant ornament.

Carpets and Textiles of Ottoman Turkey Similar ogival – or wavy –
lattice patterns enclosing tulips and other flowers continued to be
produced by Turkish silk weavers through the 16th century and

beyond (nos. 23–6), along with other characteristic Ottoman patterns such as tiger stripes, leopard spots and crescents (nos. 21, 22, 29). Turkish taste in such matters was evidently conservative and very similar designs were repeated over long periods. The strong and simple lines of the patterns, often rendered in gold on a background of crimson, give an impression of immense confidence and power. The weavers made great use of the new technique of velvet, chiefly for large hangings or covers (no. 28) saddle covers (no. 27) and especially for divan cushion covers (nos. 29–30). At the same time they continued to employ the traditional lampas weave for the silk and gold stuffs made for the striking caftans of the Ottoman court and for the inscribed stuffs which were used for tomb covers and for other religious purposes (nos. 32–3).

Unlike the silks, which were chiefly intended for use within the Ottoman Empire, the production of carpets was geared to a large export trade to Europe. Again the designs, which were notable for the powerful simplicity of their ornamental effects, were extremely traditional and remained in use for long periods. The oldest Turkish rug shown here has a design of octagons – inspired by the circle patterns of medieval silks – containing the motif of the combat of dragon and phoenix, introduced from China by the Mongols; it probably dates from the 15th century, when rugs with this pattern were depicted in Italian paintings (no. 34). The superb Mamluk carpets of Egypt and the related pieces which continued to be made under the Ottomans (nos. 35–6) have geometrical patterns of octagons and stars, related to the interlace patterns of medieval textiles. A similar geometry is seen in the Turkish rugs generally associated with the name of Holbein, although they were also depicted by many other artists; the two principal types, the large-pattern Holbein (no. 37), and the small-pattern Holbein (nos. 38–40), were both current in the 15th and 16th centuries. Related to these were the so-called Lotto carpets, depicted by that painter and many others during the 16th and 17th centuries; though most of these were certainly woven in Anatolia (no. 42), others are now thought to have been produced in European Turkey (no. 41). Numerous large carpets with more elaborate floral patterns are believed to have been produced during the 16th and 17th centuries in the area of Ushak in Anatolia and are generally known by that name; the type known as 'star Ushak', from the star-shaped compartments in the pattern (no. 43), as well as other varieties (nos. 44, 46) are illustrated in the exhibition. Another popular class were the white 'bird rugs', named from the bird-shaped leaves in the pattern, of which one variety is shown here (no. 50).

Unlike the foregoing types, which were extensively exported to Europe, prayer rugs were primarily produced for the Islamic market. Some beautiful examples from the 16th and early 17th centuries, probably produced for the Ottoman court, have patterns which are close in style to the contemporary ceramic tiles of Istanbul (no. 45). Popularised versions of these designs can be seen in many later prayer rugs. The Ushak area, besides large carpets, produced handsome prayer rugs (no. 47), many of them double-ended (nos.

48–9), in the 16th and 17th centuries. The Transylvanian rugs, so-called since so many of them were used in that area, are likewise double-ended and are depicted in many European 17th century paintings (nos. 51–2). Prayer rugs with three arches or six columns (nos. 53–4) are clearly derived from the earlier court style, as are the well-known prayer rugs of Ghiordes (no. 55).

In the 19th century a new Ottoman court workshop at Hereke produced finely knotted rugs in styles derived from early Persian carpets. Many of these pieces, like that shown here (no. 56), were at one time mistakenly classified as Persian 16th-century work.

Textiles and Carpets of Safavid Persia The Turkish products tend to be sumptuous, powerful and severe, with an ornamental repertory restricted to geometry and plant forms, whereas the Persians combine richness of effect with delicacy and elegance, and make extensive use of human and animal subjects, often in more or less naturalistic landscape settings.

These characteristics are well illustrated in a fine group of 16th century carpets in the exhibition, showing animals among scrolls (no. 61) or in landscapes (nos. 59–60), sometimes pursued by hunters (nos. 57, 58). Unlike the exact repetitions of Turkish carpets, the motifs are here constantly re-combined in new compositions by the designers, who were probably miniature-painters and were certainly strongly influenced by the arts of the book. The basic compositional framework of a central medallion and quarter-medallions in the corners – from which such carpets are sometimes classified as 'medallion carpets', though also known, from their subjects as 'animal carpets' or 'hunting carpets' – is derived from book-covers and ornamental pages. It has recently been suggested that the medallion represents the dome of Heaven and it has already been mentioned above that these parkland scenes may refer to Paradise, an interpretation which is sometimes reinforced by the presence of houris (no. 60). The dragons, phoenixes and other creatures, as well as the hunters, may represent the forces of good and evil and symbolic interpretations of this kind can be extended to many of the motifs. It would certainly be an error to ignore such symbolic resonances, but we must also take care not to fall into the opposite error of attempting to read these ornamental compositions as if they were philosophical or theological treatises.

Though most carpets in Persia as elsewhere were knotted in wool, a few of the most splendid of the 16th century carpets have a silk pile (no. 57). Under the reign of Shah 'Abbās I, in the late 16th and early 17th century there was a growing taste for carpets in sumptuous materials, not only silk but also gold and silver thread. A group of very beautiful small silk rugs of this period are generally attributed to Kashan (no. 62). Both Kashan and Isfahan produced luxurious rugs in silk and metal threads, which are often known as 'Polish' or 'Polonaise' owing to a mistaken attribution current in Europe in the 19th century. Most of these rugs are of metal thread and knotted silk pile (nos. 64–6),

92 detail

but some are woven throughout in the tapestry technique (no. 63). The exhibition also includes an important silk rug, signed and dated 1671, from the mausoleum of Shah 'Abbās II at Qum (68). A curious and interesting group of 17th century carpets of uncertain attribution are the 'Portuguese' carpets, so-called because they include a scene of European seamen (no. 67). The vase carpets, named after the vases which appear in the designs, are attributed to Kirman and can be better studied in the concurrent exhibition of Kirman carpets at the Graves Art Gallery, Sheffield, though one unusual example is shown here (no. 69). The so-called dragon carpets from the Caucasus combine plant forms from the vase carpets with dragons and other creatures from the animal carpets in characteristically stylised compositions (no. 70). The admirable rugs of the Turkoman tribes, with their fine rich colouring, are also represented here by a single example (no. 71).

Just as Persian carpets of the 16th and 17th centuries represent the summit of excellence in the design and weaving of carpets, so too the Persian silks and velvets of that period stand in a class of their own in the history of silk weaving. It is a rare and significant phenomenon that the directors of the production workshops were men of such standing that they appended their signatures both to the carpets (nos. 58, 68) and to the silks (nos. 79–83). The silk weavers, thanks to the delicacy of their techniques, could even surpass the carpet weavers in the execution of naturalistic designs and this is one of the few periods in history when patterns of human figures were the leading theme of silks and velvets. There are superb 16th century examples in the exhibition, among which the remarkable velvet tent-ceiling with hunting scenes (no. 73) and the finely preserved silk from Rosenborg Castle (no. 74) may be singled out for special mention. In the early 17th century, effects of even greater luxury and magnificence were achieved in such pieces as the extraordinary velvet from Delhi with large-scale figures of women (no. 85) and the splendid velvet coat which was a gift to Queen Christina of Sweden (no. 84). An unusual use for these fine silks and velvets is illustrated by the small pieces which were used as envelopes for diplomatic letters (nos. 86, 90). Besides the figure subjects, many superb silks and velvets were woven with floral designs (nos. 79, 87–9) and inscriptions (nos. 80–2). Although the quality of the work tended slowly to decline after the middle of the 17th century an excellent

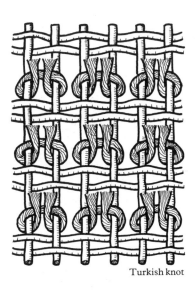

Turkish knot

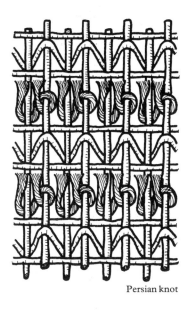

Persian knot

standard was maintained in such works as the silk coat (no. 89) and the large 19th century banner displayed here (no. 91).

Carpets and Textiles of Mughal India The fine textiles produced in the Mughal Empire cannot be omitted from any survey of Islamic art, though it is not possible to represent their full variety in a general exhibition. Some of the skilled textile craftsmen were imported from Persia and it is natural that the products are very closely related to those of that country, so much so that the origin of some examples remains controversial. Nonetheless the Persian prototypes were quickly adapted and transformed in a characteristically Mughal style.

In carpets, for example, the Mughal designers carried Persian naturalism a stage further by abandoning the symmetry and repetition which give a certain formality to all Safavid carpet designs. Instead, they treated the carpet as a picture, with excerpts from nature freely and arbitrarily disposed in a pictorial space defined and framed by the borders. This is well seen in the famous rug with birds and trees from Vienna (no. 98) and the animal carpet formerly at Belvoir Castle (no. 99). Fine prayer rugs with flowering plants under arches are also characteristic of Mughal production (nos. 100–1). Similar floral motifs are also found in silks (no. 93) and velvets (nos. 94–5) and in the beautiful sashes of silk and gold thread which were worn at the Mughal courts (nos. 96–7).

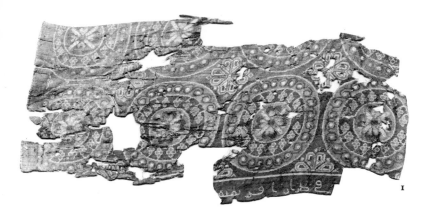

1

1 Silk cloth with circles and inscription

Two pieces, lengths 50.7cm and
21.5cm, widths 30.3cm and 15.2cm
Victoria and Albert Museum, London,
nos. 1314–1888, T.13–1960
Tunisia, Umayyad period,
late 7th-mid 8th century

The inscription embroidered in
yellow silk reads, on the smaller
piece, *Allāh marwān amir al mu..*,
[the servant of] God, Marwān,
Commander of the Faithful' and, on
the larger piece, *Fī Ṭirāz ifrīqiya*, 'in
the factory of Ifriqiya'. A further
scrap of the inscription is in the
Brooklyn Museum. The reference is
to an Umayyad caliph, either
Marwān I (684–5) or Marwān II
(744–50). The latter, who was killed
in Egypt, where these pieces were
found, is generally thought more
likely. This is one of the oldest
extant inscriptions of the official
factories (*ṭirāz*) which played such a
large part in the textile production of
the Islamic world. Ifriqiya refers to
the area of modern Tunisia. The
woven pattern comprises, on the
smaller piece, a band of pearls,
jewels and hearts and, on the larger
piece, circles containing bunches of
grapes and flowers with heart-shaped
petals. These elements, some of
which were inherited from Sasanian
art, were common in early Islamic
ornament. The weave is compound
twill, with warp of red silk and weft of
silk in four colours. The technical
characteristics are identical with those
of silks woven in the east
Mediterranean area from where, no
doubt, the Ifriqiya factory derived its
technical traditions.

Published: Guest (1906, pp. 390–1);
Guest and Kendrick (1932, pp. 185–91);
Day (1952, pp. 39–61)

2 Silk band with running figures, trees, birds and inscriptions

Length 55.8cm, width 9.5cm
Victoria and Albert Museum, London,
no. 2150-1900
Egypt or Syria, Umayyad or Abbasid
period, 8th–9th century

This piece belongs to a class of two-
coloured silks, woven as trimmings
for tunics, which have been found in
considerable numbers in Egyptian
graves, especially at Akhmim. Some
examples include Greek or Coptic
names and were evidently made for
the Christian market, while others in
an identical style, derived from late
Hellenistic art, have Islamic inscrip-
tions. The inscription below the
figures in this example is generally
agreed to be in Arabic script of the
8th–9th century. No satisfactory
reading of it has yet been proposed.
The weave is compound twill, with
warp of undyed silk and weft of silk in
two colours.

Published: Falke (1913, I, p. 47);
Kühnel (1935, pp. 81–2); Day (1954b, 2,
pp. 240–1)

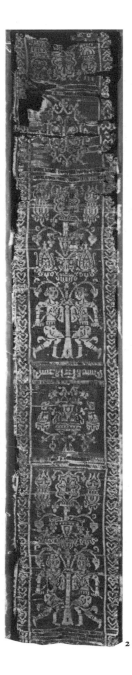

2

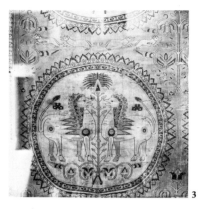

3 Silk cloth with lions and palm-tree in circles
Length 89cm, width 84.5cm
*Musée Historique Lorrain, Nancy,
no. 95-1584*
Central Asia (Bukhara area),
8th–9th century

This splendid silk is thought to have been associated with the relics of St. Amon in the cathedral of Toul, possibly at the time of the translation of the relics in 820. It is a masterpiece of large-scale pattern weaving and is the most distinguished example of a group of silks of which several have been found in European shrines and others at Ch'ien-fo-tung in Kansu. One piece, at Huy in Belgium, has a hand-written inscription in Sogdian which refers to the village of Zandane near Bukhara and has been dated, on palaeographical grounds, to the beginning of the 8th century. The conception of the design of the present piece owes much to Sasanian art and some of the details, including the tree and flower forms, have parallels in the designs found on Sasanian silver objects. Other elements, such as the frill of foliage round the circles and the stylisation of the lion, dog and fox, are characteristic of the Central Asian school of textile design. The remains of a border of hearts on the left suggests that the cloth, like other examples of the group, had borders all round in the manner of a carpet. The weave is compound twill; the warp is of beige silk and the weft is in silk of six colours, now drab, but originally bright and lively. The use of fugitive dyes is characteristic of this group of silks.

Published: d'Avennes (1877, pl. 147); Falke (1913, I, pp. 98–102); London (1931, no. 29); Ricci (1931, no. 286 bis); Shepherd and Henning (1959, pp. 15–40)

4 Silk cloth with elephants and inscription, the 'shroud of Saint Josse'
Larger piece, length 52cm,
width 94cm. Smaller piece,
length 24.5cm, width 62cm
Musée du Louvre, Paris, no. 7502
Persia (Khurasan), Samanid period,
mid-10th century

This majestic textile, known as the 'shroud of Saint Josse', is the major landmark in early Islamic silk weaving. The inscription reads *'izz wa iqbāl li'l qā'id Abī Manṣūr Bakh-takīn aṭāl Allāh baq [āhu]* 'Glory and prosperity to Qā'id Abū Manṣūr Bakh-takīn, may God prolong his existence.'
The personage named here was a Turkish commander in Khurasan who was arrested and put to death by order of his Samanid sovereign, 'Abd al Malik b. Nūh in 961. The superbly assured design with its richly caparisoned elephants, potent symbols of power, has an almost barbaric splendour and a stylisation reminiscent of jewellery or enamel. It is generally agreed that the complete design comprised two tiers of elephants, with inscriptions top and bottom, and a border of camels all around with cocks at the four corners – a composition like that of a carpet. Sasanian elements, such as the cock and the flying scarves of the camels, are associated with Central Asian elements, such as the dragon and the Bactrian camels themselves. The weave is compound twill; the warp is of red silk and the weft of silk in seven colours. The textile is a masterpiece of large-scale pattern weaving, testifying to the high quality of the silk industry in Khurasan, with its main centres at Merv and Nishapur. The pieces were found in the reliquary of Saint Josse at Saint-Josse-sur-Mer (Pas-de-Calais). It has been suggested that they were a gift from Étienne de Blois, patron of the abbey and one of the commanders of the first crusade.

Published: Enlart (1920, pp. 129–48); London (1931, no. 52); Répertoire (1933, IV, pp. 154–5, no. 1507); Pope and Ackerman (1938–9, III, pp. 2002–3, 2030, no. 3); Bernus, Marchal and Vial (1971, pp. 22–57); Paris (1971, no. 228)

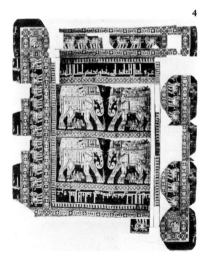

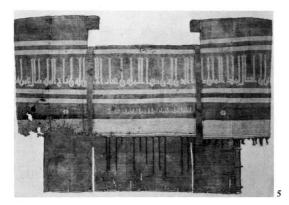

5

5 Silk cloth with inscriptions

Several pieces, length 130cm,
width 290cm overall
*Textile Museum, Washington, D.C.,
no. 3.116*
Mesopotamia or Persia, Buyid
period, about 1000

The large kufic inscription in yellow
on blue reads
> *'izz wa iqbāl li-malik al-mulūk [bah]
> ā al-dawla wa ḍiyā al-milla wa
> 'iyādh al umma [?dawla] wa tāj
> al-milla Ṭāl 'amruhu*
> 'Glory and prosperity to the king
> of kings . . . [Bah] ā al-dawla, the
> light of the community and the
> refuge of the nation . . . the crown of
> the community, may his life be
> long.'

The small inscription reads
> *bi-isti' māl abī sa'īd zādānfarrukh
> bin āzādmard al-khāzin*
> 'for the use of Abī Sa'īd
> Zādānfarrukh, son of Āzādmard,
> the treasurer.'

Bahā al-dawla was the ruler of
Mesopotamia and parts of Persia from
989 to 1012. His capital and principal
centre of activity was Baghdad. The
cloth was made up as a tunic when it
first appeared on the Paris art market
in 1926, but has since been remounted
flat. The owner at that time stated
that he had bought it in Baghdad,
but had been told that it was found at
Rayy; it is presumed to have come

from the tombs on the Naqqara
Khana hill where a number of other
silk textiles were found. The weave is
compound twill. The warp is blue
silk, the weft is of blue and yellow silk
with end bands in light green and
cream silk.

Published: London (1931, no. 73);
Guest and Kendrick (1932, pp. 185–6);
Wiet (1933, p. 21); Répertoire (1935, VI,
p. 96, no. 2177–8); Pope and Ackerman,
(1938–9, III, pp. 2009, 2031, no. 12)

6 Silk cloth with two-headed eagles carrying human figures

Length 170cm, width 65cm
*Cleveland Museum of Art, no. 62.264,
purchase from the J. H. Wade Fund*
Persia, early 11th century

This cloth, almost complete in length
and breadth, is believed to have been
found in a tomb at Naqqara Khana,
an ancient necropolis near Rayy. An
inscription at the top is a verse from a
Diwān dedicated by the poet Buḥturi
to the Abbasid caliph al-Mutawakkil
(847–61) to congratulate him on an
escape from drowning. It reads 'You
remain the Amir of the Faithful and
your preservation is for the epoch an
event of excellent quality.' The
striking pattern of the silk consists of
a great two-headed eagle, repeated
six times, grasping in its talons a pair
of quadrupeds. This ancient motif
goes back to Sumerian times and is
here combined with the theme of the
human figure carried off by an eagle,
familiar in the west through the
Ganymede myth. The cocks in the
wings of the great bird are inscribed
with the word 'pity'. The elaborate
ornamental treatment of details seen
in this silk is characteristic of a

number of pieces thought to have
come from this site. The weave is
lampas with warp-faced tabby
ground and weft-faced tabby pattern.
Warp and weft are of silk.

Published: Wiet (1948, pp. 55–63);
Day and Wiet (1951); Shepherd (1963,
pp. 65–70, and 1974); Lemberg, Vial and
Hofenk-de Graaf (1973)

6

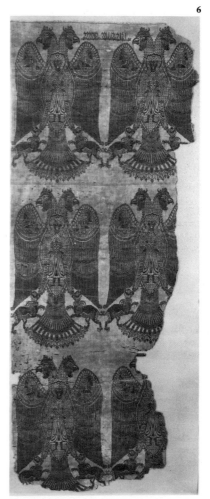

7

7 Silk pall with inscriptions

Length 212cm, width 100cm
Cleveland Museum of Art, no. 54.780,
purchase from the J. H. Wade Fund
Persia, mid-11th century

This pall is reported to have been
found together with part of a wooden
coffin in a tomb on a mountain not far
from Tehran. It is presumed to have
come from the necropolis on the hill
called Naqqara Khana near Rayy.
See also no. 6. The curved inscrip-
tion at the top, designed to encircle
the head of the deceased, reads

'Forgiveness from the Merciful,
the Compassionate, for the slave,
the sinner, 'Alī ibn Muḥammad
ibn Shahrāzād ibn Rasāwayh
al-Iṣfahānī.'

The inscription within, intended to
cover the face

'May God make my face white on
the day when the face becomes
black. I hope that God will render
me radiant on the day of
resurrection.'

This seems to refer to Koran Sura
LXXV, 22–4, which describes the
faces of the righteous as shining
(*nāḍira*) at the resurrection, whilst
that of the unrighteous are frowning
(*bāsira*).
A small circular inscription placed
near the heart reads

'May God make my heart steadfast
to his religion in honour of
Muḥammad and his family.'

The long vertical inscription

'Oh God, I confide my heart which
I bring to you in accepting the
Prophet Muḥammad, the
blessings of God be upon him and
his family and in accepting the
imams upon whom be the peace.
You are the most reliable and the
only one [with authority]. At the
moment of the questions of
Munkar and Nakir, I hope for your
mercy, oh most merciful of the
merciful!'

The reference to the imams indicates
that the deceased was a member of the
shi'a sect. Munkar and Nakir are two
angels described in the Hadīth who
are believed to question the dead in
the tomb concerning their beliefs.
The inscription placed near the
right hand

'May God give my book into my
right hand and make the reckoning
easy for me.'

That near to the left hand

'May God not give my book into
my left hand and may he not let it
be attached and hung from my
neck.'

These inscriptions refer to Koran
Suras XVII, 71 and LXIX, 19 and 25
describing how, on the day of
judgement, the righteous man will
get his record (book) in his right hand,
while the unrighteous gets his in his
left. The reference to records being
hung round the neck appears to be to
Sura XVII, 13.
The inscriptions placed by the legs

'May God make my legs steady in
the bridge of Ṣirāṭ.'
'The day when the legs tremble
there.'

The bridge of Ṣirāṭ is believed to be
suspended across the eternal fire; the
righteous pass quickly over it, but
the unrighteous miss their footing

and fall into the fires of hell. The
weave is compound tabby, with
warp and weft of silk. The colours,
now ivory and dark brown, were
originally two shades of red. The
textile was woven to shape, with
selvage all round and long tassels of
cut weft.

Published: Shepherd (1963)

8 Linen cloth, the 'veil of Saint Anne', with tapestry ornaments

Length 310cm, width 150cm
Church of Sainte-Anne, Apt
(classified historical monument)
Egypt (Damietta), Fatimid period,
1096–7

This fine linen cloth is decorated with
three bands of silk and gold tapestry,
the central band has three circles
containing pairs of addorsed sphinxes.
Above the top circle was an inscrip-
tion, now destroyed.

'In the name of God, the
compassionate, the merciful.
There is no God but God, alone,
without associate; Muḥammad is
the apostle of God.'

Around the top circle is the
inscription

'Alī is the friend of God, may God
grant him blessing. The imam
Abū al-Qāsim al-Musta'lī billah,
commander of the faithful, may the
blessings of God be upon him, on
his pure ancestors and his very
honourable descendants.'

Around the second circle

'His very honourable descendants.
The most illustrious lord al-Afḍal,
the sword of the imam, the
illustrious of Islam.'

Around the third circle

'His very honourable descendants,

the most illustrious lord al-Afḍal,
the nobility of humans.'
The two side bands show birds,
animals and inscriptions including
'This is what was made in the
private weaving factory at
Damietta in the year . . . 9 .'
The Fatimid caliph al-Mustaʻli
reigned 1094–1101 and the damaged
date must have been 489 [1096 AD] or
490 [1097 AD]. The caliph was little
more than a cipher and his chief
minister al-Afḍal Shāhanshāh was
the effective ruler of Egypt. This
cloth, traditionally known as the 'veil
of Saint Anne', was perhaps
originally intended to serve as a robe
of honour, worn with the central band
at the back and the other two bands at
the front. Both the lord and the bishop
of Apt, where this cloth is preserved,
took part in the first crusade and it
has been suggested that the cloth may
have been part of the plunder taken
from Jerusalem in 1099 or from the
defeat of al-Afḍal at Ascalon in the
same year.

Published: Marçais and Wiet (1934);
Elsberg and Guest (1936); Répertoire
(1937, VIII, pp. 36–7, no. 2864)

8

9 Silk cloth with sphinxes and plant forms

Length 61cm, width 24cm
*Textile Museum, Washington D.C.,
no. 3.212*
Persia, 11th–12th century

This cloth is believed to have been
found in the necropolis on the
Naqqara Khana hill near Rayy. The
pattern in green on red, now faded,
was of considerable size and only part
has been preserved. Interlacing bands
form angular compartments of
various shapes, of which one contains
four pairs of confronted sphinxes;
others contain foliage ornament and
one shows feathers which presumably
formed part of a large bird. The
textile is notable for the elegance of
the design and the refinement of the
execution. The weave is lampas, with
warp-faced tabby ground and weft-
faced twill pattern; warp and weft are
of silk.

Published: Ashton (1931); Pope and
Ackerman (1938–9, pp. 2015, 2035,
no. 28), Weibel (1952, p. 114,
no. 115)

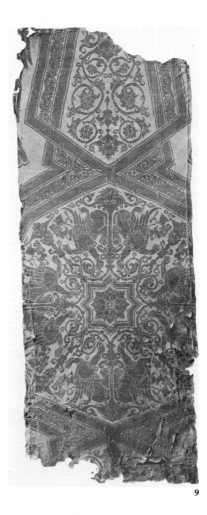

9

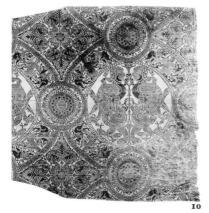

10

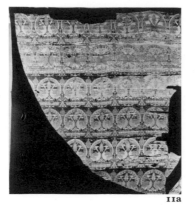

11a

10 Silk cloth with lions and harpies in circles

Length 45cm, width 50cm
*Museum of Fine Arts, Boston,
no. 33.371*
Southern Spain, about 1100

This silk comes from the tomb of Saint Pedro de Osma (died 1109) in the cathedral of Burgo de Osma. The design of harpies on the backs of lions, within circular frames showing men attacked by griffons, is strikingly inventive and finely detailed. The small medallions linking the circles bear the inscriptions which read

> *'hādhā mimmā'umila [li-ṣāḥib?*
> *madīnat al Baghdād . . .]*
> 'This is one of the things made
> [in Baghdad . . .] . .'

Despite this inscription the silk belongs to a group of textiles which are proved by abundant evidence to have been woven in southern Spain. Moreover, the spelling of the inscription is peculiar to the western Mediterranean area and is not found in the eastern Islamic world. Evidently the inscription was designed to mislead, presumably for commercial reasons. The weave is lampas, with warp-faced tabby ground and weft-faced tabby pattern. The warp is of silk, the weft is of silk with brocaded gilt membrane thread.

Published: Elsberg and Guest (1934);
Répertoire (1936, VII, no. 2363);
Day (1954); Shepherd (1957, pp. 378–81)

11 a–b Two pieces of a silk vestment with confronted peacocks, the 'cope of King Robert'

a Length 151cm, width 143.7cm;
b length 148cm, width 143.3cm
*Church of Saint Sernin, Toulouse
(classified historical monument)*
Southern Spain, 12th century

A record prior to 1791 states that the two pieces were a chasuble used to wrap the relics of Saint Exupère in 1258. Later sources, however, refer to the vestment as the 'cope of King Robert', meaning Robert of Anjou, King of Naples (died 1343). Small fragments of the same silk are also to be found in the Museo Nazionale del Bargello, Florence, the Musée de Cluny, Paris, and the Victoria and Albert Museum, London. On a dark blue ground the pattern shows pairs of confronted peacocks in six rows, with colours alternating in successive rows, together with trees, antelopes, birds and an inscription 'perfect blessing'. An attribution to Sicily has often been proposed for this silk, but most of the available comparative evidence points to southern Spain as the place of manufacture. The ornamental style belongs to the 12th century. The weave is compound twill. The warp is of beige silk, the weft is in silk of seven colours.

Published: Falke (1913, I, p. 124);
Shepherd and Vial (1965); Paris (1971, no. 237)

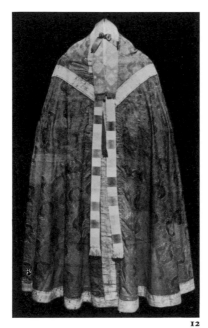

12

12 Silk chasuble, the 'chasuble of Saint Edmund', with birds in circles

*Church of Saint Quiriace, Provins
(classified historical monument)*
Southern Spain, late 12th–early 13th century

This chasuble is said to have belonged to Saint Edmund Rich, Archbishop of Canterbury (died 1241). The silk, with green pattern on a green ground, represents a later, more conventional phase of the southern Spanish school whose earlier work is illustrated in no. 10. The circles are inscribed 'Glory to God'. The weave is lampas, with warp-faced tabby ground and weft-faced tabby pattern. Warp and weft are of green silk.

Published: de Fleury (1883–9, VII, p. 169, VIII, pl. 607); Falke (1913, I, p. 118);
May (1957, p. 33)

**13 Part of a silk chasuble with
lions in circles and inscription**
Length 102cm, width 74.5cm
*Musée Historique des Tissus, Lyon,
no. 23.475*
Turkey (Anatolia), Seljuq period,
13th century

This piece is said to have come from
an abbey in Auvergne. The inscrip-
tion reads
> ['*Alā al dunyā wa*] '*l dīn Abū al
> Fatḥ Kayqubād* [*?ibn*]
> *Kaykhusraw Burhān* [*amīr al
> mu'minīn*]
> '. . . . Abū al Fatḥ Kayqubād son of
> Kaykhusraw Burhān . . .'

There were several Seljuq sultans of
Rum called Kayqubād, but the first
name Abū al Fatḥ and the father's
title identify this ruler as
Kayqubād I of Konya (1219–37).
The pattern, in gold on pink, is
notable for the power and energy of
the style. The weave is compound
twill; the warp is of tan silk, the weft
of pink silk and gilt membrane
thread.

Published: Linas (1960, pp. 17–32);
Falke (1913, I, p. 106); d'Hennezel (1930,
pl. 10); Sakisian (1935); Rice (1961,
pp. 270–1)

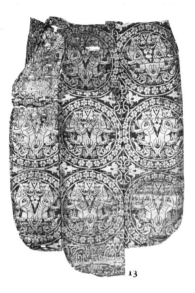

13

**14 Silk cloth with two-headed
eagles in shields**
Length 28cm, width 22.5cm
*Staatliche Museen Preussischer
Kulturbesitz, Kunstgewerbe-
museum, Berlin, no. 81.475*
Turkey (Anatolia), Seljuq period,
13th century

This silk comes from the shrine of
Saint Apollinaris, in the church of
Saint Servatius in Siegburg, where
another piece of the same cloth is still
preserved. The vigorous style of the
design is related to that of no. 13
and this silk is likely to have been
woven in the same area. The two-
headed eagle had heraldic significance
for the Seljuqs of Rum and appears on
their buildings at Konya and else-
where; see also a dragon relief from
Konya (Rice, 1961, fig. 57). The
weave is compound twill; the warp is
silk, the weft silk and gilt membrane
thread.

Published: Falke (1913, I, pp. 106–7);
Rice (1961, p. 271)

14

15

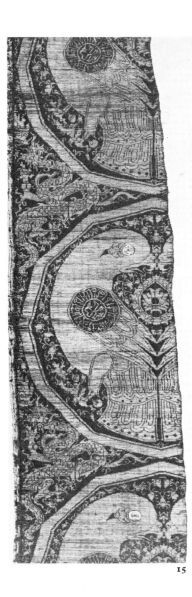

15

15 Silk cloth with birds in dodecagons and dragons between
Length 72.5cm, width 36cm
Staatliche Museen Preussischer Kulturbesitz, Kunstgewerbemuseum, Berlin, no. 75.258
Central Asia, early 14th century

This silk was formerly part of a cope in the Marienkirche, Danzig. An inscription on the wing of the bird reads

'izz li-mawlānā al-sulṭān al-malik al-'ādil al-'ālim Nāṣir [?]

'Glory to our lord the sultan, the king, the just, the wise Nāṣir . . .'
This probably refers to Muḥammad ibn Qalāwūn, the Mamluk sultan of Egypt 1293–1341. The weave is lampas, with warp-faced twill ground and weft-faced tabby pattern. The warp is silk, the weft silk and flat gilt membrane strip. Gilt strip of this type is a characteristic feature of a large group of silks used in the 14th century throughout the Islamic world and also in Europe. Many show Chinese motifs, like the dragon in this example, symptomatic of the westward flow of Chinese ornament under the Mongol domination. The place of origin of these silks is uncertain and both China and Persia have been suggested, but Central Asia is perhaps the most likely; they may well be the textiles known in Europe as 'Tartar cloths'. It is of interest that Abū al-Fidā records a gift in 1323–4 from a Mongol Khan to Muḥammad ibn Qalāwūn which included seven hundred silk cloths, some of which had titles of the sultan woven in them.

Published: Karabacek (1870); Sarre and Martin (1912, III, pl. 180); Falke (1913, pp. 54–5); Pope and Ackerman (1938–9, III, pp. 2052, 2059, no. 14)

16 Silk cloth with inscriptions and animals in stripes
Length 23.5cm, width 28cm
Victoria and Albert Museum, London, no. T.122-1921
Egypt or Syria, Mamluk period, early 14th century

This silk was found in Egypt; other fragments of the same cloth are now in the Museum of Islamic Art, Cairo, and the Benaki Museum, Athens. One stripe has a leopard attacking a gazelle beside a tree. Others are inscribed *'izz li-mawlānā al-sulṭān al-Malik a-..*, 'Glory to our lord the sultan . . .' This is a fairly early example of the striped cloths with inscriptions which were woven in large numbers throughout the Islamic world in the 14th and 15th centuries. The weave is double cloth; the warp is silk, the weft silk with a little gilt membrane thread.

Published: Guest (1923, pp. 404–7)

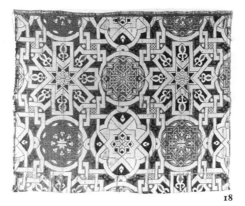

18

19

17 Silk cloth with inscriptions and floral arabesques in stripes

Length 57cm, width 89cm
*Victoria and Albert Museum, London,
no. 1105-1900*
Southern Spain, Nasrid period,
14th–15th century

The inscription reads *'izz li-mawlānā
al-Sulṭān*, repeated, 'Glory to our
lord the sultan'. This silk is a
characteristic southern Spanish
version of the type of striped and
inscribed silks that were produced
throughout the Islamic world at this
period, compare no. 16. Granada
had a reputation for striped cloths.
The weave is lampas, with satin
ground and weft-faced tabby pattern;
warp and weft are of silk.

Unpublished

18 Silk cloth with geometrical interlace

Length 57cm, width 47cm
*Victoria and Albert Museum, London,
no. 1312-1864*
Southern Spain or North Africa,
Nasrid period, 14th–15th century

Geometrical interlace, a very wide-
spread type of decoration on Islamic
textiles, was employed in silk
weaving chiefly in southern Spain and
north Africa and gave rise to a series of
boldly conceived and brilliantly
coloured silks. This example was
bought in the 19th century in
Florence, where it formed part of a
hanging behind a large wooden statue
of the Virgin. The weave is lampas,
with satin ground and weft-faced
tabby pattern; warp and weft are of
silk.

Unpublished

19 Silk cloth with palmettes, foliage and inscriptions

Length 114cm, width 19cm
*Victoria and Albert Museum, London,
no. 753-1904*
Egypt or Syria, Mamluk period,
14th–15th century

This silk, which has been used as the
orphrey of a vestment, is of a type
which was much used in Spain but
was probably imported from the
eastern Mediterranean. The pear-
shaped ornament is inscribed with
'izz li-mawlānā al-malik, 'glory to our
lord the king'. The small octofoils are
inscribed *al-Ashraf*; the suggestion
that this title refers to Qāytbāy,
Mamluk sultan of Egypt (1468–96),
is untenable, since textiles with this
pattern are depicted in paintings of
the early 15th century. The weave is
lampas, with satin ground and weft-
faced tabby pattern. The warp is of
silk, the weft of silk and gilt metal
thread.

Published: Falke (1913, II, p. 64);
Kendrick (1924, p. 41, no. 973); Schmidt
(1958, p. 163)

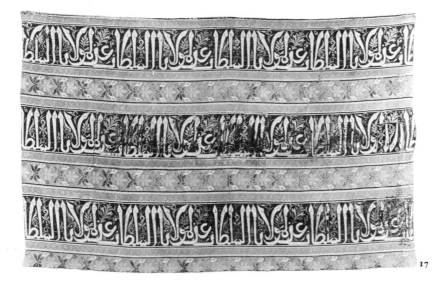

17

20

20 Silk chasuble with lattice of leaves enclosing foliate medallions

Length 127cm, width 72cm
Victoria and Albert Museum, London,
no. 664-1896
Egypt or Syria, Mamluk period,
15th century

The chasuble was made up in Spain
from a silk whose origin is uncertain,
but whose restrained formality of
design, coupled with the richness of
the materials, reflects the refined taste
of the 15th century in the Near East.
The type and scale of the pattern fore-
shadow Ottoman silks of the 16th
century (compare no. 24). The
weave is lampas with satin ground
and weft-faced tabby pattern. The
warp is of silk, the weft is of silk and
gilt metal thread.

Published: Falke (1913, II, p. 68)

21 Velvet with tiger stripes and discs

Length 76cm, width 62cm
Textile Museum, Washington, D.C.,
no. 1.77
Turkey, Ottoman period,
15th–16th century

This fragment presents a pattern
almost identical to that of the kaftan
of Mehmet the Conqueror (1451–81)
preserved in the Topkapi Palace
Museum, Istanbul. The colours,
however, are different and in this
example maroon velvet is brocaded
in silver and gold. The motifs of tiger
stripes and three discs, separately or
together, were extremely popular in
Turkish textiles, especially for royal
garments. The origin of these devices,
particularly the three discs, can be
traced back many centuries. They are
supposed to have derived from the
markings of tiger and leopard skins.
The velvet is based on satin weave;
the warp and weft are of silk, with
brocaded wefts of silver and gilt metal
thread.

Published: Mackie (1973, no. 1, p. 21)

21

22 Child's silk kaftan with tiger stripes

Length 71cm, width 78.5cm
Victoria and Albert Museum, London,
no. 753-1884
Turkey, Ottoman period,
16th century

This garment shows the motif often
identified as tiger stripes, in blue,
white and gold on a red background.
It is said to have been removed from a
royal tomb in Istanbul or Bursa. The
weave is lampas with a satin ground
and weft-faced twill pattern. The
warp is silk, the weft silk and gilt
metal thread.

Published: London (1950, no. 12)

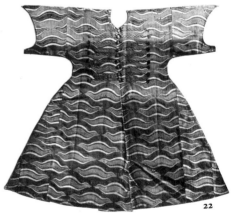

22

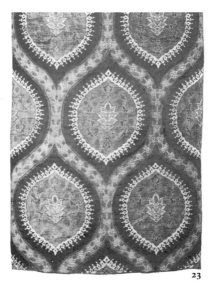

23

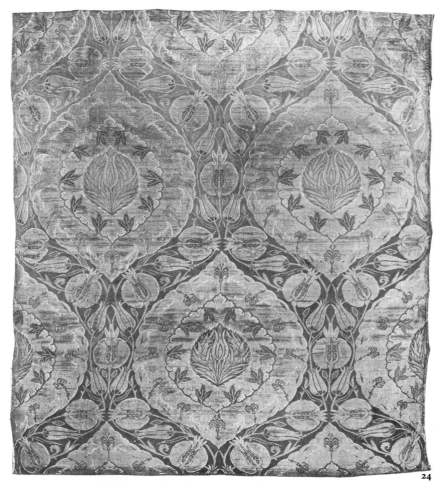

24

23 Silk cloth with flowers and leaves in an ogival lattice
Length 145cm, width (overall) 134cm
Victoria and Albert Museum, London, no. 1356–1877 and 1356A–1877
Turkey, Ottoman period, 16th century

This is a particularly fine example of the large group of Turkish silks with ogival lattice patterns. Here, a delicate design of pomegranates, flowers and leaves appears in gold, blue, red and white on a green background. The weave is lampas, with satin ground and weft-faced twill pattern. The warp is silk; the weft is silk, with brocaded gilt metal thread.

Published: London (1950, no. 1)

24 Silk cloth with an ogival lattice containing pointed medallions
Length 161cm, width 67cm
Textile Museum, Washington, D.C. no. 1.70
Turkey, Ottoman period, 16th century

This is a handsome example of the large group of Turkish silks with ogival patterns. Within the scalloped gilt medallions is a central white leaf bearing gilt carnations and tulips with a blue Chinese cloud band above and below. The background is red and the pattern is rendered mainly in gold with details in blue and white. The weave is lampas, with satin ground and weft-faced twill pattern. The warp is silk, the weft silk and gilt metal thread.

Published: Mackie (1973, no. 5)

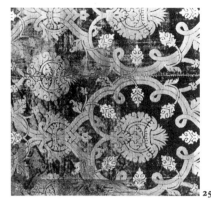

25

26

25 Velvet with ogival lattice enclosing artichokes
Length 169cm, width 127cm
*Victoria and Albert Museum,
London, no. 1357–1877*
Turkey, Ottoman period,
16th century

This is one of the many 16th-century
Turkish velvets whose designs show
clear traces of Italian influence.
On a red velvet background, arti-
choke-shaped motifs in gold thread
are framed in an ogival lattice in
gold and silver. The weave is velvet,
based on satin, with pattern in weft-
faced twill. The warp is silk; the weft
is silk and cotton with brocaded silver
and gilt threads.

Published: London (1950, no. 16)

26 Velvet with tulips and carnations in an ogival lattice
Length 284cm, width 63.5cm
Antaki Collection
Turkey, Ottoman period,
16th–17th century

The pattern of a large ogival lattice
enclosing flowers and leaves is
characteristic of Turkish textiles of
this period and may be compared
with contemporary tiles. The velvet
has a satin ground and weft-faced
twill pattern. The warp is silk; the
weft is silk and cotton, with
brocaded silver and gilt thread.

Unpublished

27 Velvet saddle-cloth with leaves and flowers
Length 58cm, width 122cm
*Royal Armoury, Stockholm,
no. 3842*
Turkey, Ottoman period,
about 1625

This cloth forms part of a complete
set of saddle-furniture given to King
Gustavus Adolphus of Sweden in
1626 by his brother-in-law, Bethlen
Gabor, Prince of Transylvania. The
velvet cover is embroidered with
fine silver and gilt wire padded with
cotton yarn and is edged with a tablet
woven fringe of silk and gold thread.

Published: Geijer (1951, p. 116, no. 104)

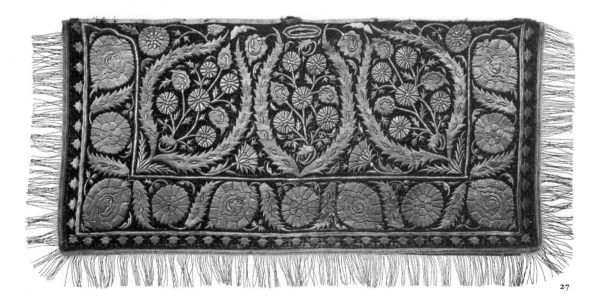

27

28

28 Part of a velvet cover with foliate stars

Length 169cm, width 63.5cm
Victoria and Albert Museum,
London, no. 92–1878
Turkey, Ottoman period,
16th–17th century

This is a complete loom-piece
destined for a cover which, when
completed, would have been made up
of two or more similar pieces. The
pattern consists of gold foliate stars
of two sizes on a background of red
velvet in the main field, and of silver
used for the border. The weave is
velvet based on satin, with pattern in
weft-faced twill. The warp is silk;
the weft is silk and cotton, with
brocaded silver and gilt thread.

Unpublished

29 Velvet cushion cover with crescents and tulips

Length 134.5cm, width 66cm
Victoria and Albert Museum, London,
no. 423–1889
Turkey, Ottoman period,
17th century

This typical divan cushion cover of
red and green velvet has large gold
crescents, a recurring motif in
Turkish textiles, enclosing garlands
of tulips. The borders at each end
consist of lappets, alternatively gold
and silver, enclosing flowers. The
weave is velvet with a satin base and
the brocaded wefts are bound in
weft-faced twill. The warp is silk; the
weft is silk and cotton, with brocaded
silver and gilt threads.

Unpublished

30 Velvet cushion cover with eight-pointed star

Length 120cm, width 67cm
Royal Armoury, Stockholm, no. 3661
Turkey, Ottoman period,
early 18th century

This cushion cover is one of a pair
presented to the King of Sweden,
Frederic I, by 'Abdī Pasha of Algiers
in 1731. They are the only precisely
datable examples of their kind. An
eight-pointed star is enclosed in a
medallion within a rectangle and is
framed by a large border of foliate
stars. Both ends of the cover have
lappet borders with stylised tulips.
The velvet has green and red pile on a
white satin ground. The warp is silk,
the weft silk and cotton with details
brocaded in silver thread.

Published: Geijer (1951, p. 111, no. 69)

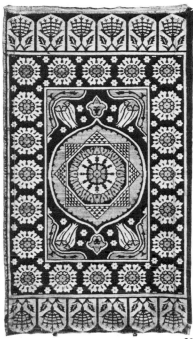

30

29

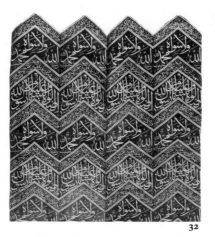

32

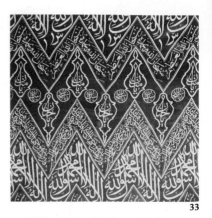

33

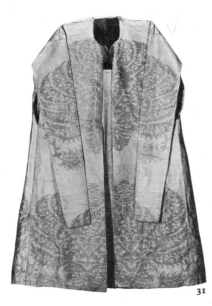

31

31 Silk court kaftan
*Staatliche Museen zu Berlin,
Islamisches Museum, no. 1.6894*
Turkey, Ottoman period,
about 1760

This kaftan with long ornamental
hanging sleeves presents a large-
scale pattern of leaves in gold on a
silver background. It is of special
interest as it is firmly dated to the
18th century. It was used by an
envoy of Frederick the Great of
Prussia for an audience with the
Ottoman sultan.

32 Silk tomb cover
Length 241cm, width 134cm
Antaki Collection
Turkey, Ottoman period,
18th century

The silk is of a type commonly used
for tomb covers and is woven with
religious inscriptions in zigzag bands
in white on green. Compare no. 33.
Top narrow band
*Raḍiya Allāh taʿālā ʿan Abī Bakr
wa ʿUmar wa ʿUthmān wa ʿAlī wa
ʿan baqiyyat al- ṣaḥāba ajmaʿīn*
'May God be pleased with Abu
Bakr and ʿUmar and ʿUthmān and
ʿAlī and with all the other
companions [of the Prophet].'
Top broad band
Allāh wa lā sawāhu Muḥammad
'God there is none but He –
Muḥammad.'
Second narrow band
*Allāhumma ṣal [sic] wa sallam ʿalā
ashrāf jamīʿ al-aubiyā wa
al-mursalīn*
'Oh God, bless and give peace to
their nobilities all the prophets and
missionaries.'
Second broad band
*Al-ṣalwa wa al-salām ʿalayk yā
rasūl Allāh*
'Blessing and peace upon you, the
Prophet of God.'
The weave is lampas, with satin
ground and tabby pattern. Warp and
weft are of silk.

Unpublished

33 Silk cloth with inscriptions
Length 70cm, width 68cm
*Victoria and Albert Museum,
London, no. 1063–1900*
Turkey, Ottoman period,
18th century

This red silk shows parallel zigzag
bands, alternately broad and narrow,
with verses from the Koran and
pious invocations.
Top narrow band
*subḥan Allāh al-aẓim subḥān
Allāh wa li-ḥamdihi [?]*
'Glory to that mighty God, glory
to God and to his praise [?].'
Second band, circles
yā subḥan – yā sulṭān
'Oh glory – oh authority.'
Second band, pendants
yā manān/ yā ḥinān
'Oh benefactor/ Oh tender one.'
Third narrow band
*qad narā taqallub wajhik fī al-samā
falanuwallīnak qibla tarḍāhā fa-wali
wajhak shaṭr al-masjid al ḥarām*
'We see the turning of thy face
[for guidance] to the heavens: now
shall we turn thee to a qibla that
shall please thee. Turn then thy
face in that direction of the sacred
mosque.' (Koran, Sura II, 144.)
Fourth wide band
*La ilāh illā Allāh Muḥammad
rasūl Allāh*
'There is no god but God and
Muḥammad is His prophet.'
Such cloths were used as covers for
the tombs of sultans and other
eminent persons. The weave is
lampas, with satin ground and
weft-faced twill pattern. Warp and
weft are of silk. A similar silk is in the
Textile Museum, Washington, D.C.,
no. 1.84. See Denny (1972, p. 65).

Unpublished

35 see colour plate, page 64

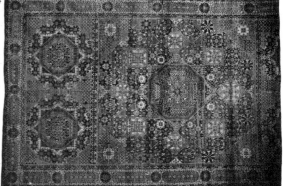

34 Animal rug

Length 172cm, width 90cm
*Staatliche Museen zu Berlin,
Islamisches Museum, no. 1.4*
Turkey or the Caucasus, first half
15th century

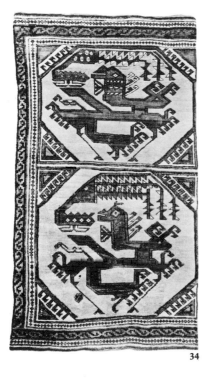

34

This is the earliest carpet in the
present exhibition and one of the
oldest complete carpets in the world
as well as one of the most famous.
Originally from a church in central
Italy, this carpet was acquired by
Bode for Berlin in 1886. Only one
other comparable carpet survives;
this is the Marby rug, from a
Swedish church, now in the
Historiska Museum, Stockholm.
This carpet has a pattern in which
stylised dragons are locked in
perpetual combat with phoenixes.
These creatures together with the
latch-hook motifs throughout the
design suggest comparisons with
later Caucasian carpets. This
example is a little coarser than the
Marby rug and the patterns differ,
but both share the same technical
features including a line of knotting
at intervals on the back of the carpet.
Such carpets with more or less
stylised animals in octagons appear in
European paintings from the mid
14th century onwards and some may
even be European copies, in various
techniques, of oriental imports. A
carpet very similar to this example
appears in a Sienese fresco by
Domenico di Bartolo, 1440–4.
Their continuing popularity in
Europe can be judged from the
portrait of Dorothy, Lady Cary, who
stands on an unworn carpet with a
simplified version of the phoenix
motif, attributable to William Larkin,
c. 1615. See Strong (1969, fig. 354).
The carpet has a woollen warp and
two shoots of brown woollen weft
after each row of knots, 7.5–8.3
Turkish knots per square cm.

Published: Sarre and Trenkwald (1926,
II, pl. 1); Lamm (1937, pp. 51–130,
106–8); Erdmann (1970, pp. 17–20)

35 Mamluk design carpet

Length 470cm, width 334cm
*Österreichisches Museum für
angewandte Kunst, Vienna, no. T.8382*
Egypt (Cairo), 16th century

Carpet-knotting in Egypt developed
independently of the industry in
Turkey, for the carpets of Cairo in
the 15th and 16th centuries were made
with the Persian type of knot. When
the Ottomans conquered the
Mamluks in 1517, the carpets in
production were of kaleidoscopic
patterns mainly in wine-red, blues
and greens. Two pieces bordered
with interlace patterns make
decorative use of a blazon appropriate
to some thirty amirs at the court of
Qāytbāy, 1468–96, see Ellis (1967,
figs. 1 and 2). The oval and roundel
border of this present carpet may
be indicative of 16th-century manu-
facture. The emphasis on the great
central star-in-octagon-in-square
with bands of subsidiary pattern
towards the ends is characteristic of
Mamluk designs, as are the tiny
umbrella-shaped leaves. Later
Cairene carpets incorporated floral
designs in Turkish style. In 1585
the Sultan brought eleven weavers
from Cairo to found the workshop
which produced the Ottoman court
rugs (see no. 45) retaining elements
of technique and colouring from the
Mamluk carpets. The warp of this
example is lustrous yellowish wool
with three shoots of red-brown wool
after each row of knots of the Persian
type, 13 per square cm.

Published: Sarre and Trenkwald
(1926, I, pl. 50)

36 Compartment carpet

Length 377cm, width 243cm
*Textile Museum, Washington, D.C.,
no. R. 34.34.4 (old no. R.7.10)*
Turkey, Ottoman period, early
17th century

Technically and stylistically, carpets
of this type were hybrids. The field
pattern, so strongly marked in
squares that it attracted the name
'compartment', in this respect is
similar to the fragment of Anatolian
carpet from the mosque at
Beyshehir, see Erdmann (1970,
pl. 44). The interlace star is
related to the Holbein carpets, but the
tiny trees and fragmented ornament
around the stars have associations
with Mamluk designs and the border
turns the corners with an elegance
found in Cairene or Persian carpets.
As in the carpets made in the Ottoman
court manufactory by Cairene
workmen, the knot used is the
Persian type and the warp is spun
and plied in the opposite direction
to warp made in Egypt. The
sophisticated court products,
however, were made with a silk warp
whereas the provincial
'compartment' carpets were made
from local material, goat hair.
Attempts have been made to equate
these carpets with pieces described as
'Rhodian' in inventories of the late
15th to 17th centuries, but this
identification has not been proved.
Fifteen knots of the Persian type per
square cm in nine colours are tied on a
warp of white goat hair. Pile and weft,
with two shoots after each row of
knots, are also of goat hair.

Published: Kühnel and Bellinger (1957,
p. 75, pls. XLIII, XLIV)

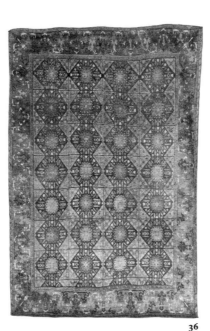

36

37

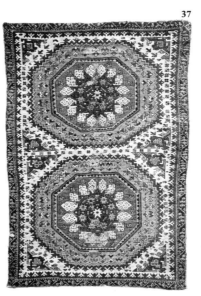

37 Large-pattern Holbein rug

Length 170cm, width 113cm
*Staatliche Museen zu Berlin,
Islamisches Museum, no. 1.29*
Turkey, Ottoman period,
16th century

Not only were an increasing number
of Turkish carpets imported into
Europe from the later Middle Ages,
but they were also depicted with
increasing frequency and realism by
European painters. Their designs
have been classified rather mis-
leadingly by painters' names. The
so-called Holbein carpets date from
the mid 15th to the early 17th century.
This example with a large octagon
within a square is of a type less com-
mon than that with small interlaced
octagons (see no. 38). Bold, bright,
primary colours seem typical of these
larger patterned Holbein carpets.
Details and borders vary but all are
characterised by interlaced and
knotted ornament. Such a carpet
appears in Crivelli's *Annunciation* in
the National Gallery, London, and
another is seen in *Two Young Princes*
attributed to Parmigianino; see
London (1960, no. 96). Other
simplified versions appear in several
early 17th century portraits, notably
that of the 3rd earl of Dorset at Knole,
Kent, attributed to Van Somer. Many
later Bergama rugs strongly resemble
this design, prompting the attribution
of the earlier group to this region of
Turkey. This example is woven with
a woollen pile with Turkish knots,
a woollen warp and two shoots of red
woollen weft after each row of knots.

Published: Erdmann (1960, pl. 37)

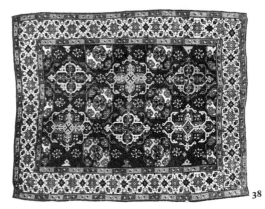

38

38 Small-pattern Holbein rug

Length 220cm, width 150cm
Museum of Applied Arts, Budapest,
no. 14785
Turkey (Anatolia), Ottoman period,
16th century

The geometrical pattern of this
carpet, with octagons of interlace
alternating in rows with cross-shaped
devices of angular foliage, was
reproduced in innumerable
Anatolian rugs and carpets, many of
which were exported to Europe. The
centres of production are not
precisely known, but are generally
thought to have been in the Ushak
area. These rugs were depicted in
European paintings from 1451
onwards and their patterns were
copied in European needlework down
to the early 17th century. The
appellation 'Holbein' derived from
the appearance of such a rug, used
as a table-cover, in Holbein's
portrait of Georg Gisze, 1532. The
uniform green-blue ground of this
rug suggests that it may be a fairly
early example: a green ground is to be
seen in Mantegna's painting of 1459
in Verona. The guard-stripe,
without the colour change, appears in
carpets of the 14th and 15th
centuries. The border, however, is of
a type found on rugs of the late 17th
century. The knots are of the
Turkish type, in wool of seven
colours, about 7 per square cm on a
white wool warp. There are two
shoots of red wool weft after each row
of knots.

Published: Batari (1974, no. 1)

39 Small-pattern Holbein rug

Staatliche Museen zu Berlin,
Islamisches Museum, no. 1.26
Turkey, Ottoman period,
16th century

This small-patterned Holbein carpet
is typical of the large numbers
imported into Europe from Turkey
for about 150 years (see also nos. 38,
40). While interlaced octagons
on contrasting grounds may be seen
in Timurid miniatures as early as the
15th century, by the following
century several different styles of
border were current. Unlike the
majority which are based upon
angular kufic script, the border of
this carpet has a stylised floral design.
It is almost identical with the border
of the carpet depicted in Holbein's
celebrated *Ambassadors* in the
National Gallery, London, dated
1533. The central field of that
carpet, however, has a large
octagon of a type which still appears
in paintings of the early 17th century.
The central field of the present
carpet compares closely with that on
the table of the *Somerset House*
Conference painted by Gheraerts in
1604, in the National Portrait
Gallery, London. Taking border and
centre together, this carpet could
have been woven at any time during
the intervening period of about 70
years. It has a woollen pile with
Turkish knots on a white woollen
warp with two shoots of red woollen
weft after each row of knots.

Published: Bode and Kühnel (1970,
pp. 29–36); Erdmann (1970, pp. 52–6)

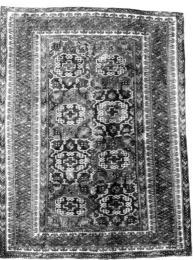

39

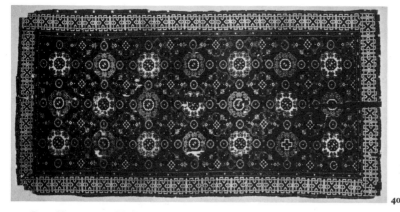

40

40 Small-pattern Holbein rug

Length 275cm, width 141cm
*Staatliche Museen Preussischer
Kulturbesitz, Museum für Islamische
Kunst, Berlin-Dahlem, no. 82.894*
Turkey (Anatolia), Ottoman
period, 16th century

The Holbein pattern, the same as
that of the rather smaller rug no. 38,
was immensely popular from the
middle of the 15th century onwards.
Comparison with similar rugs
depicted in Persian miniatures,
European manuscripts and paintings
suggests that the chequered back-
ground of this example, with
alternate red and black squares,
came into use during the 15th
century. The interlace border is
reminiscent of earlier kufic borders.
The warp is of white wool and there
are two shoots of red wool weft after
each row of knots. The knots are of
the Turkish type, 12–13 per
square cm.

Published: Berlin-Dahlem (1971a,
no. 580)

41 Lotto rug

Length 183cm, width 121cm
*National Museum, Budapest,
no. 1952.278*
Turkey, Ottoman period, 16th–
early 17th century

The 'Lotto' pattern was used in
innumerable Anatolian rugs and
carpets during the 16th and 17th
centuries, see no. 42. The angular
version of the pattern, called the
'kilim' style, has recently been
attributed to Transylvania. The
border pattern employed in this rug
was current by the middle of the 16th
century since it appears in a rug
depicted in a portrait of Lady Jane
Grey in the National Portrait
Gallery, London. The warp is of
undyed wool and there are two shoots
of light red wool weft after each row
of knots. The knots are of the Turkish
type, about 9 per square cm, in wool
of six colours.

Unpublished

42 Lotto carpet

Length 359cm, width 245cm
*The Duke of Buccleuch and
Queensberry, V.R.D. Collection,
no. Boughton 4*
Turkey (Anatolia), Ottoman period,
16th early 17th century

The pattern of this carpet consists of
stylised foliage ornament arranged so
as to form alternating rows of
skeletal octagons and crosses. Named
from its appearance in paintings by
Lotto, it first appears in a rug
depicted by Sebastiano del Piombo
in a portrait group of 1516 in the
National Gallery, Washington, D.C.
Like its older relative, the 'Holbein'
pattern, it was reproduced in a vast
number of Anatolian rugs and
carpets, whose centres of production
are unidentified but are thought to
have been in the Ushak area; the
latter attribution, however, has
recently been questioned by Ellis
(1975). The colour scheme of a yellow
pattern with blue details on a red
ground is almost invariable. This
carpet was originally a good deal
longer; the border at one end has been
made up with parts of the side
borders. The corners of the border
are designed with more care than is
usual in Turkish rugs. The warp is of
ivory wool and there are two shoots of
red wool after each row of knots. The
knots are of the Turkish type, about
16 per square cm, in wool of seven
colours.

Published: Kendrick (1914, p. 74);
Beattie (1964, no. 4)

41

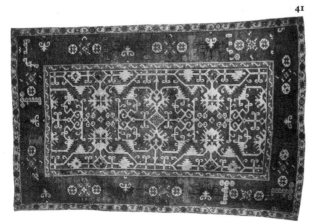

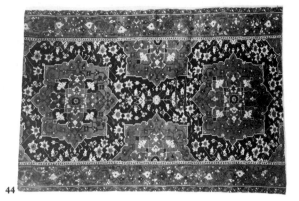

44

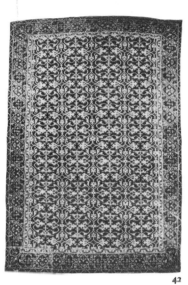

42

43

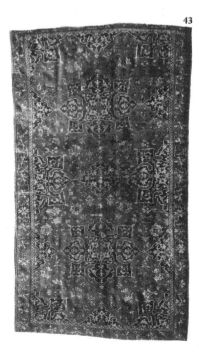

43 Star Ushak carpet
Length 322cm, width 193cm
National Trust, Hardwick Hall
Turkey (Anatolia), Ottoman period,
later 16th century

The name given to this type of carpet
derives from the eight-pointed star
alternating with a slightly smaller
lozenge in an endlessly repeating
pattern. A diversity of star and
medallion designs with similar
ornament, colouring and technique
have been ascribed to Ushak through
their likeness to more recent products
of that area, see Bode and Kühnel
(1970, p. 39). Two 17th century
Ushak designs can be seen in nos. 44
and 46, the second having a later
version of the border on this carpet.
This border is very similar to one on a
medallion Ushak in a portrait of
Henry VIII and his family made for
Queen Elizabeth c. 1570, see Strong
(1969, pl. 95). A star Ushak lies
beneath the feet of the Doge in Paris
Bordone's painting of 1534. In
1584–5 two European 'star' carpets
were made for Sir Edward Montagu
copying an Ushak design. The
Hardwick carpet is thought to date
somewhere between the prototype of
these carpets and a piece repeating the
same border in the Kunstgewerbe-
museum, Cologne, see Beattie
(1959). The knots of the carpet are of
the Turkish type, 12 per square cm,
on a warp of undyed wool. There are
two shoots of red wool weft after each
row of knots.

Published: Beattie (1959 and 1964, no. 2)

44 Star Ushak carpet
Length 276cm, width 187cm
*Staatliche Museen Preussischer
Kulturbesitz, Museum für Islamische
Kunst, Berlin-Dahlem, no. 85.981*
Turkey (Anatolia), Ottoman period,
17th century

This is a fragment of one of the lesser-
known Ushak patterns which were
studied by Erdmann (1963). The
most celebrated example of this group
was a carpet in the Berlin collection,
now destroyed, and in Detroit.
Carpets comparable with some
examples of the group are seen in
paintings of the second quarter of the
17th century. Other examples are
known in private collections. This
carpet has a woollen pile with 13
Turkish knots per square cm on a
white woollen warp; red woollen
weft, two shoots between each row of
knots.

Published: Erdmann (1963, pp. 79–97);
Berlin Dahlem (1971a, no. 582)

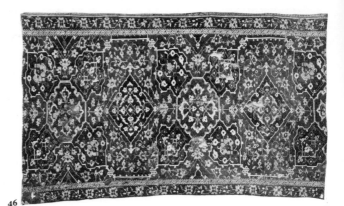

46

45 Prayer rug with flowers, foliage and arabesque ornament

Length 183cm, width 117cm
*Österreichisches Museum für
angewandte Kunst, Vienna,
no. T.8327*
Turkey, Ottoman court
manufactory, late 16th century

This rug from the former Austrian
Imperial collection includes a variety
of elements – the luxuriant
composition of the wine-red field, the
incisively drawn arabesque in the
spandrels of the arch, the Chinese-
inspired cloud ornament in the
quadrants below and the elegant
rhythmic pattern of the light blue
border – which are characteristic of
the finest Ottoman decoration and are
parallelled in the best late 16th
century tilework of Istanbul.
Carpets and prayer rugs in this style
are generally assigned to workshops

operating for the Ottoman court,
though they have also been variously
attributed to Damascus, Cairo, Bursa
and Istanbul; later Ghiordes prayer
rugs reproduce some features of the
style in a debased form. The present
rug is closely related to a technically
similar one in the Walters Art Gallery,
Baltimore, and another, less similar
technically, in the Metropolitan
Museum of Art, New York. See
Washington (1974, no. II) and
McMullan (1965, pl. 4). The warp of
this example is of green silk on two
levels and there are two shoots of red
silk weft after each row of knots. The
knots are of Persian type, about
56 per square cm, in ten colours,
chiefly wool, but cotton is used for
white and light blue areas – a
characteristic feature of a group of
these Ottoman court carpets.

Published: Riegl (1892, p. 316); Sarre and
Trenkwald (1926, pl. 56); Ellis (1969,
pl. 1); Dimand (1973, p. 200)

46 Ushak medallion rug

*Staatliche Museen zu Berlin,
Islamisches Museum, no. 1.6932*
Turkey, Ottoman period,
17th century

The export of Turkish carpets to
Europe continued unabated
throughout the 17th century. The
Levant Companies of England and
Holland imported carpets in large
numbers, and Ushak carpets are the
type most frequently represented in
paintings of the period in these
countries. Several types of design
continued to be popular well into the
19th century, though the details
frequently became stereotyped and
even inaccurate. This carpet was
probably woven in the mid-17th
century as its style is vigorous and the
details well drawn. It may be
compared with several other
examples, in the St Louis Art
Museum, the Victoria and Albert
Museum, London, and the
Metropolitan Museum of Art, New
York. It is woven on a white woollen
warp with a woollen pile of
Turkish knots and two shoots of red
woollen weft after each row of knots.

Unpublished

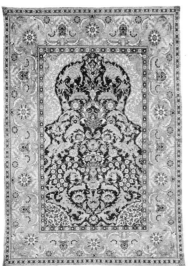

45

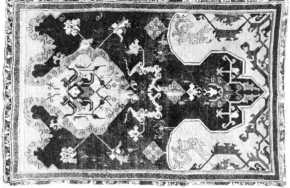

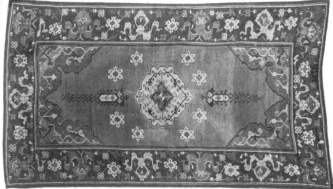

47 Ushak prayer rug

Length 180cm, width 120cm
*Staatliche Museen zu Berlin,
Islamisches Museum, no. 1.24*
Turkey, Ottoman period,
16th century

Carpets were made in Ushak from
the 16th century and they were among
the most familiar of oriental carpets
exported to Europe. Prayer rugs,
however, were rarely exported at that
time, except perhaps to other
Muslim countries, and because they
were in daily use for the prayers of
the faithful few have survived. This
splendid example may be assigned to
the early 16th century and is greatly
superior to the later rugs which
repeat some of its motifs. The
stylised cloud-band adapted from
Persian designs is a frequent motif in
Ushak rugs (compare nos. 48 and
49) but seldom is it used as skilfully
as here. The carpet has a white
woollen warp, and two shoots of red
weft after each row of knots of the
Turkish type.

Published: Bode and Kühnel (1970,
cover and pp. 49–50); Erdmann (1960,
pl. 158)

48 Ushak prayer rug

Length 162cm, width 102cm
*Victoria and Albert Museum,
London, no. T.450–1906*
Turkey, Ottoman period,
mid 17th century

The design of the border, the
interlacing stems with foliate
arabesques in the corners of the field
and the shape and ornamentation of
the central medallion are all
characteristic of 17th century Ushak

carpets, as are the colouring and
technique of this rug. Large numbers
of 17th and 18th century rugs survive
with quarters of quatrefoils placed in
the corners of the field to create
mirror-image arches. In this example,
a four-lobed medallion and a
detached pendant hang at one end in
place of a mosque lamp, suggesting
that the rug was intended for use in
prayer. The amount of detail in the
cloud-band border indicates a date
around the middle of the 17th
century for this piece: the cloud
bands are still vigorous, but the
hooked ends protruding from them
have become simple V-shapes on
three sides of the border. The rug
contains 11 knots of the Turkish type
per square cm in wool of six colours.
The white wool warp is bound by
two shoots of red wool weft after each
row of knots.

Published: London (1931, p. 25, pl. 132)

49 Ushak prayer rug

Length 296cm, width 175cm
Private Collection, England
Turkey, Ottoman period, about 1700

Basically the same type of rug as no.
48, with the same design in border
and spandrels, the slightly stiffer
treatment of the border and the loss
of some detail indicate a later date.
Also later is the invasion of the
central field by a floral motif from the
border. The ornamentation of the
central medallion resembles the
central motif on some
'Transylvanian' rugs, see
Schmutzler (1933, pls. 51, 54).
Woollen pile chiefly in red, yellow and
blue-black is in knots of the Turkish
type, 10 per square cm, on a warp of
white wool. There are two shoots of
red wool weft after each row of knots.

Published: Mustafa (1958, fig. 39);
Spuhler (1976)

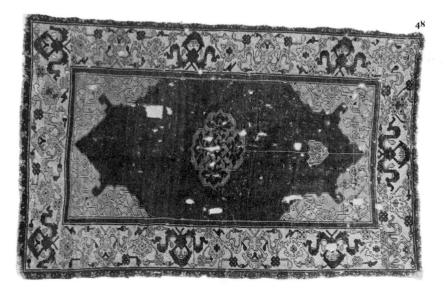

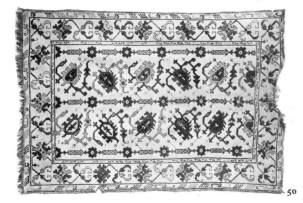

50

50 White ground rug
Length 197cm, width 145cm
Museum of Applied Arts, Budapest, no. 7968
Turkey (possibly Ushak), Ottoman period, late 17th century

White ground rugs appear in European paintings and inventories (in the latter, designated as 'Turkish') from the 1570s. The majority of surviving pieces are of the 'bird' pattern, named from a rhomboid leaf with a 'beak' at either end, from which the design on this rug is supposed to derive. But the elongated blossoms with asymmetrical angular stems seem rather to be direct descendants of the flowers in the ground pattern of Star Ushak carpets. The most common border on the 'bird' rugs is the cloud band found on many Ushak carpets of the 17th century, compare no. 48, as are the inconsequential trefoils on stalks of this carpet. Given also similarities of technique, it is possible that the white ground rugs were another product of the Ushak looms. A slightly later rug with the same border and guard-stripes has been published, see Erdmann (1955, pl. 150). A variant was in the Protestant church at Richişal, see Schmutzler (1933, pl. 16). Knots of the Turkish type, 7 per square cm, are made on a white wool warp, with two shoots of yellow wool weft after each row of knots.

Published: Végh and Layer (1925, pl. VII)

51 'Transylvanian' rug
Length 168cm, width 128cm
Museum of Applied Arts, Budapest, no. 7967
Turkey (Anatolia), Ottoman period, late 16th–early 17th century

So many rugs with this design were found in churches of Transylvania that they came to be known as 'Transylvanian', even though it was always understood that they were made in Anatolia. Western European and even American paintings of the 17th and 18th centuries show that their popularity was by no means confined to Eastern Europe. The earliest known painting showing the characteristic border and guard-stripes seen in the present rug dates from 1620, by Cornelius de Vos. Thomas de Keyser's portrait of Constantin Huygens in the National Gallery, London, dated 1627, shows the field with this type of spandrel, lamp and flowers. Some rugs have the arch at only one end, with flowers spreading over the whole field from a hanging lamp; see Dimand (1973, fig. 176, no. 81) and Schmutzler (1933, pls. 42, 43). But on most examples, as in the present case, the design has been transformed to give ends in mirror image. The design and ornamentation of the spandrels derives from the Ushak rugs, compare no. 47. This rug is woven with about 20 knots of the Turkish type per square cm on a warp of red wool. There are two shoots of red wool weft after each row of knots.

Published: Végh and Layer (1925, pl. XII), Budapest (1972, no. 178)

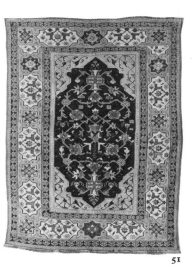

51

52

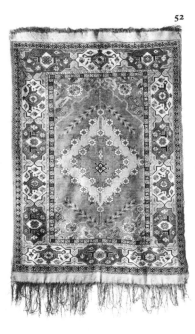

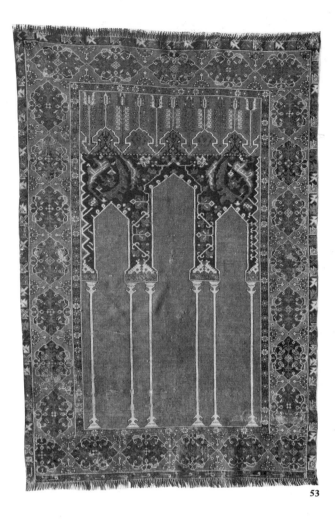

53

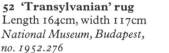

52 'Transylvanian' rug

Length 164cm, width 117cm
*National Museum, Budapest,
no. 1952.276*
Turkey (Anatolia), Ottoman period,
late 17th–early 18th century

This type of 'Transylvanian' rug (see
no. 51) probably derives its
distinctive lozenges outlined with
stems of flowers from the central
medallions with rosettes and leaves in
curvilinear form found in Ottoman
court carpets of the late 16th and
early 17th centuries. See Ellis (1969,
figs. 12, 13, 17, 18). This motif is also
found in Bergama and Konya rugs of
the 18th and 19th centuries. The
border of this rug has lost the star
shapes which separate the long
cartouches but the floral motif from
within these stars is found in the very
centre of the rug in company with the
ewer frequently portrayed in Turkish
prayer rugs as a symbol of ritual
ablution. In later 'Transylvanian'
rugs the border was further
transformed into the pattern seen in
a painting of 1741 in the Fogg Art
Museum, Harvard, by Robert Feke,
where the long cartouche contains
small rosettes around a lozenge with
a flower. The spandrel designs date
from the later 17th century, when
they are to be found in paintings by
Jacob Ochtervelt and Abraham
Snapphan around the lamp and
flower field pattern of no. 51.

Unpublished

53 Prayer rug with three stilted arches on six columns

Length 168cm, width 113cm
*Textile Museum, Washington, D.C.,
no. 34.22.1*
Turkey (Anatolia), Ottoman period,
17th–early 18th century

Rugs of this type, with the same field
and border design, appear in Dutch
paintings of the 17th century,
particularly clearly in Nicolaes van
Gelder's *Still Life* of 1664 in the
Rijksmuseum, Amsterdam. The arch
flanked by two smaller arches appears
in 16th century prayer rugs in the
Ottoman court style in the
Metropolitan Museum, New York,
and in Bucharest; see Washington
(1974, no. I) and Beattie (1968,
fig. 3). The present design appears
to be an angular, provincial version of
such curvilinear prototypes. Later

derivations of the design, simplified
still further, are seen in the Ladik
prayer rugs of the late 18th and 19th
centuries. Beattie finds these Ladik
rugs technically dissimilar from the
17th and early 18th century pieces
preserved in Transylvanian churches
which may have been made in
various parts of Anatolia; an origin
in European Turkey has also been
mooted; see Beattie (1968, pp. 251–
5). The warp is of pale red wool and
there are two shoots of pale red wool
after each row of knots. The knots are
of the Turkish type, about 15 per
square cm, in wool of eight colours.
The missing lower border has been
replaced with a side border of the
same design from another rug.

Published: Jacoby (1923, pl. 46);
Washington (1974, no. XII)

54 Prayer rug with six columns
Length 163cm, width 121cm
*Museum of Applied Arts, Budapest,
no. 7946*
Turkey (Anatolia), Ottoman period,
17th–18th century

The design of this rug, with red
columns and polychrome rosettes on
a yellow ground, is striking in its
simplicity. The triple arch motif seen
in the rug no. 53 is here reduced to
the six supporting columns only. The
warp is of yellow or yellow twisted
with brown wool and there are two
shoots of yellow wool weft after each
row of knots. The knots are of the
Turkish type, about 15 per square
cm, in wool of six colours.

Published: Beattie (1968, fig. 22);
Batari (1974, no. 7)

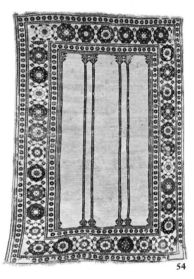

54

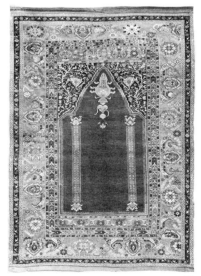

55

55 Ghiordes prayer rug
Length 175cm, width 124.5cm
*The Duke of Buccleuch and
Queensberry, V.R.D. Collection,
no. Boughton 7*
Turkey (Ghiordes), Ottoman period,
early 18th century

The border of this handsome prayer
rug is a late version of the border
designed for 16th century rugs of the
Ottoman court manufactory
(compare no. 45). The use of this
border, the shape of the prayer arch
and the columns which support it,
here transformed into long decorated
rectangles with a flower at each end,
are typical of the 18th-century rugs
made in Ghiordes. Also typical are the
disciplined knotting, comparatively
thin body and rich polychromy of this
piece. The design is distinguished by
a particularly fine hanging mosque
lamp, beneath which is a ewer
suspended upside down containing a
carnation. A later Ghiordes rug in the
Metropolitan Museum of Art, New
York, copies this feature but omits
the columns; see Dimand (1973, fig.
123). Knots are of the Turkish type in
wool of twelve colours and white
cotton, 19–20 per square cm, on a
warp of pale tan wool, with two shoots
of red wool weft after each row of
knots.

Published: London (1914, no. 38);
Beattie (1964, pl. 13, no. 15)

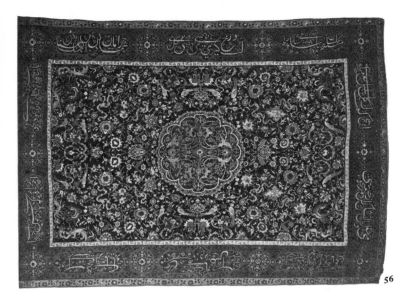

56

56 The Salting carpet

Length 233cm, width 163cm
*Victoria and Albert Museum,
London, no. T.402–1910, from the
Salting Collection*
Turkey (Hereke), Ottoman period,
probably 1860–80

This finely knotted rug in brilliant
colours, scintillating with silver, was
published in the 1880s as a Persian
carpet of the 16th century. As studies
of carpets developed, doubt was
expressed concerning date and
provenance of this and other rugs
similar in style and technique. By
1931 they were tentatively attributed
to 'the neighbourhood of
Constantinople not earlier than the
18th century'; see London (1931).
Erdmann (1966) dates them to the
first half of the 19th century,
suggesting an origin from the Sultan's
looms at Hereke, since the Topkapi
Palace Museum, Istanbul, still holds
the largest collection of these rugs.
Beattie (1968) doubted whether
Hereke produced carpets until later
in the century, which would make
this piece, published in the 1880s, an
early example. This particular design
was probably inspired by early
Persian carpets rather than a direct
copy: the fabulous beasts grouped in
the corners lack an enclosing quarter-
medallion and the disposition of the
birds is infelicitous. The verses in the
borders, by the poet Ḥāfiẓ (1320–89),
read

*May khāh va gul afshān kun : az
 dhar che mi-khāhi?
 In guft saḥar ke gul : Bulbul to
 che mi-gūyi?
Masnad bi-gulistān bar, tā shāhid
 va sāqi-rā
 Lab gīri va rukh būsi, may nūshi
 va gul būyi. . . .
Shamshād khirāmān kun va
 ahang-e gulistān kun
Tā sarv biyāmūzad az qad-e tō
 diljūyi
Emrūz ke bāzārat purjūsh-e
 kharīdār 'st
Daryāb, va buna ganji az
 māyeh-ye nikūyi
Har murgh bi-dastāni dar gulshan-e
 shāh ayyad,
Bulbul bi-ghazāli [?], Ḥāfiẓ
 bi-du'ā-gūyi*

'Call for wine, make scattering of
 roses : from fate what seekest
 thou?
 Thus at morn spoke the rose:
 Bulbul what sayest thou?
Take the cushion into the rose-
 garden, so that of the lovely
 one and the wine-pourer
Thou mayest take the lip and
 kiss the cheek, drink wine and
 smell the rose. . . .
Move thy box-tree [figure] proudly
 towards the garden
So that the cypress from thy
 stature may learn affability.
Today the bazar is aboil with
 purchasers,
 Understand that, and store a
 road-provision from the
 capital of goodness . . .
Every bird with a song comes to the
 King's rose-bed,
 The bulbul with a lyric,
 Ḥāfiẓ
 with a prayer.'

About 140 Persian knots per square
cm in fourteen colours of wool are
tied on a silk warp, with areas of
brocaded metal thread. There are
three shoots of yellow silk weft after
each row of knots.

Published: Lièvre (1880–3, IV); Beattie
(1964, no. 18 and 1968); Erdmann (1970)

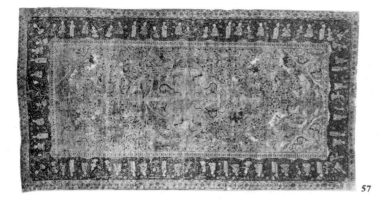

57

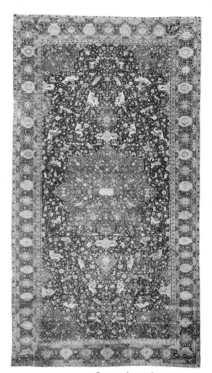

58 see colour plate, page 60

59

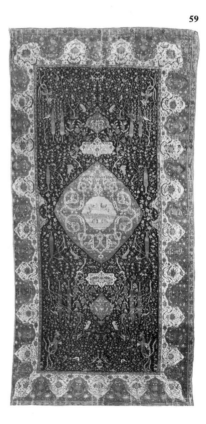

57 Silk medallion carpet with hunting scenes

Length 480cm, width 255cm
*Museum of Fine Art, Boston,
no. 66.293, gift of John Goelet,
Centennial and other funds*
Persia, Safavid period, 16th century

Hunting was an elaborate princely diversion described in Persian legend and poetry from the earliest times and depicted in every artistic medium. As a theme for carpet designs it appears in the early Safavid period and four of the most celebrated carpets of the mid-16th century belong to this group. No 58 is dated to 1542–3 but this example may well be earlier and its fine detail is enhanced by the silk pile. The other hunting carpets are in the Royal Collection, Stockholm, and in the Österreichisches Museum für angewandte Kunst, Vienna. The lifelike people and animals may be compared to those in contemporary wall-paintings, miniatures, pottery and silks but here they are set against the classic Safavid carpet structure: a field with a central medallion and dependant cartouches surrounded by a broad border flanked by two narrow ones. The carpet is woven with a silk warp, weft and pile, Persian knots per square cm, with some areas brocaded in silver-gilt thread.

Published: Sarre and Trenkwald (1929, pls. 24–6); Welch (1971)

58 Medallion carpet with hunting scenes

Length 570cm, width 365cm
*Poldi Pezzoli Museum, Milan,
no. 154, property of the Italian
Republic*
Persia, Safavid period, early 16th century

Only three of the great Safavid carpets are dated – the two Ardabil carpets, dated 1539–40 and this example. Unfortunately, the date in the central cartouche of this carpet may be read either as 929 [1522–3 AD] or 949 [1542–3 AD]. Sarre and Trenkwald preferred the later date, which seems to accord better with the style of the carpet. The design has the classic Safavid structure: each quarter of the carpet repeats exactly. The curiously stiff and almost angular palmette border and the effect of cross-hatching made by the floral stems in the ground contrast with the sinuous treatment of similar motifs in nos. 56 and 61. Within the carpet itself these formal elements contrast with the lively animals and huntsmen. This carpet was probably woven in Qazvin or Tabriz and the others in central Persia. The name Ghiyāth al-Dīn Jāmi' which appears in the cartouche together with the date possibly refers to the silk-designer or master-weaver of similar name, but this is not certain. The carpet has a silk warp, three shoots of cotton weft after each row of knots and a woollen pile with about 41 Persian knots to the square cm. One end is heavily restored.

Published: Sarre and Trenkwald (1929, pls. 22, 23); Erdmann (1960, p. 167)

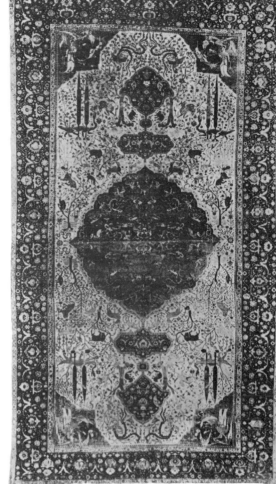

60

59 Medallion carpet with landscape and animals

Length 570cm, width 270cm
H.S.H. Charles Prince of
Schwarzenberg Collection
Persia, Safavid period, second
quarter 16th century

This medallion carpet depicting an
idealised garden embodies the finest
qualities of Safavid design. Border
and field are well balanced and the
motifs are subordinated to a single
decorative unity, but each bird,
animal or flowering tree is rendered
with astonishing naturalism. The
carpet may be closely compared in its
general design with no. 59 and
several others with similar themes,
but it is likely to be the earliest and is
certainly one of the most attractive of
the group. The design of the central
medallion epitomises its qualities:
life-like ducks in neat pairs flock in a
pond surrounded by stylised cloud-
bands. The reciprocal border
resembles that of the Chelsea carpet
in the Victoria and Albert Museum,
London, though the hunting
animals there are here replaced by
quietly perching birds. A phoenix in
each corner with a bird in its talons
provides the only touch of savagery.
The carpet has been attributed to
Tabriz. It is woven on a cotton warp
with silk wefts, three shoots after each
row of knots (two straight and the
middle wavy) with a woollen pile, 55
Persian knots per square cm.

Published: Sarre and Trenkwald (1929,
II, pl. 21)

60 Medallion carpet with landscape and animals

Length 701cm, width 368cm
Los Angeles County Museum of Art,
no. 49.8, gift of J. Paul Getty
Persia, Safavid period, mid-16th
century

This carpet depicts the Persian
concept of Paradise. To the Safavid
designer Paradise was set in a fertile
garden with flowering trees, streams,
birds and animals – some of which
were familiar from life on earth, such
as the cranes in the centre, while
others, like the phoenixes and
dragons, were borrowed from Chinese
mythology. Gentle, winged houris
are also in attendance. The structure
of this design is similar to that of the
medallion carpet no. 58. A
counterpart to the present carpet, in
the Islamisches Museum, Berlin,
was badly damaged in the war. Finer
versions of the design may be seen in
a carpet of which half is in Cracow
and half in the Musée des Arts
Décoratifs, Paris, and a fragment in
the Museum of Art, Philadelphia. In
a sense these carpets are the
ancestors of the garden carpets of the
17th and 18th centuries in which the
field is divided into formal beds of
flowering shrubs separated by water
courses. The carpet has a cotton warp
and wool and cotton wefts, three
shoots after each row of knots, with a
woollen pile of 38 knots per square
cm.

Published: Sarre and Trenkwald (1929,
II, pl. 27); Valentiner (1949); Bode and
Kühnel (1970, pp. 99–103)

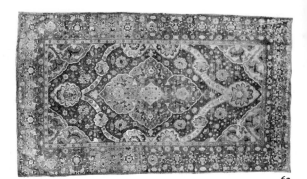

62

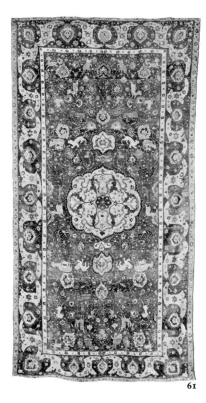

61

61 Medallion carpet with animals

Length 427cm, width 229cm
National Gallery of Art, Washington, D.C., no. C.330, Widener Collection 1942
Persia, Safavid period, mid-16th century

This classical medallion carpet epitomises Safavid taste. Although entirely symmetrical in its composition with a carefully drawn tracery of stems and a massive border, the animals are treated with extraordinary naturalism. As in the carpet no. 60 there is a mixture of real and mythical animals – *kylins* (part-dragon, part-stag) and leopards, for example. The entire design of the central medallion is based upon the Chinese cloud-band. Several features may be compared with those of no. 60, the border, the central medallion (but not its cloud-bands) and its animal style. This carpet is woven in woollen pile in Persian knots, about 30 per square cm, with woollen warp and cotton weft.

Published: Ricci (1931, no. 344, pls. 79, 80); Dilley (1959, pl. IX)

62 Silk medallion carpet

Length 244cm, width 150cm
Bayerisches Nationalmuseum, Munich, no. T.1611
Persia (Kashan), Safavid period, late 16th century

A well-defined group of very fine silk carpets has survived from the late 16th century, several of which appear to come from the same cartoon. This carpet has a counterpart in the Altman collection of the Metropolitan Museum of Art, New York and possibly another in the National Museum, Coimbra. The ribbon or band punctuated by floral panels which has been placed around the central medallion is an unusual and distinctive feature of the design. A modified version appears in a 'Polonaise' carpet in San Marco, Venice, which probably dates from 1603. The main border is unconventional and its tightly curled cloud-bands are much closer to their Chinese originals than those forming the decoration of the corner medallions. Over a dozen carpets can be attributed to this workshop which Erdmann believed was the same as that which produced the carpet no. 57. The carpet is woven in silk pile with Persian knots.

Published: Riegl (1892, no. 74, pl. LXVI); London (1931, no. 185); Pope and Ackerman (1938–9, pl. 1202); Erdmann (1970, pp. 61–5, pl. 61); Dimand (1973, no. 15)

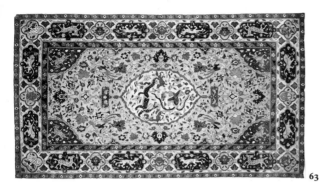

63

63 Silk and gold kilim
Length 227cm, width 130.6cm
Textile Museum, Washington, D.C.,
no. R.33.28.1. (old no. R3.51)
Persia (? Kashan), Safavid period,
1600–25

When the Polish Carmelite priest
Paul Simon visited Kashan in 1608
he saw tapestry woven rugs being
made as well as other rich carpets and
textiles. These were as much admired
by Europeans as the pile-woven silk
carpets and a number of precious
examples have survived. They are
often classed with the 'Polonaise'
pile rugs (see no. 64–6).
Arabesque and floral designs similar
to the pile-woven versions are found
but others are tapestry woven
renderings of the medallion and
animal carpets of the 16th century.
This rug is almost a pair in size and
pattern with one in the Islamisches
Museum, Berlin, acquired in 1914
from the Empress Friedrich. The
corner animals are turned the other
way in the Berlin version and there is
an inscription. Both have a central
medallion with a dragon and
phoenix in perpetual combat.
Dimand suggests that the kilims with
softer colouring, such as this
example, were probably woven in
Isfahan.

Published: Sarre and Trenkwald (1926,
II, pl. 45); Erdmann (1970, p. 219, pl. V);
Dimand (1973, pp. 65–7)

64 Silk and gold 'Polonaise' carpet
Length 259cm, width 144.8cm
Victoria and Albert Museum, London,
no. T.36–1954, gift of Christabel
Lady Aberconway
Persia (Isfahan or Kashan), Safavid
period, about 1600–20

This fragmentary carpet, woven in
silk and brocaded in gold and silver,
belongs to a group considered fitting
gifts for the princes of Europe. In
1603 and 1622 gifts of silk carpets
were made to the Doges of Venice,
some of which are still in San Marco.
Another group now in Rosenborg
Castle was sent to Denmark in 1639
by the Shaykh Ṣafī. The fame of
Persian silk carpets was such that
Sigismund Vasa of Poland
commissioned a group in 1602. Even
Queen Elizabeth of England had, in
1599, an apartment in Hampton
Court 'ornamented with silk hangings
worked in Turkish knot' – a gift from
the Earl of Leicester. This fragment
is almost identical to one in the shrine
of the imam 'Alī at Najaf in
Mesopotamia, the most venerated
shi'a shrine, probably woven in the
royal workshops at Isfahan, which is
also a reasonable provenance for this
piece. A Polish traveller of 1608,
however, reported similar carpets
being woven in Kashan and this is
also a possible provenance. Such
carpets were found in Polish
collections in the 19th century and
for this reason they came to be
grouped together under the general
misnomer of 'Polonaise'. This
carpet is woven on a silk warp and
weft with about 40 Persian knots per
square cm. One border has been cut
and rejoined.

Published: Aga-Oglu (1941); Dimand
(1973, pp. 159–60)

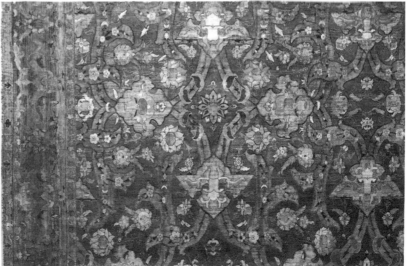

64

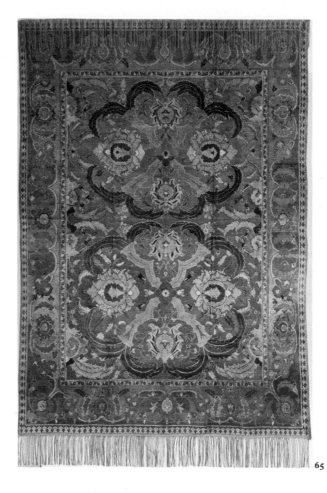

65

65 Silk and gold 'Polonaise' carpet

Length 206.4cm, width 127cm
Cleveland Museum of Art, no. 26.533, purchase from the J. H. Wade fund
Persia (Isfahan or Kashan), Safavid period, early 17th century

Throughout the 17th century silk carpets with arabesque and floral designs were woven in the royal workshops of Isfahan and Kashan for presentation to foreign potentates. There may also have been some private production when royal orders had been filled, though no examples have yet been discovered in Persia itself. This carpet is typical of the 'Polonaise' group. While there are variations in colour and in the structure of the designs, the field is often divided into two halves, as in this carpet. The two other 'Polonaise' carpets in this exhibition provide interesting contrasts in design; compare nos. 64 and 66. A similar carpet in the Kevorkian Collection was sold in 1969 and passed into the collection of J. Paul Getty. Few 'Polonaises' appear in the paintings of the period; an exception may be the carpet in the portrait of a young woman by Frans Mieris in the State Hermitage Museum, Leningrad, in which the border may be compared with this example and the field with several others. The carpet is woven in silk with Persian knots on a silk warp with a cotton weft after each row of knots.

Published: Cleveland (1970, p. 217); Dimand (1973, pp. 59–65)

66 Silk 'Polonaise' rug

Length 210cm, width 143cm
Staatliche Museen zu Berlin, Islamisches Museum, no. I.23
Persia (Isfahan or Kashan), Safavid period, early 17th century

This is an example of the splendid rugs, of silk enriched with metal thread, which were produced in Isfahan and Kashan and were often presented by the Shah as official or diplomatic gifts; see nos. 64, 65. The colour scheme of salmon pink, light green and brown, with gold and silver, is characteristic of the type. The rug, which was given to the Berlin Museum by Fürst Joh. von und zu Liechtenstein, is one of a pair; the second rug is in a private collection. Warp and weft are of silk; the knots are of Persian type, about 34 per square cm.

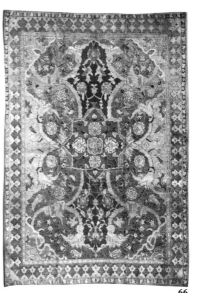

66

Published: Vienna (1892, pl. IV); Berlin (1935, fig. 14)

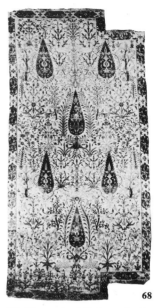

68

67 'Portuguese' carpet

Length 677cm, width 311cm
*Österreichisches Museum für
angewandte Kunst, Vienna,
no. T.8339*
Persia or India, Safavid or Mughal
period, 17th century

67

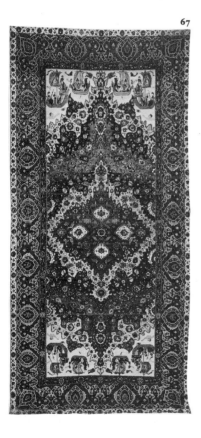

One of the finest of a group of puzzling and unusual carpets which has provoked discussion and disagreement for a century past. Others are in the Metropolitan Museum of Art, New York, in the Musée des Tissus, Lyons, the Rijksmuseum, Amsterdam, Winterthur (USA) and Knole in Kent. The stiff palmette and arabesque border appears on many 17th-century Persian carpets, but not the serrated central medallion. Are the Europeans in the corners part of a Portuguese diplomatic mission which has arrived in the Persian Gulf, or does the scene commemorate Bahādur Shāh, the last great ruler of Gujarat in north-west India? He was drowned, possibly murdered, in 1537 while travelling on a Portuguese ship outside the town of Diu. The carpet could have been made in southern Persia, or in Gujarat, or as the oldest theory suggested, in Goa. The model for the scene may be a lost miniature or even a European print. Persian weavers worked in India under Mughal patronage, so similar decorative features and techniques are to be found in the carpets of both Persia and India at this time. Later versions of this design were made as far away as the Caucasus. The warp and weft are cotton and there are 50 Persian knots per square cm.

Published: Sarre and Trenkwald (1926, I, pl. 33); Bode and Kühnel (1970, pp. 112–14); Ellis (1972, pp. 267–89)

68 Carpet with tree design

Length 188cm, width 85cm
*Iran Bastan Museum, Tehran,
no. 3380, on loan from the
Mausoleum of Shah 'Abbās II, Qum*
Persia, Safavid period, 1671

This carpet comes from a set of thirteen shaped to fit the floor of the twelve-sided tomb-chamber of Shah 'Abbās II (died 1666) at Qum. It is one of the few Persian carpets to be woven with a date and a name, Ni'matullah of Joshagan. However, the place of the family home of the master weaver is not necessarily an indication of where the carpet was made. 17th century writers mention silk carpets from Joshagan, but also from Kerman, Kashan and Isfahan. In contrast with nos. 59 and 60, the trees and birds in this garden of paradise are arranged in neat rows, the motifs repeating about a central axis. Other carpets from the set have this symmetrical repeat and also a straight repeat, suggesting that their designs may have been borrowed from woven silks where such limitations of design were unavoidable. Similar repeats may be seen in no. 69. The carpet is woven with two shoots of silk weft after each row of Persian knots, tied 50 per square cm in silk on a silk warp.

Published: London (1931, no. 334); Pope and Ackerman (1938–9, pl. 1258B, pp. 2398–9); Bode and Kühnel (1970, fig. 103)

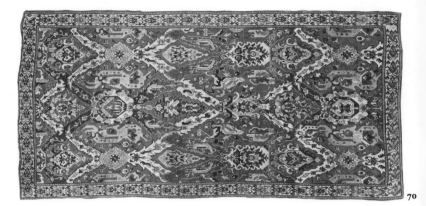

70

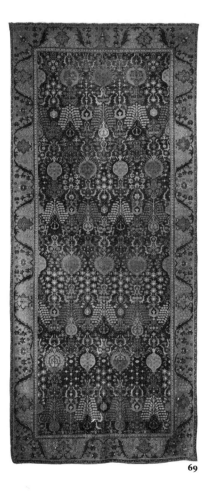

69

69 Vase carpet
Length 610cm, width 260cm
Rijksmuseum, Amsterdam,
no. RBK 17271, originally from the
Imperial Collection, Vienna
South or East Persia, Safavid period,
second half 17th century

Vase carpets may be divided into
several groups but all are elongated
with rather narrow borders and their
designs are intended to be seen from
one direction only. Their decoration
is entirely floral and among their
least conspicuous features are the
actual vases. The more usual 'vase'
carpets are based on a diamond-
shaped lattice of linked stems. See
Dimand (1973, pp. 72–7). This carpet
is a pair to one in the Österreichisches
Museum für angewandte Kunst,
Vienna. Their colouring is unusual
and the stiff horizontal lines of the
flower vases suggest a later 17th
century date, as do their rather
stylised borders. The provenance of
these carpets has been variously
proposed as Kerman, Joshagan and
Isfahan. The carpet is woven with a
cotton warp and weft, three shoots
after each row of knots, and a woollen
pile of 19 Persian knots per square
cm.

Published: Sarre and Trenkwald (1929,
I, pl. 24); Delft (1948–9, no. 20, fig. xiii)

70 Dragon carpet
Length 477cm, width 222cm
Private Collection, England
Caucasus, about 1700

Besides the highly stylised dragons (in
rows near the top and bottom) after
which these carpets are named, the
earlier examples contain other animal
forms. Here, between the dragons, are
repeated two creatures in combat, the
lower animal with hooves and a short,
thick tail and outlined head
protruding from a misshapen body.
The straggling marks on the bodies of
the animals are probably a stylisation
of the flames seen in Persian 16th-
century carpets, lapping the bodies
of the fabulous animals borrowed
from Chinese art. The system of
intersecting lozenges, boldly outlined
in contrasting colours, with large
rosettes or palmettes at the points,
also dates back to the 16th century in
silks. The transformation of these
designs is more than contemporary
rendering of a curvilinear pattern in a
rectilinear form: the dragon rugs
show degrees of stylisation and
accretion of ornament which took
time to evolve. Examples attributed
to the 18th century show a decreasing
understanding of the original designs.
This carpet has a woollen warp and
weft with 14 Turkish knots per square
cm.

Published: Aga-Oglu (1948, no. 10)

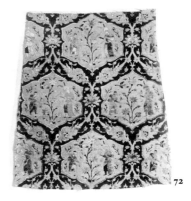

72

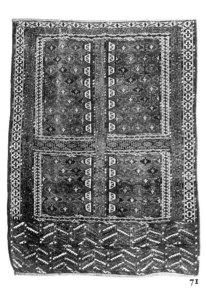

71

71 Yomut prayer rug
Length 167.6cm, width 121.9cm
Victoria and Albert Museum,
London, no. 1050–1883
Caspian region, 19th century

Nomadic Turkoman tribes lived originally in an area south of the Aral sea, east of the Caspian, north of Afghanistan and west of the Oxus river, and are today widely dispersed. The Yomuts were closest to the Caspian. Each tribe had a distinctive pattern; the diamond shaped *gul* containing a stylised flower is a feature of many Yomut rugs. The high quality of the materials, the weaving and the colouring – a rich deep red and dark indigo blue with touches of white – are common to all early Turkoman rugs. The design of this example is equally characteristic of their prayer rugs, with a cross in the field and a broad lower border. As the tribes were mixed racially, both Persian and Turkish knots are found. Their rugs became widely known in the West after only the publication of an illustrated study by a Russian governor of the Transcaspian province; see von Bogolyubow (1908–9). The warp is of undyed wool with two shoots of dark brown wool after each row of knots. The knots are of the Turkish type, 56–60 per square cm. The top of the carpet is finished with a border of Soumaq.

Unpublished

72 Velvet with figures in compartments
Height 77.5cm, width 66.7cm
Cleveland Museum of Art, no. 44.239,
purchase from the J. H. Wade fund
Persia, Safavid period, 16th century

Within a repeating design of lobed medallions, a princely figure bears on his wrist a falcon, ready to pursue a colourful duck that has flown behind a flowering tree. A servant comes forward with refreshment. In striking contrast to the delicacy of this scene are palmettes, one girdled by a black and white spotted snake, the other decorated with a lion mask in a surrounding arabesque. Textiles with gold backgrounds gained immense popularity at the court of Shah 'Abbās (1587–1629). Added richness is achieved by the velvet pile pattern in which a deep red predominates; the other colours are orange, yellow, green, two shades of blue, buff and grey. The colour combinations are different in each medallion.

Published: Underhill (1944, p. 157);
Weibel (1952, p. 120, pl. 136);
Los Angeles (1959, no. 53, p. 34);
Paris (1961, p. 201, no. 1130)

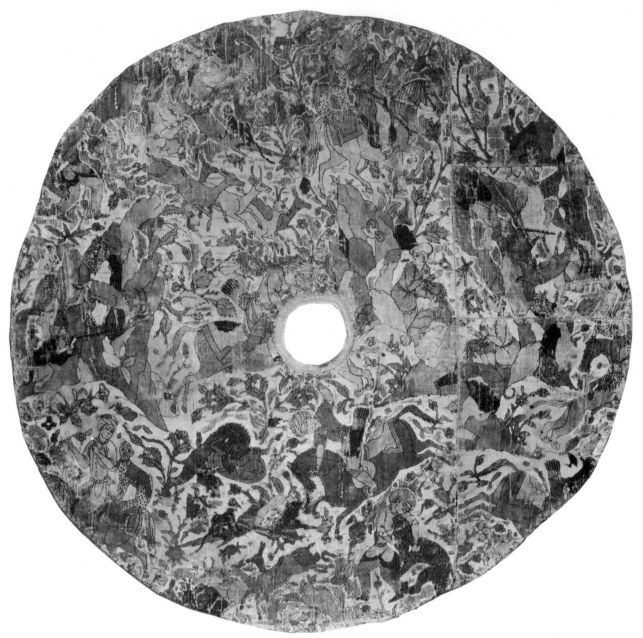

73 Velvet tent ceiling with hunters and animals

Diameter 97cm

Museum of Fine Arts, Boston, no. 28.13, gift of Mrs Walter Scott Fitz

Persia, Safavid period, 16th century'

This circular panel of velvet functioned as the ceiling of a tent and is said to have been captured by the Ottoman Sultan Sulayman the Magnificent during one of his invasions of Persia in 1543–5. It then passed to Kara Mustapha Pasha from whose hands it fell into those of a Polish general at the rout of the Turks at Vienna in 1683. Though the colours of the silk pile have faded and the original gold ground has worn away, this velvet remains one of the outstanding examples of Persian 16th century silk weaving. Depicted are scenes from the hunt: a lion devours a gazelle (compare no. 78), a lion grapples with a man, a horseman draws his bow at a group of fleeing gazelles, another turns to survey a tame cheetah that rides behind and a rifleman takes aim from behind a rock. Unfortunately, the opening for the tent pole obliterates the major portion of a fight between a horseman and a lion. The drawing of these activities, particularly the latter scene, may be compared to that in the hunting carpet, no. 57.

Published: Townsend (1928, no. 154, pp. 24–9); London (1931, no. 146); Pope and Ackerman (1938–9, pl. 1023); New York (1949, no. 36); Weibel (1952, pp. 118–20, pl. 132)

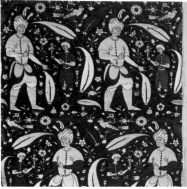

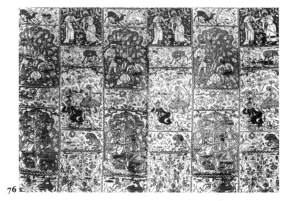

74 detail 76

74 Silk cloth with figures, leaves and flowers
Height 267cm, width 72cm
Royal Collection at Rosenborg Castle, Copenhagen
Persia, Safavid period,
late 16th century

The vigorous drawing of the figures in this magnificent silk is enhanced by immense leaves and a contrasting black ground. A prince holds out his hand to receive a bouquet which a smaller figure, perhaps a child, offers him. Aigrettes rise from the prince's turban which is wrapped around a narrow pole in the style of the period. Amidst the surrounding flowers a splendid bird sings.

Published: Martin (1901, pls. VIII, IX); London (1931, pp. 109)

75 Silk coat
State Armoury Museum, Moscow
Persia, Safavid period, 16th century

This superb coat is made from a silk of quite exceptional beauty; indeed one commentator, Ackerman, has called it one of the supreme textiles of all time. The pattern, in gold, silver and coloured silks on a light blue ground, shows a phoenix perched on a tree and Alexander hurling a rock at a dragon. The design was a favourite one and versions of it are found in other contemporary silks and velvets.

Published: Sarre and Martin (1912, pl. 196); Pope and Ackerman (1938–9, pp. 2057, 2090); Moscow (1954, pp. 342–5)

76 Silk cloth with four scenes repeated
Height 94.6cm, width 53cm
Victoria and Albert Museum, London, no. 718–1899
Persia, Safavid period, 16th century

The scenes illustrated here, as in no. 75, are probably those of a poem or story and are contained within niches in repeating bands. In one scene, a lady plays a dulcimer to an admirer; in a second, she offers refreshment to a companion; in a third, a man stirs a pot over a fire while a friend brings dishes; in a fourth, a man and a woman rest by a stream. Gazelles, leopards and lions sporting among leaves and flowers, divide each tableau. The colours are beige, tan, pale blue, pink, white, red, black and silver, and are changed in the various bands. The weave is lampas with the pattern in twill on a satin ground. Several pieces are sewn together.

Published: Martin (1901, fig. 1, p. 2); Pope and Ackerman (1938–9, pl. 1026); London (1950b, pl. 41)

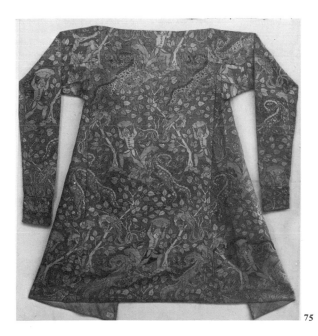

75

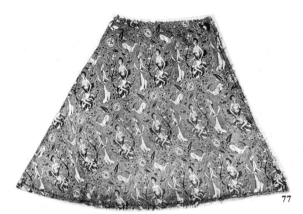

77

77 Silk cloth with a scene from the story of Layla and Majnūn

Height 34.3cm, width 47cm
*Victoria and Albert Museum, London,
no. 916–1897*
Persia, Safavid period, 16th century

The headdress and costume of Layla, seen here visiting Majnūn who sits among trees and wild animals, is that worn by ladies of the court of Shah Ṭahmāsp (1524–76) in the later years of his reign. The style closely follows that of contemporary miniatures, the painters of which were frequently responsible for textile cartoons. The fineness of the double cloth weave provides an admirable background to the delicate drawing of the design which is executed in silver, red and ivory thread. This cloth was probably a panel from a garment.

Published: d'Hennezel (1930, pl. 11);
Pope and Ackerman (1938–9, pl. 1033b);
London (1950, no. 2)

78 Silk cloth with fighting wild animals

Height 54.6cm, width 85cm
*Victoria and Albert Museum, London,
no. T.111–1929*
Persia, Safavid period, 16th century

This silk has a repeating pattern of wild animals in combat. The liveliness of the subject is well balanced by the delicate drawing and the subtlety of the green, pale yellow and orange colours. A leopard leaps in pursuit of a gazelle; a leopard, astride a mule, sinks its teeth into the flesh; a gazelle tumbles under the vicious attack of a lion. These are ancient motifs which may be traced back to pre-Islamic Persia, where they were employed in Achaemenid art to great effect. They also appear on the tent ceiling (see no. 73) and the Persian and Indian animal rugs (see nos. 61 and 99). This panel is part of a silk cope, said to have come from a monastery in northern Albania. Its central part is now in the Benaki Museum, Athens. The weave is lampas with twill pattern on a satin ground.

Published: London (1931, no. 248);
Pope and Ackerman (1938–9, pl. 1041)

79 Silk hanging

Width 24cm, height 107cm
*Musée Historique des Tissus, Lyon,
no. 29.52*
Persia, Safavid period,
16th–17th century

This spectacular hanging has a rich red ground. In a niche is a finely-drawn plant with a palmette around which butterflies hover. Linked medallions form the decoration of the border. At the bottom left-hand corner an inscription states that this is the work of Mughīth. A similar silk hanging, with a dark blue ground, is in the Victoria and Albert Museum, London.

Published: d'Hennezel (1930, pl. 20)

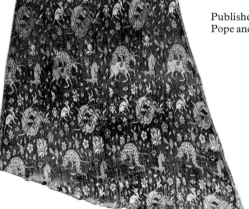

78

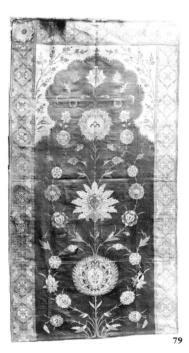

79

80

80 Silk cloth with religious texts

Length 119cm, width 90cm
*David Collection, Copenhagen,
no. 30/1971*
Persia, Safavid period, 17th century

The striking design of this cover is
composed of religious texts in blue on
a yellow ground in repeating
compartments.
The cartouches repeated at the top
and bottom give the donor's name.

> *Waqf namūd ḥajjiyya Khawānzāda
> bint Qāsim Ibānakī 153 [sic]*
> '[This was] bequeathed by
> Ḥajjiyya [the pilgrim]
> Khawānzāda daughter of Qāsim of
> Ibānaki 153 [?].'

Upper band of compartments
repeated below

> *Nād 'Alī muẓhir al-'ajā'ib*
> 'Call on 'Alī who shows forth
> miracles.'

Lowest band of compartments
repeated above

> *dhā jā al-naṣr wa al-fatḥ li'llāh*
> 'Behold victory and conquest
> belongs to God.'

In the miniature compartments
arranged vertically

> *Katabahu Muḥammad Mu'min.*
> 'Written by Muḥammad Mu'min.'
> *Bismillāh al-raḥmān al raḥīm*
> 'In the name of God the merciful
> the compassionate.'
> *Wa fatḥ qarīb*
> 'And speedy conquest,' (in mirror
> writing)
> *Naṣr min Allāh*
> 'Victory is from God.'

Along the bottom band

> *'Amal Muḥammad Ḥusayn ibn
> Hajji Muḥammad Kāshānī*
> 'Work of Muḥammad Ḥusayn of
> Hajii Muḥammad of Kashan.'

Published: Davids Samling (1975)

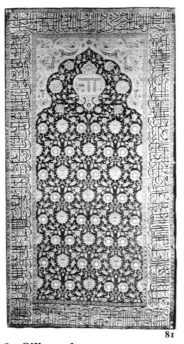

81

81 Silk tomb cover

Height 235cm, width 124cm
*Iran Bastan Museum, Tehran,
no. 3314*
Persia, Safavid period, about 1600

This tomb cover comes from the
shrine of Shaykh Ṣafī al-Dīn at
Ardabil. Its composition consists of
palmettes set among an arabesque of
floral ornament. The delicacy of the
design is offset by the bold forms of
the inscription in the border. This
inscription, in highly complicated
thuluth, appears to invoke God's
blessing on the twelve Shi'a imams.
The phrase *ṣal'alā*, 'God bless'
appears twelve times and the names
of 'Alī b. Abī Ṭālib, Ḥasan, Ḥusayn
and Ḥasan al 'Askar are easily
identifiable. There is also the
signature of Ghiyāth of Yazd, a
master weaver of great renown
working in the late 16th and early
17th centuries.

Published: London (1931, no. 129);
Pope and Ackerman (1938–9, pl. 1037)

82

82 Silk tomb cover

Width 101.6cm
Imam Riza Shrine Museum, Mashhad
Persia (possibly Isfahan), Safavid
period, 1699

The cover, woven of silk in pale
tones, has bands of inscriptions
alternating with bands of leaves and
flowers. Besides Koranic quotations,
Arabic verses, prayers and
incantations, the inscriptions
include the name of Shah Sulaymān,
who presented the cover to the
shrine of the Imam Riza at Mashhad,
and the name of the poet, Ṭāhir, who
composed the chronogram which
gives its date as 1080.

> 'The owner of the age,
> Sulaymān Pādishāh
> With whose desire the turn of fate
> and good fortune accord
> Presented to the shrine of
> King Riza
> A [i.e. this] *shudda*, with the
> utmost disinterestedness,
> Ṭāhir wrote for its chronogram
> 'A.z.S.l.y.a.n.sh.d.h. sh.d.
> v.q.f., A.m.a.m.' [1080]'

The calligrapher is named in the
border as Muḥammad Riẓā
Imāmī [?].

Published: London (1931, no. 844);
Pope and Ackerman (1938–9, p. 2134,
pl. 1084)

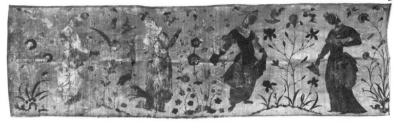

85

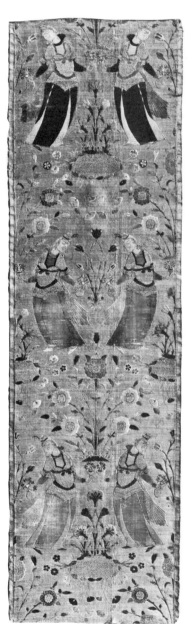

83 Velvet with female figures

Height 196cm, width 57cm
*Royal Ontario Museum, Toronto,
no. 962.60.1, gift of Mrs John David
Eaton*
Persia, Safavid period,
early 17th century

In the scene on this velvet, ladies hold
bunches of flowers and stand on
either side of a pool with flowering
plants. Two pairs of figures sway
towards each other though their faces
are turned away; the intermediate
pair have the pose reversed. A striking
sense of rhythm is created by this
courtly dance. An inscription states
that this was the work of Ṣafī. The
embroidered details are a later
addition.

Unpublished

84 Velvet coat with figures

Height 123cm
Royal Armoury, Stockholm, no. 3414
Persia, Safavid period, first half
17th century

This spectacular coat, with its design
in velvet on a gilded silver ground, is a
splendid example of the opulence of
the art of this period. Languid youths,
the epitome of indolence and leisure,
drink from cups filled from long-
necked vessels. Their poses harmonise
with the swaying motion of the plants
among which they stand. This coat
was a gift from the Czar of Russia to
Queen Christina of Sweden in 1644.

Published: Pope and Ackerman (1938–9,
pl. 1060); Geijer (1951, no. 31, pl. 15);
Stockholm (1966, no. 1469)

85 Velvet with female figures

Height 74cm, width 237cm
*National Museum, New Delhi,
no. 65.84*
Persia, Safavid period,
early 17th century

The scene on this velvet depicts four
young ladies; one with a dog, a second
with a falcon, a third with a bottle and
a fourth with a jug and bowl, wander-
ing in a landscape of flowers. Small
Chinese-type clouds adorn the sky
beyond. The fitted robes and short
jackets of the ladies are typical of the
fashion introduced under the court of
Shah 'Abbās. The naturalism of the
drawing of the dog reflects the
European influence that was begin-
ning to make itself felt in the art of
this period. This piece may be com-
pared to another example in the Royal
Ontario Museum, Toronto. The
figures are in silk pile on a gold
ground.

Unpublished

83 see colour plate, page 61

84 see colour plate, page 59

86 Velvet envelope with figures
Height 68cm, width 16.5cm
*State Archives, Copenhagen, on loan
to the Museum of Decorative Art,
Copenhagen*
Persia, Safavid period, 17th century

Falconry is the subject of the scene
depicted on this velvet, but there is a
difference in style from the examples
nos. 73–7. The figures have
become plumper, their poses more
languid and the texture of the fabric
less subtle, characteristics which are
typical of the greater luxury of the
court of Shah 'Abbās who, in 1598,
moved his capital to Isfahan. In
miniature painting the chief exponent
of the new court style was Rizā-ye
'Abbāsi whose influence was extended
throughout the 17th century and is
clearly reflected in this example. The
pattern is in velvet pile against a gold
ground, and shows youths wearing
huge turbans, with sashes wound
round their waists. Each youth holds
a falcon and a servant kneels to fill a
drinking horn from a vessel with a
long neck and handle. This velvet has
been made into an envelope which,
like no. 90, was probably used to
contain a royal letter.

Published: London (1931, no. 396B a);
Copenhagen (1935, pp. 44–65); Pope and
Ackerman (1938–9, pl. 1059)

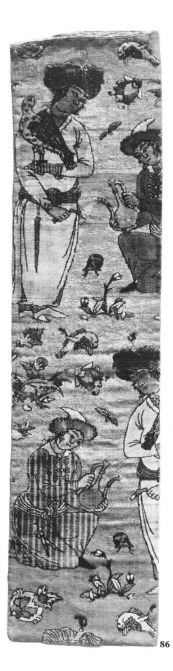

86

**87 Velvet with strawberry
plants**
Height 146cm, width 73cm
*Museum of Fine Arts, Boston,
no. 51.2477*
Persia, Safavid period, 17th century

Large leaves provide a striking back-
ground for the strawberry plants,
which bear both fruit and flowers,
depicted on this remarkable velvet.
The formality of the design is relieved
by the butterflies that hover at either
side. Other pieces of the same velvet
are in the collections of the Metro-
politan Museum of Art, New York,
and the University Museum,
Philadelphia. The design is in silk
pile on a gold ground.

Published: Reath and Sachs (1937,
pp. 129–30, pl. 88); Pope and Ackerman
(1938–9, pl. 1063c); Welch (1973–4, no. 64)

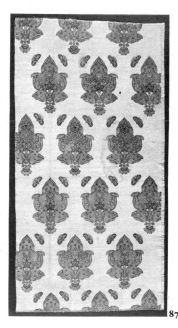

87

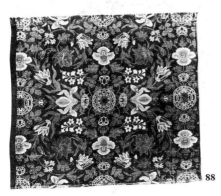

88

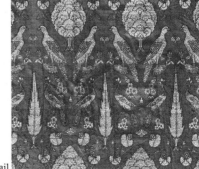

89 detail

88 Velvet with palmettes and flowers
Height 104cm, width 91.5cm
*Victoria and Albert Museum, London,
no. 733-1892*
Persia, Safavid period, 17th century

The decoration of this velvet consists
of palmettes and flowers enclosed by
floral sprays on a deep red ground. It
is a composition that became popular
among rug weavers of the 16th and
17th centuries and is characteristic of
one type of the so-called vase carpets.

Published: London (1931)

89 Silk coat with birds, trees and flowers
Height 132cm, width 190cm
*Victoria and Albert Museum, London,
no. 280-1906*
Persia, Safavid period,
17th–18th century

This luxurious coat has a delicate
repeating design of birds and
peacocks in a background of trees,
flowers and flying insects. The colours
are silver, orange and blue on a
mustard ground. Note the
exaggerated length of the sleeves
which is a characteristic of the
fashion of the courtly style of the
period and was also depicted in
miniature painting. The red border
may be a later addition.

Published: London (1931, no. 401b)

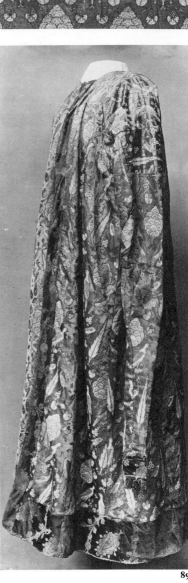

89

90

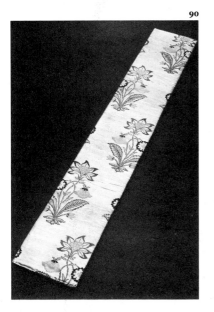

90 Silk envelope with flowers
Height 82cm, width 14cm
State Archives, Stockholm, no. 214
Persia, Safavid period,
late 17th century

This envelope was brought to Sweden
in 1682 by Ludwig Fabritius, an
ambassador of the Swedish king, and
contained a letter from the Shah of
Persia. The design of rows of flowers
in different colours is a fine example of
the floral patterns that became
increasingly popular in 17th and
18th century Persia. The gold ground
was evidently polished with a hard
implement to give an added
brilliance.

Published: Geijer (1951, no. 37, pl. 17)

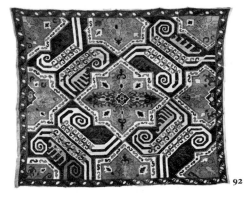

92

91 Silk banner with inscriptions
Height 360.5cm, width 203cm
Victoria and Albert Museum, London,
no. 2318-1876
Persia, Qajar period, 19th century

This banner is triangular with a triple
border of inscriptions. The outer and
inner borders, with writing on a
white ground, repeat verses from the
Koran, Sura LXVII, 51–2. The
central border, in white writing, is a
repeating series of larger cartouches,
two of which have Koranic verses in
Arabic. In between are smaller
cartouches with invocations to God.
The banner was intended for use at
religious ceremonies. The central
emblem of the lion and sun has its
origins in astrology and became the
national emblem of Persia under the
reign of Muḥammad Shāh (1834–48).
The lion usually bears a sword,
symbolising the sword of 'Alī, the
first Shi'a imam. The absence of a
sword suggests a date earlier in the
century. The design is in blue, red
and gold. The border is woven
separately.

Unpublished

92 Embroidered cover with a stylised dragon design
Height 132cm, width 111.5cm
Victoria and Albert Museum, London,
no. T.70-1909
Caucasus, 18th century

The bold design of this cover is a
highly stylised version of that found
on the so-called dragon rugs of the
Caucasus (compare no. 70). The
cover is embroidered in silk in
darning and double running stitches
in red, blue, green, yellow, orange and
ivory on a black ground. The base is
canvas.

Published: London (1950a, no. 2)

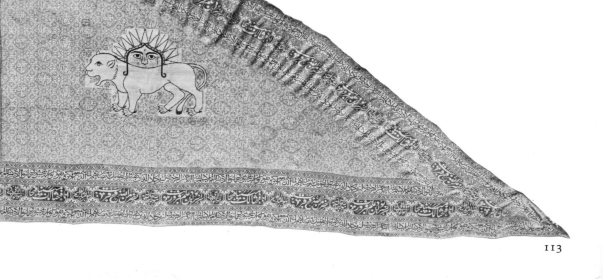

91

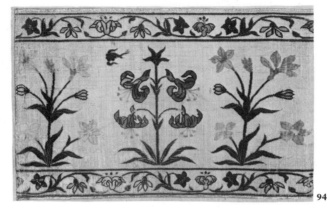

94

93 Silk hanging with flowers in a niche
Height 212cm, width 97cm
Staatliche Museen Preussischer Kulturbesitz, Museum für Indische Kunst, Berlin, no. 1.364
India, Mughal period,
early 17th century

Here a graceful flower with several blooms is set within a niche on a rich red ground. The spandrels are decorated with a floral arabesque and there is a border of a continuous floral scroll.

Published: Berlin-Dahlem (1971b, pl. 25)

93

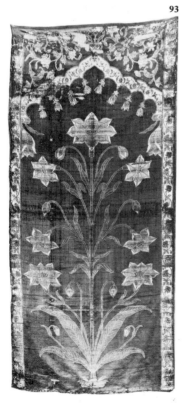

94 Velvet border with floral design
Length 298cm, width 158cm
Victoria and Albert Museum, London, no. 320–1898
India, Mughal period, 17th century

This sumptuous cut velvet is composed of two pieces, intended as borders, sewn together. The floral design is common to both Mughal India and Safavid Persia and consists of orange blooms outlined in red, alternating with yellow blooms outlined in pale blue, with rich green leaves. Here, the more naturalistic rendering of the flowers suggests an Indian attribution.

Unpublished

95 Velvet hanging with floral trellis pattern
Height 307cm, width 247cm
Private Collection England
India, Mughal period, 17th century

This large and elegant hanging, with its deep red field and sage green border, has a delicate trellis pattern formed by leafy tendrils in which rosettes and flowers may be discerned. This composition is common in Mughal carpets of the same period. The border has a wavy scroll of leaves and flowers which is repeated in a simplified form in the guard stripes.

Unpublished

96 Silk sash with a floral border
Length 322.5cm, width 51cm
Victoria and Albert Museum, London, no. 317–1907
India, Mughal period, 17th century

This is a particularly fine example of a type of sash frequently depicted in Indian miniature paintings. Similar work was also done in Persia (compare no. 97) and the flow of Persian craftsmen to India, and Indians to Persia, further confuses the problems of attribution. This silk has a wide border with a pattern of flowering shrubs in orange, outlined in red, together with green leaves, surrounded by narrow bands of undulating foliage and flowers. The field is red with a pattern of lozenges.

Unpublished

95

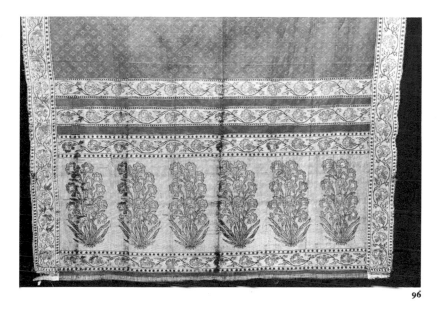

96

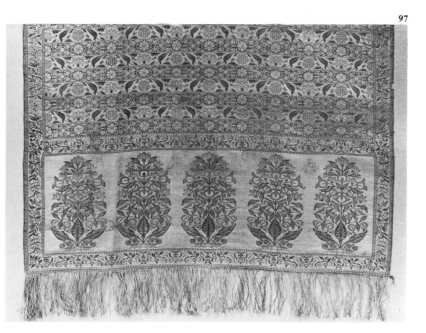

97

97 Silk sash with a floral border
Length 472cm, width 61cm
*Victoria and Albert Museum, London,
no. T.49–1923*
India or Persia, Mughal or Safavid
period, 18th century

On the back of this sash is the seal of
Āsaf Jāh, the first Nizam of
Hyderabad, and the date 1159
[1746 AD]. The wide border contains
five trees bearing flowers and fruits in
green, blue, yellow and ivory and is
surrounded by a narrow band of
floral scroll. The field consists of
alternating stripes, one containing
gold flowers on a tan ground, the
other an undulating design of flowers
and leaves. Such sashes were worn
around the waist with the wide
bordered ends hanging down. A
vogue for sashes of a similar design
also existed among the nobility of
Poland in the 18th century.

Unpublished

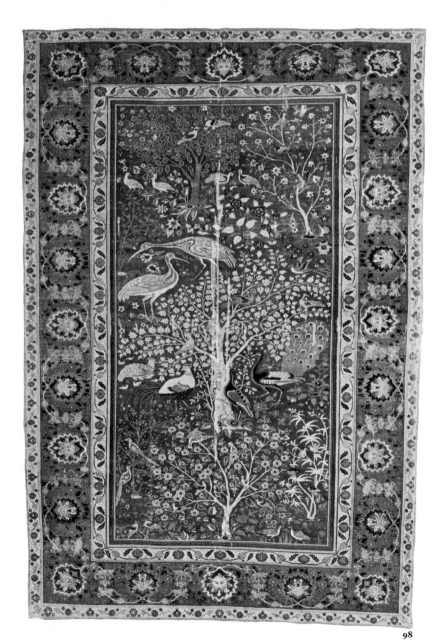

98

98 Rug with birds among trees
Length 235cm, width 156cm
Österreichisches Museum für
angewandte Kunst, Vienna, no. 0292
India, Mughal period, about 1600

This is one of the finest examples of
the free pictorial composition,
avoiding symmetry and repetition,
which is a characteristic feature of
Mughal rug design. The landscape of
trees and shrubs is animated by a pair
of cranes, a cock and hen with
chicks, a peacock and a peahen,
turtle doves, hoopoes, partridges and
other birds. The border and guard
stripes include plant ornament, lion
masks, leopards and birds. Dimand
compares this rug with the paintings
of Manṣūr and suggests that he may
have been its designer. Comparisons
have also been made with Indian and
Persian lacquered bookbindings. The
warp is of white cotton on two levels
and there are three shoots of pale red
cotton weft after each row of knots.
The knots are of the Persian type,
about 75 per square cm, in wool of
thirteen colours.

Published: Riegl (1892, pl. I); Sarre and
Trenkwald (1926, pls. 35–6); Dimand
(1973, p. 121)

99 Animal carpet
Length 403.5cm, width 191.2cm
*National Gallery of Art, Washington
no. C 328, Widener Collection, 1942
previously in the collection of the Duke
of Rutland, Belvoir Castle*
India, Mughal period, about 1625

Throughout the 16th and 17th
century Persian influence was
paramount in Mughal textiles,
modified by European influence from
the early 17th century onwards. Agra
and Lahore were the chief centres of
carpet manufacture. Carpet design
in the reign of Jahāngīr (1605–28)
resembles contemporary Persian
products but there are some
important differences. While some
traditional mythical beasts appear,
such as the winged kylins and dragons,
like that which has caught the
unfortunate deer in the centre of this
carpet, Chinese influence is in general
much less marked. Both animals and
men are much larger and more
lifelike, so that they dominate the
design. The open rich red ground and
strong colouring are typical of
Mughal carpets and show the figures
clearly. The elephants, crocodiles and
rhinoceros may be compared with
similar animals in late 16th century
Indian miniatures. While the border
of cartouches looks superficially
Persian, the palmettes have turned
into birds alternating with animal
masks. The carpet is woven with a
cotton warp and weft and has a
woollen pile, about 36 knots per
square cm.

Published: Dilley (1959, pl. 35); Dimand
(1973, pp. 119–20)

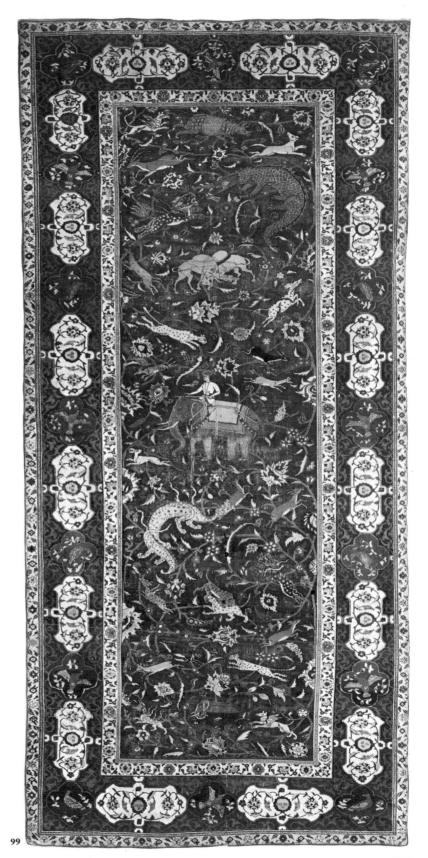

99

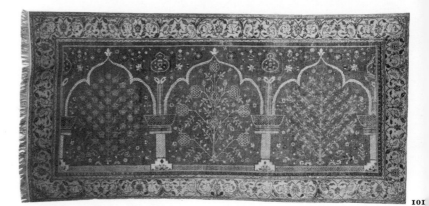

101

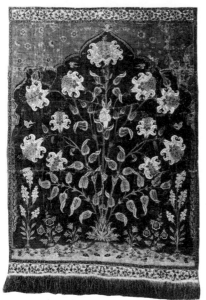

100 see colour plate, page 62

100 Prayer rug with a large flowering plant

Length 124.5cm, width 90cm (fragment)
Thyssen-Bornemisza Collection, Lugano
India, Mughal period, second quarter 17th century

This fragment of carpet, so finely knotted that it looks more like a woven velvet, displays the skill of Indian workshops under the reign of Shāh Jahān (1628–58). The exquisite depiction of the flowers and the rich, fresh colouring are typical of Indian textiles of the period. Through Persia, India borrowed many Chinese motifs, seen here in the formalised waves and clouds or rocks at the foot of the rug and the small clouds scudding away from the large central plant. Their stylisation harmonises surprisingly well with the more natural presentation of the plants. Beattie has suggested that the width of the bands or ornament at top and bottom and the patching of the centre with pieces of identical make and similar design indicate that this prayer arch was one of many in a *saph* or multiple-arch rug. The rug contains 174 knots of the Persian type per square cm, in silky wool of more than fifteen shades on a silk warp of variegated colours. There are three passes of red silk weft after each row of knots.

Published: Migeon (1903, pl. 83); Beattie (1972, pp. 67–72, pl. IX)

101 Prayer carpet with three mihrabs

Length 131cm, width 260cm
Private Collection, England
India, Mughal period, early 18th century

Large numbers of prayer rugs with a single mihrab or prayer niche for individual worship have survived. Of the *saphs*, multiple prayer rugs for family use or for the furnishing of mosques, far fewer now exist. Some of the pieces made for mosques must have assumed alarming proportions to judge from an inventory of 1674 taken from the Yeni Walid Mosque, Istanbul, recording carpets containing up to as many as 132 mihrabs. See Erdmann (1938, p. 197). This present rug contains only three arches designed as part of a continuous arcade. It may have formed part of a set of carpets; other examples with three mihrabs and seven mihrabs of the same design survive in private collections. See Ellis (1969, fig. 27). Each mihrab contains one large flowering plant, as in the earlier Indian prayer rug no. 100, but the weave is coarser, the plants are more formalised and the thick columns and continuous sill, curiously like the water-courses in Persian Garden carpets, are less graceful. The carpet contains 15 knots of the Persian type per square cm in woollen pile of six colours. Warp and weft, in three shoots, are of cotton.

Published: Washington (1974, no. XXV)

Rock Crystal and Jade

108b

Precious stones were as highly esteemed in the Islamic as in the ancient world. Apart from their more obvious use as personal adornments, they were also invested with magical and even medicinal properties and were valued as talismans or amulets. Much of the lore surrounding precious stones was a classical heritage. So too was the technique of their carving and engraving. Judging from the large number of surviving gem stones with engraved inscriptions and intended for seal ring or pendant, the gem cutter's art was in great demand from the early centuries of Islam.

Many of these early amulets and gem seals are of rock crystal. This material which in the terminology of the mineralogist is quartz, can be found in sufficiently large pieces for fashioning into vessels and objects. When polished, its limpid transparency was superior to glass which in other respects it so much resembles. To carve it required infinite patience and skill. While we cannot be sure of the precise techniques employed, we may assume that the general shape was obtained by chipping and sawing. For the finer details the bow drill was used. The French jewellers, Tavernier and Chardin, describe the gem cutter's craft in Isfahan in the 17th century. The bow drill was used with a mixture of emery and lacquer applied to the wheel. The same technique had no doubt been employed from early times not only by the hardstone carvers but also by the glass cutters; and it is no coincidence that the carving of hardstones and of glass flourished together at one and the same period and often in the same region.

One of the earliest mentions of rock crystal objects by Muslim writers is a lamp which was suspended in the mihrab of the Companions of the Prophet in the Great Mosque of Damascus. A Bedouin describes how its brilliance shone in the darkness of the sanctuary. The gift of the Caliph al-Walīd, it was brought by stealth to Baghdad at the order of Hārūn al Rashid's son Amūn, himself a connoisseur of rock crystal. The origin of this lamp is, of course, a matter of speculation; it could have been a cherished relic of the ancient world or have found its way from the Byzantine lands. Although there is no evidence for rock crystal carving in Syria during the Umayyad period, we know that in Persia this material was used for seals and jewellery under the Sasanian kings. We have fine examples of gemstones including rock crystal and cameos carved in intaglio or relief as well as large beads and pendants probably intended for parures of various kinds. The most

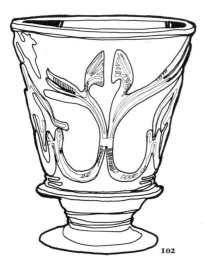

102

famous Sasanian rock crystal carving is a large roundel carved in relief
with the emperor Khusraw I (631–78 AD) enthroned and attended by
his courtiers. This is set in the centre of a large gold dish which was
once in the Treasury of Saint Denis and now in the Bibliothèque
Nationale, Paris. Set in concentric rows above this central roundel are
small circular medallions of green, red and colourless transparent glass
moulded in the form of rosettes. It seems likely that these rock
crystal carvings were produced in Mesopotamia since it is generally
believed that the superb cut glass vessels were also made in some centre
of that region which formed part of the Sasanian empire. The Khusraw
roundel would be evidence enough for the existence of an established
tradition of rock crystal carving in the Persian empire which there is no
reason to think that was interrupted by the Arab conquest in the 7th
century. The small goblet (no. 102) which was found at Qazvin was
almost certainly made somewhere in eastern Persia. The most likely
centre would have been Nishapur which in the early Islamic centuries
was producing superb relief cut glass vessels (nos. 124, 126–9, 131–2)
among them goblets of just this form. Furthermore, details of the
palmettes on the rock crystal goblet resemble those found in frescoed
fragments recovered in the course of excavations in that city.

Mesopotamia was an important centre of the glass-cutting industry
during the Abbasid period and the great polymath al-Birūnī (973–
1048) tells us in his important book on mineralogy that Basra was a
centre of rock crystal carving. It has been suggested that the beautiful
rock crystal lamp now in the State Hermitage Museum, Leningrad,
may be a product of a Mesopotamian centre, possibly Basra (no. 109).

We are on far surer ground when we come to the rock crystal
carvings produced in Egypt. We have the eye witness account of the
industry by a Persian traveller who visited Cairo between 1046 and
1050 and three pieces bearing historical inscriptions, two in the name of
Fatimid caliphs and a third in the name of a high-ranking official in the
service of the Fatimid administration. These provide dates ranging
from 975 to 1036. Some one hundred and seventy rock crystals survive
from the medieval Islamic world. By far the greater part are of Egyptian
origin. Although the finest fall within the sixty-year period provided by
the three datable examples, the industry must already have been
established as early as the second half of the 9th century when the
Abbasid governor of Egypt, Aḥmad ibn Ṭūlūn, cast aside his

allegiance to the Caliph and proclaimed himself a sovereign ruler. Of Turkish origin he had grown up in the Caliph's court and it is hardly surprising that he should have introduced to Egypt the artistic styles current in the Abbasid capital. Just as the stucco decoration in the great mosque he built in Cairo betrays its dependence on the so-called Samarra style, so too do those few rock crystal carvings which can be attributed to Tulunid Egypt. It is possible, too, that both rock crystal and glass cutting were introduced by craftsmen brought to Egypt from Mesopotamia, and even continued into the Fatimid period.

Some of the earliest Egyptian rock crystal objects were decorated in the so-called 'bevelled' style in which the outlines of the design elements are indicated by a slanting or bevelled cut. This style was also adopted in carved stucco and woodwork both in Mesopotamia and Egypt. By the beginning of the 10th century the craftsmen were attempting to carve their designs in relief. In the early attempts, the relief cutting is often rough and lacking in precision (nos. 103–4) and it was not until the close of the century that technical mastery was achieved (nos. 109–12). In the finest pieces, the ground is cut back from the relief elements to a depth of as much as 2mm.

The middle years of the 11th century were troubled by incessant political strife. In 1062 Turkish and Arab mercenaries plundered the Caliph's palaces and among the loot which was dispersed were rare rock crystal vessels. The historical Maqrīzī has included in his work graphic accounts by eye witnesses of these looted treasures among which were rock crystal vessels. Judging by the great surviving rock crystal ewers such as those in Florence, in the Treasury of San Marco, Venice, and in the Victoria and Albert Museum, London, these accounts cannot be mere hyperbole.

There is a surprisingly wide range of form and function in these Egyptian rock crystal carvings. Commonest are those vessels used as containers. The small bottles or flasks were intended probably for scent or *kohl* (nos. 104, 106, 111). *Kohl* (mascara) was an important part of women's cosmetics, and the inscription on another bottle tells us that it was destined for a woman (no. 107). The two small vessels carved in the form of a lion (no. 103) and a fish (no. 104) may also have been receptacles for scent or kohl. Other vessels intended as containers perhaps for rose water or wine were derived from contemporary glass shapes. The ewer of which the handle is missing (no. 112) is a variant of the pear-shaped ewer which seems to have been an invention of the Persian glass-makers (no. 132). The globe shaped crystal (no. 105) was probably the head of a ceremonial mace, and may be compared to the bronze macehead from Persia (no. 186). It has also been suggested that this crystal was the terminal of a sceptre but there seems to be no evidence that this emblem formed a part of the Islamic regalia.

Of particular interest are the four chessmen (no. 108). The game of chess originated in India and according to tradition was introduced into Persia in the 6th century AD. Examples of chess pieces from the Islamic world are of ivory, glass and rock crystal. These are abstract in form, and when the game reached Europe, probably via Spain or Sicily in the 11th century, the earliest European pieces follow the Islamic

prototypes. Of the fifteen pieces surviving from this particular set, some are without decoration. In order to distinguish the two opposing sides, some were decorated, others were left plain.

The decoration of the Egyptian rock crystal carvings and of those from Persia and Mesopotamia is principally foliate deriving from the palmette and its variants and is closely related to the contemporary decorative repertory of the other arts. In no. 107, however, the relief decoration is restricted to a band of kufic. Stylised birds are introduced into the decoration of the flat bottle (no. 110). The most ambitious decorative composition is that of the beautiful ewer from the church of Milhaguet (no. 112). The heraldic arrangement of birds or animals flanking a 'tree of life' is characteristic of the finest of the Fatimid rock crystal carvings.

The rock crystal carvings of Fatimid Egypt were eagerly sought after. The ampulla in the form of a fish (no. 104) found its way to Samarkand probably not long after it was made. Many reached the Church treasuries in the West, some as early as the 10th century (no. 112). The chessmen (no. 108) were, according to tradition, donated to a Church by a Count of Catalonia. This is by no means the only example of such a gift. There are similar pieces in Osnaberg Cathedral; and two wills preserved in Spain record the legacy of chess sets. These were probably given to the Church in order to be re-used for the encrustation of reliquaries and bindings since rock crystal was a rare commodity, highly esteemed.

According to the early Islamic writers, the raw crystal was drawn variously from Kashmir and the western foot-hills of the Pamirs, Badakhshan, Ceylon, the mountainous regions of Armenia and Western Persia. The Laccadive and Maldive Islands are also mentioned. But the best and purest rock crystal was imported from east Africa which was most likely the source used by the crystal carvers of Egypt.

The industry in Egypt was evidently short-lived. A rock crystal carved in the form of a crescent and inscribed with the name of the Fatimid Caliph al Ẓāhir (1021–36) already betrays signs of poor workmanship. The dispersal of the palace treasures no doubt dealt the death blow to the craft for despite later allusions in the literature to crystal carvings, none has survived. It is a curious fact, of which there is no ready explanation, that the industry seems to have disappeared until it re-emerged in India under Mughal patronage in the 17th century.

In Persia, however, the artistic possibilities of another hardstone were to be exploited in the 15th century. This was jade or in mineralogical terminology, nephrite. The Muslims inherited no tradition of jade carving from the ancient world and in the early Islamic centuries jade seems to have been unknown. Again it is al-Bīrūnī who provides us with the most reliable information about jade. According to him, the Turks of the steppes invested jade with magical properties. It was an amulet which served as a powerful protection against attack by robbers. It could ward off thunder and lightning; and the tribal magicians used it to produce rain. He mentions, too, that the Turks carved from it ornaments for belts and saddles.

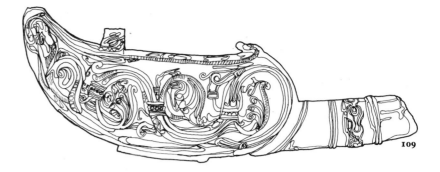

109

Chinese vessels of jade were known in the Islamic world and we
hear of one of the Rasulid rulers of the Yemen sending a gift of such
vessels to the Ayyubid Sultan of Egypt. Indeed, it is likely that the
Timurid princes of Persia were stimulated by the jade carvings of
China to introduce the craft into their own domains. The earliest
example from a Muslim workshop is the great jade slab which his
grandson, Ulugh Beg, procured and had carved for the grave of Timur.
This slab which now covers the tomb of the great conqueror in the
Gur-i Mir, Samarkand, is incised with a long funerary inscription, the
decorations being restricted to a carved stalactite moulding round the
sides. It could be argued that this is the work of a stonemason rather
than that of a hardstone carver. Nevertheless, it was Ulugh Beg who
patronised if he did not actually establish a native school of jade
carving probably in Samarkand of which he was governor from the age
of fifteen until his death in 1449. The beautiful jug of cloudy white
jade (no. 114) was made for him. His name and titles are carved in
relief in a noble script around the vessel's neck. The shape of this vessel
is derived from a type of jug whether of bronze or brass, of which the
datable examples, however, are later than the jade one. These metal
jugs, mostly lidded, were probably made in Herat; and the type must
go back as early as the beginning of the 15th century since the form was
being reproduced in blue and white porcelain of China during the
reign of the emperor Hsüan Te (1426–35).

The commonest type of jade used in the Timurid period is of a very
dark green which unless held up to the light appears as almost black.
The oval cup (no. 113) is of this type of jade. Its pure and simple lines
are in sharp contrast to the intricately carved dragon's head which
resembles closely that of the jug (no. 114). There are other examples in
jade of this form of cup which were probably made in a Persian or
Transoxianian workshop in the 15th century.

Jade continued to be carved in Persia under the patronage of its
Safavid rulers but in the 17th century primacy in the art passed to the
workshops established by the Mughal emperors of India in their
various capital cities. The Indian jade carvers, in their turn, were
certainly inspired by the jade carvings of Timurid style; for the jug
(no. 114) is one among several which eventually became the valued
possessions of the emperor Jahāngīr (1605–27) and his son Shāh Jahān
(1628–58).

Preserved in the Topkapi Palace Museum, Istanbul, is a handled jug of dark green jade similar in form, though considerably larger, to the jug. This magnificent vessel is encrusted with gold inlays of floral scrolls and a dedicatory inscription to the founder of the Safavid house of Persia Shāh Ismā'il (1501–52). It was almost certainly among the Persian royal treasure captured by the victorious Turks after the battle of Chaldiran in 1514. Perhaps it was this very vessel which prompted the Ottoman Sultan to establish a jade-carving workshop in his capital. Under Sulayman the Magnificent (1520–66) this workshop was producing small jade plaques inlaid with gold and encrusted with jewels and destined for the embellishment of bow cases and quivers. The surface of jade vessels carved in Turkey was also treated in this way such as the lobed dish (no. 115). Here the carved ornament is restricted to the leaf design carved in intaglio on the inside. The exterior is inlaid with gold and encrusted with rubies, emeralds and sapphires.

Turkish taste, however, was not wholly confined to jade carvings embellished in this sumptuous manner. The little lobed cup (no. 116) appeals to quite different aesthetic canons, depending on its organic form based on a gourd and its foliage. In this case the inspiration was clearly Chinese since the forms of the gourd and other fruits were often exploited by the jade carvers of China though the treatment of the handle and the small rosette carved in the interior is Turkish.

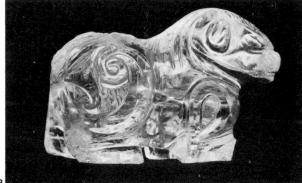

103

102 Goblet of rock crystal
Height 9.7cm
British Museum, London, no. 1954
10–131, found at Qazvin
Persia, 9th–10th century

Rock crystal carvings from Islamic
Persia are exceedingly rare. That
there was a tradition of carving in
this material is proved by the
roundel inserted into the centre of the
famous silver dish attributed to the
Sasanian emperor Khusraw I
(531–79) in the Bibliothèque
Nationale, Paris, as well as beads and
pendants of the Sasanian period
which have come to light in recent
years. The form of the goblet with
flanged rim and collar at the base of
the bowl occurs in the relief carved
glass of east Persia of the 9th and 10th
centuries. While the style of relief
carving is similar to that of the rock
crystals of Fatimid Egypt, the
decoration is rather more stiffly
disposed. The curious split-leaf
terminals with bored holes at the tip
bears a striking resemblance to those
in a wall painting at the Tepe Madrasa
in Nishapur. See Hauser and
Wilkinson (1942, p. 104, fig. 28).

Published: Ghirshman (1954, pl. 46a)

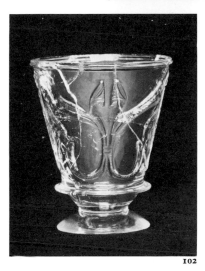

102

103 Bottle of rock crystal
Length 6.7cm, height 4.2cm
British Museum, London, no Is. 12,
Franks Bequest
Egypt, Fatimid period, first half
10th century

Relief carved in the form of a
crouching lion, the extended
forepaws missing. A circular boring
1.3cm in diameter runs from the
chest of the animal to within 1cm of
the hindquarters. The vertical boring
half-way along the body is a later
addition. This is one of fourteen rock
crystal bottles carved in the form of a
lion.

Published: Lamm (1930, taf. 75, no. 17);
Pinder-Wilson (1954, p. 86f, pl. XXXIVb)

104 Flask of rock crystal
Length 10cm
State Hermitage Museum, Leningrad
no. CA–9993, found at Samarkand,
formerly I. Krause Collection
Egypt, 10th–11th century

Carved in the form of a fish with
cylindrical boring from head up to
tail. Part of the head is missing. This
is one of some twelve rock crystal
flasks carved in the form of a fish.

Published: Pugachenkova and Rempel
(1965, fig. 215)

104

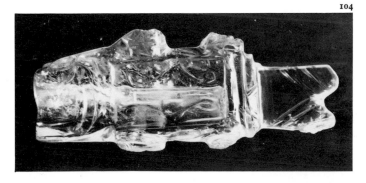

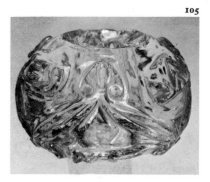

105

105 Mace-head of rock crystal carved in relief

Height (maximum) 6.6cm, diameter (maximum) 8.5cm
Museum of Islamic Art, Cairo, no. 15445 ex-Harari Collection
Egypt, Fatimid period, 10th century

Flattened globular crystal with a cylindrical hole, 2.5cm in diameter, in the centre. Its surround is chipped on both sides suggesting that it may have been masked by a metal mount. The two inscriptions, separated by a chevron band of foliate ornament, are in a very highly stylised kufic.
Iqbāl wa baraka li-ṣāḥibihi,
'Prosperity and blessing to its owner.'
Muḥammad wa 'Alī kilāhummā,
'Muḥammad and 'Alī, both of them.'

Published: Cairo (1969, no. 25)

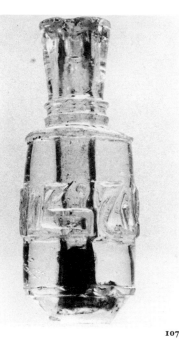

107

107 Bottle of carved rock crystal

Height 9.1cm, diameter 3–3.5cm
Museum of Islamic Art, Cairo, no. 15446, formerly Harari Collection
Egypt, Fatimid period, 10th century

The body is decorated in relief with a kufic inscription.
Baraka li-ṣāḥibatihi,
'Blessing upon its female owner.'
A further word, unread, may simply be filling. This bottle was probably intended for mascara (*mukḥula*). It has a slightly flaring neck, cylindrical body and originally a splayed foot, which has been broken off. The shafts of some of the kufic letters have wheel-cut double strokes across them, recalling the inscription on the cameo-cut glass bowl, see no 128. This type of vessel was also made in glass.

Published: Cairo (1969, no. 24)

106 Bottle of rock crystal

Height 10cm
Private Collection, France
Egypt, Fatimid period, late 10th–early 11th century

Each of the broad faces is carved in relief with half-palmettes disposed symmetrically on a vertical stem. The lower part of the body is broken and missing.

Published: Lamm (1930, taf. 71, no. 2); Kühnel (1963, p. 209, fig. 168)

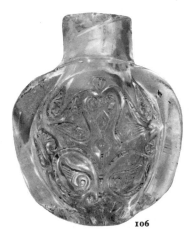

106

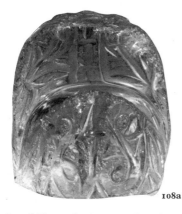

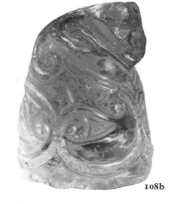

108a 108b

108 a–d Four chessmen of rock crystal

Height of c about 8cm
Private Collection, France
Egypt, Fatimid period, late 10th–
early 11th century

These four pieces are from fifteen
surviving chessmen which,
according to tradition, were given to
the parish church of Ager, a village
near Urgel in Catalonia. a is a Bishop
(Ar. *fīl*, elephant), b King (Pers. *shāh*),
c Knight (Ar. *faras*, horse), and
d Queen (Ar. *wazīr*, minister)

Published: Murray (1913, p. 764f);
Lamm (1930, tad. 77, nos. 6, 13, 14, 15);
Camón-Aznar (1939, p. 404, figs. 1–16)

109 Lamp of rock crystal

Length 22cm
*State Hermitage Museum,
Leningrad, no. EG-938*
Egypt, Fatimid period, late 10th–
early 11th century

The form of the lamp which is boat-
shaped with a projecting handle
appears to be unique. Lamm has
proposed an attribution to
Mesopotamia, second half of the
9th century, citing the acanthus scroll,
current at Samarra, as a parallel to
the scroll on the lamp. The border of
'pearls' is not found in any other rock
crystal attributed to Egypt.

Published: Migeon (1927, ii, p. 112,
fig. 281); Lamm (1930, taf. 68, no. 5)

109

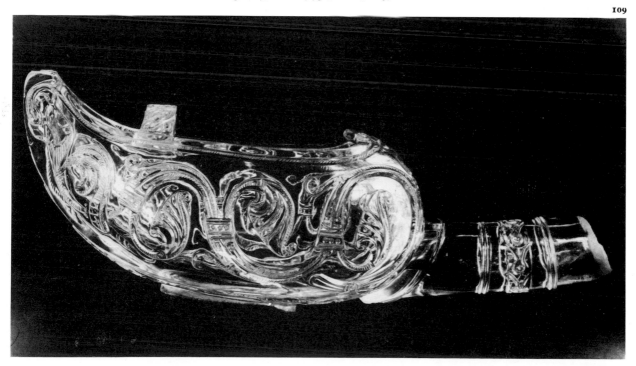

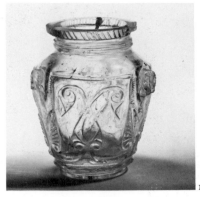

111

110

111 Jar of rock crystal
Height 10.2cm
Private Collection, England
Egypt, Fatimid period, late 10th–
early 11th century

The body is carved in relief with
three panels each containing a
palmette flanked by half-palmettes
and paired half-palmettes which
issue from the top of the complete
palmette. Three lugs separate the
panels, each with an inverted
arcade below.

Published: Ettinghausen (1955, p. 109,
pl. 1); Sotheby (8th December 1970, lot 64
with plate)

110 Bottle of rock crystal
Height 12cm
*National Archaeological Museum,
Madrid*
Egypt, Fatimid period, late 10th–
early 11th century

Carved in relief with part of the base
broken and missing. Inscribed in
kufic around top. On one side, *baraka
min Allāh*, 'Blessing from God'. In
main field on each side, paired birds
flank a scroll of half-palmettes
arranged in the form of an
inverted 'T'.

Published: Gómez-Moreno (1951, p. 341,
pl. 403a)

112 Ewer of rock crystal
Height without mounts 18cm
*Treasury of the Church of Milhaguet,
(classified historical monument),
until 1790 in the Treasury of the
Abbey of Grandmont, Haute Vienne,
where it is listed in the inventory of
1666*
Egypt, Fatimid period, early 11th
century

Handle broken and missing. Carved
in relief on main field are two eagles
with wings outstretched standing on
reversed palmettes. Scroll around
neck.

Published: Lamm (1930, taf. 67, no. 6);
Paris (1971, no. 271, and illustration)

112

113

114

113 Cup, oval in shape, of dark green jade (nephrite)

Width 15.6cm
British Museum, London,
no. 1961 2–13 1
Persia or Transoxiana, 15th century

In the middle of one of the longer sides is a loop handle carved in the form of a dragon's head with a curving neck. The foot-rim is carved in the form of a figure of eight. The type can be traced to a metal cup with loop handle used by the Mongols, the handle being intended for attachment to a belt or saddle.

Published: Sotheby (31st January 1961, lot no. 188); Pinder-Wilson (1963a, p. 49f, pl. XXVIII)

114 Tankard of cloudy white jade (nephrite)

Height 14.5cm
Fundação Calouste Gulbenkian, Lisbon, no. 328
Transoxiana (Samarkand), Timurid period, 1417–49

Handle carved separately in the form of a dragon. The shape of this vessel, unique in jade, is derived from a bronze original since there is a series of tankards with S-shaped handles in the form of a dragon ranging in date from 1456 to 1511. Arabic inscription carved in relief in thuluth script around neck.

> *al-Sulṭān al-a'ẓam mughīth*
> *al-dunyā wa-l-dīn Ulugh Beg*
> *Gurgān khalada mulkahu wa*
> *sulṭānahu*

'The Sulṭān, the most mighty saviour of the world and of religion, Ulugh Beg Gurgān – may his reign and power endure for ever!

Persian-Arabic inscription engraved on upper edge of rim in taliq script.

> *Allāhu akbar pādshāh-e haft*
> *kishvar pādshāh-e 'adālat-*
> *gustar wāqif-e rumūz-e ḥaqīqī wa*
> *majāzī Abū al Muẓaffar Nūr al-dīn*
> *Jahāngīr Pādshāh ibn-e Akbar*
> *Pādshāh Ghāzī sana 8 julūs*
> *muṭābiq sana 1022 hijrī*

'God is great. The Emperor of the Seven Countries, the Emperor dispensing justice learned in the mysteries, both true and allegorical, Abu'l Muẓaffar Nūr al-dīn the Emperor Jahāngīr son of the Emperor Akbar Ghāzī. [In] the eighth regnal year corresponding to the year 1022 H [1613 AD].'
Engraved below handle in taliq script.

> *1056 ṣāḥib qirān thānī 20,*

'1056 [1646 AD] Lord of the Second Conjunction 20 [th regnal year].

Jade was highly esteemed by Ulugh Beg for whom this beautiful vessel was made. He was the grandson of Timur and an exponent as well as a patron of the exact sciences. He adopted the title Gurgān, 'son-in-law', signifying his connexion with the illustrious house of Chinghiz Khan, in 1417 and reigned over the empire founded by his grand-father from 1447 until his death in 1449. The tankard came into the possession of the Mughal Emperor Jahāngīr in 1613 and then of his son the Emperor Shāh Jahān, who styled himself Lord of the Second (Auspicious) Conjunction, his ancester Timur having adopted the title 'Lord of the (Auspicious) Conjunction'.

Published: Lisbon (1963, no. 28 and illustration); Grube (1966, fig. 75)

115

115 Bowl of carved jade (nephrite) inlaid with gold and encrusted with precious stones
Length 16.5cm, height 4.8cm
S. Martin Summers Collection, London, at one time in the possession of the Emperor Alexander III of Russia to whom it was presented by the Amir of Bukhara
Turkey, Ottoman period, 17th century

Oval bowl with lobed sides. A leaf pattern is carved on the inside and the exterior is inlaid with gold and encrusted with rubies, emeralds and sapphires. Gold inlay and encrustations were applied to jade carving both in Mughal India and Ottoman Turkey.

Unpublished

116 Cup of carved jade (nephrite)
Length (including handle) 11.3cm, height 4cm
Private Collection
Turkey, Ottoman period, 17th century

The cup is six-lobed, each pair of lobes being separated by a vertical rib. The rim is flat and projects slightly from the side. The base is formed of a stalk which is coiled and then brought up the side to terminate in the foliate handle. On the inside centre, a small five-petalled rosette is carved in relief. This remarkable vessel is probably inspired by a half-gourd with foliage. The idea of exploiting natural forms, including the gourd, in jade originated in China. Two other jade vessels carved in the form of a half gourd have survived, one in the British Museum, London, which, according to the inscription, was in the possession of the Mughal emperor Shah Jahān and another in a private collection which, according to its Arabic inscription, was made in Turkey. Examples of open vessels of jade with horizontally projecting handles, often carved in openwork, are in the Topkapi Palace Museum, Istanbul, and have been attributed to a Turkish workshop. See Skelton (1975).

Unpublished

116

Glass

The glass industry was already flourishing in Egypt and Syria, Persia and Mesopotamia when these lands were conquered by the Arabs in the course of the 7th century: and there is no reason to suppose that it was interrupted by these events. The glass houses supplied the new political masters with their wares, adjusting as need arose to the taste and requirements of these new patrons. The disruption of the age-old political barrier between Egypt and Syria on the one hand, and Persia and Mesopotamia on the other, meant an increased commercial intercourse between these lands. This led to the fruitful exchange of artistic ideas and often to the migration of artists and craftsmen from one region to another. Thus a popular glass form in Persia is almost simultaneously imitated in the glass houses of Egypt. For this reason it is often impossible to distinguish between the glass products of countries as far apart as Egypt and Persia. The scientists have not yet devised a wholly satisfactory method of establishing these differences.

The glasses selected for this exhibition range from the 8th to the 14th century and represent some of the achievements of the principal glass-making centres in the Islamic world. Broadly speaking these six centuries can be divided into two distinct periods. First, from the 8th to early 11th century the glass-makers achieved their decorative effects by *manipulating the surface* of their glasses. In the second period from the 12th to the 14th century, when the glass houses of Persia and Mesopotamia had apparently ceased to produce fine decorated glass, the glass-makers of Syria and Egypt concentrated their main efforts on polychrome effects.

A comparatively simple method of decorating a glass surface is that of scratching or incising with a diamond. This technique was widely practised in the early Islamic centuries (8th–11th) in Mesopotamia, Persia, Egypt and Syria. The round based beaker with incised decoration (no. 120) was also found in Syria where it was most likely made. The incised lines show white since the interior walls of the V-shaped cut are unpolished. The technique allowed for a freedom of line which is apparent in the rather naturalistic treatment of the leafy foliage.

Far more beautiful effects could be obtained by cutting on the wheel which could be used both for grinding and polishing; and the glasses selected for the exhibition show the variety of ways in which wheel cutting was exploited. In Persia and Mesopotamia, the glass-

131

makers of the Sasanian period developed a particular application of the technique. By carving a series of concave facets on the curving surface of the glass, they produced a honeycomb effect in which the play of light over the concavities gave a wonderful sense of movement and vitality. The typical vessel which they treated in this manner was a hemispherical bowl which had to be thick in order to withstand the tensions caused by the grinding of the facets. For this reason, these bowls were probably moulded rather than free blown. The technique continued to be practised in these regions during the first three Islamic centuries but was now applied to an elegant form of flask with long neck and globular or bell-shaped body (nos. 122–3, 125).

By using the wheel to produce *linear* designs, the glass-makers were able to adapt to their vessels the artistic idiom which was being developed in the metropolitan centres of the Abbasid empire. Having mastered the technique of *incising* designs on glass (no. 121) they turned their attention to *carving in relief*. In the beaker from Berlin (no. 124) the carver has used his wheel on the comparatively thin wall to produce a design in shallow relief. To this purpose he has adapted the so-called bevelled style of ornament which was current in Mesopotamia and Persia in the Abbasid period. Strictly speaking this is not relief carving since the defining lines of the design are merely indicated by a cut line, slanting in section. In true relief carving the ground is carved down to leave the design standing clearly in relief such as on the flask (no. 127). It is still not clear where this technique was developed. The glass-cut wares of Mesopotamia were already famous in the West in the 9th century: and fine fragments of relief cut glass have been found at Samarra. A considerable quantity of relief cut glasses have been found in Persia in recent decades and it is likely that they were made in a centre in Khurasan, possibly Nishapur.

Another development of relief cutting was the so-called cameo glass technique. An overlay of coloured glass – usually green or blue – was applied to a surface of colourless glass. The glass-maker then carved his decoration so that the design elements were left standing in the coloured glass, the background being carved back to the colourless glass. Included in this exhibition are two beautiful examples of this technique (nos. 131–2) which are attributed to a Persian glass workshop.

Persian and Mesopotamian glasses with incised and relief cut decoration reached Egypt certainly by the 9th century. Evidence for this has been supplied by the excavations of the American Research Centre at Fustat of the earliest Islamic settlement in the southern part of modern Cairo. Whether or not it was migrant glass-makers from the eastern provinces who first introduced the glass-cutting techniques, we know that the Egyptian glass-makers had acquired these skills by the 10th century. The magnificant bowl (no. 130) carved in cameo relief with a pair of ibex and a kufic inscription shows the technical mastery which the Egyptian glass-cutters could achieve.

The relief carved decoration on the large beaker (no. 133) has an almost monumental quality. This remarkable vessel is one of a group of beakers which are generally thought to have been produced in Egypt in

133

the 12th century. On present evidence, however, the glass-makers
were no longer producing carved wares at this date. Moreover, the
shape, type of glass and style of cutting have no parallel in the glasses of
the Islamic world. Against this, the decorative composition of this
beaker has been compared to that of an Egyptian flask found near
Kairouan; and two of the group are said to have been brought back
from Syria by Jacques de Vitry, Bishop of Acre, who on his return to
Belgium in 1226 presented them to the Prieuré d'Oignies at Namur.
There can be little doubt that even if evidence is turned up to prove a
Western or Byzantine origin for these beakers, the inspiration of their
decoration and mode of cutting are from the Islamic world.

It now seems that the techniques of painting in a metallic lustre on
glass was first developed in the glass houses of Fustat. The technique is
similar to that of lustre painting on pottery. A rare and beautiful
example was discovered at Fustat in 1965 and according to its
inscription can be firmly dated in the 8th century (no. 119). The finely-
drawn decoration serves to show how at this early date the Muslim
artist had succeeded in transforming two motifs from the classical
world – the acanthus and the palmette scroll – into a new idiom.

In the period from the 12th to the 14th century the production of
fine glass wares seems to have been the monopoly of Syria and Egypt.
It has already been said above that colouristic effects were the principal
aim of the glass houses in these two countries. Colour had, of course,
already been exploited in the early period such as in the cameo-cut
technique described above. Another technique was that of marvering.
Opaque glass threads were wound around the molten vessel and then
pressed into the latter by means of a stone rod. This technique was
practised in Syria from Roman times and continued through the
Islamic period to the 14th century. In the bowl (no. 144), the opaque
white threads were wound around the transparent purple glass: the
vessel was then reheated and blown into a mould in order to obtain the
vertical ribs. In the elegant flask (no. 134), the white threads were
'combed' into a feather pattern before being 'marvered' into the
transparent purple glass. The bowl was made in Egypt, the flask in
Syria, and it was the Syrian glass-makers who invented and developed
the technique of enamelling and gilding on glass towards the end of the
12th century. Painting in fired pigments was practised in the ancient
world both in the Near East and the West; but it was the Muslim

glass-makers of Syria who perfected the technique and added the technique of gilding. Vitreous enamels, that is, coloured glass pastes, were applied to the surface of the vessel and then fixed by firing, by which means the enamels were fused onto the surface. When gilding was required, gold, too, was applied at the same time as the enamels, either in the leaf or more usually as powdered dust and likewise fused to the surface in the firing.

Most of the gilded and enamelled glass was produced in Syria. Aleppo and Damascus were the principal centres: and Aleppo probably ceased production after the devastations inflicted on it by the Mongols in 1260. On present evidence, the Egyptian glass houses were producing enamelled but not gilded glass. The glass used for these gilded and enamelled vessels is of markedly inferior quality to that of our earlier period. It often has a brownish-yellow tinge and is rarely free from bubbles. The enamellers were evidently so concerned with the decoration that they were prepared to overlook these defects. Indeed it is quite likely that the vessels were made in one glass house and then brought to another glass house which specialised in gilding and enamelling. Many of these decorators were artists who adapted motifs from the artistic repertory of the Ayyubid and Mamluk period to their vessels. Such a one is the master who decorated the great pilgrim flask (no. 136). His elaborate composition which includes arabesques, the legendary 'Talking Tree' of Islamic cosmology, and lively paintings of huntsmen, was an artist of great imaginative invention. Technically, too, this is a remarkable achievement combining, as it does, no less than eight coloured enamels with gilding.

The great basin (no. 137) is an exact reproduction in glass of a type of brass basin current in the metal working establishments of Syria and Egypt. So too is its decorative composition which combines the naskhi inscriptions with roundels containing the lotus, a 'Chinoiserie' motif popular at the period. There could hardly be a more telling example of the close relationship that existed between the arts of the period.

Among the most spectacular achievements of enamelled and gilded glass are the mosque lamps (nos. 138–40). These were intended for suspension from the ceiling of the sanctuary in the mosque, by chains or cords attached to the looped handles on the main body of the vessel. In common with many other mosque lamps, two of those exhibited (nos. 138–9) are inscribed with the beautiful Koranic verse from the Sura of Light which proclaims the significance of the lamp:

> 'Allah is the light of the heavens and the earth; his light is like a niche in which is a lamp in glass and the glass like a brilliant star, lit from a blessed tree...' (Koran, II, 35)

Many of these lamps were made to the order of a Sultan or high dignitary of state for presentation to a particular mosque or religious foundation.

Other vessels were destined probably for mere decoration such as long-necked bottles (nos. 135, 141) and vases (nos. 142–3). Characteristic of the decorated glasses of the 14th century are birds and

flowers freely drawn in a thin and fluid red enamelled line, a style of
decoration which reached Syria from Ilkhanid Persia where it may
have been adapted from Chinese originals. The same style is
rendered in full enamels on the tall vase-like goblet (no. 142) which
was acquired in China where it had quite probably found its way as
early as the 14th or 15th century – the enamelled and gilded glass of
Syria was renowned in the East as well as in the west.

In 1400 Timur captured Damascus and carried off many of its
skilled craftsmen, including glass-makers, to his capital, Samarkand.
It is doubtful if the Syrian glass industry survived this catastrophe for
we have evidence of the Venetian workshops of Murano executing
orders for enamelled glass mosque lamps for the Near East already in
the 15th century.

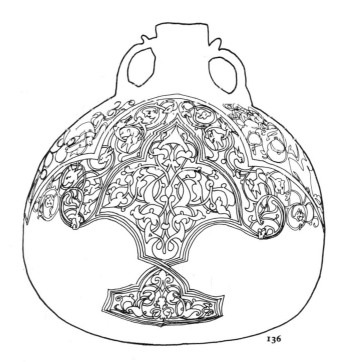

136

117

117 Octagonal inkwell of glass
Height 7.5cm, diameter 6.3cm
*Iran Bastan Museum, Tehran
no. 6849, excavated at Siraf*
Persia, 9th–10th century

The octagonal form was obtained by
blowing the molten glass into a
mould. The small loop handles
attached to the shoulder may have
been intended for suspension.

Published: Whitehouse (1974, pl. XIIb)

118 Inkwell of blue glass
Height 5.7cm
Derek Hill Collection
Persia, 9th–10th century

Blue glass, of similar form to no. 117

Unpublished

119 Goblet of lustre-painted glass
Height 9.5cm, diameter (rim) 13.5cm
*Museum of Islamic Art, Cairo,
discovered at Fustat in 1965*
Egypt, Abbasid period, 8th century

The goblet is now in the form of a
rounded cup, but a sharp break at the
base may be the remains of a stem and
a base, rather than a pontil mark. No
remains of them, however, were
discovered with the vessel. The
chestnut lustre is painted both on the
inside and outside of the colourless
glass which has a greenish-blue
tinge. This goblet provides
significant evidence for the early
development of lustre painting in
Egypt. It may be compared to a
fragment of lustre-painted glass
dated 163 AH (779–80 AD) in coptic
numerals, also in the Museum of
Islamic Art, Cairo (no. 12739/6). The
inscription painted on the exterior
of the slightly thickened rim is in
kufic.

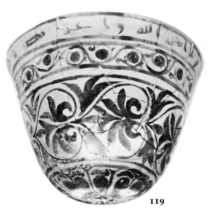

119

*Bismillāh al-raḥmān [al-raḥīm
mimmā ama] ra ʿAbd al-Ṣamad b.
ʿAlī aṣlaḥahu Allāh wa ʿazza
naṣruhu*
'In the name of God the Merciful,
the Compassionate. One of the
things ordered by Abd al-Ṣamad b.
ʿAlī may God make him prosper
and his victory be glorified.'
ʿAbd al-Ṣamad b. ʿAlī was governor
of Egypt for one month in 773 under
the Abbasid Caliph al-Manṣūr.

Published: Scanlon (1966–7, p. 105 and
1968, p. 195); Pinder-Wilson and
Scanlon (1973, pp. 28–9); Yusuf (1973,
p. 476)

118

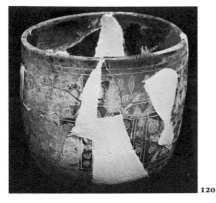

120

120 Beaker of transparent honey-coloured glass
Height 8cm, diameter 8.8cm
*National Museum, Damascus,
no. A 11403, discovered at Raqqa*
Syria, 9th century

The decoration is incised and the missing piece restored. The finely drawn decoration, characteristic of this group, was probably executed with a diamond. The technique was applied usually to coloured glasses, most commonly blue. Other examples have been found at Samarra, Nishapur and Fustat.

Published: Damascus (1964, no. 179, fig. 20, and 1969, p. 269, vitrine 7, no. 1, fig. 159)

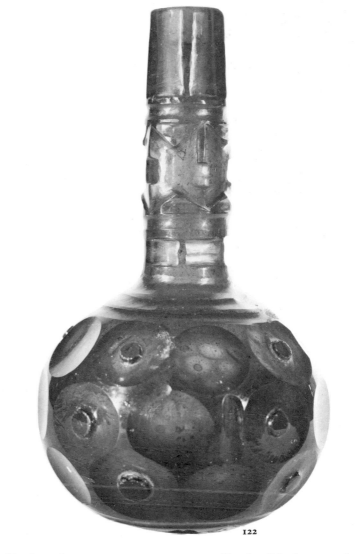

122

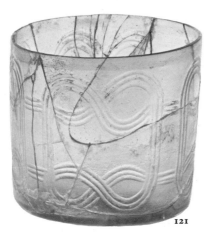

121

121 Beaker of transparent colourless glass
Height 8.7cm, diameter 9.8cm
*David Collection, Copenhagen,
no. 10/1966*
Persia, 8th–9th century

The incised linear geometric decoration is formed by the interlacing of two bands each consisting of three separate strands.

Published: Davids-Samling (1970, p. 107 and no. 20, p. 141)

122 Bottle of dark green glass
Height 20cm, diameter 11cm
*Iran Bastan Museum, Tehran,
no. 8287*
Persia, 9th–13th century

The decoration is created with wheel-cut alternate round hollow carved facets with and without a central boss. While the hollow carved facet is known as early as the 3rd or possibly 2nd century AD, the central boss is only found on raised discs in the early Islamic period. Corning (1970, p. 173, no. 16) illustrates a bottle similar in shape but decorated with three rows of raised discs, each with a central boss.

Published: Washington (1964–5, no. 604, illustration p. 163)

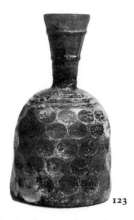

123

124

123 Flask of colourless glass with blue tinge

Height 15cm, diameter 8.5cm
British Museum, London,
no. 1959 2-18 1, Brooke Sewell
Bequest
Persia, 9th century

Pitting and patches of milky weathering. Wheel-cut decoration on body consists of five rows of oval concave facets.

Published: Pinder-Wilson (1963b, p. 36, pl. XVIa)

124 Beaker of transparent glass with a slight yellowish tinge

Height 12.5cm, diameter (upper) 9cm, diameter (lower) 6.6cm
Staatliche Museen Preussischer
Kulturbesitz, Museum für
Islamische Kunst, Berlin-Dahlem,
no. 1.4/59
Persia, 9th century

Wheel-cut decoration in the so-called 'bevelled' style in which the designs are purely linear, the outlines being distinguished by angled cuts. The main field consists of palmettes counterposed, a composition found in the first style of Samarra. See Herzfeld (1923, ornament 142, 143, 144). The upper band of freely drawn strokes and figures may be intended to suggest Arabic characters.

Published: Erdmann (1962, Abb. 4)

126 Flask of transparent green glass

Height 16cm, diameter 8cm
Iran Bastan Museum, Tehran,
no. 3766
Persia 10th–13th century

Patches of iridescence and greyish white weathering. Facet and linear cutting in the 'bevelled' style. On body, a row of counterposed palmettes, compare no. 124.

Published: Washington (1964–5, no. 608 and illustration p. 165)

126

125

125 Bottle of blue glass with silver top

Height 23cm, diameter 10.8cm
Iran Bastan Museum, Tehran,
no. 8285
Persia, 9th–13th century

Wheel-cut decoration, vertical ovals on neck and horizontal ovals on body. Silver mounts with drop spout and domical stopper are inscribed with blessings in kufic in niello.

Published: Rome (1956, no. 448, pl. 67); Washington (1964–5, no. 603 and illustration p. 162)

127

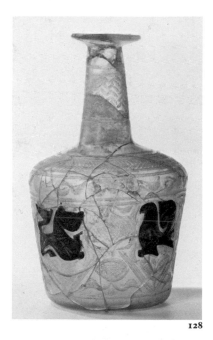

128

128 Flask of transparent colourless glass
Height 23cm, diameter 14cm
David Collection, Copenhagen, no. 2/1972
Persia, 10th century

Green and brown glass overlays are combined with cut linear decoration. In the main field is a stylised floral decoration with confronted lion and dove carved in cameo.

Published: Davids-Samling (1975, p. 19, illustration p. 20)

127 Flask of transparent colourless glass
Height 14cm, diameter 10.5cm
David Collection, Copenhagen, no. 15/1964
Persia, Nishapur, 8th–10th century

Relief cut decoration in main field consists of two rows of counterposed trefoils alternating with trefoils on a long vertical stem.

Published: Davids-Samling (1970, p. 105f, no. 16, illustration p. 136, and 1975, p. 16 with illustration)

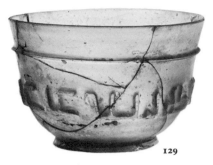

129

129 Bowl of transparent colourless glass

Height 8cm, diameter 11cm
David Collection, Copenhagen,
no. 18/1964
Persia, Nishapur, 9th–10th century

Relief cut decoration. In main field,
kufic characters in relief: *barakat*
Allāh (?) . . ., 'the blessing of
God (?) . . .'

Published: Davids-Samling (1970, p. 106f,
no. 17, illustration p. 137, fig. p. 140 and
1975, illustration p. 17)

130 Rounded bowl of colourless glass with greenish tinge and dark blue glass overlay

Height 8.5cm, diameter 12cm,
thickness 0.2–0.7cm
Museum of Islamic Art, Cairo,
no. 2463
Egypt, Fatimid Period, 10th century

The bowl is moulded and cut, the
tooling marks being clearly visible.
The varying thickness of the core
suggests that it was first mould blown
and then dipped in blue glass which
was cut away to leave the design of
two ibexes and the inscription in blue.
The core has, in addition, small
circular chips cut from the exterior.
The technique is extremely rare. The
inscription is in kufic.
 ghibṭa'izz [? li'llāh] . . .
 li-ṣāḥibihi
 'Felicity, glory [?to God?].
 to its owner.'

Published: Herz (1906, pp. 338–9, no. 90);
Cairo (1969, no. 159)

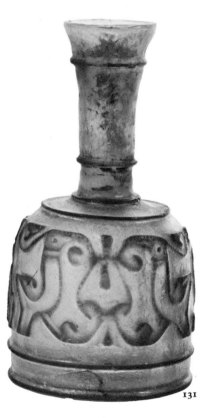

131

131 Flask of transparent colourless glass with slight yellowish tinge and green glass overlay

Height 15cm, diameter 7.5cm
David Collection, Copenhagen,
no. 3/1971
Persia, 9th–10th century

Relief cut decoration in main field
consists of a full palmette flanked by
confronted birds. The vessel was
blown from colourless glass and then
given an overlay of transparent green
glass. The green glass was removed
on the wheel leaving the decoration in
the form of a raised line notched at
intervals. The glass is similar in
technique and material to no. 130.

Published: Davids-Samling (1975, p. 17,
illustration p. 18)

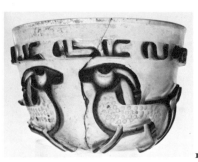

130

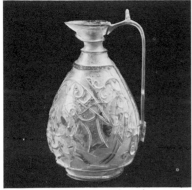

132 see colour plate, page 54

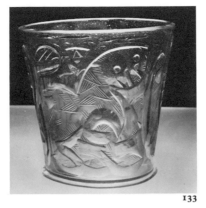

133

132 Ewer of colourless glass with an overlay of transparent green glass
Height 15.5cm
Private Collection, England
Persia, 10th century

The green overlay was removed on the wheel except for the outlines of the design as in no. 131. The main face of the body is decorated with an eagle attacking a gazelle repeated in heraldic fashion. Flanking the handle are addorsed parrots. The ewer was acquired in Persia and is probably of Persian origin. This and the so-called Buckley ewer in the Victoria and Albert Museum, London, see Buckley (1935, pp. 66–71, pl. 1 A, B), are the only surviving examples in glass from Persia of a type which was to serve as the model for the carved rock crystal ewers of Fatimid Egypt, both with regard to shape and to the style of relief carving.

Unpublished

133 Beaker of colourless glass with a smoky topaz tinge
Height 14cm, diameter (top) 12.9cm, diameter (bottom) 10.3cm, thickness (average) 1cm
British Museum, London, no. 1959 4-14 1
Islamic (?), 12th century

Relief carved with incised linear elements: a lion and a griffon confronting an eagle with outstretched wings and two paired half-palmettes placed one above the other. The projecting foot-ring is broken away at three points. This is one of the fourteen 'Hedwig' glasses, including one fragment, so-called because some are associated with the Silesian princess St Hedwig (1174–1245). While the 12th century date is generally accepted, their attribution by Schmidt to Egypt has been generally rejected. On present evidence, there is no Islamic relief cut glass of the 12th century. Phillippe suggests a Byzantine origin, but the possibility of a Western origin remains to be investigated. The similarity of the treatment of the lion's mask in this beaker and in the glass flask found near Kairouan with incised decoration has been noted by Marçais and Poinssot.

Published: Schmidt (1912); Marçais and Poinssot (1948–52, pp. 379–82); Pinder-Wilson (1960, and 1968, no. 147, p. 110); Phillippe (1970, pp. 125–41); Gray (1972)

134 Flask of transparent purple glass
Height 20cm
British Museum, London, no. 1913 5-22 39, collected by M. Durighello in Syria
Syria, Ayyubid period, 12th–13th century

This flask is decorated with opaque white marvered trails combed into a feather pattern. There are patches of iridescence. The technique of decorating glass by pressing into the surface coloured trails ('marvering') was practised in Egypt as early as the 2nd millennium BC and then in Mesopotamia and Syria through to the Islamic period.

Published: Lamm (1930, ii, taf. 29, no. 15)

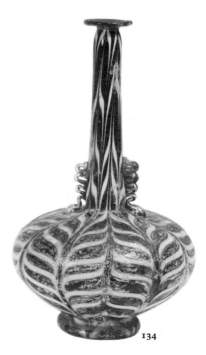

134

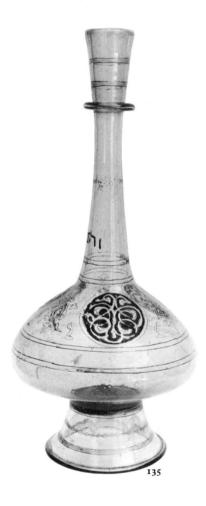

135

135 Vase of colourless glass with yellow tinge
Height 32cm, diameter (rim) 3.8cm,
diameter (belly) 15cm,
thickness at rim 0.4cm
*Museum of Islamic Art, Cairo,
no. 4261, gift of Prince Yusuf Kamal,
1913*
Syria, Ayyubid period,
mid-13th century

There are two small inscriptions in
small naskhi with no dots, both
evidently of gilt, which has worn off.
They appear now only as faint
shadows on the surface of the glass.
 Base of neck. *'izz li-mawlānā
al-sulṭān al-malik al-'ālim al-'ādil
al-mujāhid al-murābiṭ al-mu'ayyad*
'Glory to our Lord, the Sulṭān, the
King, the Learned, the Just, the
Holy Warrior, the Defender, the
fortified [by God].'
 Below the shoulders. *'izz
li-mawlānā al-sulṭān al-malik
al-'ālim al'ādil al-mujāhid
[actually wa'l-mujāhid] al-
mu'ayyad al-muẓaffar al-manṣūr
ghiyāth al-Islām wa'l-muslimīn
qāmi 'al-kafara wa'l-mushrikīn
muḥyī al-'adl fi'l-'ālamīn sulṭān
al-Islām wa'l-muslimīn al-sulṭān
al-Malik al-Nāṣir Ṣalāḥ al-Dunyā
wa'l-Dīn.*
'Glory to Our Lord, the Sulṭān, the
King, the Learned, the Just, the
Holy Warrior, the fortified [by
God], the triumphant, the
Victorious, the succour of Islam
and the Muslims, the subduer of
infidels and polytheists, the
reviver of justice in the worlds, the
Sulṭān of Islām and the Muslims,
the Sulṭān al-Malik al-Nāṣir
Ṣalāḥ al-Dunyā wa'l-Dīn.'
Ṣalāḥ al-Dīn Yūsuf (1237–59) was
the last Ayyubid ruler of Aleppo.

Both the neck and body of this bottle
have enamelled decoration sketched
in red originally on gilt. On the
shoulders there is sparse enamelled
decoration in blue and white.

Published: Wiet (1929, pp. 143–5); Cairo
(1969, no. 166)

**136 Pilgrim flask of colourless
glass with brownish-yellow tinge**
Height 23cm, width (maximum)
21.3cm
British Museum, London, no. 69 1–20 3
Syria (possibly Aleppo),
Ayyubid period, about 1250–60

Painted in blue, three shades of red,
green, yellow, white and black
enamels and gilding. On the front,
within a six-lobed cartouche, are two
polylobed cartouches containing
arabesque scrolls and surrounded by
gilded scrolls with terminals in the
form of human and animal heads. On
left side, above a roundel containing a
seated woman playing a harp, are a
horseman thrusting with his spear
accompanied by a hound and a hare
between the horse's feet with herons
flying overhead. On the right side,
above a roundel containing a seated
male figure drinking, is a horseman
thrusting with spear and animal, as on
left side, with a flowering tree above
his back. On the flat side of body is a
spoked medallion within an eight-
pointed star. The motif of gilded
scrolls, terminating in human and
animal heads, is found in carpets and
manuscript illuminations and its
inspiration has been traced to the
fabulous *waqwāq* tree of Islamic
cosmography. The fluent drawing
and colour range put this flask among

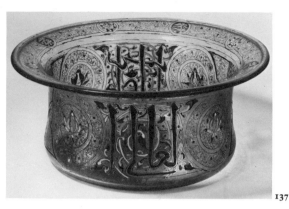

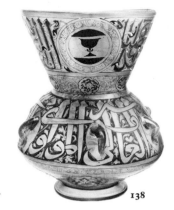

137

138

the finest examples of the glass enameller's craft. It is one of a group characterised by the introduction of large-scale figures into the decoration and attributed to Aleppo.

Published: Schmoranz (1898, pp. 17, 37f, pl. 20, 20A, 21); Lamm (1930, taf. 126, no. 18); Ackerman (1935, p. 69), and London (1968, no. 153)

137 Basin of gilded and enamelled glass
Height 12.8cm, diameter 30cm
Gemeentemuseum, The Hague, no. OG 13-1932
Syria, Mamluk period, about 1325

The dedicatory inscription in Mamluk thuluth is anonymous. The form of the vessel, as well as the disposition of the decoration, are adopted from the brass basins of Mamluk Egypt and Syria.

Published: Migeon (1903, pl. 68); Lamm (1930, taf. 179, no. 3)

138 Mosque lamp of gilded and enamelled glass
Height 34.5cm,
diameter (rim) 24.5cm,
diameter (belly) 28.5cm
Museum of Islamic Art, Cairo, no. 328, formerly in Linant de Bellefonds and Rostowitz Bey Collections, given to the Museum in 1886
Egypt or Syria, Mamluk period, 14th century

The inscriptions are in bold Mamluk thuluth. On the neck, Koran. Sura XXIV, 35. On the belly.
Bi-rasm al-maqarr al-ashraf al-ʿālī al-mawlawī al-makhdūmī al-sayfī Shaykhū al-Nāṣirī.
'By order of the most noble authority, the Exalted, the Lordly, the Masterful, holder of the Sword, Shaykhū al-Nāṣirī, mamluk of the Sultan Malik al-Nāṣir Muḥammad.'
The lower inscription is reserved on a blue ground; the blue enamelled inscription on the neck was on gilt, as is clearly visible from the inside. A curious pseudo-kufic ornament breaks the inscription. The lamp was made either for the mosque of Shaykhū in Cairo (dated 1349–50) or, more probably, for the *khānqāh* built opposite (dated 1355) which was richly endowed by Shaykhū. On the neck and below the inscription on the belly are circular medallions bearing the blazon of Shaykhū, a red cup between bars, the upper black and the lower red, a precursor of the composite blazon of the later Mamluk period.

Published: van Berchem (1894–1903, no. 475); Wiet (1929, pp. 92–3); Meinecke (1972, pp. 252–3)

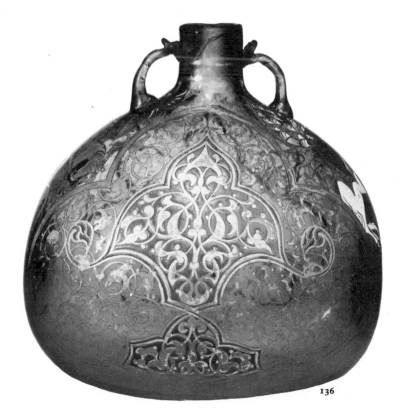

136

139 Mosque lamp of gilded and enamelled glass

Height 34cm, diameter (rim) 24cm,
diameter (belly) 20cm,
thickness 0.7cm
*Museum of Islamic Art, Cairo, no. 313,
from the madrasa of al-Nāṣir
Muḥammad ibn Qalāwūn in Cairo*
Egypt or Syria, Mamluk period,
early 14th century

Al-Nāṣir Muḥammad reigned until
1341 but that the lamp may be con-
siderably later than the madrasa, the
latest inscriptions of which are
1298 and 1303–4. Inscriptions are
found on the neck and belly in a fine
Mamluk thuluth script, but the words
are not all in the correct order.
On the neck, Koran, Sura XXIV, 35.
On the belly,

> *'izz li-mawlānā al-sulṭān al Malik
> al-Nāṣir al-Dunyā wa'l-Dīn
> Muḥammad 'azza naṣruhu*
> 'Glory to Our Lord, the Sulṭān
> al-Malik al-Naṣir al-Dunyā wa'l
> Dīn Muḥammad, may his
> victory be glorified.'

The inscription on the neck is in
bright blue on a ground of white
spiral scroll that on the belly is
reserved on a blue ground and is
broken by six handles in the usual
pointed shield-like blank panels. The
rest of the vessel is covered with fine
linear drawing in red. The base has
blank medallion on a ground of
various flying birds. The enamelling
was evidently on gilding since on
the inside there are areas where it has
not rubbed off.

Published: van Berchem (1894–1903,
no. 468); Wiet (1929, pp. 68–9); Cairo
(1969, no. 179)

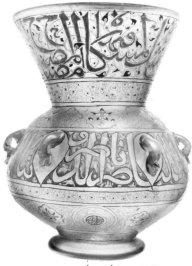

139 see colour plate, page 55

140 Mosque lamp of gilded and enamelled glass

Height 34cm, diameter (rim) 25.5cm,
diameter (belly) 18cm,
thickness 0.7cm
*Museum of Islamic Art, Cairo, no. 270,
from the mosque of Sulṭān Ḥasan in
Cairo dated 1356–63*
Egypt or Syria, Mamluk period,
mid-14th century

The lamp is densely decorated with
lotus and paeony flowers on a ground
of schematic paeony leaves. The six
handles are set in blank shield-like
panels. The decoration is reserved on
a ground of blue enamel within thinly
sketched red outlines. The
enamelling is laid on gilding, much
of which is visible from the inside.
Another lamp with the same type of
decoration, in the Museum of
Islamic Art, Cairo (no. 271), bears an
inscription in the name Sultan
Ḥasan.

Published: Paris (1878, p. 780); Herz
(1895, p. 73, no. 18); Wiet (1929,
pp. 9–10); Cairo (1969, no. 184)

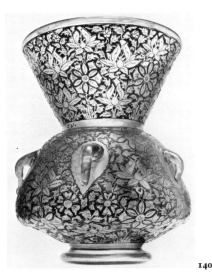

140

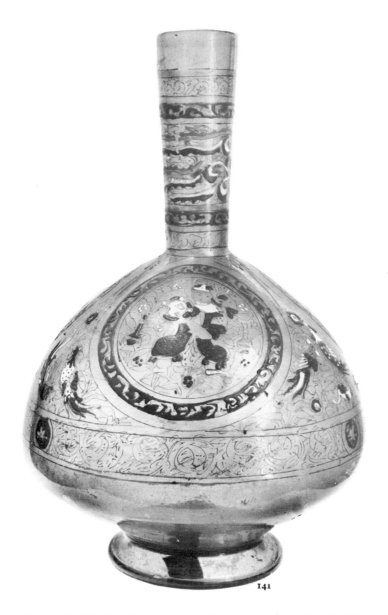

141

142 Vase of gilded and enamelled glass

Height 33.9cm
*Fundação Calouste Gulbenkian,
Lisbon, no. 2378, formerly in the
Collection of G. Eumorfopoulos
who acquired it from China*
Syria, Mamluk period, 14th century

Painted in blue, red, green, yellow
and white enamels. Various birds
appear in flight, including the
phoenix, above the water
represented in the lower band.

Published: Lamm (1930, taf. 181, no. 6);
Lisbon (1963, no. 1)

142

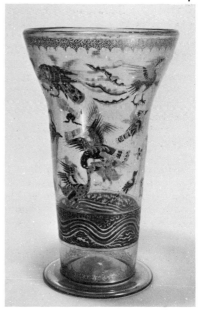

141 Bottle of gilded and enamelled glass

Height 40.4cm,
diameter (rim) 5.5cm,
diameter (base) 13.5cm,
thickness 0.4cm
*Museum of Islamic Art, Cairo,
no. 24249, ex-Prince Yūsuf Kamāl
Collection*
Egypt or Syria, Mamluk period,
mid-14th century

Large pear-shaped bottle. The neck
shows a chinoiserie phoenix in red,
white, blue, green and yellow over a
design sketched in thin red enamel of
a different consistency. On the
shoulders are large medallions con-
taining baggy-trousered musicians
and drinkers. Between these roundels
are fighting cocks flanked by ducks
and long-tailed birds. The lower part
is undecorated. The bottle may be
compared to an example in the
Metropolitan Museum of Art, New
York, formerly in the Hapsburg
Collection. See Sourdel-Thomine
and Spuler (1973, no. LII).

Unpublished

143 Vase of gilded and enamelled glass
Diameter (rim) 31.8cm
*Cleveland Museum of Art, no. 44.235,
purchase from the J. H. Wade Fund*
Syria, Mamluk period, 14th century

The 'spitoon' form of vessel, common
in India, is rare in the Islamic world.
There is a blue glass 'spitoon' of
Persian or Syrian origin, dating from
the early 8th century, preserved in
the Shosoin, Nara, in Japan, see
Pinder-Wilson (1970, p. 66, no. 10);
and two others also of blue glass
found at Fustat, one datable to the
8th–9th century; see Pinder-Wilson
and Scanlon (1973, p. 18, no. 2,
fig. 3). This is the only known
enamelled example of this type of
vessel.

Published: Cleveland (1966, p. 210)

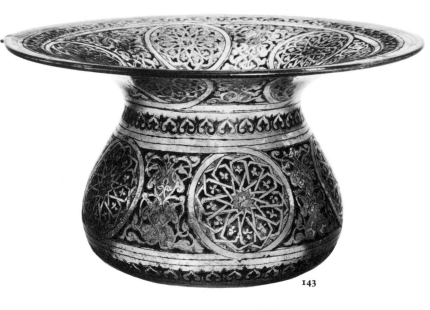

143

**144 Ribbed bowl of transparent
purple glass**
Diameter 15.2cm
*Ashmolean Museum, Oxford,
no. 1975–18, acquired through the
generosity of James Bomford*
Egypt, Fatimid period,
11th–12th century

This bowl is decorated with opaque
white threads. The vessel was first
free blown and the white threads
trailed round the lower part of the
body. It was then re-heated and
blown into a mould in order to obtain
the vertical ribbings. Finally, the
thin white threads were wound
round just below the rim and on the
rim itself, and the diminutive handle
added. This form of ribbed bowl is
characteristic of the glass houses of
Egypt in the Fatimid and Ayyubid
periods.

Unpublished

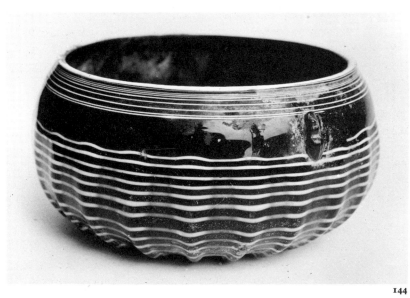

144

Ivory

Ivory was being carved in the countries of the Near East from early times. Excavations at Nimrud have revealed how adept were the Assyrian ivory carvers. In Dynastic Egypt a whole range of techniques was practised. Ivory was carved in the form of receptacles, was sculpted in the round and, used as an inlay, it served as a foil to wood.

152 detail

Ivory is a comparatively easy material to handle; for when fresh and immersed in water over a certain period, it is rendered soft enough to be carved with a knife and malleable enough to be bent. With its closely compacted grain, it can be carved into quite thin sheets; and given the right atmospheric conditions, age enhances its delicate tones. When subjected to excessive heat or dryness, however, it can warp and develop fissures which in time will split. The size and shape of the tusk, of course, limits its use to comparatively small objects or to subordinate elements in large scale decoration of wood.

In the medieval Islamic world, the principal ivory carving centres were to be found in the countries of the Mediterranean: Syria and Egypt, North Africa, Spain, Sicily and South Italy. The objects wholly carved in ivory in these centres were necessarily small, such as combs, chess and gaming pieces, and the little casket (no. 146). Ivory was rarely sculpted in the round though small ivory and bone figures have been found in Egypt and there is a carved elephant – possibly a chess piece in the National Museum, Florence.

Among the objects composed of or embellished with ivory, caskets are by far the commonest. In the smaller rectangular and cylindrical caskets the ivory sheets were glued together (no. 148) or joined by tiny ivory pins. In the larger ones, the ivory panels were attached to an interior wood frame (no. 155).

In some of the caskets exhibited, the ivory component is an embellishment. The large casket (no. 150), is wood with ivory panels, carved in openwork and backed by gilded leather, attached to each face. The wood surface of caskets is often encrusted with ivory and woods of varying tones, carved into the required shapes and fitted together like a mosaic. In the flat lid of the wood casket (no. 145), the border inscription was carved in ivory and then countersunk in the wood surface: this is properly the technique of intarsia. Besides being carved in relief and openwork, ivory was sometimes incised, stained or painted (no. 145) or painted and gilded (no. 155). Some of the carved panels exhibited were originally attached to furniture such as the panels

151 detail

(no. 151) of which the dimensions would preclude their use as decorations for a casket. The horizontal panel carved with an inscription in relief (no. 154) and the horizontal wood panel encrusted with an ivory inscription (no. 155), were very probably inset in wooden doors or screens. The five panels of ivory carved in low relief with verses (no. 156), were fixed to a wood cenotaph.

Most of these techniques had already been practised in Coptic Egypt; and the industry, so far from being disrupted, seems to have been given a fresh impetus by the Arab conquest. It was probably Egyptian craftsmen who in the early centuries of Islam carried their skills to the Muslim communities that grew up around the shores of the Mediterranean.

Nearly all the ivory used in the Islamic world was imported from East Africa which was the source of the best quality tusk, as, too, it was for Europe. Egypt's primacy among the ivory centres of the Muslim world may well have been due to its accessibility to this source. It must have been a rare and expensive commodity and the Egyptians some-times resorted to bone as a substitute. This is less finely grained than ivory and lacks its subtle tone and smooth surface.

In the 10th century, Egyptian carvers travelled west along the shores of North Africa where they established a workshop at al-Manṣuriyya in present day Tunisia. Here under the patronage of the Fatimid caliph al-Muʿizz was produced a unique ivory, the casket no. 145, at some time in the third quarter of the 10th century. Its maker, Muḥammad came of a family of east Persian origin which must have migrated to Egypt. There Muḥammad would have acquired his skill in intarsia and painting on ivory which he brought to Ifriqiya and proved in this remarkable casket.

We do not know if Egyptian craftsmen played a part in the establishment of the ivory carving industry in Andalusia which was active at about the time when Muḥammad al-Khurāsānī was working in Ifriqiya. The carved ivories of Muslim Spain are among the most remarkable of the medieval Islamic ivories and include masterpieces which can rival those of Byzantium and the West. These were produced during a little less than a century. Many were made under royal patronage for presentation to royal personages or high officials (nos. 145 and 150). Both in Cordoba and in Madinat al-Zahra – the Palatine city built near Cordoba by ʿAbd al-Raḥmān III (926–61) –

there were establishments working exclusively for the court. The workshop at Madinat al-Zahra was under the supervision of a court chamberlain and its leading artist was a certain Khalaf who carved the superb cylindrical box now in the Hispanic Society, New York.

The caskets made in these royal establishments were intended for jewels and scents, so greatly valued in the medieval world. The exquisite box carved from a single piece of ivory (no. 146), was made for the Caliph's daughter, shortly after the death of her father, 'Abd al-Rahmān, in 961. Its decoration is restricted to foliate scrolls and kufic inscription. The origin of this style of decoration can be traced to that of Umayyad Syria in the 8th century which reached full maturity under the Caliphs of Cordoba, themselves descended from the Umayyad Caliphs of Damascus. In Cordoba, there were other establishments besides the royal one, working for a wider clientèle. The fine casket with its anonymous inscription of 966 (no. 147), was the product of one such workshop. Its decoration is organised in much the same manner as on the royal ivories of Cordoba and Madinat al-Zahra.

A group of royal ivories introduces into the floral ornament vivid scenes of court life, the chase and other country pursuits. These little scenes are framed in roundels or lobed cartouches. This style of decoration was also copied in the commercial establishments such as on the casket (no. 149). Animals and birds arranged in pairs and flanking a palm tree are a prominent feature of this style. These motives were the stock-in-trade of the silk weavers of Persia, Syria, Egypt and Andalusia and these silk weavings may have been the means by which they reached the ivory workshops of Andalusia.

After the fall of the Caliphate of Cordoba, Andalusia was fragmented into a number of independent petty kingdoms. Some ivory workers from Cordoba founded a new establishment at Cuenca under the patronage of one of these rulers, the Dhu'l-Nūnid king of Toledo. This workshop was apparently in the hands of a single family, of which one member, 'Abd al-Rahmān ibn Zayyān, made the casket (no. 150) in 1049–50. Its decoration incorporates many of the motives used in the Cordoban ivories; the animals and figural scenes, however, are no longer enclosed by framing bands but are presented rather monotonously in horizontal and vertical registers. It is clear from this casket – the last documented pieces in the series of Andalusian ivory carvings – that the industry was in decline due to a lack of vitality and invention.

The technique of encrusting wood with ivory was also practised in Caliphal Cordoba although no example has survived. But when towards the end of the 11th century Andalusia became a province of the Almoravid empire, the Cordoban workshops made the beautiful minbar of wood with ivory encrustations for the Kutubīyya in Marrakesh, Morocco, a sure indication of the high standing of Andalusian workmanship.

In Norman Sicily there were Muslim establishments producing caskets in the 12th and early 13th centuries. These were composed of plain ivory sheets attached to a wood frame and painted and gilded

151 detail

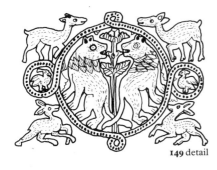

149 detail

with birds and animals, scenes of the chase and of the court. They seem to have been destined for a Christian as much as a Muslim clientele. With the suppression of the Muslim community by the Angevin rulers of Sicily, some of these workers found asylum in the Nasrid kingdom of Granada in the 13th century. A typical product of a Granadan workshop specialising in this type of painted ivories is the casket (no. 155). This workshop confined its decoration to roundels of elaborate geometric interlacings characteristic of Nasrid art, combined with naskhi inscriptions.

The wood carvings of Fatimid Egypt are deservedly famous for the imaginative handling of their decorations (nos. 442–4). The subject matter of these wood carvings was also translated into ivory where the finesse and refinement of the carving have seldom been equalled. Among the rare surviving examples are the four panels (no. 151), where the human figure, rendered with verve and spirit and enhanced with colour, are beautifully composed within the narrow confines of the frame. These panels, two vertical and two horizontal, must once have decorated a piece of furniture, perhaps a throne back.

The ivory carvers of Ayyubid and Mamluk Syria and Egypt excelled in intarsia and encrustation. These techniques were applied to the decoration of mimbars, doors and screens. Sometimes the inlaid or encrusted decoration was composed of ivory panels carved in relief with naskhi inscriptions (nos. 154–5).

Ivory seems to have been but rarely used in Persia; and little is known about the ivory carving industry there. Included in the exhibition are five precious panels which once decorated the cenotaph of Shah Ismā'īl (1502–24) in the shrine at Ardabil (no. 156). They are carved in low relief with appropriate verses from the Koran in a fine Arabic script after an original designed by a notable calligrapher of the day.

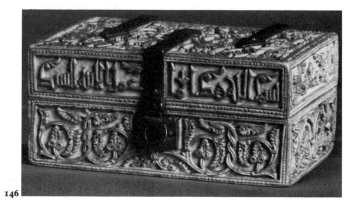

146

145 Casket of wood with ivory inlays

Length 42cm, width 24cm, height 20cm

National Archaeological Museum, Madrid, no. 887

Tunisia (Kairouan), Fatimid period, third quarter 10th century

Rectangular wood with flat lid, metal mounts and handles. Ivory plaques on each of the four sides with framing borders decorated with foliate scrolls in red and dark green. Upper side of lid has ivory plaque bordered by an inlaid ivory inscription in kufic.

> *bismillāh . . . naṣr min Allāh wa fatḥ qarīb li'abd Allāh wa waliyyihi Ma'add Abū Tamīm al-Imām al-Mu'izz [li-dīn Allāh] Amīr al-mu'minīn ṣalwāt Allāh 'alayhi wa 'alā abā'ihi al-ṭayyibīn wa dhurıyyatihi al ṭāhirīn mimma amara bi-'amalihi bi l-Manṣūriyya al-murḍiyya ṣan'a [. . h] mad al-Khurāsānī*

'In the name of God . . . help from God and speedy victory (Koran, Sura LXI, 13) for the servant of God and His friend, Ma'add Abū Tamīm, the Imām al-Mu'izz [li-dīn Allāh] Commander of the Faithful – God's blessings on him and his good ancestors and his pure descendants – one of the things he ordered to be made at al-Manṣūriyyah [the city] pleasing [to God]. The work of Muḥammad [or Aḥmad] al-Khurāsānī.'

The casket was made for the Fatimid caliph, al-Mu'izz (952–75), probably before 972 when he left his capital, al-Manṣūriyya near Kairouan, to assume the sovereignty of Egypt, which his general Jawhar had conquered in 969. The maker's surname means 'from Khurasan', that is, east Persia.

Published: Amador de los Rios (1873, p. 533); Lévi-Provençal (1931, p. 191f, no. 210); Monneret de Villard (1938, p. 15); Ferrandis (1935/40, i, p. 127f, no. 9, pl. VI)

146 Casket of ivory

Length 9.5cm, height 4.5cm, width 7cm

Victoria and Albert Museum, London, no. 301.1866

Spain (Madinat al-Zahra), Umayyad Caliphate, about 962

Lid and box are each carved from single pieces of ivory. Silver nielloed mounts may be old. Inscription relief carved in foliated kufic on edge of lid.

> *bismillāh hādha ma'umila li-ibnat al-sayyida ibnat 'Abd al-Raḥmān Amir al-mu'minīn raḥmat Allāh 'alayhi wa riḍwānuhu*

'In the name of God. This is what was made for the daughter, the lady daughter of 'Abd al-Raḥmān [or 'the Daughter of the lady, daughter of 'Abd-al Raḥmān.] Commander of the Faithful, God's mercy and His approval be on him.'

The final phrase makes it clear that the casket was made after 'Abd al-Raḥmān III's death in 961, in the royal workshop of Madinat al-Zahra, the palace-city near Cordoba.

Published: Ferrandis (1935/40, i, no. 2, pl. II); Beckwith (1960, p. 6f, pl. 2); Kühnel (1971, p. 32f, no. 20, pl. VIII)

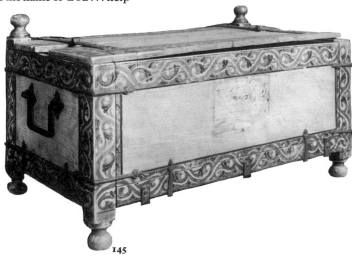

145

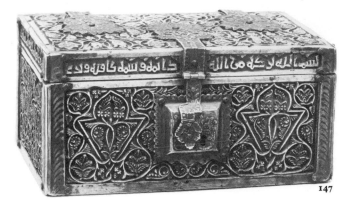

147

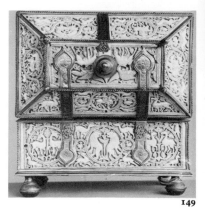

149

147 Casket of ivory

Length 20cm, height 10cm, width
12.5cm
*Musée des Arts Décoratifs, Paris,
no. 4417*
Spain (Madinat al-Zahra),
Umayyad Caliphate, 966

Rectangular casket with flat lid;
carved in relief on four sides and top
with palmettes, leaves and rosettes
growing from a scrolling stem.
Silver mounts with repoussé and
traced decoration added later.
Kufic inscription carved in relief on
all four edges of lid.

> *bismillāh baraka min Allāh [. . .]
> dā'ima wa ni'ma kāfiya wa yad
> 'āliyya wa 'āfiya shāmila wa ni'am
> sābigha wa baraka mutawāliya wa
> salāma li-saḥibihi mimmā'umila fī
> sana khams wa khamsīn wa
> thalāth mi'a*

'In the name of God, Blessing from
God [. . .] perpetual favour,
sufficient help, sublime and
complete health, abundant
benefits, continued blessing and
well-being to its owner. One of the
the things made in the year 355
[966 AD].'
The absence of an artist's signature
and dedication and the inferior
quality of execution compared to the
ivory carvings made for the Caliphal
court, may be explained by the fact
that the casket was produced in a
commercial establishment.

Published: Munich (1910, no. 215);
Ferrandis (1935/40, i, no. 255); Beckwith
(1960, pp. 14, 16 and pl. 13); Paris (1971,
no. 255); Kühnel (1971, no. 25, pl. XV)

148 Casket of ivory

Length 12.9cm, height 6.9cm,
width 9.4cm
*Museo Nazionale del Bargello
Florence, no. 81C, at one time in the
possession of a church near Logroño,
Spain; later in the Carrand Collection*
Spain (Cordoba), Umayyad
Caliphate, late 10th century

Flat topped casket. The silver gilt
mounts, enriched with semi-precious
stones and filigree, are apparently
old; at least they follow the carver's
outlines. Each side of the casket is
composed of two sheets of ivory glued
together, the front one being slightly
thicker than the rear one. Inscription
in foliated kufic is carved in relief on
the edge of the lid.

> *bismillāh baraka min Allāh wa
> yumn wa sa'āda wa ghibṭa wa
> salāma shāmila wa 'āfiya kāfiya wa
> ni'ma ṭābi'a [sic] surūr dā'im
> li-saḥibihi*

'In the name of God, blessing from
God, good fortune, happiness,
felicity, complete well-being,
sufficient health, favour . . . and
perpetual joy to its owner.'

Published: Ferrandis (1935/40, i, no. 21,
pl. XXXIX/XL); Beckwith (1960, p. 29,
pl. 26); Kühnel (1971, p. 40f, no. 34,
pl. XXI)

149 Casket of ivory

Length 26.7cm, height 21.6cm,
width 16.2cm
*Victoria and Albert Museum,
London, no. 10.1866*
Spain (Cordoba), Umayyad
Caliphate, early-11th century

The inscribed frieze on lower edge of
lid is missing and has been replaced
by plain ivory panels. Chased silver
mounts are probably from the 18th
century. The decoration is organised
in and around interlaced roundels and
is particularly dense and rich:
scenes from the chase, feasting and
music making, a woman riding in a
litter carried by a camel, elephants
and fabulous creatures such as the
winged griffon and winged ibex.

Published: Ferrandis (1935/40, i, no. 22,
pl. XLI–XLIV); Beckwith (1960, p. 29f,
pl. 27–30); Kühnel (1971, p. 44, no. 37,
taf. XXVIII)

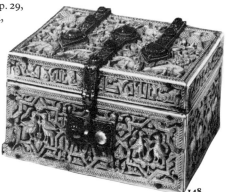

148

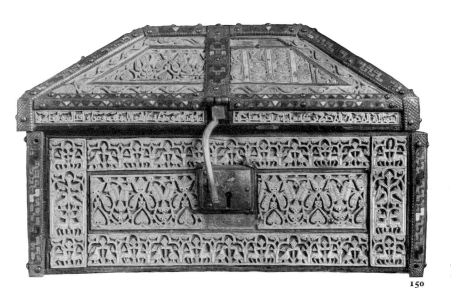

150

150 Casket decorated with carved ivory panels and ivory inlays

Length 34cm, height 23cm, width 23.5cm
National Archaeological Museum, Madrid, no. 71371, formerly in the Cathedral of Palencia
Spain (Cuenca), 1049/50

Wood casket decorated with panels carved in openwork and backed by gilded leather; cloisonné enamelled corner pieces (probably 12th century). Right panel on back slope of lid is a replacement; panel on left slope is missing. Lower edge of lid relief is carved with an inscription in foliated kufic.

bism illāh al-raḥmān al-raḥīm baraka dā['i] ma wa ni'ma shāmila [wa] 'āfiya bāqiya wa ghibṭu ṭā'ila wa'l-amr tabi'a★ wa 'izz wa iqbāl wa an'am wa ifḍāl wa hulūgh āmal li-sahibihi aṭāl Allāh baqāhu mimmā 'umila bi-madīna Qunka bi-amr al-ḥājib Ḥusām al-dawla Abū Muḥammad Ismā'il ibn al-Ma'mūn shi'l-majdayn ibn al-Ẓāfir dhi al-riyāsatayn Abī Muḥammad ibn Dhī al-Nūn a'azzahu Allāh fī sana iḥdā wa arba'īn wa [ar] ba' mi'a 'amal 'Abd al-Raḥmān ibn Zayyān
★The phrase *wa'l-amr tabi'a* is the only possible reading but makes no sense. There appears to be no obvious emendation.

'In the name of God the Merciful the Compassionate, perpetual blessing, complete favour, enduring health, ample felicity . . . glory and prosperity, benefits and excellence, fulfillment of hopes to its owner, may God prolong his life. One of the things made in the city of Qunka (Cuenca) by order of the chamberlain Ḥusām al-dawla Abū Muḥammad Ismā'il son of al-Ma'mūn dhū 'l-majdayn son of al-Ẓāfir dhu'l-riyāsatayn Abū Muḥammad son of Dhu'l-nūn – may God give him glory – in the year 441 [1049–50 AD]. The work of 'Abdulraḥmān son of Zayyān.' This is the last in the series of ivory carving produced at Cuenca where the ivory carvers found asylum under the Dhū'l-Nūnids, who ruled Toledo after the fall of the Caliphate of Cordoba. Ḥusām al-dawla, son of al-Ma'mūn, king of Toledo, was heir presumptive to the throne and governor of Cuenca.

Published: Lévi-Provençal (1931, p. 190f, no. 207); Ferrandis (1935/40, i, pp. 92–5, pl. LIII–LVII); Beckwith (1960, pp. 30, 32, pl. 32); Kühnel (1971, p. 48, no. 43, taf. XXXV–XXXVII)

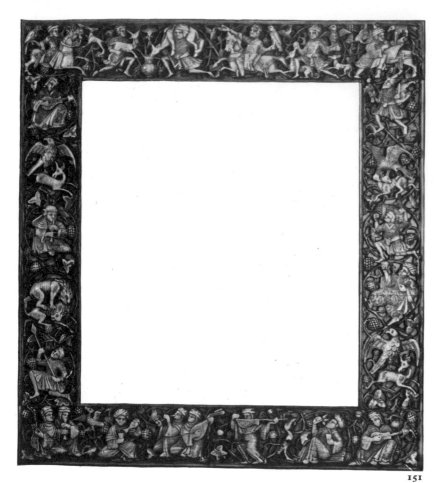

151

151 Four carved ivory plaques

Horizontal plaques: length 36.5cm, width 5.8cm
Vertical plaques: height 30.3cm, width 5.8cm
Staatliche Museen Preussischer Kulturbesitz, Museum für Islamische Kunst, Berlin-Dahlem, no. 1.6375, at one time in the Freiherr von Zu-Rhein Collection
Egypt, Fatimid period, 11th-12th century

Probably decorative plaques from a casket or a piece of furniture. The two vertical panels are incomplete, having been cut at top and bottom. Details were originally picked out in red-brown. The panels are masterpieces of ivory carving both in the handling of the material and in the composition of the design. The themes of the hunt, music and carousing are also typical of the Fatimid wood carver.

Published: Kühnel (1971, p. 68f, no. 88 A–D, taf. XCVII, XCVIII)

152 Box of ivory carved in relief

Height 9.8cm, diameter 6.7cm
Museum of Islamic Art, Cairo, no. 15443, formerly Harari Collection no. 16
Spain or Sicily, 12th century

Carved in relief on a hatched ground. On the flat top is a pair of prancing horses, perhaps unicorns, in a surround of animals pursuing one another. The cylindrical body is divided into four beaded medallions, those at the sides being blank except for small circular metal handles above and below; the other two, both slightly mutilated by the metal hinge and hasp, contain pairs of cranes. Above and between the medallions are long-tailed birds; below are animals. The base is a single piece of ivory, undecorated except for con-centric black circles. Most of the known carved ivory boxes of the Islamic world are of Spanish origin and of the 10th-11th centuries. This box, however, is very different in style to the Spanish examples and may be Sicilian work because the metal mounts of gilt brass are similar in form to those found on the painted ivory caskets generally attributed to Norman Sicily of the 12th–13th century. See Pinder-Wilson and Brooke (1973, pp. 261–305).

Published: Alexandria (1925, pl. 4); Kühnel (1971, no. 137, pl. CX)

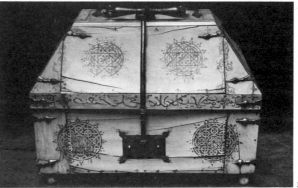

153

153 Casket of ivory
Length 38cm, width 27cm,
height 24cm
*Instituto Valencia de Don Juan,
Madrid, at one time in the parish
church of Villamuriel de Cerrato,
Palencia*
Spain (Granada), Nasrid period,
12th–14th century

The ivory panels are attached to a
wood frame and are painted and
gilded. According to Ferrandis, the
naskhi inscription on the edge of the
lid states that the casket was made for
the purpose of containing the con-
secrated host; but the text requires
further study to support the con-
clusion that the casket was made in a
Muslim workshop for a specific
Christian function. There is no
reason, however, to doubt that the
casket was produced in the Nasrid
kingdom – most probably Granada –
since the geometric designs of the
roundels are characteristic of Nasrid
art of the 14th century.

Published: Ferrandis (1935/40, i, pp. 77,
84, 216f, no. 97, pl. LXVI)

154 Plaque of ivory
Height 7.5cm, length 17.5cm
Musée du Louvre, Paris, no. 7461
Egypt, Mamluk period, 14th century

Probably a decorative plaque from a
door. Inscribed in Mamluk naskhi.
al-'izz al-da'im wu'l-jāh al-qā'im
'Perpetual glory and lasting
dignity.'

Published: Paris (1971, p. 186, no. 265
and illustrations)

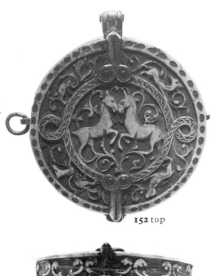

152 top

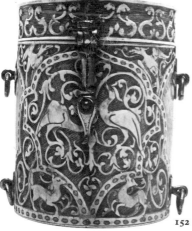

152

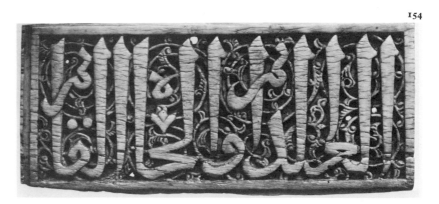

154

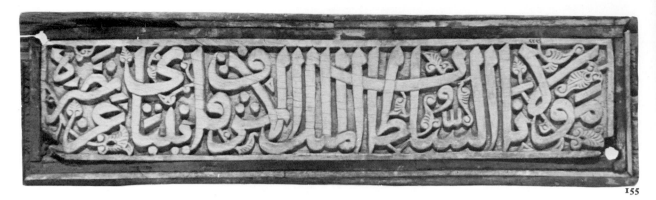

155

155 Carved panel of ivory
Length 34cm, height 9.4cm
*Museum of Islamic Art, Cairo,
no. 2334, from the funerary madrasa
of Qāytbāy, dated 1472–4*
Egypt, Mamluk period, late 15th
century

Panel is framed in wood and inlaid
with a thin band of ivory. Inscription
is flat carved thuluth script.
 *Mawlānā al-Sulṭān al-Malik
 al-Ashraf Qāytbāy 'azza naṣruhu*
 'Our Lord the Sultān al Malik
 al Ashraf [that most noble king],
 may his victory be glorified.'
The background is filled with sparse
leaves or tendrils with veined
engraving.

Published: Wiet (1930, no. 39); Cairo
(1969, no. 41)

156 a–e Five ivory panels
Length of a 20.3cm,
height of a 4.4cm
*Iran Bastan Museum, Tehran,
nos. 20508–20512*
Persia, Safavid period, 16th century

These five ivory panels are from the
tomb of Shah Ismā'il (1502–24),
founder of the Safavid dynasty,
which is in a domed structure in the
great shrine complex at Ardabil
dedicated to his ancestor Shaykh
Ṣafī. The panels are carved in open-
work with Koranic verses in a fine
naskhi script.
 a 'In the name of God the merciful
 the compassionate. O thou
 enfolded in thy mantle stand up all
 night [except a little of it for
 prayer].' (Sura LXXIII, 1–2)

b 'We, even We, created them, and
strengthened their frame. And
when we will [We can replace
them, bringing others like them in
in their stead].' (Sura LXXVI, 28)
c'Lo! We have shown him the way,
whether he be grateful or dis-
believing.' (Sura LXXVI, 3)
d '[And it will be said unto them]
Lo! This is a reward for you. Your
endeavour [upon earth] hath
found acceptance.' (Sura LXXVI,
22)
e 'And there wait on them
immortal youths.' (Sura LVI, 17)
The calligrapher's name, Maqṣūd
'Ali is signed on the back of the tomb
(information kindly supplied by
Mr A. H. Morton).

Unpublished

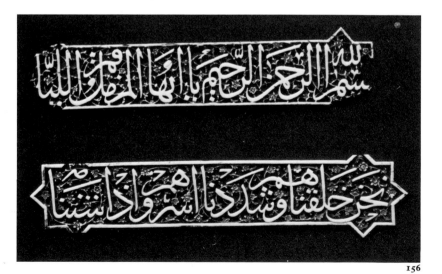

156

Metalwork

Metalwork in the Near East has always enjoyed a prestige beyond that of the other applied arts such as ceramics and textiles. Major pieces were specially commissioned and often bear dedications to the princes and great nobles for whom they were made, together with the proudly inscribed names of their makers and decorators; their very durability and impressive appearance give them a high standing and dignity all their own.

212 detail

The best pieces were of bronze or, later, brass, and their adornment was of four main types; two or more of which are usually found in combination: engraving, inlay, overlay, and repoussé. Engraving is the drawing of designs and inscriptions with the chisel on the surface of the metal. Inlay consists in the hammering of a decorative metal – gold, silver, or copper – into an area previously grooved or hollowed out in the surface to receive it. Overlay is found in two forms: firstly, the hammering-on of gold or silver in foil or thin sheets shaped to the design required, the edges being secured by rough-edged grooves cut in the background metal round the outlines; and, secondly, the scoring of the ground all over with closely cross-hatched lines to which the gold or silver wires and sheets adhere when hammered on in the required design. This last process, sometimes called damascening or *kūftgarī*, is usually employed on an iron or steel base, such as a gun-barrel, helmet, or sword-blade, and does not appear with any frequency earlier than the 15th century. Repoussé is the hammering out from behind of designs to appear in relief on the surface.

The roots of Islamic metalwork are to be found in Byzantium and Persia. The Byzantines, as inheritors of the classical culture of Greece and Rome, had already influenced the art of Persia under the Sasanians in figure-drawing and in certain forms and decorative motifs, and the Coptic art of Egypt was to exert a parallel but independent influence on the art of the Fatimids and Mamluks. Certain specialised forms found in Islamic metalwork, such as the polycandelon (no. 182) may also be traced to the West.

In the early years of the 7th century the Byzantine and Sasanian empires had both reached a state of near-exhaustion. For four hundred years they had been intermittently engaged in a series of wars, 'undertaken without cause, prosecuted without glory, and terminated without effect' in the words of Gibbon's pithy summing-up, so that the collapse of the Sasanians before the Arab onslaught is not, perhaps, so

surprising as might at first appear. Nor need we be surprised, on the other hand, to find pockets of local Persian resistance and independence left behind by the rapid course of Arab conquest, where the old arts and culture, and even the old religion, survived to a great extent.

The Arabs themselves, on the other hand, made a most important artistic contribution in the kufic script, so we naturally find that the earliest metalwork produced in the eastern half of the Islamic world under Muslim rule retains the forms and decorative styles of the old dynasty, with the occasional addition of short Arabic inscriptions. These early pieces come from the north of Persia, from Tabaristan on the Caspian and Khurasan with its great and flourishing cities of Merv, Herat, Balkh, and Nishapur; indeed, the latter became the foremost centre of culture and civilisation in the early centuries of Muslim rule, and it is perhaps significant that the great nationalist and epic poet Firdawsī sprang from the same region. In the western half of the Islamic world, we know little or nothing of the metalwork of the Umayyads of Damascus and Spain in these early centuries, but may assume that here too indigenous types were retained to a great extent, and that Arabic script was incorporated into the scheme of decoration.

Not much is known of the art of metalwork in Persia between the early 'post-Sasanian' pieces and the advent of the Seljuqs in the 11th century. A few large dishes or trays are thought to date from the Ghaznavids (Khurasan again!), but attributions of metalwork to the Samanids (9th century) and Buyids (10th century) are few and tentative. But with the Seljuqs we are on firmer ground. At first, the Seljuq pieces rely on their shapes and engraving for their aesthetic appeal; many new forms appear (though earlier examples of some of them have survived in pottery), such as candlesticks, lamp-stands, incense-burners, and spouted bowls. But by the 12th century the decoration of the larger and more important pieces is elaborated and carried out with lavish inlay and incrustation of gold, silver, and copper (no. 180). Human figures and animals are frequent, the latter sometimes 'sculptured' in the round (no. 176), and new and highly decorative forms of script – foliated, animated, and human- and animal-headed kufic and naskhi – were invented and developed. Comparable work is found during the 13th century at Mosul (no. 198), and in Egypt and Syria under the Mamluks. In Syria Christian motifs, with haloed figures, are occasionally found in the decoration of fine metalwork, but the decorative style of Mamluk work is generally more austere; figures are seldom found, and the characteristic script is a monumental but unelaborated naskhi. During the 14th century there was a flourishing school of metalworkers in Fars under the Inju and Muzaffarid rulers, in which this monumental script is combined with panels of figures, often on a fine diaper ground. The figures, tall, slim and graceful, are close to those found in miniatures produced under the Muzaffarids of Shiraz and the Jalayrids of Baghdad in the later-14th century.

Timurid metalwork, curiously enough, does not seem to have survived in as large numbers as that of the preceding periods, but the comparative dearth of actual examples is compensated by many

208

accurate representations in Timurid miniature paintings. Some new forms were developed, and old ones modified. In particular we find the graceful long-necked bottles and ewers, which have persisted in Persia and northern India ever since, and a rather squat bulbous form of jug, sometimes found with a lid, which also became popular in Turkey (see no. 163). The decoration is mostly confined to small arabesques and sparse inscriptions, and inlay is more restrained than in the earlier pieces. Fine examples of this style were produced by a small colony of Persian metalworkers settled in Venice during the alliance of that city with the Turkman monarch Ūzūn Ḥasan against the Ottoman Turks. The leading figure in this group seems to have been Maḥmūd al-Kurdī, who signed his work in both Arabic and Roman script. The designs used by these craftsmen spread all over Europe during the 16th century, and may be found on Italian bookbindings and even on Elizabethan English silver.

There is no stylistic break between the Timurid and Safavid periods in decorative metalwork, any more than in miniature painting and the art of the book. Silver enrichment seems gradually to have disappeared, and at the same time human and animal figures begin to return to the engraved designs. Among the new forms, characteristic of the 16th and 17th centuries, are the 'pillar' candlestick and the peculiar type of ewer (borrowed from China) in the form of the Chinese 'sacred jewel', which was filled through a lidded opening at the top of the hollow handle. At the same time we find a wide variety of domestic vessels of tinned copper. Earlier examples, mostly of Mamluk origin, are, indeed, not uncommon, but Safavid tinned copper is of more elegant shape and covered with finely engraved figural and arabesque ornament, in which the bold and graceful nastaliq script is often prominent. During the subsequent Zand and Qajar periods this engraved ornament became increasingly intricate and feeble, and the tradition is still maintained in the silver- and brass-work of the Isfahan bazaar.

In the Islamic world fine arms and armour have always been held in the highest esteem, and no exhibition of Islamic metalwork would be complete without a few examples. The sword (along with the horse) was celebrated in early Arab poetry as the desert rider's trusty companion, but apart from a few examples traditionally associated with some of the early Caliphs and now preserved in the Topkapi Palace Museum, Istanbul (from which, unfortunately, it was impossible to borrow for the present exhibition), nothing remains from the first centuries of Islamic conquest. The form of the early Islamic sword, however, has been preserved in the Sudan, and the formidable *kaskara*, with its short grip, cross-guard, and long straight double-edged blade, is virtually the same weapon as that with which the faith of Islam was spread from the Indus to the Pillars of Hercules. Curved blades seem to have been introduced by the Mongols, and by the 15th century had developed in two different directions: the Turkish *qilīj* on the one hand, with its almost angular curve and broadening at the point end, and on the other the graceful Persian *shamshīr*, of pronounced but regular curve and slightly tapering blade, together with its later Indian derivative the *talwar*.

218 detail

The best examples of these swords were forged of so-called 'Damascus' steel (actually of Indian origin), whose carbon content produces a variety of patterns that can be brought out by etching the surface of the blade. The best 'Damascus' blades came from Khurasan and exhibited a barred pattern known as 'Forty Steps' or 'Muḥammad's Ladder'. Such features must be carefully distinguished from 'pattern welding', a technique usually seen on fine gun-barrels, whereby patterns of a superficially similar nature were obtained by twisting and welding together bars and strips of steel of differing hardness. From the 16th century onwards Islamic blades and gun-barrels were highly prized in Europe.

Islamic armour, so far as we know, was at first founded on the helmet and mail of the Sasanian heavy cavalry. Laminated armour was introduced by the Mongols, but never entirely replaced the former style, which, with the addition of plate cuirass, arm- and leg-guards, has persisted down to quite recent times. Here again, little or nothing has survived from the early medieval period, and we have to rely largely on miniature paintings for the types and development of armour earlier than the 16th century. The finest Persian armour was made of 'Damascus' steel, but late examples of poor quality and with crude but elaborate etched decoration are often encountered. These are mostly stage properties used in the *ta'zīya*, or Passion Play, formerly mounted in every Persian city during the month of Muharram, in which the martyrdom of the imams Ḥasan and Ḥusayn at Karbala was re-enacted.

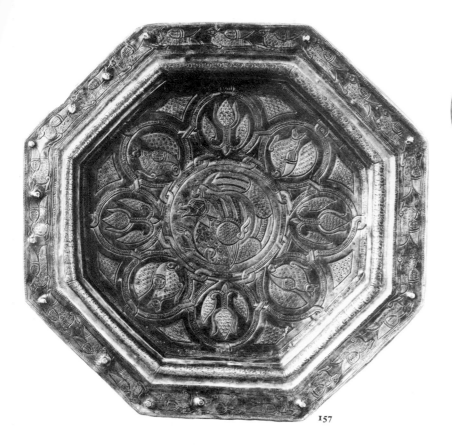

157

158

158 Bowl of beaten silver, incised and inlaid with niello

Diameter 19cm
*Iran Bastan Museum, Tehran,
no. 4173*
Persia, 11th century

The inscription reads
baraka min Allāh tāmma wa saʿād [a li] ʾl-amīr Abī al-ʿAbbās Valgīr ibn Hārūn mawlā Amir al-Muʾminin
'entire blessing from God and happiness [to] the emir Abuʾl-ʿAbbās Valgīr ibn Hārūn client of the Commander of the Faithful.'

This is one of two silver objects bearing the name of Valgīr ibn Hārūn appearing in this exhibition (see also no. 159), both of which form part of a hoard consisting of three silver bowls, two small dishes, a large dish, a ewer, two jars, a bottle and a cup. Although only seven of these bear their owner's name they clearly all belong to the same group. On epigraphic grounds they may be dated to about c. 1000, but where they were found or made remains a mystery. Wiet (1933, p. 18) suggests that the owner may have been a Dailamite prince and the objects from Azerbaijan in north-west Persia. This would certainly fit the style of the epigraphy, the closest parallel to which is found in Luristan in the west of the country, see Eilers (1941, p. 35). However, the form of the bowl and the use of epigraphic ornament are also reminiscent of certain Samanid pottery products from north-east Persia.

157 Octagonal dish of silver, beaten and chased

Diameter 35.8cm, height 3cm
Staatliche Museen Preussischer Kulturbesitz, Museum für Islamische Kunst, Berlin-Dahlem, no. 1.4926
Mesopotamia or Western Persia, Abbasid Period, 9th century

The angular form of this dish is not an easy shape for a silversmith to make and the form of moulding between the rim and central field suggests that the craftsman was copying an object from some other medium. The crude metal strips which support the rim on the underside indicate the problems that evidently arose. The main element in the decoration is the *senmurv*, a compound beast from Zoroastrian tradition, of benevolent character, and powerful in the realms of healing and fertility. Although usually associated with Sasanian art, it is here combined with interlacing roundels and large blossom motifs to create a design which is more typical of art under the Abbasids. It may, for example, be compared to designs on 9th-century Mesopotamian pottery with relief decoration and painting in lustre (eg. no. 249).

Published: Botkine (1911, taf. 26–7); Berlin-Dahlem (1971, no. 218); Sourdel-Thomine and Spuler (1973, pl. 149)

Published: London (1931, no. 139A); Wiet (1933, p. 18, no. 9, pl. III); Pope and Ackerman (1938–9, pl. 1346B)

159

160

159 Dish of beaten silver incised and inlaid with niello
Diameter 26.6cm
Iran Bastan Museum, Tehran,
no. 4172
Persia, 11th century

Outer inscription
baraka min Allāh tāmma wa saʿāda
sābigha wa salāma shām [il] a wa
ʿāfiya [?] sāli.a [?] wa niʿma
bāqiyya wa dawla nāmiyya wa imra
ṭāliʿa wa ghibṭa wa ʿizz wa yumn
wa surūr wa f.s.ṭ. [?] ḥ.r [? li]
ʾl-amīr Abīʾl-ʿAbbās Valgīr ibn
Hārūn mawlā Amīr al-Muʾminīn
'Entire blessing from God,
abundant happiness, complete
well-being, health (? unimpaired),
enduring favour, growing wealth,
waxing influence, felicity, glory,
good fortune and joy . . . [to] the
Amīr Abuʾl-Abbās Valgīr ibn
Harūn, client of the Commander
of the Faithful.'
Inner inscription
baraka tāmma wa saʿāda sābigha wa
salāma sāhāama [? = shāmila] wa
ʿāfiya sā . . . a [?] wa niʿma bāqiyya
wa dawla nāmiyya wa imra tāliʿa wa
ghibṭa wa ʿizz wa yumn wa surūr wa
basṭ [?] h.r.la [?] wa d.ra [?]
'Entire blessing, abundant
happiness, complete well-being,
health (? unimpaired), enduring
favour, growing wealth, waxing
influence, felicity, glory, good
fortune, joy and cheerfulness
[?] . . .'
This dish is from the same hoard as
no. 158. The form was introduced
into the Islamic world from Byzantine
silver and although no earlier Islamic
metal pieces survive, pottery objects
of Abbasid Mesopotamia testify to
the continued use of the style prior to
about 1000.

Published: London (1931, no. 139L);
Wiet (1933, p. 19, no. 14, pl. II);
Pope and Ackerman (1938–9, pl. 1346B)

160 Dish of silver, beaten, traced and partially gilded
Diameter 31.5cm, height 4.7cm
Bibliothèque Nationale, Cabinet des
Médailles, Paris, no. 75 C 73331
Transoxiana or Persia (Khurasan),
11th century

This is one of three dishes dug up by
peasants at Izgherli in Bulgaria in
1903 and rescued from being melted
down by the French consul at
Philippi. Also found at this site were
gold coins of the Byzantine emperors
Alexis I (1081–1118), John II
(1118–43) and Manuel I (1143–80),
suggesting that the treasure may have
been deposited in about the year
1200. Although there was a flourishing
trade from the Persian world into
Europe during the migration period
in the 9th–10th centuries (witness the
enormous number of Samanid coins
found in Russia and Scandinavia),
objects of a later date are less common.
Where this dish was made is not
certain: the decoration in the centre is
similar to that found on Samarkand
ceramics of the 10th or 11th centuries
and the shape is copied in later bronze
dishes from Transoxiana (eg. no. 185).
A provenance in Transoxiana is most
likely though one in Khurasan should
not be ruled out. The most curious
feature of the decoration of this dish
is the depiction of a nude woman with
arms outstretched in the outer band
of decoration.

Published: Degrand (1903, pl. I),
Migeon (1922a, pl. XXX);
Melikian-Chirvani (1973, pp. 12–13)

161 Dish made of two thin sheets of silver soldered together with incised decoration
Diameter 20cm
David Collection, Copenhagen,
no. 4/1966
Persia, 12th century

The inscription reads
al-iqbāl waʾl-dawla waʾl-karāma
waʾl-shajāʿa waʾl-ʿizz waʾl-baqā
waʾl-sharāfa liṣāḥibihi
'prosperity, wealth, honour,
courage, glory, long life and
nobility to its owner.'
This dish form, like that of no. 159,
has its origin in a Byzantine style. It is
unusual, however, in the manner of
its construction. The decoration is
typical of the 12th century,
particularly in the use of such a bold
kufic script.

Published: Leth (1975, p. 77)

161

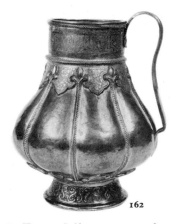

**162 Ewer of silver, repoussé
chased and gilded and inlaid with
niello**
Height 21.5cm, diameter 15.7cm
*State Hermitage Museum,
Leningrad, no. CK-585*
? Persia, Timurid period, late 14th or
early 15th century

Inscription on neck
*al-amir al-ajall al-'ālim
al-muḥtaram al-muqbal shihāb
al dawla wa'l-dīn jamāl
[a] l-islām wa'l-muslimīn . . .
al-mulūk wa'l-salāṭīn sayyid al . . .
Qāsim ibn 'Alī al-m.r.v.*
'The most splendid amir, the
learned, the revered, the
prospering, star of the State and the
Faith, ornament of Islam and the
Muslims . . . of the kings and
sultans, master of the . . . Qāsim
ibn 'Alī of Merv [?]'.
Qāsim ibn 'Alī's name also appears on
a silver bottle in the State Hermitage
Museum, Leningrad, but nothing is
known about this patron. This ewer is
a very late example of a form common
in pre-Mongol Persia (compare
no. 209), though there are too few
surviving objects known to prove an
unbroken artistic tradition.

Published: Samarkand (1969, no. 111)

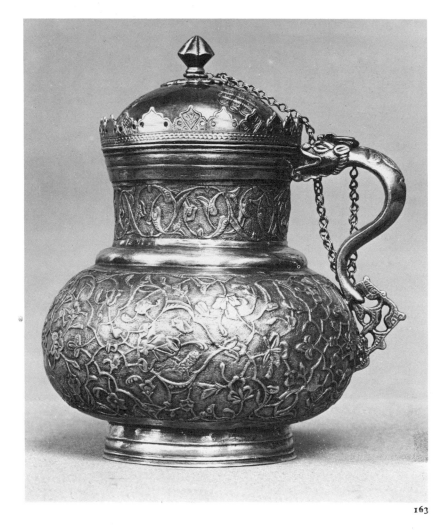

163

163 Jug of silver
Height 16cm, diameter 12.7cm
*Victoria and Albert Museum, London,
no. 158.1894*
Turkey, Ottoman period,
16th century

This splendid jug is based on a shape
common in late Timurid and early
Safavid Persia (compare no. 209), and
it may well have been copied from a
Persian object brought back by the
Ottoman Sultan Selim after his
victory over the Safavids in 1514. The
technique, however, is quite different:
Persian objects were of brass, inlaid
with silver and gold wire, whereas this
Turkish example is made of silver,
cast in relief and then gilded. The lid
is a later addition.

Published: London (1931, pl. 26)

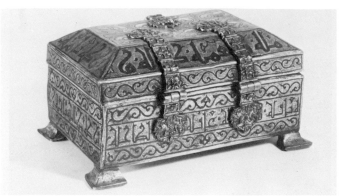

164

164 Casket of silver, incised and inlaid with niello

Length 17.7cm, width 11cm,
height 8cm
*National Archaeological Museum,
Madrid, from the treasury of San
Isidoro, Leon*
Spain, 12th century

Inscription on lid
*wa salāma dā'ima wa 'āfiya
shāmila wa ni'ima kāmila wa baraka
tāmma*
'perpetual well-being, complete
health, perfect favour, entire
blessing'.
Inscription on body
*baraka min allāh tāmma wa salāma
dā'ima [wa 'āfi] ya shāmila wa
ni'ma kāmila wa sa'āda bāqiya wa
[?]iya 'afiya li-ṣāḥibihi*
'entire blessing from God,
perpetual well-being, complete
health, perfect favour, enduring
happiness . . . health to its owner.'
The decorative limitations of solid
silver can be seen by comparing this
casket with that from the Diocesan
Museum, Gerona. In the latter, the
sheets of silver are thin and could be
worked from the back as well as the
front before being applied to the
wood. Here, only frontal work has
been possible and the resulting
design, despite the use of inlay, lacks
a three-dimensional quality. The
hinge and clasp fittings are probably
later additions.

Published: Ríos (1877)

165 Dagger with steel blade and wooden handle, both inlaid with silver, sheath covered in silver, chased, nielloed and partially gilded

Length of grip 11.5cm, length of
blade 18.2cm, length of sheath,
24.3cm
*Badisches Landesmuseum, Karlsruhe,
no. D.269*
Turkey, Ottoman period,
later 17th century

The victory of Don Juan of Austria at
Lepanto in 1571 was the first blow in
the Christian re-conquest of the
eastern European lands occupied by
the Turks. It was not, however, until
the end of the 17th century that the
Turks were finally driven from the
gates of Vienna and Hungary was
returned to the Christian fold. This
dagger, and the axe (no. 166) and
tray (no. 197) were part of the booty
which soon began to accumulate in
the castles and palaces of central
Europe as the Christians advanced.
The finest collections of this booty
are now to be found in Vienna and
Karlsruhe. This dagger illustrates
well the richness of the Ottoman
decorative arts of the period.

Published: Rastatt (1772, no. 108),
Karlsruhe (1955, no. 483, pl. 57),
Petrasch (1970, no. 37)

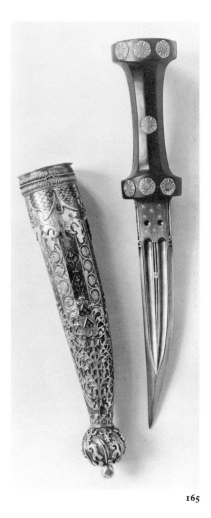

165

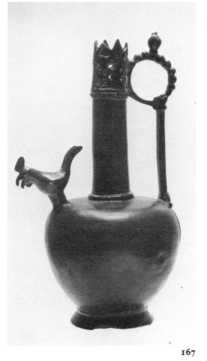

167

166 Battle-axe with damascened steel blade and wooden shaft decorated with silver and niello
Length 69cm
Badisches Landesmuseum, Karlsruhe, no. D 56
Turkey, Ottoman period,
17th century

This axe was first mentioned in an inventory of the Count of Baden Baden in 1691 and is another item from the booty captured from the retreating Turks in the 17th century (compare no. 165). Battle-axes in the Islamic world usually had a half moon-shaped blade of much larger proportions than this example, and the small blade of this axe suggests that it was probably designed for ceremonial use. The hammer-head on the opposite side of the shaft was used in battle for breaking helmets.

Published: Petrasch (1970, no. 41, pls. 40–1)

167 Ewer of cast bronze
Height 35.5cm, diameter 10.5cm
Museum of Islamic Art, Cairo, no. 15241, formerly Harari Collection
? Syria, Umayyad period, 8th century

This globular ewer on a flat base with a straight spout concealed by a cockerel leaning forwards has a long straight neck surmounted by an eight-pointed crown over a band of open-work with crude hachured engraving. The handle is jointed to the neck by a beaded ring crowned by a finial, now broken, but probably in the form of a miniature vase, and has a heart-shaped medallion at the base containing an inverted palmette. The vessel was hollow cast with a joint at the neck. The most famous ewer of this type is the so-called ewer of Marwān II in the Museum of Islamic Art, Cairo, found at the site south of Cairo where this last Umayyad caliph was killed in 750. There are several other examples, mostly distinguished by size and delicacy of engraving, in European and American collections.

Unpublished

168 Lion figure cast in bronze with incised details
Height 29.5cm, length 31cm
Staatliche Kunstsammlungen, Kassel, no. B VIII 115
Egypt or Sicily, Fatimid period,
10th–11th century

Inscription on side of back reads
'amal 'Abd Allāh al-maththāl [?]
'made by 'Abdullāh the sculptor [?].'
This weird-looking creature with its right ear and tail missing may be compared to two other Fatimid lions, one of which is uninscribed and is in the Museum of Islamic Art, Cairo, and the other which is inscribed 'by order of Shams al-Dīn governor of Egypt' in the Museum für Islamische Kunst, Berlin-Dahlem. See Cairo (1969, no. 47) and Berlin-Dahlem (1971a, no. 313). The three examples illustrate the Fatimid fashion of using cast bronze animal forms as aquamaniles or, possibly, as fountain heads.

Published: Schultz (1770, III, p. 371); Sarre and Martin (1912, pl. 154)

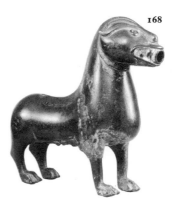

168

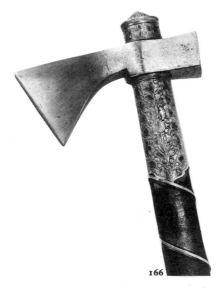

166

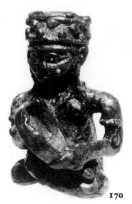

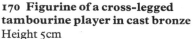

170

171

169 Figurine of a crouched hare in cast bronze
Length 12cm, width 4cm
*Museum of Islamic Art, Cairo,
no. 14487*
Egypt, Fatimid period, 11th century

This hollow cast bronze hare with ears lying flat on its back and panting mouth has a few details emphasised by contouring such as the hind legs, the ears and eyes. One ear has been broken off and two holes have been pierced in the sides. A larger circular hole in the tail appears to be original. The purpose of this bronze is unclear since the animal is too small to have served as an aquamanile.

Published: Cairo (1969, no. 44)

170 Figurine of a cross-legged tambourine player in cast bronze
Height 5cm
*Museum of Islamic Art, Cairo,
no. 6983, found at Fustat*
Egypt, Fatimid period, 11th century

This figurine is modelled in the round and has a flat jewelled head-dress and long plaited tresses hanging down over the shoulders, necklaces, arm bands and bangles at the ankles. The features are particularly finely worked, and the pointed eyes led Wiet to assume that the figurine was Mongol and 13th century in date. However, there is little Mongol cast bronze known and the features of the tambourine player are paralleled on much Fatimid lustre painted pottery showing seated figures (compare no. 276).

Published: Wiet (1930, no. 40); Cairo (1969, no. 46)

171 Lamp-stand of cast bronze
Height 50cm, diameter (base), 32cm
*Museum of Islamic Art, Cairo,
no. 8483, purchased 1929*
Egypt, Fatimid period, 12th century

The inscriptions on the base and on one facet of the shaft are purely benedictory. On the plate is a craftsman's inscription which has been read unsatisfactorily as '*amal ibn al-Makkī*', the work of ibn al-Makkī'. The pair of bold graffiti below this appear to be in pseudo-kufic. The lamp-stand consists of a plate for several lamps of a hollow shaft whose alternate facets of the central section are decorated. Fatimid lamp-stands differ from Persian stands of the 12th century and are never in open-work; however, they both share the technique of piece-casting. Both are heirs to the Roman cast bronze lamp-stands, generally with lion's paws. The persistence of this tradition which is apparent in Islamic bronze-casting up to the 12th–13th centuries, is so far inexplicable, particularly since Roman lamp-stands of this type can never have been common in the east Roman world.

Published: Wiet (1930, no. 42), Mayer (1959, no. 3576); Cairo (1969, no. 48)

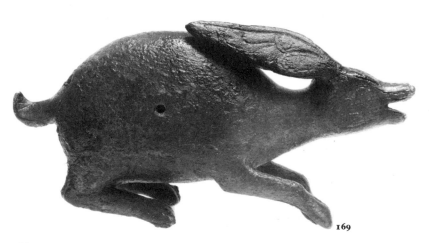

169

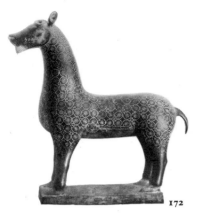

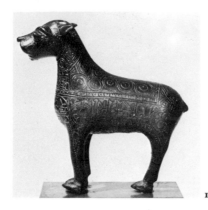

172

173

172 Deer in cast bronze with incised decoration

Archaeological Museum, Province of Cordoba
Spain (probably Cordoba),
Umayyad Caliphate, 10th century

This deer, with horns missing, was found in the ruins of Madinat al-Zahra and then passed into the hands of the monastery of San Jeronimo, where it was seen and recorded by visitors in the late 16th and early 17th centuries. It is a fountain-head, the water rising through the pipe into the hollow pedestal, up the legs into the hollow body, and thence out of the mouth. Such fountain-heads were common in Islamic Spain and one palace at Madinat al-Zahra is known to have had a fountain consisting of a basin with golden statues inlaid with pearls, which was brought specially from Constantinople. The fountain in the Court of the Lions in the Alhambra is a notable stone example. Madinat al-Zahra was the capital of the Cordoban caliphate from 936–1010 and this bronze deer, and another very much like it found in Cordoba and now in the National Archaeological Museum, Madrid, testify to the skill of the Spanish bronze casters during the Caliphate period.

Published: Migeon (1905, p. 454), Pidal (1935, V, pp. 749–50, fig. 585)

173 Deer in bronze cast and incised

Height 12.4cm
Museo Nazionale del Bargello, Florence, no. 326C
Spain, Umayyad Caliphate, 11th century

Inscriptions on body and neck are unread. This deer is a later example of the Spanish cast bronze fountain-head tradition exemplified by the piece from Madinat al-Zahra (see no. 172).

Published: Migeon (1927, I, fig. 186, p. 374); Scerrato (1966, fig. 30)

174 Mortar of bronze, cast and incised

Height 20cm, diameter 20cm
Villanueva y Geltrú Museum, Barcelona
Spain, 11th–12th century

The inscription around the rim is unread. The decoration of this mortar and its flange indicate a Spanish origin and it was found near Palencia. It is very close in form to numerous 11th and 12th century Persian examples. However, the nature of the relationship between Persia and Spain in this context is not clear owing to the scarcity of surviving cast bronze objects from the peninsula. It was through the Islamic world that the cast bronze or brass mortar came to be introduced into medieval Europe where it became such a popular object.

Published: Anonymous (1912); Gómcz Moreno (1951, fig. 394)

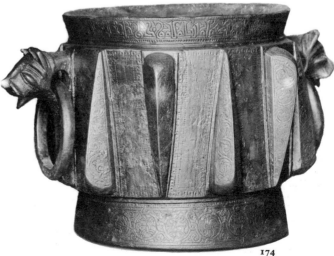

174

175 Lamp of bronze pierced and incised

Height 230cm
National Archaeological Museum, Madrid, from the Alcala de Hènarès
Spain (probably Granada), Nasrid period 1305

Pierced inscription on lamp body and spherical units
> *wa lā ghālib illā Allāh ta ʿālā*
> 'and there is no victor but God, be He exalted.'

Inscription incised on the rim of body, after the basmala
> *ṣalā Allāh ʿalā sayyidnā Muḥammad wa ʾillihi [sic] wa sallama tasliman amara mawlānā al-sulṭān al-aʿlā al-muʾayyad al-manṣūr al-ʿādil al-sayyid muttaʿid al-bilād wa ḥadd sīrat al-ʿadl bayn al-ʿibād amīr Abū ʿAbd Allāh ibn mawlānā amīr al-muslimīn Abū ʿAbd Allāh ibn mawlānā al-Ghālib billāh al-Manṣūr bi-faḍl Allāh amīr al-muslimīn Abī ʿAbd Allāh aʿlā Allāh taʿālā . . . wa kāna dhālika fī shahr rabīʿ al-awwal al-mūbarak min ʿām khansa wa sabʿa miʾa . . .*

'In the name of God, the Merciful, the compassionate, may God bless our master Muḥammad and his family and grant him full salvation. Our lord the sultan, the exalted, the fortified by God, the conqueror, the just, the master, arranger [?] of lands and tracer [?] of the course of justice among God's servants amir Abū ʿAbdullāh son of our lord, amir of the Muslims, Abū ʿAbd Allāh of our lord al-Ghālib billāh [victor in God], victorious through the bounty of God, amir of the Muslims, Abū ʿAbdullāh, may God, be He exalted, exalt . . . and that was in the blessed month of Rabīʾ al-Awwal, in the year seven hundred and five [1305 AD].'

The gaps in the inscription are due to the fact that parts of the rim are missing and that portions of the remaining inscriptions are unintelligible. This lamp, to which glass oil holders would have been fitted, is of a type which was used in western Islam in the 14th and 15th centuries. Early 16th century inventories from Alcala de Hénarès mention various portions of lamps brought from Granada and North Africa at the time of the fall of the last Islamic enclave in the peninsula, the Nasrid kingdom, in 1492. It has been suggested that this lamp is a composite object. However, stylistically it is one. The royal origin of the lamp is clear from both the dedicatory inscription which gives the titles of the third Nasrid ruler, Muḥammad III (1302–9) and the motto of the dynasty, 'there is no victor but God, be He exalted.'

Published: Ríos (1873); Kühnel (1924, pl. 119)

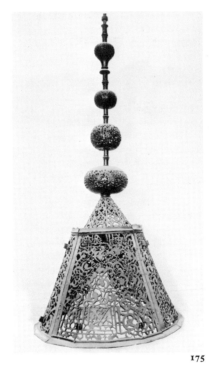

175

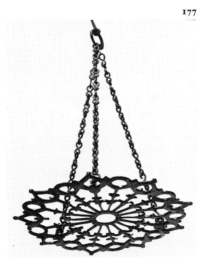

177

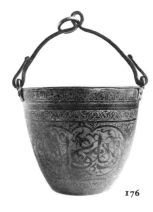

176

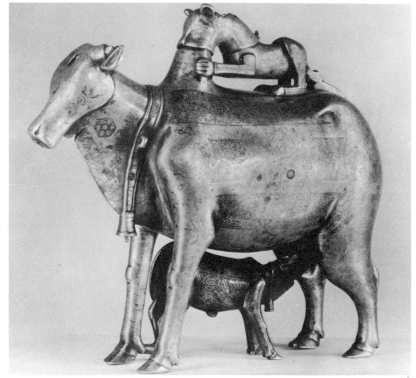

178

176 Bucket of gilded bronze

Height 17cm, diameter 19cm
*National Archaeological Museum,
Madrid*
Spain (probably Granada), Nasrid
period, 14th century

Inscription around rim
 repeat of *al-ghibṭa al-muttaṣila*
 'unceasing felicity.'
Inscription in medallions
 *al-yumn wa'l-iqbāl baraka wa
 bulūgh al-āmāl*
 'good fortune, prosperity, blessing
 and fulfillment of hopes'
Like its Persian counterparts (nos.
179–80) this bucket is based on a
classical prototype. The modification
to the classical design is small
compared to the changes effected by
Khurasani craftsmen, but the result
is pleasing. Indeed, the delicate
arabesque design gives the bucket a
buoyancy and elegance which are rare
among the products of Islamic lands
further east.

Published: Rios (1876): Kühnel (1924,
pl. 118a)

177 Polycandelon of cast bronze

Diameter 30cm
*Museum of the Great Mosque,
Kairouan*
North Africa, 11th century

Compare no. 182.

Published: Marçais and Poinssot (1948–
52, II, fig. 105, p. 451)

178 Aquamanile in cast bronze incised and inlaid with silver

Height 31cm, length 35cm
*State Hermitage Museum, Leningrad,
no. AZ–225*
Persia (Khurasan), 1206

This aquamanile is in the form of a
zebu-cow suckling her calf with a
lion attacking her back. Inscription
on the neck and head of the cow
 *īn gāv va gūsāla va shīr har sih yak
 bārū rīkhta shudast bitawfīq-e
 Yāzdan-e dādgar-e parvardgār
 bi-'amal-e Rūzba ibn Afrīdūn [ibn]
 Barzīn baraka li-ṣāḥibihī Shāh
 Barzīn ibn Afrīdūn ibn [Bar]zīn
 'amal-e 'Alī ibn Muḥammad ibn
 A l bū[sic]al-Qāsim al-naqqāsh
 bi-ta'rīkh-e Muḥarram sana
 thalāth wa sitta mi'a*
 'This cow, calf and lion were all
three cast at one time with the help
of God, the just, the nourisher, by
the labour of Rūzba ibn Afrīdūn
ibn Barzīn Blessing to its owner
Shāh Barzīn ibn Afrīdūn ibn
Barzīn. Work of 'Alī ibn
Muḥammad ibn Abu'l-Qāsim the
decorator. In Muḥarram 603
[1206 AD].'
This is the most distinguished cast
bronze aquamanile from Islamic
Persia known. Its filler hole is in the
lion's neck (the lid is missing), and
the cow's mouth acts as a pourer.
Historically, the importance of the
object lies in the inscription, which
gives details of the two makers, caster
and decorator, as well as the owner
and date. Its main interest, however,
lies in its subject and method of
manufacture. Despite being cast in
one piece, probably by the lost-wax
process, the cow and calf contrast
markedly in form and decoration
with the lion. The former, life-like,
with smooth waxy limbs and with
such details as the eyes omitted,
stand in utter peace despite the
vicious attack of the lion. The form of
the lion, which is out of scale,
suggests a carved wood model and it
is carefully embellished with the
details of eyes and mane. It is
interesting to observe the later efforts
of a religious fanatic to ensure that
the animals were 'dead' by cutting
their throats. There is a picture of
backgammon players on the cow's
right side which may be compared to
that on no. 180. The cow's right ear
and horn are missing.

Published: Dyakonow, (1939,
pp. 45–51); Mayer (1959)

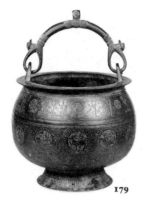

179

179 Bucket of cast bronze incised and inlaid
Diameter 21.3cm, height 18.4cm
*Walters Art Gallery, Baltimore,
no. 54.523*
Persia (Khurasan) or Transoxiana,
12th or early 13th century

The inscriptions on the upper and lower body are unread. Metal buckets occur in the pre-Islamic cultures of the Middle East and it is likely that Islamic buckets are based on the classical prototype of tapering cylindrical form known to have been produced in Egypt. In Persia, the flat-bottomed cylindrical form gave way to a round-bottomed one and then to a bucket with a rounded body, to which a foot was added. This example shows the more angular bulbous body form common in the 12th and early 13th centuries alongside the smoother shape typified by no. 177. The fact that the latter was made in Herat, and the findspots of numerous other examples, indicate that the centres of production were in Khurasan and Transoxiana. Depictions of such buckets in bath-house scenes in later miniature paintings, and the existence of an Ilkhanid piece bearing the name *saṭl* (the word used to describe the type of bucket for carrying hot water in bath-houses) seem to indicate that this was the purpose of all such objects. However, various facts contradict this. It is difficult, for example, to imagine the bucket no. 180 fulfilling its primary purpose in a bath-house, where its owner would not be looking his most regal, and where the damp atmosphere would be extremely detrimental to the bronze of which the bucket is made. Furthermore, the

sheer numbers of such buckets known, and the elaborate decoration and inlays which adorn so many (not a single undecorated piece of this form has yet been published) militate against such a theory. Despite the fact that the top of such a bucket is narrow, a use as an ablutions 'basin' seems more likely.

Published: Pope (1960, pl. 64)

180 Bucket of cast bronze, incised and inlaid with silver and copper, inlay decorated with niello
Height 18cm
*State Hermitage Museum,
Leningrad, no. CA–12687*
Afghanistan (Herat), 1163

Inscription on handle top
*bi-ta'rīkh shahr al-muḥarram sana
tis' wa khamsin wa khams mi'a*
'in the month of Muḥarram [December] in the year 559 [1163 AD].'
Inscription on handle sides
*wa'l-dawla wa'l-sa'āda wa'l-'āfiya
wa'l-niẓāma wa' [sic] wa'l-rāḥa
wa'l-karāma wa'l-tāmma
wa'l-salāma wa'l-baqā*
'wealth, happiness, health, order, ease, honour, entirety, well-being and long life.'
Inscription on top of rim
*farmūdan-e īn khidmat-e 'Abd
al-Raḥmān ibn 'Abd Allāh
al-Rashīdī ḍarb-e Muḥammad ibn
'Abd al-Wāḥid 'amal-e Ḥājib
Mas'ūd ibn Aḥmad al-naqqāsh-e
Harāt li-ṣāḥibihi khwāja 'ajall Rukn
al-Dīn fakhr al-tujjār amīn*

*al-muslimīn zayn al-ḥājj [sic]
wa'l-ḥaramayn Rashīd al-Dīn'
'Azizi ibn Abū al-Ḥusayn
al-Zanjānī dāma 'izzuhu*
'This was ordered by 'Abdul-raḥmān ibn 'Abdullāh al Rashīdī. Muḥammad ibn 'Abd al-Wāḥid cast [sic] it. Ḥājib Mas'ūd ibn Aḥmad, the decorator of Herat, made it for its owner, the most splendid khawāja Rukn al-dīn, pride of the merchants, trusted by the muslims, ornament of the pilgrimage and the two sanctuaries, Rashīd al-dīn 'Azīzī ibn Abū al-Ḥusayn al-Zanjānī, may his glory be perpetual.'
Inscription on upper body
*al-'izz wa'l-iqbāl wa'l-dawla
wa'l-sa'āda wa'l-shafā'a wa'l-dāma
wa'l-salāma wa'l-'āfiya w[a]
l-nuṣra wa'l-shukra wa'l-baqā
li-ṣāḥibihi*
'glory, prosperity, wealth, ease, happiness, [Muḥammad's] intercession, permanence, well-being, health, success, gratitude and long life to its owner.'
Inscription on middle body
*bi'l-yumn wa'l-baraka wa'l-dawla
wa'l-salāma wa'l-sa'āda
wa'l-shafā'a wa'l-tāmma
wa'l-karāma wa'l-shukra wa'l-nāṣir
wa'l-nuṣra wa'l-sa'āda wa'l-ta'yīd
wa'l-rāḥa wa'l-qūwa wa'l-'āfiya
wa'l-niẓāma wa'l-qūwa wa'l-'izza
wa'l-qiyāma wa'l-'aqabiya
wa'l-ni'ma wa'l-dawāma
wa'l-ḥamdiyya wa'l-qādir
wa'l-qisma wa'l-raḥma wa'l-baqā
li-ṣāḥibihi*
'with good fortune, blessing, wealth, well-being, happiness, [Muḥammad's] intercession, entirety, honour, gratitude, victoriousness, success, happiness, [God's] support, ease, strength,

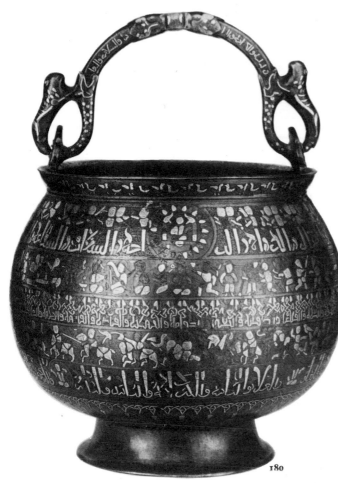

180

181

181 Mortar of cast bronze with incised designs decorated with twelve almond bosses
Height 14.5cm, diameter 16.3cm
State Hermitage Museum, Leningrad, no. CA–12711, formerly Veselovsky Collection
Transoxiana or Khurasan, 11th or 12th century

Inscription in kufic
*al-yumn wa'l-baraka wa'l-ni'ma
wa'l-dawla wa'l-'āfiya . . .
wa'l-salāma wa'l-sa'āda
wa'l-shukra*
'Good fortune, blessing, favour, wealth, health . . . well-being, happiness and gratitude.'

Bronze mortars were unknown to the cultures of the Mediterranean area and the Middle East in pre-Islamic times and were probably developed in Persia in the 10th century as copies of cruder stone objects. Mortars were used for pounding small amounts of food, such as spices or herbs in cookery, and were also an important item of alchemical and pharmaceutical equipment. They were often made of a quaternary alloy consisting of copper and lead with some tin and zinc, known in medieval Persia as *shabah mufragh*. The high lead content allowed an easier casting but gave the objects a softness whose effects are to be seen in the many surviving examples which are mis-shapen through heavy-handed pestle work. They must also have been a rather sinister source of lead poisoning.

Published: Davidovich and Litvinski (1955, p. 113, fig. 57); Pugachenkova and Rempel (1965, fig. 243)

health, order, strength, glory, resurrection, life hereafter, favour, perpetuity, praiseworthiness, power, fortune, mercy and long life to its owner.'
Inscription on lower body
*al-'izz wa'l-iqbāl wa'l-dawla
wa'l-salāma wa'l-sa'āda wa'l-rāḥa
wa'l-shafā'a wa'l-'āfiya
wa'l-shukra wa'l-nuṣra wa'l-'ulūw
wa'l-'alā wa'l-tāmma wa'l-karāma
wa'l-ta'yīd wa'l-nāṣir wa'l-raḥma
wa'l-niẓāma wa'l-dawāma
wa'l-baqā' li-ṣāḥibihi*
'glory, prosperity, wealth, well-being, happiness, ease, [Muḥammad's] intercession, health, gratitude, success, eminence, sublimity, entirety, honour, [God's] support, victoriousness, mercy, order, perpetuity and long life to its owner.'
This bucket is known traditionally as the Bobrinski bucket after an earlier owner and is one of the most celebrated examples of early Islamic metalwork. This fame is due to the

quality of its decoration which comprises a variety of decorated and decorative scripts, and scenes in which figures drink, make music, fight with staves or while away the hours with trick-track (backgammon) and also to the contents of the inscriptions. One inscription in particular (that on the top of the rim) provides important evidence for the role of merchants acting as patrons, as opposed to rulers, and indicates the way in which labour was divided in the bronze industry between castors and decorators both of whom evidently received the same recognition as the creators of the final products. Proof is also found here to bear out a statement of the 13th century cosmographer, al-Qazwīnī, that Herat was a centre of the luxury bronze industry, and this information is further pinpointed to a particular date, December 1163.

Published: Veselovski (1910), Ettinghausen (1943), Mayer (1959, pp. 61–2)

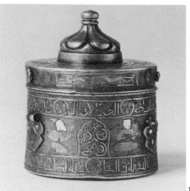

182 Polycandelon of cast bronze to hold six glass lamps, incised and inlaid with copper and silver
Diameter 49.7cm
Walters Art Gallery, Baltimore, no. 54.2363
Persia (Khurasan), Seljuq period, 12th or early 13th century

An inscription on the three bird-headed plaques reads
al-'izz wa'l-iqbāl wa'l-dawla [wa]wa'l-salāma wa'l-sa'āda [wa] wa'l-dawāma wa'l-baqā li-ṣāḥibihi
'glory, prosperity, wealth . . . well-being, happiness . . . perpetuity and long life to its owner.'

Polycandela, as their name implies, are of classical origin and were especially common in the Byzantine world during the 6th and 7th centuries. They continued to be manufactured in Spain, North Africa (see no. 177), Syria and Egypt during the Islamic period and the most elaborate and exotic examples date from late Mamluk times. In Persia, however, they never found popularity and this example is the only one known. Instead of hanging lamps from ceilings, the Persians preferred to place them on stands on the floor. It is interesting to note the projecting birds' heads on the polycandelon. Since these are also found on Persian lampstands, the object may be the product of a lampstand maker's workshop.

Published: Ettinghausen (1957, fig. 38)

183 Inkwell in cast bronze incised and inlaid with copper and silver
Height 9.5cm, diameter 8cm
David Collection, Copenhagen, no. 32/1970
Persia (Khurasan), Seljuq period, 12th or early 13th century

Inscription in cartouches on lid
al-'izz wa'l-iqbāl wa'l-dawla wa'l-sa'ād [sic] wa'l-rāḥa wa'l-baqā li-ṣāḥibihi
'glory, prosperity, wealth, happiness, ease and long life to its owner.'
Inscription in roundels on lid
'amal-i Shāh Malik
'made by Shāh Malik'
Inscription on upper body
al-'izz wa'l-iqbāl wa'l-dawla wa'l-sa-'āda wa'l-rāḥa wa'l-salāma wa'l-raḥma wa'l-baqā li-ṣāḥibihi
'Glory, prosperity, wealth, happiness, ease, well-being, compassion and long life to its owner.'
Inscription on lower body
. . . wa'l-sa'āda wa'l-salāma wa'l-ni'ma wa'l-'āfiya li-ṣāḥibihi
'. . . happiness and well-being and favour and health to its owner.'

Although small bronze inkwells were used by the Romans, glass ones seem to have been preferred in early Islamic times. Large bronze inkwells first appeared in the 11th century and one particular form, of which this is an example, became standard in Mesopotamia and Persia in the 12th century. Two types of ink were used in medieval Islam, one a soluble solid with a soot base known as *midād*, the other a liquid mixture of gallnuts and vitriol called *ḥibr*. Inkwells such as these were intended for the latter ink,

hence their name *miḥbara*. They commonly held a *līq* or piece of ink-soaked felt or wool and were also provided with an inner horizontal rim to prevent spilling, see Levey (1962). Three cords fastened to loop handles on the body and passing through loops on the lid allowed the objects to be safely carried about. Another inkwell made by Shah Malik is known, see Mayer (1959, pp. 87–93). Judging by its decoration, Shah Malik must have worked in Khurasan. Similar inkwells are known signed by craftsmen from such cities as Nishapur and Herat. The decoration of this inkwell employs revellers and animals.

Published: Pope and Ackerman (1938–9, pl. 1311A); Mayer (1959, pp. 82–3, pl. XIII)

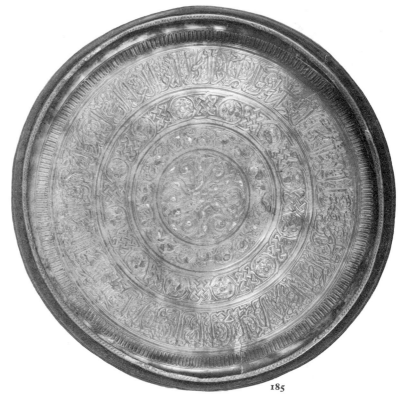

184 Mirror of cast bronze
Diameter 14.7cm
Iraq Museum, Baghdad, no. A 820
Persia, 12th–13th century

Inscription
 baraka wa yumn surūr wa saʿāda
 [wa] salāma wa ʿin [āya] [?] wa
 ʿāfiya wa taʾyīd wa taqdīr wa naṣr
 wa as . . . dāʾima [wa wa] li-ṣāḥibihi
 'Blessing, good fortune, joy,
happiness, well-being, [God's]
sympathy, health, support,
sustenance, victory . . . perpetual . . .
to its owner.'
At least four other mirrors with this
decorative design are known. One
was found at Donsk in the USSR, one
is in the British Museum, London
(no. 66.12-29.75), another is in the
Musée du Louvre, Paris, and a fourth
is in the Institute of Arts, Detroit. See
Krachkovskaya (1960, fig. 2);
Migeon (1922a, pl. 16) and Aga-Oglu
(1931, fig. 1). This example is unique
in having the pair of foxes in the
central area designed to take the
boss-handle: the mirror was
presumably held by a handle
attached to the hole near the rim. The
design appears to be a corruption of
another mirror design with two pairs
of animals in the inner field and this
example may have been cast after
another and better piece, compare
Pope and Ackerman (1938–9,
pl. 1302A). This would account for
the general lack of definition and, in
particular, the corruption of the
inscription due to the mould having
slipped at some point in the casting
process. Mirrors with relief casting
are not found in Persia much before
1100. They were almost certainly
inspired by Chinese mirrors and their
sudden appearance in the 12th
century was due to the uniting of

north China and Mongolia under the
Tartars. This permitted people and
objects to move more freely west-
wards from north China and brought
mirrors to the province of Khurasan,
the heart of the Persian metalworking
industry.

Unpublished

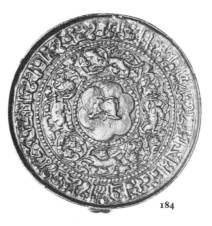

184

**185 Dish of bronze, incised and
inlaid with copper and silver**
Height 9.2cm, diameter 37cm
*University of Michigan Museum of
Art, no. 1959/1.110, purchased from
the Heeramaneck Galleries in 1959*
Transoxiana, 12th or early
13th century

Inscription on interior
 al-ʿizz al-daʾim waʾl-iqbūl waʾl
 dawla waʾl-ifḍāl waʾl-izdāl [?]
 waʾl-qadr waʾl-kamāl waʾl-faṣāḥa
 waʾl-maqāl waʾl-baq [ā]
 'perpetual glory, prosperity,
wealth, excellence, cessation of
suffering [?], status, perfection,
eloquence, fluency and long life [?].'
Inscription on exterior unread.
Other examples of this type of dish
are in the Victoria and Albert
Museum, London (no. M.31-1954),
in the Musée du Louvre, Paris (no.
3369) and two found in Semirechye in
Central Asia. See Grohmann (1963),
Melikian-Chirvani (1973, pp. 38–9),
Bernshtam (1952, p. 176) and
no. 187.

Published: Ettinghausen (1957,
figs. 28–30)

185

186

186 Mace-head in cast bronze, originally gilded

Height 7.4cm, diameter 9.2cm
British Museum, London,
no. 838–89
Persia, 11th–13th century

It is difficult to find any parallels for the pairs of lions with raised left paws which form the six blades of this mace-head and any attribution is bound to be conjectural. However, with its original gilding and set upon a sturdy metal handle, this mace-head must have been an impressive item of regalia, perhaps the proud possession of a provincial governor or petty ruler.

Unpublished

187 Dish of bronze incised and inlaid with silver

Diameter 33cm
Iran Bastan Museum, Tehran,
no. 3495
Transoxiana or Khurasan, late 12th–early 13th century

Inscription around centre has a repitition of *wa'l-baraka*, 'and blessing.' The main inscription
al-'izz wa'l-ḥamd wa'l-thanā
wa'l-jūd wa'l-sakhā wa'l-birr
wa'l-'aṭā wa'l-rīf'a wa'l-'ulā
wa'l-lutf wa'l-ridā wa'l-'ilm
wa'l-wafā' wa'l-ḥilm wa'l-ḥayā'
wa'l-shukra wa'l-jazā' wa'l-baraka
li-ṣāḥibihi
'glory, praise, commendation, generosity, liberality, piety, munificence, superiority, sublimity, God's grace and his approval, learning and faithfulness, forbearance and modesty, gratitude, just recompense and blessing to its owner.'

187

This dish and no. 185, though never analysed, are probably made of high tin bronze – an alloy of copper and about 20 per cent tin. This alloy was known in early Islamic times as *asfidroy*, literally 'white copper' or 'white bronze', and was used for bowls, stem bowls, dishes, ewers and candlesticks. Amongst the particular properties of high tin bronze is that it can be red-hot forged, like iron, and if quenched becomes reasonably malleable when cold. If permitted to cool slowly then hammered, it shatters. Three centres of high tin bronze manufacture are recorded in Islamic texts of the 10th–11th centuries: these are Rabinjan near Bukhara, Hamadan in western Persia and Sistan province in eastern Persia. Of the Hamadan industry, nothing more is known, but the products of 11th century Sistan indicate that this province depended upon Transoxiana for its inspiration. In the 12th and 13th centuries Khurasan became an important manufacturing centre and the stem bowls produced there are amongst the finest Islamic metal objects (example, the Vaso Vescovali in the British Museum, London). Transoxiana continued to produce high tin bronze objects in this later period, but of less originality. They may be distinguished from the products of Khurasan by the almost three-dimensional effect of much of the decoration, by the unusual motifs and designs used, including interlace and knot patterns and floral designs, and by the uncommon vocabulary of the inscriptions. Some examples are characterized by unusual inlays.

Published: Melikian-Chirvani (1974, pp. 42–5, figs. 13–5)

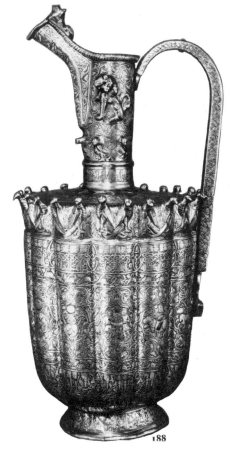
188

188 Ewer of brass, incised and inlaid with silver

Height 40cm
British Museum, London,
no. 48 8–5 2
Persia (Khurasan), late 12th or early 13th century

Inscription on neck
*bi'l-yumn wa'l-baraka wa'l-dawla
wa'l-'āfiya wa'l-qā [dira] [wa']
l-dawāma wa'l-karāma li-sā
[ḥibihi]*
'with good fortune, blessing, wealth, health, power, perpetuity and honour to its owner.'

Inscription on shoulder
*al-'izz wa'l-baqā wa'l-midḥa
wa'l-thanā' wa'l-rif'a wa'l-'ulā
wa'l-'āfiya wa'l-sanā' wa'l-birr
wa'l-'aṭā li-ṣāḥibihi abadan*
'glory, long life, praise, commendation, superiority, sublimity, health, brilliance, piety and munificence to its owner for ever.'

Inscription on upper body
*bil-yumn wa'l baraka wa'l-dawla
wa'l-sarwa wa'l-tāmma
wa'l-sa'āda wa'l-'āfiya wa'l-'ināya
wa'l-qinā'a wa'l-qādira wa'l-qudra
wa'l-dawāma liṣāḥibihi*
'with good fortune, blessing, wealth, magnanimity, entirety, happiness, health, [God's] sympathy, contentment, power, potency and perpetuity to its owner.'

Inscription on lower body
*al-'izz wa'l-iqbāl wa'l- dawāma
wa'l-qādira wa'l-nāṣira wa'l-nuṣra
wa'l-sa'āda wa'l-qinā'a
wa'l-'āfiya wa'l-ziyāḍa [?]
wa'l-baqā dā'im*
'glory, prosperity, perpetuity, victoriousness, success, happiness, contentment, health, abundance and long life perpetual.'

Inscription on foot
*bil-yumn wa'l-baraka wa'l-dawla
wa'l-sarwa wa'l-tāmma
wa'l-'āfiya wa'l-'ināya wa'l-qinā'a
wa'l-qādira wa'l-qudra wa'l-dawla*
'with good fortune, blessing, wealth, magnanimity, entirety, health, [God's] sympathy, contentment, power, potency and wealth.'

In pre-Mongol Persia most fine objects were made of a cast copper alloy. However, in Khurasan in the 12th and early 13th centuries, there existed a workshop evidently devoted to the production of quality objects made of sheet metal, usually brass. This ewer is one of the finest surviving pieces; its quality is seen not only in the sumptuousness of its decoration, but also in the skill with which the shape of the vessel has been created. The ewer was made in a number of different parts and then soldered together. The most outstanding examples of the craftsmen's technical ability are the birds which project from the shoulder and neck; these are repoussé, being almost entirely worked from the back using a tool

known as a snarling iron. This ewer is one of a fairly large extant group (compare no. 191) some of which are simply cylindrical in shape, having flat or slightly concave faces, while others, like this example, are fluted. The whole aim of the decoration is apparently to bring good luck to the owner of the object. The inscriptions state this quite clearly and the lions, birds, fish (on the inner shoulder) and peacocks (on the lower body) probably symbolise this through the qualities associated with them in the folklore tradition. The medallions on the body give astrological expression to the same ideas by presenting the planets in their domicilia – the Sun in Leo, the Moon in Cancer, Mercury in Gemini, Venus in Taurus, Mars in Aries, Jupiter (on the handle base) in Pisces, Saturn in Aquarius, Saturn in Capricorn, the planetary eclipse (see no. 194) in Sagittarius, Mars in Scorpio, Venus in Libra and Mercury in Virgo.

Published: Lanci (1845, II, pp. 63–4, pls. XXIX–XXX); Barrett (1949, pls. 6–7)

190

189 Vase of beaten bronze, incised and inlaid with silver

Height 16.3cm, diameter 12.8cm
*Walters Art Gallery, Baltimore,
no. 54.453, formerly in the Peytel
Collection, Paris*
Persia (Khurasan), 12th or early 13th
century

Inscription around neck
*al-'izz wa'l-iqbāl wa'l-dawla
wa'l-qinā'a wa'l-'izz [wa'l-shafā] 'a
wa'l-ni'ma wa'l-baqā dā'im*
'glory, prosperity, wealth,
contentment, glory, [Muḥammad's
intercession], favour and long life,
perpetual.'
Inscription around body
*al-naṣr wa'l-baraka wa'l-dawāla
wa'l-salāma wa'l- ? wa'l-iq [b] āl
wa'l-'? wa'l- ? wa'l-shukr
wa'l-dawāma wa'l- ? wa'l-shafā'a
wa'l-baqā dā'iman*
'victory, blessing, ascendancy,
well-being, prosperity, ?, ?,
gratitude, perpetuity, ?
Muḥammad's intercession and
long life always.'

189

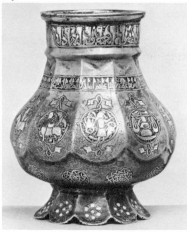

Round mouthed jug forms in bronze
are comparatively rare in early
Islamic Persia and were the particular
products of the silver and goldsmiths.
In the 12th century, however, the
great Persian school of bronze and
brass sheetmetal workers, probably
centered in Herat, started to produce
objects based on precious metal
styles. (The most exotic jug of this
type is in the British Museum,
London.) On this example the
spacing and forms of the decoration
add greatly to the balance of the
object, and the technique and
artistry of the metalworker and
inlayer complement each other in an
unusual way. The handle is missing.

Published: Pope and Ackerman (1938–9,
pl. 1317A)

190 Table-top of brass, beaten, incised and inlaid with copper and silver

Width 21.8cm, length 35cm
*Walters Art Gallery, Baltimore,
no. 54.530, acquired from the Kelikian
Collection, Paris, in 1930*
Persia (Khurasan), late 12th–early
13th century

Inscription on rim
*al-'izz wa'l-iqbāl wa'l-dawla
wa'l-sa'āda wa'l-ta'yid
wa'l-tāmma wa'l-salāma
wa'l-shafā'a wa'l-dawāmā
wa'l-kifāya wa'l-karāma
wa'l-sakāna [?] wa'l-shukr
wa'l-s [iy] āda [?] wa'l-naṣr
wa'l-nāṣir wa'l-rif'a wa'l-rāfi'a
wa'l-raḥma wa'l-rāḥa
wa'l-'āfiya wa'l-ni'ma wa'l-qadr
wa'l-qād [ir] wa'l-'ināya
wa'l-amān wa'l-iḥsān wa'l-baqā
[wa'] l-thanā dā'im li-ṣāḥibihi*

'Glory, prosperity, wealth,
happiness, [God's] support,
entirety, well-being,
[Muḥammad's] intercession,
perpetuity, sufficiency, honour,
tranquility [? for sakina],
gratitude, mastery, victory,
victoriousness, superiority,
elevation, mercy, ease, health,
favour, potency, power, [God's]
sympathy, safety, charity, long life
and perpetual commendation to its
owner.'

Made of thin sheet metal, with an
undecorated roughly finished reverse,
the edges turned back, this object was
probably designed to be a top for a
small table. Low tables or
tabourettes made of pottery are
common survivals from 12th and
13th century Syria and Persia, and
were often designed as stands for
wine-beakers. With its inset centre,
this metal top would have been
suitable for sweet-meats, nuts or
other choice foods, and would have
fulfilled an important function in the
typically floor-orientated social
gatherings of the medieval Islamic
world.

Published: Ettinghausen (1957, figs. 31,
33–4)

192

191

193

191 Ewer of beaten brass incised and inlaid with silver and copper
Height 44.8cm, diameter 19cm
Galleria Estense, Modena, no. 6921
Persia (Khurasan), 12th or early 13th century

Inscriptions are unread. This ewer is of a type common in Khurasan prior to the Mongol invasions (compare no. 188). It is an outstanding example of this group because of its extraordinary repoussé figures – the harpies around the shoulder with their curious hats and the mounted falconer on the neck with his animal-mask face. The hippo-like beast with its young and the lid on which they recline are probably not original, judging by the decoration around the lower part of the lid.

Published: Scerrato (1966, pls. 24–6)

192 Bowl of bronze, cast, incised and inlaid with silver
Height 10cm, diameter 20.5cm
Museo Civico Medievale, Bologna, no. 2128
North-west Persia, 1210–59

Inscription around outside
mimmā 'umila bi-rasm al-amīr al-kabīr al-'ālim al-zāhid al-'ābid al-warī' zayn al-hajj [sic] kahf al-ghuraba 'umdat al-mulūk wa'l-salā:ʼn Najm al-Dīn 'Umar al-Maliki al-Badri
'One of the things made for the great amir, the learned, abstemious, devout, godly, ornament of the pilgrimage, refuge of strangers, prop of kings and sultans, Najm al-Dīn 'Umar [officer of] al-Malik al-Badr.

Inscription around foot
al'izz al-dā'im wa'l-'amr al-sālim wa'l-dahr al-sālim wa'l-iqbāl al-zā'id wa'l-jadd al-ṣā'id wa'l-dahr al-musā'id wa'l-amr wa'l-baqā' li-ṣāḥibihi
'perpetual glory, secure life, secure existence, exceeding prosperity, rising good luck, favourable existence, authority and long life to its owner.'
The inscription on this bowl indicates that its owner was an officer of Badr al-Dīn Lu'lu', ruler of Mosul 1218–59 (compare no. 197). Rice has suggested that this bowl was produced in Mosul but it seems more likely that it was manufactured in north-west Persia, perhaps Tabriz, as a special order for Najm al-Dīn 'Umar. It is one of a series of bowls cast after north Persian ceramic forms which may stylistically and technically be associated with a notable group of north-western Persian cast bronze candlesticks. The workshops manufacturing these objects produced a great variety of candlesticks as well as superb stem-bowls and inkwells. Indeed, the bronze casters of these 13th and early 14th century objects were undoubtedly the most original and creative in the history of early Islamic Persia, utilising and adapting shapes from a variety of sources to produce new styles of great strength and character.

Published: Lanci (1845, II, pp. 124–5, pls. XL–XLI); Rice (1953a, pp. 232–8, pls. III–VIII)

193 Pen-box of brass, beaten, incised and inlaid with silver and gold
Length 25cm, height 4cm
Walters Art Gallery, Baltimore, no. 54.509
North-west Persia, 12th–13th century

The inscription around the sides is unread. This pen-box is a composite piece. The cover for the small compartments is much later than the rest of the object and the body cover, with horsemen and swastika pattern, is probably 13th century north Mesopotamian work. The body itself has a plaited kufic inscription of a style unparalleled on other metal objects but similar to that of two inscriptions on 12th-century tomb towers at Maragheh in Azerbaijan and an inscription on a 12th century mosque in Mosul. Hence the likelihood of this pen-box being a 12th century north-west Persian product. The shape of the box is common in this period in Khurasan and was probably designed so that it could be placed in a belt. Pen-boxes continued to be carried in this way in Ottoman lands until modern times.

Published: Pope and Ackerman (1938–9, pl. 1333B)

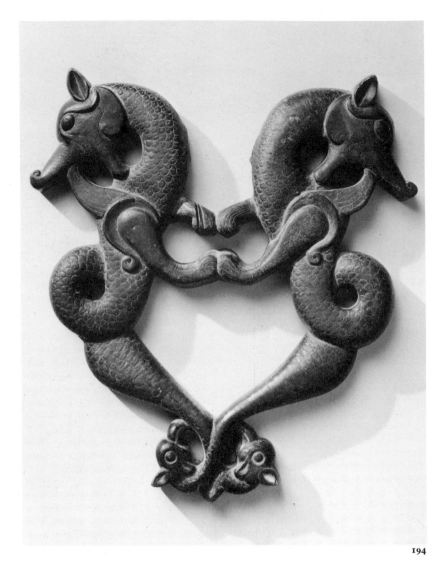

194

194 Door-knocker in the form of two winged dragons with bird-heads as tails

Height 28cm, width 24.5cm
*David Collection, Copenhagen,
no. 38/1973*
Northern Mesopotamia, Seljuq
period, late 12th or early 13th century

This cast bronze door-knocker with incised decoration is one of a pair which was attached to the doors of the Ulu Çami in Cisre, Turkey. The other is now in the Museum für Islamische Kunst, Berlin-Dahlem. The knocker is notable not only for its beautiful design but also for its planetary symbolism. In the astronomical iconography of medieval Islam the dragon represents

the planetary eclipse, and the knot – here merely a loop – the node of the orbit of the moon. Although the dragon was never a planet it was accorded planetary status and came to have an astrological and talismanic significance. See Hartner (1938). The most celebrated example of its use in the latter context is on the Seljuq Talisman Gate at Baghdad. Thus the dragon door-knocker was both an adornment and a protection for the building on which it was hung. When that building was a mosque, astrology and religion were brought together much as occured in medieval Christian Europe.

Published: Leth (1975, p. 69)

195 Ewer of brass incised and inlaid with silver

Height 38.1cm, diameter 20.6cm
*Cleveland Museum of Art, no. 56.11,
purchase from the John L. Severance
Fund*
Northern Mesopotamia, dated 1223

Inscription on neck
'amal Aḥmad al-Dhakī al-naqqāsh
al-Mawṣilī fī sana 'ishrīn wa sitta
mi'a wa'l-'izz li-ṣāḥibihi
'made by Aḥmad al-Dhakī, the
decorator, of Mosul in the year
602 [1223 AD] and glory to my
owner.'
Inscription at handle base
'amal Aḥmad al-Dhakī al-Mawṣilī
'made by Aḥmad al-Dhakī of
Mosul.'
Two graffiti of later owners on the neck read *Husayn ibn Qāsim* and *Ustā al-Muḥtasib*. The inscription on the shoulder is corrupt and evidently designed as ornament. Two other inlaid objects made by Aḥmad al-Dhakī are known to have survived, a basin in the Musée du Louvre, Paris, and another ewer in a private collection. This is the earliest of the three and one of the earliest objects signed by a Mosul artist. Although areas of the inlay are missing this ewer remains one of the finest surviving objects from 13th century Mesopotamia or Syria. It is also one of the most interesting, particularly in the scenes of everyday life which are contained within large medallions which adorn the body. Beginning to the left of the handle and proceeding clockwise: a man digs under a tree while a horseman shoots a bird, two men shoot birds in a tree, a camel rider presents a bouquet to another, a man ploughs with two oxen, a seated figure with mirror and two

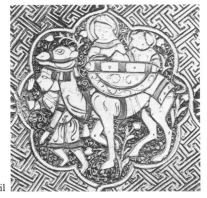

196 detail

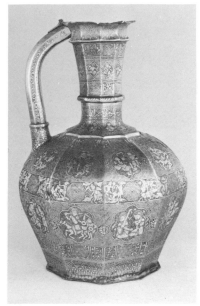

196

attendants, a flute-playing shepherd with goats and dog, a harpist and a flautist, a man grazing a donkey near a peacock, a youth on a couch with attendants, a drinker and a man shooting a bird with a blow-pipe. The smaller medallions illustrate various hunters, riders and musicians while the neck and shoulder bear scenes showing an enthroned figure with attendants in an outdoor setting. These varied scenes give a delightful vision of the courtly life, open air sports, activities and labours of the time. The lid, upper neck ring, lower part of spout and its plaque, and base are all later additions.

Published: Rice (1957a, pp. 287–301)

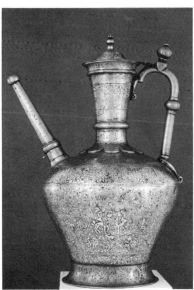

195

196 Ewer of beaten brass incised and inlaid with silver and copper
Height 30.4cm
British Museum, London
no. 66 12–69 61
Mesopotamia (Mosul), 1232

Inscriptions on the upper neck, middle neck and handle base are evidently intended as good wishes to the owner, but are all corrupt.
Inscription on the lower neck
 naqsh Shujāʿ bin Manʿa al-Mawṣilī fī shahr Allāh al-mubārak shahr Rajab fī sana tisʿ wa ʿishrīn wa sitta miʾa biʾl-Mawṣil
 'decoration by Shujāʾ ibn Manʿa of Mosul, in the month blessed by God, the month of Rajab in the year 629 [1232 AD] at Mosul.'
Inscription on shoulder which is corrupt in places
 al-ʿizz waʾl-baqā waʾl-raḥa waʾl-ʿināya waʾl-baraku waʾl ʿāfiya waʾl-ghibṭ waʾl-dawla waʾl-sulāma waʾl-ʿā[fiya] dāʾiman
 'glory, long life, ease, [God's] sympathy, blessing, health, felicity, wealth, well-being and health always.'
Inscription on lower body
 al-ʿizz waʾl-baqā waʾl-rāḥa waʾl-waqār waʾl-ʿiṣma [wa]ʾl-baraka waʾl-salāma waʾl-ʿāfiya waʾl-waqār waʾl-ghibṭa waʾl-naṣr ʿalā al-aʿdā waʾl-rifʿa waʾl-ri-ʿāya ab [ādan] li-ṣāḥibihi
 'glory, long life, ease, gravity, virtue, blessing, well-being, health, gravity, felicity, victory, over enemies, superiority and [God's] protection for ever for its owner.'

The fame of this ewer rests in its inscription which gives not only the name of the decorator and the date, but also the name of the city, Mosul, where the ewer was made. It is the only north Mesopotamian object whose provenance is known for certain and therefore forms an important item of evidence for the history of the medieval Islamic metalworking industry. With the addition of a straight spout and substantial foot, the shape would be typical of northern Mesopotamian taste for this period, very similar to no. 195. The scenes in the medallions on the body are not as original as those on this other ewer and are largely of hunting, fighting and court scenes. However, the conception and workmanship have produced here designs which are positive, bold and well-structured. There are also such subtleties as the curvilinear structure of the background pattern of the shoulder which prevents monotony. The central band of horseman and animals may contain another inscription though only an odd letter may be made out, the ingenuity of the artist having prevented it being deciphered. The spout of the ewer is missing and the base is a replacement.

Published: Reinaud (1828, II, pp. 423–39); Lane-Poole (1886, pp. 170–1); Pope and Ackerman (1938–9, pls. 1329–30)

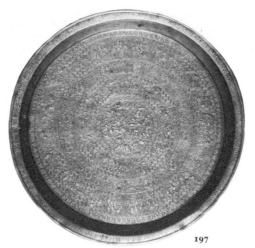

197

197 Tray of beaten brass incised and inlaid with silver
Diameter 62cm
Staatliches Museum für Völkerkunde,
Munich, no. 26–N–118
Northern Mesopotamia (Mosul),
1223–59

Inscription around rim
'izz li-mawlānā al-sulṭān al-Malik
al-Raḥim al-'ālim al-'ādil
al-mujāhid al-murābiṭ al-mu'ayyad
al-muẓaffar al-manṣūr Badr
al-dunyā wa'l-dīn sayyid
al-mulūk wa'l-salāṭīn muhyi
al'adl fī'l-ālamin sulṭān al-islām
wa'l-muslimin munṣif al-maẓlūmin
min al-ẓālimin nāṣir al-haqq
bi'l-barāhin qātil al-kufarā
wa'l-mushrikin qāhir al-khawārij
wa'l-mutamarridīn ḥāmi al-thughūr
bilād al-muslimin mu'in al-ghuẓā
wa'l-mujāhidīn abū al-yatāmā
wa'l-masākin fakhr al-'ibād māhi
al-baghyi wa'l-'inād falak
al-ma'āli qasim al-dawla nāṣir
al-milla jalāl al-'umma ṣafwat
al-khilāfa al-mu'azzama
bahlawān-e jahān khusraw-ye
Irān alb ghāzī inānaj qutlugh Bek
ajall al-mulūk al-sharq wa'l-gharb
Abū al-Faḍā'il Lu'lu ḥusām amir
al-mu'minin
'Glory to our lord the sultan al-
Malik al-Raḥīm, the learned, the
just, the holy warrior, the defender,
the fortified by God, the
triumphant, the victorious, Badr
al-Dunyā wa'l-Dīn, master of kings
and sultans, reviver of justice in the
words, sultan of Islam and the
Muslims, righting the oppressed
against the oppressors, giving
victory to the truth with proofs,
slayer of infidels and polytheists,
vanquisher of heretics and rebels,
guardian of the borders of the

Muslim lands, succour of
conquerors and holy warriors,
father of orphans and the poor,
pride of God's servants, remover of
injustice and obduracy [to God],
summit of dignities, partner in the
state, giving victory to the
[Muslim] community, splendour
of the nation [of Islam], flower of
the august caliphate, hero of the
world, monarch of Iran, the hero
[Turkish appelation], the
conqueror Īnānaj Qutlugh Bek,
most splendid of the kings of east
and west, Abu'l-Faḍā'il Lu'lu',
sword-blade of the commander of
the faithful.'
Inscription on inner side
Muḥammad ibn 'Isūn
'Muḥammad son of 'Isūn'
Inscriptions on the back
mimmā'amara bi-'amalihi al-faqir
Lu'lu' 'aḥsana Allāh jazā'ahu
bi-rasm al-khātūn al-maṣūna
Khawānrāh
'One of the things which the lowly
Lu-Lu [may God reward him well]
ordered to be made [or possibly,
was ordered [to make] for the
virtuous lady Khawānrāh.'
al-Ḥasan ibn 'Isūn
'al-Ḥasan, son of 'Isūn'
al-'abd al-dhalīl Aybek al-Ṭawīl
'the humble slave Aybek al-Ṭawīl.'
bi-rasm sharābkhāna al-badrī
'for the buttery of Badr al-dunya
wa'l-dīn.'

This tray is part of the loot taken from
the Turks at Bude in 1686 by the
Elector of Bavaria, Max Emmanuel,
and is one of four known surviving
objects made for the household of
Badr al-dunyā wa'l-dīn Lu'lu, ruler
of Mosul from 1218–59. Almost
certainly, this tray was made in
Mosul itself and bears witness to the
rich skill of metalworkers in that city
at this period. It probably dates from
the second half of Badr al-dīn's reign
since he only adopted the title
al-Malik al-Raḥīm in 1233. Evidently
commissioned for a princess, it then
found its way into the royal buttery
where it doubtless was used to serve
food to the prince and his courtiers.
The four inner medallions contain a
variety of figures including four
planets: the sun with disc-like head,
the moon with crescent, Mercury in
a seated posture, and Venus with
lute. Twenty-four outer medallions
are decorated with scenes such as a
falconer, men fighting lions, unicorns
or other mythical bird-cum-beasts,
fighting foot-soldiers, boxers,
wrestlers, drinkers, musicians,
dancers, a pair of rams, a pair of
camels and a lion attacking a bull. The
warlike character of both titles and
depictions contrasts curiously with
the fact that this object was made for
a princess and that Badr al-dīn
himself was notable for his policy of
placation rather than resistance in the
face of Mongol invasion.

Published: Flügel (1830, taf. 145);
Sarre and van Berchem (1907);
Sarre and Martin (1912, no. 3060)

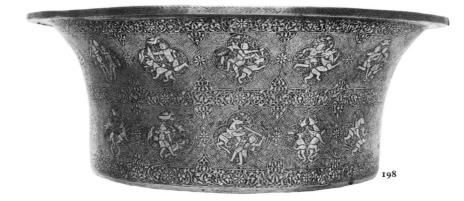

198

198 Basin of brass, incised and inlaid with silver
Height 19cm, diameter 47.2cm
Musée du Louvre, Paris, no. 5991
Syria, Ayyubid period, 1238–40

Inscription on rim
*'izz li-mawlānā al-sulṭān al-malik
al-mālik al-'alim al-'āmil
al-mu'ayyad al-muẓaffar
al-manṣūr al-mujāhid al-murābiṭ
sayf al-dunyā wa'l-dīn 'aḍud
al-islām wa'l-muslimin qāmi'
al-kafara wa'l-mushrikin qātil
al-mutamarridin muḥyi ul-'adl
fī'l-'ālamin nāṣir al-ḥaqq
bi'l-barāhin ḥāmi thughūr bilād
al-muslimin munṣif al-maẓlūmin
min al-ẓalimin abu'l-yatāmā
wa'l-masākin 'imād al-khilāfa
qasim al-mamlaka rukn al-umma
nāṣir al-milla falak al-mu'ālī quṭb
al-salāṭin muhlik ul-mulḥidin
mujammir al-mujahidīn mālik
al-riqāb al-umam sulṭān al-'arab
wa'l-'ajam bahlawān al-shām
malik al-'irāq awḥad al-'aṣr
al-mu'ayyad bu'l-naṣr ḥami
al-thughūr bi'l-ṭa'an fī al-thughar
abū'l-manā'iḥ muṣaddiq al-madā'iḥ
al-Malik al-'Ādil Abī Bakr ibn
mawlānā al-sulṭān al-Malik
al-Kāmil Abī al-Ma'ālī Muḥammad
ibn Abī Bakr ibn Ayyūb 'azza
naṣruhu*
'Glory to our Lord, the sultan, the king, the possessing, the learned, the diligent, the fortified by God, the triumphant, the victorious, the holy warrior, the defender, the sword of the world and religion (*sayf al-dunyā wa'l-dīn*), right arm of Islam and the Muslims, subduer of infidels and polytheists, slayer of rebels, reviver of justice in the worlds, giving victory to the truth with proofs, guardian of the borders of the Muslim lands, rightor of the oppressed against the oppressors, father of orphans and the poor, buttress of the caliphate, partner in the kingdom, pillar of the [Muslim] nation giving victory to the [Muslim] community, summit of dignities, pole-star of sultans, destroyer of atheists, musterer of holy warriors, dominant over the nations, sultan of the Arabs and Persians, hero of Syria, king of Iraq, unique of the age, fortified by God with victory, guardian of the borders by assailing the marauders, father of gifts, bestower of praises, al-Malik al'Ādil, Abū Bakr, son of our lord the sultan al-Malik al-Kāmil Abū al-Ma'ālī Muḥammad ibn Abī Bakr ibn Ayyūb, may his victory be glorified.'

Inscription in cartouche on outside
'amal Aḥmad ibn 'Umar al-ma'rūf bi'l-Dhaki al-naqqash
'work of Aḥmad ibn 'Umar, known as al-Dhakī, the decorator.'

Inscriptions on base
bi-rasm al-ṭishtkhāna al-'ādiliyya
'for the servery of [al-Malik] al-'Ādil'
al-Ḥusayn ibn Muḥammad ibn Aḥmad ibn amir al-mu'minin 1089
al-Ḥusayn ibn Muḥammad ibn Aḥmad, son of the Commander of the Faithful, 1089 [1678–9 AD].'
Inscriptions inside the base are corrupt, though occasional words of good wishes are recognisable. They were probably intended only for ornamental purposes. Ewers and basins (Arabic *ibriq* and *ṭisht*) were used in medieval Islam for the washing of hands before and after meals. Since this would occur at least three times each day, and in the houses of the great, important guests might also be present, ewers and basins were often the most highly valued and richly decorated objects in the household. This particular basin was the prized possession of the Ayyubid sultan of Egypt and Sultan, al-Malik al-Ādil (1238–40) and was made for him by the craftsman responsible for the ewer no. 195 Aḥmad ibn 'Umar al-Dhakī of Mosul. The style of decoration on these two objects somewhat differs, but Aḥmad's ability is clearly demonstrated in the figural compositions. Those on the inside, sadly effaced, are of hunting scenes of great originality. Here, size, foreshortening and movement of the figures and the vegetation all combine to give a feeling of depth which is most unusual in the Islamic art of the period. The beautifully inlaid and preserved figural compositions on the outside of the basin are mainly scenes of hunting, fighting and mythical themes and they may be compared to those on the tray ordered from an unknown craftsman by Badr al-Dīn Lu'lu' (see no. 197). The superior quality of the work on this basin is exemplified in the medallion showing a dynamic composition of two wrestlers (just above the inscription naming the craftsman and to the right).

Published: Jacquemart (1869, p. 324); Rice (1957a, pp. 301–11, pls. 6–9, 15e–g); Paris (1971, no. 150)

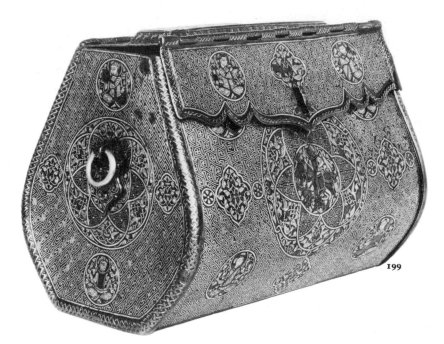

199

199 Wallet of brass incised and inlaid with silver and gold

Height 15cm, length 21.6cm
Courtauld Institute of Art, London, Gambier Parry collection, no. 96
Northern Mesopotamia,
mid-13th century

Inscription on lid
*al-'izz wa'l-iqbāl wa'l-ni'ma
wa'l-ifḍāl wa [a] bulūgh al-āmāl wa
ṣalāḥ al-a'māl wa'l-ikrām [wa]
'l-iḥlāl wa'l-iḥsān wa'l-ijmāl
wa'l-dawla malār [?] [wa'l]
wa'l-sa'āda wa['l]'l-ifḍāl
wa'l-yum[ā]n wa'l-Kamāl wa'l-*
'glory, prosperity, favour,
excellence, fulfillment of hopes,
righteousness, respect, safe return
from pilgrimage, charity,
benevolence, wealth [?],
happiness, excellence, good
fortune, perfection and . . .'

This is a unique and remarkable object which was evidently intended to represent a leather wallet such as might have held the documents and seals of a prince. Such a wallet is indeed depicted in the scene on the top of the lid where it is to be found slung over the shoulder of the fourth figure from the right who also holds a mirror. The three figures next to him hold a mace, bottle and lute while at the other end of the scene drinks are prepared and offered to the seated ruler and his consort. Together with details of clothing, including headgear, this scene provides a fascinating view of a court group of the period. While the style of decoration is typical of northern Mesopotamian work in the mid-13th century, the figures and their clothing, especially in the rendering of drapery, are more akin to early 14th century work such as is found on the famous Baptistère de St Louis in the Musée du Louvre, Paris. In a sense, therefore, this object provides a bridge between the art associated with the court of Badr al-Dīn Lu'lu' at Mosul and that of the early Mamluks of Egypt and Syria.

Published: Robinson (1967a, p. 169, no. 1, pls. 81–4)

200 Candlestick of beaten brass inlaid with silver

Height 34cm, diameter (base) 31cm
Museum of Islamic Art, Cairo, no. 15121, formerly Harari Collection
Syria or Egypt, Ayyubid period,
mid-13th century

Inscription at base of neck
*'amala al-ḥājj Ismā'īl naqasha
Muḥammad b. Futtūḥ al-Mawṣilī
al-muṭā'im ajīr al-Shujā'
al-Mawṣilī*
'work of Hajji Ismā'īl, decoration by Muḥammad b. Futtūḥ of Mosul, the inlayer, employee of Shujā' of Mosul'
Inscription around body
*al-'izz wa'l-baqā' wa'l-ẓafar
bi'l a'dā wa dawām al-'āfya
wa'l-rif'a wa'l-irtiqā'
wa'l-daw[la]*
'Glory, long life, triumph over enemies, continuance of health, superiority, higher rank and rule.'
The neck of the candlestick bears medallions of musicians, a drinking scene and a bearded clown. The upper surface of the base has the twelve signs of the zodiac, while the body has six large medallions on a zig-zag ground – two court scenes, two hunting scenes, two of flying birds, detached monstrous heads and a central scene of a hawk striking a goose, this latter scene in reserve – between bold friezes of musicians, gamers, drinkers and dancers. These scenes are generally associated with the princely life, but they may in fact be a royal apotheosis, suggesting the joys of paradise. See Shepherd (1974, pp. 79–92). This candlestick may be compared to ewer, no. 196.

Published: Wiet (1932, no. 66), Cairo (1969, no. 53)

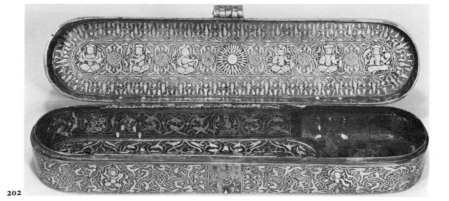

202

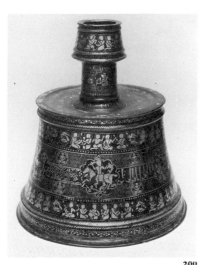

200

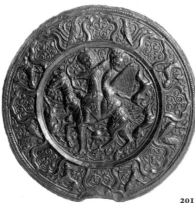

201

201 Mirror of cast bronze
Diameter 20.5cm
*Fogg Art Museum, Harvard
University, Cambridge,
no. TL 17512.2, anonymous loan*
Persia, Ilkhanid period, 13th century

The handle of the mirror is missing.
The picture on this mirror is of
Bahrām Gūr and his lyre-playing
Greek girl friend, Azāda. The story
in the *Shāhnāma* may be summarised
as follows. Bahrām Gūr took Azāda
out hunting gazelle on his racing
camel. She challenged him first to
remove the horns of a male gazelle
and give them to a female gazelle, and
then to shoot a pebble into the ear of
one of the two gazelle so that while it
was turning and scratching its ear
with its paw he could pin together the
paw, head and back of the animal with
a single shaft of his arrow. Bahrām
Gūr performed this extraordinary
feat but Azāda then accused him of
not being human but demonic. Upon
this Bahrām Gūr threw her to the
ground and trampled her to death
with his camel!

Published: London (1931, no. 229z);
Pope and Ackerman (1938–9, pls. 1300A
and B)

**202 Pen-box of brass incised and
inlaid with silver and gold**
Length 19.7cm
*British Museum, London,
no. 91 6–23 5*
Probably Persia, 1281

Inscription on front of body
 *'amal Maḥmūd ibn Sunqur fī sana
 thamānīn wa sitta mi'a*
 'the work of Maḥmūd ibn Sunqur
 in the year 680 [1281 AD].'
This round-ended pen-box form,
with its separate compartment at one
end for writing materials additional
to the pens, was probably based on a
wooden model and first seems to have
been made in metal in 12th century
Persia. It continued to be popular
after the Mongol conquests and
spread westwards, though in the
Mamluk empire a rectangular form
was also used (see no. 224). The
maker of this pen-box may have been
related to Muḥammad ibn Sunqur
al-Baghdādī who made the
magnificent Koran box, no. 214. The
decoration is rather 'international' in
style, and is difficult to pin down to
any precise region. On the base is a
fighting scene, in medallions which
adorn the inside and outside of the
body are musicians and dancers, and
the outside of the lid is decorated
with roundels containing the planets
in their domicilia (compare no. 215)
On the inner side, the planets alone
are depicted: from left to right, the
Moon with crescent, Mercury
holding a scroll, Venus playing a lute,
the Sun, Mars holding a sword and a
dripping severed head, Jupiter, and
Saturn holding a pick in one hand.

Published: van Berchem (1904, p. 38);
Pope and Ackerman (1938–9, pls. 1336A
and B); Barrett (1949, pls. 32–3)

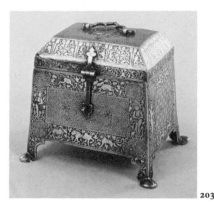

203

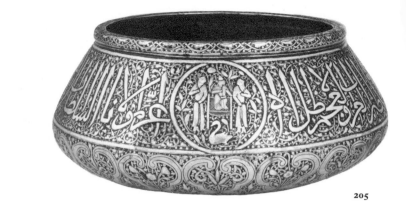

205

203 Casket of brass, incised and inlaid with silver
Length 12.5cm, width 10cm, height 12.5cm
British Museum, London, no. 1957 8–1 1
Western Persia, 14th century

A considerable number of caskets of this form have survived. This example has a characteristic band of pseudo-inscription on the edge of the lid but is rather unusual in the composition of its body decoration in which a large central area of geometric interlace is bordered by a frieze of animals and human figures. Base and fittings are not original.

Unpublished

204 Cup of bronze incised and inlaid with silver
Height 13.7cm, diameter 12.4cm
Bibliothèque Nationale, Cabinet des Médailles, Paris, no. B.N. 528
Persia, Ilkhanid period, 14th century

Inscription around rim
*ay mashrab-e ʿadhb-e kāmrānī
v'ay ʿayn-e zulālī shādmanī
bas khurran u dilkashī u maṭbūʿ
gū'i kih shikufta-ye gulsitānī
Iskander agar tūrā nadīdī
ay jām-e jahān numā-ye Mānī
dar khāṭir-e ū kujā guzhāshtī
andīshī-ye āb-e zindagānī*
'Sweet drink of success, limpid fountain of happiness,
You are most pleasant and attractive and congenial, you would say you were a blossoming flower,
If Alexander had not seen you, world-showing cup of Mānī,

How would there have come into his thoughts the idea of the water of life.'
Inscription around foot
*ay mashrab-e khurram-e dilārām
mithl-e tū nadīd chashm-e ayyām
gū'i kih namūna-ist az tu
in charkh-e kabūd-e ā'ina-fām*
'Fine-heart-easing drink, the eye of the days has not seen your like,
You would say that this blue mirror-like sky is a copy of you.'
The shape of this cup is derived from more conventional pre-Mongol Persian stem bowl forms. The positioning of the bands of inscription is also based on pre-Mongol tradition. The Ilkhanid dating is clear, however, from the contour of the cup, the style of the calligraphy, the decorative composition and the use of Persian poetry. The verses, superficially in praise of wine, have also a mystical content and are found on other wine cups of the period.

Published: Melikian-Chirvani (1973, pp. 60–1)

204

205 Bowl of cast brass, incised and inlaid with silver and gold
Diameter 23.8cm
British Museum, London, no. 1901 6–6 3
Persia, Ilkhanid period, 14th century

Inscription
ʿizz li-mawlānā al-sulṭān al-aʿẓam al-aʿdal al-aʿlam mālik riqāb al-umam mawlā salāṭīn al-ʿarab wa'l-ʿajam [wa] lā [zāla fī] ẓill [al-saʿāda]
'Glory to our lord the sultan, the most mighty, most just, most learned, dominating the nations, lord of sultans of the Arabs and Persians. [May he] not [cease to be in the] shadow [of happiness].'
Bowls of this type have survived in large numbers. The centre of the industry was probably Fars. See Melikian-Chirvani (1969). Three pieces in the Musée du Louvre, Paris, the Victoria and Albert Museum, London, and in the Musée des Beaux-Arts, Lyon, are dated to 1338, 1351 and 1347, respectively, and give a firm basis for the period of production of these bowls. Other bowls which are identical in form also appear in Egypt and Syria in the 14th century (compare no. 212) and are all apparently based on a north Mesopotamian type. This particular example is notable for the thickness and weight of its body as well as for its decoration and inlay.

Published: Pope and Ackerman (1938–9, pl. 1370A); Barrett (1949, pl. 36)

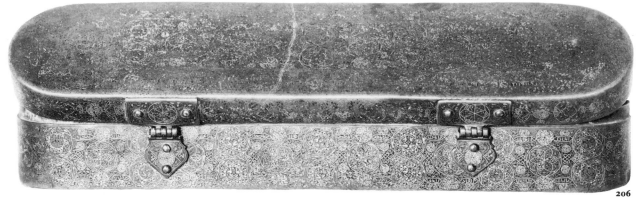

206

206 Pen-box of beaten bronze, incised and inlaid with gold and silver

Length 29.8cm
Institut de France, Musée Jacquemart-André, Paris, no. 1.1959
Persia, possibly Egypt or Syria,
late 14th–early 15th century

Upper external inscription
*['izz li-] mawlānā al-mālik
al-'ālim (a) (k) al-mu'ayyad
al-muzaffar al-manṣū[r]
al-mujā[hid] al-murābiṭ
al-muthāghir rukn al[li]-islām
wa'l-muslim[īn] mālik mulūk
wa'l-salāṭin kahf al-ṣughrā
wa'l-masā[kin] ['izz] li-mawlānā
al-mālik al-'ālim al-'ādil
al-mu'ayyad al-muzaffar
al-manṣū[r] [al-] mujāhid
[a]l-murābiṭ al-mulik al ghā[z]i
rukn [a]l-islā[m]*
'[Glory to] our Lord, the
possessing, the learned, the
fortified by God, the triumphant,
the victorious, the holy warrior,
the protector of frontiers, the
defender, pillar of Islam and the
Muslims, sovereign over [lit,
possessing] kings and sultans,
refuge of the humble and poor.
Glory to our Lord, the possessing,
the learned, the just, the fortified by
God, the triumphant, the
victorious, the holy warrior, the
defender, the conquering king,
pillar of Islam.'

Lower external inscription
*'izz li-mawlānā al-Mālik al-'ālim
al-'ādil al-mu'ayyad al-muza[ffar]
al-manṣū[r] al-mujāhid
al-murābiṭ al-muthāghir al-ghā[z]i
rukn al-islām wa'l-muslim[īn]
mā[lik] al-mulūk wa'l-salāṭin kahf
al-ṣughrā wa'l-masā[kin] ['izz]
li-mawlānā al-mālik al-'ālim
al-'ādil [a]l-mu'ayyad al-muzaffar
al-manṣūr [al-]mujāhid al-murābiṭ
al-muthāghir al-ghā[z]i*
'Glory to our Lord, the possessing,
the learned, the just, the fortified
by God, the triumphant, the
victorious, the holy warrior, the
defender, the protector of frontiers,
the conqueror, pillar of Islam and
the Muslims, sovereign over kings
and sultans, refuge of the humble
and poor. [Glory] to our Lord the
possessing, the learned, the just and
fortified by God, the triumphant,
the holy warrior, the defender, the
protector of frontiers, the
conqueror.'

Inscription inside cover
*['izz] li-mawlānā al-mālik al-'ālim
al-'ādil al-mu'ayyad al-muzaffar
al-manṣūr al-mujāhid [a]l-murābiṭ
[a]l-muthāghir [a]l-ghā[z]i rukn
[al-islām wa'l-muslimīn mālik
al-mulū]k wa'l-sa[l]āṭin kahf
al-ṣughrā wa'l-masā[kin]*
'[glory] to our Lord, the possessing,
the learned, the just, the fortified
by God, the triumphant, the
victorious, the holy warrior, the
defender, the protector of
frontiers, the conqueror, pillar of
Islam and the Muslims, sovereign
over kings and sultans, refuge of the
humble and poor.'

For the shape of this object see
no. 202. The main claim to fame of
this particular pen-box lies in the
fineness of its design. Here are
brought together motifs found on
Persian objects from the earlier part
of the 14th century and the individual
words of the inscriptions to create a
rhythm and harmony, altogether
without parallel.

Published: Bertaux (1913, p. 139);
Paris (1971, no. 141); Melikian-Chirvani
(1973, pp. 84–5)

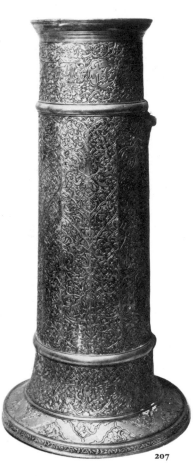

207

207 Candlestick of bronze, cast and incised

Height 45.3cm
Iraq Museum, Baghdad, no. 10469
Western Persia, Safavid period, 1562

The inscription is signed *Shams al-dīn Kāshī Kāshī* [*sic*] *sana 969* [1562 AD]. This dated candlestick, together with other similar examples in the Metropolitan Museum of Art, New York (dated 1578), and Museum of Islamic Art, Cairo (dated 1558 and 1607), indicate that this form was in fashion during a period of at least fifty years, from the reign of Shah Ṭahmasp to that of Shah ʿAbbās I. The purpose of the loop on the side of the candlestick is not clear, but may have been for a taper or snuffer of some sort. The decoration is similar to that of no. 208.

Published: Hamid (1967, pp. 149–50, pls. 7–8)

208 Candlestick of bronze, cast and incised

Height 31.8cm
Musée des Arts Décoratifs, Paris, no. 17.604
Western Persia, Safavid period, late 16th century

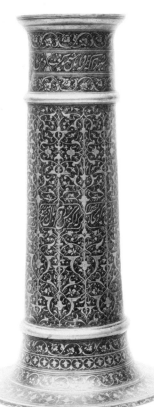

208

Inscription
Gah dil az ʿishq-i butān gah jigaram misūzad
* ʿishq har laḥza bi-dāgh-i dīgaram misūzad*
Hamchū parvana bi-shamʿ sar ū kār ast marā
* kih agar pīsh ravam bāl ū param misūzad*
Dar gham-i ʿishq-i tū misūzam ū sūzī dānist
* ʿizz-i shamʿī kih bi bālayi saram misūzad*

'At one time the heart burns at the love of the idols, at another time my liver.
 Love burns me every moment with another brand.
Just like the moth I have to do with the candle,
 For if I go forward my wings and pinions burn.
I burn in the distress of love for you, and the grandeur
 Of a candle which burns with the height of my head knew a burning.
[A candle which is so large that it is as high as my head knows what burning is.]'

Compared to earlier periods the bronze products of Safavid Persia are rather lifeless. Apart from the novelty of its form this candlestick is a standard product with the typical decoration of its period: arabesques without beginning or end, and inscriptions in a fine nastaliq script. Such objects may well have been tinned to give a superficial appearance of richness (compare no. 207).

Published: Melikian-Chirvani (1973, p. 116)

209

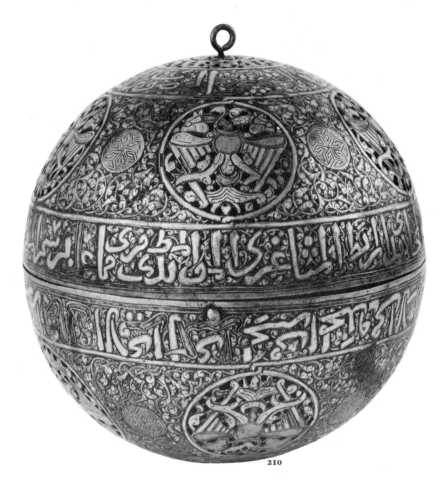

210

209 Jug of brass, inlaid with gold

Height 15.7cm
Private collection, England
Persia, Timurid period, 15th century

Inscription on the base
 'amal al-'abd Ḥusayn ibn
 Mubārak-shah fī shahr ramaḍān
 li-sana 889
 'made by the slave Ḥusayn ibn
 Mubārak-shāh in the month of
 Ramaḍān in the year 889
 [1484 AD].'
The inscription on the body is unread.
A number of jugs of this form are
known, and the range of dated
examples (1462–1511) shows that
they were popular in the late
Timurid period and under the early
Safavid rulers (compare no. 162).

Unpublished

210 Incense-burner of beaten brass, pierced and inlaid with silver

Diameter 18.4cm
British Museum, London,
no. 78 12–30 682
Syria, 1268–79

Lower inscription on upper
hemisphere
 nimmā 'umila bi-rasm al-maqarr
 al-karīm al-'ali al-mawlaw[l] ī
 al-amirī al-kabīri al-muḥtaramī
 al-makhdūmī al-safahsalāri
 al-mujāhidī al-murābiṭi
 al-muthāghiri al-mu'ayyadī
 al-muẓaffari
 'One of the things made for the
honourable authority, the lofty,
the lordly, the great amir, the
revered, the masterful, the chief of
the armies, the holy warrior, the
defender, the protector of frontiers,

the fortified by God, the
triumphant.'
Upper inscription on upper
hemisphere
 Badr al-dīn Baysari al-Ẓāhirī
 al-Sa'īdī al-Shamsi al-Manṣurı
 al-Badrī 'Badr al-dīn Baysari,
 [*officer of al-Malik*] al-Ẓāhir, [*of*
 al-Malik] *al-Sa'īd, al-Shamsi,*
 al-Manṣūrī, al-Badrī.'
Lower inscription on lower
hemisphere is the same as that on the
upper hemisphere, but omitting
al-mawlawi, substituting
al-isfahsalāri for *al-safahsalāri* and
adding *al-murābiṭi*. Upper inscription
on lower hemisphere is the same as
that on the upper hemisphere but
adding *'azza naṣruhu,* 'may his victory
be glorified' at the end. The titles
al-Ẓāhirī and al-Sa'īdī apparently
refer to two Mamluk rulers, al-Malik
al-Ẓāhir Baybars (1260–77) and
al-Malik al-Sa'īd Baraka Khān
(1277–9). The incense-burner was
probably made between 1268, when

Baraka Khān assumed his title, and
his death in 1279. Under both these
rulers and a number of their
successors Baysari was a powerful
officer. The double-headed eagle
which appears here in the circular
medallions on both spheres of the
incense-burner may well have been
his personal emblem. However, it
does not appear on the one other
object known to have been made for
him (the basin signed Dāwud ibn
Salāma dated 1252 in the Musée des
Arts Decoratifs, Paris). Objects such
as this incense-burner normally
enclosed a small iron bowl set in
gimbals, and charcoal would have
been placed in the bowl for the
burning of incense. The burner
could then be swung or rolled along
the floor of a room from one seated
guest to another. The gimbals of this
example are missing.

Published: Lane-Poole (1886,
pp. 174–7, fig. 81); Barrett (1949, pl. 22)

211

212

211 Candlestick of brass incised and inlaid with silver, copper and gold

Height 26cm, diameter 32.5cm
*Walters Art Gallery, Baltimore,
no. 54.459*
Syria, 1290–3

Inscription
*mimma 'umila bi-rasm ṭishtkhānā
al-maqarr al- 'ālī al-mawlawi
al-amīrī al-kabīrī al-ghāzī
al-mujāhid al-'ādilī al-Zaynī Zayn
al-dīn Kitbughā al-Manṣūri
al-Ashrafi*
'This is one of the things made for the servery of the lofty authority, the lordly, the great amir, the conqueror, the holy warrior, the just, al-Zaynī, Zayn al-dīn Kitbughā al-Mansūrī al Ashrafī [of the households of the sultans Qalāwūn and Khalil].'
The original candle-holder fitting for this candlestick is in the Museum of Islamic Art, Cairo, and bears a similar inscription in the name of Kitbughā, the Mamluk Sultan from 1294–6. See Wiet (1932, no. 4463, pl. XXIV). Kitbughā was deposed in 1296 but held important posts in the empire for most of his remaining life. He died in 1303. The use of *al-Ashrafī* in his title on the inscription on the candlestick indicates that this object was made during the reign of his predecessor al-Malik al-Ashraf Khalīl who ruled 1290–3. The cup in the circular shield was the insignia of the office of 'cup-bearer' to the sultan (*sāqī*), a post which Kitbughā is known to have held in his early days. He continued to use it when he became sultan and it also appears on some of his coins, but his successors dropped their amiral blazons on coming to power and adopted instead

a purely sultanic style, consisting of a round shield bearing royal titles alone. It is interesting to find here a polychrome blazon though it has yet to be demonstrated whether such colours had heraldic significance.

Published: Mayer (1937, p. 61, pl. Ia)

212 Bowl of brass incised and inlaid with silver

Height 8.3cm, diameter 18cm
Galleria Estense, Modena, no. 2064
Egypt or Syria, Mamluk period,
first half 14th century

Inscription
*al-maqarr al-karīmī al-'ālī
al-mawlawī al-amīrī al-kabīrī
al-'ālī al-'āmilī al-'ādilī al-ghāzī
al-mujāhidī al-murābiṭī al-dhukhrī
al-muthāghirī al-mu'ayyadī
al-mālikī al-kāfilī al-kāfī
al-makhdūmī al-humāmī al-niẓāmī
al-qawmī al-'awnī al-ghiyāthī
al-Malikī al-Nāṣirī*
'The honourable, the lofty, the lordly, the great amir, the lofty, the diligent, the defender, the treasurehouse [of excellence], the protector of frontiers, the fortified by God, the possessing, the sustaining, the capable, the masterful, the valiant, the well-ordering, the equitable, the help, the succour [officer of] al-Malik al-Nāṣir.'
This form of brass bowl was common in the 14th century. Mamluk empire and is here decorated in a bold cursive script, typical of the period. The text of the inscription gives the titles of an un-named Mamluk officer, evidently an emir of al-Malik al-Nāṣir Muḥammad ibn Qalāwūn who ruled from 1299–1340. The

roundels show mythical animals, on the base are animals and birds of the hunt, inside the base are fishes. These decorative motifs are probably intended to represent not only the pleasures of the present life but also the fortunes and happiness of the life 'beyond the seas'.

Published: Venturi (1883, p. 84ff);
Rice (1957b, pls. VII–X, p. 489)

213 Basin of brass incised and inlaid with silver

Height 20.3cm, diameter 46cm
*Los Angeles County Museum of Art,
no. M 73.5.125, The Nasli M.
Heeramaneck Collection, gift of Joan
Palevsky*
Egypt, Mamluk period,
13th–14th century

Inscription on inside
*al-maqarr al-'ālī al-mawlawi
al-a[mīrī] al-kabīrī al-ghāzī
al-mujāhidī al-murābiṭī
al-muthāghirī al-humāmī al-niẓāmī
al-'ālimī al-nāṣirī*
'The lofty authority, the lordly, the great amir, the conqueror, the holy warrior, the defender, the protector of frontiers, the valiant, the well-ordering, the learned, [officer of al-Malik] al-Nāṣir.'
Inscription on outside
*al-maqarr al-karīm al-'ālī
al-mawlawi al-mālikī al-amīrī
al-kabīrī al-ghāzī al-mujāhidī
al-murābiṭī al-muthāghirī
al-mu'ayyadī al-dhukhrī al-'awnī
al-humāmī al-ghiyāthī[?] al-'ālimī
al-'āmilī al-'ādilī al-maḥrū [?]
al-makhdūmī al-malikī al-nāṣirī*
'The honourable authority, the lofty, the lordly, the possessing,

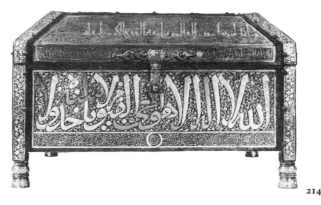

213

214

the great amir, the conqueror, the
holy warrior, the defender, the
protector of frontiers, the fortified
by God, the treasure trove of
excellence, the helper, the valiant,
the succourer, the learned, the
diligent, the just, the [?], the
masterful, [officer of al-Malik] al
Nāṣir.'
This basin follows a shape known in
Syria and Egypt in Ayyubid times
(compare no. 198). Its Mamluk
character is clear, however, in the use
of the bold cursive script as the main
element in the decoration and in the
amiral titles common on 14th century
Syrian and Egyptian objects.

Published: Los Angeles (1973, no. 307)

**214 Koran box of wood with
wooden interior fittings, covered
with bronze inlaid with silver
and gold**
Height 27cm, width 42.5cm
*Staatliche Museen Preussischer
Kulturbesitz, Museum für Islamische
Kunst, Berlin-Dahlem, no. 1.886*
Egypt, Mamluk period, first half
14th century

Inscription on the clasps
 '*amal Muḥammad ibn Sunqur
 al-Baghdādī taṭ'īm al-Ḥājj Yūsuf
 ibn al-Ghawābī*
 'made by Muḥammad ibn Sunqur,
 inlaid by Ḥajj Yūsuf al-Ghawābī.'

The other inscriptions on the box are
Koranic and include Sura II, 255,
Sura III, 26–7, Sura XXIV, 35,
Sura XXVI, 192–9, Sura LVI, 76–89,
92–5 and Sura LIX, 22–4. In the great
mosques and madrasas of Mamluk
Egypt, Korans were kept either in
boxes (*ṣundūq*) or in tall free-standing
metal cupboards (*kursī*). The maker
of this *ṣundūq*, Muḥammad ibn
Sunqur al-Baghdādī, may well have
specialised in the making of mosque
furniture, for he is also known to be
the maker of a splendid *kursī* in the
Museum of Islamic Art, Cairo, dated
to 1327–8. See Cairo (1969, no. 61).
This Koran box must date from about
the same time. It is interesting to note
that among the Suras from the Koran
inscribed on the box there is the one
devoted to the idea of God as light
(Sura XXIV). This is a common text
on 14th century enamelled glass
mosque lamps (see no. 139). Such
lamps, alongside the inlaid Koran
boxes and cupboards, reflect the
sumptuous taste of the Mamluk
military aristocracy and the
extravagant liberality which
characterized their pious
foundations.

Published: Sarre and Martin (1912,
no. 3132, taf. 156; Yusuf (1962);
Berlin-Dahlem (1971a, no. 19, pl. 69)

**215 Bowl of beaten brass, incised
and inlaid with silver**
Diameter 15cm
Musée du Louvre, Paris, no. 6032
Syria (?), Mamluk period,
14th century

The decoration of this bowl suggests
that it is probably the earliest
example of a type commonly
produced by late Mamluk and
Venetio-Saracenic craftsmen.
Among the Mamluk pieces it is also
the most lavishly decorated. The base
bears a central sun surrounded by six
planets whose astrological
significance is somewhat obscured by
the fact that they are arranged in the
wrong order. Thus: the Moon, Mars
Jupiter (in Pisces, his domicile),
Venus and Saturn. The sides bear
alternate drinkers or musicians, a
typical example of traditional Islamic
iconography, and fighting animals,
an age-old Middle Eastern motif.

Published: Migeon (1903, no. 111,
pl. XXI); Paris (1971, no. 161)

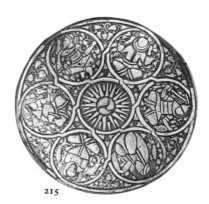

215

216 Ewer of beaten brass, incised and inlaid with silver and gold
Height 53cm
Museo Nazionale del Bargello, Florence, no. 357 C
Egypt, Mamluk period, 1363–77

Large inscription on body
*'izz li-mawlānā al-sulṭān al-Malik
al-Afḍal al-'āmil al-ghāzī
al-mujāhidī al-murābiṭī 'azza
naṣruhu*
'Glory to our Lord, the sultan,
al-Malik al Afḍal, the diligent, the
conqueror, the holy warrior, the
defender, may his victory be
glorified.'
Small inscription on body, alternating
with sections of decorative kufic
script
*'izz li-mawlānā al-sulṭān al-Malik
al-Afḍal al-'āmil al-ghāzī
al-mujāhid al-murābiṭī
al-muthāghirī al-mu'ayyad
al-manṣūr sulṭān al-islām
wa'l-muslim[īn] qātil al-kufara
wa'l-mushrikīn muhyī al-'adl
fī al 'ālamin munṣif al-maẓlūmīn
min al ẓālimīn malik al-baḥrayn
khādim al-ḥaramayn sulṭān al-islām
wa'l-muslimīn 'azza naṣruhu*
'Glory to our Lord the sultan,
al-Malik al Afḍal, the diligent, the
conqueror, the holy warrior, the
defender, the protector of
frontiers, the fortified by God, the
victorious, sultan of Islam and the
Muslims, slayer of the infidels and
polytheists, reviver of justice in the
worlds, righting the oppressed
against the oppressors, king of the
two seas [or of al Baḥrayn, eastern
Arabia], servant of the two
sanctuaries, sultan of Islam and the
Muslims, may his victory be
glorified.'

The inscriptions on the neck are
shortened versions of the above with
insignificant variations. In the
roundels are the inscription
'izz li-mawlānā al-sulṭān
'glory to our Lord, the sultan.'
al-Malik al-Afḍal was the title taken
by the Rasulid sultan of the Yemen,
Ḍirghām al-Dīn 'Abbās, who ruled
from 1363–77. The style of the script
and the vegetal motif of the decoration
of the ewer demonstrate, however,
that this is not a Yemeni but an
Egyptian product. It is, in fact, one of
a number of surviving metal and
glass objects evidently made in Egypt
for the Yemeni ruling house, the key
piece being a ewer in the Musée des
Art Decoratifs, Paris, which,
alongside the name and title of the
Rasulid ruler al-Malik al-Muẓaffar
Yūsuf (1250–95), bears the name of
the maker and the words *bi'l Qāhira*,
'[made] in Cairo'. It has often been
suggested that the Rasulid blazon
was a rosette, and whirling ones
appear on this ewer. However, as the
rosette appears on objects dedicated
to many different Yemenis, both
Rasulids and their officers, it was
evidently not a blazon in the Mamluk
Egyptian sense and may well have
been a popular decorative motif. The
only portion of the ornament of this
ewer that could have functioned as a
blazon is the inscribed shield or
roundel bearing the first three words
of the full dedication.

Published: Sarre and Martin (1912,
no. 3133, pp. 9–13, pl. 157);
Scerrato (1966, pl. 57)

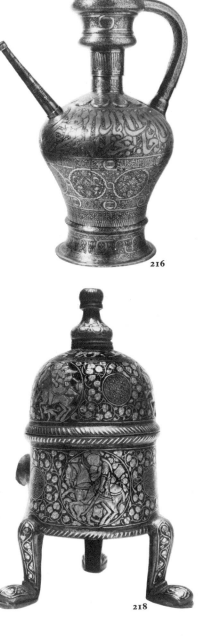

216

218

217

217 Candlestick

Height 35.6cm
Museum of Fine Arts, Boston,
no. 34.168, Ellen Francis Mason Fund
Egypt, Mamluk period, 14th century

The inscriptions on the body and
candle-holder are unread. The form
and style of this candlestick are
typical of 14th century Mamluk
work, particularly pleasing are the
'centrifugal' inscriptions within
borders of flying ducks on the body.

Published: Boston (1969, pl. 118)

218 Incense burner of cast brass inlaid with gold and silver

Height 21cm, diameter 9.3cm
Museum of Islamic Art, Cairo,
no. 24078, found in 1966 at Qus
Egypt, Mamluk period, 13th–early
14th century

This cylindrical incense burner
stands on three splayed animal's legs
with a pierced dome cover fixed by a
hasp, later wrongly replaced. The
plain brass plate bearing a socket for
the handle is also later. Inside is a
shallow bowl, evidently originally
removable, to bear grains of incense
while the base was filled with burning
charcoal. This, like the base plate, has
now been soldered on and the burner
is now unusable. Both cover and base
have large inlaid roundels depicting
mounted huntsmen. The piece is
unsigned, but the exceptionally
finely chased features of the huntsmen
strongly recall the work of
Muḥammad ibn al-Zayn (whose
signature appears on the Baptistery of
Saint Louis and the Vasselot basin in
the Musée du Louvre, Paris).

Published: al-Emary (1968, pp. 123–7);
Cairo (1969, no. 57)

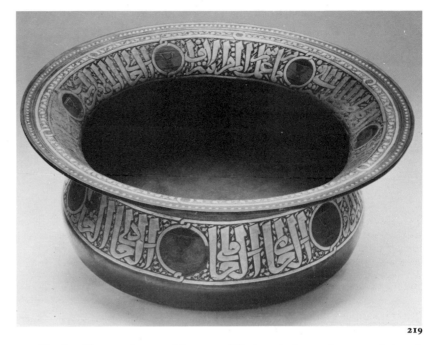

219

219 Basin of beaten brass with copper and silver inlay

Height 18.5cm, diameter (base) 36cm
Museum of Islamic Art, Cairo,
no. 24085, found in 1906 at Qus
Egypt, Mamluk period,
early 14th century

Inscription on exterior
> *mimmā ʿumila bi-rasm al-maqarr*
> *al-ashraf al-ʿālī al-mawlāwī*
> *al-ʿālimī al-ʿāmilī al-ʿādilī*
> *al-ghāzī al-mujāhidī al-makhdūmī*
> *al-[s]ayfī Ṭoqṭo al-Malikī*
> *al-Ashrafī*

'One of the things made for the
most noble authority, the lofty, the
lordly, the learned, the diligent,
the just, the conqueror, the holy
warrior, the masterful, the sword-
holder Ṭoqṭo officer of al-Malik
al-Ashraf

Inscription on rim
> *mimmā ʿumila bi-rasm al-maqarr*
> *al-ashraf al-ʿālī al-mawlāwī*
> *al-mushīrī al-ʿālimī al-ʿādilī*
> *al-ghāzī al-mujāhidī al-murābiṭī*
> *al-malikī al-makhdūmī al-sayfī*
> *Ṭoqṭo al-Malikī al-Ashrafī*

'One of things made for the
most noble authority, the lofty, the
lordly, the marshal, the learned,
the diligent, the just, the
conqueror, the holy warrior, the
defender, the royal, the masterful,
the sword holder Ṭoqṭo, [officer
of] al Malik al Ashraf.'

The inscription on the everted rim of
the basin is broken by six medallions
containing a three-field blazon of cup
between two bars, which are inlaid
with copper hammered onto a
hachured ground. The decoration is
very severe, leaving the magnificent
thuluth inscriptions to speak for
themselves. As for the name which
has been previously read unsatis-
factorily as Ṭabṭaq, it may equally be
Ṭoqṭay which is interchangeable
with Ṭoqṭū, an amir frequently
mentioned on the coins of this period.

Published: al-Emary (1967, pp. 129–30);
Cairo (1969, no. 65)

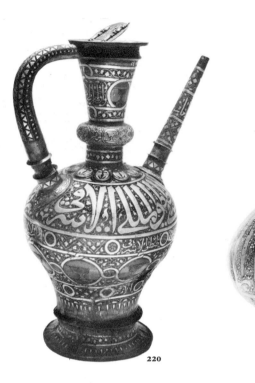

220

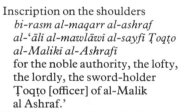

221

220 Ewer of beaten brass inlaid with gold, silver and copper with some niello ground

Height 40cm, diameter (rim) 15cm
*Museum of Islamic Art, Cairo,
no. 24084, found in 1966 at Qus*
Egypt, Mamluk period, before 1341

Inscription on neck
*al-maqarr al-ashraf al-'ālī
Ṭoqṭo 'azza naṣruhu*
'the most noble authority, the
lofty Ṭoqṭo, may his victory be
glorified.'
Inscription on the centre
*al-maqarr al-ashra[f] al-'ālī
al-mawlāwi al-'ālimī al-'āmili
al-sayfī a Ṭoqṭo al-Ashrafī*
the most noble authority, the lofty
the lordly, the learned, the diligent,
the sword-holder Ṭoqṭo
[officer of al Malik] al Ashraf.'

Inscription on the shoulders
*bi-rasm al-maqarr al-ashraf
al-'ālī al-mawlāwi al-sayfī Ṭoqṭo
al-Malikī al-Ashrafī*
for the noble authority, the lofty,
the lordly, the sword-holder
Ṭoqṭo [officer] of al-Malik
al Ashraf.'
On the neck and above the foot are
bands of circular medallions
containing the three-field blazon of
the cup-bearer (*sāqī*) – a cup or
chalice between two bars. The
junction of the neck and the body is
masked by raised tongues, each
containing a pair of confronted
falcons. The decoration is minute and
of a markedly inferior quality to the
basin no. 219 which, from its
inscriptions, was a companion piece
but may have been made in a different
workshop. Straight-spouted ewers
are traditionally used in Islam for
ritual purification but their evolution
is difficult to trace.

Published: al-Emary (1967, pp. 128–9);
Cairo (1969, no. 66)

221 Ewer of brass inlaid with gold and silver enhanced with niello

Height 30cm, diameter (rim) 10.5cm
*Museum of Islamic Art, Cairo,
no. 15126, formerly Harari
Collection*
Egypt, Mamluk period, before 1342

Inscription on neck
*'izz li-mawlānā al-sulṭān al-malik
al-nāṣir al-'ālim al-'āmil al-ghāzī
al-mujāhid al-murābiṭ al-muthāghir
al-Mu'ayyad al-manṣūr Shihāb
al-Dunyā wa'l- Dīn Aḥmad 'azza
naṣruhu*
'Glory to our lord the sultan,
al Malik al Nāṣir, the learned, the
diligent, the conqueror, the holy
warrior, the defender, the protector
of frontiers, the fortified by God,
the victorious, Shihāb al-Dunyā
wa'l Dīn [Star of the World and the
Faith] Aḥmad, may his victory be
glorified.'
Inscription on belly
*'izz li-mawlānā al-sulṭān al-Malik
al-Nāṣir al-'ālim al-'āmil al-ghāzī
al-mujāhid al-murābiṭ al-muthāghir
al-mu'ayyad al-manṣūr Aḥmad*
'Glory to our lord the sultan,
al Malik al Nāṣir, the learned, the
diligent, the conqueror, the holy
warrior, the defender, the protector
of frontiers, the fortified by God,
the victorious, Aḥmad.'
The decoration is in successive bands
of inscriptions and chinoiserie lotus
scroll on flowering trees. As usual,
both the feet and the underside of the
base are fully decorated, the latter
with an embossed eight-petalled
rosette. The brass handle is laminated
and the joint between the neck and
belly masked by an embossed ring.

Published: Rice (1953a, p. 489ff., pl. IC);
Cairo (1969, no. 68)

222

222 Basin of beaten brass inlaid with silver and copper
Height 19cm, diameter (rim) 44cm
Museum of Islamic Art, Cairo,
no. 15030, formerly Harari
Collection
Egypt, Mamluk period, about 1344

Inscription on exterior
al-janāb al-ʿālī al-mawlāwī
al-amīrī al-kabīrī al-malikī
al-ʿālimī al-ʿāmilī al-ʿādilī
al-ghāzī al-mujāhidī al-murābiṭī
al-makhdūmī al-sayfī Qushtimūr
ustādh al-dār al-karīma
Ṭuquztimūr amīr majlis ʿazza
naṣruhu
'His Highness, the lordly, the king's great amir, the learned, the diligent, the just, the conqueror, the holy warrior, the defender, the masterful, the sword-holder Qushtimūr, major-domo of Ṭuquztimūr, President of the Council, may his victory be glorified.'
The inscription on the rim is identical, except that *al-makhdūmī* replaces *al-ʿādilī* 'the just' in the third line above and is then omitted in the fifth line. It is broken by three circular medallions containing a composite blazon in a pointed oval consisting of a bar, a single-headed eagle with wings outstretched in the centre and a cup, the sign of the cup-bearer below. This is not the blazon of Qushtimūr who, evidently, preferred to use his master's blazon which perhaps explains the ungrammatical inscriptions.

Published: Wiet (1932, no. 212);
Cairo (1969, no. 69)

223 Vase of beaten brass with gold, silver and copper inlay
Height 31cm, diameter (rim) 15cm
Museum of Islamic Art, Cairo,
no. 15125, formerly Harari
Collection
Egypt, Mamluk period, before 1345

Inscription on neck
mimmā ʿumila bi-rasm al-maqarr
al-ashraf al-ʿālī al-sayfī
Ṭuquztimūr al-sāqī al-Malikī
al-Nāṣirī
'One of the things made for the most noble authority, the lofty, the sword holder, Ṭuquztimūr, the cup-bearer of al-Malik al-Nāṣir.'
Inscription on shoulders
mimmā ʿumila bi-rasm al-maqarr
al-ashraf al-ʿālī al-mawlāwī
al-amīrī al-kabīrī al-sayfī
Ṭuquztimūr al-sāqī al-Nāṣirī
'One of the things for the most noble authority, the lofty, the lordly [ie. the officer of the sultan], the great amir, the sword-holder, Ṭuquztimūr, the cup-bearer of al-Malik al-Nāṣir.'

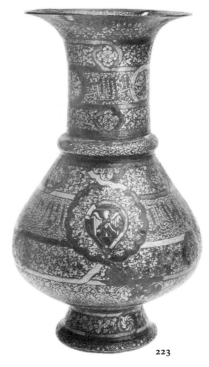

223

The metal inlay over the whole surface of the vessel, mostly in silver, is extremely fine and varied and consists of chinoiserie lotus, paeony and star-shaped flowers, panels of flying ducks and small whirling rosettes. The inlay is delicately chased, even the underside of the base is decorated. At some later date the rim of the vase was crudely pierced with four holes, perhaps to hang it as a mosque lamp. The main inscription band is broken by three blazons in a pointed roundel, consisting of a bar, a single-headed eagle with out-stretched wings in the centre and cup below. Ṭuquztimūr, who died in 1345, was for a time cup-bearer (*sāqī*) of al-Nāṣir Muḥammad who died in 1341–2.

Published: Wiet (1932, no. 171);
Cairo (1969, no. 70)

224 see colour plate, page 51

224 Pen-box of brass inlaid with gold and silver

Length 31.5cm, width 9cm, height 8cm
Museum of Islamic Art, Cairo, no. 4461, purchased 1917
Egypt, Mamluk period, 1361–3

Inscription in the lower margins on the inside of the lid

> *'izz li-mawlānā al-sulṭān*
> *al-Mālik al-malik al-manṣūr*
> *al-'ā . . . al-'āmil al-mujāhid*
> *al-mu'ayyad al-manṣūr Ṣalāḥ*
> *al-Dunyā wa'l-Dīn Muḥammad*
> *al-'āmil al-'ādil al-ghāzī*
> *al-mujāhid al-murābiṭ*
> *al-muthāghir al-mu'ayyad*
> *al-manṣūr al- . . . 'ālim al-'āmil*
> *al-'ādil al-mujāhid 'azza naṣruhu*

'Glory to our lord the Sultan, the possessing, al-Malik al-Manṣūr . . . the diligent, the holy warrior, the fortified by God, the victorious, Ṣalāḥ al Dunyā wa'l Dīn Muḥammad . . . the diligent, the just, the conqueror, the holy warrior, the defender, the protector of frontiers, the fortified by God, the victorious, the learned, the diligent, the just, the holy warrior, may his victory be glorified.'

The upper and lower margins and sides of the outside of the lid as well as the upper and lower margins, the exteriors and borders of the body of the box have inscriptions which are copious, repetitious and, on the whole, incompetently inscribed. The heroic titulature, al-Malik al-Manṣūr Muḥammad, is devoid of meaning for this ruler was in power for little more than a year in 1361–3. However, the decoration is of the richest type and the only areas where there is no inlay work are the inner faces of the lid where they fit flush with the base and the silver cover of the ink-pot which may be a later addition. The floral decoration of lotus, paeony and chrysanthemum is most obvious on the inside but the exterior has also medallions of flying birds. The base is decorated with three circular medallions, the outer two have lotuses and the central medallion has a pair of entwined chinoiseries phoenixes with star medallions filled with foliage between. The denseness of this decoration suggests that embroidery patterns might have provided the sources for the motifs.

Published: Devonshire (1919, pp. 241–5); Wiet (1932, pp. 123–5); Cairo (1969, no. 81)

225 Qumqum bottle for sprinkling rose-water or orange flower-water, of beaten brass inlaid with gold and silver

Height 22.5cm, diameter (maximum) 9cm
Museum of Islamic Art, Cairo, no. 15111, formerly Harari Collection
Egypt, Mamluk period, 14th century

The main thuluth inscription between bands of chinoiserie lotus and stylised flying birds is broken by lobed medallions containing thuluth inscriptions inlaid in gold, exactly similar in content to the principal inscription but with their shafts arranged radially.

Inscription on neck
> *al-'izz wa'l-baqā wa'l-ḥayāh*
> *[or al-jinān] wa'l-fatḥ wa'l-ma'ārif*
> 'Glory and long life [or paradise] and conquest and knowledge.'

Inscription on body
> *'izz li-mawlānā al-Sulṭān al-Malik*
> *al-Nāṣir Nāṣir al-Dunyā wa'l-Dīn*
> *al-Malik al-Nāṣir Ḥasan*
> 'Glory to our lord the sultan al-Malik al-Nāṣir, Nāṣir al-Dunyā wa'l-Din al-Malik al-Nāṣir Ḥasan.'

Inscription in the cartouches reads al-Malik al-Nāṣir Ḥasan. At the base of the sprinkler is a boss of silver cloisons containing traces of green enamel. The base has a plug with knob in the form of a nine-petalled rosette.

Published: Wiet (1932, p. 217), Cairo (1969, no. 79, pl. 15)

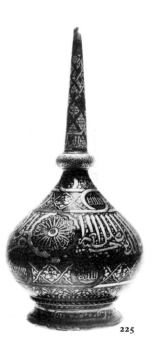

225

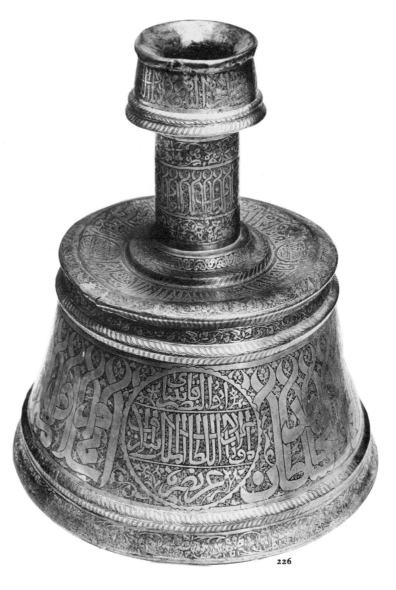

226 Candlestick of beaten brass,
body enhanced with niello

Height 45cm, diameter (base) 39.5cm
Museum of Islamic Art, Cairo,
no. 4297, purchased 1916
Egypt, Mamluk period, 1482–3

Inscription on rim
> *Hadhā mā awqafahu ʿalā al-ḥujra*
> *al-nabawiyya mawlānā al-sulṭān*
> *al-Malik al-Ashraf Abū al-Naṣr*
> *Qāytbāy bi-tarīkh sanat 887 [in*
> *words]*

'This is what was presented
to the Shrine of the Prophet [at
Medina] by our lord the sultan
al-Malik Al-Ashraf Abū al-Naṣr
Qāytbāy in 887 [1482–3 A.D.].'

Inscription on neck
> *ʿizz li-mawlānā al-sulṭān al-malik*
> *al-ʿādil al-mujāhid al-murābiṭ*
> *al-mālik al-Ashraf Abū al-Naṣr*
> *Qāytbāy*

'Glory to our lord the king, the
just, the holy warrior, the defender,
the possessing, al-Malik al-Ashraf,
Abū al-Naṣr Qāytbāy,'

Inscription on top
> *hadhā mā awqafahu ʿalā al-ḥujra*
> *al nabawiyya mawlānā al-sulṭān*
> *al-Malik al-Ashraf Abū al-Naṣr*
> *Qāytbāy ʿazza naṣruhu bi-tārīkh*
> *sana sabʿa wa thamānīn wa*
> *thamān miʾa fī shahr Ramaḍān*
> *al-muʿaẓẓam qadruhu . . . al-sulṭān*
> *Abū al-Naṣr Qāytbāy ʿazza*
> *naṣruhu*

'This is what was presented
for the Shrine of the Prophet by our
lord the Sultan al-Malik al-Ashraf,
Abū al-Naṣr Qāytbāy, may his
victory be glorified, in 887 in the
exalted month of Ramaḍān . . . the
sultan Abū al-Naṣr Qāytbāy, may
his victory be glorified.'

Inscription on body
> *ʿizz li-mawlānā al-sulṭān al-malik*
> *al-ʿādil al-mujāhid sulṭān al-Islām*
> *wa'l-muslimīn al-Malik al-Ashraf*
> *Abū al-Naṣr Qāytbāy . . . ʿizz*
> *li-mawlānā al-sulṭān al-Malik*
> *al-Ashraf Abū al-Naṣr Qāytbāy*
> *ʿazza naṣruhu*

'Glory to our lord the sultan the
king, the just, the holy warrior,
sultan of Islam and the Muslims,
al-Malik al-Ashraf Abū al-Naṣr
Qāytbāy . . . Glory to our lord the
sultan al-Malik al-Ashraf Abū
al-Naṣr Qāytbāy may his victory be
glorified.'

The candlestick is decorated with
alternate bands of inscription and
scroll-work including chinoiserie
lotus and stylised paeony scrolls. The
two donation inscriptions are in
thuluth, those exalting Qāytbāy are in
a splendid thuluth script with flame-
like shafts and some curious ligatures
more suggestive of kufic. Together
with another candlestick in the
Museum of Islamic Art, Cairo
(no. 4072), the pair formed part of the
restoration to the Great Mosque at
Medina carried out in 1480 by
Qāytbāy.

Published: Wiet (1932, p. 118)

227 Lantern of brass

Height 123cm, pyramid diameter
(top) 26cm, (bottom) 52cm
*Museum of Islamic Art, Cairo,
no. 383, from the mosque of Aṣal Bāy*
Egypt, Mamluk period,
late 15th century

Inscriptions at top
*'izz li-mawlānā al-sulṭān al-malik
al-'ālim al-ghāzī al-mujāhid
al-murābiṭ al-muthāghir al-ashraf
Abū al-Naṣr Qāybāy*
'Glory to our lord the sultan, the
learned, the conqueror, the holy
warrior, the defender, the protector
of frontiers, al-Malik al-Ashraf.'
*'izz li-mawlānā al-Sulṭān
al-Malik al-Ashraf Qāytbāy*
'Glory to our lord the sultan,
al-Malik al-Ashraf Qāytbāy.'
*'izz li-mawlānā al-sulṭān
al-malik al-'ālim al-'ādil
al-mujāhid al-murābiṭ al-Malik
al-Ashraf Abū al-Naṣr Qāytbāy*
'Glory to our lord the sultan, the
king, the learned, the just, the holy
warrior, the defender, all-Malik
al-Ashraf etc.'
Inscriptions on the pyramid
*'izz li-mawlānā al-sulṭān al-Malik
al-Ashraf al-'ālim al-'ādil
al-mujāhid [al-murā] biṭ
al-muthāghir al-mu'ayyad
al-manṣūr [sulṭān] al-islām
wa'l-muslimīn qasim amīr
al-mu'minin al-ḥājj ilā bayt Allāh
[al]-ḥarām al-Malik al-Ashraf
Abū'l-Naṣr Qāytbāy*
'Glory to our lord the sultan,
al Malik al Ashraf, the learned, the
just, the holy warrior, the defender,
the protector of frontiers, the
fortified by God, the victorious
[sultan] of Islam and the Muslims,
partner of the Commander of the
Faithful, the pilgrim of God's holy

shrine [at Medina], al Malik
al Ashraf etc.'
*Al-malik al-Ashraf Qāytbāy 'azza
naṣruhu*
'May his victory be glorified.'
*'izz li-mawlānā al-sulṭān
al-mālik al-malik al-Ashraf
al-'ālim al-'ādil al-mujāhid
al-murābiṭ al-muthāghir
al-mu'ayyad al-manṣūr sulṭān
al-Islām wa'l-muslimin qātil
al-kafara wa'l-mushrikin qasim
amir al-mu'minin al-ḥājj ilā bayt
Allāh al-ḥarām al-sulṭān al-Malik
al-Ashraf Abū al-Naṣr Qāytbāy
'azza naṣruhu*
'Glory to our lord the sultan, the
possessing al Malik al Ashraf, the
learned, the diligent, the just, the
holy warrior, the defender, the
protector of frontiers, the
fortified of God, the victorious,
sultan of Islam and the Muslims,
slayer of infidels and polytheists,
partner of the Commander of the
Faithful, the pilgrim of God's holy
shrine, the sultan al Malik al Ashraf,
Abū al Naṣr Qāytbāy. May his
victory be glorified.'

The six-sided pyramid surmounted
by a dome with three window-like
openings at its base has a finial which
deliberately evokes contemporary
minaret finials, and even the canopies
of mimbars. The lamp-sheath, dome
and sides of the pyramid are open-
work, one side had a hinged door,
fastened by swivel-pins to allow the
glass lamps to be placed inside their
holders, while the base bears twelve
rings from which a metal plate to
collect the drips must have been hung
on chains. There were nineteen lamp-
holders, but the flames could only be
seen through the pyramid and at best
must have produced a dull glow. This
lantern and a companion piece which

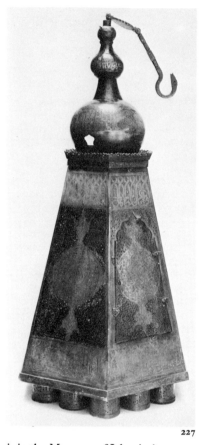

227

is in the Museum of Islamic Art,
Cairo (no.384), was not made for the
mosque of Aṣal Bāy (wife of
Qāytbāy) since Qāytbāy died in 1496
(the mosque was completed in 1499),
yet the inscriptions made no reference
to this. The allusions to his pilgrim-
age to Mecca, which he made in 1474,
may suggest that the lanterns were
made as gifts to the Ka'ba, though
they evidently never reached their
destination. Their style is similar to
that of the candlestick made for
Medina, no. 226, and it seems
reasonable to date them to the same
period.

Published: Wiet (1932, pp. 33–5); Cairo
(1969, no. 82)

228

228 Mirror of steel incised and inlaid with gold and silver

Diameter 20.8cm
*British Museum, London,
no. 1960 2–15 1*
Egypt or Syria, Mamluk period,
mid-14th century

Inner inscription
*bi-rasm al-dār al-karīma al-'āliyya
al-mawlawiyya al-ashrafiyya
al-mālikiyya al-awḥadiya
al-humāmiya al-sayyidiya
al-sanadiya al-sitr al-rafī'
wa'l-ḥijāb al-mani'*
'for the household [wife] of the
honourable, lofty, lordly, most
noble, possessing, unique, valiant,
master, authentic, the [lady with]
distinguished and protected veil.'
Outer inscription
*bi-rasm al-dār al-karīma al-'āliyya
al-mawlawiyya al-mālikiyya
al-amīriyya al-kabīriyya
al-dhukhriyya al-'awniyya
al-ghiyāthiyya al-awḥadiyya
al-humāmiyya al-niẓāmiyya
al-sayyidiyya al-akmaliyya
al-sanadiyya al-afḍaliyya
al-isfahsalāriyya al-iftikhāriyya
al-a'azziya al-akhaṣṣiyya al-sitr
al-rafī' wa'l-ḥijāb al-mani'
ṣāḥaḥā [sic] allāh*
'For the household [wife] of the
honourable, lofty, lordly,
possessing, the great amir,
treasure house [of excellence], help,
succour, unique, valiant, well-
ordering, master, most perfect,
authentic, most excellent, chief of
armies, superb, most glorious,
pre-eminent the [lady with]
distinguished and protected veil.
May God improve [?] her.'
Because ferrous metals are prone to
corrosion very few steel mirrors
remain from early Islamic times even

though textural evidence and a few
surviving examples suggest that they
were used fairly widely. A handled
mirror, probably made of steel, is
depicted in one of the scenes on the
Mosul ewer (see no. 196) and such a
style was characteristic of the Mamluk
tradition. This example, according to
the inscription, was made for the
wife of an anonymous Mamluk amir.
His blazon in the centre of the mirror
is a highly stylised pen-box which
indicates that he had been appointed
pen-box holder (*dawādār*) to the
sultan at his first amiral post. The
handle is missing from this mirror.

Published: Wiet (1958, pp. 243–7,
pl. IV)

229 Helmet of steel decorated with gold wire

Height 32cm, diameter 22cm
*Musée de l'Armée, Hôtel National des
Invalides, Paris, no. H.445*
Turkey, Ottoman period, between
1481 and 1512

Inscription around base
*allāhumma anā zājilan 'alā hāmat
al-imām al-humām wa'l-sulṭān
al-miqdām khāqān al-zamān wa
nāṣir al-islām sāḥib al-naṣr
wa'l-ta'yīd al-malik al-nāṣir
sulṭān Bāyazīd ibn sulṭān
Muḥammad Khān a'azza allāh
anṣārahu wa a'wānahu*
'Oh God, I am the head-piece for
the head of the valiant imam, the
bold sultan, the emperor of the
world, giving victory to Islam,
possessing God's help and support,
al-Malik al-Nāṣir Sultan Bāyazīd
son of Sultan Muḥammad Khān,
may God make his adherents and
his followers glorious.'

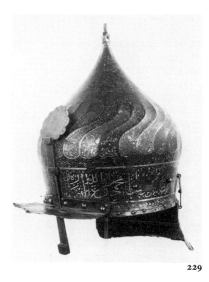

229

This helmet is of a type designed to
fit over a man's turban and is typical of
helmets used in Turkish and Mamluk
domains in the 15th and 16th
centuries. This particular example is
noteworthy as it was made for the
Ottoman Sultan Bayezid II (1481–
1512). The inlay technique employed
here is different from that used on
bronzes and brasses of this and
earlier periods. Instead of cutting or
punching shaped recesses to hold
particular pieces of inlay, the steel
workers used a technique called
kūft-garī. In this technique the whole
surface of the object is 'toothed' with
a chisel to achieve a rough surface.
The design is then drawn onto this
roughened surface onto which the
gold wire is then hammered. *Kūft-
garī* is still practised today in certain
countries such as India and Tunisia.

Published: Zaki (1961, p. 27); Paris (1971,
no. 180)

231

230 Sword of damascened steel
Length 93cm
Museum of Islamic Art, Cairo,
no. 5267
Egypt, Mamluk period, c. 1501

Inscription
al-sulṭān al-mālik al-Malik al-'ādil
al-Naṣr Ṭūmān Bāy sulṭān
al-islām wa'l-muslimīn abū al
fuqarā wa'l-masakīn qātil
al-kafara wa'l-mushrikīn muḥyī
al-'adl fī al-'ālamīn khallada Allāh
mulkahu wa 'azza naṣruhu
'The sultan, the possessing,
al-Malik al 'Ādil Abu'l-Naṣr
Ṭūmān Bāy, sultan of Islam and
the Muslims, father of the lowly
and the poor, slayer of infidels and
polytheists, the reviver of justice in
the worlds, may God prolong his
kingdom and glorify his victory.'
This curved sword has a horn hilt, a
silver gilt cross piece, and a blade
inscribed in gold. Al Malik al-'Ādil
Ṭūmān Bāy reigned only for a few
months in 1501, but it is conceivable
that the sword was made after his
deposition. It had a scabbard of
stamped leather reinforced by metal
at the edges.

Published: Zaki (1966, pp. 143–57);
Cairo (1969, no. 91)

**231 Sword with steel blade,
incomplete wooden sheath
covered with leather and
furnished with mounts of gilt
bronze with gold filigree and
enamel work**
Height 97cm, width 10cm
Staatliche Kunstsammlungen, Kassel,
no. B II 608
Spain (Granada), Nasrid period,
late 15th century

Towards the end of the last century
the Marquess of Villaseca in Madrid
is reputed to have had in his
possession the costume, sword,
dagger, double-handed sword and
knife of the last amir of Granada,
Abū 'Abdullāh Muḥammad XI. See
Riano (1879, pp. 84–5). These
articles were evidently captured,
along with Muḥammad himself, at
the battle of Lucena in 1492 by one of
the ancestors of the Marquess. The
finest of Muḥammad's arms, and the
only one bearing his name, is the
sword in the Army Museum, Madrid.
This sword is very similar but not
quite so elaborate. There is no
inscription.

Published: Sarre and Martin (1912,
no. 534, pl. 245)

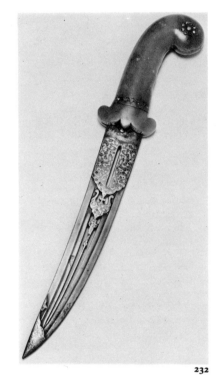

232

230

198

233

232 Dagger with steel blade
Length 35cm, length of blade 21cm
Royal Scottish Museum, Edinburgh,
no. 1890.280, originally in the
Richard Collection
Turkey, Ottoman period, late 15th–
early 16th century

Inscription is the first couplet of a
poem (*ghazal*) by the Ottoman poet
Necātī (died 1509) inscribed below
the hilt in a nastaliq calligraphy
Bir icim şu diledüm hancer-i
bürrānundan
N'ola bir kez icürürsen ne cikar
yanundan
'I besought a drink of water from
your trenchant dagger.
What if but once you should let
[me] drink, what would you lose ?'
'(I besought a sign of favour from
your piercing glance.
What have you got to lose for once
by letting me have a taste of your
favours.)'
Technically and aesthetically this
dagger is of the highest standard. The
steel blade is of a flattened diamond
section with a curved cutting edge
and central perforation. It is
decorated with interlaced arabesque
foliage, the inscription inlaid in gold.
The pistol-shaped hilt is of grey-
green jade. This example may be
compared to a dagger which belonged
to Selim I (1512–20) in the Topkapi
Palace Museum, Istanbul. The
dagger was worn as a dress accessory,
thrust into the belt which an
Ottoman gentleman wore over his
kaftan. The content of the inscription
supports a civilian rather than a
military use.

Published: London (1931, no. 832);
Rome (1956, no. 462, pl. LXXII)

233 Dagger of damascened steel
Length 34cm
St Louis Art Museum, no. 14.22,
previously in the collection of
A. U. Pope, New York
Persia, Safavid period,
early 17th century

Inscription under dragon mouth
ṣāḥibuhu Muṣṭafā Qulī Khān
Qashqā'ī
'its owner is Muṣṭafā Qulī, the
Qashgai.'
This dagger was made in the early
17th century for a leader of the
Qashgai tribes who inhabit the
country between Shiraz and Isfahan.
It has a damascened steel blade, that
is, a steel blade with a watered pattern
known in Arabic as *jawhar* and in
Persian as *firind*. The watered pattern
or damask in Persian blades is due to
the crystalline structure of the steel,
in particular the distribution of
pearlite and cementite crystals in the
metal. These crystals come about due
to the particular way the steel is made
and their distribution depends upon
the method of heating and forging the
steel cakes during the manufacture of

the blade. The visual effect is due to
the use of etching acid which reacts
differently when it comes into
contact with pearlite and cementite,
thus producing a bichrome
appearance.

Published: London (1931, no. 832R);
Pope and Ackerman (1938–9, pl. 1425D),
Welch (1973–4, no. 49, pl. 71, p. 62)

234 Plaque of open-work steel
Length 38.8cm, height 13.5cm
Victoria and Albert Museum,
London, no. M 5.1919
Persia, Safavid period, 16th century

The inscription reads
wa akhīhi asad Allāh musamman
[sic] bi'Alī
'and of his brother, lion of God,
named 'Ali.'
Acquired in Shiraz early this century,
this plaque is said to have adorned a
royal Safavid tomb. The style of
scroll work suggests a 16th century
attribution.

Unpublished

234

235 Door panel of open-work steel
Height 34.3cm, width 25.4cm
*British Museum, London,
no. OA + 368*
Persia, Safavid period, dated 1693–4

The inscription reads
*innahu min Suleymān wa innahu
bismillāh al-raḥmān al-raḥīm sana
1105 h*
'It is from Solomon and reads as
follows: in the name of God, the
merciful, the compassionate, the
year 1105 of the Hijra
[1693–4 AD].'
Sura XXVII of the Koran contains the
story of King Solomon and the Queen
of Sheba. It includes many details not
found in the Old Testament and in
verse 30 (above) the Queen of Sheba
starts to read to her noblemen a
message from Solomon demanding
submission. It may be that this door
panel was one of a set inscribed with a
large portion of this sura. On the
other hand, the inclusion of this story
on a door panel may be interpreted as
an act of egotism on the part of Shah
Sulaymān I (1666–94) under whose
reign it was made.

Unpublished

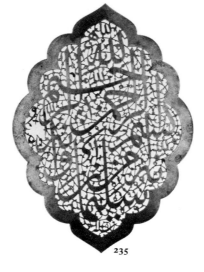

235

236 Standard of pierced steel inlaid with gold
Height 60cm, width 25.5cm
*Royal Armoury, Stockholm, no. 20/6,
previously in the collection of Prince
Sachovskoy, St. Petersburg*
Persia, Safavid period, 15th–18th
century

This standard, or banner, is of a type
still produced in Persia today.
Though it may have had a military
purpose it is more probably a
religious object, designed to be
carried on the top of a pole in the
Muḥarram procession – the annual
Shi'a tribute to the two Imams,
Ḥasan and Ḥusayn (killed at the battle
of Karbala in Mesopotamia in 680).
The inscription, which originally
embellished the border of the
standard on both sides, is now too
badly effaced to be reconstructed,
though the names of Muḥammad, the
Prophet, and of Ḥasan, are still
legible. Banners such as these are still
made by Persian craftsmen called
shabaka-kār, or steel fretworkers,
who utilise drills, files and fretsaws
to produce arabesque designs. See
Wullf (1966, pp. 72–3).

Published: Stockholm (1920, no. 237)

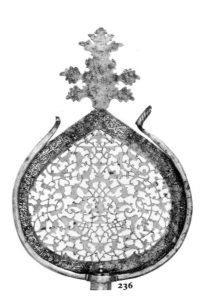

236

237a

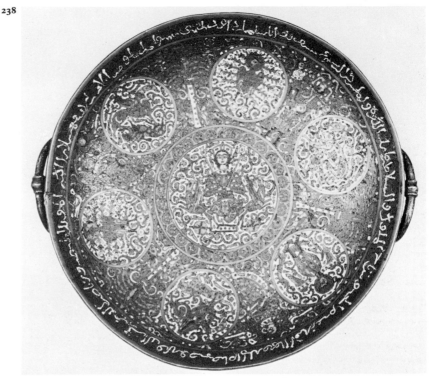

238

237a–d Four open-work steel plaques from the armature of a door

Height 13.5cm, length (maximum) 39cm
Museum of Islamic Art, Cairo, no. 15412/1–4, formerly Harari Collection
Persia, Safavid period, 17th century

Each plaque bears a different half-verse inscription referring to Muḥammad, to Fāṭima, to a warrior, perhaps 'Alī, and to Ḥasan and Ḥusayn, his two offspring. The verses, however, are out of sequence so that it is very difficult to reconstruct either the complete sense of the original or deduce the original number of plaques. The plaques are apparently cast, not forged. The nastaliq inscriptions in heavily arabicised Persian are on an open-work ground of spiral scrolls and flowers.

Published: London (1931, nos. 275/E, R, T, V, 278/6.H.V.); Pope and Ackerman (1938–9, pl. 1389)

238 Dish of bronze decorated with enamelling and copper cloisonnées, originally gilded

Diameter 22.6cm
Tiroler Landesmuseum Ferdinandeum, Innsbruck, previously in the collection of Anton von Lemmen
North Mesopotamia, 1114–44

Outside inscription is undeciphered.
Inside inscription
al-amīr al-isfahsalārī al-kabīr al-mu'ayyad al-munṣūr Nāṣir al-Dīn Rukn al-Dawla wa ṣamṣūm al-milla wa bahā' al-umma za'īm al-juyūsh tāj al-mulūk wa'l-salāṭīn qātil al-kafara wa'l-mushrikin alb Sāūghan [?] Sunqur Bek atā [?] Sukmān ibn Dāwud [sic] ibn Urṭuq sayf amīr al-mu'minīn
'The amir, chief of armies, the great, the fortified by God, the victorious, Nāṣir-al-Dīn [giving victory to religion] Rukn-al-Dawla [pillar of the state] sabre of the [Muslim] community, lustre of the [Muslim] nation, leader of legions, crown of kings and sultans, slayer of infidels and polytheists, Alb Sawghan Sunqur Bek, the father [?] Sukmān son of Dāwud, son of Urtuq, sword of the commander of the faithful.'
This dish is one of the most celebrated 'problem pieces' of Islamic metalwork as it is the only known enamelled Islamic object and its inscription shows a disconcerting ignorance of genealogy and Turkish titulature – Dāwud was the son, not the father, of Sukmān and his title was Rukn al-Dīn Dawla. As well, in form and decorative layout, this dish is the earliest known example of a gemallion, a type of vessel used for ritual washing produced in large quantities in 13th–14th century Limoges, but totally unknown in Islam apart from this single piece. In technique it is cloisonnée, not champlevé, which follows the Byzantine, not European, enamel tradition. In the centre of the dish, Alexander the Great is shown riding to heaven but the other representations are essentially Islamic in inspiration. That it was made for the Urtuqid ruler Dāwud (1114–44) is clear, but as for its provenance, the latest authority has suggested that it was the product of a north Mesopotamian workshop, working in the Byzantine tradition.

Published: Karabacek (1874, p. 36); van Berchem and Strzygowski (1910, pp. 120–8, 348–54, pl. XXI); Sarre and Martin (1912, no. 3056, pl. 159), Sourdel-Thomine and Spuler (1973, pp. 303–4, pl. XLII)

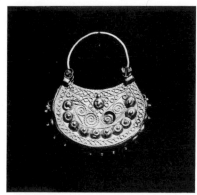

239

241

239 Earring of gold, sheet metal with filigree
Height 3.5cm
Iraq Museum, Baghdad,
no. A.10512/IM9303
Mesopotamia, 11th–13th century

Unpublished

240 Pair of earrings of gold, inlaid with turquoises and pearls and decorated with filigree
Lengths 18.2cm and 16.2cm
National Museum, Damascus,
no. A2799, found at Aleppo
Syria, Ayyubid period,
12th century

Many early Islamic earring forms, like those of other items of jewellery, were based on fashions inherited from the Roman or Sasanian worlds. These examples are unusual in the form of their central masses – a cube topped by a pyramid. But earrings with a central dome or cone and large numbers of pendant wires with beads and other shapes attached are known from both the Roman and Parthian empires, and their popularity in early Islamic times is indicated by the large numbers of silver cones from such earrings found in a hoard near Chimkent in Transoxiana, see Spitsïn (1906). One earring has its pendants attached directly to the ring.

Published: Damascus (1969, p. 209, fig. 117)

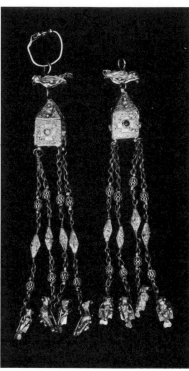

240

241 Anklet of silver, sheet metal and chased
Diameter (inside) 7.5cm
Iraq Museum, Baghdad, no. A 10356
Mesopotamia (Samarra),
11th century or later

This example and a companion piece were found in the ruins of the Qaṣr al-ʿĀshiq one of the palaces of the 9th century Abbasid capital at Samarra. Their decoration suggests that they may be rather late in date, but the popularity of chased sheet metal anklets in Abbasid time is indicated by a gold piece decorated with drinking figures and musicians. See Berlin-Dahlem (1971a, no. 157).

Published: Hamid (1967, fig. 6)

242 Bracelet of gold, once inlaid with five precious stones
Diameter (inside) 11.5cm
National Museum, Damascus,
no. A1056, found at Raqqa in 1939
Syria, Fatimid or Ayyubid period,
11th–12th century

Inscription on shorter arm
al-ʿaẓama al-dāʾima al-saʿāda
al-bāqiya al-tawfiq al-khālid
'perpetual might, enduring, happiness, eternal success.'

242

Inscription on longer arm
al-baraka al-ḥaqqa [sic] al-barra
al-niʿma al-shāmila al-namāʾ
al-ʿizz al-dāʾim al-muʿayyan
al-mulāzim al-niʿma al-ghifṭa
al-bāqiya li-ṣāḥibihi
'true and pious blessing, complete favour, growth, perpetual, fixed and continuous glory, favour, enduring felicity to its owner.'

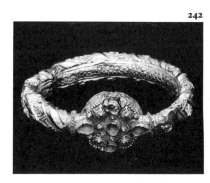

Published: Damascus (1969, p. 209, fig. 116)

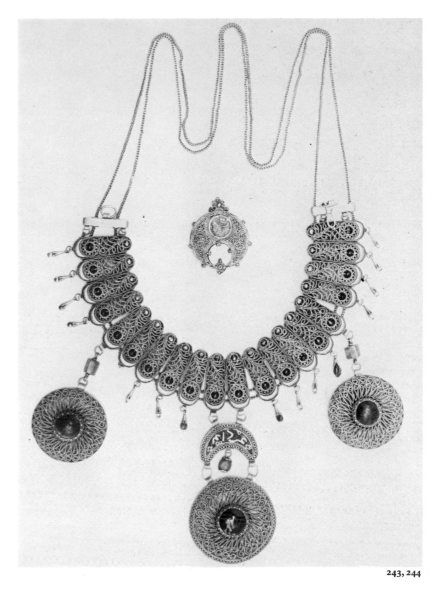

243, 244

243 Necklace with three pendants in gold with pearls and semi-precious stones
Length 24cm
*Museum of Islamic Art, Cairo,
no. 13749*
Egypt, Ayyubid period,
12th century

This necklace is composed of twenty-four bars each with gold filigree ornament in a gold shell worked in repoussé and each with a drop-pendant set with seed-pearls, amethysts and other semi-precious stones. The bars are held together by two gold chains which run between the filigree and the repoussé shell. There are three pendants all circular with fine filigree, the two outer pendants set with a bloodstone. The centre pendant hangs down from a down-turned crescent with an inscription in polychrome translucent cloisonné enamels, '*izz dā'im*, 'perpetual glory', and is set with a carbon dark amethyst.

Published: Mustafa (1955, p. 20);
Cairo (1969, no. 18)

244 Pendant of thin gold plates on a silver core
Height 4cm, width 3.2cm
*Museum of Islamic Art, Cairo,
no. 12137*
Egypt, Fatimid period, 11th century

The crescent-shaped pendant is worked on both sides with beaded wire hammered on to a gold base. The obverse bears a circular medallion with a bird and a cross in translucent enamels (green and red) with gold cloisons. The ground is somewhat decayed. Loops of gold wire on the outer and inner edges of the crescent evidently served to attach jewelled chains.

Published: Hasan (1937, fig. 245);
Mustafa (1955); Cairo (1969, no. 4)

245 Steel grill with gilding
Height 56cm, width 72.5cm
Imam Riza Museum, Mashhad
Persia, Timurid period, 1414/5

This grill was presented to the shrine in 1414 by Shāhrukh b. Timur. Some of the internal rods have disappeared and the gold inscription has been deleted in a few places. The pattern is of vertically placed diamond shapes, crossed by parallel horizontal bars. Above the grill is a naskhi inscription in relief.

amara bi-'imāra hādhā al-panjara min khāṣ mālihi al-sulṭān al-a'zam mālik al-ruqāb al-umam mu'izz al-dunyā wa'l-dīn Shāhrukh Bahādur khallada Allāh mulkahu
'The most mighty sultan, dominating the nations, glorifier of the world and the faith, Shāhrukh Bahādur, may God make his rule eternal, ordered the making of this grill from his own property.'
There is another similar inscription below

U'izza al-mawlānā [sic] al-sulṭān al-mu'azzam mālik al-ruqāb al-umam sulṭān al-salaṭin al-'arab wa'l-'ajam tammat fi shuhur muḥarram min sana 817 'amal Ustadh Shaykh Ali Khūdgar Bukhārā'ī 'amal Ustādhān kūftgar Mawlānā Shams Tabasi wa Ustādh Mahmūd kūftgar wa Ustādh [bā?] sa'ādat wa sharāfat Khawājā Ḥusayn Zāhid
'Glory to our lord the Sultan, the mighty, dominating the nations, Sultan over sultans Arab and Persian. It was finished in the months [sic] of Muharram 817. The work of Master Shaykh 'Alī Khūdgar of Bukhara, the work of master-inlayers Mawlānā Shams of Tabas and Master Mahmūd the

inlayer and Master . . . happiness and nobility Khawājā Ḥusayn Zāhid.'
There is another inscription below recording repairs and embellishments carried out in 1545/6 by Muḥammad Beg Mūṣlūtar the Turkoman; in a small cartouche to the right, above and below the main inscription, is another inscription saying 'the work of Ḥajj Muḥammad bin 'Ali Ḥāfiz al-Isfara'ini in Muḥarram 1414/5'.

Published: Mashhad (no date).

246 Copper mihrab, engraved and enamelled
Imam Riza Shrine Museum, Mashhad
Persia (Mashhad), Safavid period, 16th century

This portable mihrab was made for Ibrāhīm Riẓā b. Bahrām Mīrzā, governor of Mashhad in 1556–77.

Unpublished

247 Gold-embossed inscribed plaques
Imam Riza Museum, Mashhad
Persia, Safavid period, 1602

There are three plaques, two larger and one smaller, inscribed in nastaliq as follows:
a *amara bi-ṣiyāghat al-marqad al-ashraf al-aqdas*
b *turāb aqdām zuwwār hādhā al-ḥaram 'Abbās al-Ḥusaynī katabahu 'abd al-mudhnib [sic] 'Ali Riḍā 'Abbāsī sana 1011*
c *'amal kalb -e Riḍā mast-e 'Ali sana 1012*
a, b 'He who is but dust under the feet of the pilgrims to this shrine, 'Abbās al-Ḥusaynī [Shah 'Abbās I] ordered the decoration by goldsmiths of this most noble, most holy resting-place written by the guilty slave (or possible slave of Him who maketh men to sin) 'Ali Ridā 'Abbāsī 1011 [1602 AD].'
c 'the work of the dog of Riḍā, the drunk, on 'Ali [?] 1012.'
The inscriptions, both by Shah 'Abbās and his employees on this occasion, are remarkable instances of the humility thought proper by all at this most venerated of Shi'a shrines in Persia.

Published: Mashhad (no date).

Ceramics

406

Almost two hundred pottery vessels and tiles, ranging over nine hundred years, are included in this exhibition. The visitor cannot fail to respond to the brilliant decorative effects and the technical virtuosity of the Islamic potters. If its pottery alone were to serve as an indication of its culture, the Islamic achievement can stand on an equal footing with that of China.

Islamic pottery is made either of earthenware, that is fired clay, or of 'frit', a harder and more compact material than earthenware, which was developed in the 12th century. Vessels for the most part were thrown on the wheel. When, however, a particular shape could not be obtained in this way or when relief decoration was required, then the body material was pressed into an earthenware mould (no. 249) or modelled by hand. Simple vessels for daily practical use were supplied by local industry. In the past as in the present, it was not unusual to find such an industry in villages as well as in towns. A characteristic which the Islamic potter shares with his fellow craftsmen working in other materials is an innate desire for decoration. In some cases this could be achieved by comparatively simple means such as the large storage jar of earthenware (no. 248) where the potter has combined designs incised in the malleable clay with a sharp instrument, with patterns formed of pieces of clay attached to the surface. In the larger urban centres, however, techniques such as this could not long satisfy the artistic aspirations of the potter. Here his principal preoccupation was the application of coloured decoration to the surface of his wares; and it is this preoccupation which has directed the whole course of the ceramic history of the Islamic world.

A rudimentary way of applying colour to a pottery surface is to paint on the unfired vessel with a thin wash of clay or slip as it is usually called. The slip could be stained to the required colour – usually black or red – by the introduction of a mineral pigment. In the Near East this technique goes back to earliest times and was used in certain parts of the Islamic world. It suffered from one great disadvantage: when fired, the slip, insecurely attached to the body material, had a tendency to flake.

The only satisfactory way of attaching colour permanently to the pottery surface is by means of glaze. This is a vitreous substance which when applied to the surface of the vessel and fired in the kiln, becomes a thin glass coating. Glaze may originally have been developed in order

to render earthenware waterproof which is otherwise porous. But since glaze can be coloured, its use as a means of decoration presented endless possibilities. And it is with the development of glaze techniques that the Islamic potters achieved their greatest results.

It is due to no accident of selection that by far the greater part of the pottery displayed in the exhibition was made in Syria and Egypt, Persia and Mesopotamia. All the great artistic movements took place in these countries that form the heart land of the Islamic World. Each had a long established ceramic industry experience in a limited range of glazing techniques. It is likely, too, that the glass making industry, also well established in these countries, played a part in influencing the development of glazes. Above all, the unifying force of Islam made possible the free movement of craftsmen within the empire; so that decorative styles and techniques were disseminated rapidly from one centre to another.

One result of the establishment of the Abbasid caliphate at Baghdad, and from 836–83 at Samarra, was that the potters of Mesopotamia were stimulated to create new wares in order to meet the demands of a refined and luxury-loving court. Inspiration was provided by the white porcelains of T'ang China. These reached Mesopotamia by the sea route across the Indian Ocean and up the Persian Gulf to Basra. Since porcelain was not known in the Near East, these imported pieces were greatly valued. The local potters of Mesopotamia, endeavouring to emulate the smooth white surface of these porcelains, hit on the idea of covering their buff-coloured earthenware with a glaze rendered opaque by the introduction of tin. In fact, some of the early tin-glazed dishes are close copies of T'ang originals. But the Mesopotamian potters were far from content with mere imitation. They now began to paint in blue and green in the white tin glaze (nos. 253–7). Although they painted rather simple designs and Arabic inscriptions which might include the potter's name, the coloured glazes tended to blur at the edges when fired (no. 255). All the subsequent innovations in glaze techniques were directed to discovering a method of controlled painting on pottery.

One method discovered by the Mesopotamian potters was that of painting in lustre. The lustrous pigment consisted of a compound of sulphur, silver and copper oxides painted on the fired tin glaze and fixed in a second firing in a reducing kiln. The result is a thin metallic film imperceptible to the touch and more or less lustrous.

Although the first to paint in lustre on pottery, the Mesopotamian potters may have acquired the technique from the glass makers of Syria and Egypt who had discovered the secret of painting in lustre on glass certainly by the end of the 8th century (no. 119). At first the Mesopotamian potters used lustre paint as an overall covering of dishes with relief moulding (no. 249) evidently to simulate the appearance of a vessel of bronze, brass or gold. In this case the lustre was applied to a transparent lead glaze sometimes stained with patches of green. They next adopted it as a painting pigment on the opaque white tin glaze (nos. 258–66). In some of the earliest pieces decorated in this way, they used lustre pigment of various tones to produce a

356

polychrome effect (no. 258) but after the middle of the 9th century, they used a monochrome palette. For their designs, they drew on carved wood and stucco (no. 261) and motives which go back to Sasanian Persia such as the winged palmette (no. 259) and a stylised bird holding in its beak a foliage sprig (no. 262). In the 10th century, they introduced human figures which they rendered in a summary and stylised fashion reminiscent of contemporary textiles from Egypt (no. 263).

Towards the end of the 10th century, the Egyptian potters of Fatimid Egypt were also painting vessels in lustre. They must have learned the technique from immigrant potters of Mesopotamia. The series assembled in this exhibition (nos. 267–76, 278) provides a splendid example of the Fatimid style of decoration: abstract foliate ornament (no. 271), naturalistically drawn animals (no. 268), the fabulous gryphon (no. 273) and a boat under sail and with banks of oars (no. 269). The painters of these vessels were artists of standing and some among them signed their work (nos. 271–2, 276). Occasionally the opaque white ground was replaced by opaque green (no. 271) or turquoise (no. 278).

Syria, too, was producing lustre painted pottery in the 12th century. The decoration of these Syrian wares (nos. 298–300) has much in common with those of Fatimid Egypt and from this it may be assumed that it was Egyptian potters who brought the technique to Syria.

With the fall of the Fatimid dynasty in 1171, lustre painted pottery seems no longer to have been produced in Egypt. The technique had a great future, however, in Syria and Persia.

Another solution to the problem of combining painted designs with glaze was made by the potters of eastern Persia which in the 10th century was united with the lands beyond the Oxus under a Persian dynasty, the Samanids (874–999). At Nishapur and Samarkand (Afrasyab), principal cities of the Samanid kingdom, the potters painted their designs in coloured slips which they then covered with a transparent lead glaze (nos. 279–97). This glaze was necessarily colourless: but when the slip painting was restricted to black, the transparent glaze was sometimes stained green or yellow (no. 294). Seldom has the Arabic script been used to greater effect than in those wares where the inscription provides the sole decoration (nos. 279–83). In others, 'contour' panels are introduced as a foil to the inscriptions

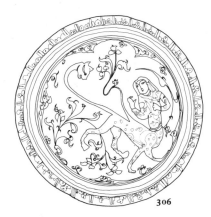

306

(nos. 237–8). Another group is painted in polychrome slip with geometric designs (no. 292). Many of the designs are those of Mesopotamian lustre wares (nos. 291, 293, 297).

Another way of decorating pottery was to incise designs through a white slip into the clay surface. When covered by a transparent glaze, whether colourless or stained green or amber, the incised lines appear as dark brown or black. The technique was practised in Persia (no. 321) as well as in Syria and in Egypt from the Fatimid to Mamluk periods (nos. 319–20). Decoration executed in this technique was purely linear. In the district of Garrus in north-west Persia, the technique was slightly varied; the ground was cut back to the clay so that the design on the slip was left standing in very low relief (nos. 322–4). The potters of this region also made tiles which they covered with a transparent green glaze (no. 325).

At another centre in north-west Persia, possibly Aghkand, the incised technique was adapted to quite another purpose. As has already been mentioned, glaze colours when applied to a glaze have an unfortunate tendency to run during firing. It was found, however, that incised lines could serve to some extent as barriers to prevent this. Here then was another step forward on the way to polychrome decoration on pottery: and the fine bowl signed by the potter Abū Ṭālib shows how effective this type of decoration can be (no. 326).

Abū Ṭālib was evidently working in a metropolitan centre since his handling of this decoration is in the style which was inaugurated in Persia, Mesopotamia and Syria under the rule of the Great Seljuqs and their successors. Seljuq decoration is alive with an almost nervous energy. Birds and animals move against a background of scrolling arabesques in which the split leaf is prominent.

Besides a radical change in the style of decoration, important technical discoveries were made in pottery and glazing techniques in the Seljuq period. Inspired by the fine porcelains imported from Sung China, the Persian potters discovered a way of producing a body clay harder and whiter than that of earthenware. This was the 'frit' material referred to above. Ground quartz was mixed with the clay so that when fired, glaze and body became perfectly fused. Because the 'frit' body was more malleable and easier to manipulate than earthenware, vessel shapes from the 12th century onward are of greater elegance and refinement. It was even possible to produce

vessels with walls thin enough to be translucent.

Among the earliest of the Persian frit wares are those inspired by the carved Ting ware of China such as the exquisite carved white bowl (no. 327). Though the form and technique are Chinese, the undulating scrolls are wholly Islamic. In other bowls, the decoration is lightly carved and the ground pierced through with small holes. When filled with the transparent glaze, these holes are translucent if held to the light. The colourless glaze was sometimes replaced by a transparent glaze of turquoise or green.

Slip painting was revived for a short period in the second half of the 12th century, probably in western Persia. The technique was similar to that of the slip painted wares of east Persia described above. In these later wares a rather thick black slip was applied to the surface of the vessel and the ground of the design cut back to the body, thus producing a firm and incisive outline: the vessel was then covered with a transparent glaze either colourless or turquoise (nos. 328–9).

The first attempts at polychrome decoration on the frit body were made by incising the outlines of the design in order to contain the colours in much the same manner as on the Aghkand wares. It is not known where precisely this ware, known as 'lakabi', was produced; but it was probably made in Persia, Syria and perhaps Egypt (nos. 340–2).

The technique of lustre painting on pottery reached Persia only in the last quarter of the 12th century when it may have been brought by Egyptian potters seeking new patrons after the fall of the Fatimid Dynasty. The earliest Persian lustre ware was made in the city of Rayy (near Tehran): and certain details of the decoration are clearly derived from the Egyptian lustre painted vessels (nos. 343, 346). One characteristic is the filling of the whole area of the face of the dish with large scale figures – human or animal – often reserved in the lustre ground (no. 344). Occasionally the lustre painting was laid on a blue glaze (no. 349). It seems that the production of the Rayy lustre wares was already in decline soon after 1200. Leadership in ceramic production had already passed to Kashan, a city about 160 miles to the south of Tehran. Its potters were to achieve fame far beyond the boundaries of their native city. The bowl painted in lustre with touches of blue and turquoise (no. 350) is among the earliest of the Kashan lustre wares and shows the typical Kashan style of decoration which is quite distinct from that of Rayy.

It may have been the potters of Kashan who were responsible for a most important technical innovation made around 1200. This was the discovery of underglaze painting. We have seen that painting in a tin glaze was unsatisfactory owing to the blurring of the colours in firing. Slip painting while not suffering from this disadvantage, allowed little freedom of the brush. The same applies to the Aghkand and lakabi techniques. Underglaze painting was made possible by the discovery that coloured pigments such as cobalt and manganese while apt to run under a lead glaze, remain perfectly stable under an alkaline glaze. The potters of Kashan seem to have been the first in Persia to have used the technique. Besides painting in black under a colourless

glaze (no. 360), they also painted in black and blue under a turquoise as well as a colourless glaze (nos. 356–60).

In yet another ware the Persian potters were able to extend their palette to as many as seven colours, by painting both under and over the glaze. The overglaze colours were applied to the fired vessel in the form of a glass paste or enamel which was then fixed to the vessel's surface in a second firing. The technique is similar to that of the enamelled glass of Syria (no. 352). Some examples of this ware which is known as 'minai', the Persian word for enamel, are decorated with narrative scenes or details evidently derived from contemporary manuscript miniatures such as the little horsemen on the bowl (no. 351), of which the colours include blue and green under the glaze and black and red enamels. Others are decorated with geometric and arabesque designs (nos. 352–4); and occasionally gilding was added (no. 355).

Raqqa, a Syrian city on the Euphrates, was also an important centre of pottery which started production towards the end of the 12th century. Like Kashan, it was producing both lustre painted and underglaze painted pottery which shares certain features with that of Fatimid Egypt; and perhaps Egyptian potters, too, emigrated to Raqqa after 1171. The potters of Raqqa excelled in the fluent drawing of their decoration in which they introduced Arabic script, often decorative rather than meaningful (no. 303), and intricate arabesques (no. 308). Occasionally they introduced human and animal figures (no. 307). At its best the decorative painting of the Raqqa wares has rarely been equalled, such as the bowl, painted in underglaze blue, black and red (no. 306).

The Raqqa potteries did not survive the devastation of the city by by the Mongols in 1259. The Mongol invasions of Persia in the 1220's were equally destructive. Rayy seems not to have recovered but the Kashan potters seem to have resumed production in the second half of the 13th century. Lustre pottery continued to be made (no. 361) but the principal effort went into the manufacture of tiles for religious buildings as far distant as Mashhad. A fine panel of interlocking star and cross tiles (no. 379) once adorned the walls of a mausoleum at Veramin near Tehran. The large frieze, decorated in relief with Koranic quotations in a majestic kufic script, is an example of the skill with which these potters were able to handle a large scale design (no. 376). One particular family – a certain Abū Ṭāhir and his descendents – manufactured lustre tiled mihrabs of which seven survive. Two frieze tiles (no. 374) were made by a member of this family.

The Mongol dynasty of the Ilkhanids set about rebuilding the civilisation of the empire they had won, with the same energy they had devoted to its destruction. The unification of Asia under the rule of the Great Khan resulted in an unprecedented exchange of trade and ideas. The style of decoration developed towards the close of the 13th and beginning of the 14th century shows a predilection for motives of Chinese origin such as the lotus, dragon-phoenix and cloud band. The style is well exemplified in the products of a pottery centre in the region

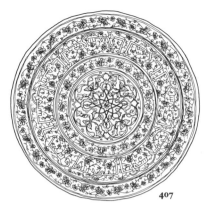

407

of Sultanabad in north west Persia and accessible to Tabriz, the
Ilkhanid capital. The Sultanabad potters produced two wares. In the
one, the vessel was covered in a grey slip on which decoration was
painted in black and raised white slip under a transparent glaze
(no. 364) and in the other, the decoration was rendered in underglaze
black, blue and turquoise (no. 368). The underglaze wares of
Sultanabad were imitated in Syria (nos. 314–5), and at the beginning of
the 14th century lustre painting on pottery was revived at Damascus,
perhaps by potters who had migrated from Raqqa after its destruction
by the Mongols in 1259. The lustre painting was applied to a deep blue
glaze, the decoration consisting of naskhi and elaborately knotted kufic
inscriptions combined with foliate scrolls (no. 311) or peacocks
(no. 313).

Other wares of Ilkhanid Persia include the so-called lajvardina type,
so called because the decoration of red and white enamel and gold leaf
was laid on a resonant blue glaze the colour of lapis lazuli
(*lājvard*) (no. 369).

With the establishment of Timur's empire, tile production became
an important industry in the great conqueror's capital city, Samarkand.
In the great tomb complex which he built for members of his family
around the shrine of the Shah-e Zinda, a much venerated Muslim
saint, the facades of the mausolea were covered with tiles of almost
every technique. Some of the most effective were carved in relief under
glazes of various colours (nos. 391–2) and were following an already
established tradition, an example of which is the fine relief carved tile
from a mausoleum in Bukhara of the middle of the 14th century
(no. 390).

Some of Persia's finest glazed tilework was made in the 15th and
16th centuries but the production of glazed pottery seems to have
declined. The blue and white porcelain of Ming China was much in
demand in Persia and other countries of the Near East from the 15th
century onwards and the few surviving Persian glazed vessels of the
period are obviously inspired by Chinese originals (no. 395). There
was, however, a revival of the pottery industry under Shah 'Abbās I
and his successors. The potters attained considerable technical
excellence with the frit body as in the beautifully potted dish and bowl
(nos. 403–4) and a large dish with floral decoration carved through the
underglaze blue (no. 399). Lustre painting was also revived and was
often combined with underglaze blue decoration (nos. 401–2). The
drawing on pottery of this period is fluent and the decoration when not
derived from Chinese blue and white porcelain consists of flowers,
birds and animals rendered in the current artistic idiom of which the
painter Riẓā 'Abbāsī was the leading exponent.

If the principal ceramic developments took place in the central
lands of Islam – Syria and Egypt, Persia and Mesopotamia – there are
two other countries of the Islamic world whose pottery holds an
important place in the history of ceramics. These are Turkey and
Spain. Although revetments of glazed tile mosaic were being made in
Anatolia as early as the 13th century, the Anatolian potters produced
no wares of consequence until the establishment of a factory at Iznik in

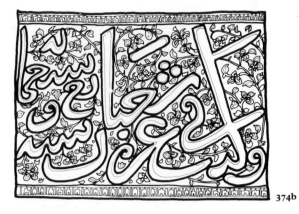

374b

north west Anatolia at the beginning of the 15th century. The early
wares of Iznik are of no great quality but at the end of the 15th century
the Ottoman court at Istanbul began to patronise the establishment.
From just before 1500 to around 1600, this factory was turning out
vessels and tiles remarkable for their quality of design and execution.
The earliest products are decorated in underglaze blue, the designs
often combining Chinese floral scrolls and cloud bands with the
classical Islamic arabesque (nos. 405–11). In the second quarter of the
16th century, turquoise and green were added to the palette and
naturalistically rendered flowers are a prominent feature of the
decoration. Around the middle of the century, the Iznik potters were
employing a palette of blue, turquoise, sage green, purple and black
(no. 413). From 1560 this palette was modified, the sage green being
replaced by a sea green, the purple by a brilliant red: and designs are
outlined in black. The decoration consists largely of flowers among
which the rose, carnation and tulip are readily recognisable
(nos. 414–9).

The Iznik potters made tiles for religious buildings in Istanbul and
the other cities of the empire. There are two magnificent examples in
this exhibition, a panel possibly from a mosque and another from an
imperial tomb (nos. 420–1).

In Muslim Spain under the Caliphate of Cordoba the principal
artistic effort was directed to architecture and its decoration. The
finest glazed ware of the period was in turquoise and manganese on a
white tin glaze – a technique derived from contemporary Egypt
(no. 422). But it was not until the 14th century that pottery became a
well established industry. The main centre was at Malaga which was
under the rule of the Nasrid kings of Granada. Here were produced
the famous vases with wing handles – their form a remote descendent
of the Roman wine amphora – painted in lustre and blue with
arabesques in a form peculiar to Andalusia. These also form the
decoration of the important lustre painted bowl (no. 423).

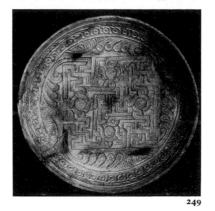

249

250

248 Jar, unglazed, decorated with carved and applied ornament

Height 65cm
Iraq Museum, Baghdad, no. A7705
Mesopotamia, 9th century

A series of large storage jars with elaborate decoration are assigned to northern Mesopotamia where they are found in great profusion, though pieces were evidently exported considerable distances, see Reitlinger (1951). This jar is an example of the earliest group. The applied decoration is made from pieces of clay rolled in the hand and formed into simple shapes on the surface of the jar with further detail incised. The band of animals which surround the body of the jar are depicted in a curious primitive style that is characteristic of the group.

Published: Baghdad (1973, no. 12, p. 60)

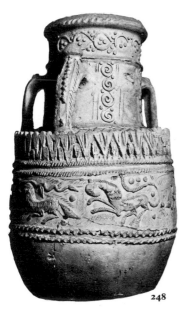

248

249 Dish with moulded decoration, yellow glaze covered with lustre and touches of green

Diameter 21.7cm
Staatliche Museen Preussischer Kulturbesitz, Museum für Islamische Kunst, Berlin-Dahlem, no. Bab. 2969, excavated at Babylon
Mesopotamia, Abbasid period, 9th century

The decoration was formed by pressing the clay over a mould in which a pattern was carved causing the design to stand in relief. The design has obvious associations with metalwork and the all-over glaze of yellow, possibly covered with a lustre coating, enhances this similarity. As the glaze tends to degrade it is often difficult to determine whether it was originally provided with lustre or not. This particular technique is probably one of the earliest Islamic fine wares to have been produced. Judging from the relatively few pieces known, it was not produced over a long period. The design of this dish shows a combination of late classical motifs, such as the swastika band, and Sasanian elements, such as the pearl border and half-palmette, characteristic of Umayyad and Abbasid art.

Published: Berlin-Dahlem (1971a, no. 163, pp. 52–3)

250 Bowl of unglazed clay with moulded decoration

Diameter 12.5cm
National Museum, Damascus, no. 17261A, found at Raqqa
Mesopotamia (al-Hira), Abbasid period, 8th century

The inscription is moulded on the exterior.
min 'amal Ibrāhīm al-naṣrānī mimmā . . . [ṣuni'a?] bi-'l-Ḥira [li-] 'l-'Amīr Sulaymān ibn Amīr al-Mu'minīn
'Made by Ibrāhīm the Christian, out of the things [made] at al-Ḥira for the Amīr Sulaymān son of the Prince of the Believers [the Caliph].'
The inscription is a most important document. Sulaymān is thought to be the son of the Caliph al-Manṣūr (754–75) who founded Baghdad. The pot was made at al-Ḥira just south of Kufa on the lower reaches of the Euphrates, but was found in excavations at Raqqa in Syria. The inscription indicates that this bowl was made to a particular order and it is suprising to find a dedication to such a highly-placed individual on a utilitarian vessel of this type. In fact, dedications to individuals are only rarely found on Islamic pottery. The lower part and base of the bowl contain decorated bands. The body is of extreme, almost egg-shell, fineness.

Published: Damascus (1969, p. 174, fig. 77)

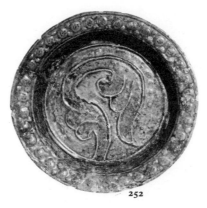

252

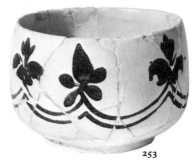

253

251 Ewer moulded in sections with relief decoration, unglazed
Height 37.2cm
National Museum, Damascus,
no. 10415A
Syria, Abbasid period, 9th or 10th century

This piece represents the continuation into Islamic times of a type of ware that had been produced for many centuries in Egypt and Syria. The decoration consists of floral or vine scrolls in a late classical manner. Other pieces, perhaps made further east, show Sasanian designs. The handle is restored.

Published: Damascus (1969, p. 174, no. 3)

252 Dish with moulded decoration, covered with green and brown glazes
Diameter 14.5cm
Victoria and Albert Museum, London,
no. C 31–1972
Egypt, Abbasid period, 9th century

Glazed moulded relief wares were made during the 9th century in both Egypt and Mesopotamia and have telling differences: the Egyptian pieces have a slightly coarser body material and are decorated with brown and green glazes, the Mesopotamian pieces have a fine body and are usually decorated with yellow and green glazes or lustre, see no. 249. The technique of moulding pottery in relief can be traced back to the Roman period in Egypt and it is thought that it was taken from there to Mesopotamia. However, one piece in the British Museum, London, has an inscription which states that it was made in Egypt by a potter from Basra in Mesopotamia. The interior of this dish shows a half-palmette motif.

Unpublished

253 Bowl painted in blue on an opaque white glaze
Height 9.5cm, diameter 12cm
Ashmolean Museum, Oxford,
no. Ash 715, NE 506, Gerald
Reitlinger Collection
Mesopotamia, Abbasid period, 9th century

Tin glazed wares of the Abbasid period, in shapes other than shallow bowls or flat dishes, are rare. This cup is the only known example of this shape though its band of palmette motifs is typical of the decoration of the blue on white wares.

Published: London (1969, p. 11, no. 9)

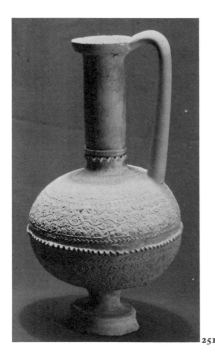

251

254

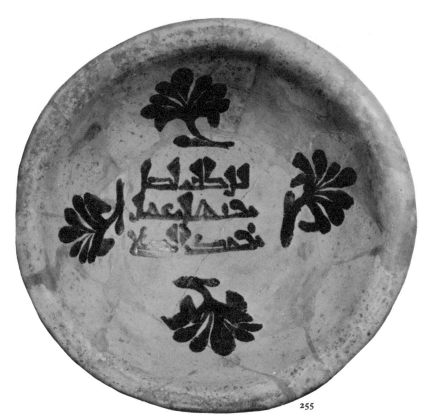

255

254 Bowl painted in blue on an opaque white glaze
Diameter 22.5cm
Museum für Kunsthandwerk, Frankfurt am Main, no. 12674
Mesopotamia, Abbasid period, 9th century

The inscription is not entirely clear and may be the signature of the potter. A bowl with an identical border pattern has the words *'amal Şāliḥ*, 'work of Şāliḥ', in place of this inscription, though written in a different hand, see Lane (1947, pl. 9a). The half-moon border which occurs in this bowl in an elaborate form is a motif also found on Abbasid lustre wares. It was used on Egyptian lustre wares in the 11th and 12th centuries and at the end of the 12th century is found on Persian wares.

Published: Düsseldorf (1973, p. 36, no. 25)

255 Bowl painted in blue on an opaque white glaze
Diameter 23.5cm
Staatliches Museum für Völkerkunde, Munich, no. 28-8-82
Mesopotamia or Persia, Abbasid period, 9th century

Inscription in the centre.
 baraka li-şāḥibihi 'amal
 Muḥammad al- . . . ?
 'Blessing to its owner, the work of Muḥammad the . . .'
Several other pieces by this potter are known, each in the same technique and with the same design of bunches of sprays, see London (1969, no. 6). Wares of this type are often only decorated with brief blessings to the owner and a signature. Tin-glazed wares, ie. those covered with an opaque white glaze, were first developed in Mesopotamia when they were painted in blue or decorated with lustre. By the end of the 9th century wares painted in blue were also being made in Egypt and Iran. This bowl is reported to have come from Rayy in Persia.

Published: Düsseldorf (1973, no. 24, p. 35)

256 Bowl painted in blue on an opaque white glaze with splashes of green
Diameter 38.3cm
Iraq Museum, Baghdad, no. A 6942, found at Samarra
Mesopotamia, Abbasid period, 9th century

The extensive splashes of green have obscured part of the signature written in blue. Only *mā 'amala*, 'made by . . .' shows clearly, but enough of the name of the potter remains in order to identify him with the potter who signed other pieces such as a bowl in a private English collection which is also splashed with green, see London (1969, no. 10) and a fragment excavated at Nishapur whence it had, no doubt, been exported, see Wilkinson (1973, p. 183, no. 4). Though several versions of the signature of the potter exist, a clear reading is still not possible.

Published: Baghdad (1973, p. 60, no. 15)

256

257

258

259

257 Bowl painted in blue on an opaque white glaze with splashes of green

Diameter 24cm
*National Museum, Damascus,
no. A 2719/4809, found at Aleppo*
Mesopotamia, Abbasid period,
9th century

The inscriptions on wares of this class often give the potter's signature though the exact reading of the inscription on this bowl is unclear. The splashes of green glaze running down from the rim in drops towards the centre are commonly found on wares of this type. The green colour in the form of a highly fluxed glaze was probably placed on the raw white glaze before firing and did not mix with the white glaze because of the viscosity of the latter during firing. The splashes are often thought to be in imitation of imported Chinese splashed wares of the T'ang period. However, no well authenticated piece of Chinese origin has yet been discovered in the Middle East. This fact and a discrepancy in the dates between the Chinese and Middle-Eastern versions make an independant Middle-Eastern development of the technique seem the more likely explanation, see Watson (1970, pp. 39–40).

Published: Damascus (1969, p. 246, fig. 138)

258 Bowl decorated in lustre on an opaque white glaze

Diameter 26.5cm
Staatliche Museen Preussischer Kulturbesitz, Museum für Islamische Kunst, Berlin-Dahlem, no. Samm. 1102, excavated at Samarra
Mesopotamia, Abbasid period,
mid-9th century

Lustre wares using more than one lustre colour were produced in Mesopotamia prior to the adoption of the monochrome palette some time in the second half of the 9th century. The polychrome wares are characterised by rather broad designs, often filled with varying patterns. The design of this bowl is unique and shows a highly stylised eagle with outstretched wings holding in its beak a curious spray. Animals and birds in heraldic poses holding sprays in their beaks are common in lustre painting in the 10th and 11th centuries both in Mesopotamia and Egypt.

Published: Sarre (1925, taf. XIII, pp. 40–1); Kühnel (1934, pp. 154–7, fig. 4); Berlin-Dahlem (1971a, no. 168, pl. 33)

259 Bowl decorated in lustre on an opaque white glaze

Diameter 26.1cm
Dr Ulrich Schultze-Frentzel Collection, Federal Republic of Germany, acquired in Persia
Mesopotamia, Abbasid period,
9th century

This piece is typical of Abbasid lustre wares in which an attempt is made to cover the whole surface with a varied pattern of different textures. In this bowl the main design, that of a Sasanian wing motif, is somewhat submerged in an overall pattern. The inspiration for this rendering may be sought in the perforated designs of contemporary stucco work. Similar designs, including the wing motif, also occur in Koran manuscript illuminations of the period. The decoration contrasts with the very plain treatment of the blue on white wares which were made in the same area, and perhaps even in the same workshops.

Published: Dusseldorf (1973, no. 100, p. 82)

260 Bowl decorated in lustre

Diameter 27cm
Museum of the Great Mosque, Kairouan
Found in North Africa, 9th century

This piece presents an unique design for lustre ware of this period: a field of foliage surrounded by a guilloche border which is interupted by four 'splashes'. Splashes combined with lustre are otherwise unknown, as is the border decoration. This may possibly indicate that it is a local North African product rather than an import from Mesopotamia. Similar foliage is however found on the imported lustre tiles decorating the mihrab of the mosque at Kairouan.

Unpublished

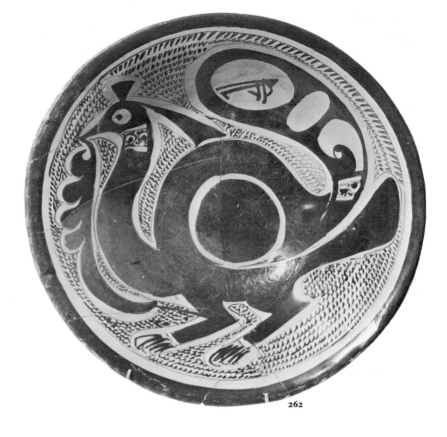

262

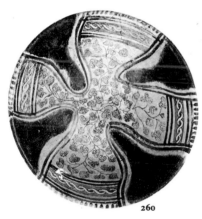

260

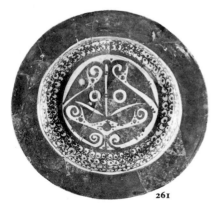

261

261 Bowl decorated in lustre on an opaque white glaze
Diameter 32.5cm
Iran Bastan Museum, Tehran, no. 3050, found at Istakhr
Persia, 9th–10th century

One of the most impressive of the early lustre vessels, both in design and technical finish. The wide lustre border is unusual, as is the use of the peacock eye motif as an interior band. The central design of interlocking half-palmettes is found on other vessels and was taken to Egypt along with the lustre technique sometime in the 10th century. Lustre was exported widely throughout the Islamic world and it is still not certain whether the large number of early lustre vessels found in Persia are of local manufacture or are imported wares. No distinctive features of design and technique have yet been analysed which distinguish pieces found in Persia from those of Mesopotamia.

Published: Melikian-Chirvani (1972, fig. 110)

262 Bowl decorated in lustre on an opaque white glaze
Diameter 26.6cm
On loan to the Brooklyn Museum, no. L. 63. 9.23
Mesopotamia, 10th century

From the abstract design of the Abbasid lustre wares there developed another type of decoration usually assigned to 10th century Mesopotamia. Here the designs of animals and figures, in varying degrees of stylisation, are set in a background of stippled contour panels. The bird (peacock?) on this bowl bears little resemblance to the highly stylised eagle of no. 258 but still bears a foliate spray in its beak, an iconographic trait that had existed in pre-Islamic times in both the Christian Middle East and in Persia.

Published: Brooklyn (1963–4, pl. 1)

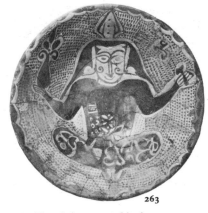

263

**263 Bowl decorated in lustre on
an opaque white glaze**
Diameter 22.5cm
*Ashmolean Museum, Oxford,
no. 1956–66, gift of Sir Alan Barlow*
Mesopotamia, 10th century

Amongst lustre painted wares with
contour panels are a number of
pieces decorated with human figures
with large almond eyes and noses
delineated by two parallel brush
strokes. The influence of Central
Asian motifs has been discerned in
these wares, for example in the pose
of the seated prince with a cup in his
hand, as is found in this bowl. The
facial features, however, may have
been derived from Christian sources,
especially textiles, where similar
iconographic conventions are found.
The bowl has been restored with
fragments from another vessel. The
word above the left shoulder of the
figure reads '*amal*, 'the work of . . .',
but no name is given.

Published: Fehervari (1963, fig. 8, and
1973, p. 46, no. 19, pl. 11b)

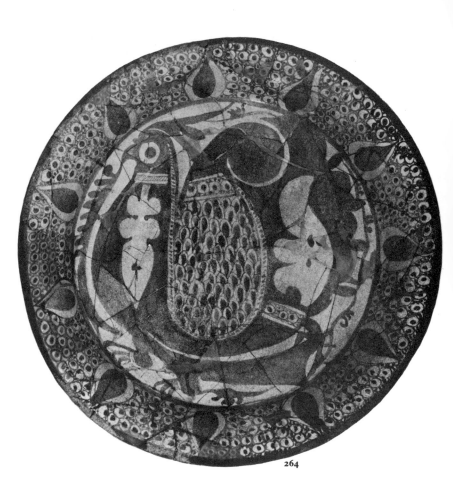

264

**264 Dish decorated in lustre on
an opaque white glaze**
Diameter 31.2cm
*Musée du Louvre, Paris, no. MAO 131,
gift of J. Homberg*
Mesopotamia, 10th century

Inscribed on the base is *baraka
li-ṣāḥibihi*, 'Blessing to its owner.'
The peacock-eye motif of the border,
the bird filling the central field, the
half-palmette forming the tail and the
spray of foliage held in the beak are all
characteristic elements of Meso-
potamian lustre wares. This dish has
no contour panels and is related to a
group of which several examples are
reported to have been found in
Persia, though local manufacture
cannot be assumed.

Published: Paris (1971, p. 46, no. 21);
Sourdel-Thomine and Spuler (1973,
abb. 151)

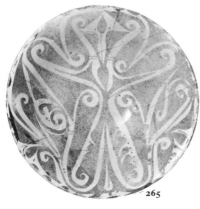

265

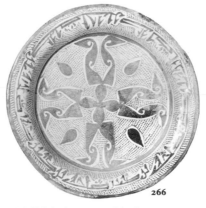

266

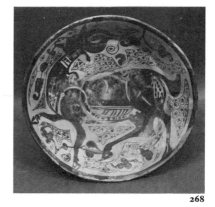

268

265 Bowl decorated in lustre on an opaque white glaze
Diameter 20.5cm
David Collection, Copenhagen, no. 26/1962
Mesopotamia, 10th century

On the base of the bowl appears the word *baraka*, 'blessing'. The decoration of interlocking half-palmettes is used here to cover the whole interior of the bowl. The design in this example has certain affiliations with the 'bevelled' style of plaster work and wood carving, used both in Mesopotamia and Egypt. The way in which the motifs interlock is common in all techniques as is the way in which the tails of the palmettes curl in sharply on themselves.

Published: Davids-Samling (1970, p. 118, no. 31, pl. 132)

266 Dish decorated in lustre on an opaque white glaze
Diameter 30.5cm
David Collection, Copenhagen, no. 14/1962
Mesopotamia, Abbasid period, 9th–10th century

The inscription round the rim is a repetition of the phrase *baraka li-ṣāḥibihi*, 'Blessing to its owner.' The rather unusual design contained within a contour panel background is formed by angular half-palmette motifs arranged in a cruciform. The shape of this dish, with its broad rim, shallow well and absence of foot-ring, is derived from a metal shape and was popular throughout the 9th and 10th centuries.

Published: Davids-Samling (1970, pp. 154–5, no. 33, pl. 118)

268 Bowl decorated in lustre on an opaque white glaze
Diameter 25.3cm
Cleveland Museum of Art, no. 44.476, purchase from the J. H. Wade Fund
Egypt, Fatimid period, 11th century

The deer on this bowl is most sensitively and naturalistically drawn, to a degree rarely found in Mesopotamian ceramic decoration, and contrasts with the abstract contour panels which fill the surrounding space. The deer holds a foliate spray in its mouth, a trait already observed in the birds on Mesopotamian lustre wares.

Published: Cleveland (1944, p. 32, and 1966, no. 701); Hollis (1945, pp. 44–5)

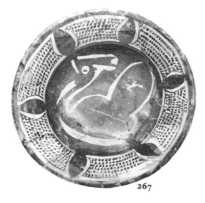

267

267 Dish painted in lustre on an opaque white glaze
Diameter 18cm
Museum of Islamic Art, Cairo, no. 16335
Egypt, early 10th century

The interior of the dish is filled with a stylised representation of a duck or swan. The style is characteristic of lustre wares from 10th century Mesopotamia but which have also been attributed to Egypt. The exterior has monochrome rings on a ground of dots and hatched lines. On the base is a signature, possibly to be read as *Dahhān*, the father of the Egyptian potter Muslim, known from many inscribed lustre examples see nos. 271–2.

Unpublished

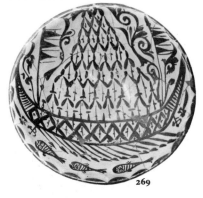

269

269 Bowl painted in lustre on an opaque white glaze

Diameter 28.5cm
*Museum, of Islamic Art, Cairo,
no. 7900, found at Bahnasa in
Upper Egypt*
Egypt, 10th century

The decoration represents a barge with a single bank of fourteen oars, anchors at prow and stern, and a schematically represented triangular rigged sail. Below are three fish with staring eyes. The boat and the fish are strikingly similar to the ships of Hatshepsut on the reliefs at Dayr al-Bahari which went to Punt c. 1495 BC, see Hourani (1951, fig. 2). The exterior of the bowl is decorated with double roundels and rather crude foliate trails in reddish lustre.

Published: Wiet (1930, no. 61); Cairo (1969, no. 93)

270 Bowl decorated in lustre on an opaque white glaze

Diameter 13.5cm
*Staatliche Museen Preussischer
Kulturbesitz, Museum für
Islamische Kunst, Berlin-Dahlem,
no. 1.267*
Egypt, Fatimid period, late 10th–early 11th century

The kite-shaped motifs are decorated with what may be a corrupt rendering of the word *Ẓafar*, 'Triumph', replacing the hares.

Published: Pinder-Wilson (1957a, p. 141, fig. 5); Berlin-Dahlem (1971a, no. 302); Düsseldorf (1973, no. 105, p. 89)

271

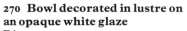

270

271 Bowl decorated in lustre over a green glaze

Diameter 25cm
*Staatliche Museen Preussischer
Kulturbesitz, Museum für
Islamische Kunst, Berlin-Dahlem,
no. 1.46/64*
Egypt, Fatimid period, early 11th century

Inscription on the base of the bowl, *'amal Muslim*, 'the work of Muslim'. Muslim was among the most prolific lustre potters of the early Fatimid period. See Jenkins (1968, pp. 359–69). One of the two dateable Egyptian lustre vessels bears his signature and the name of a courtier in the service of the Caliph al-Ḥākim bi-amr-Allāh (996–1021). The production of Muslim is characterised by a vigorous approach to design which loses little by the occasional lack of finesse, see also no. 272. The green glaze of this bowl is most unusual in wares this period but the half-palmette leaf with serrated edge and a tail curling in upon itself is characteristic.

Published: Düsseldorf (1973, no. 106, p. 89)

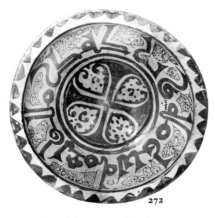

272

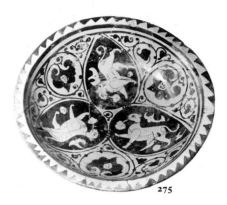

275

272 Bowl decorated in lustre on an opaque white glaze
Diameter 25cm
Museum of Islamic Art, Cairo,
no. 15958, formerly in the
Ali Ibrahim Pasha Collection
Egypt, Fatimid period, 11th century

The rounded sides of the bowl bear a kufic inscription with elegant serifs.
Ni 'ma shāmila wa baraka kāmila
'Complete favour and perfect blessing'
The inscription is painted on a ground of irregular panels with spidery scrolls. The exterior and base are covered with thinnish glaze and have double roundels on a scrawled hatched ground with the signature of the potter Muslim in a cursive script.

Published: Mehrez/Muhriz (1944, nos. 9–10); Cairo (1969, no. 98)

273 Bowl decorated in lustre on an opaque white glaze
Diameter 24.5cm
Museum of Islamic Art, Cairo,
no. 14938
Egypt, Fatimid period, 11th century

The decoration of this bowl consists of a gryphon reserved on a ground of two foliate trails which spring from its tail. The exterior is evenly glazed and has schematic decoration in gold lustre. The vessel has not been well potted and the rim, in particular, shows two marked indentations over which the fine lustre design was nevertheless painted.

Published: Hasan (1951, p. 104); Cairo (1969, no. 99)

275 Bowl decorated with lustre on an opaque white glaze
Diameter 39cm
Museum of Islamic Art, Cairo,
no. 13123
Egypt, Fatimid period, 11th century

The interior of this bowl is decorated with three almond-shaped medallions containing animals, possibly cheetahs, with bold heart-shaped palmettes between. The exterior has traces of over-fired scrawled circles in lustre. The contrast between the fine decoration and the poor potting is striking.

Unpublished

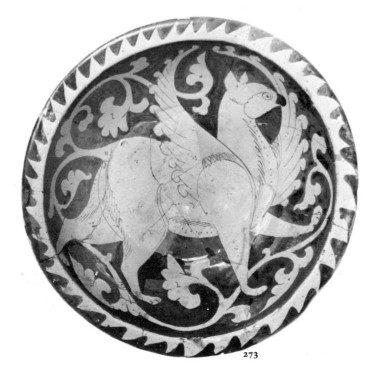

273

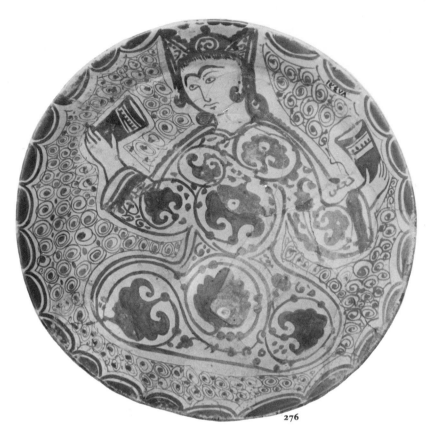

276

278

**278 Bowl decorated in lustre
on an opaque turquoise glaze**
Diameter 15.5cm
*National Museum, Damascus,
no. 13584A*
Egypt, Fatimid period, 12th century

The Egyptian potters had already
experimented with lustre painting on
coloured glazes, see no. 271, but the
painting on an opaque turquoise
glaze is perhaps the most successful.
The rich turquoise colour does not
drown the lustre decoration as is the
tendency of the dark blue, compare
no. 311. The pseudo-inscription that
forms the main motif on this bowl
occurs in a similar fashion as a border
motif in Persian lustre wares of the
late 12th century. However, Persian
lustre decoration is never found on
monochrome turquoise glazes in
spite of the popularity of that colour
for other wares.

Unpublished

**276 Bowl decorated in lustre
on an opaque white glaze**
Diameter 27.5cm
*Museum of Islamic Art, Cairo,
no. 13478*
Egypt, Fatimid period, 11th century

The decoration represents a seated
woman, or perhaps a youth, with the
face in three-quarter profile wearing
a crown below which appears a
fringe, forelocks and long tresses
falling to the shoulders. The wide-
sleeved dress is created by heart-
shaped palmette scrolls and shows no
folds. A beaker is held in each hand,
beside that in the left hand is the
signature of the potter, *Ja'far*. The
exterior of the bowl is not glazed all
over and the thin glaze shows a body
markedly more red than other
Fatimid lustre pieces. There are
traces of over-fired lustre circles.

Published: Hasan (1951, p. 99), Yusuf
(1962, p. 184); Cairo (1969, no. 108)

**277 Jar decorated with opaque
green, yellow, purple and white
glazes**
Height 30.5cm
*Museum of Islamic Art, Cairo,
no. 15980, formerly in the Ali
Ibrahim Pasha Collection*
Egypt, Fatimid period, 10th–11th
century

The decoration is of alternating
eight-pointed stars and crosses, each
of the former containing an
inscription, *baraka kāmila*, 'perfect
blessing', in purple. Pieces in this
technique are often attributed to
Fayyum but there is still no
conclusive evidence for their
manufacture there.

Published: Hasan (1938, p. 321);
Cairo (1969, no. 95)

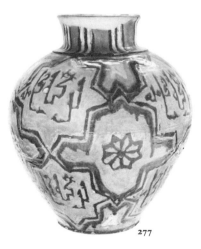

277

279

279 Dish decorated with white and black slips under a transparent glaze
Diameter 37.2cm
St Louis Art Museum, no. 283.51
East Persia or Transoxiana,
10th century

In spite of the simple technique this epigraphic ware is probably the most refined and sensitive of all Persia pottery. Nishapur and Afrasiyab, near Samarkand, are both major find spots and the ware is presumed to have been made in both places. The decoration relies entirely upon different varieties of kufic script, and the distortions and embellishments of the letters often render the inscriptions difficult to read. Such a difficulty may not have been encountered at the time of manufacture as the inscriptions consist of aphorisms and proverbs which were, no doubt, widely known. In spite of this purely epigraphic decoration no example is known which contains the signature of a potter, or a date. On this dish, the inscription reads:
 al-tadbīr qabl al-ʿamal
 yuʾminuk min al-nadam k . . .
 'Deliberation before action
 protects you from regret, k . . .'
The superfluous letter 'k' is used as a space-filler at the end of the inscription.

Published: Volov (1966, p. 117, fig. 2)

280

280 Dish decorated with white and dark brown slips under a transparent glaze
Diameter 36cm, height 11cm
Staatliche Museen Preussischer Kulturbesitz, Museum für Islamische Kunst, Berlin-Dahlem, no. 1.26/60
East Persia or Transoxiana,
10th century

This piece exemplifies the Eastern Persian epigraphic ware at its most restrained and elegant. The inscription has little pointing and the distortion of the letters consists only of the elongation of certain strokes.

Published: Erdmann (1967, pl. 37b); Berlin-Dahlem (1971a, p. 72, no. 250)

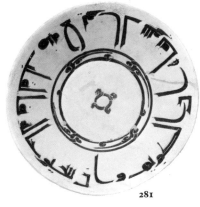

281

281 Dish decorated with white and brown slips under a transparent glaze

Diameter 20.5cm
*David Collection, Copenhagen,
no. 37/1966*
East Persia or Transoxiana,
10th century

The inscription in kufic reads
*inna al-karīm wa'inna sa'īd
ḥālahu fa'l-qalb minhu lā yazāl
sharīfan*
'As for the generous man, verily
his condition is happy and his
heart will remain noble.'
The more ornate decoration perhaps
indicates a slightly later date than the
vessels decorated with very plain
inscriptions. This inscription is
typical of the aphorisms found on
such epigraphic wares and the letters
are unusually clear with almost all the
pointing shown.

Published: Davids-Samling (1970, p. 113,
no. 26, p. 147)

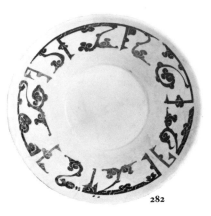

282

282 Dish decorated with white, black and red slips under a transparent glaze

Diameter 26.5cm
*David Collection, Copenhagen,
no. 22/1974*
East Persia or Transoxiana, second
half 10th century

The inscription is in ornate kufic the
letters being plaited and floriated
which indicates a later date than the
more simple inscriptions.
*man ayqana bi-'l-ḥalaf jāda
bi-'l- . . . [?]*
'He who believes in the pact [with
God] is generous to the . . . [?].'
In this dish there has been an attempt
to form a rhythmic pattern of the
letters and their foliated decoration,
which rendered the inscription
difficult to read.

Published: Davids-Samling (1975, pl. 21)

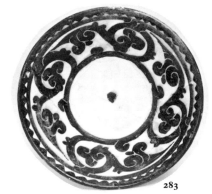

283

283 Dish decorated with white and black slips under a transparent glaze

Diameter 14cm
*Victoria and Albert Museum, London,
no. C92–1969, formerly in the
Mallet Collection*
East Persia or Transoxiana,
10th century

Floriate devices used in larger pieces
to decorate letters are formed, in this
example, into a scroll to replace the
inscription. Several other small
dishes of this type are known, some of
which contain inscriptions of the
highest quality.

Published: London (1969, p. 18, no. 37)

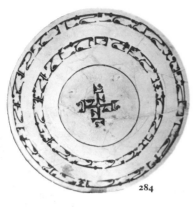

284

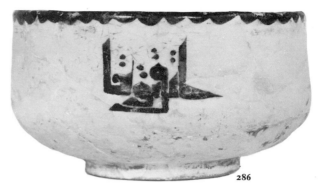

286

284 Dish decorated with white, brown and red slips under a transparent glaze
Diameter 44cm
Iran Bastan Museum, Tehran, no. 21169
East Persia or Transoxiana, 9th–10th century

Two inscriptions decorate this dish. The floriate decoration springing from the top of certain letters to fill the gaps between the high risers is intended to give the impression of two ornamental bands. The complexity of decoration seen in these inscriptions did not develop in these epigraphic wares until the latter part of the 10th century, or possibly the early 11th century.

Published: Washington (1964–5, no. 563)

286 Cup decorated with white, dark brown and red slips under a transparent glaze
Diameter 12.2cm
Staatliche Museen Preussischer Kulturbesitz, Museum für Islamische Kunst, Berlin-Dahlem, no. 1.73/62, acquired in 1962
East Persia or Transoxiana, 10th century

The characteristic forms of eastern Persian slip wares are dishes and bowls with straight flaring walls; other forms are not common. The form of this cup with a ring handle and horizontal thumb plate at the top has a long history in the Middle East in glass, metal and pottery, and derives ultimately from a common form of Roman silver drinking vessel.

Published: Berlin-Dahlem (1971a, no. 254, pl. 39)

287 Dish decorated with white, black and red slips under a transparent glaze
Diameter 38.8cm
Iran Bastan Museum, Tehran, no. 3911, excavated at Nishapur
East Persia, 9th–10th century

This piece was excavated at Nishapur in the late 1930s and was thought to have been imported from Afrasiyab. In spite of the large amount of material recovered from both sites only small differences in the decoration have been adduced to distinguish the fine epigraphic wares of these two centres. Contour panelling of the letters and a tendency to decorate the centre of the vessel with more than a simple word or dot are characteristic of Afrasiyab wares. The calligraphic styles of wares from the two sites, however, are often very similar.

Published: Wilkinson (1973, p. 146, no. 1)

285 Bowl decorated with white and dark brown slips under a transparent glaze
Diameter 27.4cm
F. Amon Collection, France
East Persia or Transoxiana, 11th century

The inscription runs across the field of the plate rather than round the border, and the decorative aspect of the letters dominates. A late date for this bowl is perhaps indicated by the less fine quality of both the calligraphy and potting. Spur marks are left on the inside by a tripod supporting another vessel above it in the kiln.

Published: Düsseldorf (1973, no. 49, p. 51)

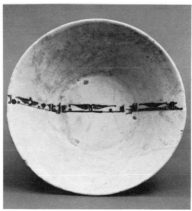

285

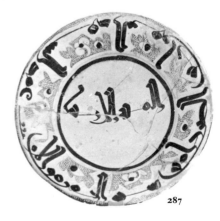

287

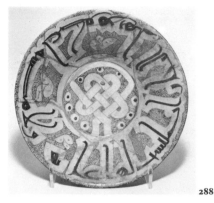

288

288 Dish decorated with white and dark brown slips under a transparent glaze
Diameter 32cm
K. R. Malcolm Collection, England
East Persia or Transoxiana,
10th century

The austerity of decoration found on other epigraphic wares is here modified by the use of stippled contour panels. Some East Persian wares are strongly influenced by Mesopotamian techniques and designs including the contour panels which are taken from a certain class of lustre ware, see no. 262. These and the decoration in the centre of the bowl indicate that it may be an Afrasiyab rather than a Nishapur product.

Published: London (1969, p. 15, no. 26)

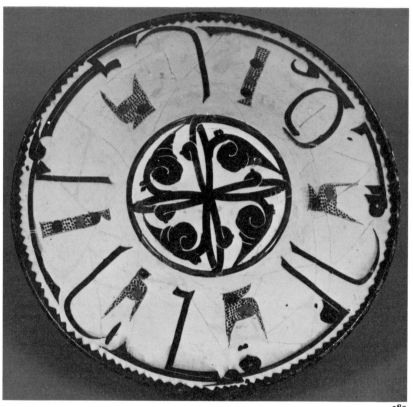

289

289 Bowl decorated with white and dark brown slips under a transparent glaze
Diameter 22.5cm
Los Angeles County Museum of Art, no. M 73.5.199, The Nasli M. Heeramaneck Collection, gift of Joan Palevsky
Transoxiana, 10th century

The contour panels are here reduced to minimal proportions and serve not as a background filler but to balance the rhythm of the inscription. The heavy foliate decoration contained within a circle in the centre may indicate an Afrasiyab product.

Published: Los Angeles (1973, no. 7)

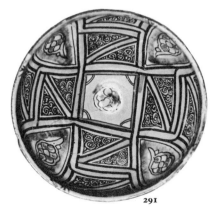

291

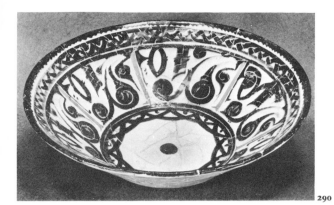

290

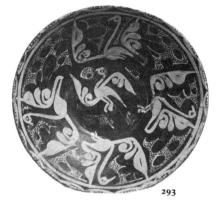

293

290 Plate decorated with white, black and red slips under a transparent glaze

Diameter 26cm
Seattle Art Museum, no. 56. Is 26.18, Eugene Fuller Memorial Collection
East Persia or Transoxiana, 10th century

The inscription consists of the repetition of a meaningless word and is purely decorative. It is thought that complexity of decoration and use of mock inscriptions indicate a late date within the epigraphic series, although the technical quality of these later pieces is by no means inferior. Dating of the East Persian slip painted wares is still very general and not a single dated or closely datable piece has been found.

Published · Volov (1966, p. 126, fig. 9)

291 Bowl decorated with green, black and yellow slips under a transparent glaze

Diameter 21cm
Iran Bastan Museum, Tehran, no. 20803, excavated at Nishapur
East Persia (Nishapur), 9th–10th century

Of the same group as no. 293, but with scrolls filling the background rather than hatched lines, perhaps in imitation of imported lustre wares. The design and colouring is, however, of purely eastern origin, as is the technique.

Published: Wilkinson (1973, p. 15, no. 47, pls. 47a & b)

292 Bowl decorated with green, black and yellow slips under a transparent glaze

Diameter 22cm
Iran Bastan Museum, Tehran, no. 3055, excavated at Nishapur
East Persia (Nishapur), late 9th–early 10th century

The simple geometric designs and basic colour scheme designate this bowl as a 'rough' ware rather than a 'fine' one. It is neither as technically competent or as artistically sophisticated as the wares with epigraphic designs which were made in the same area at the same time. The difference in quality alone, however, cannot account for the very different approach to decoration which in this ware covers the whole surface with a vivid pattern in bright colours, contrasting sharply with the austere scheme of both decoration and colour observed in the epigraphic wares.

Published: Wilkinson (1973, p. 8, no. 2, p. 30)

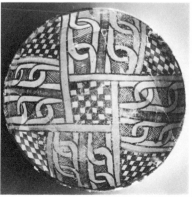

292

293 Bowl decorated with purple-brown and white slips under a transparent glaze

Diameter 28.2cm
On loan to the Brooklyn Museum, no. L.59.3.4
East Persia, 10th century

While the technique of this bowl is entirely in the East Persian tradition, certain details of the decoration, such as the half-moon border and the contour panelling, indicate that it is based on Mesopotamian prototypes. However, the drawing of the birds and, in particular, the half-palmette wings set at a distance from the body, have a calligraphic quality typical of the eastern Islamic world. The derivation from imported lustre wares is made clear from certain examples of this group which preserve the colour scheme and decorative style, but which are painted in slip *over* the glaze in imitation of the technique as well as the style of lustre painting

Published: Brooklyn (1963–4, no. 15)

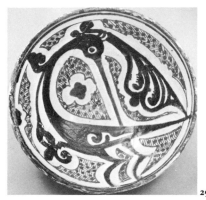

294 see colour plate, page 49

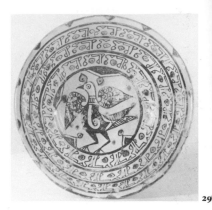

29

294 Bowl decorated with white and black slips under a yellow glaze
Diameter 18.4cm
Los Angeles County Museum of Art, no. M.73.5.130, the Nasli M. Heeramaneck Collection, gift of Joan Palevsky
East Persia (Nishapur), 10th century

The design of this bowl is taken from Mesopotamian lustre wares of the contour panel group which were exported to the eastern provinces of the Islamic world. In this example the design has undergone some changes; the contour panels are hatched rather than stippled, the undecorated borders are wider and the drawing of the bird is a little more stylised, compare no. 262.

Published: Los Angeles (1973, no. 22 and colour plate)

295 Bowl decorated with black and white slips under a transparent glaze
Diameter 14cm
Los Angeles County Museum of Art, no. M.73.5.129, the Nasli M. Heeramaneck Collection, gift of Joan Palevsky
East Persia or Transoxiana, 10th century

Birds were often used as decorative motifs in the East Persian slip wares. In this example the bird provides the principal decorative interest and its extreme stylisation, particularly in the treatment of the wings, gives the bird a strong calligraphic character. The circle on the body of the bird is a trait common in Mesopotamian and Egyptian lustre wares.

Published: Los Angeles (1973, no. 10)

296 Bowl decorated with yellow, green and black slips under a transparent glaze
Diameter 22cm
Iran Bastan Museum, Tehran, no. 3053, excavated at Nishapur
East Persia (Nishapur), 10th century

Three bands of pseudo-kufic script encircle a bird in the interior of this bowl. The inscription is a repetition of a meaningless word.

Published: Wilkinson (1973, p. 25, no. 73, pl. 73a and b)

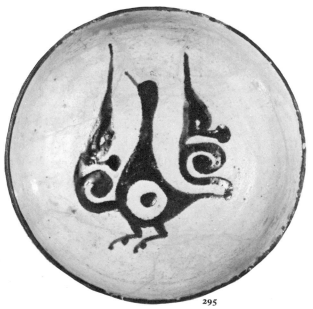

295

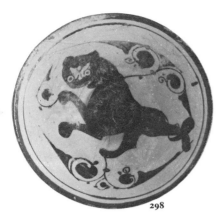

298

**298 Bowl painted in lustre on a
transparent glaze**
Diameter 20cm
*Museum of Decorative Art,
Copenhagen, no. 28/1959, found at
Tell Minis*
Syria, mid-12th century

During the 11th and first half of the
12th century, Egypt had a monopoly
of fine glazed wares, and of lustre
wares in particular. This pre-
eminence was lost on the fall of the
Fatimid dynasty in 1171. But the
mid-12th century lustre wares
discovered at Tell Minis in Syria
show that Egyptian potters already
had serious rivals. The designs of
Syrian lustre wares are based closely
on Egyptian patterns and it is most
likely that the potters themselves were
Egyptian emigrés. The Tell Minis
wares form a homogenous group and
the rather hasty spiky drawing of this
piece, not devoid of humour, is
characteristic.

Published: Davids-Samling (1970, p. 263,
no. 4)

**299 Bowl painted in lustre on a
transparent glaze**
Diameter 20.3cm
*David Collection, Copenhagen
no. Isl. 196, found at Tell Minis*
Syria, mid-12th century

The intertwining bands form
palmette motifs radiating from the
centre. Both this type of decoration
and the use of scratched ornament
in the lustre field are found on
earlier Egyptian lustre wares.

Published: Davids-Samling (1970, p. 273)

**300 Bowl with incised decoration
under a transparent glaze**
Diameter 21.3cm
*David Collection, Copenhagen,
no. Isl. 202, found at Tell Minis*
Syria, 12th century

Simple incised wares became very
popular with the advent of frit
bodies in the early 12th century and
were, perhaps, inspired by imported
porcelains from Sung China. The
design of this bowl is formed from the
single word, *baraka*, 'blessing'. The
free impulsive drawing and the use of
a single word for the design are
characteristic of Syrian pottery of this
period.

Published: Davids-Samling (1970, p. 264,
no. 12)

300

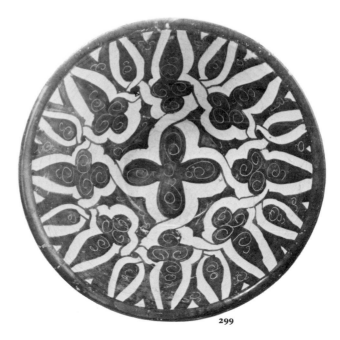

299

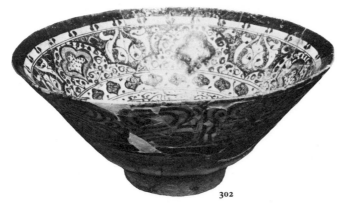

302

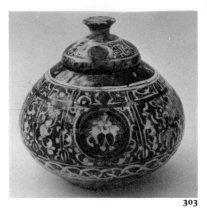

303

301 Dish decorated in lustre on a transparent glaze
Diameter 36cm
H. E. Henri Pharaon Collection
Syria (Raqqa), late 12th century

This bowl marks an interesting transition between the wares from Tell Minis and those of Raqqa which belong to the latter part of the 12th century. The form of this bowl and its decoration, a single word *al-mulk*, 'Sovereignty', is typical of the Raqqa style. The foliage itself, tri-lobate leaves and split-palmettes, is in the Egyptian idiom which was employed in the decoration of the Tell Minis wares. This suggests that the Tell Minis wares were a close forerunner of those from Raqqa, and may even have been made at Raqqa.

Published: Beirut (1974, p. 112, no. 21)

302 Bowl painted in blue under a transparent glaze and decorated in lustre
Height 26.5cm
National Museum, Damascus, no. 13076 A
Syria (Raqqa), late 12th century

Large-scale production of fine pottery, notably lustre and underglaze painted wares, started in Raqqa in the last quarter of the 12th century. They were perhaps a continuation of the Tell Minis wares given a new impetus by further groups of Egyptian emigré potters. The Raqqa potters were greatly influenced by Persian lustre wares which were exported all over the Middle East. While often indebted to Persian wares for the shapes and designs of their vessels, the Raqqa potters were able to maintain a distinctive style of painting characterised by bold free movement.

Published: Damascus (1969, p. 171, no. 2, fig. 72)

303 Vase with cover painted in blue under a transparent glaze and decorated in lustre
Height 26cm
Fundação Calouste Gulbenkian, Lisbon, no. 416
Syria (Raqqa), late 12th century

The shape of this vase, which is spherical, is rare even more so as the cover has been preserved. The design on the body and the cover illustrate the typical features of Raqqa decoration in which inscriptions and pseudo-inscriptions are closely integrated with floral motifs and medallions. The pseudo-kufic in the main field has been reduced to the simplest forms which divide the field.

Published: Lisbon (1963, no. 8)

304 Bowl painted with brownish lustre on a transparent glaze
Diameter 22.2cm
Ashmolean Museum, Oxford, no. Ash 229, NE 287, Gerald Reitlinger Collection
Syria (Raqqa), early 13th century

A single word used as a decorative motif is a common device among Raqqa wares. This particular word, *al-sirr*, 'secret', perhaps *al-surr*, 'joy', whose reading is not altogether clear, also occurs on other pieces. The shape of the bowl and the layout of design reflect the influence of contemporary Persian wares even though the motifs are peculiar to Raqqa.

Published: London (1969, no. 94)

301

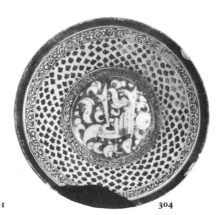

304

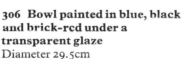

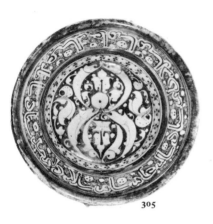

305

306

305 Bowl painted in blue under a transparent glaze and decorated in lustre
Diameter 27cm
Fundação Calouste Gulbenkian, Lisbon, no. 925
Syria (Raqqa), early 13th century

The outer band of this bowl consists of a naskhi inscription, giving standard blessing to its owner, sometimes incorrectly written. The central motif band of half-palmettes may be compared to that from no. 302, and is a device commonly found on Raqqa lustre wares.

Published: Davids-Samling (1970, p. 282); Düsseldorf (1973, no. 205, p. 148)

306 Bowl painted in blue, black and brick-red under a transparent glaze
Diameter 29.5cm
David Collection, Copenhagen, no. 54/1966
Syria (Raqqa), late 12th–early 13th century

Underglaze painting was perhaps the most important development in Islamic ceramics in the 12th century. By the end of the century both Persia and Syria were producing high-quality wares in this technique, and which country, if either, should take the credit for its development is not clear. Though Syrian wares were technically inferior to those from Persia they were often to surpass them in the control of the pigments and in their elegant and fluid drawing. In this bowl there is a highly original asymmetrical balance achieved by placing the lion-body of the sphinx at a diagonal, the spaces around being filled with small floriations.

The motif of the sphinx, which here appears with a curious monster head at the tip of the tail, is known in pre-Islamic times, but its precise significance when it appears in the Islamic period is by no means clear, see Baer (1965). A pseudo-kufic inscription decorates the rim.

Published: Davids-Samling (1970, p. 282); Düsseldorf (1973, no. 205, p. 148)

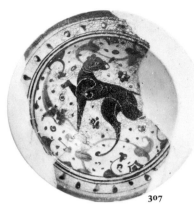

307

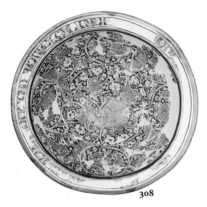

308

309

307 Bowl painted in blue and black under a transparent glaze

Diameter 27.3cm
Ashmolean Museum, Oxford, no. Ash 186, NE 270, Gerald Reitlinger Collection
Syria (Raqqa), late 12th century

A fine example of the elegance of line and fine balance of composition characteristic of the best pieces of Raqqa ware. The appearance of the dog as a decorative motif is somewhat puzzling as dogs were held in low regard in Islam. Details of the design have been scratched through the black pigment.

Published: London (1969, p. 44, no. 144)

308 Bowl painted in blue, black and brownish red under a transparent glaze

Diameter 50cm
David Collection, Copenhagen, no. Isl. 1
Syria (Raqqa), first half 12th century

One of the most splendid Raqqa bowls, both in size and in the quality of its painting. The motif of an arabesque on palmette scrolls reserved on a dark ground is taken from Persian designs on lustre tiles, see no. 378. The inscription on the outside consists of conventional blessings.

> *al-'izz al-dā'im . . al-'amr . . wa al-iqbāl*
> 'perpetual glory . . . [long] life . . . and prosperity.'

The shape of the vessel is confined to Syria and does not occur in Persia.

Published: Grube (1963, pp. 75–6, abb. 35); Davids-Samling (1970, p. 284, no. 15)

310

309 Jar with relief moulded decoration and lustre decoration
Height 32.5cm
Kunstgewerbemuseum, Cologne, no. E 2944
Syria (Raqqa), late 12th–early 13th century

A number of large jars with decoration in relief are known whose technical features relate them to the wares of Raqqa. They are usually rather crude in design and execution. The design of this jar is based on simple and powerful palmette motifs springing from foliated ribs.

Published: Cologne (1966, no. 23); Düsseldorf (1973, no. 123, p. 102)

310 Jar painted in blue and turquoise
Height 42.2cm
British Museum, London, no. 1969 4-17 1, Brooke Sewell Bequest
Syria (Raqqa), late 12th–early 13th century

The large moulded inscription which is repeated on each side of the jar reads *al-ni'ma*, 'favour'. The shape of this jar with narrow base and constricted neck is more elegant than many of its type, though the technical finish still remains somewhat crude.

Published: Migeon (1903, pl. 28)

311 Jar decorated in lustre on a deep blue ground
Height 30cm
Private Collection, France
Syria (Damascus), second half 13th century

The jar bears inscriptions on the shoulder and base. The upper inscription reads
 mimmā 'umila bi-rasm Asad al-Iskandarānī 'amal Yūsuf bi-Dimishq naqsh
 'Made for Asad al-Iskandarānī, the work of Yūsuf in Damascus, naqsh [?].'
The lower inscription reads
 mimmā 'umila bi-rasm Asad al-Iskandarām 'amal Yūsuf bi-Dimishq rabb sallam bi-raḥmatika . . .
 'Made for Asad al-Iskandarānī, the work of Yūsuf in Damascus, oh Lord, in Your mercy grant salvation . . .'

This evidence of attribution is of importance for a large group of vessels to which this jar belongs. They were first found in Sicily and given the name of 'Siculo-Arabian'. Many of them were originally used as containers for spices and fruits exported to Europe. This jar, however, was made for a Middle Eastern patron. It would appear that lustre potters from Raqqa left the city when it was destroyed by the advancing Mongols in 1259 and set up in Damascus. This piece still shows a connexion with Raqqa wares in its design. 'Damascus' wares were famous in Europe during the 14th and 15th centuries when these were listed in many apothecaries' inventories. Their production did not extend much beyond the beginning of the 15th century. It is recorded that in 1420 a piece, probably of this Damascus type, was sent by a merchant of Milan to a Spanish potter to be copied in 720 examples. Presumably, by this date, Damascus had either stopped producing or could no longer compete in price with the mass-produced Spanish wares.

Published: Lane (1957a, pp. 15–16, pl. 7); Grube (1966, pl. 29)

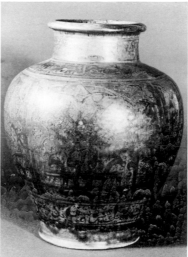

311

233

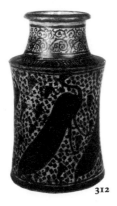

312

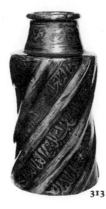

313

312 Drug jar (albarello) painted in lustre on a blue glaze
Height 33cm
Godman Collection, England
Syria (Damascus), late 13th–
early 14th century

The five peacocks that surround the body have the same elegance as that found in the Raqqa under-glazed painted wares. The background of stars is also found on the lustre bowl, no. 304. This similarity of design supports the idea that the Damascus lustre kilns were set up by refugee potters from Raqqa. It is interesting to note that the crackle of the glaze occurred during the first firing; inside the neck, lustre has been painted along the lines of the cracks to disguise the imperfection. This feature is found on other pieces of the same class.

Published: Godman (1901, pl. VIa, no. 470); London (1969, no. 180)

313 Drug jar (albarello) painted in lustre on a transparent blue glaze
Height 36.2cm
Godman Collection, England, formerly in the Drury Fortnum Collection
Syria (Damascus), 14th century

The inscription between the spirals is based on official titles, several of which are legible, though the whole makes no sense. This piece was found in Italy to which, no doubt, it was brought from Syria containing exotic spices. Albarellos were widely employed by apothecaries for the storage of spices and drugs. The contracted waist enabled jars to be easily removed from a row set side by side on a shelf.

Published: London (1885, no. 479, pl. III); Godman (1901, pl. VI), Lane (1957a, p. 16, pl. 9)

314 Jar painted in blue and black under a transparent glaze
Height 32.2cm
National Museum, Damascus, no. A 4547/12016
Syria, 14th century

In the late 13th and early 14th century wares painted in blue and black underglaze colours with simple geometric designs appeared in Persia. The style spread quickly, and by the 14th century, similar wares were being produced in Egypt and Syria. Although the technique and designs of these vessels from different countries were similar, the shapes were different. Syria produced large jars which are among the most impressive in this blue and black style. The surface of this jar is divided into panels and cartouches with pseudo inscriptions on the neck and in the panels on the body. This design is characteristic of the blue and black style and contrasts with the free painting of the lustre wares from the same city, though they may well have been made by the same potters.

Published: Damascus (1969, p. 249, fig. 140)

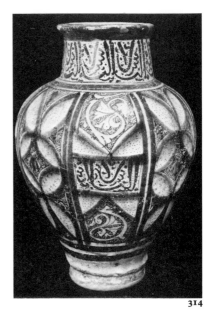

314

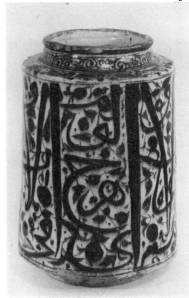

316

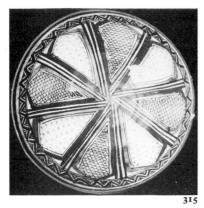

315

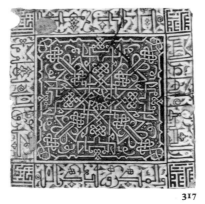

317

315 Bowl painted in blue, black and dull red under a transparent glaze

Diameter 24.5cm
National Museum, Damascus,
no. A 5356/12807
Syria, late 13th or 14th century

The division of the interior of this bowl into triangles filled with hatched backgrounds and groups of dots is a device known from the Persian 'Sultanabad' wares, though the red colour is not known in Persia, see especially no. 368. This bowl is related to the large jars and albarellos decorated in lustre or in blue and black, which are attributed to Damascus.

Unpublished

316 Drug jar (albarello) painted in blue under a transparent glaze

Height 36cm, diameter 25cm
Musée National de Céramique, Sèvres,
no. 8386
Syria (Damascus?), late 14th–early 15th century

The form of this albarello differs from other 'Damascus' pieces which tend to have taller necks and more strongly curved sides. This may indicate that this jar was made else-where in Syria, or possibly even in Egypt which was producing blue and white wares at this period. A slight Chinese influence may be noted in the small bands of decoration around the neck and shoulder. An inscription, possibly a mock inscription, covers the body.

Published: Paris (1971, p. 55, no. 69)

317 Square tile painted in cobalt and black under a transparent glaze

Height 43.5cm, width 43cm
Museum of Islamic Art, Cairo,
no. 2077, from the shrine of Sayyida Nafisa in Cairo
Egypt, Mamluk period, late 15th century

The central decoration consists of a reserved quadruple inscription
tawakkal 'alā khayr mu'in
'Trust in the best of helpers.'
with the shafts of the *alifs* and *lāms* plaiting in the centre to form a complicated star pattern. There is a border containing the Koran, Sura XXXIX, 44, with the addition of the words *ṣadaqa Allāh*, 'God speaks the truth', in blue on a white ground in elegant foliated kufic. The corners are filled by square kufic inscriptions, the upper two being *'amal Ghaybī ibn*, 'the work of Ghaybī son of . . .', and the lower two being *al-Tawrīzī*, 'of Tabriz.' Ghaybī ibn al-Tawrīzī or Ghaybī al-Tawrīzī is a well known Mamluk name and there are many pieces bearing the potter's (or potters') signatures, including a mosque lamp, entirely different in style, now in the Metropolitan Museum of Art, New York. The probability is that the workshop continued production over several generations, from about 1420 onwards.

Published: Abel (1930, pp. 61–2); Cairo (1969, no. 138); Sourdel-Thomine and Spuler (1973, no. 311)

318 Vase covered with white slip and painted in blue under a transparent glaze

Height 29.5cm, diameter (rim) 14cm
Museum of Islamic Art, Cairo,
no. 4577
Egypt or Syria, Mamluk period, 15th century

Long-necked vase with pairs of small handles above heavily moulded applied rings decorated with motifs ultimately deriving from the Chinese, including a wave-scroll at the ring and foliate trails or hachures in vertical bands. A similar vase under an imitation celadon glaze was discovered by Fustat, see Baghat (1922, pl. CVII). The inner face of the rim bears the signature of the potter, Abū al-'izz, upside down.

Published: Cairo (1969, no. 136)

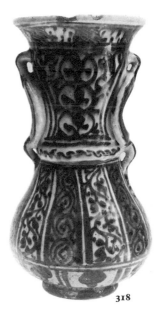

318

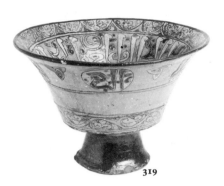

319

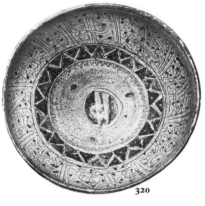

320

**319 Bowl covered with a white
slip with incised decoration,
painted in brown and white,
covered with an amber glaze**
Diameter 29.5cm
*Victoria and Albert Museum,
London, no. C162–1932*
Egypt, Mamluk period, 13th-14th
century

The inscription contains standard
blessings:
> *'al-naṣr wa'l-'iqbāl wa 'l-ni'ma
> wa'l-jadd . . . al-ifḍāl wa'l-
> kara [ā]ma*
> 'Victory, prosperity, favour,
> luck . . . excellence and honour.'

During the Mamluk period a
distinctive type of incised ware was
produced which, by its forms and
decoration, seems to have been a
cheap counterpart to inlaid metal-
work which was at that time of high
quality. Such incised wares were
often made to individual order and
bear the blazons and titles of Mamluk
officials.

Unpublished

**320 Bowl with incised designs
through a white slip covered with
an amber glaze**
Diameter 33cm
*Museum of Islamic Art, Cairo,
no. 23832, found at Jabal 'Adda in
Nubia in 1966*
Egypt, Mamluk period, 14th century

The vessel is inscribed with a
repeating pseudo-thuluth band with
kufic-like ascenders. The centre has a
circular blazon of a sword between
two bars: this may be a composite:
the sword being the sign of the sword-
bearer (*silāhdār*) and the three fields

being the emblem of the Mamluk
postal service (*barīd*). Although the
designs are evidently based on those
of contemporary metal wares such
chalice-like bowls have no extant
metal counterparts. It is very difficult
to date even inscribed pieces at all
precisely. A few pieces bear a potter's
signature, Sharaf al-Abwānī.

Unpublished

**321 Bowl covered with a white
slip through which the decoration
is incised, covered by a
transparent glaze**
Diameter 19.8cm
Private Collection
Persia, 12th century

The inscription reads
> *baraka wa yumn wa surūr wa sa'āda*
> 'blessing, good fortune, joy and
> happiness'

Incised decoration had been used all
over the Islamic world since early
times, but in the 12th century, in the
north and north-east of Persia, the
technique was greatly developed and
exploited on a number of distinct
types. Though simple in technique
and rather rough in execution the
designs are often striking. This bowl
is an example of a distinct group
decorated in a simple incised
technique of which the bird in the
centre is typical though the highly
decorated inscription is more
unusual. The design imitates those on
contemporary engraved bronzes,
see no. 161.

Unpublished

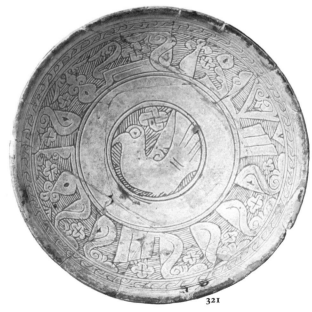

321

322

323

324

322 Bowl covered with a white slip, through which the design is carved, covered with a transparent glaze
Diameter 16.8cm
Iran Bastan Museum, Tehran, no. 972, found in excavations at Takht-e Sulayman
Persia, 13th–14th century

A group of vessels known as Garrus ware after the district in which the type was first found, shows a development over the simpler incised wares. Here the background to the design is cut away completely, leaving the design standing in relief, a technique known as champlevé. The contrast between the white slip design and the clay background is often emphasised by painting the clay with dark manganese brown. This bowl is distinguished by rather fine drawing and subtler composition than is generally found on these wares. The inscription which is to the left of the bird reads *li-ṣāḥibihi*, 'to its owner'; the 'blessing' (*baraka*) which usually precedes this phrase is missing.

Published: Schnyder (1974, pp. 92–3, pl. 11/12)

323 Bowl with white slip and carved decoration, covered with a green glaze
Diameter 36cm
Iran Bastan Museum, Tehran, no. 73/1001, found in excavations Takht-e Sulayman
Persia, 13th–14th century

The current German excavations at Takht-e Sulayman have revealed many bowls of Garrus ware of which this is an example. It has been argued that they are a development from simpler incised wares, see Schnyder (1974, pp. 85–94). The stratification provides a date in the 12th century. The design of this bowl shows roundels alternating with palmette motifs, very different in spirit to that of no. 322, to which it is related technically, and which was found on the same site.

Unpublished

324 Dish with white slip and incised decoration, covered with a transparent glaze
Diameter 24.2cm
Los Angeles County Museum of Art, no. M.73.5.213, The Nasli M. Heeramaneck Collection, gift of Joan Palevsky
Persia, 12th century

The inscription consists of the word *baraka*, 'blessing', repeated three times around the rim. The simpler form of incised decoration with a hatched background is combined on this dish with a small panel of palmette decoration in the champlevé technique associated with the Garrus wares. The green glaze is commonly found among incised wares.

Published: Los Angeles (1973, no. 98)

325

325 Tile with a white slip through which the pattern has been carved, covered with a transparent green glaze
Height 37.5cm, width 29.5cm
Ashmolean Museum, Oxford, no. Ash. 707, NE 494, Gerald Reitlinger Collection
Persia, 12th century

A number of tiles decorated in the champlevé technique under a green glaze are associated with the Garrus vessels. This piece originally had projections on the upper corner, which have been broken off, one before and one after the firing. It may have been employed as a mihrab or tombstone.

Published: London (1969, p. 23, no. 58)

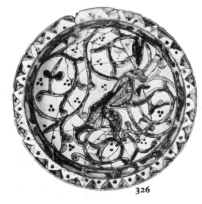

326

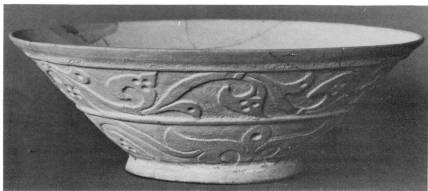

327

326 Bowl with a white slip and incised decoration, painted in green and brown under a transparent glaze, reverse green glazed
Diameter 24cm
Musée du Louvre, Paris, no. 7478
Gift of the Amis du Louvre, 1921
Persia, mid-12th century

'Akhand' ware, of which this is perhaps the best known example, is the most sophisticated, both artistically and technically, of the north-west Persian incised wares. The incised lines are used not only to outline the design but also to prevent the coloured pigments from running under the glaze. In much the same way, incised lines are used on lakabi wares at about the same time, see no. 340. 'Akhand' wares, named after a small town in north-west Persia where they were first found, were current in a large area of Azerbaijan, and closely related types were also made in Syria and round the Mediterranean. This bowl shows a hare amongst foliage; inscribed above the head of the hare is the signature of the potter, '*amal bū Ṭālib*, 'the work of [A]bū Ṭālib'. One other piece signed by Abū Ṭālib is preserved in the Art Institute of Chicago, see Pope and Ackerman (1938–9; pl. 611a)

Published: Pezard (1920, p. 78); Pope and Ackerman (1938–9, pl. 608); Paris (1971, p. 49, no. 33)

327 Bowl with carved decoration under the glaze
Diameter 19.5cm
Victoria and Albert Museum, London, no. C.185–1926
Persia, mid-12th century

The development of frit ware, which gives a perfectly white body with a degree of translucency and the possibility of thin throwing, is thought to have been inspired by the import of Chinese white porcelains to Persia during the 12th century. Pieces such as this bowl are among the earliest of this type and show a strong Chinese influence in the shape, the technique of incised decoration and occasionally in such details as the rim left free of glaze, to be later bound with a metal band. The scroll motif of this bowl, however, shows no Chinese influence. The glaze here has decayed entirely revealing the carved body.

Published: Lane (1947, p. 33, pl. 38b, and 1948, p. 23, fig. 10d)

328 Bowl with incised and pierced decoration under a turquoise glaze
Diameter 18.5cm
Iran Bastan Museum, Tehran, no. 3338
Persia, 12th–13th century

In this bowl the background of the main pattern of palmette scrolls is pierced with small holes which are filled with glaze. These 'transparencies', when held up to the light, make the pattern stand out against a shining background. Experimentation with the translucency of the material and with techniques of piercing, sometimes reached considerable complexity in the late 12th and 13th centuries.

Published: Pope and Ackerman (1938–9, pl. 598a); Lane (1947, p. 34, pl. 40a)

329 Bowl with incised and pierced decoration under a green glaze
Diameter 18.3cm
Musée du Louvre, Paris, no. 6672, acquired in 1913
Persia, second half 12th century

This bowl is very similar in technique to no. 328. The green colour is unusual, a turquoise blue mostly being preferred. The design of birds set in a band around the wall of the bowl shows an interesting continuation from the simpler clay bodied incised wares, see no. 321, to the new frit bodied wares.

Published: Paris (1971, no. 42)

331

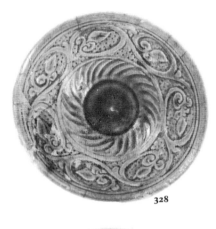

328

329

330 Dish with carved and incised decoration under a transparent blue glaze
Diameter 38.5cm
Ashmolean Museum, Oxford,
no. 1956–48, gift of Sir Alan Barlow
Persia, second half 12th century

The carving of designs on the body under monochrome glaze was a technique that was widely used in the Middle East. After the introduction of the frit body, carving and moulding were greatly exploited in both Egypt and Persia. Unlike the lustre and minai wares, they show a great deal of variation in technique and design and were certainly made at many different workshops throughout Persia. The design of birds round the inner walls on the shallow dish is similar to no. 329 and is also found in 'Rayy' style lustres at the end of the century.

Published: Pope and Ackerman (1938–9, pl. 601); Fehervari (1973; p. 78, no. 71, pl. 32a)

331 Bowl covered with a turquoise glaze
Diameter 17.7cm
Iran Bastan Museum, Tehran,
no. 4872, found at Gunbad-e Kabus
Persian, 11–12th century

The former city of Gurgan (modern Gunbad-e Kabus) in Khurasan was largely destroyed by the Mongols in 1220, but had previously been a rich and important centre. Excavations (both official and unofficial) have produced large numbers of vessels of which many, found sealed in large jars, are in perfect condition. Wasters found in official excavations prove that monochrome pieces such as this were locally produced. The shape of this vessel with its multi-lobed rim is not common.

Unpublished

330

332

332 Dish with carved decoration under a blue glaze

Diameter 18.5cm
Victoria and Albert Museum,
London, no. C68–1931
Persia, mid-12th century

This piece shows strong Chinese influence in the lobed rim and the technique of cutting the decoration. The form of the scroll and the colour, however, is unlike anything found in Chinese wares. Nevertheless, this piece was once considered to be Chinese and for 20 years was displayed as an example of T'ang stoneware.

Published: Lane (1947, p. 34, pl. 41a, and 1948, p. 24, pl. 11b)

333 Bowl with carved decoration under a transparent turquoise glaze

Diameter 15.5cm
Musée du Louvre, Paris, no. 6703,
gift of the Amis du Louvre, 1914
Persia, second half 12th century

The inscription is in kufic on a background of palmette scrolls.
> *baraka wa yumn wa surūr wa sa'āda*
> *wa baqā*
> 'Blessing, good fortune, joy,
> happiness and long life.'

The turquoise glaze that covered this vessel has for the most part degraded slightly leaving an unintentional matt surface.

Published: Pope and Ackerman (1938–9, p. 1762, figs. 616a & b); Paris (1971, p. 51, no. 45)

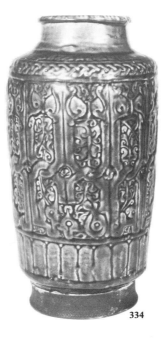

334

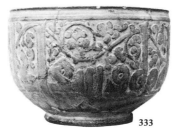

333

334 Jar with moulded decoration under a transparent blue glaze

Height 35cm
Godman Collection, England
Persia, second half 12th century

The interlaced kufic inscription which forms the main motif in the decoration of the body is intended as blessings to the owner. With the exception of the word *iqbāl*, 'prosperity', the inscription is incorrectly and illegibly written. The jar is similar in shape to no. 346 and it is tempting to attribute it to the same workshop. However, moulded monochrome glazed wares of this type were made in every part of Persia by the end of the 12th century. It was the advent of the frit body that made possible monochrome wares of such rich and pure colours because the white body under the transparent glaze produced a more brilliant colour than was possible over a clay body. Cobalt, which gives the deep blue colour, is also a powerful flux and accounts here for the streakiness of the glaze. The metal foot is a later addition.

Published: Wallis (1891, pl. v); London (1931, no. 117e)

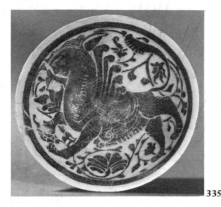

335

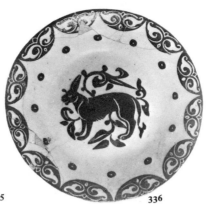

336

335 Bowl decorated in black slip under a transparent glaze
Diameter 18.5cm
*Hetjens-Museum, Düsseldorf,
no. 1972/53*
Persia (silhouette ware), second half
12th century.

The silhouette technique of this bowl may be seen as a preliminary attempt at underglaze painting. In order to prevent the colour from running, the pigment is applied in the form of a slip, a technique that had been brilliantly used elsewhere in Persia at an earlier period, see nos. 279–97. The background is then cut away to reveal the white of the body beneath, details are incised with a point. This results in clean lines and impressive drawing but also in a stiffness that only disappears with the advent of true underglaze painting at the end of the century. The silhouette technique is found in a variety of forms and decorations and certain technical details relate these wares to the same workshops that produced lustre and minai wares in the last quarter of the 12th century. This bowl is decorated with a winged mythical beast, possibly a sphinx or griffin. The face has been restored.

Published: Düsseldorf (1973, p. 72, no. 84)

336 Dish painted in black slip under a transparent glaze
Diameter 20.5cm
*British Museum, London,
no. 1956 7–28 4, gift of Sir Alan Barlow*
Persia (silhouette ware), second half
12th century

Several pieces of silhouette ware are decorated with animals surrounded by floral sprays in a distinctive style that perhaps owes its inspiration to metalwork. The shape of this dish, with straight flaring sides and a deep foot-ring, anticipates one of the standard shapes used by lustre and minai potters of the late 12th century.

Published: Lane (1947, pp. 35–6, pls. 48a & b); Fehervari (1973, no. 88, pl. 386)

337 Tankard painted in black slip under a transparent glaze
Height 16.5cm
*University Museum, Philadelphia,
no. NE-P 103*
Persia (silhouette ware), second half
12th century

The form of this tankard is also found in late 12th century wares decorated in monochrome glazes, lustre and minai painting. The torus moulding at the junction of the neck and body of this example probably derives from a metal prototype as it is unnecessary in pottery technique. The decoration is dominated by the angular kufic script which consists of standard blessings to the owner with words spelt incorrectly.

Published: Philadelphia (1916, no. 311, and 1918, no. 51); Wilkinson (1963, no. 42)

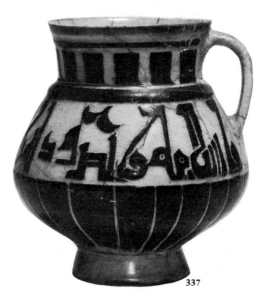

337

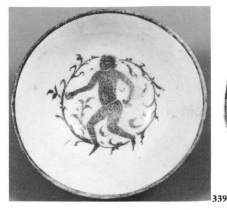

339

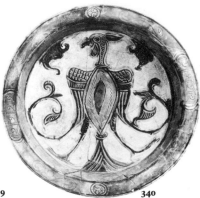

340

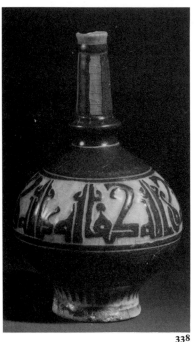

338

338 Bottle painted in black slip under a transparent turquoise glaze

Height 18cm
Staatliches Museum für Völkerkunde, Munich, no. 27-55-10
Persia (silhouette ware), second half 12th century

The inscription on this bottle is surprisingly faulty and reads
wa Allāh kafāla, 'God is sustenance.' Very similar in style and technique to no. 337 and is, presumably, from the same workshop. The shape is most unusual for wares decorated in this technique.

Published: Kühnel (1970, fig. 79)

339 Bowl painted in black slip under a transparent glaze

Diameter 21.6cm
Los Angeles County Museum of Art, no. M 73.5.259, The Nasli M. Heeramaneck Collection, gift of Joan Palevsky
Persia (silhouette ware), second half 12th century

The figure painted on the bowl is probably a dancer holding castanets and may have been inspired by contemporary shadow theatre which is known to have existed from literature, though no puppets from this period have survived. The fluent drawing anticipates the under-glaze painted wares of the beginning of the 13th century although the figure still retains some of the stiffness found in the other silhouette examples. The scroll that surround the figure compares closely with the water-weed motif of Kashan wares, of which it may be considered a prototype.

Published: Ettinghausen (1934, pp. 11–12, fig. 2); Pope and Ackerman (1938–9, pl. 750), Los Angeles (1973, no. 26)

340 Dish with incised decoration painted with blue, green and aubergine under a transparent glaze

Diameter 41cm
Staatliche Museen Preussischer Kulturbesitz, Museum für Islamische Kunst, Berlin-Dahlem, no. 1.2661
Persia or Syria (lakabi ware), mid-12th century

This plate with a heraldic bird is one of the finest examples of the so-called Lakabi ware in which an attempt is made to stop the colour running under a glaze, as yet insufficiently stable, by containing the various pigments between deeply incised lines. This technique was short lived and was succeeded by the development of true under-glaze painting in the latter part of the 12th century. Syria has the strongest claim for the production of this ware though the technique may also have been produced in Egypt and Persia.

Published: Pope and Ackerman (1938–9, pl. 606): Kühnel (1970, pl. VIII); Berlin-Dahlem (1971a, p. 22, no. 27)

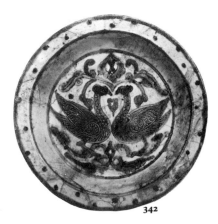

342

341

341 Dish with incised decoration painted in manganese purple under a transparent glaze
Diameter 40cm
Cleveland Museum of Art, no. 38.7, purchase from the J. H. Wade Fund
Persia or Syria (lakabi ware), second half 12th century

Many vessels of the lakabi type are reported to have been found in Persia, and a 'waster' has been found in Egypt. However, the shapes of these vessels, especially their broad flat rims, relate more to Syrian than to Persian or Egyptian wares. Though of a fairly simple technique, lakabi wares were a luxury product and were no doubt exported to the other countries of the Middle East where they may have been imitated.

Published: Hollis (1938, pp. 33–4, 39);
Pope and Ackerman (1938–9, pl. 605);
Cleveland (1966, no. 698)

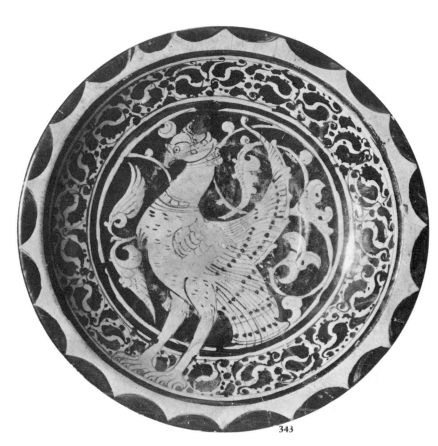

343

342 Dish with incised decoration painted in blue, green and brown under a transparent glaze
Diameter 23cm
British Museum, London, no. 1945 10–17 262, formerly in the Raphael Collection
Persia or Syria (lakabi ware), second half 12th century

The motif of affronted birds is one that originated in pre-Islamic times and was used throughout the Islamic period where its precise significance is not clear.

Published: Pope and Ackerman (1938–9, pl. 604b)

343 Dish decorated in lustre on an opaque white glaze, reverse blue glazed
Diameter 35.8cm
Staatliche Museen Preussischer Kulturbesitz, Museum für Islamische Kunst, Berlin-Dahlem, no. 1.1592, acquired in 1911
Persia (Rayy monumental style), last quarter 12th century

The production of Persian lustre wares starts quite suddenly in the last quarter of the 12th century, the earliest dated vessel is of 1179. It is thought that the technique was brought from Egypt to Persia by potters emigrating after the fall of the Fatimid dynasty in 1171. The Rayy monumental group shows a

derivation from Egyptian styles: the pattern reserved on a lustre ground is taken directly from a common Egyptian type, and the half-moon border can be traced back through Egypt to 9th-century Mesopotamia, see nos. 263 and 276. The monumental style is characterised by large-scale figures in reserve, with the background usually broken by a half-palmette scroll. The reverse is often glazed blue. The attribution to the site of Rayy is based only on slender evidence and the style was probably replaced by the Kashan style at the end of the century.

Published: Pope and Ackerman (1938–9, pl. 634a); Lane (1947, pp. 37–8, pl. 54c); Berlin-Dahlem (1971a, no. 359)

344

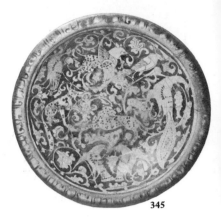

345

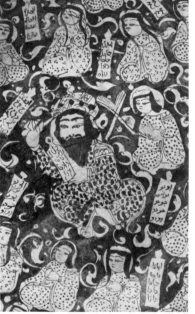

344 detail

344 Plate decorated in lustre on an opaque white glaze, reverse blue glazed
Diameter 47.5cm
David Collection, Copenhagen, no. 50/1966
Persia (Rayy monumental style), last quarter 12th century

The scene painted on this bowl has been interpreted as the meeting at school of the children Layla and Majnūn, whose unhappy love story was a favourite amongst Persia poets, especially after its celebrated rendering by the poet Niẓāmī (died 1202). One boy in short hair just above the right shoulder of the master is turned contrary to the others to face a girl with long locks. The stern schoolmaster with rod and alphabet-board in hand is surrounded by pupils in various degrees of concentration, also with alphabet-boards on which are written simple combinations of letters. A book-stand and a ewer complete the school-room furniture. In spite of the small scale of the figures, the technique of reserved pattern and the blue glazed back place this dish with other wares in the Rayy monumental style.

Published: London (1931, no. 172c);
Pope and Ackerman (1938–9, pl. 642);
Davids-Samling (1970, p. 197, no. 4)

345 Plate decorated in lustre on a white glaze, reverse blue glazed
Diameter 35.9cm
Fitzwilliam Museum, Cambridge, no. C157–1946
Persia (Rayy monumental style), last quarter 12th century

The inscription on the rim of this bowl consists of standard blessings to the owner, some parts are not legible. The heraldic style characteristic of this group of wares is here lacking and a curious asymmetrical balance is achieved by what appears to be a random grouping of the animals: the griffon, leopard, peacock and other less recognisable birds. Small birds, like the pair at the bottom of the plate, become a characteristic feature of the later Kashan lustre painted wares, see no. 350.

Published: Pope and Ackerman (1938–9, pl. 641a); London (1931, no. 159p)

346

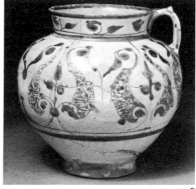

348

347

346 Bowl decorated in lustre on an opaque white glaze
Diameter 15.5cm
National Museum, Damascus,
no. A14294
Persia (Rayy monumental style), last quarter 12th century

A lustre piece of most unusual design showing a clear derivation from Egyptian lustre painting. In other Rayy style pieces, perhaps of a slightly later date, the foliage which here decorates the walls appears as the background in the main design, see nos. 343, 345. The bird in the centre is found in a similar form on Egyptian examples. On the reverse are incised standard blessings.

Unpublished

347 Vase with moulded body decorated in lustre on an opaque white glaze
Height 34cm
Godman Collection, England
Persia (Rayy monumental style), last quarter 12th century

This ewer doubtless came from the same atelier as the large plates in the same style, see nos. 343–5. The figure drawing is comparable with pieces on Egyptian lustre but the faces here are purely Persian, showing the 'moon-face' feature of the classical type of Persian beauty. The flutings of the body copy contemporary metal work and are ignored by the panels of decoration, each of which cuts across two segments. Likewise, the meander moulding on the neck is ignored by the panels of sketchy scrolls. The shape of this vase may represent an early form of the albarello, whose classic form with concave walls seems to be a Syrian rather than a Persian development.

Published: London (1885, no. 477, pl. III); Wallis (1891, pl. VI); Lane (1947, pl. 56b)

349

348 Jug decorated in lustre on an opaque white glaze
Height 14.5cm
Victoria and Albert Museum, London,
no. C186–1928
Persia (Rayy style), last quarter 12th century

The Rayy lustre wares show a great variety of styles of decoration and of shapes which reflect the sudden expansion of the production of luxury ceramics. In this small jug the lustre is applied sparingly in rather light airy arabesque designs, strongly contrasting with the heavy coverings of lustre in the monumental style.

Published: Lane (1947, pp. 37–8, pl. 56a)

349 Bowl decorated in lustre on a blue glaze
Diameter 18.5cm
Musée du Louvre, Paris,
no. MAO 485, gift of J. Soustiel
Persia (Rayy monumental style), last quarter 12th century

Vessels of this style on a blue glazed ground are rare. The palmette and two flanking half-palmettes are similar to those found in the background on the larger monumental pieces, see nos. 343, 346. The shape of this vessel is typical of Rayy lustre wares and is also found among pieces decorated in the silhouette and minai techniques.

Published: Anonymous (1974, p. 230, no. 815)

350

351

350 Bowl covered in an opaque white glaze with in-glaze blue and turquoise painting decorated in lustre

Diameter 21cm
*Gemeentemuseum, The Hague,
no. OC(1) 55–1932*
Persia (Kashan), 1219

The Kashan style of lustre painting developed about the year 1200 and probably replaced the Rayy styles. Kashan wares are distinguished from the Rayy types chiefly by the breaking up of the background with small spirals scratched through the lustre. The plump birds and richly patterned garments of the figures are also diagnostic. Numerous pieces in this style, both tiles and vessels, are dated in the first two decades of the 13th century. The poems found on these vessels are the same as found on the tiles of the second half of the century, see no. 384, but no relationship between the scenes depicted and the verses has yet been noted. The design of this bowl is characteristic and depicts a group of people sitting together either side of a cyprus tree. An inscription on the outside of the vessel gives the signature of the potter *katabahu Abū Zayd bi-khaṭṭihi* 'Abū Zayd decorated it in his own hand'. Abū Zayd was one of the leading lustre potters of the early 13th century and played an important part in the formation of the Kashan style, see Bahrami (1945, pp. 35–41). The date is written on the inside inscription *katabahu fī shuhūr sanna sitt 'ashra wa sittamiya* 'written in the months of the year six hundred and sixteen [1219 AD].'

Published: Pope and Ackerman (1938–9, pl. 707a & b)

351 Dish covered with an opaque white glaze decorated with in-glaze blue and green and black and brownish-red enamel

Diameter 23cm
*Iran Bastan Museum, Tehran,
no. 4408*
Persia (minai ware), late 12th–early 13th century

The little horsemen who occur in alternation with arabesque motifs on this dish are painted in the so-called Rayy miniature style which, as the term suggests, were taken from contemporary manuscript illumination. While lustre painting in this style probably ceased about the year 1200 when it was replaced by the Kashan style, it is possible that it continued after that date in the enamel technique to which it was particularly suited. The lightness of the drawing and the freshness of the colours are very different from the lajvardina wares which superseded minai decoration after the Mongol conquests.

Published: Tehran (no date, pl. XVIII)

352 Jug covered with an opaque white glaze painted with in-glaze blue and turquoise, and red and black enamel

Height 15.2cm
*Victoria and Albert Museum, London,
no. C 164–1928*
Persia (minai ware), late 12th century

An example of a distinctive group of minai wares, see also nos. 353–4, which are characterised by a decoration of broad arabesque and interlacing motifs and by a restricted enamel palette. The blue and turquoise are painted into the raw glaze before firing and the black and red added in a separate second firing. Copper oxide which produces the turquoise colour is a rather volatile substance and tends to become blurred in the firing, and black enamel is used to define its contours.

Published: Kühnel (1970, fig. 89)

352

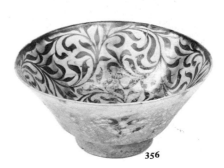

353 Bowl covered with an opaque white glaze painted with in-glaze blue and turquoise, and red and black enamel
Diameter 22.4cm
Fundação Calouste Gulbenkian, Lisbon, no. 932
Persia (minai ware), later 12th century

This bowl shows a complex design of arabesques and interlacing. It comes from a group of minai wares which may be attributed to the same ateliers that made lustre wares in the Rayy style for some sherds are known which are decorated in both lustre and enamel painting in this style.

Published: Pope and Ackerman (1938–9, pl. 694); Lisbon (1963, no. 12)

354 Bowl covered in an opaque white glaze and painted with in-glaze blue and turquoise, and red and black enamel
Diameter 21cm
British Museum, London, no. 1912 12–73, acquired in 1912
Persia (minai ware), late 12th century

Very close in design to no. 353.

Unpublished

355 Bowl decorated with inglaze and overglaze colours with leaf gilding
Diameter 12cm
Iran Bastan Museum, Tehran, no. 4410, found at Kashan
Persia (minai ware), late 12th-early 13th century

Chevron designs often occur on other minai pieces but only very few examples known where the entire walls are covered with this pattern. The drawing of the bird is unusual for wares of this type.

Unpublished

356 Bowl painted in blue and black under a transparent turquoise glaze
Diameter 20.3cm
Stephen Garratt Collection, England
Persia (Kashan), early 13th century

This ware represents the first real underglaze painted decoration achieved in the Islamic world. The black pigment is absolutely stable, but the cobalt runs and is only used in blurred streaks. The thinness of the black pigment means that it can be painted as freely as the hand wishes and this quality is exploited to the full. The water-weed pattern of this bowl is only found in the fully developed Kashan style and dates from the first years of the 13th century.

Published: London (1969, no. 156)

357

357 Bowl painted in black under a turquoise glaze
Diameter 17.5cm
F. Amon Collection, France
Persia, late 12th century

Towards the end of the 12th century painting in black under a turquoise glaze became one of the popular ways of decorating pottery and was practised in all parts of the Islamic world. Although the power of the colour turquoise to ward off the evil eye and bring good luck is often cited as the reason for its popularity, the availability and cheapness of the colouring agent, copper oxide, and the ease with which it produced a pleasing colour must have added greatly to its attraction for the potter. Cobalt, which produces the rich blues, was only found in very few places and was expensive and more difficult to manage. This bowl is unpretentious in its technique and decoration and relies on a simple arabesque for its appeal.

Published: Düsseldorf (1973, no. 196, p. 143)

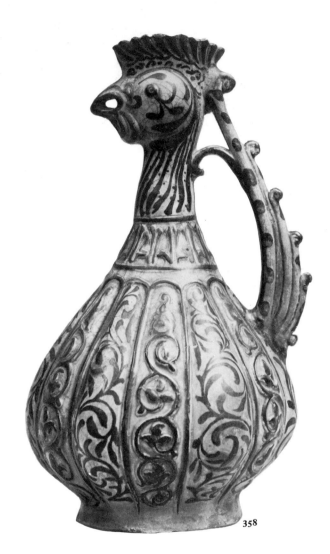

358

358 Ewer with moulded body painted in black under a turquoise glaze
Height 37cm
David Collection, Copenhagen, no. Isl. 23
Persia (Kashan), early 13th century

A mock kufic inscription runs around the neck of this ewer. Modelling pots in animal and bird shapes became popular among the Persian potters in the late 12th and early 13th century. Several examples are known of cock-headed ewers in both lustre and underglaze painted wares. The handle of this ewer is moulded in the form of a bird's tail. An interesting contrast is to be noticed here between the formal moulded scroll and the free painted water-weed motif that alternate round the body of the vessel.

Published: London (1931, no. 101a); Pope and Ackerman (1938–9, pl. 742a); Davids-Samling (1948, pl. 79)

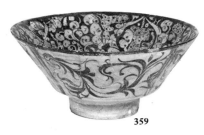

359

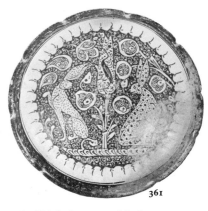

361

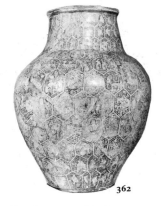

362

359 Bowl painted in black and blue under a turquoise glaze

Diameter 22.3cm
Ashmolean Museum, Oxford,
no. 1956–29, gift of Sir Alan Barlow
Persia (Kashan), early 13th century

This bowl is an example of a rare type of Kashan underglaze painted ware. The main design is reserved against a black background and consists of animals and floral motifs similar to those on lustre wares of the same period. The shape of the vessel and the water-weed motif on the exterior date it in the first two decades of the 13th century.

Published: Lane (1947, pl. 92b);
Fehervari (1973, p. 96, no. 110, colour pl. G)

360 Bowl painted in black under a transparent glaze

Diameter 21cm
Museum of Fine Arts, Boston,
no. 65.230, gift of John Goeler
Foundation
Persia (Kashan), early 13th century

The earliest dated piece of underglaze painted ware is of 1204 and the latest, just prior to the Mongol invasions, is 1215. Although none of the underglazed pieces is signed they may be attributed to Kashan. This footed bowl with flaring walls has a shape almost exclusive to Kashan, as is the water-weed pattern.

Published: Wilkinson (1963, pl. 50)

361 Dish decorated in lustre on an opaque white glaze

Diameter 19.5cm
Godman Collection, England, acquired
from Richard Collection in 1889, said
to have been found at Rayy in 1871
Persia (Kashan), second half 13th century

Lustre production in Persia was interrupted by the Mongol invasions and only a few pieces were made between 1220 and 1260. In the second half of the century the bulk of production consisted of tiles and only a few vessels. The painting on vessels becomes rather formalised and stereotyped during this period, depending heavily on tile designs. The design of this dish may be directly compared to a series of tiles dated 1267, see no. 384. The foliage with the white border and small scrolls filling the centre is characteristic of lustre painting of this period. A mock inscription encircles the inside rim.

Published: Wallis (1891, pl. III);
Godman (1901, no. 368, pl. I)

362 Jar decorated in lustre on an opaque white glaze

Height 68.5cm
Olga Ella Monheim Collection,
Federal Republic of Germany, found
at Rayy
Persia (Kashan), second half 13th century

Jars of this size are not uncommon in monochrome glazed decoration, but lustre examples are very rare. The problem of how to decorate such a large surface has been overcome in this example by dividing the area into more than 240 hexagonal panels. The device is suited to the potter used to decorating small wall tiles and the motifs themselves are similar to those found on tiles, especially a group dated in the 1260s, see no. 384, which provides a close dating for this jar. The first two bands at top and bottom of this jar are filled with various varieties of birds, the next band is filled with dog or fox-like creatures. The middle rows have slightly larger hexagons and contain animals including an elephant, gazelles and camels as well as human figures.

Published: London (1931, no. 170);
Pope and Ackerman (1938–9, p. 1584, no. 700); Düsseldorf (1973, no. 118, p. 99)

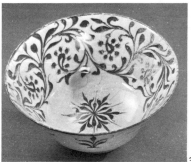

360

363

363 Cup decorated in lustre on an opaque white glaze
Height 10.6cm, diameter 19.5cm
Iran Bastan Museum, Tehran,
no. 21555 found at Takht-e Sulayman
Persia (Kashan), second half 13th
century

While other pottery finds suggest that
the site of Takht-e Sulayman in
north-west Persia was occupied for a
considerable time before Abāqā Khān
(son of Hūlāqū, reigned 1265–82)
built his summer residence there in
the 1270s, the lustre pottery all dates
from this period. The vessels, of
which this is a typical example, show
the rather heavier potting and
standardised decoration typical of the
second half of the 13th century.
A gazelle at the centre of the cup is
surrounded by a band of other
animals.

Unpublished

364 Bowl covered in greyish slip, painted in black and raised white slip under a transparent glaze
Diameter 16.2cm
Fitzwilliam Museum, Cambridge,
no. C169–1946, Oscar Raphael
Bequest
Persia (Sultanabad ware), first half
14th century

After about 1300 taste in Persian
pottery changes and a rather more
sombre and rich colour scheme is
adopted. A new class of slip wares,
the epitome of this new taste, is
decorated primarily in greys, black
and whites. Although it does not seem
to have survived beyond the mid-
14th century, these new wares are of

great interest technically for they
revert to slip painting, not as a means
of controlling colour, as previously,
but to create a relief effect. These
wares are generally attributed to
Sultanabad where many examples
are reported to have been found.
Certain characteristics of drawing
relate them to the Kashan tradition.
The design on this bowl includes
lotus flowers, a motif introduced from
China at the very beginning of the
14th century.

Published: London (1931, no. 206M);
Pope and Ackerman (1938–9, pl. 779a)

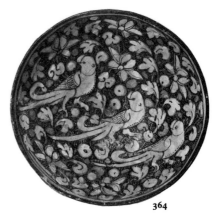

364

365 Bowl covered in a greyish slip, painted in black and a raised white slip under a transparent glaze
Diameter 20.5cm
Ashmolean Museum, Oxford, Ash 249,
NE 213, Gerald Reitlinger Collection
Persia (Sultanabad ware), first half
14th century

The design of this bowl shows four
phoenixes against a floral background.
Phoenixes drawn in exactly the same
manner are found on Kashan lustre
star tiles of the early 14th century and
raise the possibility that Sultanabad
wares were made at Kashan. Wares in
this technique were also made
elsewhere in Persia, and also in Egypt
and Syria, though different in
painting style and usually inferior in
technique. The Chinese designs
which appear shortly after 1300 are
most likely to have been taken from
textiles though the shapes of the
vessels were often inspired by Chinese
porcelains and celadons.

Published: London (1969, p. 52, no. 173)

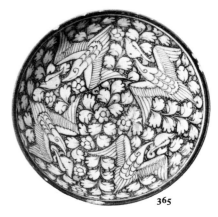

365

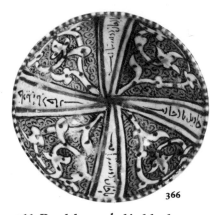

366

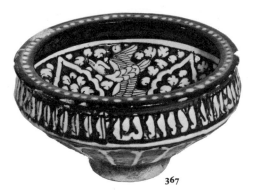

367

366 Bowl decorated in black, grey and white slips under a transparent glaze
Diameter 11.8cm
Iran Bastan Museum, Tehran, no. 21507, from Bujnurd
Persia (Khurasan), first half
14th–15th century

This bowl is decorated in exactly the same technique as the Sultanabad ware, and the designs are very closely related. However, the stiff manner of drawing, with a rather sparse use of white slip relate it to a group of similar pieces reported, like this piece, to come from Khurasan in North-East Persia. A separate centre of production there, which is derived from the Sultanabad wares but is distinct, must be assumed. These wares are of simple technique and thus easy to imitate, and the possibility exists that several provincial varieties were made in various parts of the Islamic world, see Lane (1957a, p. 14, pl. 5).

Unpublished

367 Bowl covered with a grey slip painted in white slip with dark outlines under a transparent glaze
Diameter 34.5cm
Fundação Calouste Gulbenkian, Lisbon, no. 907
Persia (Sultanabad ware), first half
14th century

The Sultanabad slip technique was particularly suited to rather large designs and many of the best examples are found on large heavy vessels with sharply articulated contours. The phoenix and animals amid foliage on this bowl are standard designs on these wares and also occur in a similar fashion on contemporary lustre wares, see nos. 361, 363.

Published: Lisbon (1963, no. 22)

368 Drug jar (albarello) painted in black, blue and turquoise under a transparent glaze
Height 33cm
British Museum, London, no. 1952 2–14 5
Persia (Sultanabad ware), first half
14th century

Evidently related to the slip-painted Sultanabad wares, underglaze painting is used in this piece to give the same effect. Every element of the design of these wares is outlined in black and the background is hatched or stippled in black. The other colours are added and the white of the ground is left in restricted areas only, as if it were an applied colour. The use of blue and turquoise gives a softer colour scheme than that of the slip painted group. This jar has its surface

divided into panels and friezes filled with floral and simple geometric motifs. It is an example of the blue and black style of potting that spread from Persia all over the Middle East during the first half of the 14th century.

Published: Lane (1957a, pp. 10–12, pl. 3)

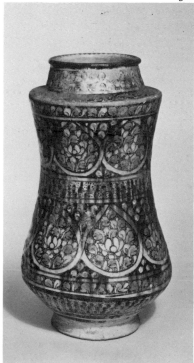

368

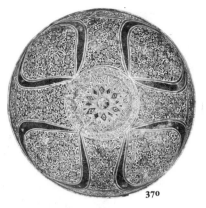

370

371

369 Jar covered with deep blue glaze decorated in red and white enamel and gilding
Diameter 17.7cm
Royal Ontario Museum, Toronto, no. 910.115.6
Persia (lajvardina ware), first half 14th century

Minai wares went out of production after the Mongol invasions of Persia and they were then replaced by the lajvardina wares. Here, enamel colours are restricted to red and white, and leaf gilding is introduced. These are applied in simple geometric patterns on a deep blue or turquoise glaze. *Lājvard* (lapis lazuli) was the name also given to cobalt which produced deep blues in glass and glazes and was used to imitate lapis which itself has no colouring effect on a glaze. The interior of the bowl is divided into five radiating panels, the exterior has an upper band divided by rosette panels.

Published: Sourdel-Thomine and Spuler (1973, pl. XLV)

370 Bowl covered in dark blue glaze decorated with red and white enamel and leaf gilding
Diameter 21.2cm
Musée du Louvre, Paris, no. MAO 4501
Persia (lajvardina ware), first half 14th century

Lajvardina wares were already being produced by 1300 at which time Abū al-Qāsim (see no. 374) devoted a section of his text on pottery manufacture to their production. He described how a *mithqāl* (*c.* 5 grams) of gold is beaten between paper into 24 sheets then cut with scissors and stuck onto the vessel with glue. The enamel colours are then applied and the piece is fired in a special kiln. The use of gold, large amounts of expensive cobalt and the extra work required for the gilding, enamelling and second firing must have made this ware extremely costly. There is a contemporary report of wares, whose description can only correspond to lajvardina types, being sent by the Sultan of Delhi to the Mongol vizier Rashīd al-Dīn in 1308. These vessels had presumably been first exported to India, see Lane (1957a, p. 7). This bowl is decorated with a cruciform design spreading from a star in the centre.

Unpublished

371 Bowl covered with deep blue glaze decorated in red and white enamel and leaf gilding
Diameter 16.5cm
Staatliche Museen Preussischer Kulturbesitz, Museum für Islamische Kunst, Berlin-Dahlem, no. 1.24/66 acquired in 1966
Persia (lajvardina ware), 1374

Part of the Arabic-cum-Persian inscription has been damaged and restored but the date remains intact.
fī ta'rīkh ghurra māh-e rajab sanna sitta wa saba'īn wa saba'miya
'On the first day of the month of Rajab of the year seven hundred and seventy-six [December 1374]'.
This bowl is most important as it bears the only date known on lajvardina wares. It is a very late piece and must be placed towards the end of the period of production. The rigid geometrical decoration of the earlier pieces is here modified by simple floral sprays that anticipate the more fluid painting style of 15th century wares.

Published: Berlin-Dahlem (1971a, no. 459); Düsseldorf (1973, no. 222, p. 161)

369

372

372 Dish covered with an opaque turquoise glaze decorated in red and black enamel and leaf gilding
Diameter 35.7cm
Musée du Louvre, Paris, no. 6456, acquired in 1911
Persia (lajvardina ware), second half 13th century

The inscription reads
*al-'izz 'al-dā'im wa 'l-'iqbāl
al-zā'id wa 'l-naṣr al-ghālib . . .
wa 'l-jadd al-ṣā'id . . . wa'l-dawla
wa 'l-sa 'āda wa 'l-salāma wa
'l-baqā li-ṣāhibihi*
'Perpetual glory, exceeding prosperity, predominant victory . . . auspicious good luck . . . wealth, happiness, well-being and long life to its owner.'
This dish differs from the usual lajvardina wares in its use of turquoise glaze and a black enamel instead of the more usual white. Fish were commonly used at this period to decorate both ceramics and metalwork and are sometimes given mystical interpretation, see Baer (1968). The shape of this dish may have been inspired by Chinese celadons which were exported to the Middle East in large numbers at this time.

Published: Pope and Ackerman (1938–9, pl. 681b); Lane (1947, p. 43, pl. 74b); Paris (1971, p. 52, no. 53)

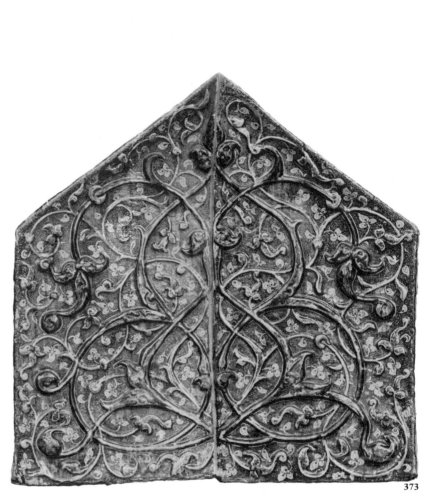

373

373 Panel of two tiles covered with an opaque white glaze, with blue and green in-glaze colours and decorated in lustre
Height 76cm, width 73cm
David Collection, Copenhagen, no. 1/1968
Persia (Kashan), second half 13th century

A series of large mihrabs made from lustre tiles are dated between 1200 and 1334 and are generally associated with the Abu Ṭāhir family of potters from Kashan who made seven out of the ten surviving complete mihrabs, see also no. 374. The various elements of the mihrab, such as the central niche, arches, columns and flanking inscriptions, were each moulded separately and assembled only after the final lustre firing. Difficulties were nearly always encountered with pieces of this size and only rarely are they free from the running of the blue and turquoise as is found here. Moulding in relief in two layers, the large blue arabesque standing in greater relief than the smaller turquoise scroll, is found only on large pieces of better quality. In this example there is a contrast between the graceful symmetrical arabesque pattern and the freely moving scroll underneath which, although symmetrical, is full of independent movement.

Published: Davids-Samling (1970, p. 194, no. 1, and 1975, p. 54)

Ceramics

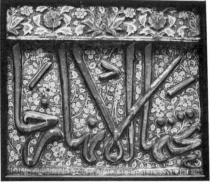

374a

374 a-b Two frieze tiles covered with an opaque white glaze painted in blue and green and decorated in lustre
Height 38cm, width (each tile) 42cm
British Museum, London,
nos. 78 12–30 574 and 575
Persia (Kashan), early 14th century

These two tiles come from an inscription frieze of which several tiles are preserved in Western collections. The text is of the first few verses of Sura XLVIII of the Koran. Of the two tiles, one contains a phrase from Sura XLVIII, 5 and the other contains the date.

> *wa kutiba fi ghurra sha'bān sana*
> *tis'a wa sab'a miya*

'Written on the first day of Sha'bān of the year seven hundred and nine [= January 1310].'

Another tile from the same set, formerly in the Manzi collection, contains the signature Yūsuf ibn 'Alī ibn Muḥammad ibn Abī Ṭāhir. Yūsuf was the most important lustre potter of the early 14th century and was the brother of Abū al-Qāsim, see no. 370. Five signed works of his survive. Both his father, 'Alī, and his grandfather, Muḥammad, are known through surviving works dating back to the beginning of the 13th century. These tiles are of the highest quality though some trouble has been encountered with the running of the blue. White patches on the inscription have been touched up with lustre.

Published: Bahrami (1936, p. 191, pl. LXIV); Ettinghausen (1936, p. 53, fig. 14): Wallis (1894, pl. II, fig. 22)

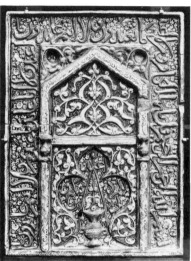

375

375 Tile covered in a white opaque glaze, painted in blue and turquoise and decorated in lustre
Height 72.5cm, width 45.8cm
Victoria and Albert Museum,
London, no. 1527–1876
Persia (Kashan), early 14th century

The outer relief inscription is from the Koran, Sura CIX; the painted inscription round the inner arch is from Sura II, 285. The inscription between the columns reads.

> *al-'abd al-ḍa'īf al-muḥtāj ilā*
> *raḥmat Allāh ta'ālā katabahu 'Alī*
> *ibn Aḥmad ibn 'Alī ibn Abī*
> *al-Ḥusayn bi-khaṭṭihi fī shuhūr ...*

'The weak slave needing the mercy of God (be he exalted) 'Alī ibn Aḥmad ibn 'Alī ibn Abī al-Ḥusayn wrote this in his own hand in the months ...'

Normally the date would follow but in this example, unfortunately, there was insufficient space. 'Alī ibn Aḥmad came from an important Kashan lustre potting family. He made a lustre tombstone dated 1305 together with Yusūf, the last member of the Abū Ṭāhir family, see no. 374, and this piece must date from about the same period. 'Alī's son, Ḥasan, signed a tombstone now preserved in the Metropolitan Museum of Art, New York. There is an exact pair to this tile, also in the Victoria and Albert Museum, London (the famous Salting mihrab), which suggests that these pieces may not be mihrabs, but tombstones. It was the practice in certain parts of Persia to place a tombstone at each side or at either end of the tomb.

Published: Wallis (1894, pl. XVI)

376 detail **378**

376 Frieze of four tiles covered in an opaque white glaze with blue painting and decorated in lustre
Each tile, height 57cm, width 47cm
Godman Collection, England
Persia (Kashan), second half
13th century

The inscription is in kufic with knotted letters.
 ... [*Al*] *lāh al-raḥmān al-raḥīm lā ilāh illā huwa al-'azīz al-ḥakim*
'[In the name of] God, the Merciful, the Compassionate, there is no God but He, the Mighty, the Wise.'
This phrase occurs three times in Sura III of the Koran. This frieze is one of the most impressive examples of lustre tiling, both in design and technique. It is not exactly clear in which way these four tiles were used; they may have formed a frieze on a wall or a large mihrab. Only one related tile survives, see no. 377. The technical achievement of covering such large areas with clean and even lustre is remarkable, and the standard of the drawing of the floral scroll background is higher than is generally found in other examples, see nos. 377–82. By the 13th century the kufic script was an archaism used only in decorative displays and the potter's unfamiliarity with the script is here shown in the confusion of some of the letters.

Published: Wallis (1894, pl. I);
Godman (1901, pl. XX);
Pope and Ackerman (1938–9, pl. 724b)

377 Frieze tile covered with an opaque white glaze painted in blue and decorated in lustre
Height 39cm, width 69cm
Staatliche Museen zu Berlin, Islamisches Museum, no. I.1277
Persia (Kashan), second half
13th century

The style of the script in this tile is very close to that on no. 376, as is the decoration of the background, and it is reasonable to assume that they were made for the same architectural setting. This tile is curved slightly at the right hand end which suggests that it was intended to fit into a niche. The other half of the tile, now in the Musée du Lyon, has a corresponding curve on the left. The text of the tile reads *lā ilāh illā Allāh*, 'There is no god but God', continued on the Lyon tile with 'Muḥammad is the prophet of God'. The border inscription consists of the first 18 verses of Sura LXXVI of the Koran, of which verses 4–13 appear on this tile.

Published: Erdmann (1967, pl. 49b)

378 Tiles covered with an opaque white glaze with blue and turquoise painting and decorated in lustre
Each tile, height 43cm
Godman Collection, England
Persia (Kashan), second half of the 13th century

The Koranic inscriptions include Sura XLVIII, verses 24–5, and Sura XXIII verse 82. These two tiles originally formed part of an inscription frieze, either at an opening or corner of a building, or possibly round a cenotaph. Two other tiles from the same set survive: a corner tile in the Musée des Arts Décoratifs, Paris, and another similar tile originally in the Macy Collection. Such was the conservatism of the Kashan potters in the design of their tiles that it is often difficult to give any precise date within the span of their production, especially in the period of 1260–1340, after the Mongol invasions. Quality is no indication of an early date in this period.

Published: Wallis (1894, pl. XIII);
Godman (1901, no. 130, pl. XXIII);
London (1969, no. 99)

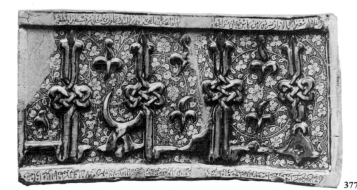

377

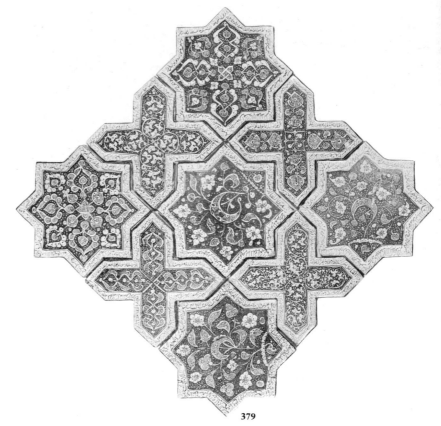

379

379 Panel of tiles covered with an opaque white glaze decorated in lustre

Each tile, diameter 31cm
*Royal Scottish Museum, Edinburgh,
9 tiles, nos. 1889 64–9; 1921–1314 a, c
& d; Ashmolean Museum, Oxford,
6 tiles no. X 289; British Museum,
London, 4 tiles nos. OA + 1121,
96 2–1 101–3; Godman Collection,
England, 22 tiles*
Persia (Kashan), 14th century

The Imamzada Yaḥyā in Veramin,
south-east of Tehran, was originally
decorated with lustre tiling. A dado
around the inside walls of the tomb
chamber was covered with star and
cross tiles, dated between October
1261 and January 1263; a large
mihrab dated August 1265, and a
small tombstone of July 1305. By the
end of the 19th century all the tiling
had been removed and is now
scattered among numerous collec-
tions. Well over a hundred star and
cross tiles have been recorded, of
which something approaching a
quarter are dated. They represent the
first major production of the Kashan
lustre potters after the lull which
followed the Mongol invasions. The
inscription on these tiles are all
quotations from the Koran, the most
common consisting of Suras I and
CXII, while several contain the
'Throne' verse, Sura II verse 255.
The designs of other tiles are based on
a limited number of floral and
arabesque motifs.

Published: Wallis (1894); Bahrami (1937,
pp. 87–91); Wilber (1955, pp. 109–10,
no. 11)

380 Tile decorated in lustre on an opaque white glaze

Diameter 31cm
Godman Collection, England
Persia (Kashan), 13th century

380

A most unusual shape of tile designed
to be set in the bottom row of a panel
of star and cross tiles. This example
and its companion (no. 381) are
related to the tile panels nos. 379 and
384. This tile differs from those of the
former panel in subject matter, and
from the latter panel in size. The date
of both these other panels in the
1260s yields a secure date for this tile.
Together with its companions, it has
streaks of lustre across the surface,
probably caused by accidental
splashes of water before firing. The
birds and fishes are a hallmark of
Kashan lustre wares. The inscription
around the border is from the Koran,
Sura XXIII, verses 26–7, and also
the phrase

> *ṣadaqa Allāh al-ʿaẓīm wa ṣadaqa
> rasūluhu al-karīm*

'The Mighty God spoke truth and
his honourable Prophet spoke
truth.'

Published: Godman (1901, pl. IVa);
London (1969, no. 101)

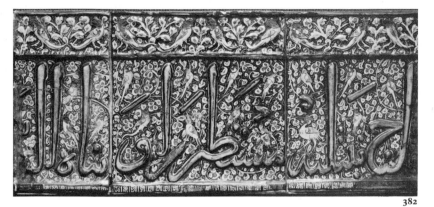

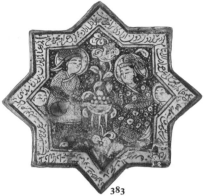

382

383

381 Tile decorated in lustre on an opaque white glaze
Diameter 31cm
Godman Collection, England
Persia (Kashan), 13th century

Inscription is from the Koran, Sura LXXXVII, verses 1–16. A companion piece to no. 380, with which it shares stylistic and technical similarities. Though gazelles appear on other lustre pieces, here the number is unusual as is the force of the design. Pieces such as this, where animals form the main decorative element, are by no means rare, and commonly occur as background decoration to tiles whose religious texts indicate that they were to be used in religious buildings.

Published: Wallis (1894, pl. XXXVII); Godman (1901, pl. IV)

381

382 Frieze of tiles covered with an opaque white glaze with touches of blue and turquoise and decorated in lustre
Each tile (average), 36cm square
Hetjens-Museum, Düsseldorf, 3 tiles, nos. 07300–1973/160; British Museum, London, 1 tile, no. OA 1122; Godman Collection, England, 1 tile; Musée des Arts Décoratifs, Paris, 1 tile, no. 7.638
Persia (Kashan), early 14th century

The inscription on these tiles does not yield a consecutive reading but is taken from the first few verses of Sura LXXVI of the Koran. One tile from this set, now in the Metropolitan Museum of Art, New York, contains the date, March 1308. There is a record that these tiles came from the shrine of 'Abd al-Ṣamad in Natanz which was erected in the same years and which, at one time, was decorated with lustre tiles. These were removed at the end of the last century. Lustre tiling was used primarily for the decoration of the tombs of Shi'a imams and imamzadas and they are not infrequently decorated with figures of animals and birds. Rarely, as in these examples, have the heads been chipped off, presumably due to iconoclastic zeal. The frieze is probably to be attributed to Yūsuf, the last recorded member of the Abū Ṭāhir potting family, see nos. 373–4, whose works date from 1305 to 1334.

Published: Wallis (1894, pl. VII); Wilber (1955, p. 133, no. 39); Düsseldorf (1973, no. 136, p. 109)

383 Tile painted in blue on an opaque white glaze decorated in lustre
Diameter 21.5cm
British Museum, London, no. OA + 1123
Persia (Kashan), 14th century

An important document both for its date and for the formula which follows it.

sana tis'a wa thalāthīn wa saba' mi"a bi-maqām Kāshān ḥamāhu 'Allāh ta'ālā 'an ḥawādith 'al-ayyām.
'[In] the year seven hundred and thirty nine [1339 AD] in the place Kashan, may God (be He exalted) protect it from the accidents of time.'
This is one of the few inscriptions which directly relate the production of lustre ware to the town of Kashan. Four other star tiles dated 1339 are known while only one piece is dated 1340. It would seem that in this year production of lustre wares at Kashan came to an end. The call for God's protection is found only on tiles of these last few years and may be a cry for help in the face of declining orders.

Published: Ettinghausen (1936, p. 59, fig. 15); Pope and Ackerman (1938–9, pl. 722f)

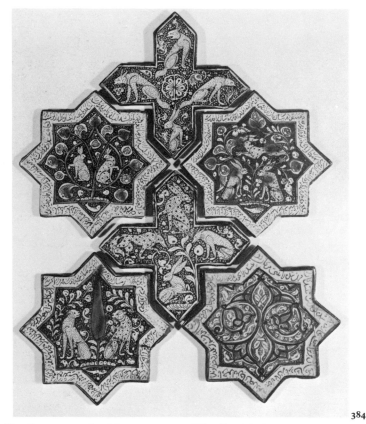

384

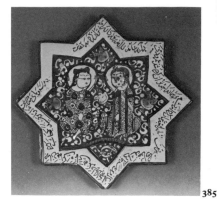

385

384 Six tiles covered with an opaque white glaze with touches of blue and turquoise and decorated in lustre

Each tile, diameter 20.1cm
Godman Collection, England
Persia (Kashan), 13th century

The inscriptions on the tiles with animal decoration are quatrains in Persian, similar in style and content. The poems on the tile with 3 hares reads

'Last night, desiring your presence, every moment
I contemplated the colour of the rose and the wine,
I drank large cups and played the rebeck,
with the memory of your lips, until the white day.'
'I have taken your goodness to the centre of my soul,
I have made known the smallest parts [of my soul] to you,
finally I have understood the whole world,
since I bore your seal on my tongue.'
'May the World Creator protect the owner of this wherever he be.'

The tile with the arabesque decoration is inscribed with the first few lines of the *Shāhnāma*. The two crosses and the star tiles with animal decoration belong to a group several of which are dated 1267. This group is thought to have once covered the walls of the Imamzada Ja'far at Damghan. The arabesque tile belongs to a group datable somewhat later in the century. Although coming from a secular epic poem, the inscription of this latter piece is religious in tone and is quite suitable for a religious building whose walls it once, no doubt, adorned. The 'secular' nature of the poems in the other tiles has led to the assumption that they were intended for the decoration of palaces and baths, but tiles with such inscriptions have also been discovered in religious buildings, see Watson (1975, pp. 66–7).

Published: Godman (1901, pl. XIXA); Bahrami (1936, pp. 186–90, pl. LXII);

385 Tile covered with an opaque white glaze painted in blue and turquoise and decorated in lustre

Diameter 20.5cm
*British Museum, London,
no. 78 12–30 561, acquired in 1878*
Persia (Kashan), late 13th–early 14th century

A rare tile from a series of which only a few examples are known. These tiles are distinguished by a curious type of foliage reserved in a lustre ground which is not broken up by stippling or scratched spirals (compare no. 384). The two-seated figures on this tile show the classical pose of figures on Kashan lustre wares which remain unchanged throughout the century and a half when it was in use, compare no. 350.

Published: Wallis (1894, pl. 22)

386 Tile painted in blue on an opaque white glaze and decorated in lustre

Height 36.4cm, width 33.4cm
*Iran Bastan Museum, Tehran,
no. 30, found at Takht-e Sulayman*
Persia (Kashan), 13th–14th century

The only secular building which can be identified with any certainty as having been decorated with lustre tiling is the kiosk of the Mongol ruler Abāqā Khān (1265–82) on the Takht-e Sulayman. Here, various types of tiles were used together, including lustre, lajvardina and different plain glazed tiles, see Naumann (1969). This example shows a horse man bearing a sword and shield surmounted by a frieze of

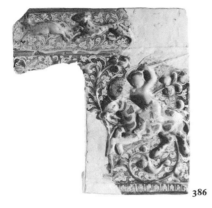

386

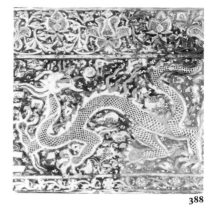

388

animals. This may be a scene from the
Shāhnāma or other popular epic
poems such as are found on other
lustre frieze tiles.

Unpublished

**388 Tile covered with a blue
glaze decorated with overglaze
enamel and leaf gilding**
Height 35cm
*Iran Bastan Museum, Tehran,
no. 21723 from the Takht-e Sulayman*
Persia (lajvardina ware),
13th–14th century

A number of frieze tiles decorated in
lajvardina technique were found on
the Takht-e Sulayman, showing
either a dragon (as on this example)
or a phoenix, see Naumann (1969,
pp. 55–7, abb. 17). They originally
formed a frieze above panels of
smaller tiles decorated in a similar
fashion. Tiles showing identical
dragons and phoenixes are known
decorated in lustre and may have been
produced from the same moulds, see
Lane (1960, pl. 2e). Lustre examples
have not however been found on the
Takht.

Published: Naumann (1969)

**387 Star tile covered with an
opaque white glaze and decorated
in lustre**
Diameter 21cm
*Iran Bastan Museum, Tehran,
no. 21730, found at Takht-e
Sulayman*
Persia (Kashan), second half
13th century

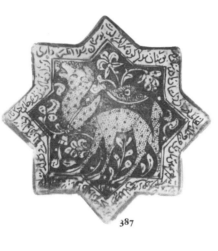

387

Moulds have been found at Takht-e
Sulayman which indicate that certain
varieties of glazed tile were made at
the site, and it is thought that some
of the lustre tiles were also made
there. Other examples of the lustre
tiles differ slightly in fabric and were
probably made in Kashan and
transported from there, see
Naumann (1969, p. 40). Several of
the tiles bear the date 671 H
[1272 AD]. The camel is a motif that
occurs several times on tiles of this
period.

Unpublished

**389 Tile covered with a blue
glaze decorated with overglaze
enamel and leaf gilding.**
Diameter 21cm
*Iran Bastan Museum, Tehran,
no. 21537, found at Takht-e Sulayman*
Persia (lajvardina ware),
13th–14th century

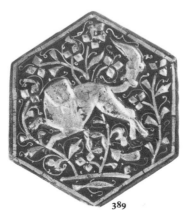

389

This tile decorated in the lajvardina
technique with a lion among foliage is
one of a number of similar types
found at the Takht-e Sulayman.
Others were decorated with gazelles
or phoenixes.

Published: Naumann (1969, p. 41,
abb. 3b and 5)

390

390 Tile carved in deep relief, covered with turquoise and white glazes
Height 125cm, width 59cm
Museum für Kunst und Gewerbe, Hamburg, no. 1908/472
Central Asia (Bukhara), Timurid period, 14th century

The 14th century saw the greatly increased use of glazed ceramic decoration on buildings. During the formative stages, especially in the eastern parts of the Islamic world, a great variety of different methods were used. During the second half of the century in Bukhara and Samarkand, several buildings were decorated extensively with carved relief tiles glazed in various colours. This example comes from the mausoleum of Buyān Qulī Khān (died 1358) in Bukhara, and presumably dates from a few years after his death, see Hill and Grabar (1967, p. 50, fig. 30). The decoration shows a large palmette scroll set on a background of finer scrolls.

Published: Berlin-Dahlem (1967, p. 56)

391 Frieze of eight tiles with carved decoration covered with white, purple and turquoise glazes
Height 21cm, length (of each tile) 31cm
Victoria and Albert Museum, London, no. 575–1900
Central Asia (Samarkand), Timurid period, 14th century

These tiles apparently come from the Shah-e Zinda in Samarkand, a complex of mausoleums dating from the late 14th and early 15th centuries, see Hill and Grabar (1967, pp. 53–4, figs. 71–89). The tombs of this complex are covered with some of the finest tile-work of the Timurid period. Carved tiles similar to those shown here cover the entrance facades of several mausolea, the most impressive of which is the tomb of Shād-e Mulk Aka, a niece of Timur, dated 1372. This particular technique was never developed in the west of Persia and even in the east was soon superseded by faience mosaic. The decoration of these tiles consists of a fine repeating arabesque motif.

Published: Lane (1960, pp. 8–9)

392 Tile with carved decoration and white, blue, turquoise and purple glazes
Height 39cm, width 19cm
Victoria and Albert Museum, London, no. 1283–1893
Central Asia (Samarkand), late 14th century

This tile comes from a frieze running around the facade of the entrance to the Mausoleum of Khoja Aḥmad in the Shah-e Zinda complex in Samarkand. The inscription on the tile reads *al-ḥikma li'llāh*, 'Wisdom is God's'. This phrase is repeated in alternation with another, *al-mulk li'llāh*, 'Sovereignty belongs to God'. A photograph of the mausoleum taken by Count Morra in the 1890s shows many tiles from this frieze missing, see Hill and Grabar (1967, pls. 74–5, p. 53).

Unpublished

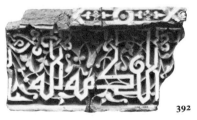

392

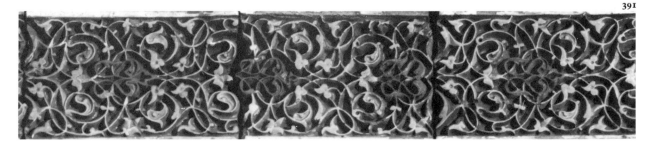

391

394

393 Tile covered with opaque white glaze over which are laid blue and turquoise glazes decorated with red enamel and leaf gilding
Height 25.4cm, width 42.5cm
Godman Collection, England
Persia, about 1400

Developed as a cheap substitute for faience mosaic, the *cuerda seca* technique combines several different colours on one tile. The colours are prevented from running together by a line of greasy substance mixed with manganese which is painted between them. The grease burns out during the firing and leaves a dull matt line (the *cuerda seca*) between the colours. The technique first appears in Persia in the 14th century and has been continually used to this day. Leaf gilding on tile work was widespread from the 14th century onwards, even on cut faience mosaic. An identical tile in the Victoria and Albert Museum, London (no. C747–1909), is reported to have been found at Khamsar near Kashan.

Unpublished

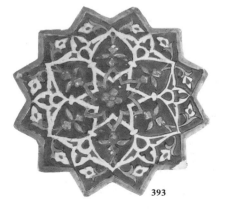

393

394 Tile with blue and turquoise glazes laid over a white glaze background
35.5cm square
*Art Institute of Chicago,
no. 1926.1186, Logan-Patten-Ryerson
Collection, said to have come from the
Royal Mosque in Isfahan*
Persia, Safavid period, early 17th century

The inscription is the Koranic phrase *Allāh lā ilāh illā huwa*, 'Allāh, there is no god but He', repeated on each side of the tile with the high risers forming an interlocking pattern in the centre. The word *huwa* is written in turquoise above the rest of the inscription which appears in white. The technique of the tile, in which several glaze colours are laid on a white background, was adopted on a large scale in the early 17th century because, it is often said, of the impatience of Shah 'Abbās at the slow progress of the cut faience mosaic decoration of his Royal Mosque.

Published: Pope and Ackerman (1938–9, pl. 528b); Welch (1973–4, no. 36)

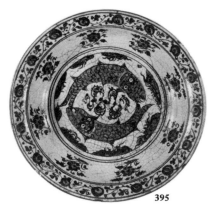

395

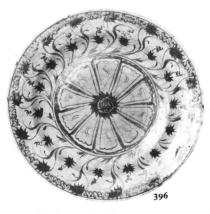

396

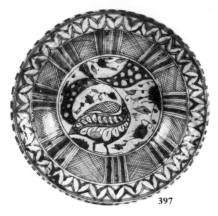

397

395 Dish painted in blue under a transparent glaze
Diameter 35.5cm
State Hermitage Museum, Leningrad, no. VG 2392, acquired in Kubachi in 1949
Persia (Kubachi ware), Safavid period, 16th century

Persian wares of the 16th century are very rare, and wares of the Kubachi type are the only ones whose production can be traced through the 15th, 16th and 17th centuries. Many elements are taken from Chinese blue and white porcelain, for which the Persian wares were a cheap substitute. The two fish containing a cloud scroll between them represented on this dish are also found on a blue and white Persian plate dated 1563–4, where they represent the sign of *Pisces* in a series of illustrations of the signs of the Zodiac, see Lane (1957a, p. 93, pl. 53b).

Published: Samarkand (1969, no. 137)

396 Dish painted in black under a turquoise glaze
Diameter 34cm
David Collection, Copenhagen, no. Isl. 3
Persia (Kubachi ware), Safavid period, early 17th century

The Kubachi wares are not altogether a homogenous group; they are named after the Caucasian village where large numbers of them were found at the beginning of this century. They were certainly not made in the village and perhaps Tabriz has the best claim for their production. Painting in black under a turquoise glaze had been practiced continually in Persia since the end of the 12th century. The foliage on the outer border is characteristic of this ware, and the radiating lotus panel is taken from Chinese models. The curious face scratched in the central star is unique.

Published: Davids-Samling (1948, p. 109, and 1975, pl. 92)

397 Dish painted in green and black under a transparent glaze
Diameter 30.5cm
Iran Bastan Museum, Tehran, no. 4515, found at Saveh
Persia, Safavid period, 16th century

The complete lack of Chinese influence is remarkable in a piece evidently dating from the Safavid period. The cross hatching of the panels in the well of the dish is perhaps a continuation of a style that began in Persia soon after the Mongol invasions in the 13th century, but the style of the painted bird is unique.

Unpublished

398 Bottle painted in blue and black under a transparent glaze
Height 11.3cm
Joseph and Jean Soustiel Collection, Paris
Persia, Safavid period, 17th century

The second opening on the shoulder of this bottle show it to be the base of a ghalyan or water-pipe. Neither the shape of the vessel nor its decoration, arabesques and sprays of leaves contained within panels, owe anything to Chinese influence which generally dominates Persia wares of this period. The base, however, bears a pseudo-Chinese mark. A large group of Persian blue and white wares, to which this ghalyan belongs, is tentatively attributed to Mashhad, a site which is mentioned in contemporary literature as one of the few places that produced fine pottery, see Lane (1957a, pp. 97–8).

Unpublished

398

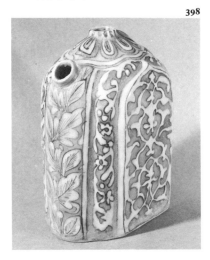

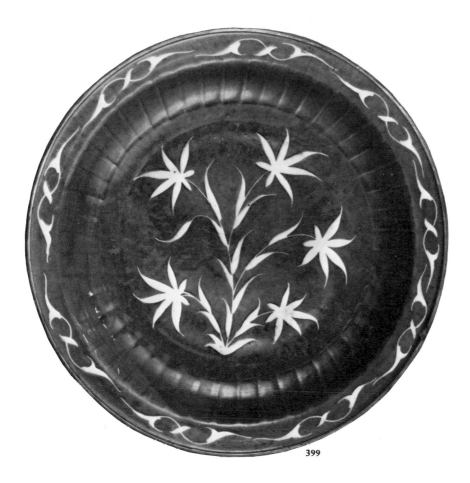

399

**399 Dish with blue slip carved
through to reveal the white
ground, covered with a
transparent glaze**
Diameter 47cm
*British Museum, London, no. 1970
2–71*
Persia, Safavid period, 17th century

Unlike the bulk of Persian
17th-century wares which are close
copies of Chinese blue and white
porcelain, this type relies less heavily
on Chinese inspiration. This dish, an
example of a rather rare group, has its
floral design cut through an overall
covering of blue.

Unpublished

**400 Plate painted in blue, black,
sage-green and red under a
transparent glaze**
Diameter 37.5cm
*Victoria and Albert Museum, London,
no. 485–1888, acquired from
R. Murdoch-Smith in 1888*
Persia, Safavid period, 17th century

A large number of pieces decorated
in polychrome are attributed to
Kerman. The colours, especially the
use of a red slip, would seem to have
been inspired by Iznik wares,
perhaps through the mediation of
Kubachi wares. There is, however,
no trace of Turkish influence in the
designs of Kerman wares. The
polychrome floral sprays of this plate
are similar to those known from
Safavid lustre wares.

Published: Pope and Ackerman (1938–9,
p. 801)

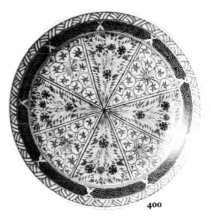

400

401

401 Bowl, interior painted in blue under a transparent glaze, decorated in lustre, exterior and blue glazed decorated in lustre
Diameter 29.2cm
Godman Collection, England
Persia, Safavid period, second half 17th century

Between the mid-14th and mid-17th century only a handful of lustre pieces are known, most of which are rather inferior tombstones. They provide, however, sufficient indication that the technique of lustre manufacture was not entirely lost. The revival of this technique in the 17th century is shown by large numbers of vessels, which are very different technically to the earlier pieces, having transparent glazes and, in general, rather hard brassy lustres. The decoration is usually in its own particular idiom which bears certain resemblances to Kerman polychrome wares and to contemporary border illuminations. Where underglaze blue is also used the influence of Chinese porcelain is often apparent. In this bowl the division of the interior into a series of panels is a rough adaption of designs found on Chinese porcelain of Wan Li date (late 16th–early 17th century).

Published: Godman (1901, no. 228, pl. V)

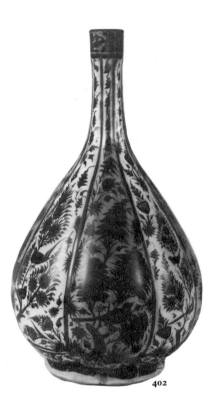

402

402 Bottle decorated in lustre on alternating white and blue glazed panels
Height 34.5cm
Godman Collection, England acquired in 1889 from the Richard Collection
Persia, Safavid period, second half 17th century

Painting in lustre on a vessel whose surface has been alternatively divided into blue and white panels is a device that is found on Persian lustre wares in the late 12th century. The shape of this bottle is typical of Safavid production, here divided into eight lobes decorated with birds and foliage.

Published: Godman (1901, no. 305, pl. VIII)

403

403 Dish with incised decoration under a transparent glaze, reverse lightly ribbed and coloured pale celadon
Diameter 23.5cm
Godman Collection, England, acquired in 1889 from the Richard Collection
Persia, Safavid period, late 17th or 18th century

This type of dish is often referred to as Gombroon ware after the port (now Bandar Abbas) from which this and other types of pottery were shipped to the West. Its place of manufacture, however, is unknown. This group is the most delicate of later Persian wares, and for the first time since the 13th century, the translucency of thin frit bodies is exploited, often forming the whole

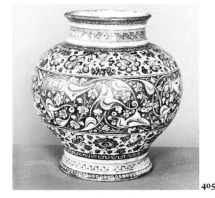

405

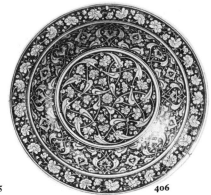

406

interest of a piece. The pale celadon colour of the reverse and the most delicate and subtle incised pattern are taken from contemporary Chinese porcelain.

Published: Godman (1901, no. 340, pl. XVI)

404 Bowl with transparent glaze, reverse bearing ribs in relief and coloured pale celadon

Diameter 21.6cm
Godman Collection, England
Persia, Safavid period, later 17th or 18th century

The appeal of this bowl lies almost entirely in the contrast between the translucent white body and the raised ribs coloured with celadon. There is an identical piece in the Victoria and Albert Museum, London (no. 2862–1876).

Published: Godman (1901, no. 347, pl. XVI)

404

405 Jar painted in blue under a transparent glaze

Height 24.5cm
Victoria and Albert Museum, London, no. C 57–1902
Turkey (Iznik, 'Abraham of Kutahya' type), Ottoman period, about 1490

The earliest of the Iznik wares are those of the 'Abraham of Kutahya' type, so-called after a dedication to this person inscribed on a small ewer, see Carswell (1972, pp. 78–9). They are all painted in blue on a white ground and share the same white body and brilliant glaze. They show a consistent development over 30 years or so before the introduction of other colours and the beginning of the so-called 'Damascus' style. Characteristic of many examples of the 'Abraham of Kutahya' type is the separation of the *hatāyi* elements (based on Chinese designs) painted in blue on white, from the *rūmi* elements (Turkish or Islamic designs) which are generally reserved in white on a blue ground. Of the few pieces of this type that can be attributed to the end of the 15th century, this jar is perhaps the earliest. It shares with other early pieces a blackish blue pigment, rather formal heavy designs and an angular profile derived from metal work.

Published: Kelekian (1910, no. 102); Lane (1957a, pp. 45–8, pl. 23a)

406 Dish painted in blue under a transparent glaze

Diameter 44.5cm
Gemeentemuseum, The Hague, no. OC(I) 6–1936
Turkey (Iznik, 'Abraham of Kutahya' type), Ottoman period, 1490–1500

A very small number of large dishes painted in a blackish blue may be attributed to the late 15th century, see no. 407, and Lane (1957b, figs. 8–9). In this example the *rūmi* element forms the major part of the design, and is painted in reserve, while the *hatāyi* design is restricted to a floral scroll around the outside of the well. The shape and the colour scheme are taken from Chinese porcelain, though the exact manner of this transmission is unclear. Both Iznik wares and Chinese porcelain are mentioned for the first time in the Istanbul palace records in an inventory dated 1495, when the Chinese collection consisted of only six pieces, which did not include any plate or dish. The small size of the collection which, it seems, had only grown to twenty-one pieces by 1505, may account for the relatively slight Chinese influence in the designs. By the time larger numbers of Chinese wares had arrived in Turkey (sixty-two pieces were taken as booty from the Persians in 1514), the Turkish potters had developed their own idiom in painting ceramics.

Published: Lane (1957b, p. 259); Düsseldorf (1973, p. 214, no. 308)

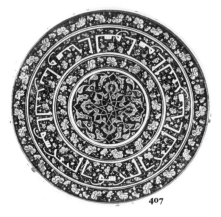

407

407 Dish painted in blue under a transparent glaze
Diameter 40cm
Musée du Louvre, Paris, no. 6321, Leg. Piet Latandrie, 1909
Turkey (Iznik, 'Abraham of Kutahya' type), Ottoman period, 1490–1500

The inscription of this piece consists of legible but meaningless words, some of which resemble those found in pseudo inscriptions on other Iznik vessels. The base is marked with a single half-palmette leaf.

Published: Lane (1957b, p. 258, fig. 8); Paris (1971, p. 59, no. 90)

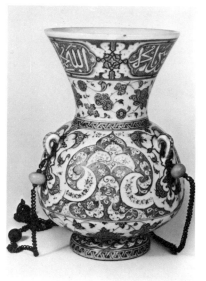

409

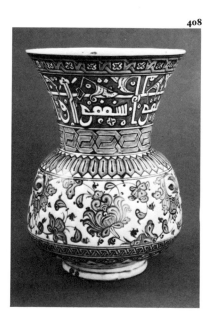

408

408 Mosque lamp painted in blue under a transparent glaze
Height 22.7cm
British Museum, London, no. 78 12–30 500, Henderson Bequest 1878
Turkey (Iznik, 'Abraham of Kutahya' type), Ottoman period, about 1510

The inscription round the neck consists of legible but meaningless words. The lamp probably belongs to a set made for the Turbe of Bayezid I who died in 1512, and while less elegant in shape and decoration than the lamp (see no. 409), which is slightly later in date, it shows an advance over the rather heavy shapes and designs of the late 15th century Iznik pieces (see nos. 405–7). The distinct three-dimensional quality in the painting of the floral scroll is characteristic of the earlier pieces in the 'Abraham of Kutahya' group.

Published: Lane (1957a, p. 45, pl. 24b and 1957b, p. 258, fig. 19)

409 Lamp painted in blue under a transparent glaze
Height 29cm
Godman Collection, England
Turkey (Iznik 'Abraham of Kutahya' type), Ottoman period, early 16th century
Inscription round the neck is from the Koran, Sura LXI, 13, followed by a panel with the names *Allāh, Muḥammad* and '*Ali*. The shape of this lamp is slightly more elegant and more 'ceramic' in form than no. 408 and probably dates from a few years later. The decoration is still restricted to blue and white, and the *rūmi* and *hatāyi* elements still occur separately. The design is most accomplished and the central band of palmette motifs can be read either as inverted white palmettes hanging from the neck on a blue ground, or as upright blue palmettes on a white ground. The painting has lost the heaviness which is found in the early Iznik pieces and the warm colour and delicate painting anticipate the 'Golden Horn' and 'Damascus' types. In this lamp, as in other Iznik pieces, the standard of the calligraphy does not equal that of the other decoration.

Published: Godman (1901, pl. XLVI, no. 1); Lane (1957a, pp. 45–8, pl. 25a and 1957b, p. 258, fig. 21)

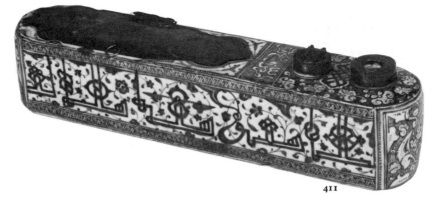

411

410 Tankard painted in blue under a transparent glaze

Height 22cm, diameter 15.5cm
*Musée National de Céramique,
Sèvres, no. 4686, acquired in 1854*
Turkey (Iznik, 'Abraham of Kutahya'
type), Ottoman period, 1520–5

The shape of the tankard is derived
from contemporary metalwork
(compare no. 163), and somewhat
resembles a lipless jug. It becomes a
common form in the suceeding
'Damascus' period of Iznik. This is
the sole surviving example in the
'Abrahama of Kutahya' class which
suggests that it was made towards the
end of the 'Kutahya' period. The
pseudo-kufic inscription which runs
round the neck is less recognisable
than other inscriptions found on
pieces of the same group and heralds
the abandonment of inscriptions in
later Iznik vessels.

Published: Lane (1957b, p. 261, fig. 31);
Paris (1971, no. 91)

410

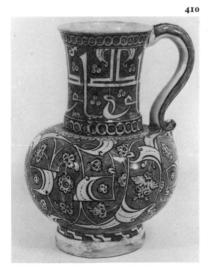

411 Pen box painted in blue under a transparent glaze

Length 30cm, width and height 6.5cm
Godman Collection, England
Turkey (Iznik 'Abraham of Kutahya'
type), Ottoman period, early 16th
century

A pseudo kufic inscription runs down
both sides. A panel at the top has an
inscription from the Koran, Sura,
LXI, 13. Like other pieces of Iznik of
the 'Kutahya' type, this unique object
is copied from a metal prototype, see
no. 202. The pale colour of blue and
the delicate floral scrolls behind the
inscription suggests a late date within
its class, perhaps contemporary with
the mosque lamp no. 409. The lack of
interest in calligraphy of the Iznik
potters is well shown here; not only
are the inscriptions poorly drawn, but
the same texts occur in a very similar
form on other pieces. The silver
mounts were added later after
part of the shaped opening to the pen
compartment had been broken.

Published: Godman (1901, pl. XLIX,
no. 296); Lane (1957a, pp. 45–8, pl. 25b
and 1957b, p. 259, fig. 23)

412 Jug painted in blue under a transparent glaze

Height 28 cm, diameter (maximum)
16cm
*Museo Civico Medievale, Bologna,
no. 1305*
Turkey (Iznik 'Golden Horn' type),
Ottoman period, 1520–35

A small group of vessels painted in
spiral floral sprays were once
erroneously attributed to the Golden
Horn. They are associated with the
'Damascus' period of Iznik both in

date (one piece is dated 1529) and
in the use of colours other than blue
and white on some examples. This
jug, with its smooth profile and
pinched lip, shows the influence of
Italian majolica wares and may have
been made for export to that
country.

Published: Sourdel-Thomine and Spuler
(1973, pl. 398)

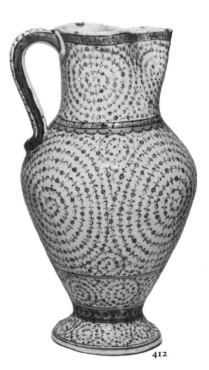

412

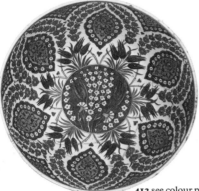

413 see colour plate, page 63

413 Bowl painted in blue, turquoise, sage-green, purple and black under a transparent glaze
Height 28cm, diameter 42cm
Godman Collection, England
Turkey (Iznik 'Damascus' type), Ottoman period, about 1550

The features which most distinguish the 'Damascus' style from the preceding 'Abraham of Kutahya' style are the free designs, tending towards naturalism, and the use of rich polychromy. The style starts somewhere in the 1520s when turquoise and sage-green are found, and naturalisic flower designs appear. By the mid-16th century, black and manganese purple are added to achieve the richest palette ever used by Iznik potters. Characteristic of this period are the tulips and dianthus flowers which appear in this bowl in a natural setting, and the small panels of black arabesques under a turquoise wash. It may be that designs for these wares were supplied by court artists as similar forms are also found on textiles and carpets of the period.

Published: Godman (1901, pl. LI, LII, no. 15); Lane (1957a, pl. 37 and 1957b, p. 270, fig. 44)

414 Dish painted in blue, green, black and red under a transparent glaze
Diameter 28cm
Staatliche Museen Preussischer Kulturbesitz, Museum für Islamische Kunst, Berlin-Dahlem, no. 1.5370
Turkey (Iznik, 'Rhodian' type), Ottoman period, second half 16th century

The 'Rhodian' style of Iznik developed out of the 'Damascus' style in about 1560. The change is seen in the colours: the subtle sage-green and manganese purple of the former group are replaced by grass-green and the famous Armenian bole red, a brightly coloured clay slip that is applied in perceptible relief. This gives the best pieces a brilliance never before achieved in ceramic decoration. The mixture of naturalistic flowers with stylised floral motifs, cloud scrolls and other abstract designs is a common feature of these wares.

Published: Kühnel (1970, fig. 121); Berlin-Dahlem (1971a, no. 559)

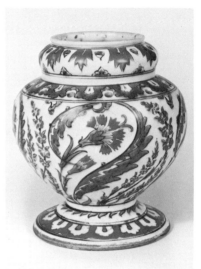

415

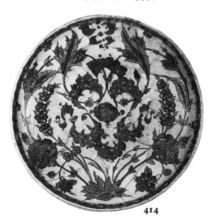

414

416

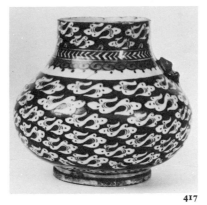

417

415 Vase painted in red, blue, green and black under a transparent glaze

Height 18.5cm
Godman Collection, England, formerly in the Gaisford St. Lawrence Collection
Turkey (Iznik 'Rhodian' type), Ottoman period, second half 16th century

The vase has pierced holes round the top of the neck and shoulders, perhaps to act as a flower vase or container for pot-pourri. The base is marked with a long-stemmed 'T' intersecting with a 'S', resembling a mark found on Italian majolica. It is possible that this piece was made for export to Italy for such trade is indicated by copies in majolica of Iznik wares.

Published: Lane (1957a, pp. 59–60, pl. 41a)

416 Dish painted in red, blue, green and black under a transparent glaze

Diameter 30.5cm
Godman Collection, England
Turkey (Iznik 'Rhodian' type), Ottoman period, second half 16th century

An example of a group characterised by an all over fish-scale pattern. The cruciform design formed by the cypress sprays and green scales may be read as four fish against a background of blue water.

Published: Godman (1901, no. 110, pl. LVIII)

417 Jug painted in blue and turquoise under a transparent glaze

Height 13.2cm, width 14.7cm
State Hermitage Museum, Leningrad, no. VG-2006
Turkey (Iznik), Ottoman period, late 16th–early 17th century

Originally with a neck and handle similar to no. 410. While polychrome painting is indicative of later Iznik periods the restricted blue and white palette does not necessarily place a piece in the earlier 'Abraham of Kutahya' class. The smoother and more typically 'ceramic' shape and the repeating cloud pattern of this piece indicate a relatively late date. The repeat pattern is derived from textiles.

Published: Miller (1972, illustration p. 142)

418 Bottle painted in black, blue, green and red under a transparent glaze

Height 32.5cm
British Museum, London, no. 78 12–30 466
Turkey (Iznik 'Rhodian' type), Ottoman period, second half 16th century

The motif of double cloud bands is found on textiles and carpets of the period, as well as on pottery vessels and tiles. This bottle illustrates the high standards of technical excellence that were often maintained even when the decoration itself was of a modest nature. The metal mounts are a later addition.

Unpublished

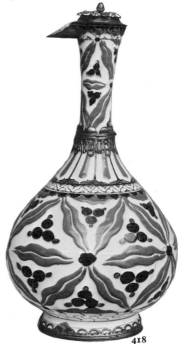

418

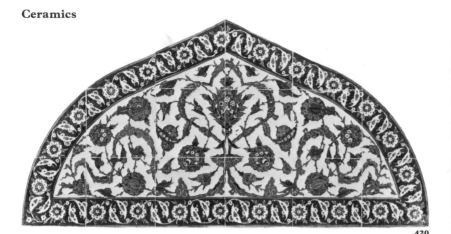

420

421 detail

419 Tankard painted in blue with red touches under a transparent glaze

Height 19cm
Godman Collection, England
Turkey (Iznik 'Rhodian' type),
Ottoman period, late 16th or 17th
century

The inscription reads
*Dār-e dunyā bir musāfirkhan [?a]
dir Göçer [āghine?] görmeyene
[sic] diwān [sic] dir*
'The house of the world is an inn.
Who does not see [? that he must
move on] is mad.'
This piece shows the standard form
of the Iznik tankard (or possibly vase)
of the second half of the 16th century
or later. Its curious angular flat
handle betrays a wooden or possibly
leather prototype. It is most unusual
for vessels of the 'Damascus' or
'Rhodian' Iznik type to bear
inscriptions, hence the particular
interest of this piece.

Published: London (1885, p. 51, no. 444);
Godman (1901, no. 81, pl. LX)

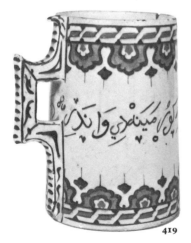

419

420 Tile panel painted in blue, turquoise, green and red under a transparent glaze

Height 70cm, width 136cm
*Fundação Calouste Gulbenkian,
Lisbon, no. 1598*
Turkey (Iznik 'Rhodian' type),
Ottoman period, second half 16th
century

This panel was possibly removed
from the mosque of Piyale Pasha in
Istanbul which was built in 1574.
Very similar panels reported to have
come from this mosque are
preserved in other European
collections. See, for example,
Migeon (1921: pl. 42) for a panel in
the Louvre. From the mid-16th
century onwards a great proportion
of the Iznik potters' output consisted
of tile work which was used exten-
sively for the interior decoration of
buildings. Panels of this shape would
be set over doors or windows.
Columns, walls and mihrabs would
be covered in similar tiling. Records
are preserved which show that the
potters worked to the special order of
the rulers to produce tiles for state
buildings. These tiles employed
patterns supplied by court artists
which were executed on paper in
Istanbul and then transferred onto
ceramic tiles in Iznik. This panel is
closely allied in style to similar panels
made for Sinan's mosque of Selim II
in Edirne and the tomb of that
sovereign in Istanbul. The carefully
planned design of curved leaves,
palmettes and ribbon-like cloud
bands is typical of the high period of
Iznik production. Even when such
tiles were mass-produced, their
quality was often extremely high.

Published: Lisbon (1963, no. 52)

421 Panel of underglazed painted tiles

Height 240cm, width (overall) 155cm
*Musée du Louvre, Paris, no. 3919/2–
265 a–d, from the tomb of Selim II,
completed c. 1575*
Turkey (Iznik, 'Rhodian' type),
Ottoman period, 16th century

The lavish ceramic decoration of the
tomb of Selim II is among the finest
productions of artists from the
Ottoman court in Istanbul and the
ceramic artists of Iznik. This large
panel, composed of sixty tiles, was
formerly found on the exterior wall of
the tomb, under a porch and to the
left of the entrance, with a companion
panel on the right. It continues a
tradition of such white-ground
decorative panels first established in
the tomb of Suleyman I in 1566, with
designs ultimately tracing back to
manuscript illustrating and book-
binding. The large composition of
leaves and palmettes under an arch
and surrounded by a blue-ground
border, was painted across the large
field of tiles. The various elements of
the design include the sinuous curved
leaves, the convoluted Chinese
cloud-bands, complex composite
floral forms and the flowering tree on
a blue ground embraced by two
exceptionally long saw-edged leaves.

Published: Migeon (1921, pl. 41); Öz (no
date, p. 31)

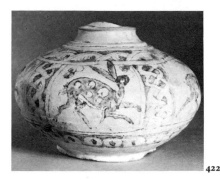

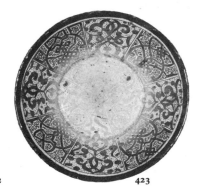

422

423

422 Jar, covered with a white slip and painted under a transparent glaze

Diameter 20cm
Archaeological Museum, Province of Granada, no. 677, found at Medina Elvira, near Granada
Spain, Umayyad Caliphate, 9th–10th century

It was under the domination of the Arabs that pottery was raised from the lowly position it had occupied under the Visigothic rulers. An interest in pottery is shown not only by the development of local fine pottery, of which this bowl is a typical example, but also by the discovery of fragments of lustre wares imported from the Middle East; see Frothingham (1951, pp. 4–6). The Spanish products, however, show little dependence on Eastern wares either in shapes or designs, and the technique – underglaze painting on a white ground – is not known in the East at this period. Even the drawing of the hare bears little resemblence to those found commonly on Mesopotamian wares.

Published: Gomez-Moreno (1951, p. 312, fig. 379c); Torres-Balbás (1965, p. 778, fig. 656)

423 Bowl covered in an opaque white glaze and decorated with lustre

Diameter 23cm
Staatliche Museen Preussischer Kulturbesitz, Museum für Islamische Kunst, Berlin-Dahlem, no. 4181, presented by F. Sarre in 1901.
Spain (Malaga): first half 14th century

On the base is a word in Arabic resembling *mālaqa* 'Malaga'. The origins of lustre painting in Spain are obscure. The technique was certainly brought by craftsmen from the East, but at what period is not certain. Whether by craftsmen from Egypt leaving after the fall of the Fatimids in 1171, or from Persia or half of the 13th century, no lustre ware of certain Spanish origin is recognisable until the early 14th century. From the mid-13th century textual references to 'golden ware' from Malaga abound, and the inscription on the base of this bowl and on other fragments confirm this attribution. The designs are painted in a Spanish idiom, which show a faint but interesting resemblance to designs on 13th and 14th century Syrian wares (see especially no. 311). The frit body used for all fine wares in the Middle-East from mid-12th century onwards was unknown in Spain. Malaga ware was an important item of export and many fragments have been found in Fustat in Egypt as well as in most countries of Europe.

Published: Düsseldorf (1973, p. 306, p. 470); Frothingham (1951, p. 15–7, fig. 6–7); Berlin-Dahlem (1971a, no. 342)

424 Tile covered in an opaque white glaze and painted in blue and decorated in lustre

Length 31cm
Instituto Valencia de Don Juan, Madrid, from the Alhambra in Granada
Spain, Nasrid period, 14th century

The inscription contains various blessings
[a]*l yumn al-dā'im al-'izz al-qā'im*
'Perpetual good fortune, lasting glory.'
The windows in the *Peinador de la Reina* (Queen's dressing room) in the Alhambra were framed by a frieze of tiles decorated in lustre, of which this piece originally formed a part. Various rooms in the Alhambra were decorated with lustre tiling, and it has been questioned whether such tiles were made at Malaga and transported to Granada, or made locally. No definite answer can be given, except that no immediate difference is noticeable between wares certainly made at Malaga and putative Granada pieces.

Published: Torres-Balbás (1949, p. 179, fig. 194); Evans (1920, p. 83, pl. XIV, fig. 50)

424

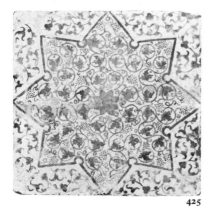

425

427

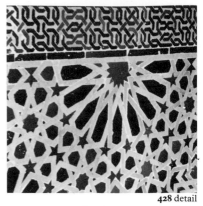

428 detail

425 Tile covered with an opaque white glaze and decorated in lustre

Height 24cm
Musée des Arts Décoratifs, Paris,
no. 15901, acquired in 1900
Spain (Malaga), Nasrid period,
late 14th–early 15th century

A large number of tiles were produced by the lustre potters for various palaces and other buildings in the Nasrid domains. Artistic contact between the Muslim state and the Christian states around it was close and is here shown by the naturalistic grapevine within the star, a naturalism and a subject adopted from contemporary Gothic decoration. The palmette scroll outside the star is typical of the Islamic decoration of the period.

Published: Frothingham (1951, p. 66–7, fig. 41)

426 Bowl, painted in lustre on an opaque white glaze

Archaeological Museum, the Alcazaba, Province of Malaga,
Spain, Nasrid period, 14th century

This bowl provides a pair to the famous ship bowl in the Victoria and Albert Museum, London, see Frothingham (1951, figs. 56–7). This has for long been attributed to Manises in Valencia, whence it is thought that potters from Moorish Malaga travelled after the decline of lustre pottery production in the Arab state. However it has recently been argued that these wares were in fact made in Malaga and are Moorish not

Christian products, as a similar vessel has been discovered in excavations in Malaga, see Llubiá (1973, p. 99, fig. 144).

Unpublished

427 Tombstone of earthenware covered with an opaque white glaze and decorated with lustre

Archaeological Museum, Huelva
Spain, Nasrid period, 1409

This piece is a most important document for the study of Nasrid wares as it is one of a very few pieces that gives a precise date for its manufacture. The form is typical for tombstones of the period and appears in stone as well as earthenware. The inscription reads

al-ḥamd li'llāh waḥdihi tuwuffiya
al-shābb al-ṭālib al-marḥūm Abū
'Abd Allāh Muḥammad ibn
al-shaykh al-faqīh al-ajall Abū
'Abd Allāh ibn Sa'īd ibn 'Alī
al-Jabali raḥimahu Allāh wa
barrada tharāhu 'ind al-zawāl min
yawm al-ithnayn al-rābi' 'ashr
li-dhī al- qa'da 'am iḥda 'ashr wa
thamāniya mi'a al-yumn wa'l-iqbāl
al yumn wa'l iqbāl
'Glory to God alone; the young student, the late Abū 'Abdullāh Muḥammad son of the shaykh the noble legist Abū 'Abdullāh son of Sa'īd son of 'Alī al-Jabali, God have mercy on him and make cool his resting place, died in the evening of Monday the 14th of Dhū al-qa'da of the year eight hundred and eleven [31st March 1409 AD] good fortune and prosperity, good fortune and prosperity.'

The date recorded is then that of the death of the student, and one must assume that the tombstone was made a short time afterwards. The design on the reverse of the tile is similar to those found on other lustre pieces from Malaga.

Published: Frothingham (1951, pp. 70–2, fig. 46); Llubiá (1973, fig. 154)

428 Panel of tiles, mosaic tiling in green, black, blue and white

National Museum of Hispano-Moresque Art, Granada, no. 1612
Spain (Granada), Nasrid period, 14th century

Dados formed of panels of tiles set in a variety of geometric patterns were greatly appreciated in the Nasrid kingdom. The patterns, often achieving considerable complexity, are constructed from fragments cut from larger tiles of different colours and on a plaster backing. The colour range is usually restricted, and white often dominates. Such tile patterns have remained continually popular in Spain until the present day. The inscription set above the panel is a repetition of the phrases

al-'izz li'llāh al-Mulk li-Allāh
'Glory is God's, Sovereignty is God's.'

Unpublished

Wood

447

Despite the perishable nature of wood, a relatively abundant quantity of woodwork, showing a high level of artistic and technical accomplishment, has survived from the major areas of the Islamic world. While much of this woodwork shares a stylistic vocabulary in common with other decorative arts associated with Islam there are, nonetheless, distinct regional variations. The type of inlay work, known as *khātam-kārī*, was well developed in Persia, whereas the use of turned wood to make openwork lattices was a feature of Egyptian woodwork. Islamic woodwork shows a chronological range from the 7th century down to the present day, although the representation is uneven for different areas. The most complete historical sequence can be traced in Egypt which not only has the most surviving pieces but also the earliest, since some carved panel fragments have been dated to the 7th century, see Pauty (1931, Pl. II). These are followed by a wealth of examples including a series of dated pieces of the 10th to 11th centuries, see Lamm (1936, pp. 90–1). Much of this Egyptian woodwork is preserved *in situ* in mosques, Coptic churches and secular buildings. In contrast the woodwork tradition of Persia cannot be studied so consistently, as the earliest examples are datable to the 10th–11th centuries and pieces have only survived in reasonable numbers from the 14th century onwards.

The development of a flourishing woodwork tradition is naturally linked to the availability of the basic material. In areas where wood was abundant such as north Persia, Turkey and the Balkans, it was used extensively as a building material. Where wood was rare as in Egypt and Arabia it was an expensive import and was consequently ornamented with the lavish care reserved for a luxury material. It is not always easy to assess the sources and types of wood because of insufficient documentation and research; in this context all too often the wood of surviving pieces has either not been determined or has been incorrectly identified. A certain amount of information is available, however, which serves as a general guide to the types of wood used. Although Egypt is thought to have been more abundantly wooded in Fatimid times (mid-10th to mid-11th centuries) than at present the bulk of its wood supplies were always imported, see Mayer (1958, p. 13). Resinous woods such as pine and cedar were imported from Turkey and Syria while plane wood (*platanus*) came also from Turkey. The Sudan and India were sources of the teak and ebony used

for more valuable objects. Sycomore (*ficus*), olive and cypress woods were more rarely used. Both Turkey and Persia could draw on their natural resources; parts of the north-west and Caspian regions of Persia were and still are intensely forested. Many species of trees were available for timber supplies such as oak from the Zagros forests, walnut, plane, cypress, elm, maple (*acer*), box, cherry, beech, lime, willow and poplar. Evenly-grained timbers like walnut, pomegranate, maple and pear were specially favoured for carving. In the arid Arabian peninsula the range of woods was narrow; palm and tamarisk and imported teak and sandalwood from India.

The function of wood in the Islamic world was primarily architectural. The brilliance and versatility of its ornament was essentially a means of making the utilitarian pleasing – a tendency which runs through all media of Islamic art. Wood was also a practical material allowing of little waste: in the hands of a skilled joiner even small fragments could be made into an attractive and functional object.

Both external and internal units of religious and secular architecture were fashioned from wood and in areas where it was in plentiful supply either entire buildings or major parts of them were constructed of timber. Turkey furnishes several splendid examples with wooden mosques of 14th and 15th century date. Similarly in domestic architecture a lavish use of wood is shown by the timber-frame houses with overhanging upper storeys found throughout Ottoman Turkey and the Balkans. In the Caspian region of Persia, buildings, such as the houses raised on platforms of Gilan province, were constructed entirely of wood. Where the main structure was of stone or brick substantial wooden fitments were added; houses and country mosques in north Persia today have deep porches with wooden pillars which are directly related to the ornate colonnaded porches or *talars* of the Chehel Situn and Ali Qapu palaces of 17th century Isfahan. Wooden fretwork windows filled with stained glass which served as sliding partitions separating rooms from each other or from the garden court were an important feature of Persian domestic architecture. In Egypt houses were given a distinctive character by the use of wooden doors and projecting balconies with windows made of turned lattice work.

Inside mosques, structural features like ceilings, domes, doors, screens isolating the sanctuary, mihrabs such as the one in the mausoleum of Sayyida Rukhayya in Cairo built between 1154 and 1160, carvings on tombs, and furniture such as pulpits or mimbars, lecterns and Koran boxes were made of wood. Domestic interiors made extensive use of wood. An essential feature of a Moslem house is the lack of specialised furniture in the Western sense. Rooms were flexible in function as they were carpeted and could be turned to different uses at will; for example, a dining-room was created by serving food on a cloth spread out on the floor. Furniture consisted of wooden chests for storing bedding and occasionally small tables and stools. Most of the woodwork therefore was structural. Ottoman houses of Turkey and the Balkans demonstrate the use of wood for elaborately decorated ceilings and panelled walls set with the cupboards and niches essential for storage purposes in the absence of wardrobes, bureaus, etc. Similar

cupboards and niches were set into the walls of Cairene houses observed during the last century with the addition of a wooden shelf running along the sides of some rooms, see Lane (1908, pp. 14–18).

Several woodworking techniques were widely practised. Common to them all is the use of small panels joined together to make items of the required size: the reasoning behind this is sensible – there was no waste of wood and the distortion caused by warping and shrinking in hot climates was minimised by being evenly distributed over smaller units. Perhaps the most widespread and earliest technique of woodworking was carving in relief which reached a high level of achievement in Egypt, Persia and Turkey. Here methods were used such as undercutting and slant-bevelling to exploit the decorative potential of wood. Another widely used technique was the synthesising of a design by applying wood strips to a foundation of beams. This was particularly favoured for ceilings of which excellent examples can be seen in Cairene and Ottoman houses. Wood worked in the carved and strip-appliqué techniques could be further embellished by painting. Some 15th century pieces from Persia show traces of paint while elaborately painted ceilings are a distinctive feature of the Safavid palaces of Chehel Situn and Ali Qapu, and of Ottoman and Cairene houses. As the use of painting developed, carving inevitably became less ornate as the painted elements supplied the decoration. Wood was also decorated by the technique of inlay in different coloured woods, ivory and bone. Two 12th century pulpits from North Africa have inlay in other woods and bone, and the 15th century pulpit from Qāytbāy's mosque in Cairo has ivory inlay. The use of mother-of-pearl inlay became widespread in Ottoman woodwork from the 17th century onwards while in contemporary Persia there developed a specialised inlay work known as *khātam-kārī* in which fine strips of wood, etc., are glued together to form meticulous geometrical patterns. These are then sliced horizontally into layers which are then stuck to a wooden foundation. Finally the technique of shaping wood by turning it on a lathe was practised: this is seen at its best in the lattice windows (*mashrabiyya*) of Cairene houses.

Islamic woodworkers were respected for their expertise and many were known by name since they signed their works, see Mayer (1958). They had the heritage of a venerable pre-Islamic tradition. Carpenters in Persia had played an essential role in building in Achaemenid times since they constructed wooden roof beams at Persepolis and Susa, and the bas-reliefs at Persepolis showing Darius and Xerxes seated on elaborate thrones are a witness to the woodturner's mastery of his craft. This skill was to continue into Islamic times. Egypt's experience included both the tradition of woodwork from Pharaonic times and the comparatively recent work of the Copts which provided much inspiration in technique and design. In Turkey carpenters had a special position closely related to that of architects; it is in fact known that several architects started their careers as carpenters. Apart from such specialised branches of the woodworker's craft such as that of the turner and inlay-worker carpenters, joiners and cabinet makers were not specifically differentiated: the term *najjār* generally covered all

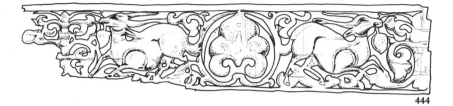

444

these trades in Arabic, Persian and Turkish.

Islamic wood illustrates the emergence of the characteristic idiom of Islamic ornament based on interlaced geometrical patterns, the complex foliate motif known as the arabesque which was often enriched with a teeming floral life, and the exploitation of the decorative possibilities of the many styles of Arabic calligraphy. A further significant contribution was made by figural representation.

The earliest Islamic wood consists of a group of panel fragments from 7th century Egypt deeply carved on one level of relief. The designs influenced by Coptic models, are variations on the trefoil-leafed vine whose stems frame figural motifs such as birds and lions. In another group of fragments of 8th century date the carving is still on one level of relief but is more shallow, while the vine scrolls are more elongated with leaves showing a tendency towards the stylisation of Sasanian half-palmettes. Carved wood panels from Takrit dated to the 8th century (no. 658) show further stylistic evolution. Their decoration consists principally of vine scrolls disciplined into deeply spiralling bands and circles in which heart-shaped palmettes with schematically rendered veins replace leaves and pine cones grow out of the tendrils. Contemporary Egyptian woodwork illustrates a more abstract style in which overlapping arches and circular motifs often enclosing palmettes are reserved against bands of deeply-cut continuous lozenges confined within dog-tooth borders. One example is a key piece as it shows the synthesis of Sasanian and Byzantine elements (no. 434). It is a frieze carved with panels containing pairs of curved Sasanian wings enfolding three globes flanking a scalloped panel containing a vine foliage tree. All these motifs are set against a background of vine trefoil worked in the Byzantine manner. The frieze is additionally decorated with bands of Arabic inscription in a squat kufic script with elongated horizontals, a form which was current in the 9th century.

Abbasid woodwork of the late 8th and 9th centuries (see no. 431) witnessed the appearance of a new style in wood carving which has close parallels in the contemporary stone and stucco work from Samarra. The technique used is slant-bevelled relief carving to give an almost padded or quilted effect. The motifs are realised on a large scale and generally consist of generous spirals, comma-like volutes, and pear-shaped drops all combining to form a smooth and symmetrical pattern; another variant employs the same vocabulary of ornament but

picks out the shapes in raised outline only. This style is closely paralleled in Tulunid Egypt (mid-9th to early 10th centuries) where it may have been introduced from Mesopotamia. Hints of the bevelled technique are already seen in early 9th century panel fragments where large circular motifs with concentric circles appear. The style developed fully to blend the Abbasid repertoire with animal motifs such as pairs of streamlined doves carved on a frieze in which traces of paint have also been found (no. 436). Deeper undercutting of the motifs modified the style in the early 10th century. It is interesting to note that the Tulunid bevelled technique continued in Egypt along with the innovations of the Fatimid period. The doors of the Al-Ḥākim mosque in Cairo are a good example of this survival since although they are carved with bevelled arabesques the foliate kufic inscriptions bear the date 1010.

Fatimid Egypt (mid-10th to mid-11th centuries) saw a great flowering of the woodcarver's art while material for comparison has survived from Persia, Turkey and North Africa. Excellent examples of both Islamic and Coptic wood have survived characterised by a great vitality which pervades a much enriched decorative vocabulary. A logical development can be traced from the Tulunid style as the softly textured bevelled motifs take on a new energy by a combination of deep undercutting and outlines picked out in bands of beading. The use of figure motifs was greatly developed either formally as in the adorsed horses' heads which appear to metamorphose out of lobes of the symmetrical arabesque foliage which entwines around them (no. 443) or in an almost naturalistic way as in the friezes of 11th century date (no. 442) from the Fatimid palace site of Dar al-Qutbiyya in Cairo. Here are a profusion of figure scenes – hunters, dancers, musicians, and merchants with camels all set within interlaced compartments on a background of spiralling trefoil scroll. Certain motifs have parallels in other Islamic art forms; the winged harpies, for example, are found on Fatimid lustre-painted pottery and in the designs of the Seljuq pottery of contemporary Persia. Comparable treatment of arabesque motifs is found in Syrian woodwork (no. 448). Fatimid woodwork of the 12th century shows increasing elaboration of detail. Two mihrabs from the mosques of Sayyida Nafisa (1138–45) and of Sayyida Rukhayya (1154–60) are carved with continuous patterns in which geometrical interlacing is combined with small units such as hexagons and stars each enfolding a separate foliate motif. This style of ornament increasingly tended to replace the lively figural decoration.

While wood from other regions of the contemporary Islamic world is less well-documented than in Egypt some general features can be deduced from the surviving pieces. In Persia few examples at present can be attributed with confidence to a 10th century date. The earliest pieces of carved wood of 10th to 11th century date include the doors from the tomb of Maḥmūd of Ghazni (998–1030), whose kingdom fell within the sphere of Persian cultural influence, and show some resemblance to the carving of early Fatimid work in their use of curved arabesque scrolls, beaded bands, and inscriptions in kufic. Some 12th-

century pieces, such as a mimbar dated 1151 in the Metropolitan Museum of Art, New York, demonstrate a continuous decoration of geometrical motifs and palmettes. Where foliage scrolls occur the forms of the leaves show their origin in the Sasanian half-palmette.

A relatively large amount of wood has survived from Turkey attributed to the 12th to 13th centuries including doors, pulpits, and Koran stands carved with geometrical and arabesque devices and representational motifs of lions, griffins, peacocks, and human figures which can be paralleled in Turkish Seljuq ceramics, tilework and stone. Although there is little contemporary woodwork extant in North Africa, there are a few important pieces of late 11th to 12th century date such as the mimbar of the Great Mosque of Algiers dated 1082 and two Moroccan mimbars from the Koutoubiya and Kasba mosques constructed between 1150 and 1160, all in carved wood using a repertoire of designs of geometrical patterns, palmettes and arabesque scrolls.

During the long period following the Fatimids, Egypt was ruled successively by the Ayyubids and the Mamluks (mid-12th to early 16th centuries). At first the Fatimid woodwork tradition continued but with increasing elaboration in the combinations of tendrils and leaves of arabesque motifs and new palmette forms. Gradually figural representation gave way to a composite style in which small inter-locking polygonal panels were filled with interlaced arabesque foliage in carved relief. Inlay in different coloured woods, bone and ivory was increasingly used. One of the most distinctive features, however, of Mamluk woodwork and indeed of Mamluk decorative arts is the replacement of kufic script by a bold variant of the cursive naskhi script known as thuluth. Here the script is the main element of the design which is formally divided into sections. A ceiling fragment of carved wood from the restorations to the Al Azhar mosque of Cairo made by the Mamluk Qāytbāy in 1494–5 shows how the treatment of calligraphy in wood resembles that of contemporary metalwork and ceramics. Here a large roundel with scalloped edge contains a thuluth inscription quoting Qāytbāy's name which is arranged as a diametrical chord. The roundel itself is framed in geometrically-shaped panels carved with arabesques reserved in relief on a plain background.

The Mamluk period also witnessed the development of the *mashrabiyya* or turned wood lattice, which continued through to the

457

19th century. It was used for screens, partitions and windows and is best seen in Cairene private houses. The basic principle is straightforward – a lattice was constructed of turned oval shapes joined together by short turned and ribbed links. An early example of *mashrabiyya* work is seen in diagonal lattice squares set into a carved wooden panel from the Madrasa of Qāytbāy at al-Jamaliyya founded in 1480–1. An almost inexhaustible range of patterns could be worked in *mashrabiyya* in varying degrees of lacelike fineness. A technique was also practised which resulted in another pattern at a subsidiary level to the main lattice. If the connecting links were extended in length extra turned shapes could be fitted into the lattice to form designs such as mimbars (no. 455) interlacing cypress trees and kufic inscriptions.

In Persia numerous pieces of a high standard exist from the 14th century onwards. The carved doors from the sanctuary of the mosque of Bayezid Bastami of 1307–9 illustrate a profusion of arabesques with inscriptions in kufic. A particularly elegant and graceful style is seen in late 14th century pieces like the carved wood Koran stand in the Metropolitan Museum of Art, New York, dated 1360, in which the arabesque motifs are enriched by flowers and palmettes of Chinese inspiration such as the lotus and peony, and inscriptions are written in a bold naskhi. 15th century woodwork continued this tradition with an increasing use of exuberant floral ornament which foreshadows the style of the Safavid period (16th to early 18th centuries). Application of painted detail also became more prevalent replacing meticulous carving.

From the 16th century onwards, the dominant influences in Islamic woodwork were those of the Ottoman Turkish empire which controlled formerly independent territories such as Egypt, Mesopotamia, North Africa and Syria, and of the Safavids and Qajars of Persia. Both were characterised by increasing use of colour and flamboyance of motif which are especially seen in the painted floral designs and narrative scenes embellishing the walls of Ottoman houses and in the intricate *khātam-kārī* inlays and painted and lacquered doors and ceilings of Persia.

429

429 Fragment of a wooden cornice carved, painted and gilt
Length 39cm, height 9.5cm.
National Museum, Damascus,
no. A 16582, from Qaṣr al-Ḥayr
al-Gharbī
Syria, Umayyad period, 8th century

Probably part of a lintel or cornice. An identical design is found on the cornice of the Mosque of 'Amr, Fustat, dated to 827. See Creswell (1932, I, pl. 42b). The scroll motif with various fillings, common to Hellenistic and Mediterranean Christian art, survives unmodified, as here, or transformed into a palmette.

Unpublished

430 Panel, probably sycomore
Height 40.5cm, width 21cm
Museum of Islamic Art, Cairo,
no. 15468
Egypt or Syria, Umayyad period, 8th century

This panel is carved in high relief with two circular scrolls issuing from a basket-like vase. The upper scroll contains a bunch of grapes and the lower a palmette vine leaf. At either side of the vase is a pendant cluster of grapes and a squashed leaf. The scrolls have acanthus-like fronds. The panel bears circular dowel-holes and was evidently part of a wooden revetment. The theme, not the style, recalls the wooden revetment panels from the Aqsa mosque in Jerusalem dated to about 715. See Sourdel-Thomine and Spuler (1973, p. 186, no. 68–9).

Unpublished

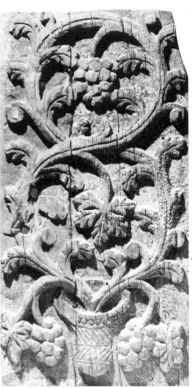

430

431 Wooden panel, ? originally attached to beam
Length 74cm, height 18.7cm
British Museum, London,
no. 1944 5-13 3
Mesopotamia, Abbasid period, 9th century

The bevelled wavy lines edging the main pattern on this panel are an adaption of the scroll motifs and surround a deeply cut pattern of bevelled lances.

Unpublished

431

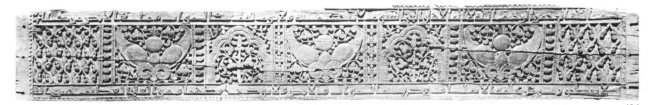

434

432 Carved panel

Height 36cm, width 24cm
National Museum, Damascus,
no. 2645/A8498
Syria, Abbasid period,
9th–10th century

This panel comes from Qal'at
al-Jabar, a site on the upper
Euphrates, and consists of a pattern
of circular grooves developing out of
each other around an axis. The
pattern is already recognisable as an
arabesque even though its elements
are not yet abstract. In the centre, the
piled vases of Hellenistic origin have
been simplified under the influence of
the third Samarran style. The leaves
growing out of the vases are
bevelled and form complementary
semi-circular shapes. The grooved
Sasanian palmettes are unmodified.
The scoring of these leaves and the
beadwork on the vases are typical of
the post-Samarran, especially
Fatimid, woodwork (compare
nos. 443, 447).

Published: Damascus (1969, fig. 125)

432

434 Section of a frieze, probably in teak

Length 192cm, height 32cm
Museum of Islamic Art, Cairo,
no. 2462, from the Great Cemetery
south of Cairo
Egypt, 9th century

Inscriptions in the upper and lower
margins are from the Koran, Suras II,
255 and IX, 13. Sura II, 255, the
Āyat al-Kursī, is a particularly
common funerary inscription. The
script is a squat kufic without dots
and is flat carved. The frieze is
divided into panels, palmettes and
rams' horns carved in high relief
alternating with panels of veined
trefoil scrolls of which two have a
foliate lance in a lobed arch, con-
ceivably intended as a mihrab. The
palmette compositions are derived
from the elements of Sasanian
crowns – the circular diadem, the
soaring wings and the horns of
Alexander. However, this particular
combination does not appear on the
coins of any of the Sasanian kings or
on pieces of Sasanian silver and is
evidently a free composition.

Published: David-Weill (1931, p. 43);
Pauty (1931, p. 12); Miles (1952,
pp. 156–71)

433 Wooden panel, ? originally attached to beam

Length 171cm, height 9.5cm
British Museum, London,
no. 1944 5-13 2
Mesopotamia, Abbasid period,
9th century

Lozenges here enclose identical
cuttlefish-like motifs. Compare
no. 435.

Unpublished

433 detail

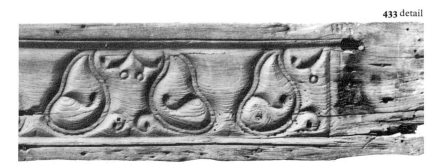

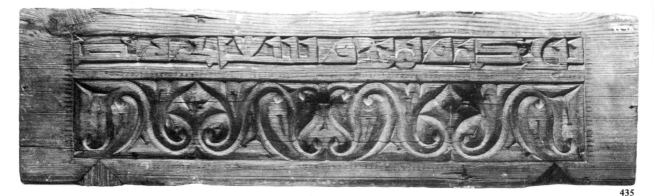

435

435 Panel of thin teak veneer

Length 83cm, height 23.5cm
Museum of Islamic Art, Cairo,
no. 3498
Egypt, Tulunid period, 9th century

Inscription
baraka wa yumn wa sa'āda li-ṣā
[*ḥibihi*]
'blessing and good fortune and
happiness to its owner.'
The veneer is laminated on to a base
to which it is fixed by corroded iron
nails. This panel has a bevelled
palmette scroll with the elements in
highest relief shaved flat. A second
panel in the Museum of Islamic Art,
Cairo (no. 3499), is exactly similar
except that it is solid teak rather than
veneer. Its inscription is almost
identical to that of this panel. Both
panels have uncarved borders with
excised joints where they were keyed
into a larger decorative scheme.

Published: David-Weill (1931, pp. 46–7),
Grohmann (1971)

436 Section of a frieze, probably of sycomore

Length 179cm, height 20.5cm
Museum of Islamic Art, Cairo,
no. 6280/2
Egypt, Tulunid period, 9th century

The bevelled frieze shows confronted
collared doves with a palmette
between and a background of swirling
wing-like palmettes. The border
above, the left hand end and the
carved decoration were thickly
painted in red and yellow ochre with
highlights in black and white,
probably on a deep blue ground. The
doves' wings have been flattened and
show pairs of dowel-holes to fix
embossed plaques which have now
disappeared. There are also dowel
holes to fix the panel to the wall.

Published: Pauty (1931, pp. 26–7)

437 Arched panel probably of teak

Height 58cm, width 45cm
Museum of Islamic Art, Cairo,
no. 13173, gift of Sir John Hume
Egypt, Tulunid period, late
9th century

This bevelled arched panel in a blank
surround has palmettes transformed
into confronted birds with their heads
drooping on their breasts. The
elements in highest relief have been
shaved flat. This is a perfect example
of the ambiguity of the Samarra
bevelled cut design in which the
design and ground merge perfectly
so that no single line can trace the
pattern. There are no indications of
painting, but a comparable painted
panel was discovered at Samarra. See
Herzfeld (1923, pl. XLII).

Unpublished

436

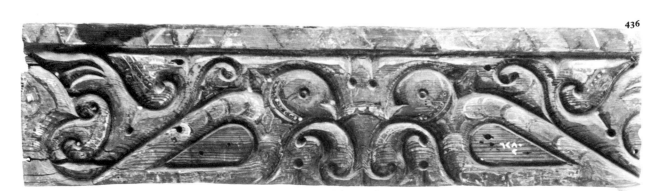

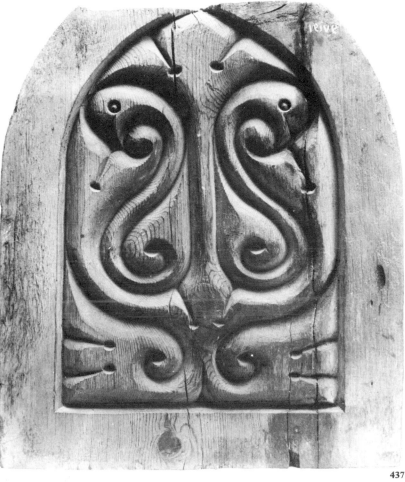

438 Fragment of a carved panel with floriated kufic inscription
Length 46.8cm, width 13.2cm
*National Museum, Damascus,
no. 14058A*
Syria (Raqqa), 11th century

This panel was discovered during the excavation of the Abbasid palace complex at Raqqa to which, however, it did not belong. The inscription reads [a]*mir al-mu'm*[*inin*], 'Commander of the Faithful.' The lettering and scrolls form distinct planes against the background and together with their unburdened elegance suggest links with the developments in the lettering on the monuments of 11th century Diarbakir in southern Turkey.

Published: Damascus (1969, p. 171, fig. 73)

437

438

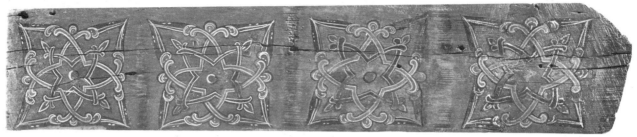

439 Painted corbel in the shape of an eagle's head

Length 70cm, height 15cm
Museum of the Great Mosque, Kairouan
Tunisia (Kairouan), Zirid period, 10th century

The head of the eagle is stylised and combined with an abstract scroll design in red, white, yellow and black. Corbels of this type appear early in north Africa and Spanish Islamic architecture and do not seem related to an eastern prototype. They have not yet been studied in depth.

Unpublished

440 Beam painted with geometric and plant designs on a red ground

Length 135cm, width 27.5cm
Museum of the Great Mosque, Kairouan
Tunisia (Kairouan), ? 11th century

The painted designs on north African beams and corbels appear to be unique in Islamic art. Their dating remains uncertain and their origins unexplored. Compare no. 441.

Published: Marçais (1925)

441a-b Two beams with painted inscriptions from beams of the Great Mosque, Kairouan

a. length 297cm
b. length 119cm
Museum of the Great Mosque, Kairouan
Tunisia (Kairouan), Zirid period, 11th century

The tree-trunks which form the beams of the transverse aisle of the Great Mosque were part of the 9th century Aghlabid foundation. They were boxed in with planks of cypress wood of which all but six bear later 11th century decoration.

Published: Marçais (1925);
Roy and Poinssot (1958, II, fas. I, p. 43c, d)

442 Section of a frieze with remains of plaster coating

Length 432cm, height 30cm
Museum of Islamic Art, Cairo, no. 3465, found during excavations at the hospital of Sultan Qalāwūn in Cairo
Egypt, Fatimid period, 11th century

The hospital of Sultan Qalāwūn was built on the site of a Fatimid palace the Dār al-Quṭbiyya (before 1063), and this wooden frieze is believed to have come from this palace. The richly varied decoration which includes huntsmen, musicians, dancers, harpies and hares is entirely characteristic of Fatimid court art and was also taken up by the painters who produced the lustre pottery for which Fatimid Egypt is celebrated (compare no. 276). There are also parallels of theme, though not of style, with the paintings on the ceiling of the Cappella Palatina in

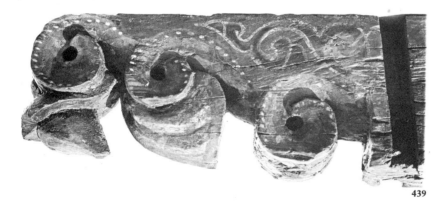

439

441 detail

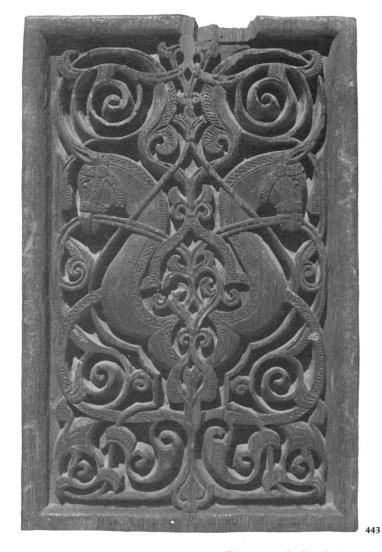

Palermo, built for Roger II of Sicily (1132–43). See Jones (1972, pp. 41–50). The frieze has traces of paint; the ground is dark blue and the figures are in red.

Published: Herz (1913, pp. 169–74); Cairo (1969, no. 220a)

443

442 detail

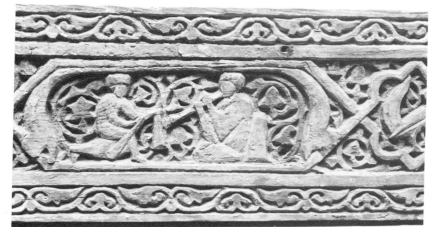

443 Door panel of teak
Height 33cm, width 21.5cm
Museum of Islamic Art, Cairo, no. 3361
Egypt, Fatimid period, 11th century

This panel is deeply incised with a striking slanting cut, clearly reminiscent of the Samarra bevelled style but without any of its ambiguity of line. The central motif, a pair of bridled horses' heads in a beaded medallion with a palmette between, is almost flat cut. This panel may be compared to another with a pair of horses' heads in the Metropolitan Museum of Art, New York. See Dimand (1932, no. 112).

Published: Pauty (1931, p. 47); Cairo (1969, no. 219)

285

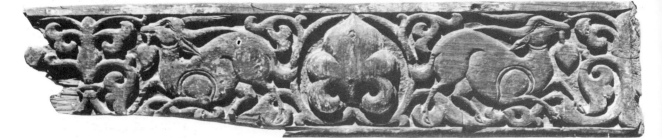

444

444 Section of a frieze, probably in sycomore

Length 143cm, height 31.5cm
*Museum of Islamic Art, Cairo,
no. 4061, found during excavations at
the hospital of Sultan Qalāwūn in
Cairo*
Egypt, Fatimid period, 11th century

This frieze, cut at either end,
originally consisted of a pair of hefty
gazelles cropping stylised Trees of
Life with embossed palmettes fixed
by iron dowels between each pair.
The eyes, ears and limbs of the
animals are enhanced with carved
detail, similar to the engraved
features of no. 169. The panel was
covered with thin gesso which served
as a base for painting or gilt, but there
are no traces of colour. The frieze was
fixed to the wall by dowels in the flat
upper border and in the lower
champfered edge.

Published: Pauty (1931, p. 44); Cairo
(1969, no. 211)

445 Section of a frieze with an embossed inscription

Length 181cm, height 23.5cm
*Museum of Islamic Art, Cairo,
no. 1744, gift of Dr. Kamāl Ḥusayn*
Egypt, Fatimid period, 11th–12th
century

The inscription
*ā wa niʿma kāmila wa saʿāda
[wa] . . .*
'. . . and perfect favour and
happiness [and] . . .'
Though there are traces of plaster
covering this beam there is no paint.
The final word of the inscription is
illegible and the disappearance of
part of the inscription may be due to
the fact that it was embossed with a
thin wooden veneer fixed with
dowels. The inscription may be
compared to those on the beams of the
mosque of al-Ṣāliḥ Ṭalāʾiʿ in Cairo
dated to 1160. See David-Weill
(1931, p. 42).

Unpublished

446 Section of a frieze

Length 132cm, height 25cm
*Museum of Islamic Art, Cairo,
no. 13148, purchased in 1935*
Egypt, Fatimid period,
11th–12th century

The frieze is inscribed with a Koranic
text from Sura II, 255, with plaited
letters and continuous undulating
scroll ground. The inscription was
too long for the space available and is
completed at the end above the line.

Unpublished

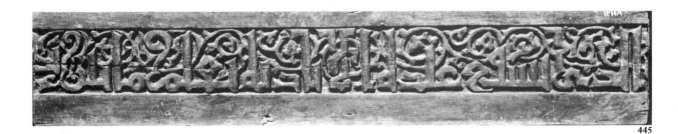

445

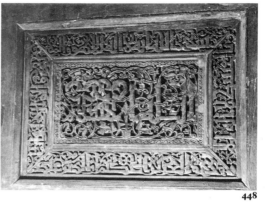

448

447 Carved panel
Height 39.4cm, width 19.1cm
Seattle Art Museum, no. 56.Is 13.2,
Eugene Fuller Memorial Collection
Egypt (Fustat), Fatimid period,
12th century

Despite the foliation, the lines of the
design of this panel are abstract. The
type of arabesque created was to
provide a model for much of Islamic
decoration that was to follow.

Published: Bowie (1970, no. 154)

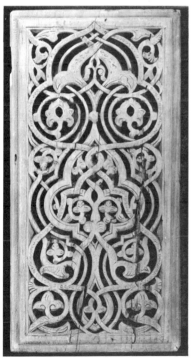

447

448 Panel of poplar wood carved on both sides with kufic inscriptions
Height 248cm, width 292cm
National Museum, Damascus, no. A97,
from the mosque of Muṣallā al-'Idayn,
Damascus
Syria, Fatimid period, 1103

The outer face is carved with the
basmala in plaited kufic and with a
dedicated inscription in
unornamented kufic
> *Abū Ja'far Muḥammad b. al-Ḥasan*
> *b. 'Alī ṣāfiy Amir al-mu'minin*
> *taqabbala Allāh minhu*
> *wa dhālika fī ashhur al-sana 497*
'Abū Ja'far Muḥammad b.
al-Ḥasan b. 'Alī, favoured by the
Commander of the Faithful, God
accepted his offering of this screen
in the course of the year 497
[1103 AD].'
The centre panel of the inner face is
carved in plaited kufic based on
circular instead of rectangular
figures, with the words *Allāh* and
al-sulūm, 'peace'. The surrounding
frieze is taken from the Koran,
Sura III, 18. The depth of the
scrollwork brings out the relative
importance of the inscription which
is pierced in the central panel, in the
background of the Koranic quotation
but in the same plane as the
dedication which surrounds this
panel. The frieze of three-lobed

leaves around the centre panel on
both sides derives from the first
Samarran style. The small vase from
which springs symmetrical foliated
arabesques is a vestige of the
Hellenistic artistic tradition.

Published: Damascus (1969, fig. 124)

449 Carved panel with inscription
Length 310cm, height 16cm
British Museum, London, no. 41618
Egypt, Fatimid or Ayyubid period,
12th century

The inscription is from the Koran,
Sura II, 264, in a stiff plain kufic script
on a regular background of slender
foliated scrolls. The words are
grouped logically in cartouches, some
letters being elongated to fill the space
available. Two factors make the
simple pattern lively, the axis of the
inscription is off-centre and the
solid eight-pointed star which forms
the smaller cartouches is doubled and
expanded at the centre.

Unpublished

449 detail

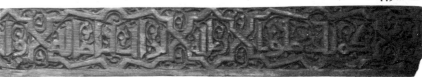

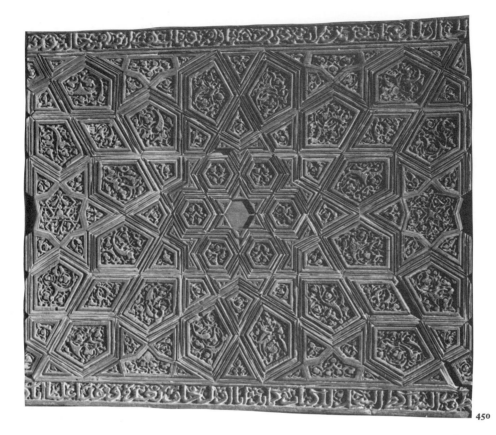

450

450 a-b *Two panels*
Height of both 66cm, width 67cm
and 79cm
Museum of Islamic Art, Cairo, nos.
408–9, from the cenotaph inside the
mausoleum of the imam al-Shāf'ī in
Cairo, dated 1211
Egypt or Syria, Ayyubid period,
about 1200

These panels are of wood inlay with
grooved strapwork forming a skeleton
inset with carved polygonal panels,
the latter are mostly teak and show
traces of black paint. Both panels
have been slightly cut down at the
sides and have a polygonal panel
missing. Inscriptions are from the
Koran, Suras XXI, 101 and LIX,
22–3, in the characteristic compressed
Ayyubid naskhi script. The angular
interlacing strapwork radiating from
central stars creating regular or
irregular polygons is first known
from the Fatimid minbar presented in
1091 to the shrine of Ḥusayn at
'Asqalān in Palestine and now in the
Ḥaram al-Khalīl, Hebron. The
technique was developed
subsequently in Syria under the
Zengids and Ayyubids but was well
established in Egypt by the late 12th
century. Some of the inset panels bear
vine-clusters.

Published: Herz (1907, p. 140);
David-Weill (1931, pp. 1–2)

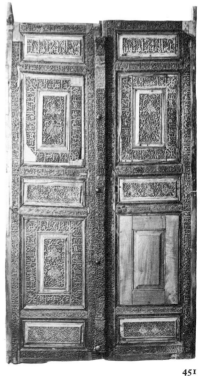

451

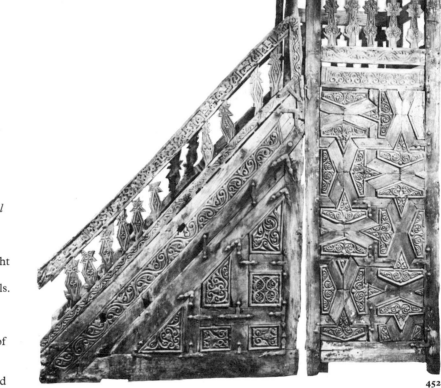

451 Pair of doors in plane wood decorated with arabesques and kufic inscriptions

Each door, height 230cm,
width 61.5cm
*Iraq Museum, Baghdad, no. A677,
from the mosque of Nabī Jurjīs, Mosul*
Northern Mesopotamia (Mosul),
Atabegid period, 12th century

Each leaf consists of two large upright panels of almost identical design between three small horizontal panels. The whole is surrounded by a frieze on which the shahada is repeated in foliated kufic. Of the horizontal panels, the two lower bear a design of repeated arabesques. The richest scheme is reserved for the topmost panels which are inscribed in foliated and almost illegible kufic

jihād yukāfī' [?] thawāban
'pious exertions [which] will be duly rewarded.'

The upright panels consist of a central panel surrounded by a frieze with plaited patterns in the corners.

al-mulk lillāh al-waḥid [repeated irregularly]
'sovereignty belongs to the sole God'

The central column bears an undeciphered motto.

Published: Fransis and Naqshabandi (1949, p. 61); Dihwaji (1961, pp. 100–12, pls. 1–4)

452

452 Mimbar with kufic inscriptions and carved inlays
Height 250cm, width 96cm
*Iraq Museum, Baghdad, no. A7209
from the mosque of al-'Amādīya, Mosul*
Northern Mesopotamia (Mosul),
Atabegid period, 1153

The inscription on the hand-rails begins with the basmala, then reads

hādhā mā taṭawwa'a bi-'amalihi mawlānā al-amīr al-ajall al sayyid . . . Hishām al-dīn Najm-al-Islām imām al-dawla [?] Sharbār Beg Qarāja b. 'Abd Allāh sayf amīr al-mu'minīn dāma 'izzuhu
'In the name of God, this (mimbar) is what was offered by our lord, the most illustrious amir, the master . . . Hishām al-Dīn, Star of Islam, leader of the state [?], Sharbār Beg Qarāja b. 'Abdullāh, sword of the Commander of the Faithful, may his glory be perpetual.'

The inscription on the panels parallel to the hand rails

Kāna al-qawwām 'alā 'amalihi wa'l-nāḍir fī maṣlaḥatihi al-qāḍi al -ajall Fakhr al-dīn 'Abd Allāh b. Yaḥyā wāfaqa farāghuhu sana thamūn wa arba'in wa khamsa mi'a . . . raḥama Allāh man taraḥḥama alayhimā wa 'alā [?] hādhā/'amal 'Alī b. Abū [sic] al-Nahī wa Ibrāhīm b. Jāmi' wa 'Alī b. Salāmā al-jurjiyyīn
'The manager of the work and the superintendant of its affairs was Fakhr al-dīn 'Abd Allāh b. Yaḥyā. Its completion corresponded to the year 548 [1153 AD]. May God show mercy to him who prays for God's mercy on them and on[?]. This is the work of 'Alī b. al-Nahī and Ibrāhīm b. Jāmi' and 'Alī b. Salāma, the Georgians.'

Published: Fransis and Naqshabandi (1949, p. 58, pl. facing p. 64); Miles (1952, 72–83, pl. IX)

289

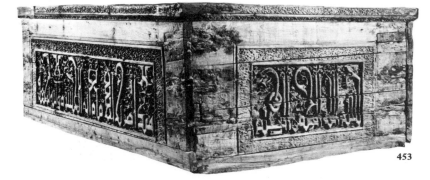

453

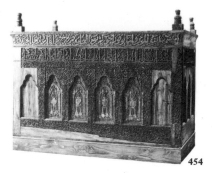

454

453 Cenotaph of mulberry wood inscribed on the sides

Length 262cm, width 195cm
height 95cm
*Iraq Museum, Baghdad, no. A. 623,
from the mosque of Salmān al-Fārisī,
near Baghdad*
Mesopotamia (Baghdad), 1227

This cenotaph was ordered by the
Abbasid caliph al-Mustanṣir for the
tomb of the seventh imam of the
Twelver shi'ites, Mūsā al-Kāẓim
(died 799). The presentation of a
cenotaph to the tomb of a saint or local
hero was a way of annexing his
popularity, and the tomb of Mūsā
was endowed by successive
conquerors of Baghdad who
relegated al-Mustanṣir's offering to
the tomb of Salmān al-Fārisī. The
inscription on the lid is taken from
the Koran, XXXIII, 33. As well, the
patron and date are given

*Hādhā mā taqarraba ilā [Allāh]
ta'ālā bi-'amalihi khalīfatuhu fī
arḍihi wa-nā'ibuhu fī khalqihi
sayyidnā wa-mawlānā imām
al-muslimīn al-mafrūḍ al-ṭā'a 'alā
al-khalq ajma'īn Abū Ja'far
al-Manṣūr al-Mustanṣir billāh
Amīral-Mu'minīn thabbata Allāh
da'watahu sana sitt mi'a wa arba'
wa 'ishr . . .*
This is what was done to seek God's
favour by his vicar on earth and the
regent over His creation, our lord
and master, the imam of the
Muslims, to whom is due
obedience from all mankind, Abū
Ja'far al-Mansūr al-Mustanṣir
billāh, Commander of the
Faithful, may God approve his
prayer in the year 624 [1227 AD].'
The plaited kufic inscription on the
sides starts with the basmala and
continues
*hādhā ḍarīḥ al-imām Abī al-Ḥasan
Mūsā b. Ja'far ibn Muḥammad b.
'Alī b. al-Ḥusayn b. 'Alī b. Abī
Ṭālib 'alayhim al-salām*
'This is the tomb of the imām Abū
al Ḥasan Mūsā b. Ja'far ibn
Muḥammad b. 'Alī b. al-Ḥusayn
b. 'Alī b. Abī Ṭālib upon all of
whom be peace.'
As with other tombs of saints, the
lettering of the geneaology of the
saints provides the decoration,
softened here and there by a frame
and a background of scrolls. The late
plaited kufic is simple compared to
eastern prototypes but unusually
eclectic in its combination of straight
and rounded elements.

Published: Fransis and Naqshabandi
(1949, pp. 55–6 and pl. facing p. 64)

454 Cenotaph of sandalwood with inscriptions and traces of paint and gilding

Length (including frame) 217cm,
width 116cm, height 136cm
*National Museum, Damascus, from
the mausoleum of Khālid b. al-Walīd,
Homs*
Syria (Homs), Mamluk period,
13th century

Commemorative plaques found in
this mausoleum date the cenotaph
and show it to have been ordered by
the Mamluk sultan al-Ẓāhir
Baybars (died 1277) on his passage
through Homs to celebrate his
victories in Armenia. See al-Ush
(1963, pp. 35, 115). The cenotaph is
incomplete as there is no lid or base.
The date, names of artist and patron
are missing on three sides represent-
ing mihrabs in which hang long
lamps (an allusion to Koran, Sura
XXIV, 35); the fourth side is incised
in thuluth with Koran, Sura, II, 255.
The top frieze is inscribed in thuluth.
Only two sections survive taken from
the Koran, III, 185 and XXXI, 33.
Below it runs a frieze in plaited kufic
on a background of scrolls. The body
of lettering is cramped against the
lower border and the scrolls
emphasise the monotony of the
upright strokes. The inscription
quotes verses from the Koran, Suras
IX, 22; XXXIX, 73; and CXII, 21.
The body of the cenotaph is divided
into panels on three sides representing
mihrabs in which hang lamps. On the
fourth side is an inscription from the
Koran, Sura II, 255.

Published: al-Ush (1963); Damascus
(1969, p. 218, fig. 121)

457a

455 Window screen (mashrabiyya) of squares with beaded diagonals
Height 142cm, length 152cm
Museum of Islamic Art, Cairo, no. 526, from the mosque madrasa of Sulṭān Ḥasan
Egypt, possibly Mamluk period, mid-14th century

The interior of this panel is a rectangle of finer work showing in silhouette a minbar and mosque lamp. The provenance is not certain since the mosque of Sultan Ḥasan was formerly a depot for woodwork collected from ancient monuments which were in danger of ruin or destruction. Mashrabiyya work is a typically Egyptian craft which was much stimulated by the shortage of fine wood for panelling and which, from the mid-12th century, developed rapidly. While there is no precisely dated material from the 14th century, such an early date for this section is by no means improbable.

Published: Wiet (1930, no. 37); Cairo (1969, no. 232)

456

456 Pair of window-shutters with identical kufic inscriptions
Height (of each) 68.2cm, width 49cm
Iran Bastan Museum, Tehran, no. 3283
Persia (Fars), Buyid period, 10th century

The inscriptions in arabic, unread, are set in mihrab-shaped scrollwork borders.

Unpublished

457a–b Two carved triangular capitals
a. Height 24.5cm, width 75.5cm
b. Height 36cm, width 74cm
Iran Bastan Museum, Tehran, nos. 1165–6
Persia (Azerbaijan), early 14th century

The advantages of building in wood are elasticity in earthquake zones and cheapness. In the early centuries of Islam, wood was used in public architecture to an extent which present remains scarcely indicate and on a grander scale than contemporary illustrations usually suggest. The carved decoration derives from Abbasid and Fatimid models. The inscribed capital b has the words *al-*[?] *ghalab, lillāh al-wāḥid*, 'victory belongs to God, the One...' inscribed in naskhi on two registers. The capitals have outer bands of a rolling wave motif which runs up the sides. On the back capital is a six-pointed star set in an arabesque decoration.

Unpublished

457b

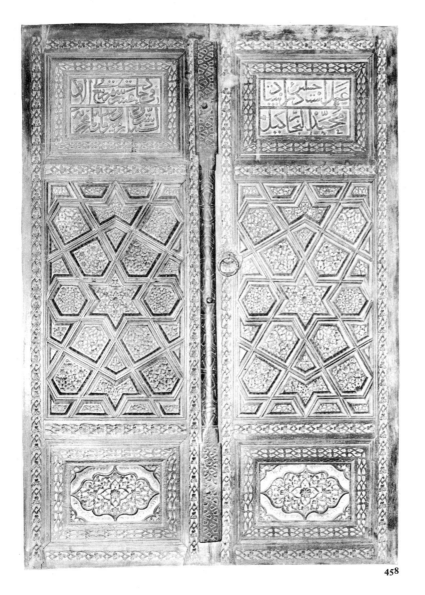

458

458 Pair of doors with geometrical and floral carving and inscriptions
Height 206cm, width 148cm
Iran Bastan Museum, Tehran,
no. 1135/3308
Persia, 1442

These doors are probably from a mosque though they are not inscribed with sacred texts. The outer frame is restored. Fastening is secured by a central column in a bronze sheath and a bronze ring-handle. Each leaf is divided into three panels, the two uppermost inscribed

'amal[?a] ustādh Ḥasan/Ḥusayn ibn ustādh Muḥammad al-Najjār ?kumila
'the work of master Ḥasan/ Ḥusayn, son of master Muḥammad the carpenter, it was completed'
fī ḥādī ashar shahr Rabī' al-Awwal fī al-sanna sitt wa-arba'īn wa thamān mi'a hijriyya
'on the 11th of the month Rabī' al Awwal in the year 846 of the hijra [1442 AD].'

The large panels consist of small interlocking pieces of wood set in raised wooden mouldings. At the centre of each is a six-pointed star enclosing a six-petalled flower set with a decorative boss, a vestige of the large nail heads used to strengthen the doors. The remaining pieces radiate from the central star and enclose fragments of a floral pattern. The patterns throughout recall contemporary book-bindings, decorated manuscript margins and floral carpets.

Unpublished

459 Panel inscribed on two lines
Length 110cm
Imam Riza Shrine Museum, Mashhad
Persia (Mashhad), Safavid period,
1554

Inscription unread

Unpublished

460a–b Two horizontal carved panels
a. length 370cm, width 24cm
b. length 210cm, width 26cm
Museo Frederico Marés, Barcelona
Spain (Toledo), ? Almoravid period,
11th–12th century

The animal medallions suggest
Fatimid stylistic influence.

Published: Terrasse (1963, p. 425, pl. 23)

461 Carved panel with foliated kufic inscription
Archaeological Museum, Province of Toledo
Spain, Almohad period, 12th century

The inscription is from the Koran,
Sura XV, 48. A monotonous central
axis is here avoided by partitioning
off the upper portions of the panel and
filling it with patterns unrelated to the
inscription. The kufic shows affinity
with contemporary north African
scripts while the foliation above is
related to simpler and bolder
Egyptian forms (compare no. 446).

Unpublished

462 Carved panel from a private house
Length 300cm
National Museum of Hispano-Moresque Art, Granada
Spain, Almohad period, 12th century

Beams inscribed with devotional
quotations and ciphers are found
both in mosques and in private houses.
This beam is decorated with a
foliated kufic inscription from the
Koran, Sura VII, 54. The problem of
how to transform an inscription into
decoration was seen and solved in
much of the Islamic world by filling
the whole surface. Thus, scrolls,
leaves and flowers were made to grow
out of the letters into the spaces
between. This mass of foliage was
contained by establishing a number of
horizontal axes marking off the body
of lettering, which remains legible.
In this example, one such axis is
explicitly marked by an unbroken
horizontal axis about three-eighths of
the way up the panel.

Published: Puertas (1971, XX, fas. I, pp.
109–12, pls. 1–2)

463 Carved panel from a private house
Length 200cm
National Museum of Hispano-Moresque Art, Granada, no. 3.981
Spain, Almohad period, 12th century

The beam is decorated with a foliated
kufic inscription reading
*al-karāma wa'l-surūr al-dā'im
liṣā [ḥib . . .]*
'Honour and perpetual joy to its
owner . . .'
The style of the kufic, with acorn
finials, broad, knobbed leaves in
profile describing near circles or
slanting sharply backwards. Here, the
round letters are not voided and there
is no marked horizontal axis. The
motto may also be compared to those
found on ivories, ceramics and other
objects.

Published: Puertas (1972, XXI, fas. 1,
pp. 161–5, pls. 1–2)

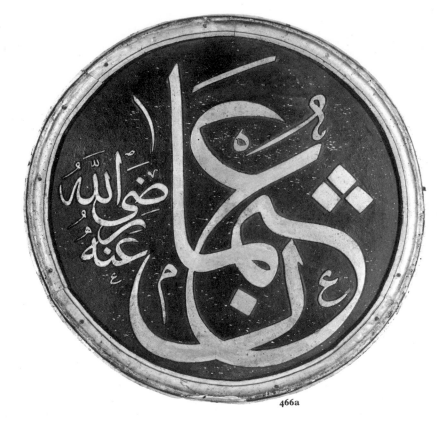

466a

464 Beam with foliated kufic inscription
Length 310cm, width 10.2cm,
height 14cm
*Instituto Valencia de Don Juan,
Madrid*
Spain (Toledo), Almohad period,
?13th century

Inscription unread.

Unpublished

465 Beam with foliated kufic inscription
Length 127cm, width 5.2cm,
height 9.8cm
*Instituto Valencia de Don Juan,
Madrid*
Spain, Almohad period, ?13th
century

Inscription unread

Unpublished

466a–d Four roundels carved in relief, painted and inscribed
Diameter of each 63cm
*Joseph and Jean Soustiel Collection,
Paris*
Turkey, Ottoman period,
18th century

Roundels of this sort are found in
most Ottoman mosques, usually
suspended from columns or set in the
pendentives beneath the dome. These
four form part of a series which
should also include 'Umar, 'Ali,
Ḥusayn and Fāṭima. They are
inscribed in thuluth *jalli*.

Published: Soustiel (1973, pp. 4, 37,
no. 44)

464 detail

465 detail

Marble and Stucco

490

In Islamic times, at least in the early and medieval periods, the supreme art among the Muslims was their calligraphy. The Arabic script proved a heaven-sent tool in the hands of Muslim artists and considerable effort went into the production of masterpieces of calligraphy, both that inscribed in stone and that written in ink in manuscript material. It is the former type, the lapidary, which concerns us here and some fine examples of which can be seen in this Exhibition.

To speak in the broadest terms, the scripts used in Arabic epigraphy are two: the early, square script, called kufic, and the later cursive, naskhi. From its name the first would appear to have connections with the city in Mesopotamia named Kufa, though any direct link with that city is impossible to prove. The meaning of the second, naskhi, is basically that of copying, that is writing at some speed and therefore naturally in a less square script. The former, dating from the very early Islamic times, and possibly earlier, began in a simple style and gradually over the years became more and more elaborate, until virtually none but the artist himself could read the inscription. It finally gave way to the cursive naskhi about the end of the 12th century, though kufic continued to be used in some places, particularly in the east of the Islamic empire, for some time alongside the cursive. Naskhi was also to develop over the centuries, reaching great heights of elaboration and artistry, though again leaving the reader with a difficult task of deciphering.

Apart from its purely decorative role, particularly as part of mosque architecture in Islam, Arabic epigraphy was put to other uses. Most importantly it was employed on tombstones, especially those of the famous and the influential and these inscriptions are therefore often of great interest to the historian. There is a third less common, though perhaps equally valuable type of Arabic inscription, that which commemorates the construction of some building or something similar.

As for the contents of these various kinds of inscriptions written in Arabic, certainly the first two, the decorative mosque inscription and the funerary inscription, will make use of Koranic quotations. Indeed mosque inscriptions are generally found to contain little else except perhaps a date of building. Funerary inscriptions begin with pious phrases and other relevant citations from the Koran before the scribe

comes to the essentials of his inscription, the name and titles of the deceased and the exact date of his death, even these containing fixed pious phrases and wishes for his safe entry into heaven. Commemorative inscriptions generally come straight to the subject and give the name and title of the builder, perhaps also the name of the man who actually undertook the work of construction. Apart from the date of construction, mention might sometimes also be made of the source of the funds from which the work was carried out.

How do the exhibits listed below in this Catalogue fit into the general remarks above? The earliest inscription, no. 470, cannot be regarded as typical of the simple epigraphic kufic, since, rather than being inscribed, it has been written onto the stone. It is therefore to be seen in the context of the written material of the early period and, while the script can still be referred to as kufic, it is inevitably more cursive than the inscribed type. The text is too fragmentary to permit comment.

Examples of simple lapidary kufic are to be found in no. 474, (probably 10th century), no. 477 (10th century), the three line inscription of no. 478 (10th century), the first band of no. 488 (10th century), and no. 487 (10th century). No. 477 also has a *basmala*, i.e. the Koranic phrase 'In the name of God, the Compassionate . . .', in what is termed foliated kufic, a term to be discussed below. No. 477 is a magnificent piece of craftsmanship and falls into the second group outlined above, the funerary inscription. No. 478 also indicates the beginnings of foliation in the second band. The simple kufic set in the arch of the mihrab in no. 474 fulfils a decorative use inside the mosque and bears the *shahāda*, the Muslim profession of faith, 'There is no god but God; Muḥammad is the Prophet of God'. Both nos. 488 and 487 show simple kufic inscriptions on columns. Whereas the latter clearly is commemorative, for the names of the ruler and the builder of the palace are given, the former is probably purely decorative.

But kufic did not remain simple in style. The beginnings of foliated kufic have already been noted above in nos. 477 and 478. Foliated kufic may be defined as having leaf-like decorations of the apices of the letters. Apart from the examples given above of this foliated script, no. 476 (14th century) should also be cited here. It is almost certainly of a purely decorative type.

Apart from foliated kufic, what is generally called floriated kufic also

developed and this kind is represented in this collection. Floriated kufic has the same basic decoration as foliated and in addition floral motifs grow out of the letters. No. 478 (10th–11th century) shows this in its fairly early development, while the inscriptions of no. 475 (11th–12th century) all show a much more advanced form. These are also mihrab inscriptions and decorative.

A further development of the kufic script was the plaited variety, even more decorative than the types described above and probably the most difficult of all to read. No. 481 (11th century) is a combination of the foliated type and the plaited – a combination perhaps typical of North Africa only. Although primarily a decorative script it is here used on a tombstone.

The only example of the cursive script, naskhi, is no. 496, dating from the 14th century and therefore showing an already fairly well developed form, carrying too all the letter dots, unlike the early simple type of naskhi and the later which became very elaborate. This is a funerary inscription.

473 detail

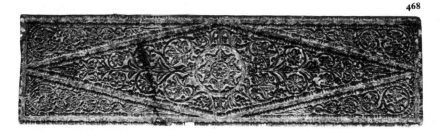

468

469

467 Slab of marble carved with a chalice or vase with leaves

Height 43.5cm, width 22.5cm
National Museum, Damascus,
no. A 17989, from Qaṣr al-Ḥayr
al-Gharbī
Syria, Umayyad period,
8th century

The chalice and leaves on this slab are related to the basket or cornucopia and sheaf theme, also known from the mosaics of the Dome of the Rock, Jerusalem. See Creswell (1942, pls. 17b, 23a, c, 26d). Here the corresponding elements are absolutely uniform and symmetrical, the 'eyes' and axial stem-and-ball so stylised that their prototypes can no longer be recognised. The combination of abstract and naturalism forms in the loose curves of the chalice set against the well-defined scrolls of fig leaves below and oak leaves above produces interacting rhythms.

Unpublished

467

468 Rectangular panel of marble carved with geometric and vegetal motifs

Length 162.5cm, width 45cm
National Museum, Damascus,
no. A 11, from the Great Mosque,
Damascus
Syria, Umayyad period,
8th century

This is the only surviving panel from a series. The framework of the design consists of an elongated lozenge enclosing a circle and inscribed in a rectangle accentuated by a raised border whose modelling recalls the 'jewellery' techniques of the tie-beams of the octagonal arcades of the Dome of the Rock, Jerusalem. See Creswell (1932, pls. 25b, c, e, 26a, c, d). The elements of the pattern are taken from the Hellenistic and early Christian repertoire of Syrian art such as vine leaves with 'eyes' and veins, grape clusters, palmettes and half-palmettes, stylised flowers and acanthus leaves enclosed in scrolls. Though naturalistic, these elements are treated as geometric units, all growing from the same scroll regardless of species. The scrolls order the pattern by grouping the elements into self-contained compartments, absolutely symmetrical in this panel. The surface is completely covered, those elements which are not identical are complementary. The scroll-motif is organised on an axis around a focal point, the central acanthus crown. This scroll motif is one of the most endurable and adaptable themes in Islamic design.

Published: Creswell (1932, pp. 176–7, pls. 62A, a, d, c); Damascus (1969, fig. 146)

469 Stucco fragment with spray of leaves, fruits and grapes

Height 110cm, width 78cm
National Museum, Damascus, from
the façade of Qaṣr al-Ḥayr al-Gharbī
Syria, Umayyad period,
8th century

Extensive use of stucco in architectural decoration was a novelty introduced by the Umayyads into Syria from recently conquered Mesopotamia. The newly rich ruling classes built themselves a series of pleasure palaces and in order that these palaces could be more quickly and completely decorated, easily worked plaster with wall paintings was preferred to the more expensive mosaics and stone facings. The technique used in the stuccoes from this castle seem to have been moulding followed by hand carving of the partly set plaster. These fragments when excavated were so fractured that it was not possible to determine the precise position of all of them on the building façade. In this spray can be seen a combination of stylisation in the uniformity of detail combined with a semi-naturalistic treatment in the freedom of rhythm.

Unpublished

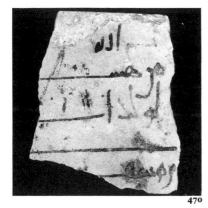

470

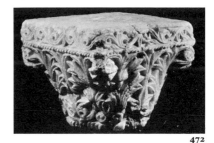

472

470 Fragment of a marble plaque with cursive kufic lettering

Height 7.5cm, width 6.5cm
*National Museum, Damascus,
no. 17978A, found at Qaṣr al-Ḥayr
al-Gharbī*
Syria, Umayyad period,
early 8th century

This plaque has been described as a fragment of a 'letter', as neither the dimensions, lettering or wording indicate a monumental architectural function. Schlumberger (1939, p. 373) has reconstructed the inscription

*bismillah . . . min Hish[ām Amīr
al-Mu'minīn ilā] . . . [a]l-Walīd
A[b]ī [al-'Abbās] [a]ḥ[madu]
Allāh ilayka [al Ḥajjāj] ibn Yūsuf*
'In the name of God, from
Hish[ām, Commander of the
Faithful, to al-Walīd Abī
al-'Abbās] [nephew and successor
of the caliph Hishām], I thank
God . . . [al-Ḥajjāj] ibn Yūsuf.'
Hishām died in 714. This fragment displays distinct decorative features such as the horizontal elongation of the script and is comparable to the kufic of contemporary Korans and papyri, as well as with contemporary coins and other epigraphic fragments. See Grohmann (1971, XVI, 4; XV, p. 2).

Published: Sclumberger (1939, pp. 366–7, fig. 21)

471 Mihrab of white marble

Height 205cm, width 114cm
*Iraq Museum, Baghdad, no. A 1185,
taken from the mosque of al-Khāṣṣakī,
Baghdad*
Mesopotamia (Baghdad), Abbasid period, 9th century

Possibly of Syrian workmanship. The scallop shell of the niche, the piled vases of the central panel, the acanthus frieze around the hood with its bead-and-reel moulding and the Corinthian capitals are all copied from Hellenistic models. The palmette at the centre of the scallop and the fluted columns, however, are Persian while the top frieze of pineapples and palmettes is a precursor of the first Samarran style (see no. 473).

Published: Sarre and Herzfeld (1911–20, II, pp. 139–45, figs. 185–7, pls. XLV–I); Baghdad (1973, p. 60, no. 11, pl. 42)

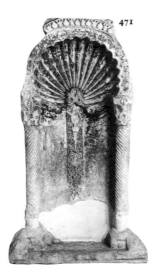

471

472 Capital of marble

Height 42cm, width 32cm (maximum)
*National Museum, Damascus,
no. 9558A*
Syria (Raqqa), Abbasid period, late 8th century

This probably dates from the same period as no. 471 and constitutes an important stage in the generally undated process of evolution from the naturalism inherited from Hellenistic art to the abstract theme of the bevelled style of Samarra (see no. 473). Herzfeld suggests that this capital and other related examples may derive from Byzantine rather than Classical models. Instead of superimposed rows of acanthus leaves, a single row of stylised spiny acanthus develops here out of palmettes. The decorations mostly occupies a single plane, steep cut against the body of the capital whose shape it emphasises.

Published: Sarre and Herzfeld (1911–20, II, pp. 352, 356ff, fig. 320)

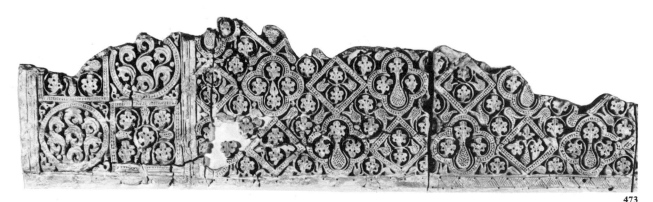

473

473 Stucco moulded and carved panelling

Length 392cm, height 65cm
*Iraq Museum, Baghdad, no. A 10481,
found at Uskaf Bani Junayd*
Mesopotamia, Abbasid period,
9th century

This piece comes from an Abbasid site that probably predates the foundation of Samarra. In 836 the eighth Abbasid caliph, al-Muʿtaṣim moved his capital up the Euphrates to avoid the chronic riots roused by his Turkish mercenaries in Baghdad. His successors, deprived of the political power provided by their bodyguard, turned their energies to building. Three decorative styles grew out of their projects. The earliest style, of which this stucco is an example, actually pre-dates the founding of Samarra and is clearly derived from the Syrian Umayyad tradition. It employs stylised compartmented but naturalistic motifs, especially the vine scroll, steep cut in stucco or wood with incised details. As the scope and pace of building operations demanded more rapid methods of decoration, stucco designs began to be cast in moulds and only finished by hand. Steep cutting was replaced by piercing and incising and the voids between motifs and compartments eventually disappeared as stylisation becomes abstraction. This second style witnesses the appearance of motifs without apparent forerunners, bringing about the break with Hellenistic models of the first style. In the third style, voids and compartments totally disappear, and abstract and complementary motifs are defined by a continuous line by isolated strokes, simultaneously suggesting the motif and its reverse. The linear pattern is filled out by gentle swellings in the wood, stone or stucco. While the second style evolved out of the first, the second and third styles did not supersede the first at Samarra; all three are found together at other sites.

Unpublished

474

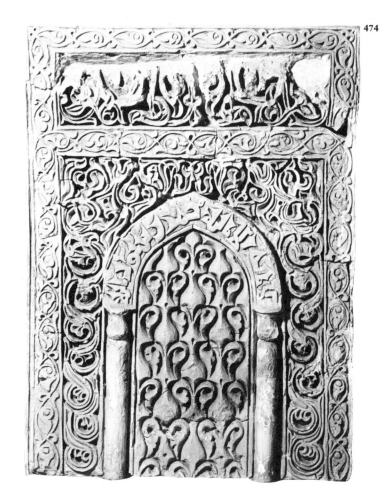

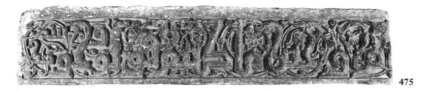

475

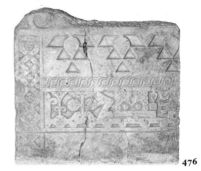

476

474 Stucco mihrab

Height 142cm, width 106cm
Iraq Museum, Baghdad, no. A 1376
Mesopotamia, Abbasid period,
? 10th century

This carved stucco mihrab has traces
of red and green paint on a blue
ground. The arch of the mihrab
spans two semi-engaged columns
with bell capitals and bucket-shaped
pedestals and is carved with the
shahada in simple kufic. Below the
niche as it was *in situ* ran a frieze,
carved in variant forms of the same
kufic with the word *Allāh*, extending
beyond the mihrab. The niche is
filled with a continuous pattern, in
the bevelled Samarran style, of
addorsed half-palmettes developing
into and alternating with bulbous
vase-like motifs. In each side two
steep-cut intertwining scrolls run
the length of the columns and
develop into an arabesque pattern of
stylised leaves over the shoulders of
the arch. The whole is enclosed in a
rectangular frieze of two intersecting
wavy tendrils joined in a double loop
over the centre of the arch. The frieze
extends above the niche forming a
second frame filled with the same
arabesque elements. On the basis of
the Samarran influences, Sarre
dates the mihrab to the 10th
century. Equally striking, however,
is its stylistic affinity to Persian stucco
and faience mihrabs of the Seljuq
periods and later, many of whose
features this mihrab contains in germ.

Published: Sarre (1908, pp. 63–76)

475a, b Two fragments from a marble mihrab with inscription in floriated kufic

a. Length 176cm, width 38cm
b. Length 164cm, width 40cm
Iraq Museum, Baghdad, no. A9886,
from the Nūri mosque, Mosul
North Mesopotamia, Zengid period,
late 11th–early 12th century

The inscription on these two
fragments is from the Koran, Sura II,
144. These fragments were taken
from a mihrab and then incorporated
in the late 12th century Nūri mosque
in Mosul. The balance between the
lower and upper registers is
maintained by the ogee-shaped
linking strokes and the S-shaped
ha and final *mim*. Typically, the
relatively sober floriations of these
letters and of *ulif-lām* draw upon
Persian models where their
possibilities were exhaustively
explored. The spreading of the last
two words over three registers
dictated by the limitations of the slab
is an early and perhaps unintentional
instance of lettering used in
combination with scrollwork to fill
the background void.

Published: Sarre and Herzfield (1911, I,
p. 7, fig. 10); Fransis and Naqshabandi
(1951, p. 215, no. 5)

476 Fragment of a slab inscribed in foliated kufic

Height 77cm, length 78cm
Iran Bastan Museum, Tehran,
no. 3280, found at Sarmāj
Persia (Kurdistan), 10th–14th
century

Ḥasanawayh was a robber chieftain
who compelled the reigning Buyid
dynasty to recognise his claim to
most of Kurdistan until his family's
usefulness as holders of this buffer
zone was exhausted in 1015. Little is
known about Ḥasanawayh but the
reputedly splendid nature of his
reign seems to be reflected in this
stone slab which may have formed
part of a triumphal inscription over
the doorway of his castle at Sarmāj.
While the merlons and criss-cross
border with its regular pattern of
stud-shaped flowers are in the
Sasanian tradition of grand
architectural ornament, the uncouth
foliation of the kufic makes the body
of the lettering illegible. The details
of the lettering may derive from tribal
rather than urban sources.
A companion piece has been
published by Dimand (1952,
pl. XIV-2).

Unpublished

477

477 White marble slab, inscribed on both sides

Height 39cm, length 75cm
*British Museum, London, no. 1975
4–151*
Egypt, Ikhshidid or Fatimid period,
9th–10th century

This slab bears two inscriptions in
kufic, both simple and foliated
 *Bismillāh al-raḥmān al-raḥīm
 hadhā qabr Muḥammad b [?] Fātik
 Ashmūnī tuwuffiya fī shahr
 Jumādā al-ākhir sana sitt
 wa-khamsīn wa-thalātha mi'a
 ḥasbunā Allāh*
'In the name of God, the
merciful, the compassionate, this is
the tomb of Muḥammad b [?]
Fātik of Ashmūnī who died in the
month of Jumādā II in the year
356 [967 AD], God is our
sufficiency.'
 Bismillāh al-raḥmān . . .
'In the name of God, the
merciful . . .'

Ashmūnī refers either to a small town
in the Nile delta (Ashmun) or a town
in Upper Egypt (al-Ashmunain).
The vertical edges of the slab are cut
back towards one side. This,
together with the scale and
incompleteness of the second
inscription, suggests that this slab
once formed part of a cenotaph,
perhaps of a child, which was later
dismantled and re-used to make a
funerary stele. If so, the second
inscription would provide a
terminating date for three other
fragments, related in epigraphic style
in the Museum of Islamic Art,
Cairo. The unique kufic may be an
upper Egyptian derivative, its
sculptural quality stems from the
bevelled Samarra style of stucco and
wood carving imported by the
governor Aḥmad b. Ṭūlūn (ruled
868–84). On stylistic grounds,
therefore, the second inscription
seems to require a dating in the
9th century.

Unpublished

478 Border of a marble cenotaph inscribed on three sides

Length 193cm, height 13cm
*Museum of Islamic Art, Cairo,
no. 2908, acquired from the Ministry of
Waqfs in 1901*
Egypt, Fatimid period, 10th century

Inscription on the upper surface is
from the Koran, Sura III, 16–17. On
the side
 *. . . [a] l-mu'minīn ṣalawāt 'alayhi
 wa'alā abā'ihi al-ṭāhirīn wa
 ibnā'ihi al-akramīn wa li-rabībihi
 al-amīn . . . manqūsh fī rukhāma
 dufinat ma'hum tārīkh al-maktūb
 fīhā Shawwāl sana khams wa . . .*
'[Commander of] the Faithful,
may God's blessings be upon him
and his pure ancestors and upon
his most honourable descendants
and upon his trusted step-son [or
father], carved on a [piece of]
marble buried with them and with
the date, Shawwāl of the year . . . 5
written.'
This is the only inscription known
relating to the burial of the relatives
of a Fatimid caliph, though it is
unclear why the marble column was
buried as well. The cenotaph must
either be from a family tomb, the
Turbat al-Za'farān, on the site of the
present khan al-Khalīlī, which was
destroyed in 1170, or else from the
mosque of al-Qarāfa in the great
cemetery south of Cairo, founded in
978 by the wife of the caliph
al-Mu'izz' in which some of his
relatives are buried. The kufic
inscriptions are flat-carved with
smoothed sides and with sparse
grooved foliations to some letters.

Published: Wiet (1971, pp. 34–5, no. 51)

478 detail

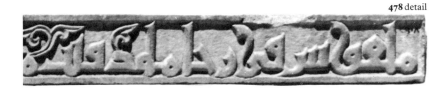

479

481

479 Frieze from a marble cenotaph

Height 40.5cm, width 55.5cm
*Museum of Islamic Art, Cairo,
no. 15551/3*
Egypt, Fatimid period,
10th–11th century

The inscription is from the Koran,
Sura CXII, 3. The flat uncarved
margins of the panel enclose a high-
relief kufic inscription, almost in the
bevelled style, with one letter in the
form of a five-petalled rosette with a
plumed leaf above. A second panel
from this cenotaph, also in the
Museum of Islamic Art, Cairo
(no. 15551/1), bears an elegant
funerary graffito on the reverse,
though without a date. The earliest
specimen of such finely carved
friezes is in the cenotaph of Khadija
bint Muḥammad (died 939) in
Cairo near the mausoleum of the
Abbasid caliphs. In the present case,
the personage was evidently a
Shi'ite, hence the Fatimid dating.

Published: Cairo (1969, no. 188)

480 Relief in marble of a ruler drinking and a musician

Bardo Museum, Tunis
Tunisia, Fatimid period,
(?) 10th century

Though wine drinking and its
depiction are blasphemous in Islam,
representation of the ruler drinking
are frequent in Fatimid art (compare
no. 276). This motif seems to have
been an ancient central Asian
symbol of sovereignty and appears in
Abbasid paintings and coins as well
as in Persian miniature paintings and
ceramics.

Unpublished

480

481 Fragment of a marble funerary stele with foliated kufic inscription

Length 60cm, height 34cm
*Museum of the Great Mosque,
Kairouan*
Tunisia (Kairouan), Fatimid period,
1048

This fragment is only part of a stele.
The inscriptions are from the Koran,
Suras I, III, 18 and 185, and
XXXVIII, 67–8. As well, a date is
given
*min sana arba'īn wa arba' mi'a
wa-huwa shahida*
'of the year 440 [1048 AD], [he
died] bearing witness [that there is
no god but God].'
The other half of the fragment gives
the names of the deceased and of the
craftsmen. See Roy and Poinssot
(1958, pp. 622–3, no. 474). The two
friezes of stylised acanthus leaves are
a feature peculiar to Spain and North
Africa. The alphabet is closely related
to that of an inscription on a screen in
the al-Mu'izz in Kairouan. See Flury
(1920, Anhang). Unusual are the
pendant foliations with curling ends,
the palmette-like foliations of *ha'* and
the circular knots in the upwards
strokes of *wāw* and final *mīm*.

Published: Roy and Poinssot (1958,
pp. 622–3, no. 474, pls. 71–3)

482 Carved marble panel
Height 127cm, width 31.5cm
Museum of Islamic Art, Cairo,
no. 7049
Egypt, Ayyubid period,
13th century

This half-panel is decorated in high
relief with pointed oval compartments
containing harpies, a winged sphinx
and two human figures holding
beakers and bottles while being
swallowed (or regurgitated) by scaly
fishes. This suggests an allusion to
Jonah and the whale, though the pair
of figures drinking is difficult to
explain. The border consists of a
frieze of fishes alternating gaping and
with closed mouths. The aquatic
character of these themes suggests
that this slab may have been a
shādurvān, 'weir', or an inclined slab
over which water trickled from a wall
fountain into a pool. Many
comparable Ayyubid and Mamluk
panels survive in Cairo, though they
mostly have a chevron pattern
designed to enhance the rills of water.
Such slabs are a common feature of
domestic and palace architecture
throughout the Islamic world.

Published: Cairo (1969, no. 193)

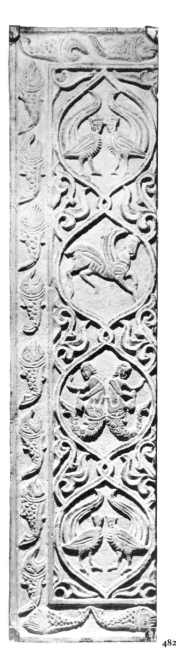

482

483 Window grille of marble
Archaeological Museum, Province of
Cordoba
Spain (Cordoba), Umayyad
Caliphate, late 8th–9th century

This grille is probably one of a series
of different designs copied from
earlier Syrian models. They may be
compared with stucco door and
window grilles from Qaṣr al-Ḥayr
al-Gharbī and Khirbat al-Mafjar.

Published: Torres-Balbás (1965, figs.
392–3)

483

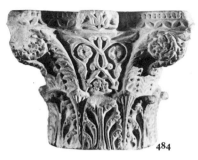

484

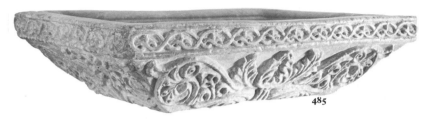

485

484 Corinthian marble capital with kufic inscriptions

National Archaeological Museum, Madrid
Spain (Cordoba), Umayyad Caliphate, 10th century

Classical capitals from sites in North Africa and Spain were re-used extensively by Umayyad builders in their own structures. The corinthinan capitals from Spain remain close to classical models in that they retain the superimposed rows of acanthus leaves, distinct volutes and abacus, which mask their underlying forms but emphasise their weight carrying function. In this early example, the modelling of the acanthus leaves is still naturalistic but the volutes have undergone a considerable degree of stylisation. The addorsed palmettes beneath the inscription, a motif of Sasanian origin, and the symmetrical design of flowers and scrolls, on the opposite side, are purely surface decoration. The fragmentary inscription has been reconstructed by Gómez-Moreno (1952, p. 51)
 'In the name of God, blessing on the amir 'Abdulraḥmān [II], son of al-Ḥakam, may God confer honour upon him.'

Published: Gómez-Moreno (1941, no. 6, pl. 2a, and 1952, p. 51); Terrasse (1963, pl. 15)

485 Rectangular marble basin with chamfered sides and carved scrolls

National Museum of Hispano-Moresque Art, Granada, no. 3.669
Spain, Umayyad Caliphate, 10th century

The Archaeological Museum, Toledo, has a Visigothic basin of similar design, see de Aragones (1958, pl. 10). The problem of the stylistic relationship between Visigothic and Islamic art in Spain still remains to be investigated.

Published: Maldonado (1968, pls. 8a, b, c)

486

486 Panel of marble from wall or door surround

Archaeological Museum, Province of Cordoba
Spain (Madinat al-Zahra), Umayyad Caliphate, 936–76

The palace complex at Madinat al-Zahra, on which the caliph 'Abd al-Raḥmān III is said to have spent a third of his annual revenue over a period of thirty years, has still not been completely excavated or reconstructed. The evidence suggests that the Umayyad prince was attempting to recreate in some way the desert palaces of his ancestors in Syria. The wall decorations are particularly reminiscent of Syrian models.

Published: Sourdel-Thomine and Spuler (1973, p. 282, pl. 96)

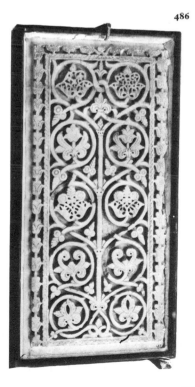

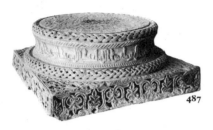

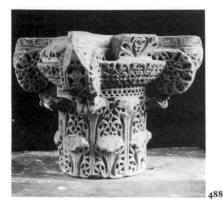

487

488

487 Base of marble with kufic inscription
Site Depot, Madinat al-Zahra
Spain (Madinat al-Zahra),
Umayyad Caliphate 953–4

Inscription reads
> *bismillāh baraka min Allāh li-'abd*
> *Allāh 'Abd al-Raḥmān amīr*
> *al mu'minīn abqāhu Allāh mimmā*
> *'umila 'alā yadāy Shunayf fatā'ihi*
> *wa-mawlihi ithayn wa arba'in*
> *wa-thalāthami'a 'amal Sa'd*
> *'abdihi*

'In the name of God, God's blessing on God's servant 'Abdulraḥmān, Commander of the faithful, may God give him long life One of the things made with the help of Shunayf, his young slave and servant [in the year] 342 [953–4 AD]. The work of his servant Sa'd.'

The construction of the palace at Madinat al-Zahra (see no. 486) stimulated a process of artistic synthesis which affected the designs of column capitals and bases especially. The distinct areas of the Corinthian capital are retained and even accentuated, but the naturalism is eliminated, as the surface is evenly patterned. The modelling of the palmette seems to be a conscious blending of classical and eastern motifs.

Published: Ocana-Jiménez (1945, no. 1a, p. 155); Sourdel-Thomine and Spuler (1973, p. 203, pl. 98b); Torres-Balbás (1934, pp. 342–3)

488 Capital of marble with kufic inscription
National Archaeological Museum, Madrid
Spain (Segovia), Umayyad Caliphate, 960–1

The dated inscription is unread. The basket work technique of this capital suggests a Byzantine rather than a classical model.

Published: Torres-Balbás (1958, pl. 424)

489 Rectangular marble ablution basin
Archaeological Museum, Province of Seville
Spain, Umayyad Caliphate, 10th century

One of a number of early undocumented basins and fragments with animal motifs. The detail and naturalism of this basin (the gait of the ducks, the scoring of their feathers and of the turtle's scales, and fishes' fins) set it, and contemporary examples, apart from earlier Fatimid models and the vogue for animal sciences as does the unexplained plant motif of the lower frieze.

Published: Gómez-Moreno (1952, p. 191, fig. 251)

489

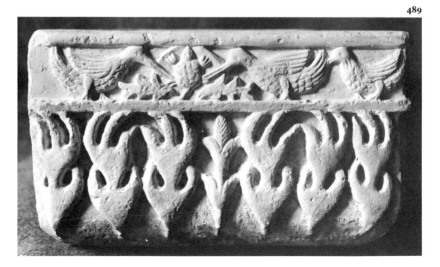

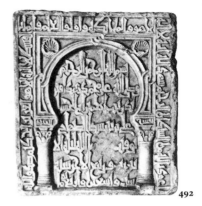

492

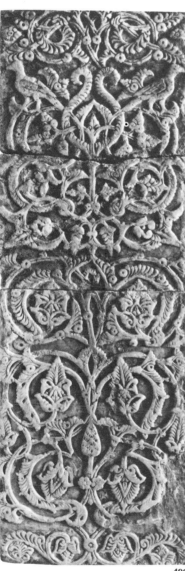

490

490 Carved panel of marble from wall or door surround

Height 148cm, width 49cm
Archaeological Museum, Province of Toledo
Spain, Muluk al-Tawa'if period, third quarter 11th century

This panel is decorated with scrolls, palmettes, pine-cones and birds. Here the paramount stylistic influence seems to be that of Syrian decorative art of the type employed at Mshatta.

Published: Gómez-Moreno (1952, p. 214, fig. 272); Sourdel-Thomine and Spuler (1973, pl. 183)

491 Capital and base of marble with kufic inscriptions

Archaeological Museum, Province of Toledo
Spain (Toledo), ?Almoravid period, 11th century

The inscription is unread. The process of stylistic synthesis initiated at Madinat al-Zahra (see no. 487) continued to make vigorous progress in provincial workshops after the fall of the Umayyads and the political fragmentation of the Iberian peninsula. Characteristic are the use of bead-and-reel mouldings and the prominence given to the abacus.

Published: Maldonado (1966, pp. 360–2, fig. 9)

492 Mihrab-shaped marble funerary stele of a princess

Height 36cm, width 32cm
Archaeological Museum, The Alcazaba, Province of Malaga
Spain (Cordoba), Almoravid period, 1103

The niche of the mihrab is inscribed after the basmala
wa ṣallā Allāh 'alā Muḥammad hādhā qabr badr bint al-amīr Abī al-Ḥasan 'Alī b. Tā'shā al-Ṣanhājī tuwuffiyat raḥimaha Allāh laylat al-ithnayn niṣf Rabī al-ākhir sana sitt wa-tis'īn wa-arba'mi'a
'God's blessings on Muḥammad, this is the tomb of Badr, daughter of the amir Abū'l-Ḥasan 'Alī b. Tā'shā al-Ṣanhājī. She died, may God have mercy upon her, on the night of Sunday 14th Rabī' II in the year 496 [27th January 1103].'
On the columns is the signature of the sculptor al-Ayyād. The frieze which surrounds the columns is inscribed with verses from the Koran, Sura III, 18 and 95. The dead are buried with the head towards Mecca, hence the significance of the mihrab, giving the direction towards Mecca. The ornaments of the spandrels are classical scallops widely used in western Islam. The decorative effect of the inscription depends on slight exaggerations typical of Spanish and North African kufic and on a consistent treatment of recurring and related letters and combinations.

Published: Lévi-Provencal (1931, pp. 30–4, no. 24); Sourdel-Thomine and Spuler (1973, p. 257, pl. 185)

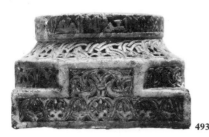

493

495

493 Column base of alabaster with interlace pattern and inscription

Height 19cm, width 29cm
*Instituto Valencia de Don Juan,
Madrid*
Spain (Toledo), Almoravid or
Almohad period, 12th century

Inscription unread

Published: Torres-Balbás (1958, p. 424)

494 Sections of a stucco panel with traces of paint

Length 132cm, height 63cm
Museo Frederico Marés, Barcelona
Spain (Toledo), Muluk al-Tawa'if
or Almoravid period, ?12th century

Alternate medallions are here filled
with animal paintings a few traces of
which may still be discerned.
Terrasse dates these panels later than
the 12th century and dates their
geometric characteristic to
conscious archaism.

Published: Terrasse (1963, p. 426,
pl. 20, 2)

495 Octagonal capital

*Archaeological Museum, Province of
Granada Museum, Granada,
no. 2091*
Spain, Umayyad period,
14th century

Foliage decoration surmounts
a series of eight niches.

Unpublished

496 Tombstone of marble with cursive inscription

Length 150cm, height 23cm
*Instituto Valencia de Don Juan,
Madrid, from Niebla (Hueva)*
Spain, Nasrid period, 1328–9

This prismatic stele presents a shape
common throughout the Islamic
world. It is inscribed on four sides,
one line on each side. The text is
highly unusual as it contains no
Koranic formulas.

> *dufina bi-hādhā al-qabr rajul min
> ahl-al-khayr Abū Fāris ʿAbd
> al-ʿAzīz bn [sic] al-Shaykh
> al-marḥūm Muḥammad ibn [sic]
> Ziyād al-Balansī sana tis'at [sic]
> wa-'ashrīn wa-sab' mi'a raḥmat
> Allāh ʿalayhi wa katabahu ibnuhu
> Faẓl [sic] wa hājja ʿanhu nafa ʿaḥu
> Allāh bihi wa bi-barakat riẓāhu
> [sic]*

'Beneath this tombstone was
interred virtuous Abū Fāris ʿAbd
al-ʿAzīz, son of the late shaykh
Muḥammad b. Ziyād al-Balansī
[of Valencia] in the year 729
[1328–9 AD]. God's mercy be
upon him. This was written by his
son of Faḍl who performed the
pilgrimages [to Mecca] on his
behalf [after his death], may God
grant him the benefit of it and the
blessing of this approval.'

Published: Lévi-Provencal (1931,
no. 146, pl. XXXI)

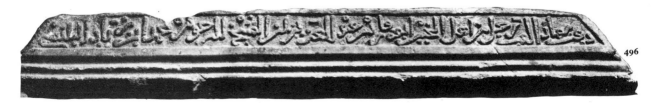

496

Arts of the Book

565 detail

In the general introductions the unique status of the Arabic script in Islamic society has been stressed both as a bond uniting all Muslims in all periods and also as the most important and universal language for artistic expression and decoration. This status derives from the belief that it was the chosen medium for the recording of the Word of God in the Koran. The special exhibition in the Kings Library at the British Museum, London, organised by the British Library Authority, displays the full story unfolding through history of the copying of the Koran in an impressive sequence. But it would not be possible to do justice to the artistic progress of calligraphy and illumination without including here other manuscripts of the Koran since these represent so large a proportion of surviving evidence for these arts up to the 12th century and some of the noblest and most monumental examples of book production in the later centuries.

The measured dignity of the early vellum Korans with their sparse gold and polychrome enhancements appropriately opens the sequence (nos. 498–9) in a style which was practised throughout the community so that it is not possible to discriminate between one centre and another of the Islamic world in the attribution of these early 8th–9th century oblong kufic pages. They are followed by the simultaneous development under Fatimid and Seljuq rule in the 10th–11th centuries of a more sophisticated and self-conscious style of kufic in upright pages with geometric title pages of great abstract beauty, bound in leather covers over wood in a similar style (nos. 501 and 504). With the irruption of the Seljuq Turks a fresh interest in pattern whether in building or in the book is shown in various kinds of interlacing in brick vaulting and stucco decoration. But nowhere is this kind of art so immediately available as in the illumination of manuscripts (nos. 508, 513–4).

The next high point is in the Ilkhanid period in Persia after the conversion of Ghazan to Islam in 1295, rivalled by the contemporary work in the Mamluk centres in Cairo and Damascus (nos. 527–8) which continues into the fifteenth century. The Mongol invasions of 1222 to 1258 for all the immense damage inflicted on the cities of Persia, Mesopotamia and Syria led on the one hand to dispersal of refugee craftsmen and so to wider diffusion of the arts and on the other to far closer and more direct contact with the art of China at the other end of the Mongol empire. Here was an old and mature culture in which the first and greatest art was painting.

The great minister of the Ilkhanids Ghazan and Uljaytu, the Jewish doctor administrator, theologian and historian, Rashīd al-Dīn, himself a convert to Islam, was fascinated by Chinese science, printing, historiography and painting. In his time there started in the Mongol capitals of Tabriz and Sultaniyeh the practice of ordering fine books of history with illustrations which added to the interest of the text by vivid pictures of events which could be projected into contemporary idiom dress and architecture in landscape (no. 530). Hitherto only limited categories of books had been illustrated in the Islamic world, mainly scientific where they had inherited from Greek practice a tradition of astronomical, botanical and medical books or bestiaries. This continuous aspect of the book is a major feature of the special exhibition of Islamic science at the Science Museum, South Kensington. Here we show a few examples for the sake of their artistic merit and interest. However even works like the book on the Fixed Stars by al-Ṣūfī (no. 500) based upon the Greek of Ptolemy has illustrations redrawn in an Islamicised style; and the same is true of the translations of the *Materia Medica* of Dioscorides (nos. 518–23). In all these, the foreign realism or illusionism has been modified to admit the patterning and symmetry which was a constant bias in Islamic art, but vitalised also by touches from direct observation of nature especially in a feeling for animals. But all remained conceptual with no concession to the passing moment. None the less there was already a tendency to add to these works unnecessary detail of figures or trees and plants for the sake only of decoration. A special instance of such irrelevant adornment is to be seen in the frontispieces prefixed to each volume of the great collection of Arabic songs the *Kitāb al-Aghānī* (nos. 515–7). These may be inspired by the example of author and patron portrait in Byzantine manuscripts; but these are more hieratic and correspond more closely to a Sasanian tradition of royal portraits of which no example survives: they are there to claim royal protection even when the work was probably not a royal commission. The Caliph at first, and thereafter all Muslim rulers, claimed to have inherited the wordly as well as the civil and military authority of their predecessors in the Mediterranean and the old Persian empire, and thus to have appropriated all outward panoply of crown, throne, and the courtly style of the hunt and the luxuries of pages, musicians and dancing girls. This kind of frontispiece was later modified and henceforth became stylistically no different from the other illustrations, only preserving the tradition of depicting the patron in suitable princely occupation, hunting or receiving the book commissioned from the author or copyist.

Very different was the new tradition inaugurated under the later Ilkhanids, in which the sense of space and movement was adapted from the great vertical or horizontal paintings of China to the framed area of the book, by the device of ruthless cutting off of the composition both at the top and sides. A generation after Rashīd al-Dīn (died 1318) this new concept was extended to include the dramatic treatment of the great Persian epic, the *Shāhnāma* or 'Book of Kings' (nos. 533–4) and before the end of the 14th century to lyric and romantic poetry, especially the 'Quintet', *Khamsa* of Nizāmī and his imitators like

509 detail

Khwājū of Kirman and Amīr Khusraw of Delhi, none of whom had anticipated that their poetry would be illustrated but realised on their own descriptive and metaphorical powers. When this final step was taken the painters had a rather different task, although they might still be called on to illustrate an event from the legend of Alexander the Great or an exploit of Bahrām Gūr the great hunter. Now all was to be conceived on a visionary plane where the natural setting was as important as the action in achieving the mood of the poet. Although history was still illustrated by the Persian or Turkish or Mughal miniaturist, he was now free to show the world as the mirror or expression of the divine creation. This stage of development in the art of the miniaturist like all periods of transition is one of special interest and this is reflected in the fullest possible representation which has been sought through the selection of the exhibits (nos. 548, 550–1, 555).

After the decline and break up of the Ilkhanid empire in 1336 the greatest patrons of the arts are remembered to have been the Jalayrids, rulers of a Mongol succession state based on the twin capitals of Tabriz and Baghdad. The most important of these reigns for the arts of the book were those of Uways (1358–74) and Aḥmad (1382–1410). The surviving work of the first reign is almost entirely preserved in Istanbul and is therefore unfortunately not represented in this exhibition; but for the second we have the evidence of four key manuscripts (nos. 541–5) to show the break through, from the mixed tradition of illustration tied to the text to a penetration into the world of imagination equal to that of the poet, as shown in one of the master-pieces of the time and the earliest to contain the authentic signature of a painter, Junayd, whose fame is recorded in a text of 150 years later (no. 544).

By this date 1396 we have already reached the age of Timur, that great and ruthless conqueror who in all his savage campaigns took care to save the leading artists and craftsmen. Many were removed to his capital Samarkand, including calligraphers and painters; but it has yet to be shown that this capital was a major centre for the arts of the book as it was for architecture and its decoration with tilework. His son and successor Shāhrukh was a generous supporter of scholarship and book production at his capital Herat, but it was the next generation which produced a crop of princely connoisseurs who were artists themselves. We are privileged to see for the first time since the 15th and 16th centuries juxtaposed such masterpieces as the two anthologies prepared in Shiraz for Iskandar Sultān (died 1414) with other examples of his workshop (nos. 550–5) and the actual hand of his cousins Ibrāhīm and Baysunghur (nos. 554, 558) who were both accomplished calligraphers. It was Baysunghur who founded in Herat in a brief fifteen years a school that remained for generations the standard to which artists aspired in Persia, Turkey, Transoxiana and the Sultanate and Mughal realms of India. Baysunghur is explicitly said to have recruited his library staff from Tabriz, including the painters Sayyid Aḥmad and Khawājā 'Alī and the bookbinder Qiwām al-Dīn who is said to have invented filigree cut-out work. Two early examples are shown in the exhibition (nos. 559 dated 1431 and 564 dated 1448) both

from Herat. Another technique was also developed in Herat, the use of moulds in decorating the outer covers instead of laborious hand tooling (no. 549). By the second half of the 15th century large moulds were in use with pictorial designs covering the main field of the cover first found about 1446 (nos. 607–8). Again, the use of painted lacquer on binding seems to have begun in Herat in the time of Sultan Ḥusayn at the end of the 15th century: but the wider use of this practice came in the first half of the 16th century when they became very close to miniature painting (nos. 602, 605–6).

Nos. 556–7 represent the work of the two greatest scribes of the time in Herat, ‘Alī Ja‘far who was pupil of Mir ‘Alī of Tabriz the inventor of of nastaliq script, and Muḥammad b. Ḥusayn called Shams al-Dīn Baysunghūrī who taught fine writings to the prince himself and designed monumental inscriptions on the mosque of Gawharshad wife of Shāhrukh at Mashhad. The school is equally noteworthy for its illumination. But for this art the finest period may well be under the Turkman rulers of Western Persia and Mesopotamia who after 1453 absorbed the greater part of the Timurid empire except for Khurasan (nos. 572–3), and after the revival of Timurid art in Herat under Sultan Ḥusayn Bayqara (1470–1506).

This is the classic age of the arts of the book in Persia, when the school achieved perfect balance between the miniature and the writing and illumination of the manuscript and when relation between figures, architecture and landscape were harmonious without insipidity. Sensibility assured the perfection of gesture to convey relation and choice of colour to give emotional warmth. How great a part was played by the master Bihzād will never now be known but his is the name which has eclipsed all others of his contempraries in reputation. Three of the most famous of the manuscripts containing his best attested work are shown together with several other candidates for consideration as his work or at least as being near to him in style (nos. 580–3).

Although the ‘classic’ Persian style of miniature painting was formed in Tabriz under the Jala’ir, it reached maturity in Herat after a short honeymoon period in Shiraz under the impetuous prince Iskandar. Shiraz was an old centre of Persian culture, lately the home town of Ḥāfiẓ, greatest of lyric poets, and of new developments in architecture. Herat though long a large and wealthy city standing at the gateway from Persia and the West to Central Asia had not previously been capital of a major state, as it became under Shāhrukh in 1405 on the death of his father Timur. He had been governor in Herat since 1397 and never deserted it until his own death in 1449. It immediately outshone Timur’s capital of Samarkand. All the Timurids were steeped in Persian culture and art; and although themselves Turks by race and speech, they had whole-heartedly accepted both Islam and the heritage of Persian poetry and architecture. At the same time Turkish poetry was encouraged and Turkish scholarship protected (no. 561). After 1449 there were bitter internal feuds in the Timurid family and much territory was lost to the Turkman including the Persian heartland of Shiraz and Isfahan; but there was no complete breach in Herat where

575

616

Abū Saʿīd was in control almost throughout this time until his death in 1468. Then it entered on a second period of flowering under Sultan Ḥusayn, who still controlled the area of greater Khurasan stretching from the south-east corner of the Caspian to Ghazni and Kandahar, to Merv and Balkh, some 750 miles from east to west and 400 from north to south, now divided between Afghanistan, Persia and Soviet Turkmenistan. Thus Herat in the 15th century in many ways resembled the contemporary city states of Italy both in their patronage of humanism and the arts and in internecine violence and political intrigue, but where scholarship, witty talk and fine penmanship were equally esteemed.

However there was a serious undercurrent to life in Herat; these same circles built and endowed large numbers of religious foundations mainly for the benefit of the Sufi teaching orders. Shāhrukh himself had built a shrine complex at Gazur Gah a few miles from the city of Herat which had grown up around the tomb of the mystic ʿAnsarī (1006–81) and he visited it as a pilgrim once a month.

What is the secret of this classic art of the Persian miniature? The effect is built up from a combination of closely focused, intensely felt images, some human, some architectural, some of natural life, plants or animals. The essence of each of these is seized at its most typical, that is its most complete position, so as to exhibit its qualities fully displayed – a flower in bloom, a horse in action, girls in graceful pairs bathing or picking flowers; men as heroes or experiencing extremes of grief or concerted action; the saint Yūsuf fleeing from Zulaykhā through miraculously opening doors (no. 581). Here the architecture is rich and complex, arranged in a pattern which has only as much structural coherence as can be accepted by the willing mind. So none of the images is as much an illustration of a particular subject as something to be enjoyed purely for design, colour and association. The compositions are combinations of visual types, just as the poems are built up of an infinite variety of individual images, all conventional but felicitously united so as to form a new harmony. This persistent and sometimes repetitive use of single figures or groups thus corresponds to a literary usage; but the miniature is not literary: its beauties are formal, patterns of line and colour covering the whole surface of the picture space which is often enlarged freely outside the framed area of the text pages into the margins, but never so violently as to break the unity of the book. This unity was helped by the identity of design used in buildings and their pictures and in manuscript decoration by the illuminator.

But the miniature had a deeper significance in this classic age; it expressed more immediately than the poetry the Sufi view of art. Jāmī, the great exponent of the concept of beauty as the essence of the Creator and therefore as source of all love and devotion, could write (in E. G. Browne's translation)

"Tis love alone from thyself will save thee
Even from earthly love thy face avert not
Since to the Real it may serve to raise thee."
And again:

"Each mundane atom He a mirror made
And His reflection in each one displayed".

So each human face is a faint reflection of the divine face. So in no. 581 Yūsuf is presented as the ideal of human beauty taken as a type of celestial beauty (hence his halo) while Zulaykha is the personification of overmastering love and so can represent the soul of the mystic. For at the end of the poem when Zulaykha and Yūsuf are finally united she has a vision of celestial beauty and so passes over the bridge (a common Sufi metaphor) to love of divine perfection which eclipses her earthly love.

Sharing in this same cultural life during the second half of the 15th century were the courts of the Turkman princes first of the Black Sheep branch and then of the White. They inherited some of the tradition of book production from the Herat of Shāhrukh and some of the older artists of the Jalayrid period in their capitals of Baghdad and Tabriz (nos. 568–74). This north-western school is of special significance for the future because the Safavid house which ruled all Persia during the 16th and 17th centuries sprang from Ardabil north of Tabriz and in the furthest corner of Azerbaijan and they were moreover closely related to the White Sheep Turkman. Consequently when Shāh Ismā'īl I was able to establish a court it was at Tabriz where he had conquered the White Sheep family, whose library staff he inherited. The young Safavid school thus started with a style of rich and exuberant brilliance (nos. 590–1) that made a lasting contribution to the great painting school of his successor Shah Ṭahmāsp (1524–76).

In the first half of this long reign the Persian arts of the book reached their highest point of excellence in professional control and richness of invention. Organisation of the library allowed of a great level of production and the accomplishment of such extraordinary achievements as the completion of a *Shāhnāma* with no less than 258 whole page miniatures: of these only two carry signatures while the names of many artists of the time are recorded: so here is an opportunity for endless attribution, but the greatest praise must still go to the two successive masters of this team Sultan Muḥammad who had taught the young Shah as prince to draw and understand the art; and after about 1540 Mīr Musawwir (nos. 595–6, 600).

These manuscripts were written by the best calligraphers of the age, Sultan Muḥammad Nūr and Shah Maḥmūd of Nishapur who was surnamed Zarīn Qalam (Golden Pen): both were pupils of leading scribes of the previous generation, the first of Sultan 'Alī of Mashhad and the second of 'Abdī of Nishapur, thus demonstrating the chain of artistic descent which permitted the maintenance of such standards of excellence. In addition two of them (nos. 596, 599) also bear the signatures of masters of illumination, while we have already praised the technical achievements in binding at this time and especially the pictorial bindings in lacquer and moulded leather. Around 1545 the Shah began to lose interest in the book arts and although other members of his family stepped in to provide patronage, especially Ibrāhīm Mīrzā the Shah's nephew and governor of Mashhad until his murder in 1577 (see no. 614); but Qazvin as the royal capital still

claimed the top artists, such as those represented in the recently discovered manuscript of 1573 (no. 613).

There is some evidence that this was however fading before the brilliance of the younger team of artists who worked in no. 613 who also had started to show their virtuosity in a number of separate figure studies which were to claim an increasing share of their time in the new reign of Shah 'Abbās I (1587–1629). One of these artists Sādiqī Beg was named head of the court library in 1596 and no. 621 may well have been offered to him by his pupils as a splendid tribute to him on that occasion. The son of the second of these older artists 'Alī Asghar was to earn an even greater reputation under the name of Aqā Rizā as a figure painter.

In him we can see the flowering of this elegant and often exuberant line in compositions where figures combine in intricate patterns of an almost abstract beauty (no. 620); in later life Riza seems to have found court patronage too restrictive and to have given full reign to this tendency to mannerism in figure drawings of great virtuosity either in ink (no. 631) or colour (no. 632). Thus did the formal qualities of design always strong in Islamic painting become dominant in later Safavid work. Riza was the man of the hour and he was followed by his son Shafi' and his pupil Mu'īn, a master of a more fluid, less staccato line. This was indeed an individual expression of a more general less extreme tendency, to which manuscripts such as nos. 633–4 bear witness. In them what had been pattering of margins with designs called descriptively *abri* (literally cloud forms) and a special technique of book adornment invaded the field of the miniature and becomes dominant, so that the figures look as though they were themselves wind-borne.

Here we see the link between calligraphy and two of the other major themes illustrated in Room I of the exhibition – the arabesque and the figure – also shown in the arts of the book. We have some examples of more or less fully developed sketches in which designers have shown how the modulated line articulates an action-picture of a bird (no. 641), or can become a full-blown design for use in the applied arts (no. 627). How calligraphy itself can develop into a regulated kind of decoration is seen in the Turkish imperial *ṭughrā* (nos. 622, 637) with a degree of control beyond any craft today, yet with a free interpretation within the stated bounds. The popular counterpart may be seen in the frequent formation of calligraphy into bird or animal forms animating the slogans of sectarian propaganda or charm. So the example of the 19th century resembles that of a thousand years earlier on the Samanid pottery (no. 295 compared with no. 641).

578a detail

497c

499

497 a-d Four fragments from painted floor compositions

Overall dimensions
a height 22.5cm, width 11.5cm
b height 21.5cm, width 23cm
c height 41.7cm, width 41cm
d height 28.5cm, width 25cm
National Museum, Damascus, from Qaṣr al-Ḥayr al-Gharbī
Syria, Umayyad period, about 730

In 1936, at the palace of Qaṣr al-Ḥayr al-Gharbī not far from Damascus, Schlumberger discovered substantial remains of wall and floor paintings which had once decorated two large halls. The two large compositions which were found there and which are now housed in the National Museum, Damascus, are of the earth goddess with tritons, and of musicians and a hunter pursuing gazelles. The goddess is eastern Roman in style but the hunting scene displays strong Sasanian influences. These four fragments are from unidentified subjects but they all are eastern in style, displaying the strength of Persian influences in matters of artistic production under the caliph Hishām (ruled 724–43). Fragments b and d represent floral

and vegetal decoration and are outlined in a darker colour so that the design may be distinguished from the background. The design contains a straight line suggesting that it may have belonged to a border decoration. Fragments a and c are parts of figures. The bushy eyebrows and beard imply that a is a figure of a man, whereas c seems to be that of a woman wearing a three-lobed earring and a headdress which passes beneath the chin.

Published: Schlumberger (1946–8, pp. 86–102); Ettinghausen (1962, pp. 33–6)

498 Double-page from a Koran on vellum

Height 31cm, width 81cm
National Library, Tunis, no. 197 Rudbi
Mesopotamia (?Baghdad), Abbasid period, 9th century

The text is from Sura XXXIII, and is written in kufic in gold on a blue background. Similar pages are in the Fogg Art Museum, Harvard (no. 1967, 23), the Museum of Fine Arts, Boston (no. 33.686) and the Chester Beatty Library, Dublin (MS 1405) and these pages are said to have come from a Koran presented to the mosque of Mashhad by the caliph al-Ma'mūn (ruled 813–37). Closer to the style of this double page is a small leaf in the Freer Gallery of Art, Washington (no. 45.16) though this leaf has lost most of the blue pigment and the writing is in black ink. See Atil (1975, no. 2).

Unpublished

499 One page with gold heading, a rosette and 5 lines of kufic from a Koran on vellum

Height 23.5cm, width 34cm
Iran Bastan Museum, Tehran, no. 4289
Persia, 9th-10th century

This Koran consists of 154 folios with gilt Sura headings. In the colophon is written *katabahu wa dhahhabahu* [copied and gilt by] 'Alī ibn Abī Ṭālib. No date is given. 'Alī, the fourth caliph (ruled 656–61), is traditionally credited with the invention of the kufic script, named after his capital, the newly founded city of Kufa. No Koran manuscript of such an early date has survived and ascriptions to 'Alī found in colophons are undoubtedly apocryphal. All early Korans are written on vellum and are oblong in shape. The earliest known paper manuscript is dated 972 and the present fragment is certainly earlier than this though it is difficult to be certain of its place of origin since there is little if any stylistic differences between Korans produced in Syria, Mesopotamia and Persia at this time.

Published: Bahrami (1949a, no. 2)

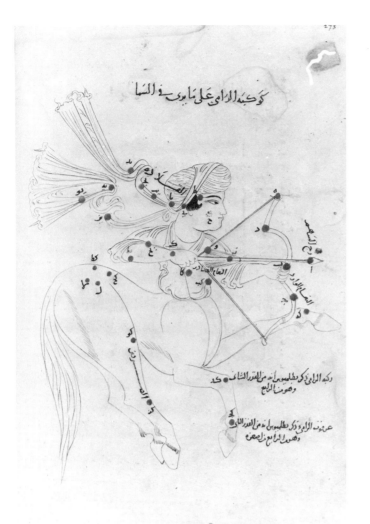

كوكبة الرامي على ما يرى في السما

دكة الرامي ذكر بطليموس على اثه من القدر الثالث كد وهو من الدبع

عنوة الرامي وذكر بطليموس على اثه من القدر الثالث وهو من الرابع الراي اصغر

500

501 Double-page from a Koran
Height 45cm, width 30.8cm
National Library, Tunis
Tunisia (Kairouan), Zirid period,
early 11th century

The text of this Koran is written in
kufic, of the rihani type, in black ink
with coloured vowels. This is one of
the first known examples of vowelling
according to the method of the
grammarian al-Khalīl b. Aḥmad.
This Koran was copied and bound by
the calligrapher ‘Alī b. Aḥmad
al-Warrāq and this double page has
the verses from Sura II, 255. Another
page of the same manuscript contains
a text which indicates that the Koran
belonged to Fāṭima, governess of
prince Abū Mannad b. Bādīs b.
al-Manṣūr b. Zīrī (ruled 996–1016),
who gave it to the Great Mosque at
Kairouan in 1020. See Roy and
Poinssot (1950, pp. 28–31).

Unpublished

**500 Ṣuwar al-Kawākib
al-Thābita, ‘Forms of the Fixed
Stars’, by ‘Abdulraḥman
al-Ṣūfī**
Height 26.3cm, width 18.2cm
*Bodleian Library, Oxford, MS.
Marsh 144*
Persia (Shiraz), Buyid period,
1009–10

This manuscript consists of 419
folios with 75 drawings bound in
plain 17th century leather. The
colophon indicates that the book was
copied and illustrated by al-Ḥusayn
b. ‘Abdulraḥmān b. ‘Umar b.
Muḥammad, the son of the author.
This illustration represents a figure of
the constellation Sagittarius. The
linear quality of the illustrations of
this manuscript may perhaps be
explained by their having been
originally traced from a celestial
globe with engraved figures. The
work was commissioned from
al-Ṣūfī by the Buyid amir ‘Aḍud
al-Dawla in about 960. This copy was
probably made in Shiraz, the Buyid
capital, and its style is a fusion of
Abbasid Mesopotamian influences
with the older Sasanian Persian
traditions. ‘Aḍud al-Dawla also
commissioned al-Ṣūfī to make a large
silver celestial globe. This manuscript
is the earliest known example of
al-Ṣūfī’s work and is also one of the
earliest examples of Islamic book
illustration.

Published: Wellesz (1959, pp. 1–27);
Ettinghausen (1962, pp. 50–3);
Robinson and Gray (1972, no. I, p. 9);
Jones (1975, pp. 10–2)

502

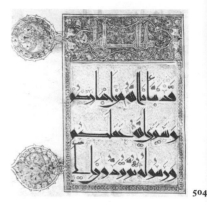

504

502 Page from a Koran
Height 26cm, width 33cm
*Museum of the Great Mosque,
Kairouan*
Tunisia (Kairouan), Zirid period,
about 1048

This page comes from a koran
dedicated to the Great Mosque at
Kairouan by the Zirid prince
al-Muʿizz b. Bādīs (1015–61) and was
found in an abandoned room in the
mosque. Within an ornate border is
the Koranic text which is inscribed in
kufic beginning with the word
bismillāh, 'in the name of God.' The
words are surrounded by gilt vegetal
motifs.

Unpublished

503 Double-page from a Koran written on vellum
Height 14.5cm, width 20.7cm
*Museum of the Great Mosque,
Kairouan*
Tunisia (Kairouan), Zirid period,
10th–early 11th century

These two pages are decorated with
two semi-circles and an interlacing
border which is an unusual design to
find on a Koran. On the reverse of one
of these pages is an inscription in gilt
on a background of vegetal motifs.
The inscription consists of two words
of which only the first is legible and
reads *huwa*, 'he is . . .'. Like no. 502,
this is one of the many pages found in
the Great Mosque at Kairouan.

Unpublished

504 Double-page from a Koran
Height 26cm, width 20.5cm
*Imam Riza Shrine Library,
Mashhad, no. 71*
Persia (Khurasan), Seljuq period,
1073

This Koran is one of sixteen parts
copied and decorated by ʿUthmān
ibn Ḥusāyn al-Warrāq with an
illuminated frontispiece, dated to
1073. The headings at the top of these
pages are decorated with kufic on a
floriated ground, below which are
four lines written in Samanid kufic
script. In the margins are two gold
illuminated palmettes. This manu-
script is a classic example of early
Persian paper Korans. By 1073
Khurasan was under Seljuq rule but
the style of the script used here is
conservative.

Published: Bahrami (1949a, no. 47);
Maʾani (1966, nos. 70–1)

503

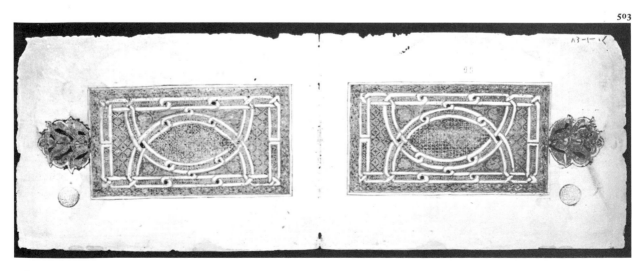

507

505 Cover from a leather binding

Height 11.3cm, width 17cm
*Museum of the Great Mosque,
Kairouan*
Tunisia (Kairouan), Zirid period,
11th century

This is the upper cover from a
binding of reddish brown leather
placed on a poplar wood board. Its
decoration is hand tooled and
consists of two rectangular fields
inside one another containing
interlacing geometrical designs. This
conforms with the decoration of
other bindings which were found in
the Great Mosque at Kairouan.

Published: Marçais and Poinssot
(1948–52, p. 197, pl. XXIIb);
Peterson (1954, pp. 41–64, pl. 17)

506 Part of a leather binding

Height 22cm, width 14.3cm
*Museum of the Great Mosque,
Kairouan*
Tunisia, Aghlabid period,
10th century

This is part of a binding in which the
decoration was applied by blind
tooling on leather placed on a wooden
board, compare no. 505. The border
consists of interlacing circular shapes
with a dot in each. This is a
characteristic motif which recurs in
many of the bindings found in the
Great Mosque at Kairouan. The
central field is occupied by intricately
braided or plaited bands. The reverse
of this side would have functioned as
the bottom of the box or cover and
consists of a piece of leather on which
a dedication is written in kufic letters
stating that it was a gift to the mosque
made by an Aghlabid princess.

Unpublished

507 Lower side of a leather binding

Height 11.5cm, width 18cm
*Museum of the Great Mosque,
Kairouan*
Tunisia, Fatimid period,
9th-10th century (perhaps 11th
century)

The decoration of the raised central
palmette is placed horizontally with
scroll-like leaves emerging towards
the four corners. The design of the
interior of the palmette is also found
on capitals of late Sasanian buildings
and in the mosaics of the Dome of the
Rock, Jerusalem. The raised
technique of decoration was achieved
by glueing cords on to the poplar
wood board on which was placed the
leather which was then tooled. The
other side is covered with parchment.
This binding is one of several found
in an abandoned room of the Great
Mosque at Kairouan (see also nos.
505–6). This example, however,
differs from the others in its technique
which is of Coptic origin and is
related to the 7th century Anglo-
Saxon binding of the St. Cuthbert
gospel at Stonyhurst College.

Published: Marçais and Poinssot (1948–
52, pp. 56, 231); Peterson (1954); Miner
(1957, no. 43, pl. XIII); Ettinghausen
(1959a, pp. 113, pl. b)

505

506

508 Koran
Height 41.5cm, width 28.5cm
University Museum, Philadelphia,
MS. NE-P27
Persia (Hamadan), Seljuq period,
12th century

This Koran consists of 215 folios
copied in naskhi script, illuminated
by Maḥmūd Ibn al-Ḥusayn al-Kātib
al-Kirmānī in Hamadan in 1164.
Between each two lines of the text is
an arabic commentary written in red
on the slant in smaller naskhi script.
The Sura headings are heavily
decorated with a different design for
each. The binding is later. This
manuscript was given as a donation to
the Azhar mosque in Cairo by the
amir Aḥmad Jāwīsh (died 1786). The
first page is elaborately decorated
with a geometrical pattern of inter-
secting white lines forming 21
medallions, six of which have a blue
ground, the others a gold ground.
The last page, shown here, contains
the colophon and is decorated with a
large diamond-shaped figure filled
with a rosette of intersecting circles.
The four sides of the diamond are also
intersected by half circles. The
colophon is contained in the rect-
angular field at the top and bottom of
the page. The scribe-illuminator
Maḥmūd is not otherwise known, but
he completed his work in one of the
Seljuq capitals, Hamadan. The
illumination and decoration are of the
highest quality and Ettinghausen has
compared them with the architectural
decoration of the mosque at Qazvin,
slightly earlier in date.

Published: Ettinghausen (1935,
pp. 92–102)

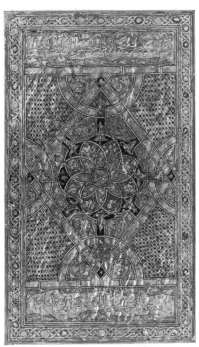

508 see colour plate, page 52

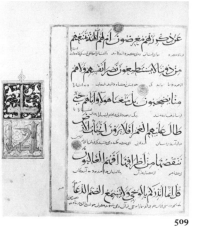

509

509 Double-page from a Koran
Height (of each page) 41cm,
width 33cm
Iran Bastan Museum, Tehran,
no. 3496
Khurasan, Ghurid period,
12th century

This Koran is in four volumes with
interlinear commentary and Persian
translation. It was copied in thuluth
by Muḥammad bin 'Īsā bin
Muḥammad 'Alī Nīshāpūrī Lithī for
Ghiyāth al-Dīn Muḥammad bin Sām
Amīr Ghūr in 1188, presumably in his
capital Firuzkhuh in Khurasan (now
in Afghanistan) the site of which is
unknown, but may be marked by the
famous minaret of Jam which bears
the name of this sultan. The
manuscript was given as a donation by
Shaykh al-Islām Aḥmad Jāmī in 1256
and was preserved in his tomb at
Turbat-i-Shaykh Jam until 1898
when it was removed to the Museum.
The leather binding is contemporary
with the manuscript.

Published: Bahrami (1949a, nos. 30–3 and
1949b, no. 52); Ettinghausen (1954,
p. 470); Golombek (1971, p. 31)

510 Binding of leather
Height 17.4cm, width 14.5cm
*Staatsbibliothek Preussischer
Kulturbesitz Orientabteilung, Berlin,
Or. Oct. 3196*
Syria (Damascus), Ayyubid period,
12th century

This binding contained the
manuscript *Riyāḍat al-Muta'allimīn*,
'Exercise of the Instructed', by
Aḥmad b. Muḥammad ibn al-sanā,
dated 1182 by two attestations. Only
the back and flap of the binding are
preserved. The tooled decoration is
created by three different units
repeated in two complete borders,
the central one appearing only at the
sides. Corner pieces and flower in the
central field.

Published: Weisweiler (1962, 52, fig. 60,
pl. 41)

**512 Page from the Mufīd
al-Khāss (second part), by Abū
Bakr Muḥammad b.
Zakarīyā al-Rāzī**
Height 24cm, width 16cm
*Imam Riza Shrine Library,
Mashhad, no. 103*
Mesopotamia (Mosul) or Persia,
Seljuq period, about 1200

This manuscript was dedicated to the
ruler of Mazandaran and was
illustrated with human, animal and
plant figures. It was formerly in the
possession of the Mamluk sultan
al-Malik al-Ṣāliḥ Ismā'īl (ruled
1342–5) and was given by Nādir
Shāh to the shrine of the imam Riza at
Mashhad. This page (folio 31) depicts
three medicinal plants. The human
figures between have haloes typical of
manuscripts illustrated in
Mesopotamia in the late 12th and
early 13th centuries. The line of
foliage forming the ground line also
occurs in paintings of this school and
period. Pre-Mongol miniatures from
Persia are so scarce that it has not yet
been possible to assign this
manuscript to Mesopotamia or
Persia.

Published: London (1931, no. 535c);
Binyon, Wilkinson and Gray (1933, no. 7);
Pope and Ackerman (1938–9, pl. 514);
Bahrami (1949b, no. 50)

513 Koran
Height (of each page) 39cm,
width 31cm
Imperial Library, Tehran, no. 55–60
Persia (Khurasan), Seljuq period,
1209–11

This Koran, with translation and
commentary of Ṭabarī in thuluth,
was copied by As'ad b. Muḥammad
b. Abū Khāyr b. Aḥmad b. Abū
al-Ḥusayn Sahlawiyya of Yazd and
illuminated by Aḥmad b. Abū Naṣr
b. Abū al 'Umar b. Abū 'Atīq. The
title page has a rare example of the
signature of the illuminator whose
work is characteristic of the late
Seljuq style of south-east Persia.

Published: Bahrami (1949a, no. 36–41
and 1949b, no. 53, pl. 25); Atabay (1974,
no. 53, pp. 110–3)

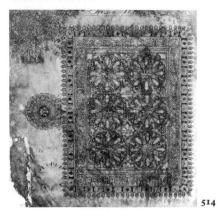

514

514 Koran with commentary by Ṭabari

Height 39cm, width 30cm
*Bibliothèque Nationale, Paris,
Cabinet des Manuscrits, Sup.
Pers. 1610*
Persia, Seljuq period, 13th century

This Koran is in 310 folios and was
copied in Azerbaijan in 1220–5 for
the library of Abū al-Qāsim Hārūn
ibn 'Alī ibn Ẓafar Dindān. This
patron was minister of Uzbek, an
atabek of north-west Persia. The
binding is in black leather. The
frontispiece to the commentary is
decorated with a geometric design
contained within three borders. On
the left, outside the borders, is a
medallion. This style was later to
influence the heavily decorated
Korans copied in Egypt in the 14th-
15th centuries for the Mamluk sul-
tans. This Koran is the first of seven
volumes which Ettinghausen (1935,
p. 101) has judged to be among the
finest examples of pre-Mongol
Persian manuscripts.

Published: Blochet (1926, p. 138, pl. 97);
Paris (1973, no. 170)

515 Kitāb al-Aghāni, 'The Book of Songs', by Abū al-Faraj al-Iṣfahāni, volume 2

Height 26.5cm, width 20.5cm
*National Library, Cairo, Adab fārsī
579/2*
Mesopotamia (Mosul), 13th century

Abū al-Faraj al-Iṣfahāni (897–967), a
descendant of the last Umayyad
Caliph, was patronised by the
Buyyids and Hamdanids and col-
lected the songs chosen, at Harūn al-
Rashīd's command, by famous
musicians, adding many others, and
assembling information about the
Arab poets, the ancient Arab tribes
and the court of the Umayyads and
Abbasids, thus giving a conspectus of
Arab society from pre-Islamic to
Abbasid times. This work was, in
fact, an invaluable source for
quotations by historians and
philologists of the 8th century
though the work was neither
systematically nor chronologically
organised. It was many times copied,
though most surviving copies are
13th century and later and no other
manuscripts appear to be illustrated.
This example was in 20 volumes only
seven of which are known to have
survived but of which only six retain
frontispieces. These frontispieces
have nothing to do with the text but
illustrate princely themes such as
hunting, enthronement or listening to
music and dance. The enthroned
ruler has often been identified as
Badr al-Dīn Lu'lu', ruler of Mosul
from 1218, largely on the basis of an
inscription on the *ṭirāz* arm band in
several of these frontispieces.
Ettinghausen (1962, p. 64) accepts
the identification but argues that
these volumes are at a remove from
royal manuscripts. Badr al-Dīn

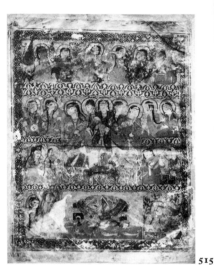

515

Lu'lu' ruled at Mosul from 1218 but
had to wait until 1231 before he was
recognised by the Caliph as a reigning
prince. The 2nd volume is written in
black thuluth script in 174 folios but
the headings of each song are in fat
black-edged gold naskhi. This
frontispiece is arranged in four
registers and shows women dancing.
In the centre in a rectangular panel
are women treading a water-wheel
over a pool with ducks and fishes.
See also nos. 516–7.

Published: Rice (1953b, p. 128)

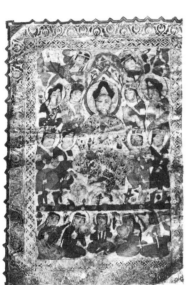

516

517

516 Kitāb al-Aghānī, 'The Book of Songs', by Abū al-Faraj al-Iṣfahānī, volume 4
Height 26cm, width 17cm
National Library, Cairo, Adab fārsī 579/4
Mesopotamia (Mosul), 13th century

This frontispiece (folio 2a) represents a ruler enthroned with genii above surrounded by emirs or soldiers bearing symbols of their office. The colophon (folio 198) names the scribe Muḥammad b. Abī Ṭālib al-Badrī.

Published Rice (1953b, p. 128); Ettinghausen (1962, p. 64)

517 Kitāb al-Aghānī, 'The Book of Songs', by Abu al-Faraj al-Iṣfahānī, volume 20
Height 28.6cm, width 21.5cm
Royal Library, Copenhagen, Arabic Ms, 168
Mesopotamia (Mosul), 13th century

This volume was copied by Muḥammad b. Abī Ṭālib b. al-Badrī and is dated 1219. The presence of the two flying genii above the rider's head in this frontispiece indicates a clear relationship with classical victories even if they do not hold wreaths. Such flying figures are also found in the spandrels of the Sasanian relief of Khusraw II at Taq-e-Bustan in Persia. The rider with a falcon is framed in a double border and probably represents Badr al-Dīn Lu'lu' whose name appears on his arm band. However, such depictions should not be regarded as portraits, but as ideal effigies of rulers.

Published: Stern (1957, pp. 501–3); Melikian-Chirvani (1967, p. 19)

518

518 Khawāṣṣ al-Ashjār, 'The Properties of Plants', by Dioscorides
Height 46cm, width 30cm
Imam Riza Shrine Library, Mashhad
Mesopotamia, early 13th century

The *Materia Medica* of Dioscorides was translated from Greek into Arabic in the 9th century, probably in Baghdad, the seat of the Abbasid caliphate. The original type of scientific illustrations which accompanied the text were transformed by Islamic artists into genre scenes. This manuscript consists of 284 folios with 677 figures of plants and 284 of animals. The original Greek names of the plants are indicated by notes in Syriac. This volume was presented by Shāh 'Abbās to the shrine of the Imam Riza in 1608. The binding is new. The plants depicted here are drawn in a manner not far removed from the Greek originals with fully displayed roots as is appropriate to a scientific work but the human figures are in a Mesopotamian style. This miniature is of the Euphorbia tree. Grube attributes the manuscript to about 1155–65 antedating the miniatures from the manuscript of 124 (see nos. 520–1).

Published: London (1931, no. 535a); Binyon, Wilkinson and Gray (1933, no. 6, p. 25); Bahrami (1949a, no. 51); Grube (1959, IV, p. 171, pls. 12–4)

519 Miniature from the Khawāṣṣ al-Ashjār, 'The Properties of Plants', by Dioscorides
Height 28.7cm, width 19.9cm
Dr. Richard Ettinghausen Collection, New York
Mesopotamia (Baghdad), about 1200

This miniature is a true botanical illustration, similar to those of no. 518 and represents the plant sesamoides. The tendency towards decoration and the making of symmetrical patterns is well illustrated in this miniature.

Published: Binghamton (1975, no. 33)

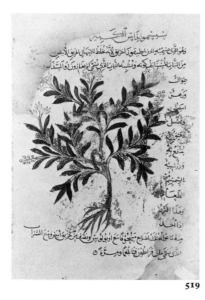

519

520 Page from the Khawāṣṣ al-Ashjār, 'The Properties of Plants', by Dioscorides
Height 32cm, width 23cm
Private Collection
Mesopotamia (Baghdad), 1224

This miniature and no. 521 were among 31 cut out from a manuscript now in the Hagia Sophia Library, Istanbul (no. 3703), some time before several of these were included in the Munich exhibition of 1910. The manuscript now contains 202 folios and one figural miniature as well as numerous plant illustrations; it is dated 1224. This miniature shows a boat with oars on the river Gages and a two-storeyed arcade with a face peering through each arch. The text describes the use of amber for uterine pains.

Published: Munich (1910, pl. 4); Marteau and Vever (1912, I, p. 49); Martin (1912, pl. 5a); Migeon (1927, pp. 124–6); Buchthal (1942, no. 22); Grube (1959, no. vi)

521 Page from the Khawāṣṣ al-Ashjār, 'The Properties of Plants', by Dioscorides
Height 32cm, width 23cm
Private Collection
Mesopotamia (Baghdad), 1224

See no. 520. This miniature depicts the patient consulting with two physicians. The text discusses the cure for aconite poisoning (leopard's bane).

Published: Munich (1910, pl. 4); Marteau and Vever (1912, I, p. 49); Migeon (1927, pp. 124–6); Buchthal (1942, no. 23); Grube (1959, no. vi)

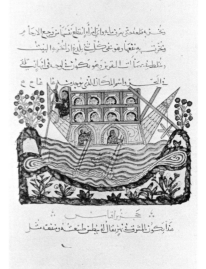

520

521

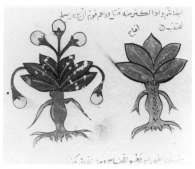

522

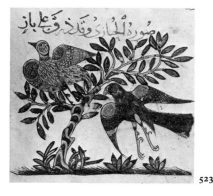

523

522 Khawāṣṣ al-Ashjār, 'The Properties of Plants', by Dioscorides

Height 24.6cm, width 17.2cm
Bodleian Library, Oxford, MS. Arab. d. 138, gift of Sir William Osler in 1926
Mesopotamia (Baghdad), 1240

This manuscript consists of 210 folios with illuminated medallions and headings at the beginnings of maqalas 3, 4 and 5. It was copied by al-Ḥasan b. Aḥmad b. Muḥammad al-Nashawī in 1240. The binding in embossed leather is 17th century Persian work. The numerous coloured drawings of plants are contained mostly in maqalas 3 and 4 and are not exceptional though they display a greater degree of realism as a result of a direct observation of nature than other examples (compare no. 519). This miniature (folio 120a) shows a plant at the stages before and after flowering. The plant is known as luffāḥ or yaqṭīnī and resembles the aubergine when it becomes yellow. Luffāḥ is also the fruit or produce of the mandrake tree. See Lane (1863, I, p. 2666).

Published: Dubler and Teres (1953–9, II, introduction and pp. 237–442); Grube (1959, pl. ix, fig. 9); Robinson and Gray (1972, no. 2, p. 9)

523 Manāfi' al-Hayawān

Height 23cm, width 15cm
British Library, London, Or.2784
Mesopotamia (Baghdad), about 1250

This manuscript is an Arabic treatise on animals and on the medicinal properties of various parts of their bodies compiled from the works of Aristotle and 'Ubaydullāh ibn Jibrīl ibn Bakhtīshū'. The latter came from a family of Syrian Christian doctors who worked for the Abbasid caliphs in Baghdad in the 8th century. This manuscript is written in the naskhi script and has its text pages out of order. There is, unfortunately, no colophon to give the date, scribe or place of execution. The paintings illustrate the sections on birds, animals, fishes and crustaceans and there are also portraits of Aristotle and ibn Bakhtīshū' (see folios 96r and 101v, respectively). The style of the paintings is old-fashioned, preserving the conventions of the earlier Mesopotamian school. They must have been completed shortly before the sack of Baghdad in 1258 and display considerable sensibility and liveliness in their execution. This miniature (folio 228v) illustrates a bustard and falcon. The text states that the bustard is proverbially the most stupid of birds and there is a saying 'he is more stupid than the bustard.'

Published: Rieu (1894, no. 778, p. 531); Martin (1912, I, figs. 5–6, II, pls. 17–20); Buchthal (1942, p. 34, figs. 34–6, 39, 41); Ettinghausen (1962, p. 136)

524 Binding of Muḥtaṣar Gharīb al-Ḥadith 'A Summary of Strange Tales,' by Abū 'Alī al-Ḥusayn b. Aḥmad al-Astarābādī

Height 28.5cm, width 17cm
Staatsbibliothek Preussischer Kulturbesitz Orientabteilung, Berlin, Or. Oct 3162
?Egypt, manuscript dated to 1071, binding probably 13th century

This binding has a design of geometric interlacing enclosing rosettes with a double border of stamped units. The flap is stamped with different stamps to make up the design. This binding was probably made for the manuscript at a later date. It is also partly restored.

Published: Weisweiler (1962, no. 51, fig. 5, pl. 3)

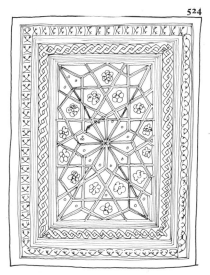

524

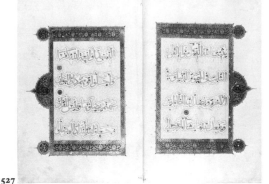

525 Binding of a manuscript by Abū Dāwud Sulaymān b. al-Asʿad
Height 26.5cm, width 17.5cm
Staatsbibliothek Preussischer Kulturbesitz Orientabteilung, Berlin, Or. Quart 1210
Syria, Mamluk period, manuscript copied in 1099, binding late 13th century

This binding is made of one piece of leather and the decoration has been stamped. The flap and spine are damaged and the back has been restored.

Published: Weisweiler (1962, no. 20, fig. 38, pl. 24)

526 Double-page of a Koran
Height 50.5cm, width 38cm
Iran Bastan Museum, Tehran, no. 3550
Persia (Tabriz), Ilkhanid period, 14th century

This opening is of an incomplete Koran illuminated by Muḥammad b. Ibāk, copied in thuluth by Aḥmad b. Suhrawardī, and dated to 1304–5. The leather binding is contemporary; it is blind tooled and stamped and is signed ʿAbd al-Raḥmān. Aḥmad b. Suhrawardī was one of the best pupils of the great calligraphic master Yāqūt who served under the last Abbasid caliph, Mustaʿṣim. He survived his master, who was killed by the Mongols in 1258, and designed monumental inscriptions for several mosques in Baghdad. Afterwards he worked at the Ilkhanid court in Tabriz. The cover of this manuscript is the oldest signed Persian binding. This frontispiece is created by a

complex geometric interlace pattern, the interior of which and surrounding band are in arabesque decoration.

Published: Bahrami (1949a, nos. 51–4 and 1949b no. 56, fig. 26); Ettinghausen (1954, pp. 462–3, fig. 350)

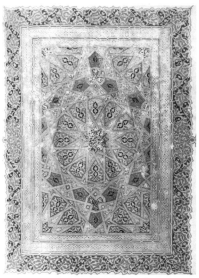

526 see colour plate, page 53

527 Koran
Height 48.5cm, width 35cm
British Library, London, Add. 22409
Egypt, Mamluk period, 1304

This Koran is the fourth of seven volumes written in thuluth by Muḥammad ibn al-Waḥīd in 1304 and gilded and illuminated by Muḥammad ibn Mubādir and Aydughdī ibn ʿAbd Allāh al-Badrī for Rukn al-Dīn Baybars who became sultan of Egypt. The script used here is written against a finely drawn hexagonal design and enclosed in ornate borders of gold interlacing bands. Between the borders, above and below, are gold arabesque designs decorated with red, each with a rounded palmette extending into the margin. The same arabesque design is used, enclosed in plain gold borders, in these four palmettes as well as in the central ansa on each page. The entire design is predominantly gold upon a blue background. The three small rosettes within the text mark the verse divisions and are of different designs throughout the Koran. It is instructive to compare this Koran, copied and illuminated in Cairo under the Mamluks, with contemporary Ilkhanid examples from north-west Persia (see nos. 528–9, 532).
There is much in common, especially in the use of Chinese floral elements in the decoration, but the Mamluk style is more architectural and therefore more explicitly worked out. Nevertheless, it is possible to speak of an 'international style' in the manuscripts of this period. See Ettinghausen (1962, p. 175).

Published: Arnold and Grohmann (1929)

529

529 Majmūʻa al-Rashīdiyya, 'Theological Works', by Rashīd al-Dīn

Height 53cm, width 36cm
Bibliothèque Nationale, Paris,
Cabinet des Manuscrits, Arabe, 2324
Persia (Tabriz), Ilkhanid period,
14th century

This manuscript in 376 folios was
copied in 1309–10 in Tabriz by
Muḥammad ibn Maḥmūd ibn
Muḥammad al-Amīn al-Baghdādī
who was also known as Zūd navīs, or
'one who writes fast'. It was illumi-
nated with the help of Muḥammad
ibn al-ʻAfif al-Kāshī who also signed
it. The frontispiece which is shown
here has a wide border decorated with
vegetal motifs enclosing a central
space filled with decorated octagons.
Above and below the enclosed space
is a blank area. The ansae contain the
signatures of the two illuminators.
The interlaced knot here first em-
ployed in manuscript decoration is
found in earlier metalwork and is also
related to contemporary architectural
decoration.

Published: Martin (1912, pl. 238);
Pope and Ackerman (1938–9, pp. 1956–8,
pl. 936b); Blochet (1926, pp. 139–140);
Paris (1973, no. 209, p. 76)

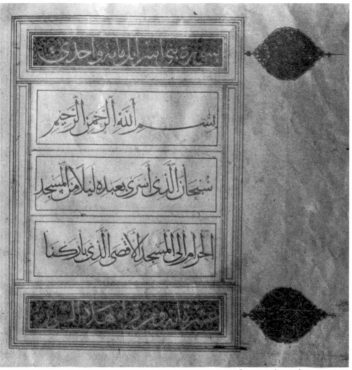

528a see colour plate, page 50

528 a–b Two volumes of a Koran

Height 55cm, width 38cm
National Library, Cairo, no. 72
Persia, Ilkhanid period, 1314–5

This Koran was copied in thirty parts
for Uljaytu by ʻAbdullāh Muḥammad
b. Maḥmūd al-Hamadānī in 1314–5.
Both volumes are in stamped and gilt
leather bindings of the period with a
decorated flap, the inner faces
covered with stamped and foliate
arabesque. The two volumes a–b, are
of 37 and 36 folios, respectively, with
five lines of thuluth script in gold
with black outlines. The illuminated
double-page frontispieces, Sura
headings and end-pieces are in blue
black, white and gold. Volume a is
part 15 of the Koran and here shows
the opening Sura of the text
(folio 3l). Volume b is part 21 of
the Koran and here shows the
illuminated frontispiece in alternating
octagons of gold, black, blue and

white (folios 3l–4r). On the medallion
illuminated in gold there is further
illumination in gilt overlaying the
name of the calligrapher ʻAbdullāh
Muḥammad b. Maḥmūd
al-Hamadānī and the date 1314–5.
This frontispiece, like those of the
other volumes, bears a dedication
waqf dated 1326 in favour of the
domed mausoleum attached to the
funerary foundation of Bektimur
al-Sāqī in the southern cemetery,
Cairo. Ibn Iyās recounts that Sultan
al-Ghūrī installed the Koran in his
own madrasa inside Cairo and that
Bektimur paid 1,000 dinars for it. See
Wiet (1945, p. 66). There are few
more important Koran manuscripts,
either historically or aesthetically.

Published: Wiet (1932, pp. 68–73);
Ettinghausen (1954, pp. 461–2);
Cairo (1969, no. 281)

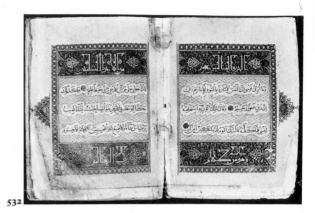

532

530 Jāmi' al-Tawārīkh, 'World History', by Rashīd al-Dīn
Height 43.5cm, width 30.5cm
Royal Asiatic Society, London, no. A26
Persia (Tabriz), Ilkhanid period, 14th century

This manuscript copied in 1314 consists of 59 folios and 35 miniatures and contains fragments of the history of the Prophet, the history of India, with the account of the Buddha, part of the history of the Jews, and of the history of China. On folio IIa is the seal of Shāhrukh, son of Timur. Another large portion is in the University of Edinburgh Library (no. 20) and is dated 1307–8. It is difficult to overemphasise the importance these manuscripts, although fragmentary, as an authentic survivor from the famous scriptorium established and endowed by Rashīd al-Dīn in a suburb of Tabriz called 'Rashīdiyya' when he was vizier to the Ilkhanid ruler Uljaytu. The author was commissioned by his master to produce a world history and had at his command scholars and artists from all over the wide Mongol dominions. The miniature shown here (folio 34a) depicts Śākyamuni holding out two pomegranates to the devil who appears as an ascetic. The Chinese influence in the style of the painting dominates.

Published: Morley (1854, no. 1, pp. 1–11); Martin (1912, I, p. 17, II pls. 27–32); London (1931, no. 537b); Binyon, Wilkinson and Gray (1933, pp. 45–6); Gray (1961, pp. 24–6 and 1976); Meredith-Owens (1970, p. 195)

531 Binding of the al-Risāla al-Sayfiyya, by al-Urmāwī
Height 26.5cm, width 18.5cm
Staatsbibliothek Preussischer Kulturbesitz Orientabteilung, Berlin, Or. Quart 2008
Syria (Damascus), Mamluk period, 14th century

This manuscript was completed in 1314 or shortly afterwards. It was copied by a pupil of the author who was living in Damascus and who died there in 1315. The binding is decorated with tooled and stamped designs and gilt. There are double border lines with platting designs. The back and spine have been restored.

Published: Weisweiler (1962, no. 34, fig. 18, pl. 12)

532 Koran
Height 31.1cm, width 23.6cm
Museum of Fine Arts, Boston, no. 29. 58, Helen and Alice Colburn Fund
Persia (Maragheh, Mongol period, 14th century

This Koran was copied by 'Abd Allāh ibn Aḥmad ibn Faḍlallāh ibn 'Abd al-Ḥamīd and is dated 1338. The title page shown here comes from the thirteenth section of the Koran and is elaborately illuminated. The top and bottom fields have stylised lotus flowers on either side of kufic script. The text in the middle is written in naskhi reserved in a background of stylised wave pattern. There is a triangular ansa at the side. Contemporary binding is tooled and partly gilt. 15th century Turkish Korans clearly derive from Korans of this type, especially in the designs of the binding and illumination. See Ettinghausen (1954, p. 465). The Mongol vocabulary of design is still dominant with its use of Far Eastern lotus and peony and the Chinese wave convention as a background pattern. Another section of this Koran is in the Chester Beatty Library, Dublin.

Published: Pope and Ackerman (1938–9, pl. 938b)

533

533 Miniature from Shāhnāma, by Firdawsī

Height 21cm, width 21cm
*Musée d'art et d'histoire, Geneva,
Pozzi Collection, formerly in the
Demotte Collection*
Persia (Tabriz), Ilkhanid period,
14th century

This miniature and no. 534 once
formed part of a manuscript of the
Shāhnāma, the greater part of which
is lost. The sixty known miniatures
from it are scattered among public
and private collections of Europe and
America. They are universally
recognised as marking the final
evolution of the Mongol style under
the Ilkhanids in Persia and as the
most dramatic and moving illustra-
tions to the great epic which exist.
Although some authorities attribute
their production to a period of fifty
years or more, it seems best to
envisage the sustained impetus of
their production as belonging to the
single reign of the last effective
Ilkhanid ruler, Abū Saʿīd (died
1335), at his capital Tabriz. This
miniature depicts an encounter

between Zāl, father of Rustam, and
Bahmān, son of Isfandiyār, prince of
Persia. Zāl is always recognisable
because of his albino colouring. The
composition of the miniature is
unusually symmetrical and the
rendering of perspective by means of
the stepped grassy ridges is skilful.
The colour scheme with the gold
background is brilliant in effect. The
special quality of this manuscript, as
with other pages of this great series,
lies in the pathos of the embrace
between the heroes of different
generations. The artist would have
expected his readers to recall the
subsequent rift between the two
families here represented. The title of
the miniature is inserted in a label
above.

Published: Schulz (1914); Blochet (1928,
no. 4, pl. IV and 1929, pl. XLVI);
Brian (1939, no. 18); Stchoukine (1958,
pp. 83–96); Robinson (1974, no. 2)

534 Miniature from Shāhnāma, by Firdawsī

Height 21.9cm, width 19.6cm
*Worcester Art Museum, no. 1935.24.
Jerome Wheelock Fund, formerly
in the collection of Demotte*
Persia (Tabriz), Ilkanid period,
14th century

See no. 533. This miniature
represents Bahrām Gūr hunting
onagers. The surrounding text
describes his ability to shoot the
onager so that the arrow strikes the
buttocks and passes through the
breast. The miniature, however, does
not agree. Stories of princely or
heroic hunting feats long preceded
the Islamic period in Persia. Bahrām,
the historic Vahrām V (421–39), the
Sasanian monarch who had been
brought up in the hard life of the
north Arabian court, was still
popularly remembered for his
bravery in war and chase.

Published: London (1931, no. 218a);
Binyon, Wilkinson and Gray (1933, no. 29,
p. 47); Brian (1939, pp. 97–112);
Grube (1962a, pp. 13–20, no. 13 and
(1968a, p. 185, no. 12)

534 detail

535

535 Miniature from Kitāb fī Ma'rifat al-Ḥiyal al-Handasiya, Treatise on Automata, by Ismā'īl b. al-Razzāz al-Jazarī

Height 31.2cm, width 17cm
Musée du Louvre, Paris, no. 7875
Egypt (Cairo), Mamluk period,
14th century

This manuscript was copied in 1354 by Muḥammad b. Aḥmad al-Ismīrī at the order of the amir Naṣr al-Dīn Muḥammad b. Tulak al-Ḥarrānī who was in the service of the sultan Salāḥ al-Dīn Ṣāliḥ (ruled 1351–4). At least three of the illustrations from this manuscript have inscriptions in the name of this sultan. This page comes from the manuscript once in Hagia Sophia Mosque Library, Istanbul (no. 3606), now in the Suleyman Library, Istanbul, which contains 246 folios and 14 miniatures. This miniature, like others from the same manuscript, is less instructive concerning the operation of the clocks than those depicted in an earlier manuscript dated 1315 and now dispersed but excels in decorative design and monumental quality. See Atil (1975, pp. 102–1). al-Jazarī wrote his work on automata for Nāṣir al-Dīn Maḥmūd, the Urtuqid ruler of Diyarbakir (died 1222). The different clocks are described in the first section.

Published: Munich (1910, no. 577);
Martin (1912, pl. 4);
Blochet (1923, pp. 210–7); Sakisian (1929, p. 20, pl. 21); Paris (1971, no. 322)

536

536 Koran

Height 73cm, width 50cm
National Library, Cairo, no. 8
Egypt (Cairo), Mamluk period,
mid-14th century

This Koran dated 1356 consists of 413 folios and was presented as a donation by sultan Sha'bān to the madrasa of his mother, Khwānd Baraka, in the Khaṭṭ al-Tabbāna in Cairo in 1368. It was probably commissioned for the mosque of Sulṭān Ḥasan, Cairo. There seem to be at least two hands employed in spite of the colophon which names the copier as Ya'qūb b. Khālid b. Muḥammad b. 'Abdulraḥmān al-Ḥanafī. The double-page frontispiece shown here (folio 2) consists of a central twelve pointed star in gold and blue with white outlines and a little green. The inscriptions are in round ended oblong panels with a ground of rich chinoiserie foliage. These panels are the same on all the illuminated pages but the gold leaf, unlike the 15th century Korans of Barsbay is not impressed.

Published: Bourgoin (1892, pls. 23–4)

537

539

537 Koran
Height 72.8cm, width 52cm
National Library, Cairo, no. 10
Egypt, Mamluk period, 1372

This Koran consists of 217 folios of
fine Mamluk thuluth script. The
colophon (folio 216) gives the date as
1372 and the name of the copier
'Ali b. Muḥammad al-Muktib [sic]
al-Ashrafī. The Koran was given as a
donation by sultan Sha'bān in 1376 to
his *khāngāh*, mosque and madrasa in
the Khaṭṭ Bāb al-Wazīr near the
citadel of Cairo. Compare no. 536
The double-page shown here (folio 3)
is inscribed with Sura I and the
opening verses of Sura II. The
headings are in white kufic on gold
grounds but the script, black with
gold outlines on chinoiserie cloud-
scrolls, is enclosed by borders of
different colours on each of the two
pages.

Published: Cairo (1969, no. 290)

538 Binding of leather
Height 19.5cm, width 12.5cm
*Victoria and Albert Museum, London,
no. 373/1885*
Egypt, Mamluk period,
late 14th century

The outside of this binding is of dark
brown leather, decorated with star-
shaped medallions surrounded by a
border, tooled and partially gilt. The
inside of the cover is coloured ochre
yellow and has a stamped decoration.
This binding may be compared to
one in the Freer Gallery of Art,
Washington, made for the amir
Aytmish al-Bajasī (died 1400) under
the sultan Barqūq at Cairo.
See Ettinghausen (1954, fig. 356,
p. 468) and Atil (1975, no. 40).

Unpublished

539 Koran, first half
Height 50cm, width 35cm
*National Museum, Damascus,
no. 13615*
Syria (Damascus), Mamluk period,
14th century

This Koran was given as a donation
by the Mamluk amir Ibrāhīm ibn
Maḥmud al-Sayfī Manjak. The
double page shown here contains the
verses from Sura I in thuluth inset
within a decorated frame. Above and
below the writing are decorated
fields. In the outer margins of each
page are three ansae.

Published: Damascus (1969, p. 225,
fig. 129)

538

541

541 Kalīla wa Dimna, Fables by Bidpai with Persian translation
Height 24cm, width 16cm
National Library, Cairo, Adab fārsī 61
Persia, Timurid period, 14th century

This manuscript consists of 116 folios; the colophon contains the date 1343–4 but no scribal signature. The manuscript is modestly illustrated with miniatures of which only the last two scenes are full-page. The miniatures appear to be rather later in date than the colophon. Though they show some influences from the contemporary Jalayrid school they are better attributed to the school of Shiraz at about the time of Timur's conquest of that city in 1387–8. Ettinghausen suggests that they date from 'several decades after the colophon' and implies a Turkish connexion for the carpets depicted. However, Duda attributes them to Tabriz in the 1390s. In any case, the miniatures demonstrate an interesting stage in transition to the Timurid style of Shiraz. The miniature displayed here (folio 85) depicts the emperor of India having a learned discussion.

Published: Stchoukine (1935, pp. 140f); Ettinghausen (1959a, pp. 105–8); Duda (1972, pp. 153–220).

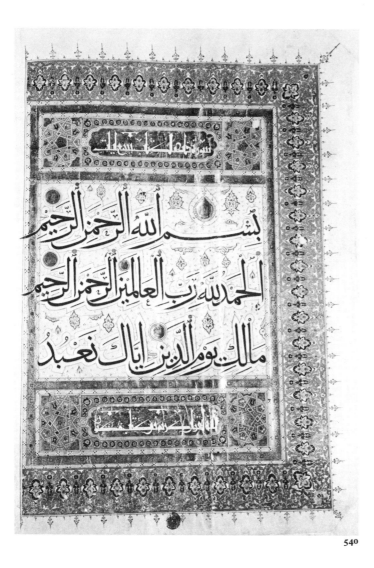

540

540 Koran
Height 99.5cm, width 78cm
National Library, Cairo, no. 17
Egypt, Mamluk period, 1417

The Koran in 232 folios is written in black thuluth, varying considerably in dimensions and execution, mostly hung from impressed lines. Decoration is in pressed gold leaf and varying tones of red, pink, mauve, blue, green, white and black. The double-page frontispiece (folios 2 l–r) shown here consists of square panels filled with polychrome stylised chinoiserie buds arranged in fours with a red central medallion and gold crosses between. Above and below are long panels of highly mannered kufic in gold on a blue ground with polychrome floreated scrolls. On the upper margin of folio 2l is a short record of a donation in a later hand stating that this Koran was given to the mosque-madrasa of al-Mu'ayyad Shaykh at the Bab. Zuwayla in Cairo in 1419. There is no marginal ornament but the crenellated border is particularly sumptuous. The final page bears the scribe's signature Mūsā b. Ismā'īl al-Kinānī al-Ḥanafī al-shahīr [known as] bi'l-Hijjīnī and dated 1417.

Published: Cairo (1969, no. 292)

542

542 'Ajā'ib al-Makhlūqāt, 'The Wonders of Creation', by an unknown author

Height 31cm, width 22cm
Bibliothèque Nationale, Paris,
Cabinet des Manuscrits, Sup. Pers. 332
Baghdad, Jalayrid period,
14th century

This manuscript consists of 248
folios with 95 miniatures and an
illuminated frontispiece. It was
copied by Aḥmad al-Harawī for the
library of the Jalayrid Sultan Aḥmad
Khān ibn Uways and was completed
in 1388. This anonymous work
follows in part the tradition of
Mamluk illustration of Qazwīnī but
also conforms to the new style which
was being evolved under the Jalayr
rulers at their capitals in Tabriz and
Baghdad. Stchoukine has suggested
that most of the miniatures of this
manuscript were added later but this
seems an unnecessary complication
for a work produced in a transitional
period when divergencies of style
between different artists might be
expected. This miniature (folio 160b)
depicts the harvesting of pepper.

Published: Blochet (1926, p. 79); Massé
(1944); Stchoukine (1954, pp. 32–3);
Paris (1973; no. 237, p. 91)

543

543 Kalīla wa Dimna, Fables by Bidpai, Persian translation of Naṣrullah b. Muḥammad b. 'Abdulḥamīd

Height 23.5cm, width 17cm
Bibliothèque Nationale, Paris,
Cabinet des Manuscrits, Sup.
Pers. 913
Baghdad, Jalayrid period,
14th century

This manuscript consists of 217
folios with 74 miniatures. The
colophon states that it was copied by
Ḥāfiẓ Ibrāhīm and completed in
1392. It is bound in a Persian
embossed and gilt leather binding
and was once in the library of Shah
Wallād, the son of Aḥmad Jalayr.
Without a doubt, this manuscript is
a product of the school promoted by
the leading art patron of the day,
sultan Aḥmad Jalayr (ruled 1382–
1410). As with the illustration for a
Khamsa of Niẓāmī now in the British
Library, London (Or. 13297),
produced in 1386–8, the miniatures
in this manuscript are, for the most
part, somewhat pedestrian. However,
they occasionally display a vitality
and sensibility. This miniature
(folio 54b) shows fishing at night.

Published: Stchoukine (1954, p. 33,
no. V, pls. 2–3); Walzer (1969, p. 72);
Paris (1973, no. 236)

545

544 Mathnawī poems by Khwājū Kirmānī

Height 32cm, width 24cm
British Library, London, Add. 18113
Baghdad, Jalayrid period,
14th century

The three poems in this manuscript were copied for the last Jalayrid ruler, Aḥmad Jalayr, by the famous calligrapher Mīr 'Alī ibn Ilyās Ṭabrīzī at Baghdad in 1396 and illustrated by Junayd al-Sulṭānī. An inscription on folio 45 gives the name of this artist and it is likely that he was responsible for the nine miniatures in this manuscript. The calligrapher is remembered as being the inventor of the nastaliq script. This manuscript is a landmark in the history of Persian painting as the

earliest major example of the classic style of the 15th century. Illuminations within the text, whether of headings or of frontispieces, are of arabesque designs and are of superb quality. The compositions take up the entire page with a few lines of poetry enclosed in a frame which is set within the miniature. The miniature shown here (folio 40) depicts Humāy, son of Shah Hūshang, and Humāyūn, the Chinese princess, being entertained with wine and music in a garden. It is a fine example of the romantic and delicate art of Persian miniature painting which evolved at this time. Chinese elements are still strongly visible in the features of the faces and in the ceramic flasks on the table. The landscape, however, is purely Persian in spirit.

Published: Martin (1912, II, 45–50); Barrett (1952, pls. 8–9); Stchoukine (1954, pls. IV–VIII); Gray (1961, pp. 46–7 and 1940, pl. 4); Meredith-Owens (1973, pl. I)

545 Kitāb al-Bulhān, Astrological Work, by Abū Ma'shar al Balkhī

Height 24.1cm, width 16.5cm
Bodleian Library, Oxford, MS. Bodl. Or. 133
Baghdad, Jalayrid period,
end of 14th century

This manuscript consists of 176 folios with 83 miniatures and a modern European binding. It was copied for Ḥusayn of Irbil in 1399 and the illustrations were painted during the reign of the last ruler of the Jalayrid dynasty, Aḥmad ibn Uways (ruled 1382–1410), renowned as a patron of the arts. In the miniatures illustrating the original section of this composite work, conflicting artistic traditions may be seen at work. The international Islamic tradition of scientific illustration is modified here by the artistic sophistication of the Jalayrid court. Rice believed that Italian influences might here be detected, not unlikely in cosmopolitan Tabriz, but the Western influence is more likely to be Byzantine. 128 of the folios belong to the first period of 1399 and include 78 miniatures, eleven of which are of the Seasons. This miniature (folio 38b) is entitled *al qawl 'alā faṣl al-rabī'*, 'speaking of the season of Spring'. Beneath the chapter heading is a figure sitting beneath a tree playing an instrument surrounded by trees, flowers and birds.

Published: London (1931, no. 534a, and 1951, no. 7); Binyon, Wilkinson and Gray (1933, no. 13, p. 26); Rice (1954b, pp. 3–7); Robinson and Gray (1972, no. 3)

544

546

546 Page from the 'Ajā'ib al-Makhlūqāt, 'The Wonders of Creation', by al-Qazwīnī

Height 29.2cm, width 19cm
Ashmolean Museum, Oxford, Gerald Reitlinger Collection, no. Ash. 25
Syria, Mamluk period,
early 15th century

This miniature represents the constellations Centaurus and Corvus. It may be compared to another in which these two constellations are depicted (Centaurus in the reverse direction) in the Freer Gallery of Art, Washington. See Atil (1975, p. 121, no. 60). That miniature is now assigned to late 14th century Mesopotamia. Ettinghausen (1962, pp. 178–9) suggests a more precise date, 1370–80. This miniature would appear to be slightly later in date. It combines the heraldic quality of design with a refinement of colouring.

Unpublished

547 Binding of Al-Nahr al-Madd min al-Baḥr, 'The River flowing in from the sea', volume 1, by Abū Hayyān

Height 25cm, width 16cm
Staatsbibliothek Preussischer Kulturbesitz Orientabteilung, Berlin, Or. Quart. 2012
Egypt (Cairo), Mamluk period,
15th century

This manuscript is in two volumes. Its colophon states that it was copied in 1400 and it bears a Cairo ownership mark of 1421. The leather covers are decorated with stamped octagons filled with rosettes and gilt. The back spine and edges are new.

Published: Weisweiler (1962, no. 35, fig. 16, pl. 11)

548 Detached leaf from a Diwān by Salmān Sawājī

Height 17cm, width 10cm
Musée d'art et d'histoire, Geneva, Pozzi Collection
Persia (Shiraz), Timurid period,
15th century

This is an important addition to the small group of chinoiserie drawings which can be definitely associated with the workshop of the first Timurid patron of book arts, Iskandar b. 'Umar Shaykh, grandson of Timur. It does not seem likely that this was established before 1409 when he was 22 years old and entering on his second governorship of Shiraz, the first having been nominal only, from the age of seven to twelve. He would have been able to recruit trained artists from the school of Sulṭān Aḥmad at Tabriz after his

death in 1410, just as his cousin Baysunghur was to do in 1420, six years after Iskandar's own death in 1414. It is possible that he might have started his patronage while governor of Yazd from 1405 to 1407, see Stchoukine (1966 p. 99) which would permit of his having commissioned the manuscript dated 1407 now in the Topkapi Palace Museum, Istanbul (Hazine 796). This drawing is on tinted paper and shows a landscape with trees, flowers, animals and birds against a high horizon and a gold sky. On the verso of the leaf is an illuminated heading announcing the beginning of the *ghazaliyyat*.

Published: Robinson (1974, no. 6)

548

549

549 Binding of Ẓafarnāma by Hamdullah Mustawfī
Height 33cm, width 25cm
British Library, London, Or. 2833
Persia (Shiraz), Timurid period,
1405

This chronicle was composed in verse as a sequel to the *Shāhnāma* by Firdawsī which is included in the margins. This copy by Maḥmūd al-Ḥuṣaynī is dated 1405 in Shiraz and consists of 780 folios bound in strong covers of leather on pasteboard. The dark red doublures are plain apart from the gold roll-tooled borders which also decorate the black leather outer covers and flap. These also bear blind-stamped medallions, pendants and spandrels outlined in gold and decorated with an arabesque design. It is reasonable to accept this binding as contemporary with the copying of the manuscript and it may be compared to a binding in the Topkapi Palace Museum, Istanbul (no. H. 976), which is dated 1407 from Yazd, and has filigree work on the inside of the covers, similar to nos. 559 and 564, both of which are Herat manuscripts. These bindings are among the earliest to show the use of moulded designs which were to develop during the second half of the 15th century into pictorial designs.

Published: Rieu (1894, pp. 172–4)

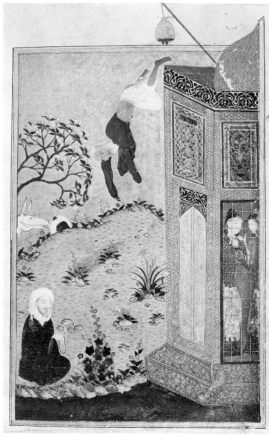

550

550 Miscellany
Height 19cm, width 13cm
British Library, London, Add. 27261
Persia (Shiraz), Timurid period,
1410–1

This 'pocket encyclopaedia' contains poems in addition to works on religious law, astronomy, astrology and geometry. It is written in naskhi and nastaliq in the margins as well as in the centre of the pages by two scribes, Muḥammad al-Ḥalwā'ī al-Jalālī al-Iskandarī and Nāṣir al-Kātib ('the scribe'). It was copied for Iskandar b. 'Umar Shaykh, a grandson of Timur at Shiraz in 1410–1 and contains 21 full page miniatures as well as 17 folios of small drawings and some marginal paintings. There are finely illuminated title pages, frontispieces, headings and 'thumb-pieces'. Iskandar b. 'Umar Shaykh was one of the most noted patrons of the arts of the book. He ruled over Fars in the south of Persia with his capital at

Shiraz until his deposition and death in 1414. Artists who had formerly worked for Sultan Aḥmad in Tabriz and Baghdad (see nos. 542–4) moved to the Shiraz academy after the fall of the Jalayrids and produced manuscripts there noted for the small size and exquisite workmanship. The compositions in this manuscript provided models for artists throughout the 15th century. The first 14 miniatures illustrate the *Khamsa* of Niẓāmī and others illustrate incidents from the *Shāhnāma* and *Humāy wa Humāyūn*. This double page scene (folio 305v) accompanies a poem in praise of 'Alī and depicts the miracle in which he saved a Christian monk who had flung himself from the roof of a monastery.

Published: Rieu (1881, II, pp. 868–71);
Stchoukine (1954, p. 41, pls. 16–20);
Pinder-Wilson (1958a, pls. 1–2);
Gray (1961, pp. 69–73)

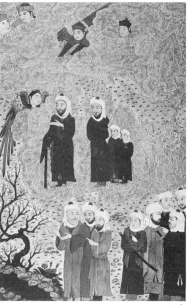

552

551 a-c Two miniatures and a page of illumination from an anthology of 36 different works in verse and prose
Height 27.4cm, width 17.2cm
Fundação Calouste Gulbenkian Lisbon, L.A. 161, formerly in the Yates Thompson and E. Rothschild Collections
Persia (Shiraz), Timurid period, early 15th century

This Anthology was copied by Maḥmūd al-Ḥusaynī and Ḥasan al-Ḥāfiẓ in Shiraz for Iskandar b. 'Umar Shaykh, in 1410–1. It consists of 440 folios, divided into two volumes, with 34 miniatures and two double-page compositions. The binding is of leather. A rare feature which it shares with nos. 550 and 552 is the triangular decorative thumb piece. This manuscript is a masterpiece of the period and was, without doubt, produced under the personal supervision of the prince Iskandar. There is a lavish use of gold and lapis lazuli and much attention was given to the writing and decoration in light colours of each

page of the text. Miniature a (folio 86) depicts a battle scene between the armies of Alexander the Great and Darius, with the imprisonment of the latter. It is the more traditional of the two miniatures with its chain of mounted knights appearing on the horizon in a cleft of hills. Miniature b (folios 264b–5a) is without close rival in Persian painting, both for its Shi'a spirit and for the extraordinary drama of the inferno on the left-hand page in which the hot flames contrast with the light gold of the heavenly refulgence surrounding the imams standing opposite. Here, eight imams appear on the day of judgement with the prophet Muḥammad, 'Alī, Ḥasan and Ḥusayn to look down from paradise with the kings and queens on earth. c (folio 129) is an illuminated page with drawings of birds, deer and a dragon amid foliage.

Published: Martin (1926, pl. XIX); Pope and Ackerman (1938–9, pl. 860); Gray (1961, pp. 69–72, pls. 74–7, 79); Lisbon (1963, no. 117); Ettinghausen (1972, pl. 15)

552 Anthology
Height 28cm, width 19.5cm
Fundação Calouste Gulbenkian, Lisbon, L.A. 158
Persia (Shiraz), Timurid period, early 15th century

This anthology includes *Mantiq al-Ṭayr, 'Language of the Birds'* by 'Aṭṭār *Iqbālnāma, 'The Book of (Alexander's) Fortune'* by Niẓāmī and *Rawḍat al-Anwār, 'The Garden of Lights'*, by Khwājū Kirmānī. It was copied by Ḥasan al-Ḥāfiẓ for Iskandar b. 'Umar Shaykh in 1412–3 probably in Shiraz. The three sections each have an illuminated dedication and an illuminated title page. There are triangular thumb-pieces, a feature it shares with no. 550. This manuscript contains no miniatures but illustrates the wonderful quality of illumination achieved by the school of Iskandar (see also nos. 549–50). The calligrapher is the same Ḥasan al-Ḥāfiẓ and, no doubt, the illuminators are also the same. But here there are no exercises in chinoiseries such as in nos. 548, 550 and 551. At this time, Shiraz was pre-eminent in these arts and a special feature developed at this period was the combination of naturalistic flowers with an almost architectural lay-out to provide a firm structure. This double illuminated title page is written in naskhi and is surrounded by decorated panels with scroll-like motifs. The outer border has ansae.

Published: Lisbon (1963, no. 118)

553 Mathnavī-ye Mathnavī, 'The Rhyme of Rhymes'
Height 20.8cm, width 13.7cm
Fundação Calouste Gulbenkian, Lisbon, L.A. 168
Persia (Shiraz), Timurid period, 15th century

The titles of many Arabic and Persian books, as here, are not intended to give any clear idea of the contents. This manuscript, with illuminated rosette and double frontispiece, was copied for Ibrāhīm b. Shāhrukh b. Timur in 1419, the ruler who succeeded Iskandar in power and patronage at Shiraz in 1414. This double-page frontispiece contains the opening of a poem enclosed in panels with scroll-like designs. It is surrounded in the margins by a text written diagonally. The free floral decoration is still prominent here but the framing is more complex and relates rather to carpet design than architecture.

Published: Lisbon (1963, no. 119)

554 Koran
Height 81.7cm, width 61.7cm
Imam Riza Shrine Library, Mashhad, no. 414
Persia (Shiraz), Timurid period, 15th century

This Koran was written in thuluth by Ibrāhīm Sultān b. Shāhrukh b. Timur in 1424. It was bound in 1886. Only a fragment of 16 folios now survives. Ibrāhīm Sultān, like his brother Baysunghur, was a highly trained and skilled calligrapher. He is said to have been a pupil of Mīr Muḥammad Shīrāzī. See Qadi-Ahmad (1959, p. 69,

553

554

footnote 196). He designed monumental inscriptions for public buildings in Shiraz of which he was governor, and copied a Koran of great size, two cubits high and one and a half cubits wide. During the lifetime of his cousin Iskandar Sultān b. 'Umar Shaykh (died 1414), Ibrāhīm was governor of Isfahan. He then took over Shiraz and lived there until his death in 1434. These first two pages of the Koran contain the *fātiḥa* with illuminated headings in kufic on floral scroll ground. The text is on a grisaille ornamented background of lotus flowers.

Published: Pope and Ackerman (1938–9, pl. 940A); Bahrami (1949, no. 62); Ma'ani (1966, no. 61)

555 a-b Two miniatures from an Anthology
Height 24cm, width 15.7cm
Staatliche Museen zu Berlin, Islamisches Museum, no. 1.4628
Persia (Shiraz), Timurid period, 15th century

This Anthology with 29 miniatures bears a dedication to prince Baysunghur in an illuminated rosette on folio Iv. It is signed by the well-known calligrapher Maḥmūd al-Ḥusaynī of Shiraz in 1420, one of the two scribes who copied no. 551 for Iskandar. Still earlier, he copied no. 549. Since he used the new nastaliq script, he must certainly have been a pupil of Mīr 'Alī of Tabriz (see no. 544). Although Baysunghur was settled at Herat at this time, this is a Shiraz manuscript with miniatures in a more traditional Shiraz style than nos. 550–1, harking back to the end of the 14th century in

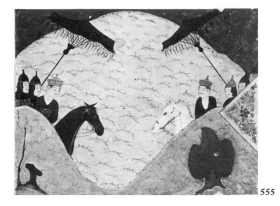

555

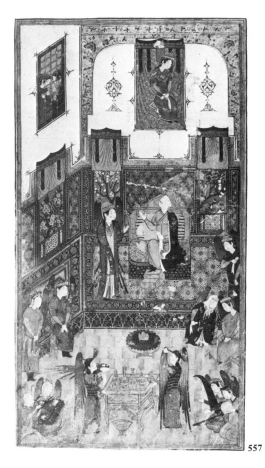

557

its simplified landscape and flat
architectural planes. Miniature a
(folio 91b) shows Iskandar meeting
the emperor of China. In miniature
b (folio 64b) Humāy sees for the first
time Humāyūn at the window. The
use of coulisses to conceal much of the
opposing armies of miniature a recalls
epic poems of 1397, British Library,
London (Or. 2780).

Published: Kühnel (1931, pl. 133);
Pope and Ackerman (1938–9, p. 1847,
pls. 862a, 864b); Stchoukine (1954, p. 42);
Gray (1961, p. 95); Enderlein (1969)

556 Khursraw and Shīrīn
by Niẓāmī

Height 23.4cm, width 18.3cm
*Academy of Sciences, Oriental
Institute, Leningrad, no. B 132*
Khurasan (Herat), Timurid period,
15th century

This manuscript with illuminated
dedication and frontispiece was
copied by ʻAlī Jaʻfar, in 1421. The
most celebrated calligrapher of his
time, ʻAlī Jaʻfar was a pupil of Mīr
ʻAlī Tabrīzī (see no. 544) and was
brought from Tabriz by the young
prince Baysunghur to Herat where he
lived under the protection of his
father Shāhrukh who made him
wazir in order to keep him at his side.
In Herat he formed his scriptorium
with Jaʻfar at the head to which he
recruited an outstanding team of
illuminators, miniaturists and
binders. Among the other surviving
work of Jaʻfar is a *Niẓāmī* of 1420 in
the British Library, London (or.
12087), a *Bustān* of Saʻdī of 1426 in the
Chester Beatty Library, Dublin, the
famous *Shāhnāma* of 1430 in the

Gulistan Palace Library, Tehran and
the *Kalīla wa Dimna* of 1431 in the
Topkapi Palace Library, Istanbul
(no. H. 362). All these books excel in
their illumination. Here is displayed
the illuminated frontispiece.

Published: Samarkand (1969, no. 53)

557 Humāy wa Humāyūn by
Khwājū Kirmānī

Height 25.7cm, width 15.6cm
*Österreichische Nationalbibliothek,
Vienna, cod. NF 382*
Khurasan (Herat), Timurid period,
15th century

This manuscript was copied at Herat
by Muḥammad b. Husāyn, called
Shams al-Dīn Baysunghurī, for
Baysunghur in 1427–8. The three
miniatures which illustrate this
romantic poem are all more or less

severely damaged. This one,
depicting prince Humay in the
palace of the fairies and beholding
for the first time the portrait of
princess Humāyūn, daughter of the
emperor of China, is the best
preserved. As compared with the two
manuscripts copied for Baysunghur
in 1426–7 the *Bustān* in the Chester
Beatty Library, Dublin, and the
Anthology in the Berenson Collection,
Italy, they are somewhat old-
fashioned in style but of a quality
worthy of the Baysunghur
scriptorium in which this copyist was
in the front rank. Wellesz has shown
that the composition was derived
from the Shiraz manuscript (no. 551)
made for Iskandar, thus indicating
the relation between the workshops
of these two Timurid princely
patrons.

Published: Flügel (1865, p. 544, pl. 561);
Wellesz (1936)

558

558 Two pages from a Koran

Height 177cm, width 101cm
*Imam Riza Shrine Library, Mashhad,
no. 89*
Persia, Timurid period, 15th century

These two pages come from eight
preserved in the Mashhad Shrine
Library; there are also other pages
in the Malik Library and in the Iran-e
Bastan Museum, Tehran. This
Koran was copied by Baysunghur
Mirzā, a skilled calligrapher as well as
being the greatest patron of his time,
especially for the arts of the book. He
lived in Herat where he was vizier to
his father Shāhrukh and died there in
1433 at the age of thirty-eight worn
out by an excess of wine. He designed
two monumental inscriptions for the
Gawharshād mosque and madrasa at
Mashhad founded by his mother, but
these have not survived. The few
remaining pages from this giant
Koran were discovered not many
years ago in a village near Mashhad.
These pages are written in naskhi
script.

Published: Ma'ani (1966, no. 59)

559 Binding of 'History of Isfahan', copied by Ja'far al-Baysunghurī

Height 23cm, width 14cm
*British Library, London, Or. 2773,
from the Gobineau Collection*
Khurasan (Herat), Timurid period,
1431

The outsides of the covers of this
binding are decorated with gold roll-
tooled frames and have central gold
and brown oval medallions and
pendants which are stamped with a

floral design. The flap has similar
gold frames with a central round
medallion. The doublure is
decorated with an oval sunk
medallion and pendants outlined
with gold tooling. The medallions
and pendants are inlaid with a design
of red-brown leather filigree
arabesque tendrils on a blue
background. This binding may be
compared with others which may be
confidently attributed to the library
workshop of Baysunghur (see no.
556) such as those which enclose
two copies of the *Kalīla wa Dimna*
dated 1429 and 1430 in the Tokapi
Palace Museum Library, Istanbul
(Revan 1022 and Hazine 362).

Unpublished

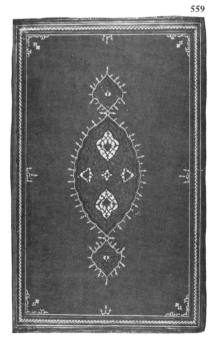

559

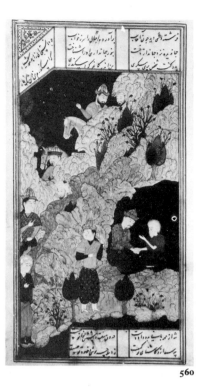

560

560 Khamsa, Five Poems, of Nizāmi

Height 29cm, width 17.5cm
*State Hermitage Museum, Leningrad,
no. VP 1000*
Khurasan (Herat), Timurid period,
15th century

This manuscript consists of 502
folios with 38 miniatures and was
copied by Maḥmūd for the library of
Shāhrukh in 1431. Shāhrukh
managed to retail control over most
of the Persian part of Timur's empire
from his capital at Herat. Like so
many princes of his family he was a
patron of scholars with an important
scriptorium. He was able to
re-establish the text of the *Jāmi'
al-Tawārīkh* of Rashīd al-Dīn (see
no. 530) whose works had been
scattered and also commissioned a
continuation of this history from
Ḥāfiz-e Abrū. Most of the works
surviving from his scriptorium are
historical. This miniature (folio 393a)
depicts Iskandar visiting a hermit in
the mountains.

Published: Denike (1923); Akimushkin
and Ivanov (1968, pl. 3); Samarkand
(1969, no. 10)

561 Anthology written in Persian and Uighur
Height 36cm, width 27cm
British Library, London, Or. 8193,
presented in 1918 by R. S. Greenshields,
formerly in the possession of the Hon.
A. Seton
Persia (Yazd), Timurid period, 1431

This manuscript was produced in
Yazd, an important centre of
manuscript illumination in the
15th century, and was commissioned
by Jalāl al-Dīn Fīrūz Shāh (1407–44),
a minister of Shāhrukh and a
principal protector of Turkish
cultural interests. See Hofman (1969,
pp. 118–21). Manṣūr Bakhshī, who
copied the anthology in 1431, was
himself a poet and part of this
manuscript was also composed by
him. Uighur was abandoned by the
Turks when converted to Islam in
favour of the Arabic script but was
revived and used again during the
13th to 15th centuries. The design of
this illumination (folios 14b–15a)
includes heads of wolves, dragons
and birds as well as those of men. The
triangles on each of the three sides are
decorated with scrollwork. The
outline of the designs seems to be
carried out with the aid of stencils and
colour stippled on in light shades but
including gold and silver. This
technique seems to have been a
speciality of east Persian work in the
mid-15th century. Other examples are
in the Chester Beatty Library,
Dublin (nos. P122 and P127, dated
1432 and 1440).

Published: Clauson (1928, pp. 99–130);
Esin (1972, II, pp. 53–73, pls. VIB,
VIIIB)

561

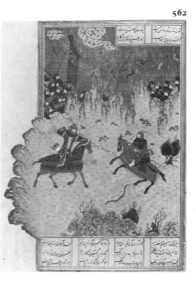

562

562 Shāhnāma, by Firdawsī
Height 33.5cm, width 22cm
Royal Asiatic Society, London,
no. P. 239
Khurasan (Herat), Timurid period,
about 1440.

This manuscript bears the seals of the
Mughal emperors from Bābur to
Aurangzeb and an autograph note by
Shāh Jahān. There are 31 miniatures
in the manuscript and this one (folio
296) depicts the shooting of
Isfandiyār by the rival hero Rustam.
The painting overlaps the edge and in
the top left hand corner are followers
carrying a banner on which is
written *al-Sulṭān al-A'zam*, [the most
mighty sultan] *Muḥammad Jūkī*.
Muḥammad Jūkī was a son of
Shāhrukh and died in 1445.
Compared with the work of the Herat
school in the lifetime of Baysunghur,
the miniatures in this manuscript give
a greater importance to landscape and
heighten the romantic feeling. In this
miniature the many small mountain
peaks, which conceal the greater
part of the two armies awaiting the
result of the duel, recall the use of the
same compositional device in Shiraz
miniatures some forty years earlier.
Both Robinson and Wilkinson have
detected the influence of Shiraz of the
period of Ibrāhīm. Here in Herat,
however, there is a more brilliant
colour employed and, above all, a
more imaginative vision as witness
the other miniatures from this
manuscript.

Published: Morley (1854, no. 18);
Binyon and Wilkinson (1931, pl. 18);
Binyon, Wilkinson and Gray (1933,
no. 67, p. 93); Robinson (1951, pp. 17–23);
Stchoukine (1954, no. XXXVIII,
pp. 55–6)

563 Kalīla wa Dimna by Abū al-Ma'ālī Naṣrullāh
Height 31cm, width 23cm
Library of Sipah-Salar Madrasa, Tehran, no. 1340
Persia, Turkman period,
15th century

The manuscript of this Persian translation is dated to 1447. It consists of 271 folios copied in nastaliq script by Sharaf al-Dīn Ḥusayn Sulṭānī with 21 miniatures, finely illuminated headings and sarlauh with thuluth inscriptions in gold. The calligrapher may be the same as the copyist of no. 570 who is from Shirvan.

Published: Artola (1957, p. 8, no. 10)

564 Binding of Shāhnāma of Firdawsī
Height 35.5cm, width 25.5cm
Bodleian Library, Oxford, MS. Pers. C.4
Khurasan (Herat), Timurid period,
15th century

After the death of Shāhrukh in 1447, Herat remained in the hands of the Timurid family although its possession was disputed among several of the princes. This binding encloses a manuscript copied in 1448 by 'Abd Allāh b. Sha'bān b. Ḥaydar al-Ashtarjānī which may have been left unfinished at that time. The outside of the binding is black and contains a central medallion tooled with designs of animals with quarter medallions in the four corners. The interior and flap are maroon and decorated with medallions of filigree work on a blue and gilt background.

Published: London (1931, no. 538c); Binyon, Wilkinson and Gray (1933, no. 65, p. 74); Robinson (1958a, no. 675); Robinson and Gray (1972, no. 27, p. 14)

565 Binding from Kitab Tāj al-Ma'āthir fī al Ta'rīkh, 'The Crown of Exploits in History', by Ḥasan Niẓamī
Height 28.2cm, width 19.5cm
Österreichische Nationalbibliothek, Vienna, no. A.F. 70, acquired in Cairo in 1749
Turkey, Ottoman period,
15th century

This manuscript is from the library of Sultan Bayezid II (ruled 1481–1512). This binding is in leather with the decoration partly blind and partly gilt. The border is an intertwined geometrical pattern. In the centre is a fine medallion formed of a central blind decorated area and surrounded by a tooled and gilt decoration. Although twice attributed to Samarkand, whether before or after 1455, this binding is not in the Herat style. The Mamluk influence is very strong, thus suggesting that it is more probably a Turkish than a Persian binding. The inner covers are similarly decorated.

Published: Flügel (1865, no. 951); Gottlieb (1910, no. 30)

564

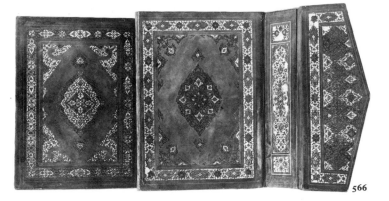

566

566 Binding of leather

Height 35.8cm, width 81.6cm
*Cleveland Museum of Art, no. 44.495,
purchase from the J. H. Wade fund*
Khurasan (Herat), Timurid period,
about 1440

This binding is of reddish-brown
hand tooled leather, gilt and painted
blue and green. It is decorated with a
central medallion on each side of the
cover. These medallions are
decorated with scroll-like designs as
are the borders, corners and the flap.
The finest example of this type of
binding encloses a manuscript of the
poems of Farīd al-Dīn 'Aṭṭār copied
in Herat in 1438 and now in the
Topkapi Palace Museum Library,
Istanbul (A III 3059). See
Sourdel-Thomine and Spuler
(1973, pl. LIV).

Published: Munich (1910, I, no. 631);
Cleveland (1944, no. 40); Paris (1961,
no. 1087, p. 194)

567 Binding of leather

Height 18.8cm, width 11cm
*Staatsbibliothek Preussischer
Kulturbesitz Orientabteilung,
Berlin, Or. Oct. 3285*
Turkey (Karaman), Ottoman period,
15th century

This binding contains a collection of
Persian mystical poems which has a
colophon dated 1430. The binding
was probably made for the manu-
script and is decorated with hand
tooled scroll-like vegetal motifs and
highly stylised and symmetrical
stamped floral motifs in panels above
and below. The back edges and spine
have been renewed.

Published: Gratzl (1928, pls. VIII–IX);
Weisweiler (1962, no. 53, fig. 22, pl. 15)

568 Kalīla wa Dimna translated into Persian by Naṣrullāh Abū al-Ma'ālī

Height 29cm, width 20cm
Imperial Library, Tehran
Persia (Tabriz), Turkman period,
about 1460

This manuscript consists of a double
frontispiece and 30 miniatures and is
illuminated with title headings. No
date is given. Ever since its first
disclosure to the world in 1931 this
manuscript has been saluted for the
beauty of its miniatures and
especially for the sensitivity of its
animal drawings. Recognised as a
15th century manuscript in the
Herat tradition, Robinson has
convincingly shown its true date to
be about 1460. It now falls into place
as one of the masterpieces of the
library of the 'Black Sheep' Turkman
Jahān Shāh (died 1467) established in
Tabriz. It shows the survival and
even development of the Herat
school of the first half of the century.
This miniature depicts the four
friends; the crow, the mouse, the
tortoise and the deer.

Published: London (1931, no. 541b);
Binyon, Wilkinson and Gray (1933,
no. 44, p. 65); Pope and Ackerman
(1938–9, pls. 865–8); Bahrami (1949a,
no. 61, p. 26); Gray and Godard (1956,
pls. X–XV); Robinson (1958b, pp. 3–10)

565

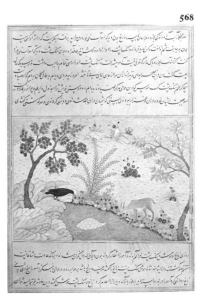

568

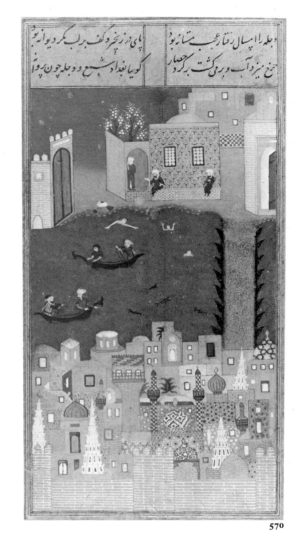

570

569 Miniature from an unidentified manuscript of Niẓāmī

Height 17cm, width 11cm
Musée d'art et d'histoire, Geneva, formerly in the Pozzi Collection
Persia (?Tabriz), Turkman period, 15th century

This miniature depicts Iskandar and the seven sages and is unsigned. It probably comes from an *Iskandarnāma, Book of Alexander*, copied between 1455–65 under Turkman rule. It may be compared to an illustration of the same subject in the Staatsbibliothek, West Berlin, which is dated 1450–6 at Herat. See Stchoukine (1973, pl. 3). This miniature might well be a Turkman version painted at Tabriz about ten years later under the Qara-Qoyunlu Jahān Shāh (died 1467) or his con Pīr Budāq (died 1465). Robinson attributes this miniature to Shiraz, 1475–85.

Published: Robinson (1974, no. 15)

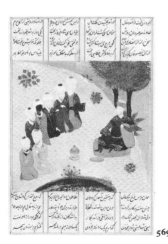

569

570 Anthology

Height 23cm, width 13cm
British Library, London, Add. 16561
Persia (Shirvan), Turkman period, 15th century

This *Anthology* was copied by Sharaf al-Dīn Ḥusayn al-Sulṭānī ('the royal scribe') at Shirwan in 1468. The works included poems by Ḥafiẓ, Amīr Khusraw, Kātibī, Bisāṭī, Jāmi' and Tūsī and this illustration (folio 60r) accompanies a poem by Naṣir Bukhārā'ī (died about 1370) and represents the Tigris in flood at Baghdad. Other poems are also illustrated and there are seven single miniatures and one double-page painting in all. The text is written in nastaliq on tinted glazed and gold-sprinkled paper with an illuminated frontispiece. No mention is made in the colophon of the patron of this manuscript, but he may have been the Shirwānshāh, Farrukh Yasār (1462–1501), an independent ruler but subservient to the Aq-Qoyunlu. The manuscript which is of fine quality is one of the few northern provincial Persian works of which the place and date of execution is known. Shirwan on the west coast of the Caspian Sea was under Turkman hegemony and the early stage of the Turkam style is evident in the large turbans, round heads and short figures which appear in these miniatures.

Published: Rieu (1881, II, pp. 734–5); Robinson (1967b, no. 109); Stchoukine 1954, p. 61, no. L)

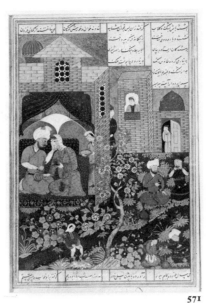

571

573

571 Miniature from the Shāhnāma of Firdawsī
Height 34cm, width 23.5cm
*Museum of Fine Arts, Boston,
no. 60.634, gift of John Goelet*
Persia (Tabriz), Turkman period,
about 1480

This is a page from a manuscript
formerly in the Bektashi Teke,
Istanbul, and now in the Turkish
and Islamic Museum, Istanbul.

Published: Martin (1912, pls. 65–6);
Sotheby (31st July 1971, lots 307–12)

572 Khamsa, 'Five Poems', by Amīr Khusraw
Height 26.5cm, width 16cm
*Library of Sipah-Salar Madrasa,
Tehran, no. 461*
Persia (Tabriz), Turkman period,
15th century

This manuscript with 445 folios was
finished in 1480–1 for Ūzūn Ḥasan
Aq-Qoyunlu, the Turkman ruler,
who, however, died in 1478 before its
completion. It may have been
finished for his son Ya'qūb (died
1491), presumably in Tabriz. The
manuscript has a finely illuminated
frontispiece shown here and one
miniature added for 'Abd al-'Azīz,
the Shaybanid ruler of Bukhara
(1540–9).

Unpublished

573 Anthology of Persian poetry
Height 20.8cm, width 8cm
British Library, London, Or. 13193
Persia, Turkman period, about
1470–80

This anthology is in the tradition of
the exquisite small manuscripts which
were produced in Shiraz during the
15th century. It contains verses by
twenty Persian poets, most of whom
lived in the 15th century. The small
nastaliq script is sometimes written in
gold and each folio has decorations and
gold or ornamented borders as well as
figures of angels, men, dragons or
birds. The polished paper is tinted
pink, black or blue on some folios
while others are of marbled paper in
the Turkman style as well as finely
illuminated headings in colours and
gold with titles on four of them in
florcated kufic script. There are two
inscriptions written in gold letters on
a silver ground (folios 8r and 33r)
dedicated to Abū al-'Izz Yamin
al-Dīn Yūsuf (died 1490), one of the
five sons of Ūzūn Ḥasan the ruler of
Persia of the Aq Qoyunlu (White
Sheep) confederation of Turkman
tribes. The manuscript has a red
leather binding decorated with gold
tooling. The pages shown here
(folios 140v, 141r) are decorated
with angels and two seated men,
one holding a mace and the other
playing a lute.

Published: Meredith-Owens (1969–70,
pp. 122–5)

574 a-b Two miniatures from Khawarnāma, 'The Adventures of 'Alī b. Abī Ṭālib', by Ibn Husām
Height 40cm, width 27.7cm
Museum of Decorative Arts, Tehran, nos. 436/437 and 438/439
Persia (Shiraz), Turkman period, 15th century

This manuscript consists of 645 folios, originally 685, with 155 miniatures of which 115 still remain in the manuscript. The remainder are are to be found in collections all over the world. The colophon states that the manuscript was copied in 1450 which makes it the earliest known copy of the work, contemporary with the life of the poet, but illustrated later. On some of the miniatures are found the signature Farhad and the dates 1476–86. There is a committed, passionate quality about this unique illustration of the Shi'a work which suggests that it drew upon popular traditions as its source of inspiration. Although the style of the miniature is characteristic of the school of Shiraz, the principal figures are more expressive and there is a folk-like disregard for the ordinary conventions of scale and perspective Miniature a represents 'Alī looking over the hill towards mounted horsemen on board a ship arriving ashore. Miniature b depicts 'Alī taking a meal on a carpet out of doors.

Published: Gray (1961, pp. 104–7); Robinson (1965, pl. 83 and 1967, no. 125)

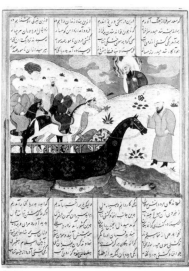

574a

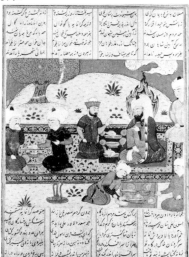

574b

575 Binding of Thubūt al-Ḥujja, 'The Certainty of Reason', by Abū Bakr al-Ḥamawī
Height 17.6cm, width 14cm
Staatsbibliothek Preussischer Kulturbesitz Orientabteilung, Berlin, Or. Quart 84
Egypt, Mamluk period, 15th century

This binding is of one piece of leather with hand tooled lines and dots arranged in a geometrical interlace pattern and with a stylised floral repeat border from stamps.

Published: Weisweiler (1962, no. 13, fig. 12, pl. 8)
See drawing p. 313

576 Binding of Al-Kawākib al-Thurīyya fī madḥ Ḥayr al Barīyya, 'The Pleiades in Praise of the Garden of Creation', by Sa'īd al-Buṣīrī
Height 42.5cm, width 31.2cm
Staatsbibliothek Preussischer Kulturbesitz Orientabteilung, Berlin, Or. Fol. 1623
Egypt (Cairo), Mamluk period, 15th century

This manuscript was written for sultan Qāytbāy who gave it in 1476 as a donation to the library of the madrasa he had erected in al-Sahra. The manuscript must have been copied between 1468–76. The leather binding is decorated with a central medallion of gilt and blue lattice work on a background of green silk. The corner pieces are gilt, the edges are stamped gilt with lines painted blue. The flaps are similar.

Published: Weisweiler (1962, no. 6, pl. 32, no. 51a, b)

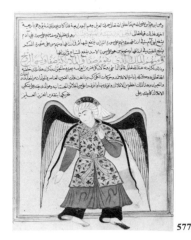

577

577 'Ajā'ib al-Makhlūqāt wa Gharā'īb al Mawjūdāt, 'Wonders of Creation and the Rarities of Things,' by Zakarīyā ibn Muḥammad ibn Maḥmūd al-Qazwīnī

Height 34cm, width 27cm
British Library, London, Or. 4701
Egypt, Mamluk period, late
15th century

This undated Arabic manuscript consists of two parts concerned with the heavens and with the earth. It begins with the sun, moon, constellations, and other heavenly bodies, continues with the inhabitants of the heavens, and then goes on to sections on geography and natural history with a final chapter on man. Qazwīnī used a Persian work of the same title which had been compiled a century earlier and Qazwīnī's work in turn was translated from Arabic into Persian and other languages. It was a popular book for illustration and some manuscripts have more than four hundred small drawings accompanying the various sections. This manuscript has no colophon and is illustrated with numerous diagrams in the sections devoted to the heavens, oceans, animals, birds, insects and monsters. This double-page miniature (folios 37v, 38r) depicts the angels, man, lion, eagle and cow – which bear God's throne to the right, and the angel al-Rūḥ to the left.

Published: Rieu (1894, no. 1287, p. 829)

578 a-b Two pairs of leaves detached from a Koran

Height 35.4cm, width 25.3cm
Fundação Calouste Gulbenkian,
Lisbon, M.20, M27
Turkey, Ottoman period,
15th century

These leaves come from a richly illuminated Koran written for Sultan Bayezid II (ruled 1481–1512). The first double opening a has a frame of kufic script in white superimposed on an arabesque ground with a twelve-petalled central rosette and double border of interlace and lobed medallions. b contains the opening Koran Suras in thuluth script with interlinear Persian glosses set in a floral arabesque ground, with rich illuminated panels above and below, and with borders of more arabesque motifs, thumb pieces and ansae in the outer margins. These leaves are exceptionally fine examples of Ottoman illumination and may be compared with architectural decoration at Bursa and Edirne, earlier in the 15th century.

Published: Martin (1912, p. 102, pls. 264–7); Pope and Ackerman (1938–9, p. 1962); Lisbon (1963, no. 115)

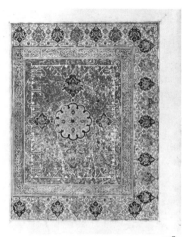

578a

578b

579a

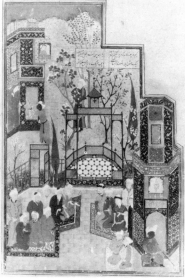

579b

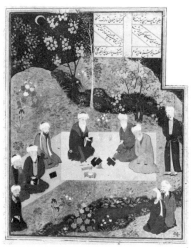

579d

**579 a–d Four volumes of a
Khamsa by Mīr 'Alī Shīr Nawā'ī**
a Height 13.5cm, width 20cm
b Height 27.5cm, width 20cm
c Height 13.5cm, width 10.6cm
d Height 20.6cm, width 14cm
*Bodleian Library, Oxford, MS.
Elliott, 287, 408, 317, 339*
Khurasan (Herat), Timurid period,
15th century

These four volumes are dated 1485 in
Herat and have been bound
separately. Volume 1 consists of the
*Ḥayrat al Abrār, The Perplexity of
the Pious,* and consists of 57 folios,
4 miniatures, a double illuminated
frontispiece and rosette containing
a dedication to the prince Badī'
al-Zamān, son of Sultan Ḥusayn
Bayqarā. These four manuscripts,
formed a *Khamsa* with the *Layla wa
Majnūn* manuscript now in the John
Rylands Library, Manchester
(Turk. MS. 3). The miniatures are
the work of several painters and the
text is written in Chagatay Turkish.
a shows the double illuminated
frontispiece which is finely executed.
Volume 2 is in 78 folios with one
miniature and illuminated heading.
This volume contains the *Farhād wa
Shīrīn* and miniature b (folio 66a)
shows the bringing of news to
Farhad of the death of Shīrīn.

Volume 3 consists of 65 folios with 2
miniatures and illuminated headings.
Miniature c (folio 21b) shows
courtiers waiting around an empty
throne from the *Sab'a Sayyāra,
The Seven Planets.* Volume 4 consists
of 97 folios with 4 miniatures,
enclosed in an 18th century lacquer
binding with floral decoration.
Miniature d (folio 95b) depicts a
discussion between mystics in a
garden from the *Sadd-e Iskandar,
Alexander's Rampart.* This miniature
is one of the best of the series and is
signed *al-'abd Qāsim 'Alī* in red
between the columns of the text.
Stchoukine attributes this painting to
Bihzād.

Published: London (1931, no. 543A, D);
Arnold (1931, p. 97, pl. 22); Binyon,
Wilkinson and Gray (1933, nos. 79–80);
Robinson (1954a, pp. 263–70 and 1958a,
nos. 606–16); Robinson and Gray (1972,
nos. 17–20, p. 11); Stchoukine (1954,
pp. 69–70); Gray (1961, pp. 115–21)

580 Double-page miniature from Muraqqa'-e Gulshan, 'The Rose-Garden Album'
Height 41cm, width 26cm
Imperial Library, Tehran, no. 1663
Khurasan (Herat), Timurid period, about 1485–90

This album was collected and mounted by the masters at Jahāngīr's court in India. This double-page miniature depicts a young prince in a garden seated among his harem surrounded by musicians, servants and dancers. An inscription on a book on the right-hand page reads 'portrait of sultan Ḥusayn Mirzā, the work of Bihzād.' This miniature has been accepted as partly the work of Bihzād by Pinder-Wilson and Stchoukine, but both believe that it was completed by pupils of the master. Gray places it not earlier than 1490, perhaps later in spite of the age at which Sultan Ḥusayn (born 1439) is represented. The rayed sun might be later but a similar image appears on folio 273v of the manuscript in the British Library (Or. 6810) which is accepted as by Bihzād by Pinder-Wilson and, alternatively, by Stchoukine, as by a pupil. This double-page must have been executed as frontispiece to a manuscript for Sultan Ḥusayn himself. The figures are all posed with masterly skill, and the scene is informal.

Published: London (1931, no. 601); Binyon, Wilkinson and Gray (1933, no. 163, p. 192, pl. LXVII); Bahrami (1949a, no. 30); Stchoukine (1954, p. 71, 125–6, no. LXXVII); Gray and Godard (1956, pls. 16–7); Gray (1962, pls. 16–7); Atabay (1974, no. 159, pp. 334–368).

581 Bustān by Sa'dī
Height 30.5cm, width 21.5cm
National Library, Cairo, Adab fārsī 908
Khurasan (Herat), Timurid period, 15th century

This manuscript with double frontispiece and four miniatures was copied by Sulṭān 'Alī al-Kātib in 1488 for the Sultan Ḥusayn Mirzā. One page at the end of the manuscript was added later in 1541. A seal at the end of the manuscript is of Yarbūdāq ghulām-e Shāh with the date 1643. There is also an owner's seal of Shāh 'Abbās I. The binding is later. The importance of this miniature and the others in the manuscript lies in the authenticity of the signatures of Bihzād which permits a study of the Herat school of painting in the work of its greatest master under Sultan Ḥusayn Bayqarā. This illustration depicts Yusuf fleeing from the importunities of Zulaykha who has led him into the innermost room through seven doors which she had locked behind. At his prayer they fly open and he escapes. Signed on the arch by 'the humble' Bihzād with a date equivalent to 1488. This is five years after the composition of the most famous poem on the theme of Yūsuf and Zulaykhā by Jāmī when Herat must have known much of it by heart. The illustration here conforms to the version of Jāmī except that no wall-paintings are shown which Zulaykha had prepared and in which she had herself represented in the arms of Yūsuf. A Bukhara version of this miniature with an attribution to Bihzād is in the Bodleian Library, Oxford (MS. Marsh 517) attributed there to Tabriz 1515–20. See Robinson (1958a, no. 688).

Published: Martin (1912, p. 44); Schulz (1914, p. 112); London (1931, no. 543b); Wilkinson (1931, pp. 61–7); Binyon, Wilkinson and Gray (1933, p. 98, no. 83); Stchoukine (1935, no. 2, p. 140); de Lorey (1938, pp. 25–44); Mustafa (1959, pl. 4); Cairo (1968, pp. 21–7, no. 8); Golombek (1972, pp. 28–9).

581 see colour plate, page 56

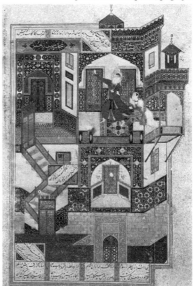

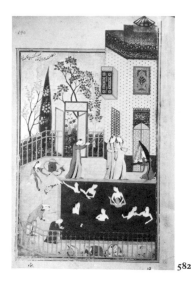

582

582 Khamsa by Niẓāmī

Height 25cm, width 17cm
British Library, London, Or. 6810
Khurasan (Herat), Timurid period,
late 15th century

This manuscript was dedicated to the
amir 'Alī Fārsī Barlās. It contains
22 miniatures and fine illuminations
and lacks a colophon, but the date
1494–5 and dedication appear in an
inscription within a miniature. The
attributions to artists in the lower
margins of the miniatures were
probably added when the manuscript
belonged to the library of the Mughal
emperor Jahāngīr. 'Alī Fārsī Barlās
was probably an amir of the Sultan
Ḥusayn Bayqara who ruled at Herat
from 1468 until his death in 1506 and
who maintained a brilliant academy
employing the finest artists headed by
Bihzād. This miniature (folio 190r)
maintains the large composition with
lines of verse set in a frame within the
painting, similar to that seen a
century earlier. It depicts the owner
of a garden discovering maidens
bathing in the pool, and is probably
by Bihzād. This story of the discovery
was told to Bahrām Gūr by the
Greek princess in the white pavilion
on Friday. It comes from the fourth
of the five poems which make up the
Khamsa, namely the *Haft Paykar*,
'*Seven Pavilions.*'

Published: Martin and Arnold (1926);
Stchoukine (1950, pp. 301–13 and 1954,
no. LXXXI, pp. 131–6); Pinder-Wilson
(1958b, columns 600–4); Gray (1961, pp.
113–24); Robinson (1967b, no. 29)

583 Khamsa, 'Five Poems', of Niẓāmī

Height 19cm, width 12cm
British Library, London, Add. 25900
Khurasan (Herat), Timurid period,
late 15th century

This manuscript is dated 1442–3 but
of the nineteen miniatures it
contains only one is of the same date
as the manuscript. The scribe of the
minute and exquisite nastaliq script
is unknown. Fourteen of the
miniatures are later Herat work and
three bear the signature of Bihzād
between the lines of the text. The date
of these later Herat miniatures is
undoubtedly the same as that given
in the inscription of folio 77v, that is
1492–3. The remaining four
miniatures are in the Tabriz style of
about 1535. The illumination of the
title pages, frontispieces and headings
as well as that within the miniatures
is very fine. The exhibited miniature
(folio 110v) depicts a madrasa and
bears geometric and arabesque
designs. It is an interesting study of a
mosque with the mimbar on the left.

Published: Martin (1912, I, fig. 249);
Stchoukine (1954, pp. 76–8, pls. 77–82);
Gray (1961, p. 112); Robinson (1967b,
no. 24)

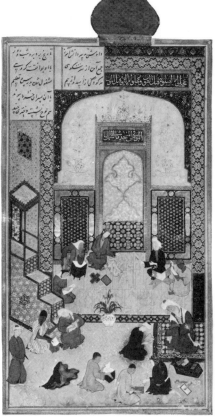

583

584

586

584 Manṭiq al-Ṭayr, 'Language of the Birds', by Farīd al-Dīn 'Aṭṭār

Height 24cm, width 16cm
British Library, London, Add. 7735
Khurasan (Herat), Timurid period, about 1500

This manuscript is a mystical poem describing man's search for God, told as an allegory of the birds led by the hoopoe, who set out to seek the *simurgh* or phoenix whom they had elected as their king. The work has many anecdotes including the short story of two foxes, of only three couplets, in which the female fox asks the male when they will meet again, to which he replies that if they live long enough, it will be in the furrier's shop. The miniature illustrating this story (folio 84r) depicts the two foxes running out of the frame across the margin, one looking back at the prince who sits, falcon on wrist, on his horse watching. The attendant huntsman has a cheetah sitting behind him on his piebald horse's quarters which he holds with a chain and which looks disdainfully away from the fleeing foxes. The manuscript is without a colophon so that the place, date and patron are not known. The nine miniatures are in the later Herat style and display the influence of Bihzād. The simpler version of this style suggests a date of about 1500.

Published: Robinson (1967b, no. 31)

585 Binding

Height 23.1cm, width (total) 35cm
Victoria and Albert Museum, London, no. 423/1896
Persia or Turkey, about 1500

The outside of this binding is of black moulded leather gilt and decorated with floral motifs. The centres of the moulded flowers are painted blue. The interior is of brown leather decorated with a medallion and cornerpieces of black and gilt lattice work on a blue background.

Unpublished

585

586 Khamsa, 'Five Poems', by Amīr Khusraw

Height 27cm, width 18cm
British Library, London, Add. 24983
Khurasan (Herat), Timurid period, early 16th century

This manuscript is a fine example of the style of illumination connected with Herat under the patronage of Sultan Ḥusayn Bayqara (died 1505–6). This frontispiece is painted in two tones of gold against a background of lapis lazuli with an arabesque design in colours covering the entire surface. The heading, written in white kufic script against a gold background, is surrounded on all four sides by arabesques on blue to form a rectangle enclosed within borders of intricate geometrical designs. The wider of the two main borders is of a 'plaited' design in gold and that on the outer edge is a 'braided' design in pale blue. Above the rectangle the predominant colour is blue covered with similar arabesque scroll work and enclosed in a gold border with exaggerated arabesque tendrils and leaves and with a small medallion painted in red and blue. In spite of the dedication the dates given in the colophon are 1511–2, six years after the death of Sultan Ḥusayn.

Unpublished

587 Khamsa, 'Five Poems' by Jāmī

Height 34.2cm, width 23.5cm
Imperial Library, Tehran, no. 709
Central Asia (Bukhara), Shaybanid
period, early 16th century

This manuscript of 203 folios was
copied, the first poem for Sultan
Ḥusayn Bayqara in 1481, the
remainder by 'Alī al-Ḥusāynī
al-Harawī in 1522. Each poem has a
double-page frontispiece miniature
within an illuminated border. The
second frontispiece depicts dancing
dervishes and is attributed to Ḥaydar
'Alī, son of the sister of Bihzād. The
style points to its having been
executed in Bukhara.

Published: London (1931, no. 544b);
Minorsky (1931, pp. 71–5); Binyon,
Wilkinson and Gray (1933, no. 129);
Bahrami (1949a, no. 68).

588 Bustān by Saʿdī

Height 23.4cm, width 14cm
Imperial Library, Tehran, no. 2197
Central Asia (Bukhara), Shaybanid
period, 16th century

This manuscript was copied by Mīr
Ḥusayn al-Ḥusaynī al-Kātib
al-Sulṭānī in 1554 at Bukhara. It has
an illuminated frontispiece and four
miniatures, of which the third carries
a dedication to 'Abdullāh Munshī,
the head of the royal library,
evidently of the Uzbeg ruler Yar
Muḥammad of Bukhara (1550–7). It
depicts the reception of two dervishes
by Malik Ṣāliḥ, the Ayyubid ruler of
Damascus. This scene is also
represented in the Bibliothèque
Nationale, Paris, Bustān (Supp. Pers.
1187) of the following year. See
Blochet (1929, pl. CXVII). This
manuscript was later in the Mughal

imperial library and carries an
autograph of Jahāngīr dated 1605.

Published: Bahrami (1949b, no. 81);
Gray (1961, p. 151).

589 Illuminated frontispiece from an unknown manuscript

Height 31.5cm, width 21.5cm
*Musée des Arts Décoratifs, Paris,
no. 27. 658–7*
Bukhara, Uzbek, Shaybanid period,
16th century

In the early 16th century, first at
Herat then afterwards at Bukhara and
Shiraz, there grew up the practice of
adorning manuscripts with double
frontispieces which combined
traditional illumination with figures
of angels (*pari*), generally in flight.
This example is from the school of
Bukhara probably belongs to the
period 1525–30. It may be compared
to another from Shiraz dated 1529
now in the Chester Beatty Library,
Dublin (P 196) and one from Herat
dated 1523. See Binyon, Wilkinson
and Gray (1933, pl. LXXVIIIb).
The Bukhara school of painting
excelled in complex arabesque
patterns while preserving the figural
style from Herat.

Unpublished

587

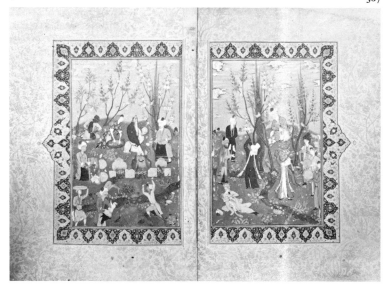

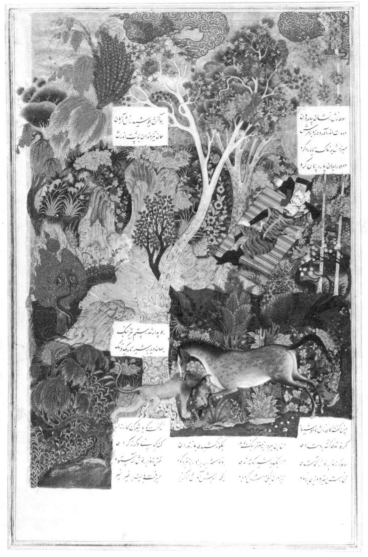

590

591

**591 Dastān-e Jamāl wa Jalāl,
'Story of Jamāl and Jalāl,
by Muḥammad Asafī**
Height 30.5cm, width 20cm
University Library, Uppsala, O Nova 2
Persia (Tabriz), Safavid period,
early 16th century

Apart from the miniatures in this
important manuscript there are few
others which can be attributed
without question to the period of the
first Safavid ruler, Ismā'īl I. This
manuscript is distinguished as being
the earliest known from the Safavid
period and is dated in the colophon to
1502. Two of the miniatures arc dated
1503 and 1504. This miniature
(folio 5a) depicts Dindār giving
advice to Jalāl. It shows a
continuation of the Turkman court
style in Tabriz and is probably
painted by the same hand as are the
other miniatures from this manu-
script, though they are all unsigned.
They may be compared to the earlicr
miniatures of the great Rothschild-
Houghton *Shāhnāma* which arc in a
similar rich style with great tufts of
vegetation. It seems that some
painter of Tabriz, trained at the
Aq-Qoyunlu court, may have been
working on these miniatures as early
as 1510. See Martin (1912, p. 127).

Published: London (1931, no. 715c);
Binyon, Wilkinson and Gray (1933,
no. 119, p. 126); Zettersteen and Lamm
(1948); Welch (1972a, pls. 22v, 23v)

**590 Miniature from a Shāhnāma,
by Firdawsī**
Height 31.8cm, width 20.8cm
*British Museum, London, 1948
12–11 023, Bernard Eckstein
Bequest formerly Schulz and Martin
Collections*
Persia (Tabriz), Safavid period,
early 16th century

The sleeping Rustam is saved from a
lion by his horse Rakhsh. The text
and miniature are not internally
marginated. This miniature was
formerly part of a group of four, the
other three of which have now been
lost. The Safavid *kulah* or turban
base appears in two of the other
miniatures of this small group, thus
providing a *terminus a quo*, while
the luxuriant foliage indicates a date
not far from no. 591. The miniature
is not quite finished, especially in the
area of the chinar tree, up which a
snake is climbing towards a bird's
nest. Pigments as well as design and
drawing are of the highest quality and
indicate a preparation for a court
library. The date is probably not
later than about 1505.

Published: Munich (1910, nos. 650–5);
Martin (1912, I, fig. 23); Schulz (1914, II,
pls. 36–7); Kühnel (1922, pl. 42); Gray
(1940, pl. 10); Robinson (1954a, p. 105,
and 1967b, p. 99, no. 137)

593

592 Kulliyāt, by Sa'dī

Height 23.8cm, width 14.5cm
Bodleian Library, Oxford, MS.
Fraser 73
Persia (Shiraz), Safavid period,
early 16th century

This manuscript is the first volume of
this three volume work and consists
of 177 folios with double frontispiece
and contemporary leather binding.
It was copied at the foundation of
Ḥaḍrat Mawlāna Ḥusām al-Dīn
Ibrāhīm at Shiraz in about 1516–22.
This illuminated title page is signed
Rūzbahān who was among the
leading calligraphers in Shiraz. That
he was also an illuminator is not
unusual.

Published: Robinson (1958a, no. 695);
Stchoukine (1959, no. 96, p. 101);
Qadi-Ahmad (1959, p. 67); Robinson and
Gray (1972, no. 30, p. 15)

593 Chinoiserie scrollwork drawing

Height 13.2cm, width 18.5cm
Fogg Art Museum, Harvard
University, Cambridge,
no. TL 21022.12, Anonymous Loan
Persia, Safavid period, early 16th
century

This exercise in decoration illustrates
admirably the impact of Chinese
influence on the arabesque tradition
in Persia. Here the terminal dragon
head and the cloud patterns are
almost purely Chinese motifs but
they are combined in an un-Chinese
way into an overall formal design
which negates their independent
validity. Such work, known in
Persian as *abri* or cloud design, was
the work of specialist illuminators
working mainly in the margins of
manuscripts.

Unpublished

594 Selected works of Niẓāmī

Height 19.5cm, width 25.5cm
Victoria and Albert Museum,
London, no. 618/1886
Persia, Safavid period, 16th century

This manuscript with contemporary
binding is dated 1522. The double
page illumination is signed by
'Abd al-Laṭif

Unpublished

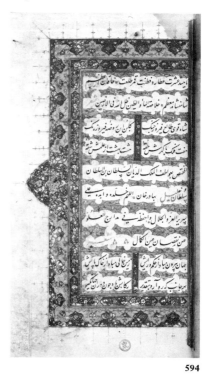

594

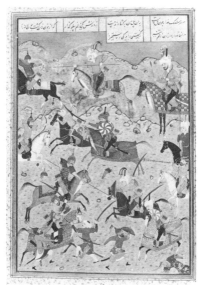

595b

595a-b Two miniatures from a Khamsa, 'Five Poems', by Niẓāmī

Height 17.3cm, width 12.1cm
*Metropolitan Museum of Art,
New York, no. 13.228.7*
Persia (Tabriz), Safavid period,
16th century

This manuscript was copied by
Sulṭān Muḥammad Nūr in 1525 with
14 miniatures and contemporary
moulded and gilt binding. The
scribe was son and pupil of Sulṭān ʿAlī
Mashhadī. Miniature a (folio 207a)
depicts Bahrām Gūr in the Black
Pavilion on Saturday from the Haft
Paykar. Miniature b (folio 279a)
shows a battle between Alexander the
Great and Darius. It is easy to under-
stand how Martin came to attribute
this latter miniature to Bihzād for it
contains certain features which are
characteristic of this artist. For
example, the group of seven figures
in the foreground is lifted straight
from the *Niẓāmī* in the British
Library, London (no. 583, folio 8)
which is generally accepted as an
authentic work of Bihzād and is dated
to about 1493. It is indeed a simplified
and arrested version of that
composition that appears here in a
manuscript of the next generation.

Published: Jackson and Johannan (1914,
pp. 58–67); Martin (1927); Robinson
1953); Gray (1961, pp. 127–9); Grube
(1968a, no. 64)

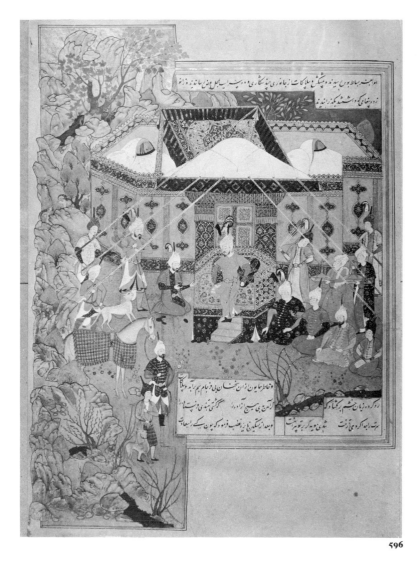

596

596 Ẓafarnāma, by Sharaf al-Dīn ʿAlī Yazdī

Height 37cm, width 23cm
Imperial Library, Tehran, no. 708
Persia, Safavid period, 16th century

This manuscript was copied by
Sulṭān Muḥammad Nūr in 1529 and
illuminated by Mīr ʿAzud. The 24
miniatures are attributed in the
colophon to Bihzād but they are the
work of the school of Sulṭān
Muḥammad. The manuscript is
contained in a stamped leather bind-
ing. Although authorities reject the
ascription of the miniatures in this
manuscript to Bihzād, Welch
believes that they might have been
planned by him. Since the calli-
grapher was the royal scribe who also
copied no. 595, which also contains

echoes of Bihzād, some connexion is
indeed likely. This miniature (folio
596) shows the presentation of a
horse, hunting cheetah and grey-
hound to a prince. The relation of
figures to landscape is similar to that
in the *Niẓāmī* in the British Library,
London, (no. 582), which was
produced under the direction of
Bihzād. See Martin and Arnold
(1926, pls. 23–4). The figures of this
miniature, however, are in the new
Safavid style as may be seen in
no. 597.

Published: London (1931, no. 543c);
Binyon, Wilkinson and Gray (1933, no.
137, p. 132); Bahrami (1949b, no. 72,
p. 32); Stchoukine (1959, p. 59); Gray
(1961, pp. 132–3); Welch (1972b, p. 60)

597 Kulliyāt of Mīr 'Alī Shīr Nawā'ī

Height 38cm, width 26.5cm
Bibliothèque Nationale, Paris,
Cabinet des Manuscrits, Sup Turc 316
Persia (Tabriz), Safavid period,
16th century

This two volume manuscript was
copied by 'Alī Hijrānī at Herat in 1527
and was later in the Indian Mughal
library. Volume 1 consists of 469
folios with 6 miniatures by unknown
artists (attributed by Stchoukine to
Shaykh Zāda). The miniature (folio
350) from volume 1 depicts Bahrām
Gūr on horseback hunting onagers.
Blochet attributes this painting to
Bihzād. This manuscript is one of the
major products of the early period of
Shah Ṭahmāsp. Although copied in
Herat it must have been decorated
with miniatures in the royal library at
Tabriz under the direction of Sulṭān
Muḥammad to whom Welch
attributes this miniature. Others may
be by his son Mīrzā 'Alī and one
miniature repeats the same subject as
in no. 595 which is ultimately derived
from Bihzād. Such borrowings of
successful compositions in this period,
first at Herat and then later at Tabriz
and Bukhara, are commonly found.

Published: Blochet (1926, p. 95, pls.
XLVIII–LI and 1929, pl. CXXIV);
Sakisian (1929, pls. 111–2, 114–6);
Binyon, Wilkinson and Gray (1933,
pp. 111–2); Stchoukine (1959, p. 56,
no. 8); Gray (1961, p. 131); Paris (1973,
no. 266)

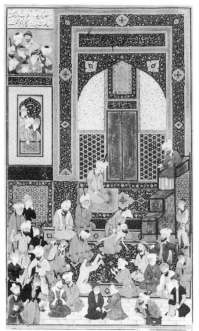

598a

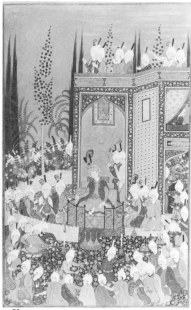

598b

598a-b Two miniatures from a Divān, by Ḥāfiẓ

Height 25.9cm, width 15.2cm
Fogg Art Museum, Harvard
University, Cambridge,
nos. TL 17443.5–6, anonymous loans,
formerly in the L. Cartier Collection
Persia (Tabriz), Safavid period,
about 1533

This manuscript with five miniatures
was executed in honour of Sām
Mīrzā b. Shāh Ismā'īl. It is
contained in a contemporary
lacquer binding. Miniature a
depicts 'a preacher delivering a
sermon in a mosque'. The words
'*amal-e Shaykh Zāda*, 'the work of
Shaykh Zāda' may be detected at the
extreme base of the picture. This
painter was a pupil of Bihzād.
Miniature b shows a prince sur-
rounded by his court painted by
Sulṭān Muḥammad whose name
appears in the diamond shaped design
directly beneath the seated prince.
Above the archway on the right are
the words al-Ghāzi Abū al-Muẓaffar
Sām Mīrzā. These two miniatures
are among the most beautiful of the
middle period of the reign of Shah
Ṭahmāsp and the two signatures that
they carry are likely to be genuine,
naming two of the most famous
artists of the day. Sām Mīrzā,

brother of Shah Ṭahmāsp was
governor of Herat from 1522 to 1529
but he was then no more than a child
having been born in 1517. There is
little doubt that these miniatures
must have been executed at Tabriz,
the seat of the court, as a gift for the
young prince. Sulṭān Muḥammad
was head of the painting academy
there from about 1520. Sām Mīrzā
continued his patronage of the arts of
the book until his death in 1561.

Published: Marteau and Vever (1912,
nos. 94–5); Sakisian (1929, pl. 121);
London (1931, no. 546c); Binyon,
Wilkinson and Gray (1933, no. 127,
p. 128, pls. 84a, b); Pope and Ackerman
(1938–9, pl. 895); Stchoukine (1959, no.
12, p. 60); Gray (1961, pp. 130–7);
Welch (1972b, pp. 56–60)

599

601

599 Gulistān wa Bustān of Sa'dī
Height 29.6cm, width 19cm
*Fundação Calouste Gulbenkian,
Lisbon, L.A.180, acquired in 1924
from the family of Colonel J. Sotheby
who brought it to England in 1689*
Persia (Shiraz), Safavid period,
16th century

This manuscript was copied by
Murshid al-Kātib al-Shīrāzī at
Shiraz in 1527–8. It contains 13
miniatures and is enclosed within a
contemporary leather binding. The
illuminated frontispiece is signed
Ghiyāth al-Dīn Maḥmūd Shīrāzī
who is reported to have been the
inventor of gold sprinkling or margin
decoration and unrivalled in the art.
He died in 1535. See Qadi-Ahmad
(1959, p. 189).

Published: Lisbon (1963, no. 125)

600 Khamsa, 'Five Poems', by Niẓāmī
Height 37cm, width 25.5cm
British Library, London, Or. 2265
Persia (Tabriz), Safavid period,
16th century

This manuscript was copied for
Shah Ṭahmāsp by the scribe Shāh
Maḥmūd Nishapūrī known as the
Zarin-Qalam, 'golden pen', at Tabriz
in 1539–43. The manuscript is in
nastaliq script and contained 14
contemporary miniatures some
signed by, or attributed to, the court
artists Sulṭān Muḥammad and his
contemporaries. This copy of the
Khamsa is deservedly one of the most
famous Persian manuscripts. The
influence of Bihzād is here found and
his pupil Mīrak was responsible for
four of the miniatures of this manu-

script. Mīr Sayyid 'Alī who painted
one of the miniatures was one of two
artists who went to India at the behest
of the Mughal emperor Humāyūn,
after the latter's exile in Persia, to
found the Mughal school of painting.
This miniature represents the ascent
of the prophet Muḥammad through
the heavens (the *mi'rāj*) and was
probably painted by Sulṭān
Muḥammad. Every aspect of this
manuscript is superb, such as the fine
polished paper with illuminated title
pages and headings with borders
painted in two tones of gold with
scenes of animals and birds against
backgrounds of flowers and streams.
The manuscript was still in the royal
library at the time of Fatḥ 'Alī Shāh
and he had it rebound in 1797 in
covers painted by his court artists
with scenes of himself hunting.

Published: Martin (1912, pls. 130–140,
252–5); Binyon (1928); Pope and
Ackerman (1938–9, pls. 896–9);
Stchoukine (1939, pp. 69–75); Welch
(1972b, fig. 15)

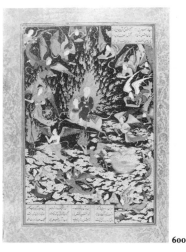

600

601 Binding removed from a manuscript
Height 18cm, width 10.5cm
*Bibliothèque Nationale, Paris,
Cabinet des Manuscrits, Sup. Pers.
2050 (150), Marteau Bequest*
Persia (?Herat), Safavid period,
first half 16th century

This binding is tooled and gilt with
motifs of four animal heads and two
heads of women with long hair
surrounded by Chinese dragons and
fawns. At both extremities are two
verses in Persian; the whole is
bordered with scroll-like designs.
The interior is decorated with black
lattice work on blue ground.

Published: Blochet (1923, pp. 279–88);
Paris (1973, no. 258)

602 Binding with lacquer on leather
Height 49cm, width 33cm
Museum für Kunst und Gewerbe, Hamburg, no. 1894.27
Persia, Safavid period, 16th century

This binding is lacquer-painted including gold and silver and shows a scene of trees, birds, some in flight amidst clouds, and three beasts of prey attacking deer. The earliest lacquer-painted binding from Persia dates from about 1483 made in the Herat library of Sultan Ḥusayn Bayqara. However, pictorial lacquer work only begins to be employed under the Safavids in the first half of the 16th century.

Published: Munich (1912, p. 501, pl. 33); Kühnel (1925, p. 86, no. 45); Erdmann (1967, pl. 66)

603 Binding with lacquer on leather of Qiṣas al-Anbiyā, 'Biographies of the Prophets', by Ḥusayn Bayqara
Height 28cm, width 18cm
Bibliothèque Nationale, Paris, Cabinet des Manuscrits, Sup. Pers. 775
Persia (Shiraz), Safavid period, 16th century

This manuscript consists of 363 folios with 5 miniatures and is undated. It was brought back from Egypt by Napoleon in 1801. The painted lacquer binding shows a scene of birds in green and gold and may be dated to about 1520. This type of decorative subject is found on the wall and ceiling paintings in the royal pavilion at Nayin, dated to about 1560. See Luschey (1969, pls. 75–6).

Published: Blochet (1920, pl. 4); Stchoukine (1959, pl. 41, p. 110); Paris (1973, no. 234, p. 90)

604 Binding of Yūsuf wa Zulaykhā, by Jāmī
Height 20.3cm, width 13cm
Bodleian Library, Oxford, MS. Hyde 10
Persia, Safavid period, 16th century

The manuscript belongs to the period of Shah Ṭahmāsp, the colophon only gives 94, perhaps 940 (1533AD). The cover is embossed, gilt and decorated with a central medallion and vegetal motifs. The inside is of red leather and is decorated with medallions of black lattice work on a gilt background. Moulded bindings such as this are more difficult to date closely since elaborate moulds continued to be used over a considerable period.

Published: Robinson (1958a, pp. 696–8); Robinson and Gray (1972, no. 37, p. 19)

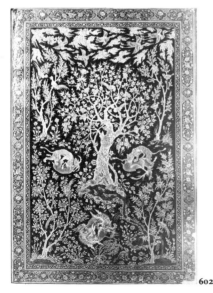

602

603

604

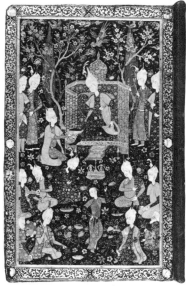

605 see colour plate, page 58

605 Diwān by Nawā'ī

Height 24cm, width 14.5cm
British Library, London, Or. 1374
Persia (Tabriz), Safavid period,
about 1550

Painted lacquer binding, signed
Sayyidī 'Alī. Leather was originally
used in the 16th century for painted
book covers but proved to be an
unsuitable surface for pigment which
cracked and flaked. Pasteboard made
of layers of paper stuck together and
given a leather edging was more
generally used and proved to be a
satisfactory medium. The pasteboard
was sized with gypsum or chalk and
coated with successive layers of
transparent lacquer, each layer being
polished as it was applied and when
dry. The design was painted in water
colours and a final coat of lacquer
applied to protect the painting. The
cover shown here is painted in vivid
colours against a black background
with lavish use of gold and with a
design which employs the stylised
clouds and birds of Chinese origin.
The arabesque border design in
ribbon form is painted in black on a
gold background. On the steps of the
throne appears the signature of
Sayyidī 'Alī.

Unpublished

606 Binding of lacquer on leather

Height 40cm, width 25cm
*British Museum, London, no. 1948
12–11 027–8, bequeathed by Sir
Bernard Eckstein, formerly in the
Kunstgewerbe Museum, Düsseldorf*
Persia, Safavid period, 16th century

The outside of the covers shows a
feasting scene. The cover has been
damaged and a blue ground is partly
revealed under the lacquer by
flaking. It is to be noted that the
white has flaked off more than any
other colour. The inside of the covers
shows a hunting scene on a gold
ground which includes a man
kneeling (top left-hand corner)
holding a musket. Pictorial lacquer
binding was not introduced before
the reign of Shāh Ṭahmāsp and
stylistically this binding may be
attributed to about 1540.

Published: Munich (1910, no. 848,
pl. 30); Schulz (1914, pls. 196–7);
London (1931, no. 126E); Pope and
Ackerman (1938–9, p. 1985, pl. 973)

606

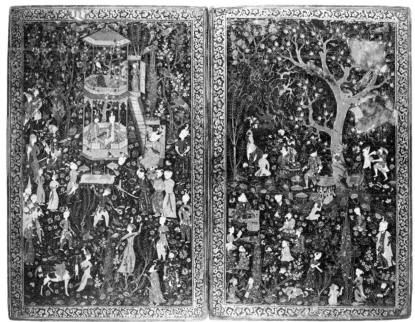

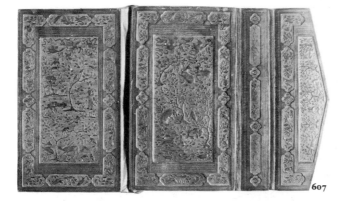

607

607 Binding in leather

Height 26.5cm, width (whole)
44.5cm
*Fundação Calouste Gulbenkian,
Lisbon, L.A. 189*
Persia, Safavid period, early 16th
century

The binding is moulded and gilt and
decorated with designs of animals,
birds and fish in a landscape. On the
front cover is a young prince with
bow and arrows. The inside is
decorated with filigree work on a
blue ground. The flap is decorated
with falcon, hare and crouched deer.
There is a second binding in the
Fundação Calouste Gulbenkian,
Lisbon, in which the same moulds
have been used. See Pope and
Ackerman (1938–9, pl. 963). This
binding is larger, having, in addition,
moulded borders with inscriptions
and floral elements. These moulds
are also used on a binding in the
Topkapi Palace Museum, Istanbul
(Revan 991) enclosing an undated
manuscript of Kātibī attributed to
the royal Turkman school of the last
quarter of the 15th century. These
moulds must have been used over a
long period of time and it is not
always possible to be certain the
bindings are contemporary with the
manuscripts they enclose though
they can hardly be earlier without
showing signs of adaption.

Published: Pope and Ackerman (1938–9,
pl. 963, p. 1983); Lisbon (1963, no. 129)

608 Binding in leather

Height 36.5cm, width 23cm
*Musée des Arts Décoratifs, Paris,
no. 8733, acquired in 1896 from the
Schaffer Collection*
Persia (Qazvin) Safavid period, or
Central Asia (Bukhara), 1525–40

This binding is moulded and gilt
with a design of animals and flying
birds. The borders are of arabesques
with scroll-like decoration, the out-
side border has floral arabesques in
panels with alternate rosettes. In
view of the resemblance between
this binding and one in the
Bibliothèque Nationale, Paris (Sup.
Pers. 985), enclosing a Niẓāmī
manuscript copied at Bukhara in
1538, this binding too may be
assigned to the Uzbek court at
Bukhara between 1525 and 1540.
See Migeon (1927, figs. 60–1).

609 Binding in leather of a Koran

Height 49.5cm, width 36cm
Musée du Louvre, Paris, no. U45
Persia, Safavid period, 16th century

The outside of the covers are
embossed with several stamps and
gilt and are decorated with a central
medallion and scroll-like designs.
The borders contain hadiths in
praise of the Koran, an unusual
feature. The inside of the covers are
decorated with medallions of gilt
filigree work on red, blue, black and
green backgrounds. This binding is
very similar to one in the Metro-
politan Museum of Art, New York
(no. 56.222). That example is
smaller but jewelled.

Published: Paris (1971, no. 305)

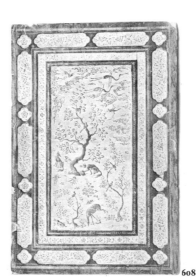

608

609

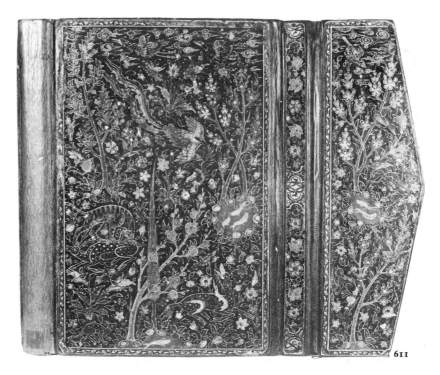

611

610 Ẓafarnāma, 'Book of Victory', by Sharaf al-Dīn 'Alī Yazdī
Height 33.5cm, width 21cm
British Library, London, Or. 1359
Persia (Shiraz), Safavid period,
16th century

Brown leather binding (interior). The
central medallion and the spandrels
are decorated with a brown paper
filigree of arabesque design against a
blue background and are raised on a
central panel. This panel has an
embossed ribbon-cloud scroll design
interspersed with stylised flowers in
blue or red. The two pendants are in
gold. The sunken border surrounding
the panel has a blue and gold floral
design and is outlined in gold with a
panelled border decorated with gold
filigree paper on blue. The entire
design is enclosed in a roll-tooled
meander border in gold and is
repeated in part on the flap doublure.
These covers appear to be
contemporary with the manuscript
which is dated 1552, copied by a
Shiraz scribe.

Unpublished

611 Binding of lacquer on leather enclosing Yūsuf wa Zulaykha, by Jāmī
Height 25cm, width 15.2cm
*Bodleian Library, Oxford MS.
Greaves I, acquired in 1678 from the
collection of Dr. Thomas Greaves*
Persia, Safavid period, 1569

This manuscript consists of 154 folios
with a double frontispiece and 6
miniatures. The binding is
contemporary. The outside is of dark
green lacquer painted in gold and

colours and decorated with designs of
animals and vegetation. The inside
of the cover is of leather decorated
with gilt filigree work on a blue and
green background.

Published: London (1931, no. 144a,
1951–2, no. 77); Binyon, Wilkinson and
Gray (1933, no. 207, p. 144); Pope and
Ackerman (1938–9, pl. 975); Robinson
(1958a, no. 1021–6, p. 140); Robinson and
Gray (1972, no. 34)

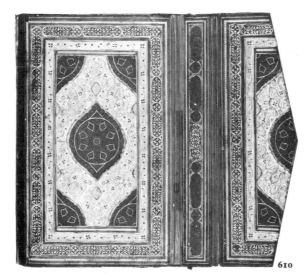

610

612a-b Two miniatures from an unidentified text of the Fālnāma, 'Book of Omens'
Height 59cm, width 44.5cm
Musée d'art et d'histoire, Geneva, Pozzi Collection
Persia (Qazvin), Safavid period, 16th century

These two pages are remarkable for their size. These miniatures have been attributed by Grube to Tabriz in the mid-16th century and by Robinson to Shiraz and later to Qazvin about 1550–60. Miniature a is probably a scene of mourning, apparently taking place in front of a mihrab and, therefore, in a mosque rather than a tomb chamber. Miniature b has been identified as the Ka'ba but this is always represented as a black cube. The dome depicted here should indicate that this is rather a tomb chamber erected above the grave of someone with a cult, which, the minarets signify, has subsequently become attached to a mosque. The figures praying must be pilgrims and the teachers in the foreground would then be located in a madrasa attached to the complex. Until the text which these miniatures illustrate can be identified, no closer definition of the subjects is possible. Other miniatures identified as coming from the same manuscript are in the Metropolitan Museum of Art, New York (no. 50.232), The Fogg Museum of Art, Harvard University, Cambridge, the Worcester Museum of Art, the Chester Beatty Library, Dublin (no. 395), and the Musée d'Art et d'Histoire, Geneva, Pozzi Collection. See Grube (1962a, no. 61); Robinson (1967b, no. 147 and 1974, no. 36).

Published: Robinson (1974, nos. 35, 37)

613 Garshāspnāma, 'The Exploits of Garshāsp', by Abū Naṣr 'Alī ibn Aḥmad Asadī
Height 35cm, width 23.5cm
British Library, London, Or. 12985
Persia (Qazvin), Safavid period, 1573

This book was written as a complement to the *Shāhnāma* of Firdawsī of whom Asadī was a contemporary. This copy contains eight miniatures of which three are signed by artists of whom particulars are given in the *Ta'rikh-e 'Ālam ārā-ye 'Abbāsī, 'The History of 'Abbās, the Ornament of the World'* by Iskandar Munshi who lived during the reign of Shah 'Abbās (died 1629). The author praised the painter Muẓaffar 'Alī highly saying he was 'incomparable in his time' and that he 'was a pupil of Master Bizhād and had learned his craft in his service and had made progress to the height of perfection.' This painter worked under the patronage of both Shah Ṭahmāsp and Shah Ismā'īl II and died in 1576. This miniature (folio 5r) is by Muẓaffar 'Alī and depicts Firdawsī and the court poets of Ghazni. It illustrates a famous anecdote about Firdawsī which is quoted in the preface. The three court poets of Sultan Maḥmūd of Ghazni were conversing in a garden when they were approached by a stranger who wished to join them. 'Anṣarī, one of the assembled poets, told the stranger that only poets were admitted to their company and that he must prove himself by supplying the fourth line to a verse for which they then composed the first three lines. Firdawsī produced a line which contained illusions to ancient heroes and 'Anṣarī recognising his knowledge told Sulṭān Maḥmūd that here had

612a

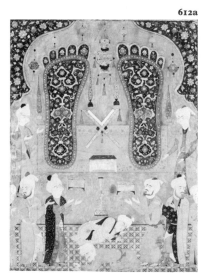

612b see colour plate, page 57

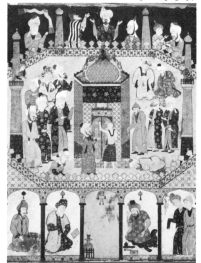

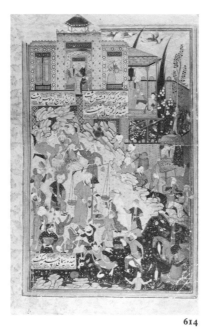

614

615

arrived a poet competent to continue the *Shāhnāma* begun some twenty years before by Daqīqī who did not live to complete the work. The manuscript was copied by Mīr 'Imād al-Ḥusaynī in 1573 who worked in Qazvin and Tabriz before being employed by Shah 'Abbās at Isfahan where he died in 1615. It was said of him that a single line in his handwriting was sold for a gold piece even in his lifetime. This manuscript contains two finely illuminated frontispieces and numerous section headings. The binding which is decorated with gilt paper doublures of intricate patterns probably dates from the 17th century. This manuscript is of special importance because it is securely dated 1573 at Qazvin and contains the signatures of three celebrated painters of the day, the other two being Sādiqī and Zayn al-'Abidīn.

Published: Robinson (1967b, no. 48)

613

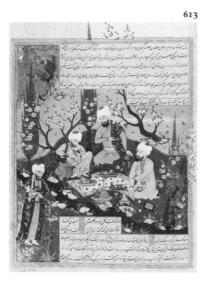

614 Yūsuf wa Zulaykha, by Jāmī

Height 40cm, width 26cm
British Library, London, Or. 4122
Persia (Mashhad), Safavid period, 16th century

This manuscript with illuminated title-pages and borders was copied by Shāh Muḥammad al-Kātib and contains 15 miniatures painted in the Mashhad style. This miniature (folio 76v) depicts an old woman bidding for Yūsuf with a yarn of cotton in the slave market. This miniature is characteristic of others in the manuscript and is treated in a lively style as can be seen in brawling men and interested spectators around the central action. Zulaykha is secretly watching from the curtained palanquin on her camel on the right whilst the old woman offers her cotton as the price of Yūsuf who sits beside the merchant. The scribe sometimes referred to as Shāh Maḥmūd is known to have worked at Mashhad in about 1570.

Published: Gray (1961, pp. 144–5); Stchoukine (1959, pls. 50, 51)

615 Binding of Divān, by Ḥāfiz

Height 34cm, width 21cm
Bibliothèque Nationale, Paris, Cabinet des Manuscrits, Sup. Pers. 1309
Persia (Shiraz), Safavid period, 16th century

This manuscript consists of 191 folios, 11 miniatures and frontispiece, and is undated. The leather binding is embossed with a hot copper plate and gilt. The inside is undecorated. It may be dated to about 1570–80.

Published: Blochet (1902, no. 1592); Stchoukine (1959, no. 144, p. 118); Paris (1973, no. 248, p. 96)

616 Binding of Sharḥ al-baḥr al-zahhār, 'The Lucid Explanation of the Sea'

Height 32.3cm, width 22cm
Staatsbibliothek Preussischer Kulturbesitz Orientabteilung, Berlin, Glaser 195
South Arabia, 16th century

This binding encloses a manuscript dated in the colophon to 1583. The outside of the cover is decorated with stamped motifs of stylised floral units arranged in a star. The inside is similar and is of red leather. The back spine and edges have been renewed.

Published: Weisweiler (1962, no. 72, pl. 19, no. 12)

617 Koran
Height 79cm, width 54cm
Iran Bastan Museum, Tehran,
no. 3310
Persia, Safavid period, 16th century

This Koran dated 1581 was copied by
Shams al-Dīn Muḥammad
'Abd Allāh for the Ardabil shrine. The
first and last four pages are sump-
tuously decorated and the manuscript
is bound in leather. The frontispiece
is very ornate, gilt and coloured.

Published: London (1931, no. 862); Pope
and Ackerman (1938–9, pl. 966); Bahrami
(1949a no. 82 and 1949b no. 95)

618 Gulistān and Bustān
by Sa'dī
Height 29cm, width 18.5cm
British Library, London,
Sloane 2951
Persia (Shiraz), Safavid period,
16th century

These pages (folios 171v, 172r)
have marginal designs of birds,
plants and animals painted in gold at
the beginning and around the
miniatures. The unusual paintings of
angels and ribbon clouds are only
found on these two leaves. The clouds
were a Chinese convention adopted
by Persian artists as also was the style
of the angel's hair done up in top-
knots. The angels both carry flagons
and dishes but in addition, in this
manuscript, they are holding
tambourines, a harp and, more
unusually, a peacock. The text
consists of the *Gulistān* written in the
centre of the page with the *Bustān* in
the margins. It is written in nastaliq
script within gold borders surrounded
by floral designs also on gold. The
folios are decorated with triangles
containing arabesque designs on a
blue background. The name of the
scribe, Qiwām ibn Muḥammad
Shīrāzī, appears at the end of the
marginal text in the left-hand folio.
He was active about 1570–90, and
this must be the period of the
manuscript.

Unpublished

618

620

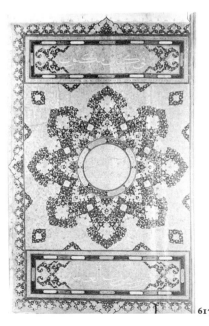

617

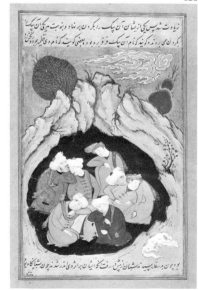

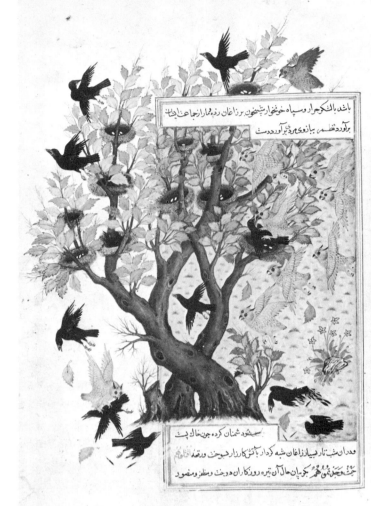

621

619 Silsilat al-Dhahhab by Jāmī
Height 24.5cm, width 15.5cm
Imperial Library, Tehran
Persia (Qazvin?), Safavid period,
1569–70

Copied by Bābāshāh Isfahānī at
Tabriz with 14 miniatures.

Published: Robinson (1965, pl. 49)

**620 Qiṣaṣ al-Anbiyā, 'Stories of
the Prophets', by Isḥāq Nīshāpūrī**
Height 29cm, width 19cm
*Bibliothèque Nationale Paris, Cabinet
des Manuscrits, Sup. Pers. 1313*
Persia (Qazvin), Safavid period,
16th century

This manuscript consists of 192
folios with 20 miniatures. The
colophon is missing and there is a
defaced royal dedication. This
miniature (folio 160b) depicts the
seven sleepers of Ephesus and their
dog. They slept in the cave where
they were imprisoned from the reign
of the emperor Decius to the time of
Theodosius the Younger with whom
they talked and then died. Another
miniature (folio 79b) bears the
signature of Riza, which can be
accepted as a genuine ascription to
Aqa Riza. A date of about 1590
would suit the early part of his
career at the court of Shah 'Abbās I,
for whom this manuscript was
probably prepared.

Published: Migeon (1927, p. 175);
Blochet (1910, pls. 30–2); Gray (1961,
p. 162); Stchoukine (1964, pp. 138–9);
Paris (1973, no. 232)

**621 Anwār-e Suhaylī, 'The
Lights of Canopus', by Ḥusayn
ibn 'Alī al-Wa'iz al-Kāshifī**
Height 30cm, width 21cm
The Marquess of Bute, MS. 347
Persia, Safavid period, 16th century

The *Anwār-e Suhaylī* of 36 folios
with 106 miniatures was one
version of a collection of traditional
fables, originating in India,
translated into Pahlavi and then
rendered into Arabic by Ibn al
Muqaffa' (died 760) as *Kalīla wa
Dimna*. Successive Persian
translations from the Arabic then
followed such as this example made
by Ḥusayn ibn 'Alī al-Wa'iz
al-Kāshifī, a preacher and Koranic
commentator of Herat during the
reign of Sultan Ḥusayn Bayqara.
This manuscript was copied by Ibn

Na'im Muḥammad al-Ḥusaynī
al-Tabrīzī in 1593. This miniature
(folio 167a) shows the owls attacking
the crows in their tree. It was painted
by Sādiqī Beg for whom the
manuscript was written. Sādiqī Beg
was court painter under Ismā'īl II
(ruled 1576–8) and Shah 'Abbās I
(ruled 1588–1629). Robinson
assumes that all the 106 miniatures
of this manuscript were painted by
the master Sādiqī Beg himself, but
seeing that it was prepared for him it
is more likely that they are the work
of his pupils presented to him on the
occasion of his being appointed to
the court.

Published: Stchoukine (1958, p. 44);
Robinson (1972, p. 50); Welch (1973–4,
pp. 22–7)

624

622 Rawḍat al-Ṣafā, 'History of the Prophets' by Mīrkhwānd
Height 34cm, width 22cm
Imperial Library, Tehran, no. 503
Persia, Safavid period, 16th century

Copied in 1590 by Qasim 'Alī al-Kātib Shīrāzī with 17 miniatures. The miniature shown here (folio 39v) depicts 'Alī with his famous two-pronged sword being welcomed by his horse.

Unpublished

623 Ajā'ib al-Makhlūqāt, 'The Wonders of Creation', by Qazwīnī
Height 30.2cm, width 19cm
Iran Bastan Museum, Tehran, no. 20342
Persia, Safavid period, 1595

623

This manuscript consists of 614 folios copied by al-Awhadī al-Ḥusaynī with 71 miniatures. This miniature depicts angels.

Unpublished

624 Ṭughrā of Sulaymān the Magnificent
Height 34.2cm, width 61cm
British Museum, London, 1949 4–9 086
Turkey, Ottoman period, 16th century

The *ṭughrā* or calligraphic emblem of each Ottoman sultan served both as a badge and as an official signature. The *ṭughrā* reads
Sulaymān Shāh ibn Salīm Shāh Khān al-Muẓaffar dā'iman
'Sulayman Shāh son of Salīm Shāh Khān always triumphant.' *Ṭughrā* are sometimes of great size according to the importance of the firmān at the head of which they were painted. This example has been cut off so that the precise date is missing. The *ṭughrā* of Sultan Sulaymān the Magnificent (ruled 1520–66) are perhaps the finest. Each Ottoman sultan had a *ṭughrā* designed in a significantly different shape but there was a general evolution of form from the decorative beginnings under Bayezid II (ruled 1481–1512). This *ṭughrā* must be dated towards the end of the reign of Sulaymān in about 1560. The letters are executed in blue outlined in gold.

Published: Kühnel (1942, p. 75 and 1955, pp. 64–82); Pinder-Wilson (1960–1, pp. 23–5); Wittek (1948, pp. 311–4); Bombaci (1965, pp. 41–55); Grube (1968b, no. 36)

625 Drawing in black and golden yellow of a pheasant
Height 10.5cm, width 15.8cm
British Museum, London, no. 1930 11–12 04
Turkey, Ottoman period, late 16th century

This type of calligraphic drawing, as in no. 593, shows the close connexion between the arts of writing and drawing in Persia and Turkey. Sometimes the design may depict three or four animals with a single head and in this example, a pheasant has its head in five different positions. These drawings exhibit exercises in skilful penwork and display an attitude to the natural world parallel to that of the use of detached heads as decorative elements in complex designs in book decoration or in textiles and carpets. At the bottom of this drawing is the signature of Shah Qulī who originally came from Tabriz and was a pupil of Mirāq Naqqāsh. Shah Qulī was director of the imperial school at Constantinople during the reign of Sultan Sulaymān the Magnificent. The signature may have been added later and the attribution to Shāh Qulī is doubtful.

Unpublished

626

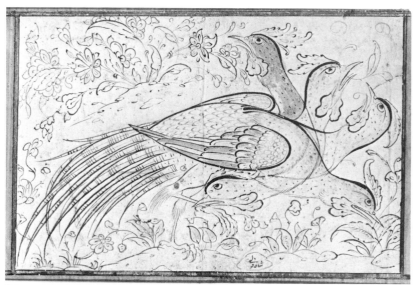

625

627

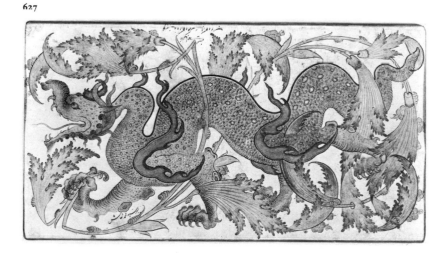

626 Binding of a Koran
Height 39cm, width 25.5cm
Bibliothèque Nationale, Paris,
Cabinet des Manuscrits, Arabe 418
Turkey, Ottoman period, 1594

This Koran is copied in naskhi script
and illuminated. It was given to a
mosque in Hungary by Sinān Pasha,
commander of the Turkish army
which reduced Hungary in the
campaign of 1594. He was made
Grand Vizier in 1593. The leather
binding with flap secured by two
silver clasps is decorated with scroll-
like designs and panels of Koranic
inscriptions.

Published: Stchoukine (1966, p. 37);
Paris (1973, no. 181, p. 66)

627 Drawing of a cloud dragon
Height 16.2cm, width 30.4cm
Fogg Art Museum, Harvard
University, Cambridge,
no. TL 20580.1, anonymous loan
Turkey, Ottoman period,
16th century

The line running along the back of
the dragon together with the row of
tightly curled locks running along the
lower jaw of the dragon and the scroll
it is clasping in its claw are all factors
which make this drawing one of the
finest of its kind. It is signed at the
bottom, Mīr Sayyid Muḥammad
Naqqāsh. Grube has demonstrated
the connexion between such drawings
and some of the tile compositions
produced at Iznik for the imperial
palaces in Istanbul.

Published: Grube (1962a, pp. 213–6);
Welch (1972a, p. 291)

367

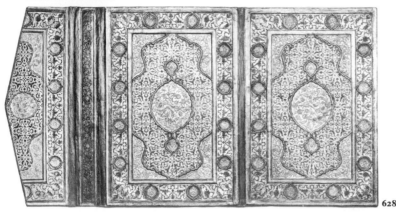

628

628 Binding of leather
Height 44.5cm, width 30cm
Fundação Calouste Gulbenkian,
Lisbon, no. R.44
Turkey, Ottoman period, about 1584

The covers are decorated with a
central medallion and corner pieces
stamped separately. The inside is also
stamped and the whole is gilt. This
binding is very similar to that in the
Topkapi Palace Museum, Istanbul
(Hazine no. 1523), which is dated
1584. See Çiğ (1971, pp. 38–9).
Compare also Pope and Ackerman
(1938–9, pl. 980).

Unpublished

629 Binding of leather
Height 15.2cm, width 25.7cm
Victoria and Albert Museum,
London, no. 55/1897
Turkey, Ottoman period,
16th century

The outside of the cover is of brown
leather with block stamped corner
pieces, in the centre is a gilt
medallion. The spine has gilt tooled
decoration as has the inside which is
of red leather.

Unpublished

630 Binding of Qiran-e Sa'adayn 'The Conjunction of Two Excellencies', by Amīr Khusraw Dihlawī
Height 11.7cm, width 26.8cm
Fundação Calouste Gulbenkian,
Lisbon, L.A. 187
Persia, Safavid period, early 17th
century

This manuscript was copied by
Sulṭān Muḥammad Nūr in 1515. It
has three miniatures in the court
style of Shah 'Abbās and one
unfinished illuminated title page. The
manuscript bears the donation seal to
the shrine at Ardabil. The binding
which is not contemporary with the
manuscript is of leather and has
moulded and gilt vegetal designs on a
blue, black, red and green
background. The binding is signed
on the inside of the flap Muḥammad
Ṣāliḥ al-Tabrīzī.

Published: Pope and Ackerman (1938–9,
pl. 978); Lisbon (1963, no. 141);
Ettinghausen (1972, pl. 19)

629

630

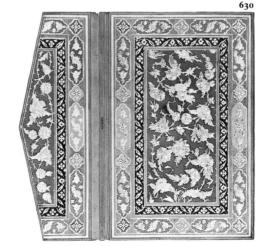

631 Drawing from a Muraqqa', Album

Height 22cm, width 16cm
Bibliothèque Nationale, Paris, Cabinet des Manuscrits, Arabe 6074
Persia (Isfahan) Safavid period, 17th century

This drawing (folio 20a) depicts a seated youth with a spray of flowers. It is drawn in ink with touch of colour, a red and gold belt and a white and blue striped turban. It is signed by Aqā Riẓā and may be dated to about 1600.

Published: Blochet (1926, p. 119, pl. LXXI); Sakisian (1929, pl. 168); Pope and Ackerman (1938–9, III, p. 1890); Stchoukine (1964, p. 104, pl. XXXIIIb)

632 Drawing from a Muraqqa', Album

Height 32.8cm, width 21.5cm
Imperial Library, Tehran, no. 1633
Persia (Isfahan), Safavid period, 17th century

This drawing of a handsome dervish holding a cup of wine and bringing his hand up to his head is signed by Riẓā 'Abbāsī and dated 1624. This is a fine example of the late work of Riẓā 'Abbāsī. He is identical with 'Aqa Riẓā.

Published: Atabay (1974, no. 144, pp. 297–8)

633 'Ajā'ib al-Makhlūqāt, 'The Wonders of Creation', by Zakarīyā ibn Muḥammad al-Qazwīnī

Height 29.8cm, width 17cm
Walters Art Gallery, Baltimore, W.652
Persia (Herat), Safavid period, 17th century

This manuscript consists of 214 folios with 14 miniatures written in the library of the governor of Khurasan, Ḥusāyn Khan Shamlu at Herat. It was completed in 1613. This miniature (folio 137b) depicts the *Waqwāq* tree. Although copied in Herat the miniatures are in the court style. Compare a *Shāhnāma* dated 1599 from Herat, see Robinson (1975, p. 177).

Published: Gray (1961, pp. 165–6); Grube (1962a, no. 104)

631

633

634

635

634 Shāhnāma by Firdawsī

Height 44.4cm, width 28cm
Her Majesty The Queen, MSA/6
Persia, Safavid period, 17th century

This manuscript contains 148
miniatures with one double
frontispiece, copied by Muḥammad
Ḥakim al-Ḥusāynī for the library of
Khān ʿAlī Qarajaghay Khān, a
nobleman under Shah ʿAbbās II and
keeper of the sanctuary at Mashhad.
The manuscript was completed in
1648. It was presented to Queen
Victoria by the wife of Kāmrān Shāh,
prince of Herat in 1839. This
miniature (folio 514b) depicts
Ardashīr and Gulnār on horseback.
It is attributed to Muḥammad
Qasīm, a leading painter under Shah
ʿAbbās II.

Published: Stchoukine (1964, p. 148,
pl. LII-LIII); Robinson (1967b, no. 78)

635 Koran

Height 24cm, width 17cm
Private Collection, England
North India, Sultanate period,
dated 1398

This is possibly the finest as well as
the earliest of a group of surviving
manuscripts from Northern India
with related script and decorative
repertory. Other dated examples are
two larger Korans, one in the National
Museum of Pakistan, Karachi,
(N.M. 1957–1033), dated 1447 and
another in the India Office Library,
London (Arabic 4142, Storey 1051),
dated 1453. A manuscript with
decorations in the same tradition
which may also be firmly associated
with the successor state of Jaunpur is
a Persian anthology in the British
Museum, London (Or. 4110).
This Koran in Arabic with inter-
linear Persian translation consists of
550 folios with 34 pages of illumina-
tions and decorated Sura headings. It
was copied by Maḥmūd Shaʿbān who
is described in the colophon as a
resident of the fort of Gālyūr (modern
Gwalior). The Arabic of the text
provides a fine example of the bihari
script which appears to be a
formalised derivative from an

extremely angular cursive naskhi
script current in the 11th century
empire of the Ghaznavids in
Afghanistan and the Punjab. The
more cursive hand of the interlinear
Persian translation and concluding
matter, undoubtedly of the same
scribe, is also characteristic of
surviving North Indian manuscripts
of the pre-Mughal period. Apart from
a limited amount of clearly distin-
guishable redecoration and repairs
done upon a number of damaged
pages (in the 18th century?), the
original illuminations of this manu-
script show a bewilderingly rich
repertory of ornament current in the
greater Delhi Sultanate at the time
before it was destroyed by Timur's
invasion. There appears to be a
survival of a post-Ghaznavid style as
well as an adaptation of indigenous
Indian floral ornament and colour
schemes. A strong influence from
Ilkhanid Persia is also present. The
double page illumination shown here
(folios 40v, 41r) is in gold, black,
blue, brown, yellow, red and opaque
white, beginning the third section of
Sura II, 253.

Unpublished

636

636 Binding of leather
Height 25.7cm, width 14.2cm
Victoria and Albert Museum,
London, no. 424/1896
Turkey, Ottoman period,
17th century

The leather is dark red and is
decorated on the outside with a gilt
and stamped central medallion,
corner pieces and border. The inside
is decorated with a lattice work
medallion and corner pieces on a blue
background. The style is close to
that of a binding dated 1665 in the
Turkish and Islamic Museum,
Istanbul (no. 401) and is a fine
example of the fully developed
Turkish binding. See Çiǧ (1971,
pl. XXI).

Unpublished

637 Firmān
Height 252cm, width 85cm
Ahuan Collection
Turkey, Ottoman period, 1777

This *firmān* or official decree entirely
in gilt script headed *ṭughrā* of Sultan
'Abdulḥamīd I (ruled 1774–89)
nominates Maḥmūd Pasha to the
office of grand vizier. This is a
complete document, presumably of
top quality.

Unpublished

637

638 Alf Layla wa Layla
Height 43.5cm, width 30cm
Imperial Library, Tehran, no. 2244
Persia (Tehran), Qajar period,
1860

This manuscript in six volumes
consists of a total number of 2280
pages of which 1134 are illustrated.
Each illustrated page contains 3 to 6
miniatures. The text is 30 lines to the
page. The copyist was Muḥammad
Ḥusayn Ṭihrānī, the 'Royal Scribe'.
The whole was completed in seven
years by 42 artists of which 34 were
painters. Abū al-Ḥasan Khān Ṣāni‘
al-Mulk was in charge of the painting.
The lacquer covers were the work of
Mirza Aḥmad.

Published: Sanghvi, Ghirshman and
Minorsky (1971, p. 111)

638

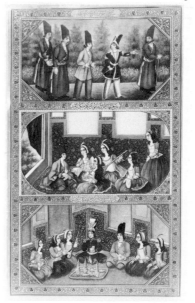

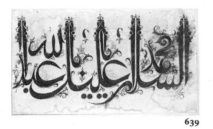

639

639 Blessing to Muḥammad
Height 19.3cm, width 34.2cm
Fogg Art Museum, Harvard
University, Cambridge, no. 1958.235,
gift of John Goelet
Persia, Qajar period, 19th century

This calligraphy is decorated with
vegetal motifs. It is signed Mir
Muḥammad and dated 1815. This
semi-popular art shows the vitality
and continuity of the calligraphic
tradition which, indeed, is still alive
in Islamic lands.

Unpublished

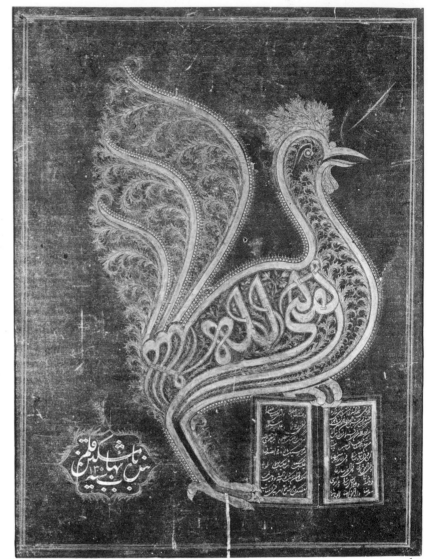

641

640

640 Binding of painted leather
Height 18.1cm, width 10.5cm
Victoria and Albert Museum,
London, no. 801/1942
Turkey, Ottoman period, about 1825

The leather is painted green and is
decorated with incised and gilt
vegetal motifs. This unusual style of
binding may owe something to
Western influence which was strong
in early 19th century Istanbul, but in
any case, the design is free, confident
and effective.

Unpublished

641 Calligraphic peacock
Height 47.8cm, width 35.8cm
Fogg Art Museum, Harvard
University, Cambridge, no. 1958.197,
gift of John Goelet
Persia, Qajar period, 1888

Within the peacock are the words
Bahā ullāh. It is signed by Mishkin
Qalam and dated 1888. Mishkin
Qalam is well known as having
employed his calligraphy for the
Bahā'ī faith. The peacock is standing
upon an open book which contains
writings of the Bahā'ī faith – a
sophisticated way of using calligraphy
for religious propaganda.

Unpublished

Architecture

Architecture is central to any understanding of Islamic art; this is the case not only because it is the setting for the other arts but because it is in Islamic architecture that many of the dominant themes have found their fullest expression. In this respect it may be analogous to Gothic art in Northern Europe. It is perhaps conceivable that the art of the Florence of the Medicis might be understood from a knowledge of 15th century painting; in fact architecture is often shown in the paintings and could be sensed through them. It would be virtually impossible however to have any feeling for the art of Isfahan at the time of Shah 'Abbās two centuries later, without an awareness of its architecture.

It was therefore considered crucial that architecture should be represented in this exhibition in such a way that its critical role could be understood and that sufficient examples should be seen in detail to enable both its control of space and of decoration to be appreciated.

The method which was chosen was to use colour slides of Islamic architecture, many of which were taken especially for this exhibition in the early part of 1975, and to project these in such a way that several parts of a building can be seen almost simultaneously; so that the eye can move from seeing the dome of a mosque to glancing at the detail on a column in the way in which it does when in an actual building. The slides are therefore back-projected simultaneously onto nine screens in order to build up such a mosaic of images. This also makes possible a comparison between elements – between different forms of tile decoration or between geometric systems at different scales for instance – by looking at a number of examples at the same time.

The sequence starts by showing the geographic extent of the Islamic world at different periods and the scenery which forms the background to much of its architecture. It then attempts to illustrate the typical texture of an Islamic city and some of the activities that occur within it and to which its architecture inevitably relates. The principal spatial and decorative themes, and the similarity of these at different scales, are shown before a number of building types are illustrated in historical sequences. The main sites and buildings shown are listed below and cover a period of about a thousand years. The intention is to emphasise the unity of Islamic architecture and the continuity of its tradition in a number of countries, despite the obvious regional variations which occur in an area which stretches from the north-west coast of Africa to

northern India. Central to that tradition is the architecture of the mosque and its religious symbolic forms.

The concluding section deals with the Islamic idea of the enclosed garden as an earthly paradise and uses the Alhambra as one of many possible examples in which many of the dominant elements of Islamic art can be seen together.

The following list indicates the principal sites at which photographs have been taken of cities, mosques, tombs, gardens and other monuments. Further examples of architecture are illustrated by miniature painting. The slides have not been chosen as a comprehensive survey but, rather, for their visual impact:

Agra, Balkh, Cairo, Cordoba, Damascus, Delhi, Divrigi, Edirne, Fatehpur Sikri, Fez, Granada, Isfahan, Istanbul, Kairouan, Kashan, Konya, Lahore, Marrakesh, Samarkand.

Photographs are by Roland and Sabrina Michaud, the commentary is based on notes by Titus Burckhardt. The sequences are edited and devised by Michael Brawne.

Additional photographs of miniatures are by Ellen Smart and the photograph of the mihrab and mosque enclosure of Bilad-Zahran in Saudi Arabia is by Geoffrey King.

Bibliography

In the catalogue entries bibliographical references are reduced to the name of the author and the year of publication, followed by the volume, page, plate or figure number. The bibliography is laid out in the same manner; the entries are arranged according to author and year of publication. References to exhibition catalogues appear under the city in which the exhibition was held followed by the date or, when there is a single author, under the name of that author.

Abel, A.
1930, *Gaibi et les grands faienciers d'epoque mamlouke*; Cairo
Ackermann, P.
1935, "The Talking Tree", *Bulletin of the American Institute for Persian Art and Archaeology, IV*, New York
Aga-Oglu, M.
1931, "A note on bronze mirrors", *Bulletin of the Detroit Institute of Arts*, 13
1941, *Safavid rugs and textiles, The collection of the Shrine of Imam 'Ali of Al-Najaf*, Colombia University
1948, *Dragon Rugs*, catalogue of an exhibition at the Textile Museum, Washington D.C.
Aini, K.
1966, *XVI century miniatures illustrating manuscript copies of the works of Jami from the USSR collections*, Moscow
Akimushkin, O. F. and Ivanov, A. A.
1968, *Persidskiye miniatyury XIV–XVII*, Moscow
Alexandria
1925, *Exposition d'Art Musulman, Les Amis de l'Art Alexandrie*
Amador de los Rios, R.
1873, "Arquetas arabigas de Plata y de marfil . . ." *Museo Español de Antiguedades*, VIII
Anonymous
1912, "Almirez arabe", *Museum: revista mensual de arte espanol*, 2, Barcelona
1974, "Chronique des Arts", *Gazette des Beaux Arts*, LXXXIII, Paris
de Aragones, D. M. J.
1958, *Museo Arqueologico de Toledo*
Arnold, T. W.
1931, *The Islamic Book*, London
Arnold, T. and Grohmann, A.
1929, *The Islamic Book*, Munich
Artola, G. T.
1957, *Bidpai manuscripts from Istanbul and Tehran*, Madras
Ashton, L.
1931, "The Persian Exhibition. IV. Textiles, some early pieces", *Burlington Magazine*, LVIII
Atabay, B.
1974, *Catalogue of Manuscripts in the Library of H.I.M. The Shah*, 4 volumes, Tehran
Atil, E.
1975, *Art of the Arab World*, Freer Gallery of Art, Smithsonian Institution, Washington D.C.
d'Avennes, P.
1877, *L'art arabe*
Baer, E.
1965, *Sphinxes and Harpies in Medieval Islamic Art*, Jerusalem
1968, "Fish-pond Ornaments on Persian and Mamluk Metal Vessels", *Bulletin of the School of Oriental and African Studies*, XXXI
Baghat, A.
1922, *La céramique égyptienne de l'époque musulmane*, Basle
Baghdad
1973, *Guide-Book to the Iraq Museum*
Bahrami, M.
1936, "le Probléme des ateliers d'étoiles de Faience Lustrée", *Revue des Arts Asiatiques*, X
1937, *Recherches sur les Carreaux de Revêtement Lustré du XIIIe au XVe Siècle*, Paris
1945, "A Master-Potter of Kashan", *Transactions of the Oriental Ceramic Society*, vol. 22
1949a, *Catalogue of the Quran exhibition in the Tehran Archaeological Museum*
1949b, *Iranian Art, Treasures from the Imperial Collections and Museums of Iran*, Metropolitan Museum of Art, New York
Ballion, A.
1974, *Islamic textiles*, Benaki Museum, Athens
Barrett, D.
1949, *Islamic Metalwork in the British Museum*, London
1952, *Persian Painting in the fourteenth century*, London
Batari, F.
1974, Catalogue of *Alte Anatolische Teppiche aus dem Museum für Kunstgewerbe in Budapest*, Steiermärkischen Landesmuseum Jvameum, Graz
Beattie, M.
1959, "Antique rugs at Hardwick Hall",

Bibliography

Oriental Art, N.S., V
1964, *Catalogue of the Rug in Islamic Art*, Temple Newsom House, Leeds
1968, "Coupled – column prayer rugs", *Oriental Art*, XIV, 4
1972, *The Thyssen – Bornemisza Collection of Oriental Rugs*, Castagnola
Beckwith, J.
1960, *Caskets from Cordoba*, London
Beirut
1974, *Art Islamique dans les collections privées libanaises par le Musée Nicolas Sursock*
van Berchem, M.
1894–1903, *Materiaux pour Corpus Inscriptiorum Arabicarum Egypte I*, Paris
1904, "Notes d 'archéologie arabe' ", *Journal Asiatique* 2nd ser III
1912, *Meisterwerke*
van Berchem, M., and Strzygowski, J.
1910, *Amida*, Heidelberg
Berlin
1935, *Islamische Teppiche*, Staatliche Museen
Berlin-Dahlem
1967, *Austelling der Museum für Islamische Kunst*
1971a, *Museum für Islamische Kunst, Islamische Kunst in Berlin*
1971b, *Museum für Indische Kunst, Katalog*
Bernis, C.
1956, "Tapicerica Hispano – Musulmana (Siglos XIII Y XIX)", *Archivo espanol de Arte*, XXIX, Madrid
Bernshtam, A. N.
1952, *Istoriko-arkheologicheskie ochermi tsentralnovo Tyan-Shanya i Pamiro-Alaya, Materiali i issledovaniya po arkheologii SSSR* 26, Moscow/Leningrad
Bernus, M.; Marchal, H. and Vial, G.
1971, "Le suaive de Saint Josse", *Bulletin de Lisson du Centre International d'Etudes des Textiles Anciens*, no. 33,
Bertaux, E.
1913, *Musée Jacquemart-André. Catalogue itineraire*, Paris
Binghamton
1975, *Islam and the Medieval West*, loan exhibition at the University Art Gallery, Catalogue compiled and edited by S. Ferber
Binyon, L.
1928, *The Poems of Nizámi*, London
Binyon, L. and Wilkinson, J. S.
1931, *The Shahnama of Firdawsi*, Oxford
Binyon, L., Wilkinson, J. V. S. and Gray, B., 1933, *Persian miniature painting including a critical and descriptive catalogue of the miniatures exhibited at Burlington House*, Oxford
Blochet, E.
1920, *Les peintures des manuscrits orientaux de la Bibliothèque Nationale*, Paris
1923, *Notices sur les manuscrits persans et arabes de la collection Marteau*, Paris
1926, *Les enluminures des manuscrits orientaux – Turcs, arabes, persans – de la Bibliothèque Nationale*, Paris
1928, "*Peintures* orientales de la collection Pozzi", *Société Française de reproductions de Mss à peintures, Bulletin*, XII
1929, *Musulman Painting, XII–XIIIth century*, London
Bode, W. van and Kühnel, E.
1970, *Antique rugs from the Near East*, London (translated by Ellis)
von Bogolyubow, A. A.
1908–9, *Tapis de l'Asie centrale . . .*, St. Petersburg
Bombaci, A.
1965, "Les Toughras enlumines de la collection de documents Turcs des archives d'etat de Venice", *Atti del secondo congresso internazionale di Arte Turca. Venezia 1963*, Naples
Boston
1969, *Bulletin of the Museum of Fine Arts*
Botkine
1911, *Catalogue collection Botkine*, St. Petersburg
Bourgoin, J.
1892, *Précis de l'Art arabe*, Paris
Bowie
1970, *Islamic Art across the World*, Indiana University Art Museum
Brian, D.
1939, "A Reconstruction of the Miniature Cycle in the Demotte Shah Namah", *Art Islamica*, VI
Brisch, K.
1961, "Las celosías de la Mezquita de Córdoba", *al-Andalus*, 26
Brooklyn
1963–4, *Catalogue of the Exhibition of the Erickson Collection*, Brooklyn Museum
Buchthal, H.
1942, "Early Islamic miniatures from Baghdad", *The Journal of the Walters Art Gallery*, V
Buckley, W.
1935, "Two glass vessels from Persia", *Burlington Magazine*, LXVII
Budapest
1972, Exhibition at the Iparmüveszeti Museum
Carswell, J.
1972, *Kutahya Tiles and Pottery from the Armenian Cathedral of St. James, Jerusalem*, Oxford
Catesjón, R.
1945, "Nuevas excavaciones en Madinat al-Zahra": el salon de "Abu al-Rahman III", *al-Andalus*, 10
Cairo
1969, *Islamic Art in Egypt*
969–1517, Exhibition Catalogue, Ministry of Culture of the U.A.R.
Camón-Aznar, J.
1939, "las piezas de cristal de roca y arte Fàtimí encontrades en Espana : Cote del Monasterio de Celanova", *al-Andalus*, IV
Çiğ, K.
1971, *Türk kitap kaplari*, Istanbul
Clairmont, C. W.
1964, "Some Glass Vessels in the Benaki Museum, Athens", *Annales du ze Congrès des Journées Internationales du verre*, Liège
Clauson, G. L. M.
1928, "A Hitherto unknown Turkish Manuscript in 'Uighur' Characters", *Journal of the Royal Asiatic Society*, January
Cleveland
1944, *Loan Exhibition of Islamic Art, Cleveland Museum of Art*
1966, *The Cleveland Museum of Art Handbook*
1970, *The Cleveland Museum of Art Handbook*
Cologne
1966, *Majolika*, Kunstgewerbemuseum
Copenhagen
1935, *Kunstmuseets Aarsskrift*
Corning
1970, *Journal of Glass Studies, Corning Museum of Glass*, XII
Creswell, K. A. C.
1932, *Early Muslim Architecture . . .* Part One, Oxford
1942, *Early Muslim Architecture . . .* Part Two, Oxford
1969, *Early Muslim Architecture . . .* 2nd Revised Edition, Oxford
Damascus
1964, *Exposition des verres Syriens à travers l'histoire organisée à l'occasion du 3e congrès des Journées Internationales du verre au Musée National de Damas de 14–21 Novembre*
1969, *Catalogue du Musée National de Damas, publié à l'occasion de son Cinquantenaire*
David-Weill, J.
1931, *Catalogue Général du Musée Arabe du Caire : les bois à épigraphes jusqu'à l'époque mamlouke*
Davidovich, E. A. and Litvinski, B. A.
1955, *Arkhelogichesk Ocherk Isfarinskovo Raiona, Trudi Akademiya Nauk Tadzhikskoi SSR*, 35, Stalinbad
Davids-Samling, C. L.
1948, *C. L. Davids-Samling I*
1970, *Fjerde del Jubilaeumsskrift*,
1975, *Islamisk Kunst*, Copenhagen
Day, F. E.
1952, "The tiràz silk of Marwàn", *Archaeologica Orientalia in Memoriam Ernst Herzfeld*
1954a, "The inscription of the Boston 'Baghdad' silk", *As Orientalis*, I
1954b, "Review of *Two Thousand Years of Textiles* by Adel Conlin Weibel", *Ars Orientalis*, I
Day, F. E. and Wiet, G.
1951, "Review of Wiet's *Soieries Persanes* and subsequent controversy between Wiet and Day", *Ars Islamica*, XV–XVI

Degrand
1903, "Le trésor d'Izgherli", *Comptes rendus de l'Académie des Inscriptions et Belles-Lettres*
Delft
1948–9, *Dosterse tapijten*, exhibition
Denike, B.
1923, *The art of the East*, Kazan
Denny, W. B.
1972, "Ottoman Turkish textiles", *Textile Museum Journal*, III, 3
Devonshire, R. L.
1919, "Sultan Salâh ed-Din's writing box in the National Museum of Arab Art, Cairo", *Burlington Magazine*, XXXV
Dihwaji, S.
1961, "Jámi al-Nabí Jurjis fi'l-Mausil', *Sumer*, 17
Dilley, A. H.
1959, *Oriental rugs and carpets*, New York
Dimand, M. S.
1932, "Arabic Woodcarving of the ninth century", *Bulletin of the Metropolitan Museum of Art*, XXVII
1952, "Studies in Islamic Ornament. II. The Origin of the Second Style of Samarra Decoration", *Archaeologica Orientalis in Memoriam Ernst Herzfeld*, New York
1973, *Rugs in the Metropolitan Museum of Art*, New York
Dodd, E. C.
1974, "On a bronze rabbit from Fatimid Egypt", *Kunst des Orients* VIII/1–2
Dubler and Teres
1953–9, *La meteria medicade Dioscorides*, Barcelona
Duda, D.
1972, "Die Malerei in Tabriz unter der Sultan Uwai und Husain", *Der Islam*, 49 (2)
Düsseldorf
1973, *Islamische Keramik*, Hetjiens – Museum in cooperation with the Museum fur Islamische Kunst, Berlin-Dahlem
Dyakonov, M. M.
1939, "Bronzovi Vodoley 1206 g". *Mémoires du IIIè Congrès International d'Art et d'Archéologie Iraniens*, Moscow/Leningrad
Eilers, W.
1941, "Ein früislamische Küfi-Inschrift aus Luristan", *Zeitschrift der Deutschen Morgenländischen besselschaft*, N.F. 20
Ellis, C. G.
1967, "Mysteries of the misplaced Mamluks", *Textile Museum Journal*, II, Washington D.C.
1969, "The Ottoman Prayer Rugs", *Textile Museum Jocombal*, II, 4
1972, "The Portuguese Carpets of Gujarat", *Islamic Art in the Metropolitan Museum of Art*, ed. R. Ettinghausen
1975, "The 'Lotto' pattern as a fashion in carpets", *Festschrift für Peter Wilhelm*

Meister, Hamburg
Elsburg, H. A. and Guest, R.
1934, "Another silk fabric woven at Baghdad", *Burlington Magazine*, LXIV
1936, "The Veil of Saint Anne", *Burlington Magazine*, LXVIII
al-Emary, A. A.
1967, "Studies in some Islamic objects newly discovered at Qus", *Annales Islamologiques* VII, Cairo
Enderlein, V.
1969, *Die Miniaturen der Berliner Baisonqur-Handschrift*, Leipzig
Enlart, C.
1920, "Un tissu persan du Xc siècle", *Académie des Inscriptions et Belles-Lettres, Fondation Eugéne Piot, Monuments en Mémoires*, XXIV
Erdmann, K.
1938, "Kairener Teppiche: Teil I Europäische und islamische Quellen des 15–18 Jahrhunderts", *Ars Islamica*, V, 2
1960, *Orientalknot carpets*
1962, "Neuerworbere Gläser der Islamischen Abteilung, 1958–61," *Berliner Museen, Berichte ans dem ehem, Preussischen Kunstsammlungen*, II
1963, "Weniger bekannte Uschab-Muster", *Kunst des Orients*, Bd, IV
1967, *Iranische Kunst in Deutschen Museen*, Wiesbaden
1970, *Seven Hundred Years of Oriental Carpets*, London (translated by Beattie and Herzog)
Esin, E.
1972, "Four Turkish Bakhshi active in Iranian Lands", *V International Congress of Iranian Art and Archaeology, 1968*, Tehran, vol. II
Ettinghausen, R.
1934, "Early Shadow Figures", *Bulletin of the American Institute for Persian Art and Archaeology*, 1/6
1935, "A Signed and dated Seljuq Qur'an", *Bulletin of the American Institute for Persian Art and Archaeology*, IV, 2
1936, "Evidence for the Identification of Kashan Pottery", *Ars Islamica*, III
1943, "The Bobrinski 'kettle': patron and style of an Islamic bronze", *Gazette des Beaux-Arts* series 6, 24
1954, "The covers of the Morgan Manafi Manuscript and other early Persian bookbindings", *Studies in art and literature for Belle da Costa Greene*, Princeton
1955, "Interaction and Integration in Islamic Art", *Unity and Variety in Muslim Civilisation*, ed. G. Von Grunebaum, Chicago
1957, "The 'Wade Cup' in the Cleveland Museum of Art, its origin and decorations", *Ars Orientalis*, II
1959a, "Near Eastern Book Covers and their influence on European bindings. A report", *Ars Orientalis*, III 1959b, "New light on Early Animal Carpets",

Aus der Welt der Islamischen kunst ; Festschrift für Ernst Kühnel, Berlin
1962, *Arab Painting*, Geneva
1972, *Persian Art*, Calouste Gulbenkian Collection, Lisbon
Falke, O. von
1913, *Kunstgeschichte der Seidenwebererei*
Fehervari, G.
1963, "Two early 'Abbasid lustre bowls and the influence of Central Asia", *Oriental Art*, N.S.IX
1973, *Islamic pottery : a Comprehensive study based on the Barlow Collection*, London
Ferrandis, J.
1935/40, *Marfiles de Occidente*, tomo I, 1935, tomo II, 1940, Madrid
Fleury, R. de
1883–9, *La Messe*
Flügel, G.
1830, "Einige nähere Andeutungen über die Handschriften auf der Bibliothek in München . . ." *Wiener Jahrbücher der Literatur*, 49
1865, *Die arabischen, persischen und turkischen Handschriften der kaiserlich-königlichen Hofbibliothek zu Wien*
Flury, S.
1920, *Islamische Schriftbänder, Amida Diarbekz, XI. Jahrhundert – Anhang : Kairuan, Mayyafariqin, Tirmidh*, Bâle-Paris
Fransis, B. and Naqshabandi, N.
1949, "al-áthár al-khashab fi Dár al-Athár al-'Arabiyya", *Sumer* V
1951, "Al-maharib al-qadima, fi Mathaf al-Qasr al-'Abbasi bi-Baghdad", *Sumer*, 7
Frothingham, A.
1951, *Lustreware of Spain*, New York
Galerkina, O.
1970, "On some miniatures attributed to Bihzad from Leningrad collections", *Ars Orientals*, VIII
1973, *Iranian miniatures of the fifteenth and sixteenth centuries in the Sultzkov Stchoukina Public Library*, Leningrad
Geijer, A.
1951, *Oriental Textiles in Sweden*, Copenhagen
Ghirshman, R.
1954, *Iran, From the Earliest Times to the Islamic Conquest*, Penguin, London
Girbal, E. C.
1877, "Arqueta Relicario de la Catedral de Gerona", *Museo Espanol de Antiquidades*, Madrid, 8
Godman,
1901, *The Godman Collection of Oriental and Spanish pottery and glass 1865–1900*, London
Golombek, L.
1971, "The Chronology of Turbar-i Shaykh Jam", *Iran*, IX
1972, "Towards a Classification of Islamic Painting", *Islamic art in the Metropolitan Museum of Art*, New York

Bibliography

Gómez-Moreno, M.
1926, *Catalogue Monumental de Espana : Provincia de Leon*
1940, "El bastón del Cardenal Cisneros", *Al-Andalus*, 5
1941, "Capiteles árabes documentaros", *al-Andalus*, 6
1951, *El Arte Arabe Espanol hasta los Almohades. Arte Mozarabe, Ars Hispaniae : Historia Universal del Arte Hispanico*, iii, Madrid
1952, *Ars Hispanial : Historia universal del arte hispanico : III : el arte arabe espanol hasta los Almohades ; ars mozarabe*, Madrid
Gottlieb, T.
1910, *K.K. Hofbibliotek, Bucheinbände : Auswahl von technisch und geschichtlich bemerkenwerten Stücken*, Vienna
Gratzl, E.
1928, *Jahrbuch der Einbandkunst*, II
Gray, B.
1940, *Masterpieces of Persian miniatures painting*, New York
1961, *Persian Painting*, Geneva
1962, *Persian miniatures from ancient manuscripts*, A Mentor-UNESCO art book
1972, "Thoughts on the origin of 'Hedwig' Glasses", *Colloque International sur l'Histoire du Caire 27 Mars – 5 Avril, 1969*, Cairo
1976, *The World History of Rashid al-Din*, London
Gray, B. and Godard, A.
1956, *Persian miniatures – Imperial Library*, New York Graphic Society, by arrangement with UNESCO
Grohmann, A.
1963, "Die Bronzeschale m. 31–1954 in Victoria and Albert Museum". *Beiträge zur Kunstgeschichte Asiens. In Memoriam Ernst Diez*, Istanbul
1971, *Arabische Palaegraphie*, II, Vienna
Grube, E.
1959, "Materialien zum Dioskurides Arabicus", *Aus der Weld, der Islamischen Kunst Festschrift Für Ernst Kühnel*, Berlin
1962a, *Muslim Miniature Paintings from the 13th to 19th century, from collections in the United States and Canada.* Exhibition Catalogue, Venice
1962b, "Miniatures in Istanbul libraries", *Pantheon*, XX
1963, "Raqqa Keramik in der Sammlung des Metropolitan Museum in New York," *Kunst des Orients.* IV
1966, *The World of Islam*, New York and Toronto
1968a, *The Classical style in Islamic painting. The early school of Herat and its impact on Islamic painting of the later 15th, 16th and 17th centuries*, New York
1968b, 'The Ottoman Empire', *The Metropolitan Museum of Art Bulletin* January

Guest, A. R.
1906, "Notice of some Arabic inscriptions on textiles in the South Kensington Museum", *Journal of the Royal Asiatic Society*, London
1923, "Further Arabic inscriptions on textiles", *Journal of the Royal Asiatic Society*, London
Guest, A. R. and Kendrick, A. F.
1932, "The Earliest dated Islamic textiles", *Burlington Magazine*, LX
Hamid, A. A.
1967, 'Dirasa li ba'd al-tuhaf al-ma 'dania al-islamia fi l-mathaf al-'iraqi, *Sumer*, 23
Hartner, W.
1938, 'The pseudo-planetery nodes of the moon's orbit in Hindu and Islamic iconographies", *Ars Islamica*, 5
Hasan, Z. H.
1937, *Treasures of the Fatimids*, Cairo, in Arabic
1938, *On Islamic Art*, Cairo, in Arabic
1951, "New pieces of Fatimid lustre-wares", *Bulletin of the Faculty of Arts*, XIII/2, Cairo University, in Arabic
Hauser, W. and Wilkinson C. K.
1942, 'The Museum's excavations at Nishapur", *Bulletin of the Metropolitan Museum of Art*, New York XXXVII
d'Hennezel, H.
1930, *le Décordes Soieries d'Arts*, Paris
Herz, M.
1895, *Catalogue sommaire des monuments exposés dans le musée National de l'Art Arabe*, Cairo
1906, *Catalogue raisonnée des monuments exposés dans le musée National de l'Art Arabe*, 2nd edition, Cairo
1907, *Descriptive catalogue of the objects exhibited in the National Museum of Arab Art*, Cairo
1913, "Boiseries fatimides aux sculptures figurales", *Orientalisches Archiv* III/4, Leipzig
Herzfeld, E.
1923, *Die Wandschmuck der Bauten von Samarra und siene Ornamentik*, Berlin
Hill, D., and Grabar, O.
1967, *Islamic Architecture and its Decoration 800–1500*, London
Hollis, H.
1938, "Two Iranian Pottery Bowls", *Bulletin of the Cleveland Museum of Art*
1945, "Two Fustat Bowls", *Bulletin of the Cleveland Museum of Art* (June)
Hourani, G.
1951, *Arab Seafaring*, Princeton
Inostrantsev, K. A.
1908, Soobrazheniya po dvum voprosam musulmanskoy afkheologii otnosyaschimsya k Rossii", *Zap. Vost. Otd. Imp. R. Arkheol. Obshchestva*, 18
Jackson and Johannan
1914, *Catalogue of the collection of Persian manuscripts presented to the Metropolitan Museum of art at New York by A. S. Cochran*

Jacoby, H.
1923, *Eine Sammlung orientalischen Teppiche*, Berlin
Jacquemart, A.
1869, "Exposition de l'Union Centrale des Beaux-Arts", *Gazette des Beaux-Arts*
Jenkins, M.
1968, "Muslim, an early Fatimid ceramist", *Bulletin of the Metropolitan Museum of Art*, XXVI/9, New York
Jones, D.
1972, "The Cappella Palatina in Palermo: Problems of attribution", *Art and Archaeology Research Papers (AARP)*, 2, London
1975, "Notes on a tattooed Musician: a drawing of the Fatimid period", *Art and Archaeology Research Papers (AARP)*, 7, London
Karabacek, J.
1870, 'Die liturgischen Gewander mit arabischen Inschriften aus der Marienkirche in Danzig", *Mitteilungen des Österreichischen Museums für Kunst und Industrie*, III
1874, *Beiträge zur Geschichte der Mazjaditen*, Leipzig
Karlsruhe.
1955, *Der Türkenlouis*, Badisches Landesmuseum
Kelekian, D.
1910, *The Kelikian Collection of Persian and Analogous Potteries 1885–1910*, Paris
Kendrick, A. F.
1914, "Carpets at Boughton House, *Burlington Magazine*, XXV
1924, *Catalgoue of Muḥammadam Textiles of the Medieval Period*, Victoria and Albert Museum
Kendrick, A. F. and Guest, R.
1926, "A silk fabric woven in Baghdad", *Burlington Magazine*, XLIX
Krachkovskaya, V. A.
1960, "O bronzovikh zerkalakh Donskovo Muzeya", *Issledovaniya po Istorii Kul'turi Narodov Vostoka*
Kühnel, E.
1922, *Miniaturmalerei im Islamischen Orient*, Berlin
1924, *Maurische Kunst*, Berlin
1925, *Islamische Kleinkunst*, Berlin
1931, "Die Baysonghur – Handschrift der Islamische Kunstabteilung", *Jahrbuch der Preuszischen Kunstsammlungen*, cII
1934, "Die Abbasichischen lüsterfayencen", *Ars Islamica*, I
1935, "La tradition copte dans les tissus musulmans", *Bulletin de la Société d'archéologie copte*, IV
1942, *Islamische Schriftkunst*, Berlin
1955, "Die Osmanische Tughura", *Kunst des Orients*, II
1963, *Islamische Kleinkunst*, 2nd edition. Brunswick
1967, "Some observations on Buyid silks", *Survey of Persian Art*, XIV
1970, *Islamic Art*, London
1971, *Die Islamischen Elffenbein-*

skulpturen *VIII–XIIIJh*, Berlin
Kühnel, E. and Bellinger, L.
 1957, *The Textile Museum Catalogue raisonné : Cairena rugs and others technically related, 15–17th century*, Washington D.C.
Lamm, C. J.
 1930, *Mittelterliche Gläser und Steinschnittarbeiten a.s dem Nahen Osten*, Berlin
 1936, "Fatimid Woodwork, its Style and Chronology", *Bulletin de l' Institut d'Egypte*, XVIII, Cairo
 1937, "The Marby Rug", *Orient-Sällskarpets arsbok*
Lane, E. W.
 1863, *Arabic-English lexicon*, London
 1908, *The Manners and Customs of the Modern Egyptians*, London
Lane, A.
 1947, *Early Islamic Pottery*, London
 1948, "Sung Wares and the Saljuq Pottery of Persia, *Transactions of the Oriental Ceramic Society*, vol. 22
 1957a, *Later Islamic Pottery*, London
 1957b, "Ottoman Pottery of Isnik", *Ars Orientalis*, II
 1960, *Guide to the Collection of tiles in the Victoria and Albert Museum*, London
Lane-Poole, S.
 1886, *The Art of the Saracens in Egypt*, London
Lanci, M.
 1845, *Trattato delle simboliche rappresentanze arabiche*, 2 vols, Paris
Lemberg, M., Vial, G. and Hofenk-de-Graff,
 1973, "Les soieries Bouyides de le Fondation Abegg à Berne", *Bulletin de Liason du Centre International des Textiles Anciens*, 37, Lyon
Leth, A.
 1975, *The David Collection : Islamic Art*, Copenhagen
Levey,
 1962, "Medieval Arabic bookmaking and its relation to early chemistry and pharmacology", *Transactions of the American Philosophical Society*, N.S. 52, 4
Lévi- Provencal, E.
 1931, *Inscriptions arabes d'Espagne*, Leiden-Paris
Lièvre, E.
 1880–3, *Musée graphique*, IV
Linas, C. de.,
 1860, *Anciens vêtements-sacerdotaux et anciens tissus conservés en France*, Paris
Lisbon,
 1963, *Oriental Islamic Art, Collection of the Calouste Gulbenkian Foundation*, Museo Nacionale de Arte Antiga
Llubiá, L. M.
 1973, *Ceramica Medieval Española*, Barcelona
London,
 1885, *Illustrated Catalogue of Specimens of Persian and Arab Art exhibited in 1885*, Burlington Fine Arts Club

 1914, Guide to an exhibition of Tapestries, Carpets and Furniture lent by the Earl of Dalkieth, Victoria and Albert Museum
 1931, *Catalogue of the International Exhibition of Persian Art*, Royal Academy of Arts
 1950a, *Brief Guide to Turkish and Woven Fabrics*, Victoria and Albert Museum
 1950b, *Brief Guide to the Persian embroideries*, Victoria and Albert Museum
 1951, *Fifty Masterpieces of Textiles*, Victoria and Albert Museum
 1960, *Italian Art and Britain*, Royal Academy of Arts
 1968, *Masterpieces of Glass*, British Museum
 1969, *Islamic Pottery 800–1400*, Victoria and Albert Museum
de Lorey, E.
 1938, "Behzad", *Gazette des Beaux Arts*, 6e per XX
Los Angeles,
 1959, *Woven Treasure of Persian Art*, catalogue of an exhibition at the Los Angeles County, Museum
 1973, *Catalogue of the Nasli M. Heeramaneck Collection, Los Angeles County Museum of Art*
Luschey, I. S.
 1969, "Der Wand- und Deckenschmuck eines safavidischen Palastes in Nayin", *Archäologische Mitteilungen aus Iran*, NF2
Ma'ani, A.
 1966, *Catalogue of the Qur'an exhibition*, Mashhad
Mackie, L. W.
 1973, *The Splendour of Turkish Weaving*, the Textile Museum, Washington, D.C.
Maldonado, B. P.
 1966, "Nuevos capitoles hispano-musulmanes en Sevilla", *al-Andalus*, 31.
 1968, "Influjos occidentals en el arte del califato de Cordoba", *al-Andalus*, 33
Marçais, G.
 1925, "Coupoles et plafonds peints de la Grande Mosquée de Kairouan": *Notes et documents publiés par la Direction des Antiquites et Arts*, Paris-Tunis
Marçais, G. and Poinssot, L.
 1948–52, *Objets Kairouannais IXe au XIIIe siècle*, Tunis
Marçais, G. and Wiet, G.
 1934, Le "Voile de Sainte Anne" d'Apt, *Academie des Inscriptions et Belles-Lettres, Fondation Eugène Piot, monuments et mémoires*, XXXIV
Marteau and Vever
 1912, *Miniatures Persanes Exposées au musée des arts décoratifs*, Paris
Martin, F. R.
 1901, *Die Persichen Prachstoffe im Schloss Rosenborg*, Copenhagen
 1912, *The Miniature Painting and Painters of Persia, India and Turkey from the 8th to the 18th century*, London

 1926, *Miniatures from the period of Timur in a Mss. of Sultan Ahmad Jalair*, Vienna
 1927, *The Nizami manuscript from the library of the Shah of Persia, now in the Metropolitan Museum at New York*, Vienna
Martin, F. R. and Arnold, T. W.
 1926, *The Nizami Manuscript in the British Museum*, Vienna
Mashhad
 no date, *Guide to the Museum of the Shrine of Imam Riza*
Massé, H.
 1944, *Le livre des merveilles du Monde*, Paris
May, F. L.
 1957, *Silk textiles of Spain, eighth to fifteenth century*
Mayer, L. A.
 1937, "New material for Mamluk heraldry", *Journal of the Palestine Oriental Society*, 17
 1952, *Mamluk costume*, Geneva
 1958, *Islamic Woodcarvings and their Works*, Geneva
 1959, *Islamic Metalworkers and their work*, Geneva
McMullan, J. V.
 1965, *Islamic Carpets*, New York
Mehrez/Muhriz, G.
 1944, "Fatimid lustre wares in the collection of "Alī Ibrāhīm Pāshā", *Bulletin of the Faculty of Arts*, VII, Cairo University, in Arabic
Melikian-Chirvani, A. S.
 1967, 'Trois manuscrits de l'Iran seldjoukide", *Ars Asiatiques*, XVI
 1969, "Bronzes et cuivres iraniens du Louvre I, *Journal Asiatique*
 1972, "Baba Hatem. Un chef d'oeuvre inconu d'époque Ghaznévide en Afghanistan" *The Memorial Volume of the Vth International Congress of Iranian Art and Archaeology, 11–18 April, 1968*, Tehran.
 1973, *Le bronze iranien*, Paris
 1974, "Les bronzes du Khorassan I", *Studia Iranica*, 3, pt. 1
Meineke, M.
 1972, "Zur mamlukischen Heraldik", *Mitteilungen des Deutschen Archaeologischen Instituts, Abteilung Kairo. XXVIII/2*, Cairo
Meredith-Owens, G. M.
 1969–70, "A new illustrated Persian anthology", *British Museum Quarterly*, XXXIV
 1970, "Some remarks on the miniatures in the Society's Jami al-Tawarikh", *Journal of the Royal Asiatic Society*, London
 1973, *Persian Illustrated Manuscripts*, British Museum Publications, London
Migeon, G.
 1903, *Exposition des Arts musulmans au Musée des Arts Décoratifs*, Paris.
 1905, "Notes d'archéologie musulmane", *Gazette des Beaux-Arts*, I
 1921, *Musée du Louvre : L'Orient*

Musulman, Paris
1922a, "Orfèvrerie d'argent de style oriental trouvée an Bulgarie", *Syria*, 3
1922b, *Musée du Louvre : L'Orient Musulman*, Paris
1927, *Manual d'Art Musulman*, 2nd edition, Paris
Miles, G. C.
1952, "Mihrab and anazah", *Archaeologica Orientalia in Memoriam Ernst Herzfeld*, New York
Miller
1972, *Turkish Ceramics*
Miner, D. E.
1957, *The history of bookbinding, 525–1950 AD. An exhibition organised by the Walters Art Gallery*, Baltimore
Minorsky, V.
1931, "Two unknown Persian manuscripts", *Apollo*, February
Monneret de Villard, U.
1938, *Monumenti dell'Arte musulmana in Italia. I. – La cassette incrusta della Cappella Palatina di Palermo*, Rome.
Morley, W.
1854, *A Descriptive Catalogue of the historical manuscripts in the Arabic and Persian languages preserved in the library of the Royal Asiatic Society of Great Britain and Ireland*, London
Moscow
1954, *Gosudarstvenngo Oruzheinaya Palata Moskovskogo Kremlya*
Munich
1910, *Ausstellung von Meisterwerken Muhammadanischen Kunst*
Murray, H. J. R.
1913, *A History of Chess*, Oxford
Mustafa, M.
1955, *The Museum of Islamic Art. A Short Guide*, Cairo
1958, *Unity in Islamic Art*, Cairo
1959, *Miniatures of the school of Behzad in Cairo collections*, Baden-Baden
Naumann, E. and R.
1969, "Ein Kösk in Sommerpalast des Abaqa Khan auf dem Takht-é Sulaiman und seine Dekoration", *Forschungen für Kunst asians : in mem. Kurt Erdmann*, Istanbul
New York
1949, *6000 Years of Persian Art*, exhibition at the Iranian Institute
Ocana-Jiménez, M.
1944, "Inscripciones árabes descubiertas an Madinat al-Zahra' en 1944", *al-Andalus*, 10
Öz, T
1957, *Turk kumas va kadifeleri*, Istanbul
no date, *Turkish Ceramics*, Ankara
Paris
1878, *Gazette des Beaux Arts*, 1878, Notice of the exhibition held in the Galéries Orientales du Trocadéro
1961, *Sept mille ans d'art en Iran.* Catalogue of an exhibition held at the Petit Palais
1971, *Arts de l'Islam, des origines a 1700 dans les collections publiques françaises,*

Orangerie des Tuileries
1973, *Trésors d'Orient*, Bibliothèque Nationale
Pauty, E.
1931, *Catalogue général du Musée Arabe du Caire : les bois sculptés jusqu'a l'époque ayyoubide*
Petersen, T.
1954, "Early Islamic Bookbindings and some of their Coptic Relations", *Ars Orientalis*, I
Petrasch, E.
1970, *Die Türkenbeute*, Badische Landesmuseum, Karlsruhe
Pezard, M.
1910, *Le Céramique Archaique de l'Islam et ses Origines*, Paris
Philadelphia
1916, *Catalogue of the Special Exhibition held at the University Museum*
Phillipe, J.
1970, *Le Monde Byzantin dans l'Histoire de la verrerie (Ve–XVIe siècles)*, Bologna
Pidal, R. M., ed.
1935, *Historia de Espana* 6 vols., Madrid
Pinder-Wilson, R. H.
1954, "Some rock crystals of the Islamic period", *British Museum Quarterly*, XIX
1957a, "An early Fatimid Bowl", *Aus der Welt der Islamische Kunst, Festscrift für E. Kühnel*, Berlin
1957b, *Islamic Arts, 100 plates in colour*, London
1958a, *Persian Painting of the 15th Century*, London
1958b, "Bihzād", *Encyclopedia Universale dell'Arte.*
1960, "A Hedwig Glass for the Museum", *British Museum Quarterly*, XXII
1960–1, 'Tughras of Suleyman the Magnificent", *British Museum Quarterly*, 23
1963a, "A Persian jade cup", *British Museum Quarterly*, XXXVI
1963b, "Cut-glass vessels from Persia and Mesopotamia", *British Museum Quarterly*, XXVII
1968, "Pre-Islamic Persian and Mesopotamian Islamic and Chinese (Glass)", *Materpieces of Glass*, British Museum, London
1970, "Glass in Asia during the T'ang period: *Pottery and Metalwork in T'ang China, their chronology and external relations, Colloquies on Art and Archaeology in Asia*, no. 1, University of London
Pinder-Wilson, R. H. and Brooke, C. N. L.
1973, "The Reliquary of St. Petroc and the Ivories of Norman Sicily", *Archaeologia*, CIV, Oxford-London
Pinder-Wilson, R. H. and Scanlon, G. T.
1973, "Glass finds from Fustat", *Journal of Glass Studies*, XV
Pope, A. D., and Ackerman, P. (eds.)
1938–9, *A Survey of Persian Art*, 6 vols, Oxford

Puertas, A. F.
1971, "Tabla Epigrafiada Almohade", *Miscelanea de Estudios Arabes y Hebraicos*, XXI, Granada
1972, "Tabla Epigrafiada Almohade", *Miscelanea de Estudios Arabes y Hebraicos*, XXI, Granada
Pugachenkova, G. A., and Rempel, L. I.
1965, *Istoriya Isskustvo Uzbekistana s drevheischich Vremen de seredunui deryatnadtsatoga veka*, Moscow
Qadi-Ahmad
1959, "Calligraphers and Painters", *Freer Gallery of Art Occasional Papers*, III, 2, Washington D.C., translated from the Russian by V. Minorsky
Rastatt
1722, *Inventory of the "Turkish Rooms"*, Karlsruhe
Reath, N. A. and Sachs, E. B.
1937, *Persian Textiles and their technique from the sixth to the eighteenth centuries*, New Haven
Reinaud, J. T.
1828, *Monuments arabes, persanes, et turcs du cabinet de M. le duc de Blacas et d'autres cabinets.* 2 vols. Paris
Reitlinger, G.
1951, "Unglazed relief pottery from Northern Mesopotamia", *Ars Islamica*, XV-XVI
Répertoire
1933, *Répertoire Chronologique d'epigraphic arabe*
1935, *Répertoire Chronologique d'epigraphic arabe*
1936, *Répertoire Chronologique d'epigraphic arabe*
1937, *Répertoire Chronologique d'epigraphic arabe*
Riano, J. F.
1879, *The Industrial Arts of Spain*, London
Ricci, S., de.
1931, *Catalogue of an exhibition at the Hotel de Sagan*, Paris
Rice, D. S.
1953a, "Studies in Islamic metalwork III", *Bulletin of the School of Oriental and African Studies*, XV/2, London
1953b, "The Aghani miniatures and religious painting in Islam, *Burlington Magazine*, XCV
1954a, "Review of Archaeologica orientalis in Memoriam Ernst Herzfeld", *Ars Orientalis*, I
1954b, "The Seasons and the Labors of the months in Islamic Art", *Ars Orientalis*, I
1957a, "Inlaid brasses from the workshop of Ahmad al-Bhaki al-Mawsili", *Ars Orientalis*, 2, 26
1957b, "Two unusual Mamluk metal works", *Bulletin of the School of Oriental and African Studies*, XX
Rice, D. T.
1965, *Islamic Art*
Rice, T. T.
1961, *The Seljuks in Asia Minor*

Riegl, A.
1892, *Orientalische Teppiche*, Vienna
Rieu, C.
1881, *A Catalogue of the Persian Manuscripts in the British Museum*, II
1894, *Supplement to the Catalogue of the Arabic Manuscripts in the British Museum*, London
Riis, P. J., (ed.)
1969, *Hama. Fouilles et recherches 1931–1938, IV, 3. Les petits objets médiévaux sauf des verreries et poteries*, Copenhagen
Ríos, R. A. de los
1873, "Lámpara de Abú-Abdil-Láh Mohámmad III de Granadá", *Museo Español de Antiguidades*, 21, Madrid
1876, "Acetre Arabigo", *Museo Español de Autigüedades*, 7
1877, "Arquetas arabiqas de plata y de marfil", *Museo Español de Antiquidades*, Madrid, 3
1893, "Trofeos militares da la Reconquista", *Estudio acerca de las ensenas musulmanes del Real Monasterio de las Huelgas (Burcos) y de la catedral de Toledo*, Madrid
Robinson, B. W.
1951, "Unpublished paintings from a XVth century 'book of kings'", *Apollo Miscellany*, June
1953, *Persian painting in the Metropolitan museum of art*, New York
1954a, "Origin and date of three famous Shahnameh Illustrations", *Ars Orientalis*, I
1954b, *Bulletin of the John Rylands Library*, 37
1958a, *A Descriptive catalogue of the Persian painting in the Bodleian Library*, Oxford
1958b, "The Teheran Kalila wa Dimna, a reconsideration", *Oriental Art*, N.S.1V, 3
1965, *Persian Drawings*, New York
1967a, "Oriental metalwork in the Gambier-Parry collection", *The Burlington Magazine*, March
1967b, *Persian miniature painting from collection in the British Isles*, London
1972, "Two persian manuscripts in the library of the Marquess of Bute", *Oriental Art*, Spring
1974, *Miniatures Persanes, Donation Pozzi, Cabinet des Estampes – Musée d'art et d'histoire*, Geneva
1975, *Persian Paintings and Manuscripts in Art at Auction: the year at Sotheby Parke Bernet, 1974–5*, London
Robinson, B. V., Gray, B.
1972, *The Persian art of the Book*, Oxford
Rome
1956, *Mostra d'Arte Iranica*, Palazzo Brancaccio
Roy, B. and Poinssot, P.
1950, *Inscriptions arabes de Kairouan*, Tunis
1958, *Les Inscription arabes de Kairouan*, Tunis

Sakisian, A.
1929, *La Miniature Persane du XIIe au XVIIe siècle*, Paris and Bruxelles
1935, "Tissus Royaux Arméniens des Xe, XIe, at XIIIe siècles", *Syrie*
Samarkand
1969, *The Catalogue of the all-union exhibition on the arts of the Timurid period*
Sanghvi, R., Ghirshman, R. and Minorsky, V.
1971, *Persia, the Immortal Kingdom*, London
Sarre, F.
1908, Mobam Ali am Euphrat, ein islamische Bandenkmal des X. Jahuhunderts', *Jahrbuch der Königbeher preussischer Kunstsammlunger*
1923, *Islamic Bookbindings*, Berlin
1925, *Die keramik von Samarra*, Berlin
Sarre, F. and van Berchem, M.
1907, "Das Metallbecken des Atabeks Lulu von Mosul in der Königlichen Bibliothek zu München", *Münchner, Jahrbuch der Bildenden Kunst*, I
Sarre, F. and Herzfeld, E.
1911–20, *Archäologische Reise im Tigris und Euphratgebiet*, Berlin
Sarre, F. and Martin, F. R.
1912, *Die Ausstellung von Meisterwerken muhammedanischer kunst in München 1910*
Sarre, F. and Trenkwald, H.
1926, *Ancient Oriental Carpets*, I, Vienna and Leipzig (translated by A. F. Kendrick)
1929, *Old Oriental Carpets*, II, Vienna (translated by A. F. Kendrick).
Scanlon, G. T.
1966–7, "Fustat Expedition: Preliminary Report 1965", *Journal of the American Research Centre in Egypt*, V
1968, "Fustat and the Islamic art of Egypt", *Archaeology*, XXL/3, June
Scerrato, U.
1966, *Metalli Islamici*, Milan
Schlumberger, D.
1939, "Les fouilles de Qasr el-Heir el-Gharbi (1936–38)", *Syria*, XX
1946–8, "Deux Fresques Umayyades", *Syria*, 25
Schmidt, R.
1912, "Die Hedwigsgläser und verwandte fatimidische Glas – und kristall-schnittarbeiten", *Schlesiens Vorzeit in Bild und Schrift*, N. F., vi
Schmidt, H. J.
1958, *Alte Seidenstoffe*
Schmoranz, G.
1898, *Altorientalische Glas – Gefässe Herausgegeben von K. K. Österreichischen Handelsmuseum*, Vienna (English version, Vienna and London, 1899)
Schmutzler, E.
1933, *Altorientalische Teppiche in Siebenbürgen*, Liepzig
Schnyder, R.
1974, "Medieval Incised and Carved

wares from North West Iran", *The Art of Iran and Anatolia from the 11th to the 13th century, colloquies on Art and Archeology in Asia*, no. 4, University of London
Schultz, S.
1770, *Der Leitungen des Höchsten nach seimen Rath auf den Reisen durch Erupoa, Asia und Africa*, 5 parts
Schulz, P. U.
1914, *Die persisch – islamische Miniaturmalerei. Ein Beitrag zur kunstgeschichte Irans*, Leipzig
Segall, B.
1938, *Museum Benaki. Katalog der Goldschmiede-Arbeiten*, Athens
Shepherd, D. G.
1957, "A dated Hispano – Islamic silk", *Ars Orientalis*, II
1963, "Three textiles from Raiy", *Cleveland Museum of Art Bulletin*, I
1974, "Banquet and Hunt in medieval Islamic iconography", *Gatherings in Honour of Dorothy E. Miner* (Walters Art Gallery, Baltimore)
Shepherd, D. G. and Henning, W. B.
1959, "Zandanéji identified", *Aus der Welt der islamische Kunst, Festscrift für Ernst Kühnel*
Shepherd, D. G. and Vial, G.
1965, "La chasuble de Saint-Sernin", *Bulletin de liaison du Centre International d'Etude des Textiles Anciens*, 21, Lyon
Skelton, R.
1975, "Characteristics of later Turkish Jade Carving", *Proceedings of the Vth International Congress of Turkish Art held in Budapest*
Sotheby
31st January 1961, *Sale Catalogue*
8th December 1970, *Sale Catalogue*
31st July 1971, *Sale Catalogue*
Sourdel-Thomine, J. and Spuler, B.
1973, *Propyläen Kunstgeschichte, Die Kunst des Islam*, Berlin
Soustiel, J.
1973, *Objets d'art de l'Islam*, Paris
Spitsin, A.
1906, "Iz killekcsii Imperatorskago Ermitazha", *Zapiski Russkogo Arkheologicheskogo Obshchestvo*, 8
Spuhler, F.
1976, *Islamic Carpets and Textiles in the Keir Collection* (translated by G. and C. J. Digby)
St. Petersburg
1852, *Catalogue des manuscrits et xylographes orientaux de la bibliothèque Impériale Publique*
Stchoukine, I.
1935, "Les manuscrits illustrés musulmans de la Bibliothèque du Caire", *Gazette des Beaux Arts*, 6, XIII
1950, "les peintures de la Khamseh de Nizami du British Museum", *Syria*, XXVII
1954, *Les peintures des manuscrits Timurides*, Paris

1958, "Les peintures du Shah-Nameh Demotte, *Arts Asiatiques*, V
1959, *les peintures des manuscrits Safavis de 1502 á 1587*, Paris
1964, *Les peintures des manuscrits de Shah Abbas Ier à la fin des Safavis*, Paris
1966, *La peinture turque d'après les manuscrits illustrés. Ier partie de Sulayman Ier à Osman II. 1520–1622*, Paris
Stern, S.
1957, "A New Volume of the illustrated Aghani Manuscript", *Ars Orientalis*, II
Stockholm
1920, *Förtecknig över Greve Kellers samling av orientaliska och europeiska vapen.* Auction catalogue no. 225, Stockholm, ABH. Bukowskis konsthandel
1966, *Christina Queen of Sweden*, exhibition at the Nationalmuseum
Strong, R.
1969, *The English Icon: Elizabethan and Jacobean portaiture*, London and New York
Tehran
no date, *The Iran Bastan Museum Presents its Masterpieces representing 25 centuries of Art during 25 centuries of Empire.*
Terasse, H.
1963, "Sculptures tolédanes provenant du Taller del Moro au Musée Marés de Barcelone", *al-Andalus*, XXVIII
Torres-Balbás, L.
1934, "Basas califales decurades", *al-Andalus.* 2
1951, "Bibliography of Spanish Muslim Art 1939–1946", *Ars Islamica*, 15–16
1958, "Por el Toledo Mudéjar: el Toledo aparente y el oculs", *al-Andalus* XXIII
1965, "Arte Califal", *Historia de España*, Madrid
Townsend, G.
1928, "A Persian Velvet", *Bulletin of the Museum of Fine Arts*, Boston, 28, no. 154
Underhill, G.
1944, "A Shah Tahmasp Velvet", *Cleveland Museum of Art Bulletin*, XXXI
al-Ush, A. F.
1963, "Les bois du mausolée de Khalid Ibn al-Walid à Homs", *Ars Orientalis*, V
Valentiner, W. R.
1949, "A masterpiece of Persian art", *Los Angeles County Museum, Bulletin of the Art Division*, 3, 1
Vegh, J. de and Layer, C.
1925, *Tapis Turks provenant des église et collections de Transylvanie*
Veselovski, N. I.
1910, *A bronze vessel from Herat, dated 559 H. (1163 AD)*, St Petersburg
Venturi, A.
1883, *La R. Galleria Estense di Modena*
Vienna
1892, *Orientalische Teppiche*, K. K. Öst Handelsmuseum

Villanueva-Estengo, J. L.
1803–52, *Viaja litererio à las Iglesias de Espana . . .* 22 vols, Madrid-Valencia
Volov, L.
1966, "The Plaited Kufic on Samanid Epigraphic Pottery", *Ars Orientalis*, VI
Wallis, H.
1891, *Persian Ceramic Art in the Collection of F. Ducane Godman, F.R.S. I The Thirteenth Century Lustre Vases*, London
1894, *Persian Ceramic Art in the Collection of F. Ducane Godman F.R.S. II The Thirteenth Century Lustre Wall-Tiles*, London
Walzer, S.
1969, "A manuscript of the persian Kalila wa Dimna", *Oriental Studies IV*, Oxford
Washington, D.C.
1964–5, *7000 Years of Iranian Art*, circulated by the Smithsonian Institution, National Gallery of Art, Washington, D.C.
1974, exhibition of Mayer Rugs, Textile Museum. Catalogue by L. Mackie with essays by R. Ettinghausen and M. Dimand
Watson, W.
1970, "On T'ang soft glazed pottery", *Pottery and Metalwork in T'ang China, their chronology and external relations, Colloquies on Art and Archaeology'in Asia*, no. 1., University of London
Watson, O.
1975, "The Masjed-i 'Ali Quhrúd: An Architectural and Epigraphical Survey", *Iran*, XIII.
Weibel, A. C.
1952, *Two Thousand Years of Textiles*, New York
Weisweiler, M.
1962, *Der islamische Buchbeinband des Mittelalters nach handschriften aus deutschen, holländischen, und türkischen Bibliotheken*, Wiesbaden
Welch, S. C. Jr.
1971, *Boston Museum Bulletin*, 69
1972a, "Two drawings, a tile, a dish and a pair of scissors", *Islamic art in the Metropolitan Museum of Art*, New York
1972b, *The Shah-nameh of Shah Tahmasp*, New York
Welch, A.
1973–4, *Shah 'Abbas and the Art of Isfahan*, Catalogue of exhibitions held at Asia House Gallery, New York and the Fogg Art Museum, Harvard University, Cambridge
Wellesz, E.
1936, "Eine Handschrift aus der Blütezeit früh timuridischer Kunst" *Wiener Beiträge zur Kultur und Kunstgeschichte Asiens*, 10
1959, "An early Al-Sufi manuscript in the Bodleian Library in Oxford: a study in Islamic Constellation images", *Ars Orientalis*, 3

Whitehouse, D.
1974, "Excavations at Siráf, Sixth Interim Report", *Iran, Journal of the British Institute of Persian Studies*, xii
Wiet, G.
1929, "Lampes et Bouteilles en Verre Emaillé" *Catalogue general du Musée du Caire*, Cairo
1930, *Album du Musée Arabe du Caire*, Cairo
1932, "Objets en cuivre", *Catalogue général du Musée Arabe du Caire*
1933, *L'exposition persane*, Cairo
1945, *Journal d'un bourgeois du Caire*, Paris
1948, *Soieries Persanes*
1958, "Inscriptions mobilières de l'Egypte musulmane", *Journal Asiatique*, CCXLVI
1971, *Catalogue général du Musée de l'art Islamique du Caire, Inscriptions historiques du pierre*
Wilber, D. N.
1955, *The Architecture of Islamic Iran, the Il-Khanid Period*
Wilkinson, J. V. S.
1931, "Fresh light on the Herat painters", *Burlington Magazine*, LVIII
Wilkinson, C. K.
1963, *Iranian Ceramics*, Asia House, New York
1973, *Nishapur Pottery of the Early Islamic Period.* Metropolitan Museum of Art, New York
Wittek, P.
1948, "Notes sur la Tughra Ottomane", *Byzantion*, XVIII
Wullf, H. E.
1966, *The Traditional crafts of Persia*, Cambridge, Massachusetts
Yusuf, A. R.
1962, "*Potters of the Fatimid Period and their Styles*", Cairo, in Arabic
1973, "Etude sur le verre égyptien", *Colloque International sur l'histoire du Caire*, ed. A. Raymond, M. Rogers and M. Wahba, Berlin-Cairo
Zaki, A. R.
1961, "Introduction to the study of Islamic arms and armour", *Gladius*
1966, "Important swords in the museum of Islamic Art in Cairo", *Vaaben-historiske Aarboge*, XIII, Copenhagen
Zbiss, S. M.
1955–60, *Corpus des inscriptions arabes de Tunisie*, Institut National d'archeologie et arts, Tunis
Zettersteen, K. V. and Lamm, C. J.
1948, *Mohammed Asafi: the story of Jamal and Jalal. An illuminated manuscript in the library of Upsala University*
Zoka, Y.
1962, *Honar wa Mardom*

Further Reading

General

Ettinghausen, R., ed
 1972, *Islamic Art in the Metropolitan Museum of Art*, New York
Grabar, O.
 1973, *The Formation of Islamic Art*, New Haven and London
Grube, E.
 1966, *The World of Islam*, New York and London
Kühnel, E.
 1966, *Islamic Art and Architecture*, London (translated by K. Watson)
Monneret de Villard, U.
 1966, *Introduzione all studio del' archeologia islamica*, Rome
Otto-Dorn, K.
 1967, *l'Art de l'Islam*, Paris
Rogers, M.
 1976, *The Spread of Islam*, Oxford
Sourdel-Thomine, J. and Spuler, B.
 1973, *Propyläen Kunstgeschichte. Die Kunst des Islam*, Berlin
Wulff, H.
 1966, *The Traditional Crafts of Persia*, Cambridge, Massachusetts

Textiles

von Bode, W. and Kühnel, E.
 1970, *Antique rugs from the Near East*, London
Erdmann, K.
 1970, *Seven Hundred Years of Oriental Carpets*, London (translated by M. Beattie and Herzog)
Islamic carpets from the collection of Joseph V. McMullan, 1972, catalogue of the Arts Council exhibition at the Hayward Gallery, London
Öz, T.
 1950, *Turkish textiles and velvets, 14th to 16th centuries*, Ankara
Reath, N. A. and Sachs, E. B.
 1937, *Persian Textiles*, Oxford

Glass

Lamm, C. J.
 1930, *Mittelerlich Gläser und Steinschnittarbeiten aus dem Nahen Osten*, Berlin

Masterpieces of Glass
 1968, British Museum, London

Ivory

Beckwith, J.
 1960, *Caskets from Cordoba*, London
Kühnel, E.
 1971, *Die islamischen Elfenbeinskulpturen VII–XIII Jh.*, Berlin

Metalwork

Barrett, D.
 1949, *Islamic metalwork in the British Museum*, London
Fehervari, G.
 1976, *Islamic Metalwork of the Eighth to the Fifteenth Century in the Keir Collection*, London
Melikian-Chirvani, M. S.
 1973, *Le Bronze iranien*, Musée des Arts Decoratifs, Paris

Ceramics

Carswell, J.
 1972, *Kutahya Tiles and Pottery from the Armenian Cathedral of St. James, Jerusalem*, Oxford
Grube, E.
 1976, *Islamic Pottery of the Eighth to the Fifteenth Century in the Keir Collection*, London
Lane, A.
 1947, *Early Islamic Pottery*, London
 1957, *Later Islamic Pottery*, London

Arts of the book

Arnold, T. W.
 1965, *Painting in Islam*, New York
Arnold, T. W. and Grohmann, A.
 1929, *The Islamic Book*, Munich
Ettinghausen, R.
 1962, *Arab Painting*, Geneva
Gray, B.
 1961, *Persian Painting*, Geneva
Robinson, B. W. editor
 1976, *Islamic Painting and the Arts of the Book*, London
Robinson, B. V. and Gray, B.
 1972, *The Persian Art of the Book*, Oxford

Photographic Credits

All photographs supplied by lenders except as below:

Direction de l'Architecture Archives Photographiques, Paris. 8, 11–12, 112
William Bandieri, Modena. 191, 212
René Basset, Lyon. 13
Beedle and Cooper, Northampton. 55
Bildarchiv der Stiftung Preussischer Kulturbesitz, Berlin. 124, 151, 157, 214, 249, 258, 270–1, 280, 286, 340, 343, 371, 414, 423
J. E. Bulloz, Paris. 206
John Carswell, Beirut. 301, 663
A. C. Cooper, Ltd., London. 26, 32, 49, 70, 95, 101, 111, 132, 312–3, 325, 334, 347, 356, 361, 376, 378–82, 384, 393, 401–5, 409, 411, 413, 415–6, 419, 490, 546, 632
Maurice Chuzeville, Hauts-de-Seine, France. 4, 154, 198, 215, 264, 326, 329, 333, 349, 370, 372, 407, 535, 609
Studio Dulière, Brussels. 520, 521
Sophie Ebeid, Cairo. 105, 107, 130, 135, 138–141, 152, 155, 167, 169–71, 200, 218–27, 230, 237, 243–4, 267, 269, 272–3, 275–7, 317–8, 320, 430, 434–7, 442–4, 446, 450, 455, 478–9, 482, 528, 536–7
Zs D. Erdökürti, Budapest. 41, 52
Atelier Frankenstein, Vienna. 35, 98
Gemeentelijke Dienst voor Schone Kunsten Stadhouderstaan, Holland. 137, 406
Girardon, Paris. 13
Basil Gray, Berkshire. 428, 461, 568, 587, 596
Cecilia Gray, London. 253, 283, 304, 307, 325, 365

Robert Harding Associates, London. 120, 184, 207, 239–42, 248, 250–1, 256–7, 278, 302, 314–5, 346, 429, 432, 438, 448, 451–4, 467–8, 471, 475, 499, 504, 515, 516, 518, 528, 540, 554, 558, 574, 662
R. Lalance, Meudon la Forêt, France. 316, 410
Westdeutsche Landesbank, Berlin. 335
Martin Lings, Westerham. 504
Ampliaciones y Reproducciones Mas, Barcelona. 110, 145, 150, 164, 172, 174–6, 422, 483, 485–9.
Roland Michaud, Paris. 125, 156, 284, 287, 292, 397, 515–6
Ann Munchow, Aachen. 362
Central Lettering Records, Central School of Art and Design, London. 461, 661
B. W. Robinson, London. 621, 638
Marge Tan, London. 42, 68, 80, 82, 186, 427, 455, 489, 532, 541, 555, 557, 565, 587, 599
Richard Wagner, Budapest. 38, 50, 51
R. Wilsher, Chesterfield. 43
Ralph Pinder-Wilson, London. 119
Service Photographique de la Réunion des Musées Nationaux, Paris. 106, 108, 311
Landesbildstelle Rheinland, Düsseldorf. 259, 285, 357
Victoria and Albert Museum, London. 75, 115
Derek Whitty, London. 177, 260, 439, 440, 481, 502–3, 505–7
Fotograf Ole Woldbye, Copenhagen. 127, 129, 265–6, 299, 300, 308

Addenda and Corrigenda

642 Silk cloth with flowers in an ogival lattice

Length 122cm, width 66cm
Benaki Museum, Athens, no. 3894
Turkey, Ottoman period,
16th century

A large number of Turkish silks and velvets, as well as contemporary Italian stuffs, are based on this type of lattice with ogival compartments. On this silk the compartments, on a red background, frame a serrated leaf-shape containing a symmetrical stylised bouquet of tulips and carnations. The weave is lampas, with satin ground and weft faced twill pattern. The warp is silk, the weft silk with brocaded gilt thread.

Published: Ballian (1974, pl. 11)

642

643 Silk cloth with palmettes, flowers and leafy stems

Length 138cm, width 67cm
Benaki Museum, Athens, no. 3897
Turkey, Ottoman period,
16th century

The freely drawn flowers and foliage of this fine silk, in gold and silver on a red ground, are reminiscent of two superb silk robes in the Topkapi Palace Museum, Istanbul, which are associated with Bayczid II (1481–1512), but are in the style of the later 16th century. The weave is lampas with a satin ground. The warp is silk; the weft is silk with brocaded silver and gilt metal thread.

Published: Öz (1951, pl. CXIX, p. 205); Ballian (1974, pl. 9)

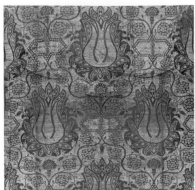

646 detail

644 Silk kaftan with pomegranates enclosing flowers
Length 130cm
Benaki Museum, Athens, no. 3900
Turkey, Ottoman period,
16th century

Kaftans are extremely simple in cut; their beauty resides in their sumptuous material. This example is of red silk with undulating stems and large pomegranates in gold, white and blue. The sleeves have been supplied from another, inferior silk. The weave is lampas with satin ground.

Published: Öz (1951, pl. CXVIII, p. 197)

645 Velvet saddle-cover with tulips and carnations
Length 187cm
Benaki Museum, Athens, no. 3784
Turkey, Ottoman period,
16th–17th century

This is a rare instance of an object with a complex outline woven to shape in two sections and assembled for sale, but evidently never used. The boldly stylised tulips, carnations and other plant forms are arranged in an ingenious way to fill the awkwardly shaped field. The pattern is in silver and gilt thread on a background of red velvet pile.

Published: Öz (1951, pl. XCIII, p. 151); Ballian (1974, pl. 14)

646 Silk cloth with large tulips in a lattice of undulating stems
Length 229cm, width 66cm
Benaki Museum, Athens, no. 3889
Turkey, Ottoman period,
17th century

The large ornate tulips and the wide expanse of gold thread in this cloth are characteristic of 17th-century Turkish taste. The excellent state of preservation of this piece is quite exceptional. The weave is lampas with a satin ground. The warp is silk, the weft silk and gilt thread.

Published: Rice (1965, p. 202)

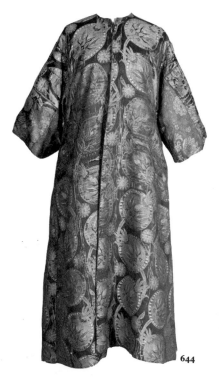

644

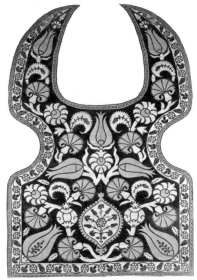

645

647

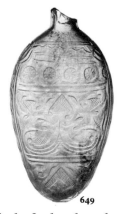

649

647 Velvet cushion cover with pattern of reciprocal cresting
Length 229cm, width 66cm
Benaki Museum, Athens, no. 3786
Turkey, Ottoman period,
16th century

The striking pattern of the main field, repeated in the border, is sometimes known as reciprocal cresting; it is based on the architectural cresting of walls. The red velvet pile forms the outlines of the pattern; the remainder of the surface is covered with silver and gilt thread.

Published: Öz (1951, pl. LXXXII, p. 116); Ballian (1947, pl. 13)

648 Plaque of bone
Length 15cm, width 7cm,
thickness 2.4cm
Benaki Museum, Athens, no. 10411
Egypt or Syria, Umayyad period,
first half 8th century

Possibly a decorative plaque from a piece of furniture with birds and hare among a vine scroll. The rendering, related to that from the facade of the Umayyad palace of Mshatta, is in the Greco-Roman tradition and is a notable example of the Umayyad decorative style.

Published: Migeon (1927, i, p. 338, fig. 146); Kühnel (1971, p. 26, no. 5, taf. II)

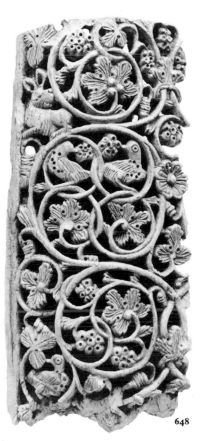

648

649 Flask of colourless glass with brownish tinge
Height 17.2cm
Benaki Museum, Athens, no. 3338
Egypt, 12th century

Carved in relief with a hare on one side and an upright leaf with voluted half-palmettes at base on the other. The cutting is bevelled.

Published: Clairmont (1964, p. 134, no. 8)

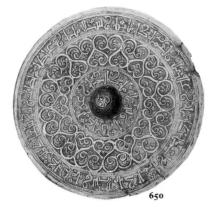

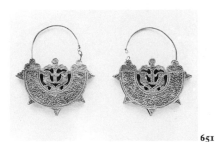

650

651

650 Mirror of bronze with silver plate decorated in repoussé and chased
Diameter 18cm
Benaki Museum, Athens, no. 13770
Egypt, Fatimid period, late 12th or early 13th century

Inner inscription
wa baraka tāmma wa salāma dā'ima wa 'āfiya
'blessing entire, well-being perpetual, health.'
Outer inscription
wa salāma la wa ghibṭā [sic] wa sa 'āda baraka tāmma wa salāma dā'ima [?] wa ni'ma dā'ima wa 'āfiya wa ni'ma dā'ima
'well-being, felicity, [?], happiness, blessing entire, perpetual [?] well-being, perpetual favour, health and perpetual favour.'
The history of Fatamid metalwork is extremely obscure at present and many known bronze objects from this period are still unstudied. The palmettes and stems on this mirror have a somewhat eastern Islamic flavour, but the style of the kufic inscription, with its closest parallel in an inscription dated to 972 in the mosque of al-Azhar, Cairo, and the 'comma' border, a decorative feature known in other Fatimid bronze pieces, indicate its Egyptian provenance. Technically the mirror is unparalleled; other Islamic mirrors are probably composed of bronze layers of different qualities to produce a good reflecting surface, but no other known example has a silver back.

Published: Grohmann (1967, I, pl. xix)

651 Pair of earrings of gold, sheet metal with filigree and granulation
Height 4.4cm
Benaki Museum, Athens, no. 1863
Egypt or Syria, Fatimid period, 10th–12th century

This earring shows a style of crescent which seems to have been popular during the Fatimid period. It was found at Fustat and other pieces are known. Here the crescent is wide but flat, and its two points curve towards each other to the extent that they sometimes almost meet. These examples are extremely fine, and the alternation of filigree and granulation was probably designed to display the skill of the jeweller.

Published: Segall (1938, no. 286, pl. 56)

652 Pair of earrings of gold, sheet metal with filigree and granulation
Height 5.5cm
Benaki Museum, Athens, no. 1862
Spain, Nasrid period, 14th century

Inscription
bism Allāh al-raḥmān al-raḥim wa ṣalā Allāh 'alā Muḥammad
'In the name of God, the compassionate, the merciful, may God bless Muḥammad.'

Published: Segall (1938, no. 285, pl. 57)

Unpublished

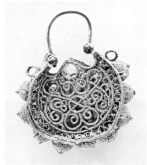

652

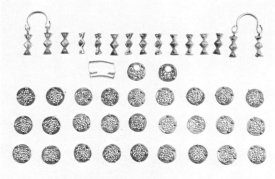

653

656

653 Set of belt fittings of bronze, gilded with silver rivets

Diameter of discs 3cm and smaller
Benaki Museum, Athens, no. 1900–44
Syria, Ayyubid or early Mamluk period, 13th century

One other set of belt fittings of this form is known, that bearing the name of the nephew of Salāḥ al-Dīn (Saladin), al-Malik al-Ṣāliḥ Ismāʿīl (died 1266); see Mayer (1952, pl. IX). The origin of the style is uncertain but it is quite different from the belt form common in Persia from the 6th century and widespread over nomadic Central Asia and eastern Europe. The Ayyubid style is known to have continued to be popular under the Mamluks. The Mamluk historian al-Maqrīzī gives a description of the robes of honour given by sultans to amirs and mentions such objects; the most distinguished belts had between the uprights a central roundel and two side ones set with rubies, emeralds and pearls, the next had one roundel only set with stones, the lowest had but one roundel without any stones. Mayer (1952, p. 58). In this example the twin suspension loops are to hold the normal twin-mounted sword. The buckle has lost its tongue and the purpose of the two roundels with off-centre open discs is not clear.

Published: Segall (1938, no. 323, pl. 53)

654 Ring of gold with granulation and filigree

Height 2.6cm
Benaki Museum, Athens, no. 1888
Persia, 13th century

Published: Segall (1938, no. 311, pl. 60)

654

655 Ring of gold with turquoise-coloured enamel

Diameter 2.1cm
Benaki Museum, Athens, no. 1886
Syria, 10th–11th century

Inscribed *al-ʿabd Idrīs*, 'the slave Idrīs'.

Published: Segall (1938, no. 309, pl. 59)

655

656 Jar decorated in lustre

Diameter 5.7cm
Benaki Museum, Athens, no. 1168
Persia, 12th century

A deep red or ruby lustre was used in conjunction with a gold lustre to give the righest colour scheme used by the lustre potters. The rugby pigment is, however, rather unstable owing to its high copper content, and often spreads a red haze over the surrounding area. It was perhaps for this reason that its use was never extensive and was abandoned altogether during the second half of the 9th century. The shape of this little jar is most unusual for lustre ware of this period.

Unpublished

657

657 Bowl decorated in lustre on opaque white glaze
Diameter 22cm
Benaki Museum, Athens, no. 1157
Egypt, Fatimid period, late 9th–
early 10th century

At some time in the 10th century
lustre wares ceased to be produced in
Mesopotamia. It has been argued
that Egypt produced wares in the
Mesopotamian style from the
beginning of that century, but such
pieces are difficult to distinguish
from imports. This bowl illustrates
the distinctive Egyptian lustre ware
that developed at the end of the
century though the interlocking
motifs and hares still retain a
Mesopotamian character. For the
significance of rabbits and hares in
Fatimid art, see Dodd (1974).

Published: Jenkins (1968)

658 Bowl decorated in lustre on an opaque white glaze
Diameter 38.5cm
Benaki Museum, Athens, no. 11121
Egypt, Fatimid period, 11th–12th
century

Many of the Egyptian lustre vessels
depict scenes in a surprisingly
naturalistic fashion. For their
stylistic characteristic see Jones
(1975, pp. 4–5). This fragment
depicts a musician, probably female,
with a lute. To be noticed are the
various shapes of metal ewers that
surround the figure, one with a round
body holding a large flower seems to
rest on a metal stand. Other lustre
vessels painted in a similar style
show various aspects of the 'courtly
life'.

Unpublished

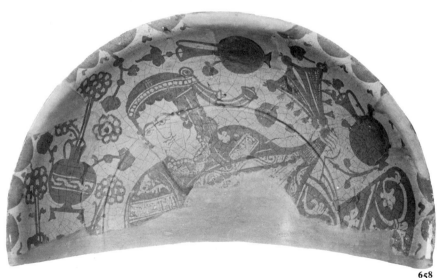

658

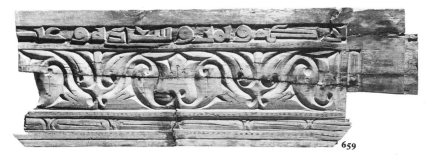

659

659 Carved panel originally attached to beam
Length 73cm, height 24cm
Benaki Museum, Athens, no. 9142
Egypt, Fatimid period, 10th–11th century

The upper-frieze reads
bakara wa-yumn wa-saʿāda wa-ghibṭ [a] [li-ṣāḥibihi]
'blessing, good fortune, happiness and felicity [to its owner].'
The kufic lettering is cramped as compared to that on no. 435 which bears a shorter version of the same motto. Emphasis on the rounded heads of some letters draws attention to the upper register.

Unpublished

660 Pair of carved doors
Height 225cm, width (of each) 123cm
Benaki Museum, Athens, no. 9121
Mesopotamia (Takrit), Abbasid period, 8th–9th century

These doors may well pre-date the foundation of the city of Samarra though they display all the characteristics of the first Samarran style.

Published: Damascus (1969, p. 209, fig. 117)

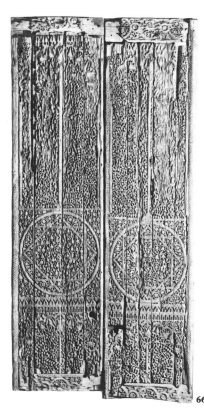

660

661 Carved wooden panel
Archaeological Museum, Province of Toledo
Spain, Almohad period, 12th century

Unpublished

662 Koran with lacquer binding
Height 35cm, width 22cm
Imam Riza Shrine Library, Mashhad, no. 228
Persia, Safavid period, 1687

This Koran consists of 339 folios in Naskhi script, 4 lines per page. The artist is given as Muḥammad Riẓā Shīrāzī. The binding is painted with three flowers.

Unpublished

663 Collection of gold jewellery
National Museum, Beirut
Syria, Ayyubid, Mamluk and Ottoman periods, 12th–19th centuries

Unpublished

664 Double-page from a Muraqqa', Album
Height 22.4cm, width 16.3cm
State Library, Leningrad, Dorn 489
Central Asia (Bukhara), Shaybanid period, early 16th century

These miniatures (folios 26b, 27a) represent a scene of a madrasa in a garden. Galerkina attributes them to about 1484 and considers them to be a single composition. Akimushkin and Ivanov prefer a date in the early 16th century. However, all these authorities attribute the miniatures to the Herat school. Martin also believed that they were the product of the Herat school and ascribed them to Bihzād in about 1500. Galerkina endorses this attribution and connects the miniature of a seated youth writing (folio 27a) with the famous 'Portrait of a Painter', now in the Freer Gallery of Art, Washington. There does, indeed, seem to be some connexion here, for though the pose is not identical the unusual kaftan shape is similar. There are correspondences in pose with other figures among the paintings of Bihzād but not close enough to be a compelling indication of a unique relationship. In any case, such relationships are also to be seen in the manuscripts from Bukhara through the first half of the 16th century. It is of great interest to place this album beside the best attested work of the master Bihzād himself.

Published: Martin (1912, pl. 180); Akimushkin and Ivanov (1968, pl. 25); Galerkina (1970, pl. II)

665 Dīwān by Amīr Khusraw Dihlawī
State Library, Leningrad, PNS 104
Mesopotamia (Baghdad), Turkman period, 1465

This is an illuminated manuscript with no miniatures copied for Pīr Budāq the Qara-Qoyūnlū in 1465 by Maḥmud Pīr Budaqi.

Unpublished

666 Gū-wa-Chawgān, 'The Ball and Polostick', by 'Arfī
Height 22.4cm, width 11.8cm
State Library, Leningrad, PNS 106
Khurasan (Herat), 16th century

This manuscript was copied by Mīr 'Alī al-Katin as-Sulṭānī probably in Bukhara about 1540–5. There are three miniatures.

Published: Akimushkin and Ivanov (1968, pls. 53–4, 56)

667 Bustān by Sa'dī
Height 19cm, width 12.5cm
State Library, Leningrad, PNS 269
Central Asia (Bukhara), 1575

This manuscript was copied by Mīr Ḥusayn al-Ḥusaynī al-Mashhur b. Mīr Qulangi.

Published: Dyakonov (1964, pls. 21–3)

668 Mosque lamp of gilded and enamelled glass
Height 35·6cm
Godman Collection, England
Syria, Mamluk period, first half 14th century

The lamp has six handles and is raised on a high foot. Inscribed in blue around the neck on a ground of white scrollwork is the word *al-ālam*, 'the wise', repeated and interrupted by medallions. Each of these medallions contains a lotus on a blue ground encircled by a band of scrolls with four escutcheons. Below this band another frieze is painted on the inside of the glass. The shoulder has a frieze of roundels each containing foliation. The main register has floral scrolls on a blue ground. On the underside of the main body and on the foot are roundels and cartouches containing floral ornament.

Published: Godman (1901, p. 72, no. 19, pl. LXXII); Lamm (1930, I, p. 467, no. 169 and II, pl. 194:5)

669 Mosque lamp of gilded and enamelled glass
Height 35.2cm
Fitzwilliam Museum, Cambridge, no. C.4 – 1949
Egypt, Mamluk period, about 1350

The lamp has six loop handles. On the neck is an inscription from the Koran, Sura XXIV, 35; on the body an inscription is dedicated to Sayf al-'Din Shaykhu'l-'Umari, a prominent Mamluk amir who died in 1357.

Published: Winter, C., 1958, *The Fitzwilliam Museum. An Illustrated Survey*, London, p. 103, pl. 24

The following are not exhibited
Textiles
8, 57, 68, 75, 81–2
Glass
138–141
Metalwork
197
Ceramics
427
Wood
445
Arts of the Book
509, 513, 518, 526, 568, 617, 619, 632, 638

Additional information
480 Published: Skik, K., ed., 1974, *Musée du Bardo, Département Musulman*, p. 25, no. A58, fig. 19